1979

Italian Painting

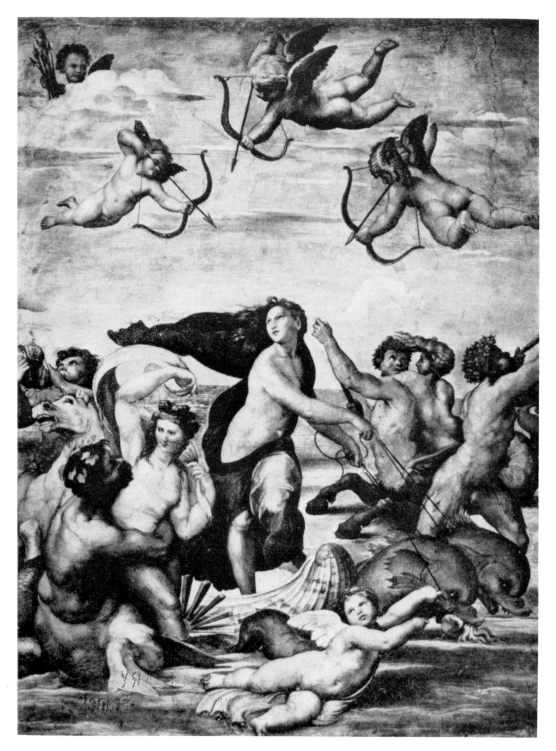

RAPHAEL: Galatea (1514). One of the frescoes in the Villa Farnesina, Rome (Anderson)

Italian Painting

1200-1600

~~~~~~~~~~~~~~~~~~~~~~~~~~~~~~~~~~~~~~~~~~~~~~~~~~

Ernest T. DeWald

HACKER ART BOOKS
NEW YORK, N.Y. 1978

International Standard Book Number 0-87817-219-X.

To the memory of
*ALBERT MATHIAS FRIEND, Jr.*
*to whose fertile mind*
*this volume is much in debt*

# Foreword

~~~~~~~~~~~~~~~~~~~~~~~~~~~~~~~~~~~~~~~~~~~~~~~~~~~~~~~~~~~~~~~~~~~~~~~~~~~~~~~~~~~~~

DURING WORLD WAR II a dedicated group of experts and myself had been commissioned to safeguard and salvage much of the art of Italy exposed to the rigors and misfortunes of war. The enthusiasm I had always felt for Italian painting from visits to museums and collections at home and abroad was heightened immeasurably by this close association with the displaced paintings, and on returning to academic activities I believe I was able to communicate some of this enthusiasm in the lecture hall and in museum work. I felt, however, the necessity of refocusing attention more widely on the great achievements of Italian painters in such a way that the student beginner and the amateur could both understand these paintings better in the light of the times in which they were produced and enjoy them for their intrinsic beauty and power of communication.

This book treats the development of Italian painting from 1200 to 1600, since during this period there occurred the prelude to the Renaissance, the Renaissance itself, and the reactions against High Renaissance ideals. In other words, we witness in the paintings the development of a significant period of human culture as an organic unit with a beginning, a middle, and an end.

Although there are many links connecting it with the more immediate past, the Baroque period of the seventeenth century has its own characteristics as a new movement, rising as it does from the ashes of the Renaissance. It is a period, however, that, together with the Rococo of the eighteenth century, merits treatment in a separate publication worthy of its importance and achievements.

In the first chapter attention is centered on questions of style without the knowledge of which the beginner would find himself unnecessarily hampered in his judgment, understanding, and enjoyment of the paintings produced in the thirteenth and fourteenth centuries. In the chapters that follow, special attention has been given to the discussion of thirteenth-century painting which is apt to be by-passed or curtailed in general books on Italian painting; yet, the knowledge of it is essential in order to obtain a correct picture of the development of painting in Italy.

It is obvious that in a book for beginners problems of attribution—the

concern of professional art historians—cannot be discussed, but in some important instances such problems are presented or outlined. Many of the minor painters or schools also have no place here. Information about them can be found in publications cited in the various bibliographical lists.

Since this book is primarily for English-speaking students and readers, the bibliographies have been restricted to important books and articles written in, or translated into, English. Exceptions are made in cases where knowledge of a sourcebook written in another language is essential. Exceptions are also made for publications that consist primarily of plates in color or in black and white, useful for consultation and illustration.

I warmly acknowledge indebtedness to my colleagues Professor George Rowley, Dr. Gertrude Coor, and Dr. George P. Mras for helpful suggestions, discussions, and ideas in the preparation of this volume. I am also much indebted to Miss K. Higuchi and her efficient staff in the Slides and Photograph Section of the Department of Art and Archaeology of Princeton University for their generous cooperation.

<div align="right">E. T. DeW.</div>

Princeton, N. J.
January 14, 1961

Contents

PART I

The Thirteenth Century

Introduction to Italian Painting

AT the end of the twelfth and throughout the thirteenth century, in Tuscany and in adjacent regions of Italy, an increased demand for painting stimulated an increased production. In earlier medieval times, painting, such as manuscript illuminations, icons, and frescoes, had in the main been fostered and developed in the scriptoria,* the workshops, and the cloisters of monasteries as useful for religious purposes. The artist-painters almost always were monks or lay brothers and generally were anonymous. In the late twelfth and early thirteenth centuries, however, painters more commonly were laymen working in their own shops and were members of a civic guild, their names appearing in the membership lists of the guild, in contracts, and in other civic documents.

Without question, one reason for the increased demand for painting and for the development of painting as a secular craft in Tuscany, Lombardy, and nearby areas was the growth and the power of the city-states that arose out of the adverse economic and political conditions. After the collapse of the West Roman Empire, Italy was torn apart and kept in a state of virtual anarchy by the successive barbarian invasions from the north and by the incursions of the Byzantines and the Saracens from the eastern Mediterranean. Rome, once the center of an empire, had become the city of the popes and played an important role in the development of medieval Italy. By the end of the eleventh century three spheres of influence had been es-

* The scriptoria in a monastery were those restricted areas in which manuscripts were written, copied, and illumined.

tablished in the peninsula: the imperial territory controlled by the German emperors as part of the Holy Roman Empire; the papal territory north and south of Rome plus the cities of Ravenna and Rimini on the Adriatic coast; and the Regno, or Kingdom, of Southern Italy and Sicily, so called after the conquest of these regions by the Normans in the latter half of the eleventh century.

In the imperial territory to the north, differences of opinion on matters of Church and imperial policy frequently produced open conflicts between popes and emperors. In order to be assured at such times of a certain amount of personal and economic security against the depredations of roving bands of soldiers, the inhabitants of these regions flocked to the fortified cities. These eventually grew into city-states and republics that on several occasions formed leagues against the emperor. In 1176, for example, the Lombard League handed Frederick Barbarossa a galling defeat. A league of Tuscan cities against Barbarossa's grandson Frederick II was less successful. Frustrated, the cities formed leagues against each other in an attempt to seize the power in Tuscany. In succession, the predominating position in Tuscany was held by Lucca, Pisa, Florence, Siena, and then again by Florence.

As these cities grew in power and wealth their rivalries were not only political but also cultural. Each vied with the others in the production of architecture, sculpture, and painting. Individual artists were acclaimed and used as good propaganda in the cultural rivalries. Artists' signatures on their paintings frequently included the name of the city in which they were active, such as "Guido da Siena." All this was the initial phase of that revival in art and culture that reached its crowning point in the periods of the High Renaissance and the Baroque in the sixteenth and seventeenth centuries, in which the cities of Rome, Venice, Bologna, and Naples also participated.

Another reason for the increased demand for painting was the spread of the two newly founded religious orders, the Franciscan and the Dominican. The Dominican rule was confirmed in 1216; the Franciscan in 1223. Both injected new life into the medieval Church. St. Francis, born at Assisi in Umbria, went about preaching the importance of living the simple life, with Charity and Poverty as companion virtues. Known as God's troubadour, St. Francis "sang" of the beauties of God in Nature, retold Biblical stories in terms of the most simple human experiences, and ministered to the poor, the sick, and the outcast. St. Dominic, a Spanish monk, active both in France and Italy, built up a militant preaching order to combat heresy. Its members were to take their inspiration from the proselyting fervor of the early apostles of Christ and were highly trained in church doctrine and law. The intellectual giant of the Middle Ages, St. Thomas Aquinas, was a Dominican.

Each of these orders grew rapidly after the death of its founder; each tried to outdo the other in zealous activity that manifested itself visually in rival building programs. During the latter half of the thirteenth century and during the fourteenth, Franciscan and Dominican monasteries and churches

sprang up throughout central and northern Italy. Almost every city had its Franciscan *and* its Dominican church, one competing with the other in size and in splendor of decoration. For example, in Florence the most important churches after the cathedral were the Franciscan church of Santa Croce and the Dominican church of Santa Maria Novella, built at opposite ends of the city.

What is important here is that, in contrast to the earlier Benedictine and Cistercian orders, the Franciscans and the Dominicans built their monasteries and churches in cities, the churches, like the Gothic cathedrals in France, becoming parts of the civic unit. Hence the rivalries in church-building not only between the cities but also between the religious orders brought with them many demands for painting as decoration for these new buildings. Obviously religious subject matter predominated in the paintings. Secular themes were to be found in the wall decorations of castles, private palaces, and town halls, but the demand for them was limited.

Fresco Painting and Panel Painting

The painted decoration in churches falls into two categories: fresco painting and panel painting.* Fresco painting appears as decoration of the interior walls of a church, such as the walls of the nave, the side aisles, the transepts, the choir and sanctuary, and the chapels. The walls of an adjoining cloister were also frescoed. On the exterior of the church, the façade and the narthex or porch could receive frescoed decoration. Since the subject matter was taken from Biblical sources or from the legends of saints, the purpose of the frescoes was didactic as well as decorative.

Panel paintings, as the words imply, were painted on wooden panels and were portable. The subject matter consisted essentially of representations of Christ on the cross, of the Madonna and Child, and of the individual figures of saints. Whether large or small, panel paintings were essentially objects of devotion to be placed on altars. On occasion, large crucifixes and panels of the Madonna or of some saint were suspended from the rafters above the sanctuary or were attached to the upper molding of an iconostasis (choir screen). They were also carried in processions.

The panel paintings placed on altars—that is, the altarpieces—varied in type and shape.† The earliest type, and one rarely found after the thirteenth century, is the ancona, or dossal. It is a simple rectangle in shape with either a horizontal or vertical axis. The figure of the Madonna or of some saint occupies the central position on it and is flanked by a series of small painted rectangles in which episodes from the life of the central figure are represented. The panels with vertical axis at times terminate at the top with a triangle or gable or with a semicircle. The semicircular termination is pro-

* Panel painting and fresco painting are described more fully in the Appendix. Other terms are explained in the Glossary.
† Crucifixes are in a special category and will be described in the next chapter.

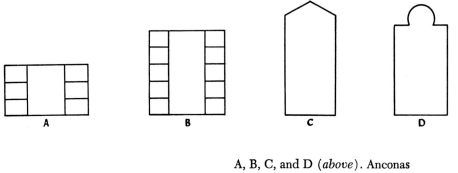

A, B, C, and D (*above*). Anconas

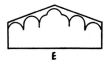

E (*left*). Dossal

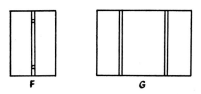

F (*above*). Diptych
G, H, and I (*above*). Byzantine-derived triptychs

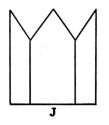

J (*left*). Gothic triptych

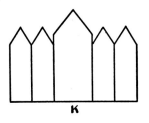

K (*left*). Polyptych

L (*right*). Developed
altarpiece with predella

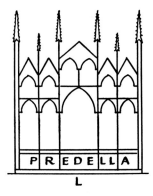

duced by the projection of a part of the halo of the central figure. A polygonal dossal also makes its appearance toward the end of the thirteenth century. Its decoration consists of a series of half-length figures set under an arcade of semicircular, trefoiled, or pointed arches. Christ or the Virgin occupies the center arch; two or three saints, to right and left, flank the central figure.*

Toward the end of the thirteenth century also, hinged types of portable altarpieces, large and small, became popular. According to the number of sections in their construction, they are known as diptychs, triptychs, or polyptychs. The diptych consists of two rectangular panels of equal size closing in on each other like the covers of a book. The triptych has a central panel twice the width of the two side panels that are hinged to the central panel and, when closed, fit over it like shutters. Ivory triptychs imported from Byzantium and from Gothic France were the models determining the shapes of the wooden Italian triptychs of this period. If based on a Byzantine model, the termination at the top of the central panel would be either rectangular or semicircular. At times a combination was achieved by recessing a semicircle beneath the rectangular top; in that case the side panels were made to fit the semicircle. If the model was Gothic, the central panel terminated in a triangular gable, characteristic of Gothic architecture. The polyptych, because of its multiple parts, was as a rule rigid, not hinged.

At the beginning of the fourteenth century, the great Sienese painter Duccio created a kind of superaltarpiece. It was of monumental size and was architecturally constructed with a base, middle, and top. The base, known henceforth as the predella, contained a band of narrative scenes; the middle or main part consisted of the representation of the Madonna with her entourage of saints and angels; and the top was covered with Gothic pinnacles. In the late fourteenth and in the first half of the fifteenth centuries this type of altarpiece developed often into an elaborate architectural extravaganza, at times resembling a miniature cross-section of a five-aisled Gothic cathedral with its flamboyant decoration on the exterior.

The Background of Styles

No style of art suddenly appears fully developed, like Athena springing from the head of Zeus. There are always antecedents and contributory elements, the past and the contemporary. Style, like time, is an "ever-rolling stream." Therefore before taking up the study of painting in Italy from about 1200 to 1600, we should familiarize ourselves somewhat with the major stylistic currents in European art that contributed to the formation of the painting styles in central Italy and Tuscany around the year 1200. Otherwise a plunge back to that time might well leave us confused and lacking in understanding.

* Similar dossals appear among the icons in the monastery of St. Catherine on Mt. Sinai in the Red Sea peninsula.

We choose as the point of departure for our study the period around 1200 not because there had been no painting in Italy before that time but because certain events in the political and religious life of medieval Italy about 1200 provided the impetus for a renewed activity in the arts of architecture, sculpture, and painting in Tuscany and central Italy. This activity was to reach its climax in the High Renaissance of the sixteenth century.

There are four European styles with which we should have some acquaintance as we begin our study. The oldest of these is the Classic style, the product of the ancient cultures of Greece and Rome. It is the ancestor of most later styles produced in Europe no matter how changed they may have become from the original. Its roots never died, but furnished the impetus for many subsequent Classical revivals, one of which we shall encounter in fifteenth-century Italy. The three other styles present in medieval Europe at the time we begin our survey of Italian painting were the Byzantine, the style of eastern Europe, and the Romanesque and the Gothic, the styles of the west.

The Classic Style

Classic representational art was primarily concerned with the human figure as a physical material entity. This figure, however, was subjected to a certain proportional relationship of parts to produce an ideal of physical beauty. This was best achieved in sculpture and in the representations of the nude male [1.1] and the traditionally draped female forms, the nude female figure appearing in later Greek and in Roman art. The Greek passion for the beauty of form was such that the drapery, when used, was represented as diaphanous or as if wet and clinging to the form [1.3]. This use of drapery to express the form beneath is called *functional drapery*.

In relief sculpture too, in order to have these ideal figures predominate, the composition was kept very simple and there was no indication of environment, the backgrounds being neutral or tinted with a plain color. A prime example of this type of relief is the famous Orpheus, Eurydice, and Hermes in the National Museum in Naples [1.2]. Like two parts of a parenthesis, the end figures of Orpheus and Hermes turn to enclose and emphasize the beautiful figure of Eurydice.

The major elements of the Classic style, then, are natural, ideal human forms as the main elements of a composition, functional drapery, neutral backgrounds, and simple, balanced compositions.

(*Opposite*) 1.1 (*top left*). GREEK: Idolino (4th cen. B.C.). Bronze. Museo Archeologico, Florence (Alinari)

1.2 (*top right*). GREEK STYLE: Hermes, Orpheus, and Eurydice (Roman copy). Marble. Museo Nazionale, Naples (Alinari)

1.3 (*bottom*). GREEK: The Three Fates (5th cen. B.C.). Marble. British Museum, London (Hirmer Verlag, Munich)

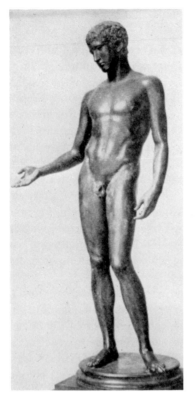

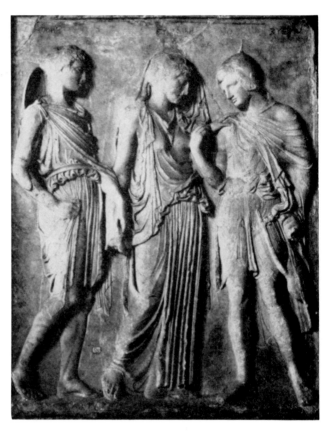

The Byzantine Style

In the fourth century A.D. the emperor Constantine the Great had transferred his capital from Rome to the city of Byzantium on the Bosporus, later to be known as Constantinople. There grew up in consequence in the eastern Mediterranean an empire known as the East Roman or Byzantine Empire to distinguish it from the slowly disintegrating West Roman Empire. Because of its geographic position this Byzantine Empire absorbed many ideas and elements of culture, government, and art that were Near Eastern as well as Roman. In contrast to the western empire, it grew in power and influence until it dominated not only the eastern Mediterranean but also reached out in the west to Italy, Sicily, and even Spain. Its vitality was finally broken by the Turks after the capture of Constantinople in 1453. During this period of over a thousand years a succession of great dynastic families built up a culture rivaling that of ancient Persia in learning and splendor and established a powerful theocracy in which the emperor and the orthodox Christian Church played the leading roles.

The art produced in the capital city and in the great monasteries of Byzantium mirrors this linking of the dogmatism of the Orthodox Eastern Church with the magnificence of the autocratic imperial court. The Byzantine style, after passing through various phases of development, reached its height from the tenth to the fifteenth centuries. Its essential characteristics during these centuries are most readily revealed in the great mosaic compositions decorating the apses, domes, vaults, and walls of still-existing Byzantine churches. These represent Christ and the Virgin, scenes designating the major feast days of the church year, and episodes from the Old and New Testaments and from the lives of the saints. The figures of individual saints, lined up along the walls as though for inspection, are frequently present too. This wealth of religious subject matter is also found in the minor arts, for example, in manuscript illuminations, ivory carvings, icons, and enamel plaques, all of which had their liturgical uses.

The Christian religion from its beginning had no regard for the material world but stressed the Other World, the Immaterial—"Love not the world, neither the things *that are* in the world. . . . For all that *is* in the world . . . passeth away." [*] Consequently the Christian concepts dominating Byzantine art were quite the opposite of the concepts dominating Classic art. The interest in the material, physical beauty of the human form of Classic art had no place in Byzantine art. What was important in the latter was visually to make clear to the beholder the dogmas of the Church, to acquaint him with its major feast days, and to teach him the significant events of sacred history. Hence the three-dimensional figures of Classic art were supplanted in Byzantine art by two-dimensional, flat ones whose drapery and anatomical details reduced to abstract forms could furnish elements for

[*] John 2:15–17.

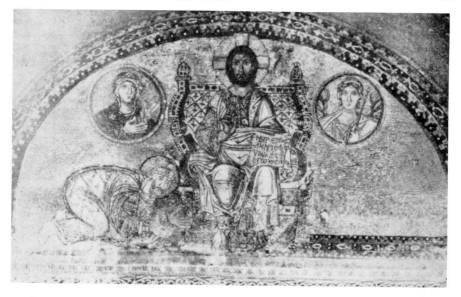

1.4. BYZANTINE: Leo VI Prostrate before Christ (10th cen.). Mosaic. Narthex of Santa Sophia, Constantinople

the creation of rhythms and patterns in the compositions. The figures themselves were endowed with identifying attributes and with expressive gestures to strengthen their didactic intentions.

A few cogent examples of mosaics will suffice to illustrate the major characteristics of the Byzantine style and the concepts behind them. The enthroned figure of Christ or of the Virgin, flanked by saints or often by temporal rulers, appears frequently as decoration for the apses or the lunettes in Byzantine churches. From time immemorial the throne has been the symbol of majesty, of power and authority. In the despotic East this authority was supreme, with power over life and death. Consequently whoever is seated on the throne assumed these attributes that evoked in the minds of the beholder reactions of awe, reverence, fear, obedience, and adoration. In the mosaics, then, these reactions were applied to the figures of Christ and the Virgin as king and queen, or as emperor and empress. Christ often carries a book, the Bible, thus giving it authority. The Virgin in most cases holds the Christ child on her knee, the Christ child wearing a cross-nimbus to indicate His divinity. Therefore the Virgin is both queen and Mother of God. But king and queen of what? Christ and the Virgin are not represented as corporeal realities. They are not three-dimensional nor do they call attention to their physical attributes. They are created in two-dimensional areas, their drapery folds and what were once modelings of light and shade having been reduced and abstracted to linear or flat patterns of color. In other words, they are not king and queen of any place in the material

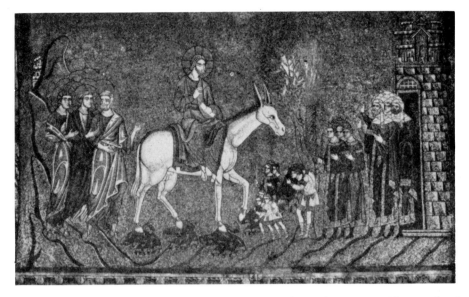

1.5. BYZANTINE: Christ's Entry into Jerusalem (13th cen.). Mosaic. Choir arch of nave, St. Mark's, Venice (Anderson)

world but of the other, the immaterial, world. They are set against a gold background that further emphasizes their *unreality*. Nothing is there to call to the mind of the beholder any attempt to reproduce nature in the material sense. Thus the concept and its expression in the Byzantine style of Christ and the Virgin is that the one is King and All Powerful, the Pantocrator, and the other is the Queen of Heaven and the Mother of God—the supreme authorities in the other world toward whom the worldly beholder reacts with awe and adoration, respect and fear. Even the highest temporal authorities are subservient to them and receive their own authority to rule from them. A mosaic in the vestibule of Santa Sophia in Constantinople depicts the Emperor Leo prostrate before the throne of the Christ [1.4]. In another, in the church of the Martorana in Palermo, Christ is setting the crown on the head of King Roger of Sicily.

Another characteristic of Byzantine art is its creedlike, its dogmatic, quality. For example, in the sixth-century Gospel book from Rossano the episode of Christ entering Jerusalem on Palm Sunday is represented with the most significant details as told in the Gospel narrative. Seven hundred years later, in the thirteenth-century mosaic in St. Mark's in Venice [1.5] the same scene is represented with only the slightest variation in the placement of certain figures. The same is true for other Biblical scenes and for the figures of saints, prophets, and apostles. Once the type was established, its essentials did not vary. There was no room for individual interpretation. Even in our own time, in the Slavic countries where, before the Bolshevist revo-

lutions, the Orthodox Eastern Church predominated, religious scenes and saintly personalities were still being painted as they were painted in the heyday of Byzantine culture. All had been determined. By whom? By what? By the Church, by its dogma. At the Council of Nicaea (A.D. 787) the pronouncement had been made that "The composition of the figures is not the invention of the painters but the law and tradition of the Catholic Church, and this purpose and tradition is not the part of the painter (for his is only the art) but is due to the ordination and the disposition of our Fathers." Consequently where the Orthodox Eastern Church held sway, the dogma held its iron rod over the representation of religious subject matter. Art can change only when the concept changes. When that concept is tied to a dogma concerned with the immaterial world there is no place for material change or invention.

You may well ask, "How could such an apparently static art, harnessed by dogma, have had any appeal whatever to the illiterate masses who frequented the churches?" The answer lies in the effect on the simplest beholder of the wondrous color of the mosaic and in the organization of the rhythms of abstract form and color. No one who has ever stepped from the brilliant outdoor sunlight into a church the walls of which are covered with mosaic decoration will forget the breath-taking effect of the colored light pervading the interior. It is not an intellectual experience, first of all; it is an emotional one. Gradually out of the general haze of colored light definite color spots and rhythms catch the eye, and then only gradually does the spectator investigate the figures and the stories that are depicted for his instruction in the mosaics on the walls, vaults, and domes. It could never occur to him to question whether the anatomical details of the figures are correctly rendered, whether the figures are beautiful or ugly. There is no appeal to the material, the physical, in that sense. But nowhere else is any more effective emotional realization of dogma expressed to the beholder by the use of abstract form, color, rhythm, and design. An impressive example of this is the wonderful figure of the Madonna in the apse of the cathedral at Torcello [1.6] in the Venetian lagoon. The isolated, dark-blue silhouette of the lone Virgin holding the Christ child, made all the more effective by the multiple rhythm of the twelve apostles lined up at the base of the apse, emerges from the gold background to proclaim to all worshipers the doctrine of the Church that she is indeed the Mother of God.

The compositional simplicity of Byzantine mosaic representations is a survival of the Greek type of composition, and so too is the use of neutral backgrounds against which the figures are set. In Greek times the backgrounds apparently were colored. Here they are gold. In either case the intent and purpose are the same: to focus all the attention on the figures. But here the similarity ends. An apt comparison can be made between the Orpheus, Eurydice, and Hermes group [1.2] and the mosaic Crucifixion in the eleventh-century church of Daphni near Athens [1.7]. In both, three figures are arranged in a parenthesislike composition emphasizing the central

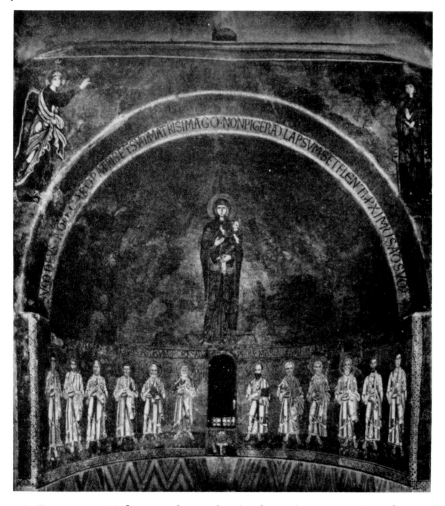

1.6. BYZANTINE: Madonna and Apostles (13th cen.). Mosaic. Central apse, Cathedral, Torcello (Anderson)

figure: Eurydice and the crucified Christ. But whereas in the former the emphasis is for the sake of physical beauty, in the latter it is for the sake of the religious idea conveyed. This is not the historical crucifixion with details of the setting and of the crowds that must have been present. It is as abstracted from reality as it can be. Only the three principals present at the death of Christ are here: the Virgin, Christ, and St. John. They are so placed that the attention is focused on the Crucified, not as an ideal physical example of a man but as the Saviour of mankind by the act of His death. It is the significance of the crucifixion in Christian dogma that is stressed, and it is stressed by means of the traditional Greek type of composition.

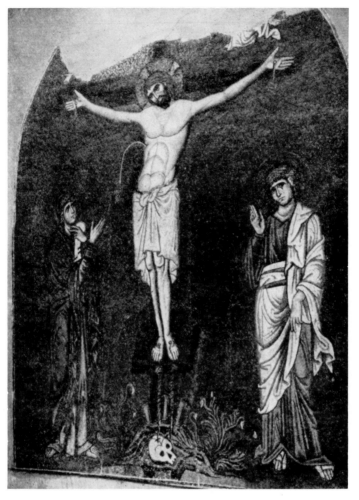

1.7. BYZANTINE: Crucifixion (11th cen.). Mosaic. Monastery Church, Daphni (Alinari)

In the development of the Byzantine style, then, we can note the breakdown of the Classic, the infiltration of Near Eastern colorism, and the triumph of stylization in the reduction of form to pattern, which made this stylized form an excellent vehicle for dogmatic religious ideas. The simplicity of formal composition remained Greek, but the composition emphasized a religious idea rather than a material form. In addition, Byzantine decorative and emotional possibilities were limitless.

It is most essential to be familiar with this Byzantine style since it was a dominating factor in the formation of west European painting styles from the eleventh to the thirteenth centuries.

The Romanesque Style

In the meantime, in western Europe styles were being developed out of a fusion of native Celto-Germanic elements with late Classic ones. Such Classic elements were brought up from southern Europe and from the eastern Mediterranean in the wake of Christian missionary activities and of pilgrimages made by devotees to the Holy Land. Elements characteristic of the native art were ornamental, decorative motifs, such as spirals, interlaces, and lacertines (that is, ribbonlike motifs with animals biting one another). These were found on buckles, brooches, daggers, and horse trappings, and expressed the restless vitality of the barbaric Nordics.* To these decorative elements gradually were added representational ones—the human figure in particular—appearing in the illustrated manuscripts imported from the south and east, such as Bibles and gospel and liturgical books, as well as on carved ivories and other cult objects. The manuscripts served as models to be copied in the newly established monasteries of the west and north to supply them with their own service books. Thus local styles of painting were developed in the monastic centers, styles that spread and intermingled as manuscripts were exchanged or on loan between monasteries. Styles were also spread along such pilgrimage routes as those leading from northern and western France to Santiago de Compostela in Spain.

Instead of a political unity, such as the Byzantine Empire in the east, a series of feudal states grew up in the west during the earlier medieval period. In time, distinctive styles of art developed in these areas and are differentiated by names designating the regions in which they were produced, such as Burgundian, Provençal, Languedoc, or Catalan.

The term *Romanesque* is a blanket one to cover the various twelfth-century styles that were the final products of the fusion of stylistic elements pointed out in the preceding paragraphs. The term itself derives from the fact that, particularly in the religious and secular architecture of that period, elements of decoration and structure were borrowed from ancient Roman architectural monuments still in evidence in various regions of western Europe. Romanesque painting, however, as seen in manuscript illuminations, in panel paintings, and in frescoes, has nothing Roman about it but developed out of the manuscript styles previously mentioned that were becoming more and more rigid and stylized as the result of repeated infusions of Byzantine stylistic elements. These manuscript styles never became completely Byzantine, however, because there was always present in their make-up the naïve emotional vitality of western art with its tendency to force figures into exaggerations of form and expression. But we do note that the powerful Byzantine influences had a tendency to produce a similarity of style in the latter part of the twelfth and in the early thirteenth century in widely separated regions of the west, such as in France, the Rhine countries, England,

* These motifs are also present in the illuminations of the famous ninth-century Book of Kells in Dublin.

1.8. ROMANESQUE: Madonna between Prophets (12th cen.). Fresco. Apse, San Silvestro, Tivoli (Ministry of Public Instruction)

northern Spain, and Italy [1.8]. One might even speak of an International Romanesque style in painting at this time. In Italy the Romanesque painting style was apt to be much more Byzantinized than it was in France and elsewhere in the north and west. This was particularly true of the regions of central and southern Italy because of their greater distance from the transalpine monasteries and their proximity to Byzantine centers of culture in the western Mediterranean, such as Sicily. In the region between Rome and Naples, for instance, a painting style that was developed in the abbey of Montecassino, to be known as the *Benedictine* style, had ingredients similar to those of the Romanesque style elsewhere—that is, Byzantine and local monastic manuscript elements—but a larger proportion of the Byzantine elements. This was unquestionably the result of the presence of Byzantine artists called to Montecassino by the abbot Desiderius in the eleventh century to help in the redecoration of the abbey church. This style, emanating from the mother house at Montecassino, spread to other Benedictine foundations in Italy.* Hence this Benedictine-Romanesque style was bound to be

* As an early example of this Benedictine style we cite the eleventh-century frescoes at Sant' Angelo in Formis near Capua [1.9]. Later examples are present in the Benedictine monasteries at Subiaco, near Rome, and in Rome itself in the Sylvester chapel of the church of the Santi Quattro Coronati.

1.9. BENEDICTINE-RO-MANESQUE: Christ and the Adulterous Woman (11th cen.). Fresco. Nave, Sant' Angelo in Formis (Anderson)

one of the elements present in the paintings we are to consider as products of the city-states of Tuscany.

The Gothic Style

There was still another style that came forcefully into play in the thirteenth century to affect the styles developing in Tuscany, Umbria, and adjacent regions. This was the Gothic style that was to allow Italian painters of the thirteenth and fourteenth centuries to break out of the strait jacket of Byzantine and Romanesque two-dimensional stylizations and express themselves in a style more suited to the more human emotional interpretations of religious subject matter current at that time.

It was in northern France during the latter half of the twelfth century that the style known as Gothic began to take form. It reached its high moment during the thirteenth century in the architecture, sculptural decoration, and stained glass of the great cathedrals, such as those in the cities of Chartres, Paris, Amiens, and Rheims. It was the style that was to spread throughout western Europe contemporaneously with the revival of painting in Tuscany, and it was to become for western Europe what the Byzantine style was for eastern Europe.

The concept behind the Gothic style was essentially much more human than that behind the Byzantine and accounts for the striking differences between them. Contrasting a Gothic Madonna, such as the Vierge Dorée at Amiens [1.10] with a Byzantine one, such as the Torcello Madonna [1.6]— granting the fact that the Gothic example is in sculpture and the Byzantine one in mosaic (for sculpture lent itself more readily to the expression of the Gothic concept just as the flat mosaic was the supreme Byzantine medium) —we find the Gothic Madonna fundamentally more human. It is the idea of the *mother* in the Mother of God that is being stressed. While she wears a

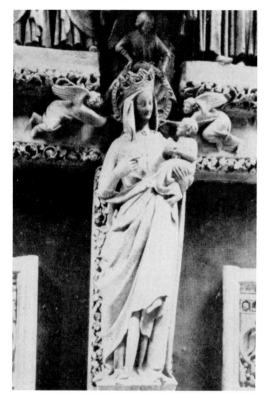

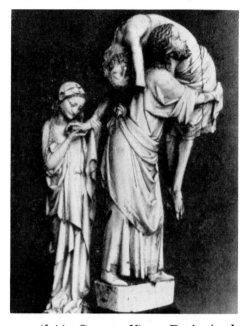

1.10 (*left*). GOTHIC: Vierge Dorée (13th cen.). Stone. South transept portal, Cathedral, Amiens. 1.11 (*above*). GOTHIC: Deposition of Christ (13th cen.). Ivory. Louvre, Paris (Archive Photographiques)

halo and crown to indicate her divinity and regality, the Madonna turns toward the Christ child and He turns with interest to her as any human mother and child would do. This is only one instance of the new naturalism that was to pervade Gothic art.

But this Gothic naturalism was not the Greek naturalism that had been concerned with the beauty of the human form. It was there to make more emotionally real the human content and situations inherent in religious stories and doctrines. This Gothic naturalism is found chiefly in the faces and the hands. The rest of the body usually is covered with heavy drapery folds used *expressively* to stress the three-dimensional bulk of the figures and not *functionally* to express the form beneath, as in the Classic style. These drapery folds were then organized so as to lead the eye to the emotional center of the group or composition. In the Vierge Dorée the folds of the drapery on the right-hand side lead to the Christ child on the Virgin's arm, and the eye of the spectator wanders from head to hand exploring the tenderness exchanged between mother and child.

One of the most humanly moving representations of the Deposition of Christ is a Gothic ivory group in the Louvre [1.11]. Joseph of Arimathea,

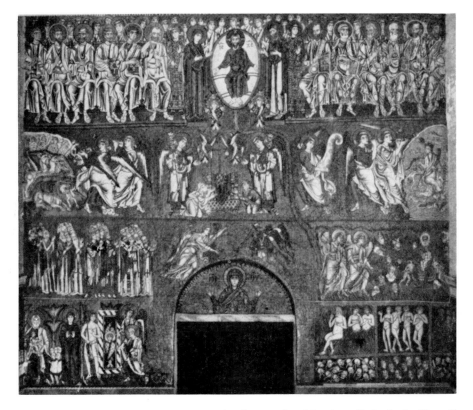

1.12. BYZANTINE: Last Judgment (12th cen.). Mosaic. Cathedral, Torcello (Alinari)

to whom the body of the Saviour was delivered after the crucifixion, carries the broken, angular form of Christ with the greatest care and solicitude. The Virgin Mother follows, and with bowed head caresses and raises His dead right hand to her tearful cheek. All the emotional expression is in the faces, the hands, and the posture of the figures, and the drapery serves as an accompanying accent to these emotions in the hunched-up folds of Joseph of Arimathea's mantle and the slow-falling rhythm of the Virgin's garment. As in the Vierge Dorée, the drapery folds with their curvilinear accents also serve a definite decorative purpose.

Since both the Byzantine and the Gothic styles were concerned with the expression of religious concepts—the Gothic is a more humanly emotional one—a comparison of two representations of the Last Judgment will clarify the distinctions of each. The one at Torcello [1.12] is a huge mosaic covering the interior west wall of the cathedral; the other representation of the Last Judgment [1.13] is sculptured on the west portal of the cathedral at Bourges, France.

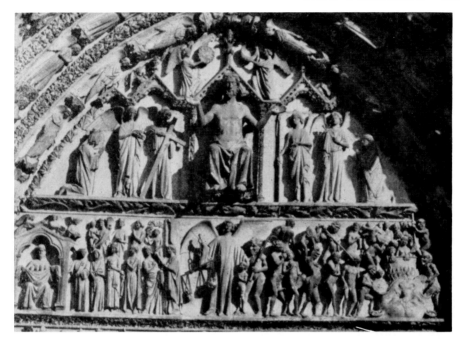

1.13. GOTHIC: Last Judgment (13th cen.). Stone. West portal, Cathedral, Bourges (Archives Photographiques)

In the Torcello mosaic [1.12], the Byzantine artist represents the Last Judgment as though it took place in an imperial judgment hall. Christ, although displaying the wounds in His hands and feet, is clad in a royal purple mantle. He is seated as judge on the throne, flanked by the Virgin and St. John the Baptist and by the twelve apostles, six seated on either side like so many members of a jury. Below Christ stand archangels dressed in the costumes of court heralds. St. Michael weighs the souls, and below, to left and right, are the groups of the Blessed in Paradise and the Damned in Hell. The whole scene has an impressive austerity to strike fear into the hearts of the spectators.

In the sculptured portal at Bourges [1.13], the same general elements of the scene are present—the Virgin, St. John the Baptist, St. Michael weighing the souls, the Blessed and the Damned—with significant differences. Christ, although seated on the throne of judgment, is nude to the waist to show the wound in His side. He holds up His hands and exposes His feet to spotlight the stigmata, the nail marks of His crucifixion. He is not primarily the judge, as at Torcello, but the Saviour who sacrificed Himself on the cross for mankind. In like manner the expression of the bliss of the Blessed in Paradise and of the terror of the Damned in Hell are made physically more manifest at Bourges than at Torcello. The chirping bliss on the

birdlike faces of the three souls safe in Abraham's bosom is actually comic. Not that these emotions are not present in the Torcello mosaic, but they are presented in a different manner that is highly indicative of the differences between the Byzantine and the Gothic modes of expression. At Torcello these emotions are achieved in a typical Byzantine abstract fashion. The six apostles seated to the right and left of the throne of Christ balance each other as pattern accents but, you will notice, the stylized drapery folds of the apostles on the left fall in straight rhythms, giving the effect of calm and the drapery folds of the apostles at the right are full of restless curves. It so happens that the straighter, calmer rhythms on the left are directly above the group of the Blessed in Paradise who repeat these straight rhythms themselves, whereas the restless rhythms are above the Damned writhing and twisting in the fires of Hell. By means of the more abstract elements of stylized design and rhythm, the Byzantine achieves what the Gothic expressed by the actual rendering of the human emotion.

The Byzantine, then, dominated by the dogmatic religious concept that contains no vagaries of human emotion, achieves an emotional expression nevertheless by the abstract means of color, pattern, rhythm, and decorative design. The Gothic allows human emotion to color the religious concept and open the door to naturalism in order to express this. Both styles have their own specific strength and weakness. But it must be said that in the Byzantine style the religious concept, tied as it was to Church dogma, never loses the power and grandeur of that dogma. In the Gothic style, where that concept is tied to human emotions, religious concepts can become either as grand as the highest human emotions or as trivial and mannered as emotions at times can be. As a civic rather than an imperial style, the Gothic emphasized human emotions as applied to religious teaching.

Style Factors in Thirteenth-century Italian Painting

We shall see characteristic elements of the Classic style appearing in some frescoes at the end of the thirteenth century, but not until the fifteenth century and later do they play an important role in Italian painting.

The major style factors in twelfth- and thirteenth-century Italian painting were the Byzantine and Romanesque. The Byzantine had been a familiar and influential style in Italy ever since the sixth century when the Emperor Justinian made Ravenna an exarchate and extended Byzantine political control over south Italy and the coastal cities, such as Amalfi. Although Ravenna was lost to the Lombards early in the eighth century, the Byzantine control over the south of Italy was to last for five hundred years, until the conquests of the Normans. During this period, Byzantine monasteries were founded in the south, and Byzantine craftsmen and artists migrated to Italy, particularly during the iconoclastic controversy in their homeland in the eighth and ninth

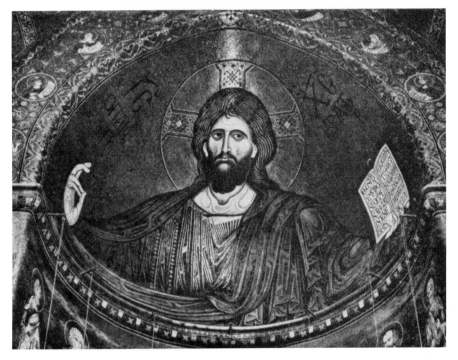

1.14. BYZANTINE: Pantocrator (12th cen.). Mosaic. Apse, Cathedral, Monreale (Alinari)

centuries. It was only natural, then, for illuminated manuscripts, icons, and other cult objects in ivory, gold, and enamel to be imported into these regions, and for local art products to bear the stamp of the Byzantine style. Some, in fact, were the work of artist-craftsmen imported from Constantinople, as was the case at Montecassino previously mentioned. Even after the Norman conquest, magnificent mosaics in the Byzantine style were still to be produced as decoration for the churches at Monreale [1.14], Cefalù, and Palermo in Sicily. At the other end of Italy, the brilliant mosaics in the cathedral of St. Mark's and the fabulous gold and enamel altarpiece, the *pala d'oro*, on the high altar, brought as loot to Venice after the fall of Constantinople to western crusaders in 1204, kept the Byzantine style before the eyes of local artists.

The Romanesque style, in Italy as well as elsewhere in western Europe, was after all, as we have stated, the result of a mixture of imported Byzantine elements with the styles of local scriptoria. Hence the style that we shall first meet in the early paintings in Tuscany will be a Byzantinized Romanesque style to which from time to time during the thirteenth century new Byzantine impulses will be added resulting from trade and other connections between Italy and the eastern Mediterranean.

The Gothic style in painting made its appearance in Italy toward the end of the thirteenth century. Like the Byzantine, it too was an imported style. It is found in monastic churches built by French Cistercians as early as the twelfth century in regions to the north and south of Rome and even in Tuscany. However, it was the great wave of French culture that poured into Italy in the last thirty years of the thirteenth century in the wake of the Angevin conquests that caused the Gothic style to take root and manifest itself in the sculpture and painting of Italy as well.

We had mentioned previously that the difficulties between the popes and the emperors of the Holy Roman Empire had kept northern Italy in a state of confusion and insecurity and had resulted in the development and growth of the city-states. This struggle came to a climax in the thirteenth century with the accession of Frederick II, the Hohenstaufen, to the imperial throne. He had inherited the imperial territory in north Italy from his father Henry IV and the Norman kingdom of South Italy and Sicily through his mother, the Norman princess Constance. Being an ambitious as well as a brilliant individual, he aimed to control all Italy, even including the papal territories after the popes had begun to scheme against him. A death struggle between popes and emperor ensued. Frederick died suddenly in 1250. The popes decided to rid themselves—and Italy—of the Hohenstaufens. When Urban IV, a Frenchman, was elected to the papal throne in 1261 he appealed to Louis IX of France. Louis dispatched his brother, Robert of Anjou, with his armies to Italy. Robert made certain that no members of the Hohenstaufen family should survive. Of Frederick's two young descendants, popular in later medieval romance, Manfred was killed in battle in 1268 and Conradino, captured, was beheaded at the age of fifteen in a public square in Naples the following year.

The Angevin court was set up in Naples, and French fashions, manners, and styles became the order in Italy. In the arts, architecture and sculpture responded to the Gothic style more immediately than did painting, where the more traditional Byzantinized Romanesque persisted until the end of the century, although at times certain Gothic decorative elements made their appearance. But a switch to a new style in painting as different as the Gothic was from the Byzantinized Romanesque would necessitate a radical change in concept regarding the subject matter represented. This was supplied by the Franciscan movement that had been preparing the ground since early in the century for more human interpretations of religious stories and episodes as against the more doctrinal and dogmatic interpretations of earlier times. The two-dimensional, flat, stylized figures of Byzantinized Romanesque painting were no longer able to express adequately this new content, but the Gothic style was, especially in its sculpture with its three-dimensional naturalism. It was this Gothic sculpture as it appeared in Italy that was to furnish the models, as we shall see, for the Gothic style in painting at the end of the thirteenth century.

BIBLIOGRAPHY *

The Classic Style:

Swindler, M. H. *Ancient Painting from the Earliest Times to the Period of Christian Art.* New Haven, Yale University Press, 1929.

Beazley, J. D., and Ashmole, B. *Greek Sculpture and Painting to the end of the Hellenistic Period.* Cambridge, University Press, 1932.

Lullies, R., and Hirmer, M. *Greek Sculpture,* rev. ed. New York, Harry N. Abrams, 1957.

Richter, G. M. A. *A Handbook of Greek Art.* New York, Phaidon Publishers, 1959.

The Byzantine Style:

Dalton, O. M. *Byzantine Art and Archaeology.* Oxford, Clarendon Press, 1911.

Peirce, H., and Tyler, R. *Byzantine Art.* London, E. Benn, 1926.

Byron, R. *The Byzantine Achievement.* New York, Alfred A. Knopf, 1929.

Anthony, E. W. *A History of Mosaics.* Boston, P. Sargent, 1935.

Rice, D. Talbot. *Byzantine Art.* Oxford, Clarendon Press, 1935.

—— *The Art of Byzantium.* London, Thames and Hudson, 1959.

Demus, O. *The Mosaics of Norman Sicily.* New York, Philosophical Library, 1950.

—— *Byzantine Mosaic Decoration.* Boston, Boston Book and Art Shop, 1951.

The Medieval Styles:

Faure, E. *History of Art,* trans. by W. Pach, vol. II. New York, Harper & Brothers, 1921–1930.

Thompson, J. W., and Johnson, E. N. *An Introduction to Medieval Europe.* New York, W. W. Norton & Company, 1937.

Morey, C. R. *Medieval Art.* New York, W. W. Norton & Company, 1942.

Anthony, E. W. *Romanesque Frescoes.* Princeton, N. J., Princeton University Press, 1951.

Dupont, J., and Gnudi, C. *Gothic Painting,* trans. by S. Gilbert. Geneva, Skira, 1954.

Grabar, A., and Nordenfalk, C. A. J. *Romanesque Painting from the Eleventh to the Thirteenth Century,* trans. by S. Gilbert. New York, Skira, 1958.

Mâle, E. *The Gothic Image. Religious Art in France in the Thirteenth Century,* trans. by D. Nussey. Gloucester, Mass., Peter Smith, 1958.

* In addition to the bibliographies cited at the end of each chapter, a selected General Bibliography in English will be found on pages 571–572.

✦ 2

The Panel Painting
of Lucca and Pisa

V ASARI, the painter-pupil of Michelangelo and the biographer of painters, sculptors, and architects, claimed that Cimabue, who was active in Florence at the end of the thirteenth century, "shed the first light on the art of painting." Apparently accepting Vasari's statement as gospel truth, many books on Italian painting and many courses given in that subject have taken the works of Cimabue as their point of departure. However, the hundreds of paintings—anconas, crucifixes, and Madonnas—surviving from the century before Cimabue offer evidence of an activity in Tuscany, produced by the conditions described in Chapter 1, that gives the lie to Vasari's statement. Cimabue, as we shall see, came not as the beginning but as the culmination of this activity. This was made abundantly clear in the great exhibition (the *Mostra Giottesca*) in Florence in 1937 where to the amazement of the visitor room after room was filled with exciting paintings antedating the works of Cimabue and Giotto by many decades. With some of these paintings we shall begin our study, concentrating attention first on those produced in the rival city-states of Tuscany. The two oldest political rivals were Lucca and Pisa.

Lucca

Lucca had become the most important city in Tuscany during the earlier medieval period, favored by emperors and a free city after 1119. Despite its rivalries with Pisa and Florence, it prospered during the twelfth and thirteenth centuries, so that it is not surprising that we find in Lucca evidences of the earliest local painting styles in Tuscany.

26

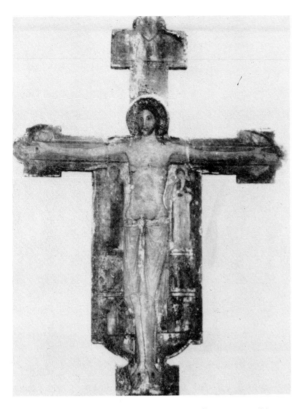

2.1. GUGLIELMUS: Crucifix
(1138). Panel painting,
118⁵⁄₁₆″ x 82⁵⁄₁₆″. Duomo,
Sarzana (Soprintendenza)

A crucifix [2.1] now in the *duomo* at Sarzana near Spezia is the earliest painted panel we shall consider. Guglielmus (William) the painter signed his name and gave the date 1138 in a jingling medieval Latin rhyme in the space above the head of Christ.

The shape of this crucifix is unusual. The rectangular projections at the top and the two arm-ends terminate in semicircles, and the long apronlike panels flanking the corpus of Christ are rounded at the bottom, giving a chalicelike appearance to the frame at the bottom of the cross. The top projection contains the complete scene of Christ's Ascension. The projections at the arm-ends have the symbols of the evangelists and the two prophets Isaiah and Jeremiah. In the apron panels are the Virgin and St. John, each accompanied by one of the other Marys, and below these figures a series of scenes from the Passion cycle: the Betrayal, the Flagellation, Christ taking farewell of the women of Jerusalem, the Deposition, the Entombment, and the Marys at the Tomb. The Denial of Peter is, as it were, cut in half, with the accusing maid to the left and Peter to the right of Christ's legs between the scenes of the Flagellation and the Deposition.

The pecularities of the frame of the Sarzana cross and the choice of subjects used on the various extensions are found again in two other cruci-fixes still in Lucca: one in the church of San Michele and the other [2.2] in the Museo Civico but formerly in the church of the Servi. The correspond-ences with the Sarzana cross are so striking and the variations so slight that

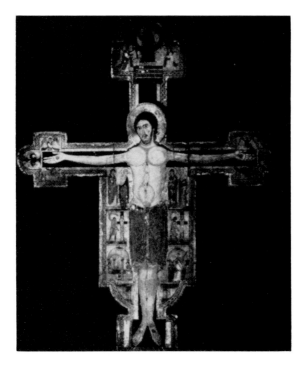

2.2. LUCCHESE SCHOOL: Crucifix (12th–13th cen.). Panel painting, 86¹¹⁄₁₆″ x 71¼″. Museo Civico, Lucca (Alinari)

we must consider the Sarzana panel as the ancestor for these two Lucca crosses. The frames have the same semicircular terminations at the top and side extensions and also the chalicelike shape at the bottom. The Ascension at the top has been abbreviated to the enthroned figure of Christ and two attendant angels, but the ends have the symbols of the evangelists although omitting the additional prophet figures. In their place the San Michele cross has an angel at each end, and the Museo Civico cross has a decorative fleuron. Mary and St. John appear to the left and right in the top register of the scenes on the apron panels; in the Museo Civico cross an additional Mary is added to each figure, as in the Sarzana cross. In the second register, these crosses introduce a feature that was to become characteristic of the Lucchese school: the two thieves crucified with Christ (one to the right and the other to the left of Christ's corpus), each having his legs broken by an executioner. In the third register are the scenes of the Entombment and the Marys at the Tomb. The divided scene of the Denial of Peter occurs in the San Michele cross to the right and left of Christ's feet.

In style the crosses at Lucca are more developed and more controlled than the Sarzana cross and must be dated toward the end of the twelfth century; they are in a style that is related to the Benedictine-Romanesque style. The peculiar treatment of Christ's eyelids, with the split parallel lines at the tear duct, was anticipated in the frescoes at Sant' Angelo in Formis [1.9] and in the figures of a triptych in the *duomo* at Tivoli. In the Entombment scene at the sides of the crucifixes, the sarcophagus of Christ is of the ancient Roman strigillated type that also appears in the Sant' Angelo frescoes.

The Berlinghieri

During most of the thirteenth century, painting in Lucca was dominated by the work of a remarkable family headed by the man who signed himself in the Latin form "Berlingerius" on a crucifix now in the Museo Civico at Lucca. His name appears again in the 1228 treaty of peace with Pisa, together with the names of his three sons, Bonaventura, Barone, and Marco.

Berlinghiero's signed crucifix [2.3] is one of extreme simplicity and beauty. Iconographically it follows the earlier Lucchese tradition but abbreviates it. The Virgin and two angels are all that remain of the Ascension; the customary roundel at the top with the bust of Christ is missing. The arm-ends have the symbols of the four evangelists, and the panels flanking the corpus are entirely filled by the large-scale full-length figures of the Virgin and St. John. Below, to right and left of the suppedaneum (the block on which Christ's feet are nailed), are the figures of the maid and St. Peter from the Denial scene.

Although these iconographic details establish their derivation from the earlier Lucchese crosses, the style of the Berlinghiero painting shows striking changes owed to the presence of some new Byzantine influence in Lucca.* The embroidered and jeweled garments of the angels at the top resemble the costume worn by Byzantine court heralds. The Virgin figure flanking the body of Christ is very close in style to the Virgin in the Deisis mosaic [2.4] in St. Mark's, Venice, and the delicate golden ornaments falling from the border of the Virgin's mantle at the shoulder are present also in a mosaic at Monreale in which King William presents the church to the Virgin. The fine-lined stylized treatment of Christ's hair and, particularly, the curvilinear repeats in the beard are inspirations from still other Byzantine mosaics. Very striking is the comparison of Christ's head on the crucifix with the head of Christ in the Daphni mosaics [1.7] or with the Pantocrator head in the apse of Monreale [1.14] where even the two small hairs projecting from between the loops of Christ's beard at the chin are to be found.

One other detail needs to be noted: the threadlike design running around the cross outside the pearl border. It has the strange form of a double curve, top and bottom, with small hornlike corner elements, making it resemble a conventionalized wineskin. We will call attention to this motif several times later because it became characteristic of the Berlinghieri and of those painters influenced by them, a trademark, as it were, of Lucchese influence.

A number of other crosses are closely related to this crucifix by Berlinghiero, but we cannot consider them in this book.

In the church of St. Francis at Pescia, not far from Lucca, is one of the masterpieces of thirteenth-century Tuscan painting—an altarpiece bear-

* See Evelyn Sandburg Vavalà, *La Croce Dipinta Italiana*, Casa Editrice Apollo, Verona, 1929, p. 546. This huge publication on Italian painted crosses is the most important work on the subject.

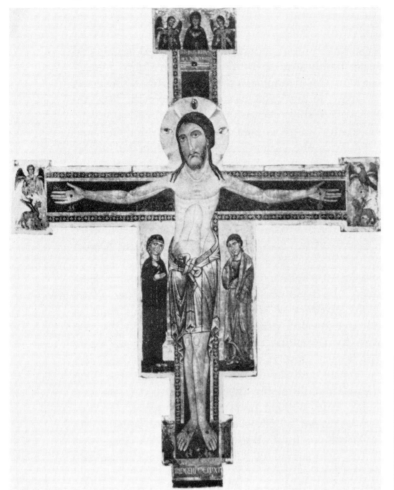

2.4 (*right*). BYZANTINE: Detail from 13th cen. mosaic. St. Mark's, Venice (Anderson)

2.5. BONAVENTURA BERLINGHIERI:
St. Francis Altarpiece (1235).
Panel painting, 61¾₆″ x 46″. San
Francesco, Pescia (Anderson)

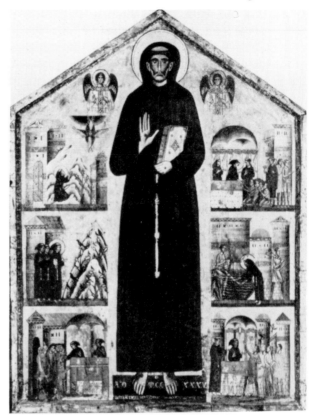

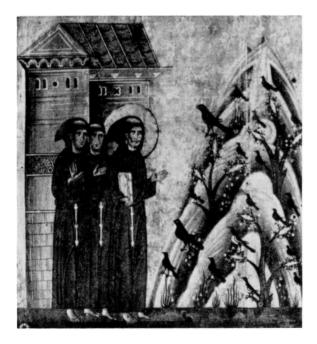

2.6. BONAVENTURA BER-
LINGHIERI: St. Francis
preaching to the Birds,
detail of [2.5]. San Fran-
cesco, Pescia (Anderson)

ing the figure of St. Francis [2.5]. It is dated 1235 and is signed by Berlinghiero's son Bonaventura. It is vertical in shape, with a gabled top. St. Francis stands in the center, facing front, with his left hand grasping a large book and his right raised to show one of the stigmata, others appearing on his left hand and on his feet. A half-length angel in jeweled garment is placed to either side of his shoulders. Below each angel and flanking the figure of the saint are three scenes from his life, including miracles, the Sermon to the Birds, and the Receiving of the Stigmata. The date and the signature of the artist appear about the feet of the central figure.

In this panel also, evidences of some new contact with Byzantine art are apparent. They are manifest in the form and posture of St. Francis himself, which are duplicated in rows of saints in Byzantine mosaic cycles and manuscripts. The effective use of stylization in the features of the saint give him a serious, dry, ascetic look. The small scenes at the sides might almost have been taken from an illuminated Byzantine manuscript, for note the round turrets and the gabled structures, the cornices of which are decorated with a stylized leaf ornament (the Lesbian leaf), and the conventionalized rhythms that establish the rocky elements of the landscape.

In the scene of St. Francis preaching to the birds [2.6], Bonaventura shows his genius in the treatment of the abstract form elements as a supplement to the emotional content of the event. Here the contrast between linear rhythms, essentially rectilinear on the left side of the scene and predominantly curvilinear on the right, express the emotional contrast between St. Francis' seriousness of purpose, linked with the wonder of his companions, and the excitement and twitter of the birds directing their attention toward him. A master stroke is the tiny, sparkling, pearl-shaped blossoms scattered like dew over the mountainside, bespeaking the chirpy restlessness inherent in the birds whose eagerness otherwise is frozen in their stencillike forms.

This panel at Pescia is the earliest of a series of St. Francis altarpieces of the thirteenth century. As early as 1228, two years after St. Francis died, there was a Franciscan foundation at Lucca, and it well may be that the type and iconography of the scenes from the saint's life were established at Lucca, indeed in the workshop of the Berlinghieri.

Although attempts have been made, nothing can be ascribed with certainty to Berlinghiero's two other sons, Barone and Marco. From accounts we know that Barone was a Franciscan monk and is traceable as a painter at Lucca between 1240 and 1284, and that Marco painted miniatures in a Bible for a priest in Lucca in 1250. But of the number of panels that show a style close to the signed pieces not one can be definitely ascribed.

Apart from the Byzantine abstractions already mentioned, the characteristic features of the style of the Berlinghieri were the strongly delineated and stylized lights and shadows and the long oval faces with a tendency to become a bit jowly at the bottom. These features, plus the decorative border motif, to which attention has been called, will appear in other Tuscan styles, as we shall see shortly.

Pisa

A seafaring city from the time of the Romans, Pisa continued its naval operations in the western Mediterranean throughout the medieval period. Having liberated Sardinia from Saracen marauders, Pisa helped the Normans in their conquest of Sicily, furnished ships for the First Crusade, and laid the foundations for the great maritime commerce that brought wealth and political power to the city. Its naval victory over the Moors and triumph over the rival city of Amalfi in the twelfth century were followed by imperial concessions of control over the coastal area as far south as Civitavecchia and by the establishment of feudal rights in Naples, Salerno, and other regions in southern Italy and Sicily. Pisan ambitions led first to friction with Lucca, its ancient rival, but it was the struggle with Genoa for control of Sardinia and Corsica and with Florence over that city's outlet to the sea that brought about the downfall of its power. Defeated by the Genoese fleet in 1284, Pisa never recovered and eventually had to submit to Florence's domination of Tuscany.

It was in the heyday of its power, in the twelfth and thirteenth centuries, that Pisa produced the painters who developed the style we call "Pisan" in contradistinction to other Tuscan styles. As at Lucca, our first impressions of Pisan painting come from a group of crucifixes dating in the twelfth century. Here we shall briefly discuss only four, all by anonymous painters: the crucifix at San Frediano in Pisa [2.7], crucifix no. 432 in the Uffizi in Florence, and crucifixes nos. 15 and 20 [2.8 and 2.10] in the Museo Nazionale in Pisa.

Although these four crucifixes show no unity of style, all are similar in shape and in the decorative layouts of the parts. The arms of each cross have rectangular projections, that at the top sometimes terminate in a semicircle. The apron panels also are rectangular and lack the rounded bottom that was found in the early Lucchese crosses. The most characteristic feature of the Pisan crosses is the use of six scenes from the Passion or Resurrection cycles on the apron panels. The Virgin and St. John do not flank the body of Christ as they did in the Lucca crucifixes but, when present, are placed in the projections of the horizontal arms.

The figure style of the San Frediano cross [2.7] somewhat resembles that of the Sarzana cross [2.1] with its flat, papery forms and threadlike outlines of Romanesque miniature style gone to seed. The colors, however, revealed by recent cleaning, give a gay effect and compensate for the weak draftsmanship.

In the Uffizi cross, the posture of Christ's body and the tilt of His head are similar to those in the San Frediano cross, but the small fanlike tufts of His beard, which appear also on the small figures of Christ in the scenes along the side of the cross, are quite unlike anything we have seen before or will see later. The whole style of the figures in these Passion scenes is a strange and yet forceful one [2.9]. The outlines are sharp and the movement in the lines of the drapery is clearly articulated. The large heads out of proportion to the bodies, the curiously Mongoloid features, and the white

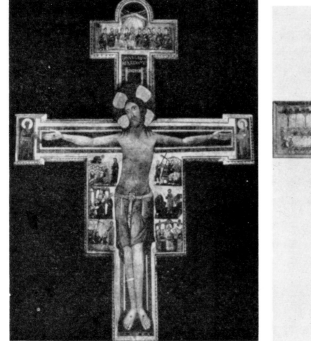
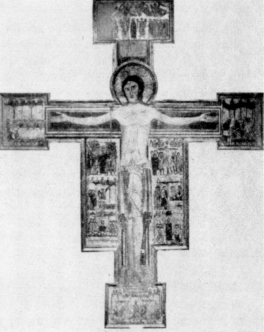

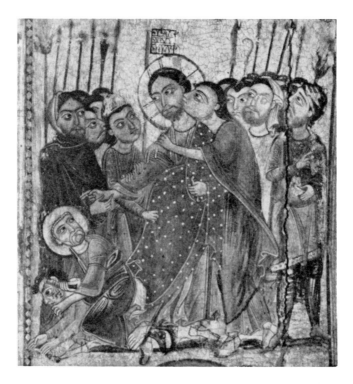

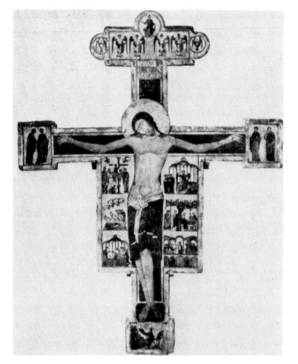

2.7 (*opposite, above left*). PISAN SCHOOL: Crucifix (13th cen.). Panel painting, 126⁹⁄₁₆″ x 92⅝″. San Frediano, Pisa (Soprintendenza)

2.8 (*opposite, above right*). PISAN SCHOOL: Crucifix (12th cen.). Panel painting, 111⅞″ x 94⅝″. Museo Nazionale no. 15, Pisa (Alinari)

2.9 (*opposite*). PISAN SCHOOL: Betrayal of Christ, detail of Crucifix (13th cen.). Uffizi no. 432, Florence (Soprintendenza)

2.10 (*above*). PISAN SCHOOL: Crucifix (13th cen.). Panel painting, 118⁵⁄₁₆″ x 82⁵⁄₁₆″. Museo Nazionale no. 20, Pisa (Soprintendenza)

2.11 (*right*). PISAN SCHOOL: Pietà, detail of 2.10 (13th cen.). Panel painting. Museo Nazionale no. 20, Pisa (Soprintendenza)

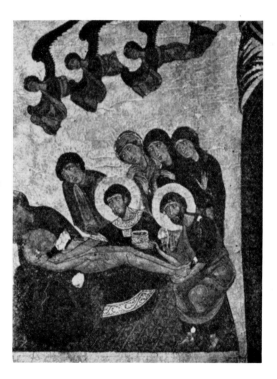

dots placed beside the pupils of the eyes to heighten expression create a bizarre but powerful effect. We may have here a reflection of one of the many "foreign" stylistic elements that found their way from the Near East, in the wake of Pisa's cosmopolitan sea traffic, into the workshop of one of Pisa's painters.

Although the style of crucifix no. 15 [2.8] in the Museo Nazionale in Pisa is quite different from the styles of the two just mentioned, it is much more easily placed. It is sophisticated and well ordered in the use of stylizations of the draperies, the gestures, the forms, and even the hair as well as in the composition of its parts. The whole ensemble is pervaded by a certain dry elegance that points to a well-grounded painting tradition such as might have flourished in some monastic scriptorium in the West. Any Byzantine characteristics present have been digested and absorbed into a western Romanesque manuscript style. The turreted architecture in some of the backgrounds is surely Western and so is some of the iconography in such scenes as the Last Supper and the Washing of the Feet of the Disciples.*

Crucifix no. 20 [2.10], also in the Museo Nazionale, is one of the most significant of all the early crucifixes. Although its form and decorative layout are typically Pisan, it has many striking differences from the three crucifixes we have been considering. The purple-stained vellum on which it is painted, together with the gold backgrounds and haloes, produces an effect of regal richness similar to that of the imperial manuscripts of the Carolingian and Byzantine scriptoria, which were written in gold letters on similarly purple-stained parchment. This crucifix by an anonymous Pisan is assuredly one of the great artistic achievements of early Italian painting, to be set beside Bonaventura Berlinghieri's altarpiece of St. Francis [2.5]. The refined elegance of the grouping of the archangels and seraphs in the abbreviated Ascension scene at the top, the extraordinary diagonal rhythms of the three angels hovering above the Pietà group [2.11], and the sensitive arrangement of figures and settings in the scenes in general reveal a knowledge of Byzantine esthetic principles far beyond anything previously achieved in Italy. Nothing comparable to it will be seen until we come to the fourteenth-century works of the great Sienese painter Duccio.

Two more observations should be made about crucifix no. 20. *First,* the six small scenes on the apron panel flanking Christ's body show consecutive episodes that took place after the Crucifixion: the Deposition, the Lament over the Body, the Burial of Christ, the Three Marys at the Tomb, the Pilgrims and the Supper at Emmaus, and the Doubting Thomas. None of the other crucifixes has this sequence; as a rule, they divide the scenes between episodes that took place before and after the Crucifixion, the obvious central feature of the cross. *Second,* for the first time in these early Italian crosses Christ is represented as dead. Heretofore He appeared erect, with head up

* Edward B. Garrison has made very cogent comparisons between the style of this crucifix and certain central Italian manuscripts. (See his *Studies in the History of Mediaeval Painting,* "L'Impronta," Florence, 1953–54, pp. 198ff.)

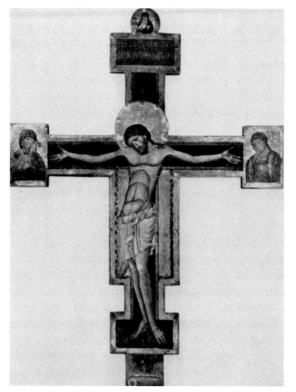

2.12. GIUNTA PISANO: Crucifix (13th cen.). Panel painting, 68⅞" x 51¾". Santa Maria degli Angeli, Assisi (Anderson)

and eyes open, looking out at the beholder as though presenting Himself dogmatically as the victim for mankind. This type of open-eyed dogmatic Christ is found in Early Christian art and was common in the West in medieval times in frescoes and, particularly, on Limoges enamel reliquaries and crosses. Byzantine art, on the other hand, generally represented Christ as dead on the cross.

Giunta Pisano and His Influence

It was the Pisan painter Giunta (1202?–1258), however, who was to establish and make popular a new and simplified type of crucifix on which the body of Christ was represented as dead. In this type [2.12] the Virgin and St. John in bust form were placed at the arm-ends. At the top of the cross the rectangular crosspiece contained the title identifying Christ as King of the Jews, following the account in the Gospels. It was either abbreviated to the traditional INRI or written out IESUS NAZARENUS REX IUDEORUM. Above this was a circular termination with the bust of Christ, all that remained of the Ascension scene that traditionally was at the top of a crucifix. The apron panels no longer contained figures or scenes but were filled with decorative motifs in imitation of brocaded stuffs.

The body of Christ took on certain new characteristics: the closed eyes, the inclined head, the two locks of hair with S-shaped, whiplike ends falling over the left shoulder (and sometimes also over the right), the curious lozenge-shaped muscle just below the pectoral line, the very pronounced tortoise-shell stylization of the abdominal muscles, and the general S-shaped curve of the body.

Besides the crucifix illustrated here, which is in the church of Santa Maria degli Angeli in Assisi, two similar crosses bear Giunta's signature. One is in the church of San Ranierino at Pisa and the other, on which the signature emerged only after a cleaning in 1936, is in San Domenico at Bologna. A fourth crucifix, both signed and dated, was made in 1236 for Brother Elias, the friend of St. Francis, and was probably the earliest of Giunta's known crucifixes. It hung in the basilica of St. Francis at Assisi but fell and was ruined sometime before the seventeenth century.

This new type of suffering or dying Christ is derived from that found in Byzantine mosaics, manuscript, icons, and enamels. We mentioned in Chapter 1 the various Byzantine infiltrations in the painting style of medieval Italy, and in the case of Giunta's paintings the connection is especially close. Practically identical types of the Crucified are found among icons of the thirteenth century at Mt. Sinai and in a liturgical manuscript, now in Perugia, from St. Jean d'Acre, the crusader kingdom once under the jurisdiction of Pisa. Pisa's commercial and maritime activities, as we said, were widespread and famous during the crusade period, and therefore an importation of manuscripts and other cult objects from the eastern Mediterranean to Pisa or vice versa could easily account for the similarities of style found in both areas.*

Another striking detail of iconography that appears in some of Giunta's crucifixes and in those at Mt. Sinai and from St. Jean d'Acre is the differentiation of the streams of blood and water gushing from Christ's side in the curving lines of red and white, a tradition that was present in the eleventh-century mosaic of the Crucifixion [1.7] at Daphni, outside Athens.

Why Giunta should choose this specific Byzantine type of the dying or dead Christ has naturally been the subject of much speculation. Was it the result of a new stream of Byzantine influence similar to the one that had also left its mark on the works of the Berlinghieri? More likely the choice was owed equally to the Byzantine influence and to the more human emotional approach toward religion in general and toward the suffering of Christ in particular that had been introduced by St. Francis. It was just ten years

* Just how close the thirteenth-century paintings of Tuscany and Venice were in style and iconography to those of the eastern Mediterranean has been brought into sharp focus by the researches at the monastery of St. Catherine on Mt. Sinai in the Red Sea peninsula. The Greek scholar George Soteriou has published many of its icons (see bibliography at end of chapter), and the joint expeditions of the universities of Princeton, Michigan, and Alexandria, Egypt, will shortly publish the results of their surprising finds and work. Photographs and advance reports already have been published in various newspapers and periodicals. Noteworthy also are the published studies of Prof. Hugo Buchthal on the manuscript-miniature paintings of the Holy Land in the period of the Crusades (see also bibliography).

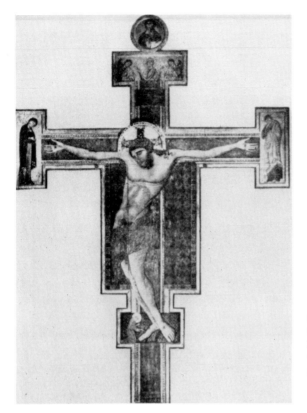

2.13. St. Francis Master: Crucifix (1272). Panel painting, 191⅝" x 139⁹⁄₁₆". Pinacoteca no. 21, Perugia (Alinari)

after the saint's death that Giunta was commissioned to paint the large crucifix for the basilica at Assisi. He repeated this representation of the Christ expiring from His sufferings, instead of the more traditional dogmatic type, in the crucifix for Santa Maria degli Angeli [2.12], the Franciscan church second in importance only to the basilica itself because it was built over the cell in which St. Francis had lived and died. The very fact that this type was used in the churches at Assisi would account for its presence in Franciscan churches elsewhere and for its rapid spread throughout Tuscany, Umbria, and contiguous regions.

The Master of St. Francis of Assisi

Among the many painters whose works show the deep imprint of Giunta's style is an anonymous Umbrian known as the St. Francis Master, or the Master of St. Francis. He acquired his pseudonym because on many of his crosses he painted the figure of St. Francis kneeling at the feet of Christ. A crucifix [2.13] in the Perugia Gallery, bearing the date 1272, is by his hand. He must have been closely associated with the Franciscan Order, for he painted among other things a crucifix now in the sacristy of St. Francis at Assisi as well as the faintly discernible frescoes in the lower church show-

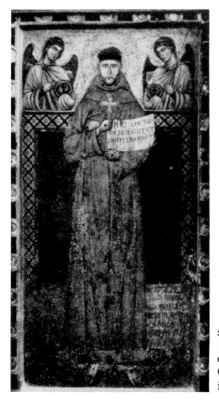

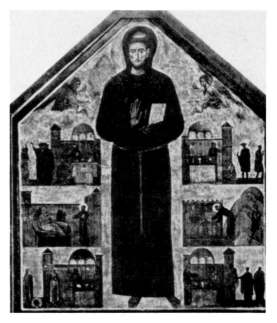

2.14 (*left*). St. Francis Master: Portrait of St. Francis (13th cen.). Panel painting, 41⅞″ x 22½″. Santa Maria degli Angeli, Assisi (Alinari) 2.15 (*above*). School of Giunta: St. Francis Altarpiece (13th cen.). Panel painting, 64⁵⁄₁₆″ x 50⅞″. San Francesco, Pisa (Anderson)

ing episodes from the Passion of Christ and the life of St. Francis. He also painted the full-length portrait of St. Francis on the plank that the saint used as a bed and that is now preserved in the church of Santa Maria degli Angeli [2.14].

The style of the St. Francis Master is a bit drier and his treatment of Christ's body more mannered than Giunta's. He also varied the decorative layout of his crosses. Sometimes he painted the Virgin and St. John in full length at the arm-ends; at other times he filled these ends with large diamond-shaped or circular designs, in which case the Virgin and St. John were placed back on the apron panels. Frequently he also reintroduced as an abbreviated Ascension the half-length figure of the Virgin flanked by two angels in the top rectangle below the medallion with the bust of Christ.

Another painter close to Giunta in style was responsible for the altarpiece [2.15] in San Francesco in Pisa, depicting the full-length St. Francis flanked by six scenes from his life. It is the second in the series of such altarpieces, the first being the one at Pescia signed by Bonaventura Berlinghieri [2.5]. There is no doubt that an interrelation exists between the two, both in iconography and in style. This interrelation between Lucca and Pisa will become progressively more apparent.

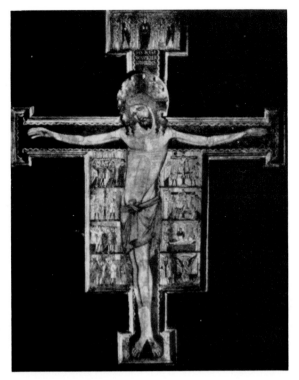

2.16. ENRICO DI TEDICE: Crucifix (13th cen.). Panel painting, 100″ x 82″. San Martino, Pisa (Alinari)

The di Tedice Family

In Pisa, contemporary with Giunta, was a family of painters, the sons and grandson of a certain Tedice. Whether or not Tedice himself was a painter we do not know, but there exist works signed by two of his sons, Enrico and Ugolino, and by one of his grandsons, Ranieri the son of Ugolino.

Enrico's name appears in a document of 1254. Until the seventeenth century an undated crucifix [2.16] bore his signature, *Enrico quondam Tedice me pinxit,* but then the signature disappeared. This crucifix, in the church of San Martino in Pisa, retains in general the old Pisan type of cross with Passion scenes on the apron panel and with the full Ascension minus the roundel with Christ's bust at the top. At the arm-ends are very shallow projections filled only with the crenelated border decoration, so commonly found on Pisan crosses, that runs around the whole cross. The style of the head and corpus of Christ is influenced by Giunta but completely lacks vitality or crispness. The figure style of the Passion scenes displays a similar softness and feebleness but shows that Enrico had some contact with the work of Berlinghiero of rival Lucca. The stylized strands of hair and the jowly faces bear additional witness to this. Also, at the base of the cross, to the right and left of Christ's feet is the divided scene of the Denial of Peter, further evidence of contact with Lucca.

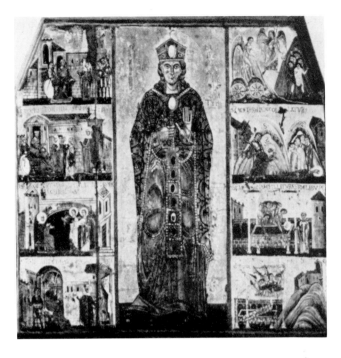

2.17. PISAN SCHOOL: St. Catherine Altarpiece (13th cen.). Panel painting, 44½″ x 41½″. Museo Nazionale no. 3, Pisa (Alinari)

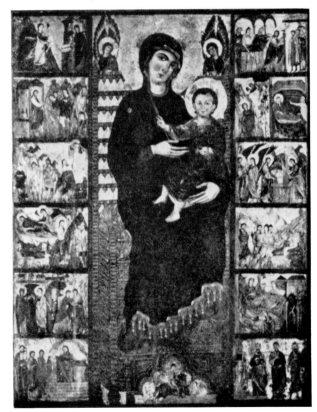

2.18. SAN MARTINO MASTER: Madonna Altarpiece (13th cen.). Panel painting, 62 1/16″ x 48½″. Museo Nazionale no. 7, Pisa (Alinari)

The Berlinghieresque influence is very apparent in a related work, the altarpiece of St. Catherine of Alexandria [2.17] in the Museo Nazionale in Pisa. The saint, regally attired with jeweled crown and a mantle of brocaded eagles, stands facing the front, flanked on each side by four stories of her aggressive and much-martyred existence. The conspicuous fold along the ground at the bottom of her garment is found in many a Madonna and saint in Byzantine mosaics and ivories. The style of the painting on this panel is very close to that of Enrico di Tedice, but it shows a greater firmness and strength than is usual in Enrico's work.

A charming legend * about this altarpiece claims that on September 23, 1235, the panel with the figure of St. Catherine appeared erect in the stream of the Arno, to the consternation of many onlookers. The archbishop of Pisa organized a procession of clerics and monks with cross and candles in an attempt to take the image from the waters, but it could not be moved until the prior of San Silvestro at Pisa, endowed with supernatural powers, arrived and carried it off to his monastery. There it remained until, centuries later, it was installed in the Museo Nazionale. Since the relics of St. Catherine had been taken to Mt. Sinai in the ninth or tenth century and since the monastery there, thereafter called St. Catherine's, possessed a venerated early icon not dissimilar from the altarpiece at Pisa, it is tempting to conjecture another connection here between Pisan paintings of the thirteenth century and models from the eastern Mediterranean. The legend of the Pisan altarpiece appearing in the Arno would then be symbolic of the introduction of the cult of St. Catherine at Pisa from beyond the sea.

The only signed work of Enrico's brother Ugolino is now in the Hermitage Museum in Leningrad. Although damaged in some areas, it still exhibits a style so close to that of Giunta that Ugolino might easily have been in his workshop. There is nothing to suggest the style of Enrico.

Ranieri d'Ugolino, the third member of the Tedice family, signed a crucifix now in the Museo Nazionale in Pisa—no. 17. It is not reproduced here because of its bad state of preservation, but despite this it does display a very effective style. The layout of the crucifix is the simplified one introduced by Giunta, and the figure of the Christ, too, follows the type Giunta established. But the hands are rendered with the thumbs turned in over the palms, according to the earlier Pisan tradition and the one used by the other members of the Tedice family, whereas Giunta spread out all five fingers. Another divergence from the Giunta type is the single nail pinning Christ's feet to the cross, a characteristic feature of Gothic crucifixions. The Gothic form was used by Niccoló Pisano on his sculptured pulpit at Siena and became common in fourteenth-century painting. The total effect of Ranieri's crucifix is one of emotion deeply felt and full of pathos. It makes, as has been suggested by Mme. Vavalà,† a transition between the dramatically rendered crucifixes by Giunta and those of Cimabue (3.20 and 3.21).

* Related by Enzo Carli in *Pittura Medievale Pisana*, Milan, 1958.
† Vavalà, *op. cit.*

A most important but anonymous master is responsible for two signif-
icant altarpieces now in the Museo Nazionale in Pisa: one, no. 6, of St. Anne
and the Virgin and the other, no. 7, the Madonna from San Martino in Pisa
[2.18]. The latter is most impressive, one of the great altarpieces of the
thirteenth century. It shows the Madonna seated on an elaborately tooled
wooden throne. Two half-length angels are placed on the top rung of the
ornate ladderback of the throne, one on either side of the Madonna's head.
Twelve small panels, eleven with scenes from the life of the Virgin and one
containing four standing saints, flank the centrally placed Madonna. Beneath
the cusped opening of the footstool of the throne is the scene of St. Martin
on horseback dividing his cloak to share it with a beggar.* A mixture of
style currents are present in this altarpiece. Some are Byzantine, some Luc-
chese, but they are chiefly Pisan in the feeling and action of the small scenes
and in the echoes of Giunta's style. Such details as the heads of the two
angels, their pose, and the treatment of the eyes are so close to those of
the heads of the Virgin and St. John on Ranieri's crucifix that they almost
appear to be by the same hand. Contrarily, other elements, such as the pose
of the Madonna and Child, seem to be connected with works of such later
artists as Cimabue and Duccio, which would date this altarpiece well into
the third quarter of the thirteenth century.

Pisan painting, then, was characterized by its two types of crucifixes, the
earlier one with many scenes and the later more simplified one, and by its
distinctive style. Before Giunta, the Pisan style was as varied as the life of
the city was cosmopolitan; the later crystallization into greater uniformity
as it appears in Giunta's work was the result of new or renewed Byzantine
influences as well as influences from Lucca. The Lucchese influence was
stronger in its effect on the Tedice family; the Byzantine was stronger on
Giunta.

Giunta's style was the more vital and vigorous, and so it was from his
workshop that the streams of influence went out to other regions of Italy.
We have seen how his type of cross and Christ with closed eyes and S-shaped
body curve spread through Umbria after Giunta's presence at Assisi. And if
we have observed influences from Lucca affecting the style of the Tedice
or even contributing some elements to Giunta's milieu, such as appear in the
St. Francis altarpiece in Pisa, the reverse was also true: some of the Luc-
chese crosses around and after the middle of the thirteenth century definitely
show the effect of Giunta's innovation. For example, the cross [2.19] in the
convent of the Oblates at Careggi near Florence is so close in style to Ber-

* Because of this scene and because the altarpiece came from the church of San
Martino, the painter has been called the Master of San Martino. The altarpiece has also
been attributed to Ranieri d'Ugolino (see E. B. Garrison: *Italian Romanesque Panel
Painting.* New York, 1949). Enzo Carli, *Pittura Medievale Pisana* (see bibliography), at-
tributes it to the anonymous painter-illuminator of an Exultet manuscript in the Museo
Civico in Pisa, whom he considers to be the same as the Master of San Martino.

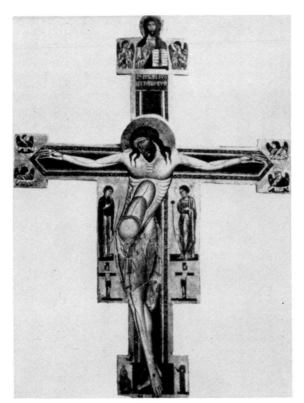

2.19. SCHOOL OF BERLIN-
GHIERI: Crucifix (13th cen.).
Panel painting, 71″ x 52″.
Convent of the Oblates, Flor-
ence (Alinari)

linghiero that some have attributed it to him. Yet the Christ is the closed-eye type, and in style and form shows the obvious influence of Giunta.

By the middle of the thirteenth century two predominating styles had thus emerged in Tuscany, that of Berlinghiero and his family in Lucca and that of Giunta and his workshop in Pisa. Each was strong enough to have some effect on the other. Each was to pass on the fruits of its accomplishments and become an important contributor to the painting styles of thirteenth-century Florence and Siena.

Appendix: Spoletan Crosses

As an aside or appendix to this discussion of the crucifixes of Lucca and Pisa, two crosses from the region of Spoleto, the old Duchy of Spoleto, at the other end of the Umbrian valley from Assisi and Perugia, claim our attention. They not only give us an impression of the earlier type of crucifix in this region before Giunta's type took over, but each is of particular interest by itself. The one in the cathedral of Spoleto [2.20] is the next earliest dated cross known after the Sarzana crucifix [2.1]. It bears the date 1187 and the damaged signature of the painter, Alberto Sotio, and is painted on parchment like the crucifix no. 20 at Pisa [2.10]. Much simpler in its decorative features than the Lucchese and Pisan crucifixes, Sotio's cross has only

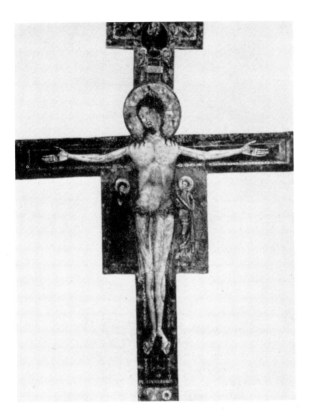

2.20. ALBERTO SOTIO: Crucifix (1187). Panel painting, 109⅝″ x 78⅞″. Cathedral, Spoleto (Anderson)

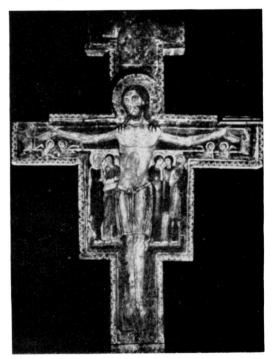

2.21. SPOLETAN: Crucifix (13th cen.). Panel painting, 82″ x 58¾″. Santa Chiara, Assisi (Anderson)

the Virgin and St. John the Evangelist on the apron panel. At top, as an abbreviation of the Ascension, Christ steps heavenward in a glory * supported by four angels. Beneath the suppedaneum is a small hill, representing Golgotha, on which can be seen Adam's skull. There are no extensions at the arm-ends. All these elements establish the Spoletan type of crucifix to be found in other crosses of the vicinity.

In style, the linear stylizations of features and draperies are unusually hard and metallic, giving to Christ's face a curious birdlike quality. The draperies of the Virgin, of St. John, and of the angels almost give the effect of an enamel technique with the wirelike highlights and the pockets of color or shadow. The anatomic conventions of Christ's body, the treatment of the abdominal lines, and, in particular, the muscular indications within the upper and lower arms also suggest enamels. Although these conventional stylizations are found in the Lucchese crosses, they are rarely so wirelike as here, nor are the arm muscles so completely turned into small "island" areas similar to those on Limoges enamels. Add to this the evidence of the vermiculated leaf ornament on the cross in Christ's nimbus and of the ornament of the quatrefoil within a stepped motif that runs around the borders of the cross, and we can be almost certain that Sotio was acquainted with and in part influenced by the art of the medieval enamel workers.

The second crucifix [2.21] presently is in the church of Santa Chiara at Assisi; formerly it was in the little church of St. Damian outside the city walls. It has very special interest because it is the cross that, according to legend, spoke to St. Francis and brought about his conversion. Its form is the Spoletan one—that is, it has no projections at the arm-ends, the Virgin and St. John flank the body of Christ without any additional scenes, and the Ascension scene at the top shows Christ stepping heavenward in a glory. But in the Assisi cross many more angels are present, ten in all, than in that by Sotio. This is especially interesting because St. Francis had an enthusiasm for angels. The extra figures accompanying the Virgin and St. John on the apron panels and the small half-length angels about the hands of Christ echo the Sarzana-early Lucchese type of cross. The decorative Lesbian-leaf border around the cross became a common feature in Umbria.†

* A characteristic of Western illuminated manuscripts of the tenth to twelfth centuries.
† A fragment from another Spoletan crucifix is in Walters Art Gallery in Baltimore. All that is left of a crucifix now lost is the figure of the Virgin from the left apron panel. Sensitive and moving, it is very close to Sotio's in style. The folds of the drapery, though, are more curvilinear and swinging than those used by Sotio himself.

BIBLIOGRAPHY

Simonde de Sismondi, J. C. L. *History of the Italian Republics in the Middle Ages.* New York, E. P. Dutton & Company, 1906.

Offner, R. *Italian Primitives at Yale University.* New Haven, Yale University Press, 1927.

Vavalà, E. Sandberg. *La Croce Dipinta Italiana e l'Iconografia della Passione.* Verona, privately printed, 1929. (Sourcebook for crucifixes)

Garrison, E. B. *Italian Romanesque Panel Painting.* Florence, Leo S. Olschki, 1949.

—— *Studies in the History of Mediaeval Italian Painting,* 3 vols. Florence, "L'Impronta," 1953–1957.

Soteriou, G. A. and M. G. *Icones du Mont Sunai,* 2 vols. Athens, Collection de l'Institut Français d'Athènes, 1956. (Plates in vol. I)

Buchthal, H. *Miniature Painting in the Latin Kingdom of Jerusalem.* Oxford, Clarendon Press, 1957.

Carli, E. *Pittura Medievale Pisana.* Milan, A. Martello, 1958. (For the plates of Pisan painting)

◆ 3
Painting in
Florence and Siena

THE sanguinary feud between the Guelphs and Ghibellines in Italy greatly heightened the already bitter political rivalry between Florence and Siena. Originally this Guelph-Ghibelline feud was an early twelfth-century affair between two south German princely houses, the Hohenstaufens of Swabia and the Welfs of Bavaria. The partisans of the former were to be known as Ghibellines * and the supporters of the latter as Guelphs. Hence, when the Hohenstaufen emperor Frederick I (Barbarossa) invaded Italy, his partisans were also known as Ghibellines, while Frederick's enemies in the cities of the Lombard League and the supporters of the pope in his struggle with Frederick became known as Guelphs. It was only with the death of Frederick II in 1250 and of his immediate successors in 1266 and 1268 that this struggle for power between the papacy and the empire came to an end.

In the meantime, Guelph and Ghibelline factions had grown up in most cities of central and northern Italy, with one or the other party predominating. In Tuscany, Florence, as a supporter of papal policies, was Guelph; Siena, favoring the emperor was Ghibelline. The situation, however, was further complicated by the fact that these opposing parties produced civil wars and feuds within the cities themselves, in which case their adherence to the papal or imperial policies often became blurred. For example, the murder in

* The name is derived from Waiblingen, one of the Hohenstaufen castles, which name was also used as a battle cry. The substitution of a *G* or a *GU* in Italian for a German or English *W* is common, for example, Guglielmo for William or Gualterio for Walter.

49

Florence on Easter Day 1215 of a young nobleman (Buondelmonte) belonging to the Guelph faction brought into the spotlight such a local feud. Hence for decades on end Italy was kept in a state of confusion as a result of warring factions: pope versus emperor, one city against another.

It is not surprising, therefore, to find various religious outbursts during the thirteenth century as expressions of popular hunger for peace amid the ceaseless feuding and bloodshed. The year 1233 became known as the Hallelujah Year because people went about greeting each other with a triple hallelujah. They also sang songs of acclamation, *Laudes,* or lauds, in praise of the members of the Trinity and the Blessed Virgin. 1233 was also the year in which the Order of Servites (Servants of Mary) was founded in Florence, and 1233 was the year when the itinerant Dominican Fra Giovanni da Vicenza preached and staged a year of truce in which enemies were to forget their grievances, praise the heavenly powers, and make peace.

Another significant popular expression for peace was the Flagellanti movement, initiated in Perugia by the young ascetic Raniero Fasani in 1259–1260. This was perhaps brought about by the fact that people were aware of the prophecy of Gioacchino da Fiore (late twelfth century) that the era of the Holy Spirit would begin in the year 1260 and that the Antichrist would have appeared ten years before, 1250, which Antichrist some had thought to have been Frederick II and others Pope Nicholas IV. In any case, a revivalistic fever to make peace and do good sent the Perugians, singly or in processions, to squares and churches, stripping themselves to the skin, beating themselves with knotted whipcords, and chanting penitential songs and lauds in which the main themes were episodes from Christ's Passion or the Sorrows of the Virgin.

After about two years the hysteria had worn thin, but not until groups had been organized to apply order and discipline to aims and actions. Among these groups were the Society of the Disciplined (*Disciplinati*) of Jesus Christ at Perugia, the Society of Life (*Vita*) at Bologna, the Society of Death (*Morte*) at Mantua, and the Society of the Beaten Ones (*Battuti*) at Modena. Other societies were formed whose members went about acclaiming the Virgin with hymns, as people in 1233 had done in their enthusiasm for the cult of the Virgin.

All this, together with the growth of the Franciscan and Dominican orders mentioned in Chapter 1, had direct bearing on the increased demand for Madonnas during the second half of the thirteenth century and on the size of the Madonna altarpieces, even, as we shall see, on their iconography.

Meanwhile, in Florence, after the death of Frederick II in 1250, the Guelphs had scored a great victory and ousted the imperial Ghibellines. But the real victor at that time was the *popolo,* the populace, and for the next ten years the first popular government, the *primo popolo,* was master in Guelph Florence. Feeling its young strength, Florence tried to secure control of all Tuscany, and victories were won over Pistoia, Pisa, and Siena. A treaty of alliance was signed in 1255 with Siena, Florence's greatest rival

for power. When Frederick's natural son Manfred was crowned at Palermo in 1258, imperial hopes were fired anew; Ghibelline exiles from Florence connived with the Sienese; and in the great war that broke out between the two cities, Florence was totally defeated at Montaperti in 1260.

Siena's victory was short-lived. After the arrival of French forces in Italy at the request of the pope, the French and the Guelphs took Florence in 1267 and the next year, when Conradino was beheaded, the power of the Hohenstaufens was broken. Pope Nicholas II fruitlessly attempted to reconcile the Guelphs and the Ghibellines, but Florence remained Guelph for two hundred years more.

Between 1270 and 1280 a great economic boom took place in Florence. Population increased at a high rate; a second circle of walls was built; Florentine banking houses were entrusted with the pope's banking operations; and trade increased because of favors granted the city by the Angevin Charles and the king of France. Merchant guilds became so strong that in 1283 they established their own government, freed from the noble aristocracy. This government was composed of representatives, called Priors, of the foremost guilds. The merchant guilds, called the *arti maggiori*, were seven in number—the lawyers, the notaries, the cloth, the wool, and the silk merchants, the money dealers, and the furriers. The shopkeepers and artisans made up twenty-five less important guilds, the *arti minori*. Five of these, known as the *arti medie*, were asked to take part in the government of the merchant guilds. By the end of the thirteenth century Florence was well on its way to commercial success and political domination of Tuscany. In this political and economic setting it was to develop its styles of painting and eventually take the lead in Tuscany in that field too.

Florence

The beginnings of Florentine painting are still hidden in the realm of conjecture. Possibly Florence was as slow getting started in the field of art as it had been in politics. Certainly Lucca and Pisa had anticipated Florence in both fields. Although painters' names are recorded in the thirteenth century, no works can be associated with most of these names. But there can be no doubt that when Florentine painting emerged in the thirteenth century it bore the marks of dependence on the schools of Lucca and Pisa.

A claim for Florentine origin is made for a crucifix [3.1] in the Bigallo, Florence. With the abbreviated Ascension at the top, comprising the Virgin in half length flanked by two angels beneath a roundel with the bust of Christ, its form is related to that used by Berlinghiero. The mourning Virgin and St. John at the sides, the knot and fold of the loincloth, and the scene of Peter's Denial at the bottom of the cross are all in the Lucchese Berlinghiero tradition. But the artist has made everything softer in treatment, and the decorative border motifs are not those of Lucca.

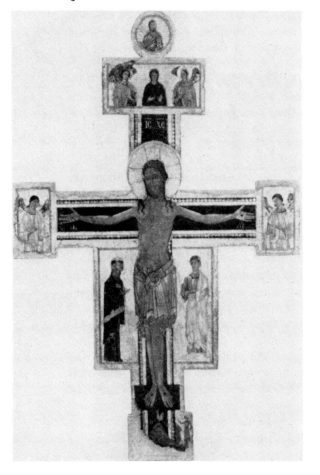

Called the Bigallo Master after the name of the museum where the crucifix now is, this anonymous artist active in the second quarter of the thirteenth century established a style that is found in a number of paintings: a series of Madonna panels [3.2] in various collections and the altarpiece of San Zenobius, the early Christian bishop of Florence, in the Opera del Duomo. Characteristic elements of the Bigallo Master's style are (1) the throne made up of projecting moldings of Lesbian-leaf motifs facing each other, with one molding separated from the next by flat bands; (2) the low rectangular footstool; (3) the frontal position of the Madonna and Child, the Madonna resting one hand on the Christ child's shoulder, the other touching His feet; (4) the drapery fold between the knees of the Madonna and the dots on Her garment; and (5) the standing angels or other figures to the right and left of the Madonna's shoulders.

If the modeling of the features on the figures inclines to be flat and the expressions to be rather bland, the opposite is true of three anonymously

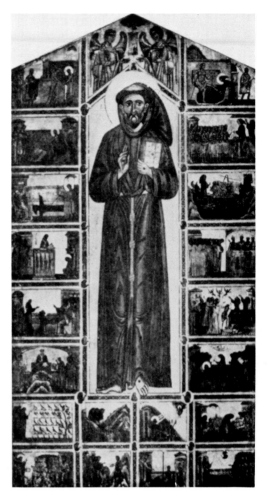

(*Opposite*) 3.1 (*left*). BIGALLO MASTER: Crucifix (13th cen.). Panel painting, 70⁹⁄₁₆″ x 47¹¹⁄₁₆″. Bigallo Museum, Florence (Soprintendenza)

3.2 (*right*). BIGALLO MASTER: Madonna Enthroned (13th cen.). Panel painting, 39⁷⁄₁₆″ x 24¼″. Collection George R. Hann, Sewickley, Pa. (Courtesy Mr. Hann)

3.3 (*right*). FLORENTINE SCHOOL: St. Francis Altarpiece (13th cen.). Panel painting, 92¼″ x 50¹⁄₁₆″. Bardi chapel, Santa Croce, Florence (Alinari)

painted panels of the early third quarter of the century that display an even closer relationship with the style of Berlinghiero and his son Bonaventura. These are highly significant works, for they are definitely antecedents, if not contemporaries, of the early style of Coppo di Marcovaldo, the first Florentine artist whose name and works we know and who was active from the middle of the thirteenth century on. The three panels are the St. Francis altarpiece [3.3] in the Bardi chapel in Santa Croce, Florence, the St. Michael altarpiece [3.4] in the church of Sant' Angelo at Vico l'Abate, and the crucifix no. 434 [3.5] in the Uffizi, formerly in the Accademia in Florence. In all three the treatment of the hair, the oval and jowly heads, and the strong highlighting of the features show their dependence on the style of the Berlinghieri. The decorative borders on the St. Francis altarpiece and on the crucifix have the "wineskin" motif so usual in the Lucca school.

The Bardi St. Francis [3.3], like the one in Pisa [2.15], is derived in type from the St. Francis on the Pescia altarpiece [2.5]. He even has the

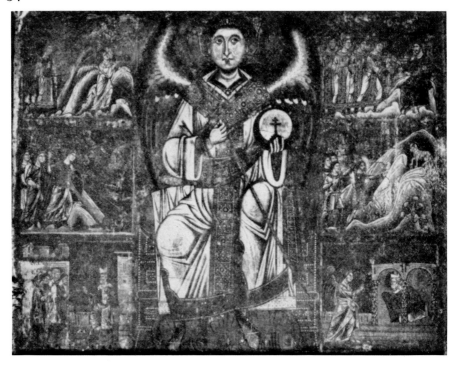

same strange ear. But in contrast to the other two, the St. Francis altar-piece in the Bardi chapel has many more scenes from the saint's life—twenty as against six. And yet there is sufficient similarity in the iconography of certain of the scenes to establish a link among all three altarpieces. An un-usual feature in the Bardi panel is the presence of a number of small medal-lions containing busts of Franciscan monks. These are inserted in the bor-ders around the figure of the saint and at the corners of the four scenes below him. All these little figures have their hands raised to the saint ex-cept the ones on axis with him. The one at the apex of St. Francis's head is nimbed and seems to be a repeat of the saint himself. Three in the bor-der at the bottom have partially disappeared because the panel has been pared down. This, as far as I know, is the earliest example in Italian paint-ing of such border medallion figures, so effectively used by Duccio in the Rucellai Madonna [5.1] and by Cimabue in the Madonna in the Louvre [3.19].

In the Vico l'Abate altarpiece [3.4], the effectiveness of abstract forms, colors, and patterns of light and dark in rhythm is forcefully shown, both in the central figure of St. Michael enthroned with his wonderful wings and in the scenes at the sides, such as the Bull on Mt. Gargano. These are all painted on a silver background instead of the more usual gold one.

The crucifix no. 434 [3.5] in the Uffizi, although reflecting the style of Berlinghiero in the small scenes on the apron, is strongly influenced by

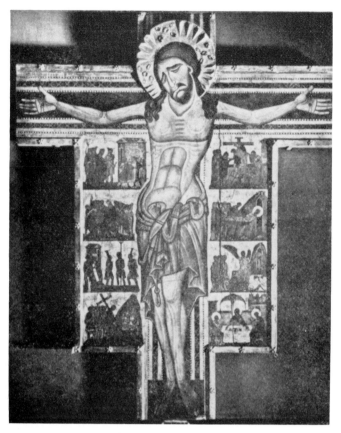

(*Opposite*) 3.4. FLORENTINE SCHOOL: St. Michael Altarpiece (13th cen.). Panel painting, 38⅝″ x 48⅞″. Sant' Angelo, Vico l'Abate (Alinari)

3.5. FLORENTINE SCHOOL: Crucifix (13th cen.). Panel painting, 118⁵⁄₁₆″ x 79⅞″. Uffizi no. 434, Florence (Anderson)

Giunta Pisano in the treatment of the head, the corpus, and the loincloth of Christ. The cross itself, which has been cut down at the ends and at the top and bottom, shows another Pisan feature in the Passion-Resurrection scenes on the apron panels, so popular on crucifixes before the simplifications introduced by Giunta. It is a crucifix of great expressiveness and power and, like the Vico l'Abate altarpiece, again demonstrates how telling abstract stylizations can be in the rendering of emotions.

Coppo di Marcovaldo and His Contemporaries

In style it is only a step from this crucifix to crucifix no. 30 in the Gallery of the Palazzo Communale [3.6] at San Gimignano. This, in turn, is but a step from another [3.7] in the *duomo* at Pistoia. All three crucifixes have similar scene sequences on the apron panels as well as interrelated styles. For example, in three scenes that the San Gimignano and Pistoia crucifixes have in common, certain details are almost identical—the way in which Judas approaches Christ, the gesture of the High Priest pointing at Christ in the Trial scene, and the curious vertical cliffs in the Pietà. The Berlinghieresque figure style and the "wineskin" motif in the borders of the Uffizi and San

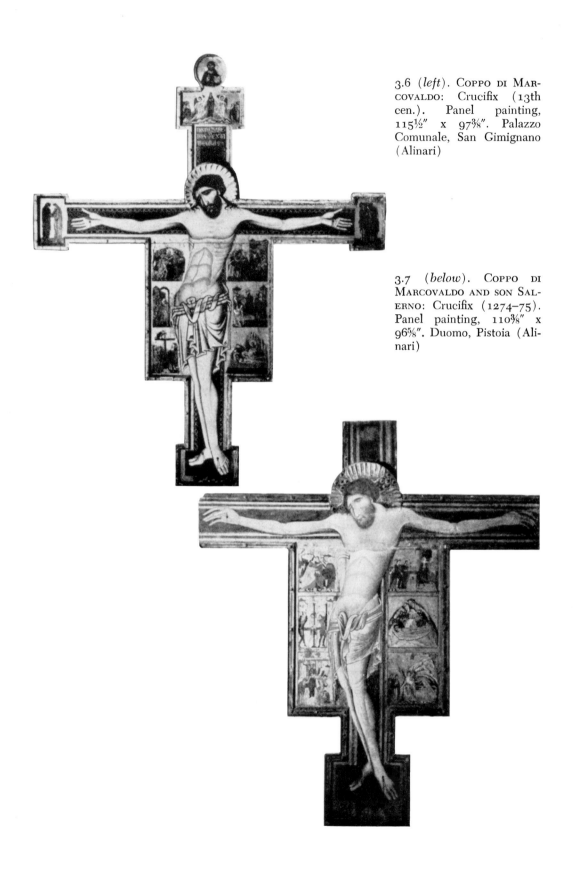

3.6 (left). COPPO DI MAR-
COVALDO: Crucifix (13th
cen.). Panel painting,
115½″ x 97⅜″. Palazzo
Comunale, San Gimignano
(Alinari)

3.7 (below). COPPO DI
MARCOVALDO AND SON SAL-
ERNO: Crucifix (1274–75).
Panel painting, 110⅜″ x
96⅝″. Duomo, Pistoia (Ali-
nari)

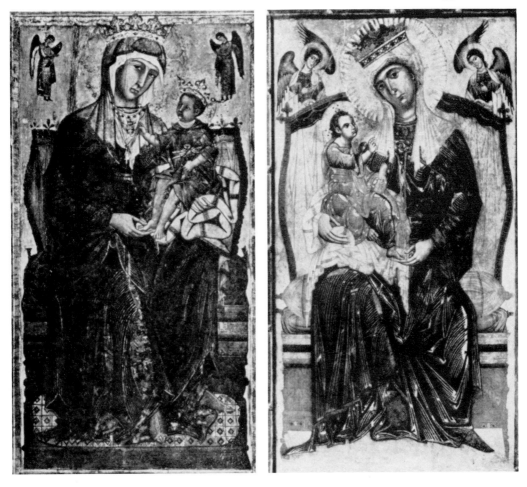

3.8 (left). COPPO DI MARCOVALDO: Madonna Enthroned (1261). Panel painting, 86¾" x 49⁵⁄₁₆". Santa Maria dei Servi, Siena (Anderson). 3.9 (right). COPPO DI MARCOVALDO: Madonna Enthroned (c. 1265–70). Panel painting, 93⅞" x 53³⁄₁₆". Santa Maria dei Servi, Orvieto (Anderson)

Gimignano crosses indicate contacts with the Lucchese tradition, while the type of Christ and the historiated apron panels echo the Pisan. In all three crosses the separate streams of blood and water are represented issuing in a similar manner from the side of Christ. In the San Gimignano and Pistoia ones the manner is identical.

The Pistoia crucifix is mentioned in a document of the year 1274. It was to be painted by "master Coppo and his son Salerno." From another document we know that Coppo's father was a certain Marcovaldo. Hence his name, Coppo di Marcovaldo, Coppo the son of Marcovaldo. He is one of the earliest Italian painters about whom we have certain documented knowl-

edge. We know that he served in the Florentine army, a conscript no doubt, as a shieldbearer in the famous battle of Montaperti in 1260. Coppo apparently was taken prisoner by the Sienese and in the church of the Servi in Siena is the magnificent Madonna [3.8] that he painted in 1261 for the Order of Servites. The signature of the artist and the date have recently come to light again after a cleaning. Within fifty years after it was painted, however, the faces of the Madonna and Child were repainted by a pupil of Duccio for some unknown reason. We shall meet another instance of this procedure later.

This Coppo Madonna is an important landmark in the development of Italian painting in the thirteenth century. She stands at the head of a long series of Madonnas painted in the latter half of the century when the increase in importance and production of Madonnas is so striking. As was said earlier in this chapter, this was apparently due to the renewed and special attention being given to the cult of the Madonna. Consequently it is not surprising that Coppo painted this Madonna for the Servites, the Servants of Mary, and that his other surviving Madonna [3.9] was painted for the Servites at Orvieto. Other great painters of the period were also painting for the Servites.

The type of Madonna that Coppo painted is important to note. She is the Byzantine Hodegetria ("she who points the way") seated on a high-backed throne, with her left hand supporting the Christ child on a special cloth and her right hand touching one of His feet. Her mantle is covered with thin gold lines like fish bones, such as appear on the Pantocrator, Christ the All-powerful [1.14], in Sicilian mosaics. The Servite Madonna at Orvieto reverses the position of the one at Siena and places two half-length angels above the back of the throne instead of the two small-scale standing angels in the Siena Madonna. These Madonnas by Coppo were copied and had a wide influence in Tuscany and Umbria. We shall have occasion to revert to them when we discuss the works of Guido da Siena.

By comparing the pose and facial types of the two standing angels in the Servite Madonna in Siena with the Holy Women in the right-end projection of the crucifix in the San Gimignano museum [3.6], we can correctly attribute that cross to Coppo in an earlier phase of development.*

Still other documents indicate that Coppo was working in the chapel of San Jacopo in the Pistoia cathedral in 1265 and again in 1269. Documents for 1274 concern the painting of a crucifix, a Madonna, and a St. John the Evangelist for the choir of the same cathedral and a crucifix and a St. Michael for the altar of that archangel saint. Coppo was commissioned to paint these with his son Salerno who apparently had to be gotten out of debtors' prison at Pistoia to help his father and to work off some of his debts. The crucifix [3.7] that was painted for the choir is now in the sacristy of the cathedral at Pistoia. The softer quality of the treatment of the corpus of Christ would

* See article by Gertrude Coor in Bibliography at end of this chapter.

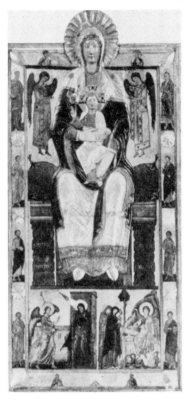

3.10. COPPO DI MARCOVALDO (SHOP): Madonna Enthroned (13th cen.). Panel in low relief and painting, 98⅝" x 48½". Santa Maria Maggiore, Florence (Anderson)

seem to indicate that Salerno did the major work on it. But the closeness of details of style and iconography of the apron panels that we noted before between the San Gimignano cross and the one at Pistoia seems to indicate that Coppo's guiding hand was present in the latter.

We should mention as a curiosity an altarpiece of the Madonna [3.10] in Santa Maria Maggiore in Florence in which painting and sculpture are combined. The Madonna and Child, enthroned and frontal, are polychromed in low relief. The two standing angels above the Madonna's shoulders, the apostles in the borders, and the two scenes beneath the Madonna's throne (the Annunciation and the Three Marys at the Tomb) are painted. The painting style, certainly close to Coppo's, indicates that this is perhaps from his workshop. The heavy leaf motif that appears on the Madonna's throne is the same as that used by Coppo in his two Madonnas and on the crown of the Madonna at Orvieto.

A contemporary of Coppo was Meliore di Jacopo or Meliore Toscano. The two painters must certainly have known each other because from documents we learn that they shared similar experiences. Both were listed among those who fought at Montaperti and both worked on the decorations of the chapel of San Jacopo in the cathedral of Pistoia, although Meliore preceded Coppo at Pistoia; documents place him there in 1239, 1246, and 1253.

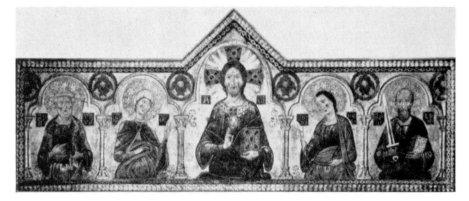

3.11. MELIORE: Christ and four Saints (1271). Panel painting, 33⁷⁄₁₆″ x 82¾″. Uffizi, Florence (Alinari)

The altarpiece [3.11] bearing his signature and the date 1271, now in the Uffizi, would consequently represent work of Meliore's late period. Its shape is the rather unusual one of a low rectangular panel. A gable rises from the middle of the top above the half figure of Christ, which is set higher than the four flanking half figures of St. Peter, the Virgin, St. John the Evangelist, and St. Paul. Each figure is beneath a trefoiled arch supported on double colonnettes, that of Christ being higher than the rest. It is an elegant piece of work, full of echoes of Byzantine craftsmanship in the use of gold lines and linear stylizations. The effect is enriched by the large haloes engraved with floral designs and by the crystal cabochons set in Christ's cross-nimbus, His bordered mantle, and the cover of His book.*

A fine altarpiece in the church of San Leolino at Panzano has also been attributed to Meliore. In the center of the panel the enthroned Virgin is flanked by St. Peter and St. Paul, both turned toward her with gestures of obeisance. Two scenes each from the life and martyrdom of SS. Peter and Paul enclosed in pearl borders flank the central figure.

In its general layout and rich decoration, an altarpiece [3.12] in the Musée des Arts Decoratifs, Paris, is closely related to this altarpiece at Panzano. Again we have as the central feature the enthroned Madonna flanked by two saints, this time Andrew and James. Because the throne is high-backed, the saints stand partly to its rear and rest one hand on its back. The six scenes on the sides are from the life of the Virgin. Each has

* It is tempting to consider this type of dossal-altarpiece as an adaptation of the Deisis icons found on Byzantine iconostases. An example of this Byzantine type can be found illustrated in fig. 117 of Vol. I of G. Soteriou's publication on the icons of Mt. Sinai, cited in the Bibliography on page 48. There we see the bust-length figure of Christ flanked by the Virgin, St. John the Baptist, SS. Peter and Paul, the Four Evangelists, and two military saints. Meliore substituted St. John the Evangelist for the Baptist, but SS. Peter and Paul are there, and we have evidence that originally the dossal was longer.

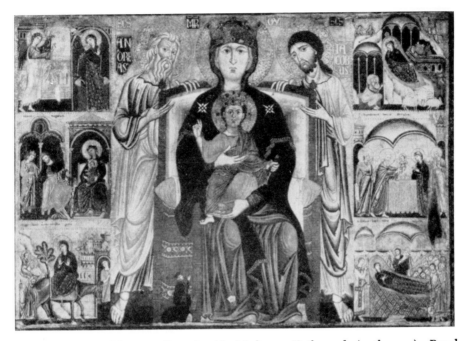

3.12. MAGDALEN MASTER: Dossal with Madonna Enthroned (13th cen.). Panel painting, 36⅝" x 53¾". Musée des Arts Decoratifs, Paris (Anderson)

a pearled border like those in the Panzano piece but in the spaces above the scenes an explanatory verse has been added. The richly incised floral haloes and the cabochons set in the crowns of the Virgin and the Christ child recall the effect of Meliore's altarpiece, but the figure style differs perceptibly from his. The altarpiece belongs to a whole group of panels that have been associated with the painter who did the dossal of St. Mary Magdalen and the eight stories of her life in the Accademia at Florence. An anonymous artist, he has been called the Magdalen Master. He seems to have been active from the early 1260's to the end of the century and must have been a prolific painter of uneven quality if we are to judge from the panels attributed to him. He is also an early example of an eclectic, because from among his many panels we can see elements echoing the work of Berlinghiero, Coppo, Meliore, and Cimabue in addition to that of the mosaic masters of the dome of the Baptistery at Florence.

The Baptistery Mosaics

Before we can proceed to a discussion of Cimabue we need to mention the contemporary mosaics that were being created in Florence.

Frequently in our survey of Tuscan painting we have remarked on the new impulses from Byzantine art that were being manifested. The paintings of Berlinghiero and his followers at Lucca showed Byzantine influences.

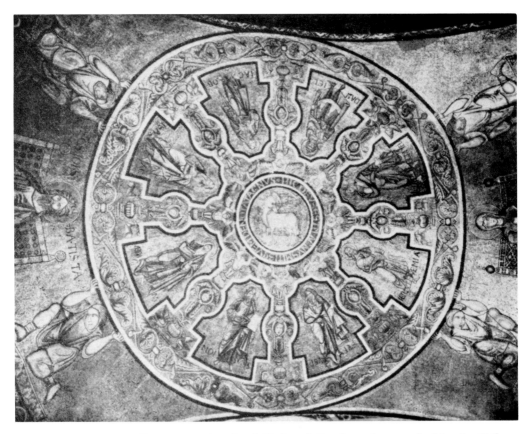

3.13. ITALO-BYZANTINE: Lamb of God and Prophets (*c.* 1225). Mosaic. Tribune vault, Baptistery, Florence (Alinari)

Giunta's new type of the dying or dead Christ had been taken literally from Byzantine models, and details of his style were derived from Byzantine prototypes. In the hands of his followers these had almost the quality of stencil reproductions. And the types of Coppo and his Florentine contemporaries heightened these harsh stylizations. Although we can point to manuscripts, icons, or mosaics—mosaics even in Italy, such as those at Venice, Lucca, Spoleto, and San Miniato in Florence—that might account for the Byzantinisms of painters in the later twelfth and early thirteenth centuries, how do we explain the persistence of this strong Byzantined style in Tuscany in the last quarter of the thirteenth century when in sculpture and architecture the Gothic style had already broken through?

One answer, it seems to me, lies in the most elaborate and magnificent mosaic decoration in Tuscany, that of the tribune and dome of the Baptistery in Florence, in which presumably some Florentine artists took part. We know that as late as 1302 Cimabue, a Florentine painter, was commissioned to work on the apse mosaics in the cathedral of Pisa. Why, then,

shouldn't earlier Tuscan painters have assisted in the mosaics in Florence and been influenced by the Byzantine mosaic technique imported to Italy by artisans from the eastern Mediterranean and imitated by local artisans?

The tribune, or dais, of the Florence Baptistery was added in 1200. Its vault [3.13] is decorated with the earliest mosaics in the Baptistery, which, according to the inscription, were done in 1225 by a Franciscan monk Jacobus. The date has been questioned because in the inscription Jacobus, or Jacopo, calls himself a monk of "St. Francis" and Francis of Assisi was not canonized until 1228. But as Raymond van Marle, the late Dutch art historian, has suggested, it is quite possible that the inscription was added at a slightly later date when Francis had already been canonized.

The mosaic decoration of the vault of the tribune consists of a large wheellike design supported at each of the four corners of the vault by an Atlas figure crouching on one knee on top of a Corinthian capital. In the center of the design, which is the center of the vault, stands the Lamb of God encircled by an inscribed band. Between every two spokes of the wheel is the frontal full-length figure of a prophet. In the spaces between the wheel and between the Atlas figures on the columns are the enthroned figure of the Madonna on one side and that of St. John the Baptist, the patron saint of Florence, on the other.

The lower surface of the arch leading from the tribune into the main area of the Baptistery is decorated with vine motifs and with medallions enclosing heads of Christ, the apostles, and the prophets.

The great expanse of the octagonal dome over the Baptistery is covered with glittering mosaics making an overwhelming impression of splendor. The inner surfaces of the dome are divided horizontally into a series of receding bands. The two bands at the very top form what is known as a "tent of heaven," beneath which the drama of the beginning and end of all things is unfolded. In the uppermost band stands the Christ-God as the Creator surrounded by seraphs and flanked by pairs of angels representing the various categories of the Heavenly Hosts: Thrones, Virtues, Powers, Dominations, Principalities, Archangels, and Angels. Below Christ-God as Creator is the huge figure of Christ as Saviour and Judge seated on a rainbow of heaven within a jewel-studded glory [3.14]. At the top of the glory are two trumpet-blowing angels, each flanked by others bearing symbols of Christ's Passion. At the base of the glory the dead are rising from their tombs, awaited by angels and devils. In two rows beneath the symbol-bearing angels and flanking Christ's glory are the Virgin and the Baptist as intercessors, the apostles attended by angels, and the Blessed and the Damned in heaven and in hell. The remaining five sections of the dome are divided into four bands, each containing a series of scenes from a Biblical cycle: the Creation cycle up to the Flood; the Joseph cycle; the life of Christ; and the life of St. John the Baptist. The figures in these scenes, being in smaller scale than those of the Last Judgment, tend to emphasize the importance of that final event.

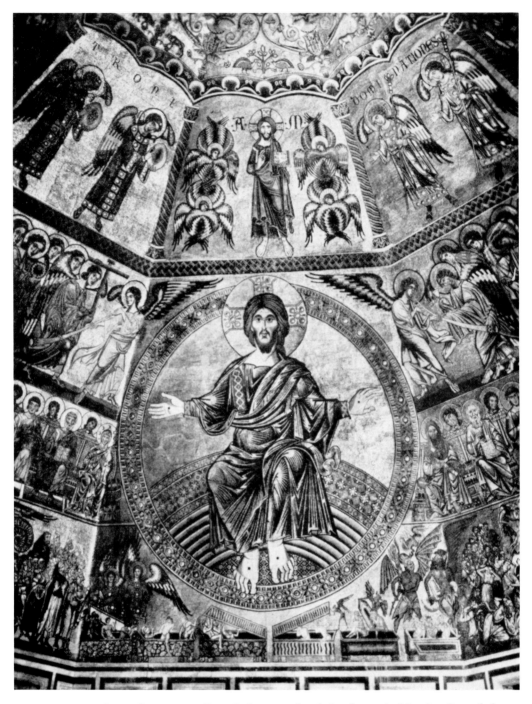

3.14. ITALO-BYZANTINE: Last Judgment, detail (13th cen.). Mosaic. Central dome, Baptistery, Florence (Alinari)

The date of these mosaics and the identification of the artists at work on them is still a matter of conjecture. Vasari mentioned a Florentine Andrea Tafi as the creator of the Heavenly Hosts and Last Judgment mosaics. Tafi, according to Vasari, had gone to Venice, worked there in the mosaic technique, and brought back to Florence to help him a Greek by the name of Apollonius. Nothing has ever been found to substantiate this. There are documents dated 1271 and 1272 that mention raising funds for the mosaics. Ten years later, 1281, more money was needed. In 1297 an Apollonius is mentioned as a Florentine painter. In 1301 two artists, Bingus and Pazzus, were dismissed for misappropriating funds, and a Constantinus and son were commissioned to work on the mosaics and to invite other artists from Venice. All this would indicate that work was going on during the last quarter of the thirteenth century and that both Florentine and Venetian artists and artisans were employed. The mere fact that funds were needed in 1271 and 1272 and again in 1281 would indicate that the work had been begun earlier.

A division in style apparent in the mosaics would also indicate that the work was done over a period of time. Stylistically the Last Judgment cycle is close to the tribune mosaics that date around 1225, but the narrative Biblical cycles suggest a date at the end of the thirteenth century or even early in the fourteenth. The crucifixion in the cycle of the life of Christ, for example, uses the type of dead Christ with bent knees found in painting after Gothic influences had made themselves felt. Because of certain stylistic similarities in the Last Judgment mosaics and the works of such painters as Coppo, Meliore, and the Magdalen Master, a mid-thirteenth-century date might be implied for the earlier mosaics.* The interrelation in style between these mosaics and local Florentine painters might be explained by the fact that the mosaics exerted a stylistic influence on contemporary painters; it might also be explained by the fact that Florentine artists had a hand in the mosaic work. The names of Coppo and Cimabue have been suggested in this connection, and we know, as mentioned earlier, that Cimabue was commissioned to work on the apse mosaic in the cathedral of Pisa. This would seem to indicate that painters of this period were also trained in or were familiar with the technique of mosaic.

One other thing, however, should be pointed out. In spite of the Byzantine look of these mosaics in general, many details of both style and iconography were at home in Italy and seem to be throwbacks to earlier Italian usage. I mention the motifs of the Tent of Heaven and of the Lamb of God enclosed in a medallion. These are found in Early Christian mosaic decoration in Rome and Ravenna. The Christ of the Last Judgment is closely related in type to the Saviour as represented in twelfth- and thirteenth-century

* Compare the leaf crown on the king in the front row of the Redeemed in the mosaic with the leaf crown on Coppo's Madonna at Orvieto [3.9] or the head of Christ of the Last Judgment and the head of Meliore's Christ [3.11]; or the stylized line of the lower eyelid and the drapery folds in the figures of the angels and the apostles of the Last Judgment with those of the Magdalen Master [3.12].

altarpieces of the Roman school, such as the one at Sutri [4.3]. And the angels of the Heavenly Hosts with the red spots on their cheeks are descendants of those in the frescoes of Sant' Angelo in Formis.*

The mosaics in the Florence Baptistery are the last of a series of monumental decorations in that medium in medieval Italy. They set before us a stylistic panorama in which we can distinguish the elements that contributed to the formation of the style and iconography of Italian painting up to the end of the thirteenth century: Early Christian, Byzantine, Benedictine-Romanesque, and local Tuscan. They include also a forecast of the future in the Gothic Christ in the Crucifixion scene.

Cimabue

With our background of knowledge of all that has preceded, Cimabue no longer appears so completely new as Vasari would have had us believe.

There is little documentary knowledge about Cimabue and his work. We know that he was at Rome at one time, for a 1272 document in the archives of Santa Maria Maggiore mentions him as among the witnesses to a writing placing the nuns of St. Damian under the protectorship of Cardinal Fieschi. In 1301, in a document at Pisa, his name appears as a worker on the apse mosaic of the cathedral. The figure of St. John the Evangelist [3.15] in that mosaic is specified as his in a document of the following year. Two other documents of the year 1301 (which turned up as wrapping paper in a grocery shop) indicate that Cimabue and a certain Giovanni di Apparecchiato of Lucca were commissioned to paint a Maestà (Madonna in Majesty) for the church of Santa Chiara at Pisa. This altarpiece was to be adorned with tabernacles and colonnettes and with a predella containing stories of the Blessed Virgin and of the apostles. The result was a type of altarpiece very different from those we have met before, one that seems to foreshadow the type used by Duccio in his famous Maestà [5.5] for the cathedral of Siena, begun seven years later. Unfortunately no trace remains of this work by Cimabue.

A glimpse into Cimabue's character is given by Dante in the much-quoted couplet from Canto XI of the Purgatory where the suffering of those who in their earthly existence had been guilty of the sin of pride is described: "Cimabue thought that he was supreme in the art of painting, but now Giotto is the rage." To this an early fourteenth-century commentator on Dante adds that Cimabue was a proud and impetuous person who would destroy any of his paintings no matter how good if an adverse remark about it was made.

* Note also that Christ's hands in the Last Judgment mosaic are turned to indicate "thumbs up" for the Saved and "thumbs down" for the Damned. These were, of course, derived from the fateful gestures of the Roman emperors in the amphitheater. They appear on Early Christian sarcophagi as well as in the eleventh-century Last Judgment frescoes at Sant' Angelo.

3.15. CIMABUE: St. John, Evangelist (1301–2). Mosaic, detail. Apse, Cathedral, Pisa (Brogi)

The St. John [3.15] in the Pisa mosaic is the only documented figure remaining to give us an idea of Cimabue's style. It is dated 1301–1302, shortly before his death. It is therefore an example of Cimabue's late style of approximately the last two decades of the thirteenth century and is our only point of reference from which attributions can be made. Consequently we must reverse the more normal sequence of attributions from early style to late and begin with Cimabue's later style and end with the earlier.

Among the works attributed to Cimabue by Vasari are the frescoes at the sanctuary end of the upper church * of St. Francis at Assisi. The frescoes have to do with the objects of St. Francis' particular devotion. St. Bonaventura, as Minister General of the Friars Minor, decreed in 1266 that his own version of St. Francis' life should henceforth be the orthodox one. In it he speaks of the saint's great love for the Virgin, for the apostle-princes Peter and Paul, and for the angels, Michael in particular. He relates how the intensity of St. Francis' fervor for the Crucified induced the appearance of Christ's wounds on his own body. Thus are found in the left transept representations of St. Michael and other angels, Michael's fight against the dragon,

* The basilica of St. Francis at Assisi, built on a hillside, is in two levels, the Upper Church and the Lower Church. It was begun in 1228, two years after the death of the saint, and consecrated in 1253. After the victory of the "Worldly" branch of the order over the "Spiritual" group, the decoration of the basilica was begun on a grand scale. Most of it was carried out between about 1260 and 1360.

and scenes from the Apocalypse in which angels took part. The right transept is dedicated to SS. Peter and Paul, the frescoes representing scenes of their miracles and of their martyrdom. In the apse are scenes from the final events of the Virgin's life, her death, her assumption, and her enthronement in heaven with Christ. On the east wall of both the right and the left transepts is a large crucifixion scene with St. Francis at the foot of the cross [3.16]. In the cross vault over the choir are the four evangelists writing their gospels.

Unfortunately, time and perhaps inexperience or experimentation with the colors and the medium on the painter's part have faded or so changed the colors in most of the frescoes on the sanctuary and transept walls that their effect is that of a photographic negative. Certain comparisons with the mosaic figure of the St. John at Pisa [3.15], however, are possible. The evangelist St. Matthew in the choir vault, the figures of Christ and the Virgin in the Assumption scene, and several of the figures, especially the St. John, in the Crucifixion [3.16] in the left transept have a number of common characteristics: the tilt of the head, the shock of hair like a lion's mane, the long curved noses with bulbous ends, the sharply highlighted fork where the nose meets the eyebrows, and the heavily gouged-out drapery folds. These are all so close to the characteristics found in the figure of the St. John in Pisa as to indicate that Cimabue was the master-painter directing the work in the sanctuary end of the upper church at Assisi. The presence of a creative genius of such maturity, spirit, and vitality as Cimabue was reputed to be is apparent in the great Crucifixion scene on the left transept wall. Here the narrative details of the scene are built up to an overpowering dramatic effect by means of the flutter of Christ's loincloth, the excitement and grief of the angels, the milling crowds about the cross, and the arms of the Magdalen lifted hysterically toward the Crucified and countered by the arms of the centurion and of one of the Jews at the right. Then there is the small but effective figure of St. Francis huddled in ecstatic rapture at the foot of the cross.

On the east wall of the right transept in the lower church at Assisi is a frescoe of the Madonna enthroned among four angels [3.17] that, because of stylistic connections with the frescoes in the upper church, can also be attributed to Cimabue. Its iconography has special interest. In earlier Tuscan Madonnas, angels, if present, were represented in small scale (in full length, half length, or bust form in medallions) and placed above the Madonna's throne [3.8]. Here four large-scale standing angels, two on either side, are ranged about the Madonna's throne as though supporting it. Beside them to the right stands the lone figure of St. Francis bearing the stigmata. The throne, turned to show one side, is constructed of spoollike details resembling cabinetwork similar to those on the thrones of Christ and the Vir-

(*Opposite*) 3.16 (*top*). CIMABUE: Crucifixion (*c.* 1280–85). Fresco. Left transept, Upper Church, St. Francis, Assisi (Casa Edit. Francescana) 3.17 (*bottom*). CIMABUE: Madonna Enthroned and St. Francis (*c.* 1280–85). Fresco. Right transept, Lower Church, St. Francis, Assisi (Casa Edit. Francescana)

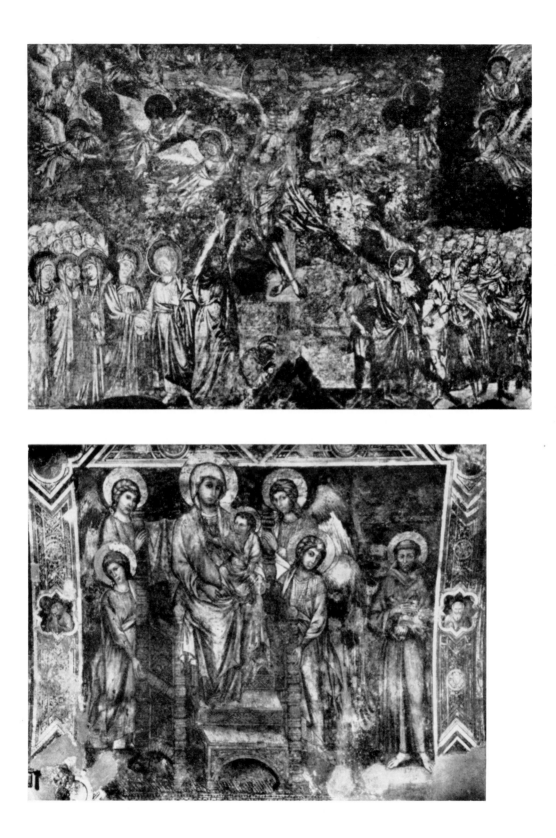

gin in the frescoes of the upper church. This new iconography of the enthroned Madonna in which surrounding angels now play such an important part must have resulted from St. Francis' particular devotion to angels, which also caused Cimabue to paint a whole gallery of heavenly messengers in the left gallery of the upper church and to introduce them in other frescoes in the sanctuary end, especially in the Crucifixion scenes and in those of the Apocalypse. This fresco of the Madonna must have enjoyed special veneration, because it was not covered over when in the fourteenth century the transepts and the crossing of the lower church were completely decorated with frescoes by Florentine and Sienese painters.*

Linked closely to this fresco in style and iconography is the great panel painting of the Madonna [3.18] from the church of Santa Trinità in Florence, now hanging in the Uffizi. This is the Madonna with which many courses on Italian painting begin. The first striking feature is its size, which can never be realized from study of a photograph. The Madonna by Coppo and the Madonna we will shortly see by Guido da Siena were larger than usual, measuring approximately seven and nine feet in height, respectively. This Madonna is about twelve feet high. Duccio's Rucellai Madonna [5.1] of about the same date is almost fifteen feet high. We shall say more about this increase in scale when we discuss the Duccio Madonna.

The Uffizi Madonna could easily be an elaborated version of the Madonna fresco in the lower church at Assisi. Instead of the four angels about the throne of the Madonna in the fresco, there are eight in the Uffizi painting, four on either side. The two angels in the front row are so closely related to the corresponding two in the fresco that they seem to rely on the same cartoon, or preparatory drawing. The throne itself with its high, curved back, its projecting sides, and its curved stepped footstool is a jeweled one. Small slender colonnettes of turned woodwork and foliate knobs, similar to those on the throne in the fresco, are set in front of the projections of the throne and of the substructure on which the throne is raised and slightly recessed. This substructure follows in shape the front face of the throne. Under its arched openings appear in bust form the figures of Jeremiah, Abraham, David, and Isaiah with scrolls containing prophesies of the coming of the Messiah. This elaborate throne, although it has details similar to those in the fresco in the lower church, is almost identical with the one in the fresco of the Enthronement of the Virgin in the apse of the upper church. The prophets' and the angels' heads can also be duplicated in that fresco.

The Uffizi panel is an elaborate and magnificent tribute to the Madonna whose cult was being so enthusiastically revived. Some of the enthusiasm is caught by Cimabue in the sweeping rhythms of the angels' draperies, in

* Two iconographic details are worth pointing out: (1) the position of the throne in this fresco, showing one side as well as the front, is found in Sienese paintings of the Madonna, e.g., Guido's Madonna in the Palazzo Pubblico, Siena [3.24]; (2) the type of Madonna touching the foot of the Christ child, as here, who raises His hand in blessing is adapted from Coppo's Madonnas, e.g., the Madonna of the Servi, Siena [3.8].

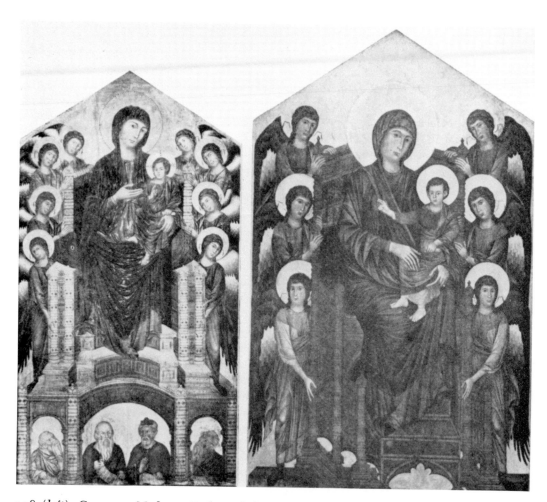

3.18 (*left*). CIMABUE: Madonna Enthroned (*c.* 1285–90). Panel painting, 151¾″ x 78⅞″. Uffizi, Florence (Anderson) 3.19 (*right*). CIMABUE AND ASSISTANTS: Madonna Enthroned (1285–1300). Panel painting, 167¼″ x 108⅝″. Louvre, Paris (Alinari)

the movement of their heads, and in the flash of their rainbow-colored wings. These dynamics are in striking contrast to the silhouetted pattern of the Madonna's dark-blue mantle and red robe covered with Byzantine gold hatchings. Yet in spite of the stiffening effect of this hatching, many curvilinear rhythms in the drapery folds of both the Madonna and Christ child carry over into the movement of the angels at the sides. The twist of the angels' bodies is also reflected in the seated figure of the Madonna. Note how the lower half of the body with the Madonna's feet on the two levels of the footstool faces toward the left while the upper part of Her body turning toward the Christ child faces toward the right. This turning posture was already partly indicated, although in reverse, in Coppo's Orvieto Madonna.

The monumental Madonna from San Francesco, Pisa, now in the Louvre [3.19] in Paris, has also been attributed, with reason, to Cimabue. It is even

larger than the Uffizi panel and follows the pattern and iconography of the enthroned Madonna surrounded by angels as established by the Assisi and Uffizi Madonnas. The Louvre Madonna shows six angels, three on either side of the throne. The throne, constructed of the same type of cabinetwork, spoollike decorative elements as seen in the two other Madonnas, is so placed that one side of it is visible as well as the front. This was also the case in the Assisi Madonna and will be found in Sienese Madonnas to be cited later. The figure of the Christ child in its general posture resembles its counterpart in the Uffizi Madonna but in the gesture of blessing with arm extended it recalls the Assisi fresco. More will be said about the Louvre Madonna in our discussion of the Sienese master Duccio.

The lack of vigor in style and expression in comparison with the Uffizi Madonna suggests that much of the execution of the Madonna in the Louvre was turned over to assistants in the workshop. This could easily be true at a time when Cimabue was very busy. We know from documents that in 1301-1302, while he was working on the apse mosaic of the cathedral at Pisa, he was also committed to furnish an elaborate altarpiece for Santa Chiara, another Franciscan church in Pisa—the Louvre Madonna, as previously mentioned, having been painted for San Francesco in that city.

There is another panel-painting attributed to Cimabue that lies along the periphery of his style as we have seen it at Assisi. It is the huge crucifix [3.20], formerly in the refectory of Santa Croce in Florence, that now hangs in the Uffizi. It is the end-product of thirteenth-century crucifixes, particularly of the type introduced by Giunta Pisano. Its derivation from the Giunta type is obvious in the simplified form of the cross with no figures in the apron panels flanking the corpus of Christ, in the busts of the Virgin and St. John at the ends of the crosspiece, in the S-shaped corpus of the Christ twisting in the final agony, in the wide-open hands with tensed, spread fingers, and in the drooping head with the hair falling over the left shoulder in serpentine strands.* What is remarkable is Cimabue's attempt to give three-dimensional form to Christ's body by breaking away from the harsh stylizations of the muscles of the torso, of the arms, and of the legs and by replacing them with a softer modeling to give substance and weight to the form. The amazing use of a diaphanous loincloth through which the form of the thighs can be seen was revolutionary and prophetic of the renewed interest in physical form that was to come in the following centuries.† Whether the execution of this crucifix is entirely by Cimabue's hand or is in part the work of assistants is of no special importance. As a painting it is an astounding climax to thirteenth-century representations of the Crucified, as the Trinità Madonna in

* Cimabue had the opportunity while working at Assisi to come in close contact with the works of Giunta and of the St. Francis Master: (1) in Giunta's crucifixes in the basilica of St. Francis and in Santa Maria degli Angeli, and (2) in the frescoes of the St. Francis Master in the lower church.

† Having earlier been in Rome where he undoubtedly learned the fresco technique, not common in Tuscany in the thirteenth century, Cimabue could have acquired this interest in form from the observation of Classical sculpture surviving in that city.

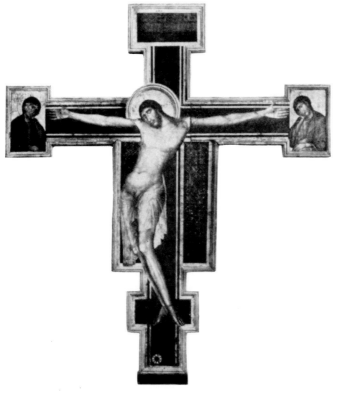

3.20 (*above*). CIMABUE: Crucifix (*c.* 1280–85). Panel painting, 176⅝″ x 153⅝″. Uffizi, Florence (Anderson)

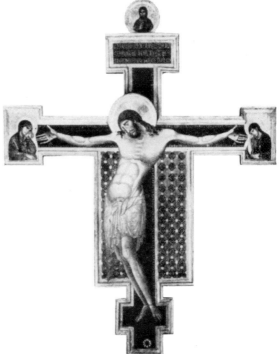

3.21 (*right*). CIMABUE: Crucifix (*c.* 1270–75). Panel painting, 134⅜″ x 104″. San Domenico, Arezzo (Anderson)

the Uffizi is for the representations of the Virgin and Child, and as the Assisi fresco is for the narrative representations of the crucifixion scenes.

The impressive crucifix in San Domenico at Arezzo [3.21] must be considered as a link bridging the distance between Cimabue's late style and that of his predecessors, Giunta and Coppo. In form it has all the simplified elements of Giunta's crucifixes: the decorative nonhistoriated apron panels and the busts of the Virgin and St. John at the ends of the crosspiece. These are also present in the Santa Croce cross in the Uffizi. But whereas in the Santa Croce crucifix the modeling of the corpus of Christ is soft and plastic, in the Arezzo one the anatomical details of the corpus are still rendered by the harsh stylized lines used by Giunta and the St. Francis Master and by Cimabue's predecessors in Florence, the anonymous master of the Uffizi crucifix no. 434 and Coppo. To these Byzantinisms is added the gold-shot surface of the vermilion loincloth. It has been suggested, because of certain resemblances in the head and the features of the Christ, that this crucifix was done in the workshop of Coppo where the younger Cimabue might have been trained. It is, however, too accomplished and imposing to be considered as a shop piece or even as the work of one who has not yet reached his prime. Surely it is the equal, even the peer, of any crucifix since the time of Giunta.

The chronological sequence of Cimabue's important works as we now know them would then be: work in Rome (conjectural); the crucifix in San Domenico, Arezzo; the Assisi frescoes; the Trinità Madonna; the Santa Croce crucifix; the Madonna from Pisa; the lost altarpiece from Santa Chiara, Pisa; and the mosaic figure of St. John in the cathedral at Pisa. Interestingly, most of these works were done for churches connected with the Franciscan order.

With the accomplishments of Cimabue, Florentine painting of the thirteenth century reached its peak. His style epitomizes the important styles produced in Tuscany up to his time that had found their way to Florence or were at home there: the Lucchese, the Pisan, that of the St. Francis Master and of his predecessors in Florence, particularly Coppo. As the result of his sojourn in Rome Cimabue became the first Tuscan painter to make important use of fresco—rare in Tuscany before that time. His attempt to render the form of Christ more plastically may also be due in part to observations made in Rome. Certainly his dramatic expressiveness as seen in his crucifixes and in the Assisi frescoes show the effect on him of Franciscan emotionalism as well as of the growing Gothic spirit which he still sought to express in the old conventional forms. Cimabue was both the culmination of the old style and a pathfinder in the direction of the new. His influence on contemporary painters was great.* To trace it further would be of no purpose here; for another creative spirit, Giotto, was at hand, and he, as a "modern," had a new gospel to preach at Florence and in Italy generally.

* We see it especially in crucifixes of the later thirteenth century in which Cimabue's softer treatment of Christ's body and the use of a diaphanous or windswept loincloth (sometimes both together) appear. A crucifix closely copying Cimabue's Santa Croce crucifix, even the diaphanous loincloth, now in the Lucca gallery, is signed by Deodato Orlandi of Lucca and bears the date 1288. This gives us a date before which Cimabue's crucifix from Santa Croce must have been painted.

Siena

As Siena grew as a city-state it attached itself to the imperial cause, possibly because of commercial rivalry with Florence and the political ambitions of that Guelph city with its papal support. Be that as it may, Sienese merchants and moneylenders were so successful, even in France and England, that in the third decade of the thirteenth century they were made papal bankers despite their Ghibelline politics. After the battle of Montaperti, when Florence was routed, the interdict of the pope against Siena put an end to this banking privilege, which the Florentines took over. This, together with the blows delivered against the imperial cause, made the Sienese merchants a little less fervently Ghibelline. Sienese Guelphs, expelled after Montaperti, were recalled and admitted to the government that eventually became an oligarchy of the Nine, merchant-controlled. It lasted until the middle of the fourteenth century and built up Siena's wealth to a high point.

A group of the earliest surviving paintings associated with Siena shows the same variety of Romanesque styles that we observed elsewhere in Tuscany and Umbria. Earliest in date is an altar frontal [3.22] of 1215 in the picture gallery at Siena. In the center section Christ is seated in majesty on an arc of Heaven within a star-studded aureole, or mandorla. He is flanked by two small angels. The symbols of the four evangelists are at the corners of the aureole. Except for the angels, all the figures are in painted low relief. Three painted scenes on either side of the central feature are separated by heavy stucco borders and seem to contain episodes or miracles connected with the Holy Cross. Their style is feeble; their state of preservation is quite poor.

Related to this altar frontal but more advanced in style is a Madonna [3.23] in the museum of the Opera del Duomo in Siena. This panel was ob-

3.22. SIENESE SCHOOL: Christ in Glory and Miracles of the Holy Cross (1215). Panel altarpiece, stucco and painting, 40⅝" x 37⅞". Pinacoteca no. 1, Siena (Alinari)

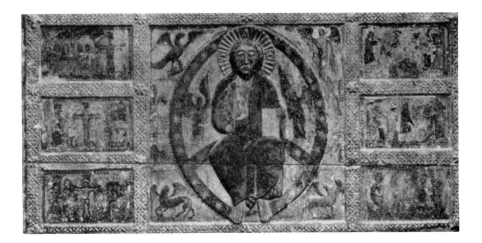

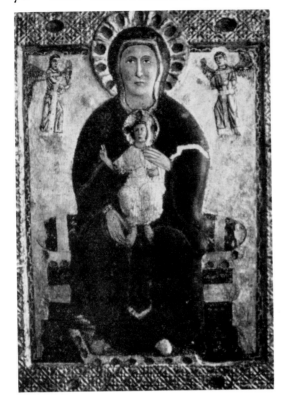

3.23. SIENESE SCHOOL: Madonna Enthroned (1225–50). Panel with relief and painting, 38⅜″ x 26⅜″. Opera del Duomo, Siena (Brogi)

viously the center section of a frontal similar to the one of 1215. Here too the frontally enthroned Madonna flanked by two angels is painted in low relief. The stucco frame is identical with that of 1215. In its original state it must also have had scenes from the life of the Virgin flanking the central figure.

Although there are a number of early Sienese crosses in existence, they have little interest for us here, either esthetically or stylistically. We can proceed then to the work of Siena's first great master, Guido, the counterpart of the Florentine Coppo.

Guido da Siena

There has been much discussion and little decision about the dates of Guido's activity. The argument centers on the date of the Madonna [3.24] now in the Palazzo Pubblico at Siena but originally in the church of San Domenico. Of the Hodegetria type, the Madonna is seated beneath a trefoiled molding on a high-backed throne from the curved top railing of which brocaded drapery is suspended. Three three-quarter-length angels of small scale fill each spandrel of the trefoiled arch and bend toward the Madonna with gestures of adoration. At the base of the throne is a long inscription giving

Guido's name and the date 1221. Whether this date is correct or whether the inscription was repainted and originally read 1271 has long been argued. A very recent cleaning of the panel, together with X-ray examination, shows no such repaint. And yet the Madonna, in style, size, and almost every other respect, belongs with those from the middle of the thirteenth century and later.

The average height of Madonna panels of the earlier part of the century was between three and one half and five and one half feet. Coppo's Madonnas and this one by Guido measure between seven and eight feet. The change in size can be explained by the revived activity in the cult of the Virgin and the use of these paintings in processions. The connection between the Guido Madonna and the one Coppo di Marcovaldo did for the church of the Servi in Siena [3.8] has been pointed out many times. But whether it was Guido who influenced Coppo or vice versa depends, of course, on the date of the Palazzo Pubblico Madonna. The elements that these two paintings have in common are worth noting here.

First, of the small number of Madonnas preserved from the first half of the thirteenth century, few represent the full-length enthroned type. Those that do, belong to the frontal type, for example, the Madonnas of the Bigallo Master [3.2]. Guido and Coppo used the previously explained Hodegetria type of Madonna in which the Virgin, turned slightly to one side, holds the Christ child on her arm or lap. *Second,* the throne is high-backed, whereas those of the earlier Madonnas are without any back. After Guido and Coppo, the Hodegetria type with high-backed throne became popular. *Third,* the use of thin gold lines covering the drapery of the Madonna and Christ child is characteristic of both Guido and Coppo. It is a feature found in Sicilian and Italian mosaics, particularly the great figures of Christ as Pantocrator at Monreale [1.14] and Cefalù, or the Christ of the Last Judgment [3.14] in the Baptistery at Florence, and in some icons at Mt. Sinai. *Fourth,* a wiry gold line runs around the hem or edge of the Madonna's mantle, making it stand out from the body in stiff lines and curves. Guido's use of a ribbonlike border for the garment accentuates the starched or metallic effect. *Fifth,* the fine light woolen cloth, decorated with tiny designs, which the Madonna uses as a support for the Christ child is found, I believe, only in the works of these two masters or in those that are copies or derivatives.

One difference is that the throne of Guido's Madonna has a feature not found in the work of Coppo and certainly not before his time—it is set at an angle so that two sides can be seen at once. This not only helps to accentuate the turned posture of the Madonna but also emphasizes, even though slightly, an effect of going back in space and getting away from strict frontality. The twist of the Christ child's legs accomplishes this too. Other great artists later in the century were to make use of this turned throne.*

* Compare the two Cimabue Madonnas cited, the one at Assisi and the one in the Louvre.

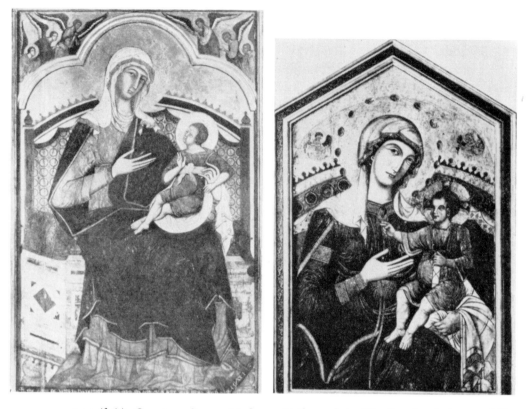

3.24 (*left*). Guido da Siena: Madonna Enthroned (12??). Panel painting, 111½″ x 76½″. Palazzo Pubblico, Siena (Grassi)

 3.25 (*right*). Guido da Siena: Madonna Enthroned (cut down) (1262). Panel painting, 55¼″ x 38⅜″. Pinacoteca no. 16, Siena (Alinari)

Just as Coppo's Madonna and Child at Siena had their faces repainted by a pupil of Duccio early in the fourteenth century, so the faces of Guido's Holy Mother and Child in the Palazzo Pubblico were repainted—apparently by the same painter. For an examination of Guido's facial types we must therefore turn to the angels in the spandrels of the trefoil. But there are other Madonnas by Guido's hand from which we can study his Madonna type.

One of these is the Madonna no. 16 in the Siena gallery [3.25]. According to an inscription it once bore, it was painted in 1262 for the Brotherhood of the Blessed Virgin Mary (the Servites), just one year after Coppo painted his Madonna for the church of the Servi at Siena. Although this Guido Madonna has been cut down to about half its original size, the relationship between the two is still obvious, especially in the posture and gestures of the Christ child and in the headdress of the Madonna.*

In the Capella del Voto, the chapel of the Vow, in Siena cathedral is a Madonna closely related to but weaker in style than no. 16 in the Siena

* Other Guido Madonnas are no. 7 and no. 587 in the gallery at Siena.

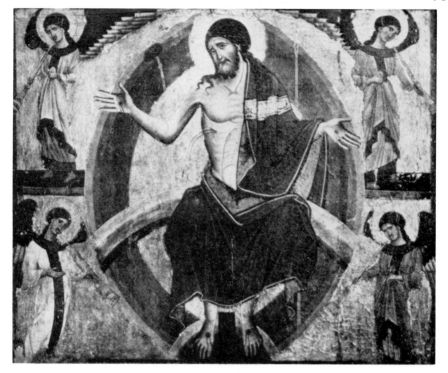

3.26. GUIDO DA SIENA (ASSISTED): Last Judgment, detail (13th cen., last quarter). Panel painting, 55¼″ x 39″. Diocesan Museum, Grosseto (Alinari)

gallery; it is known as the Madonna del Voto. It is a shop piece. Tradition has it that this is the Madonna painted after the battle of Montaperti in gratitude to the Virgin for saving the city. Cut down in size also, it once occupied a position on the high altar of the cathedral before the installation of Duccio's great Maestà [5.5].

The panel in the cathedral of Grosseto with the representation of the Last Judgment [3.26] is intimately associated with Guido's style. Beautiful in color and strong in drawing, it shows the mingling of styles so common in Tuscany toward the last quarter of the thirteenth century. Here Christ is seated on the arc of heaven in a style very much akin to the Crucified painted by the Pisan Giunta. The shape of the head, the whiplike locks falling over the shoulders, the parallel strands of hair, and the anatomical stylizations, including the almond-shaped muscle below the breast line, all reflect the conventions established by that great innovator, although the angels and the figures approaching the doors of Paradise still echo, but faintly, the Lucchese mannerisms of Berlinghiero and his followers.

Twelve small panels [3.27], all measuring approximately 14″ x 18½″ and scattered through five collections, seem once to have been parts of one

3.27. GUIDO DA SIENA: Annunciation (c. 1270). Panel painting, 13⅞″ x 19″. The Art Museum, Princeton University

altarpiece by Guido. Apparently at some time wings were added to the Palazzo Pubblico Madonna, and Tizio, an eighteenth-century writer, states that he saw them hanging separately from the Madonna when it was still in the church of San Domenico. Attempts have been made to consider these twelve panels as parts of the shutters of the Palazzo Pubblico Madonna. They are, at least, parts of a cycle of scenes from the life of Christ.* The background of most of them is very similar—two towers or ends of buildings, one on each side, connected by a low parapet like many of the backgrounds of martyrdom found in the Byzantine miniatures of the Menologion (liturgical calendar) in the Vatican Library. The style of the panels varies in quality, indicating that assistants were employed in the painting of them.

An important survival from the milieu of Guido's workshop is the altarpiece dedicated to St. Peter, no. 15 in the Siena Gallery [3.28]. The Prince of the Apostles is enthroned in the center beneath a trefoiled arch (usual with Guido), with half-length angels in the spandrels. The throne is highbacked with the curved rail and hanging brocades found in Guido's painting elsewhere [3.24]. The bits of arcading and four-part leaf motif within a square as well as the knob terminations of the uprights of the throne are derivatives of Guido's workshop. The throne itself shows three sides at once —going that in the Palazzo Madonna one better. In the six scenes at the side, three illustrate episodes in the life of Christ, including the Calling of Peter and Andrew, and the others illustrate episodes from Peter's life. Two of the Christ scenes, the Annunciation and the Nativity, have special interest since they are almost identical with the same scenes in the group of twelve panels dis-

* The panels and their locations are as follows: the Annunciation (The Art Museum, Princeton University), the Nativity (private collection, Lausanne), the Adoration of the Magi (Lindenau Museum, Altenburg), the Flight into Egypt (Altenburg), the Presentation in the Temple (Lausanne), the Massacre of the Innocents (Siena Gallery, no. 9), the Betrayal (Siena, no. 10), the Flagellation (Altenburg), Christ Ascending the Cross (Archiepiscopal Museum, Utrecht), the Crucifixion (Siena, no. 11), the Deposition (Siena, no. 12), and the Entombment (Siena, no. 13). (See J. H. Stubblebine in Bibliography at end of chapter.)

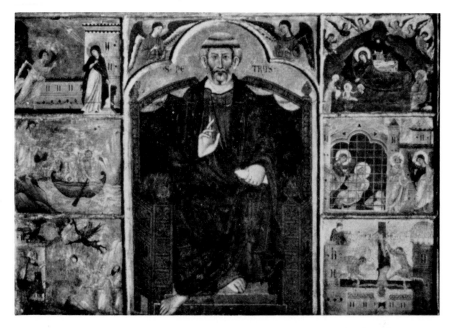

3.28. St. Peter Master: St. Peter Altarpiece (1275–1285). Panel painting, 39⁷⁄₁₆″ x 55¹¹⁄₁₆″. Pinacoteca no. 15, Siena (Alinari)

cussed above, although the tree in the Annunciation now at Princeton [3.27] has been omitted and in the Nativity scene the position of Joseph and the attitudes of some of the angels are changed from those in the Lausanne panel. In spite of these derivations and similarities and the effectiveness of the color, this St. Peter altarpiece is much weaker in technique than the work of Guido or his immediate workshop, and must therefore be considered as a school piece.

In Guido, then, we have arrived at a master whose style was powerful enough to create a school and a tradition for Siena in the second half of the thirteenth century, as Giunta had done for Pisa, and Coppo and Cimabue for Florence.

Other Sienese Masters

An altarpiece of unusual finesse and delicacy of execution, no. 14 in the Gallery at Siena, was produced by an anonymous artist, known as the Master of the St. John Altarpiece, who had no connection with Guido and his style. The center figure of St. John the Baptist is badly rubbed, but the twelve scenes from his life that flank the enthroned saint display an elegance found nowhere else at this time in central Italy. Despite architectural backgrounds and iconographic types of some figures obviously based

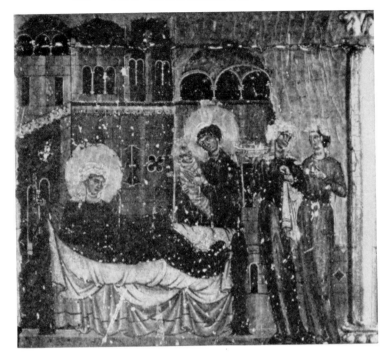

on Byzantine sources, we find here a suggestion of a stylistic current from Gothic France in the attenuation of the figures and in the pliant curvilinear swing of the bodies of the ladies attending St. Elizabeth in the scene of the birth of St. John [3.29] and in another of Salome dancing before Herod and his queen. It has been suggested that here we have the master of Duccio. And this may be true, for the softness and elegance of that great master's style is forecast nowhere else in earlier Sienese painting.

A painter from Arezzo by the name of Margaritone is worthy of note. He was active from about 1260 to 1290. Vasari mentions him, presumably because he came from Vasari's hometown. Not an outstanding painter, Margaritone interests on several accounts. Most of his paintings that survive bear his signature. Four of these are Madonnas, the ones at Monte San Savino and in the National Gallery, London, being dossals with scenes flanking the Madonna, while those at Montelungo and in the National Gallery of Art, Washington, D. C. [3.30], are cutouts from similar dossals. Except in the Monte San Savino dossal, the Madonna and Child are represented in the strictly frontal position. The influence of the Bigallo Master is very evident, not only in the use of this type of Madonna and Child but also in such details as the dots on the Madonna's mantle and the type of throne in the Montelungo and Washington panels as well as in the small figures flanking the Madonna in the upper half of these panels. The fleur-de-lis crown worn by all four Madonnas and the lion throne of the London and Monte San Savino panels suggest a

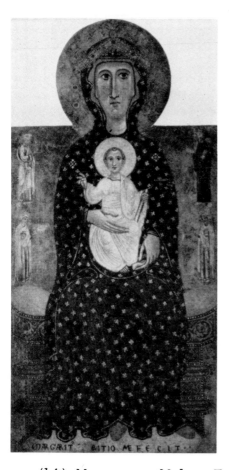

3.30 (*left*). MARGARITONE: Madonna Enthroned (signed; *c.* 1270). Panel painting 38⅛″ x 19½″. National Gallery of Art, Washington, D. C. Samuel H. Kress Collection
3.31 (*right*). MARGARITONE: St. Francis of Assisi (signed, 1270–80). Panel painting 51¼″ x 20⅞″. Pinacoteca, Arezzo (Anderson)

connection with French Gothic objects. Margaritone apparently was much in demand for full-length portraits of St. Francis of Assisi. At least six signed panels in which the saint is portrayed have survived. There are two principal poses with slight variations in detail: in one St. Francis holds a cross in his right hand; in the other [3.31] he displays the nail mark in his right hand.

We have seen that, in Tuscany, the style of Berlinghiero and his family in Lucca was the first important style to develop in the first half of the thirteenth century, growing out of a fusion of the contemporary Benedictine-Roman style with certain fresh Byzantine impulses. In Pisa the most significant and widely influential style of Giunta evolved out of that city's cos-

mopolitan background but was colored by the Berlinghieri style of Lucca plus new Byzantine infusions to which Franciscan emotionalism was applied. In Florence, a mid-thirteenth-century group of paintings also displayed the strong influence of the Berlinghieri and, to a certain extent, that of Giunta. The Bigallo Master and Coppo di Marcovaldo (and to a lesser extent Meliore and the Magdalen Master) emerged as the most significant painters before Cimabue and, excepting the Bigallo Master, showed stylistic affinities in their work with the Baptistery mosaics. Most of the Madonnas painted by the various anonymous masters in the last thirty years of the thirteenth century were derived in one way or another from the types established either by the Bigallo Master or by Coppo and, toward the end of that period, by Cimabue and Duccio also. In Siena, of course, the important master was Guido whose style is related to the tradition that produced the rather hard-lined features and harsh modeling found in Giunta and Coppo. The interrelation between Guido's Madonna type and that of Coppo was noted.

BIBLIOGRAPHY

Douglas, R. L. *History of Siena.* London, John Murray, 1902.

Weigelt, C. H. "Guido da Siena's Great Ancona—A Reconstruction," *Burlington Magazine* LIX, 1931, pp. 15ff.

Nicholson, A. *Cimabue; a Critical Study.* Princeton, N. J., Princeton University Press, 1932.

Schevill, F. *History of Florence.* New York, Harcourt, Brace & Company, 1936.

Coor, G. "A Visual Basis for the Documents Relating to Coppo di Marcovaldo and His Son Salerno," *Art Bulletin* XXVIII, 1946, pp. 232–247.

Carli, E. *Sienese Painting.* Greenwich, Conn., New York Graphic Society, 1956. (Early pages)

Stubblebine, J. H. "An Altarpiece by Guido da Siena," *Art Bulletin* XLI, 1959, pp. 260ff.

◂ 4

The Contributions
of Rome

W E have followed the developments in painting that were taking place in Tuscany and adjacent regions during the period between the late twelfth and later thirteenth centuries. Now we need to learn something of the painting produced in the Roman area during this same general period, because at the end of the thirteenth century the painting of Tuscany and of Rome were to be interrelated.

It was during this period that many of the Roman churches destroyed during the eleventh-century Norman raids were being rebuilt and redecorated, the redecoration calling for the services of stonecutters, mosaicists, and painters. These craftsmen were not lacking in Rome, for that city had a long tradition in mosaic and fresco decoration dating back to Classic times and persisting through the Early Christian and medieval periods. One particular group of craftsmen in stonework known as the Cosmati—several of the more important in the group bore the name of Cosma—was active throughout the twelfth and thirteenth centuries. We mention them because their work is reflected in frescoes by Roman painters in the last quarter of the thirteenth century and even in Tuscan paintings as late as the early fourteenth century. These men—the Cosmati—decorated floors, singing galleries, pulpits, bishops' thrones [4.1], paschal candlesticks, and other pieces of church furniture as well as colonnettes and architraves of cloisters with small pieces of marble, porphyry, verd antique (a dark-green stone), and gold glass in circular, rectangular, cubical, and diamond shapes. These had been sawed or taken from ancient Roman columns, revetments, and floors. The beauty and glitter of

85

4.1. Cosmati work: Episcopal Throne and Screen (13th cen.). Stone and mosaic. San Lorenzo fuori le mura, Rome (Alinari)

this Cosmati work can be seen in many churches in and out of Rome, for example in the famous cloisters of St. John Lateran and of St. Paul's outside the Walls (San Paolo fuori le mura).

Next in importance in the thirteenth century to the work of the Cosmati in the redecoration of Roman churches were the accomplishments of the mosaicists and fresco painters. Many important apse mosaics date from this period, such as those in San Clemente, San Paolo fuori le mura, Santa Maria in Trastevere, and Santa Maria Maggiore, and the mosaics in the loggia of the façade of the last-named basilica. The master mosaicists of these monuments, as we shall see, were often masters in the art of wall decoration as well. But before we discuss the accomplishments of the fresco painters of the last half of the thirteenth century, it is essential that we be cognizant of two interesting groups of panel paintings produced earlier in the century—even reaching back into the twelfth century—in Rome and vicinity.

Panel Painting and Fresco Painting

One group of panel paintings consists of a series of representations of the Virgin known as the Madonna Avvocata [4.2], so called because with hands raised she seems to be interceding with heaven for the worshiper before her.

4.2 (*above*). ROMAN SCHOOL: Madonna Avvocata (early 13th cen.). Panel painting, 31½″ x 15¾″. Santa Maria in Campo Marzio, Rome (Com. Archeo. Crist.)

4.3 (*right*). ROMAN SCHOOL: Christ Enthroned (early 13th cen.). Panel painting, 63⅟₁₆″ x 28⅜″. Duomo, Sutri (Gab. Foto. Naz.)

She is represented in half length, with her body turned slightly to the left or right, and without the Christ child. This unusual type of the Virgin was traditional in Rome and was used as far back as the sixth century, for example in the icon over the altar of the church of Santa Maria in Aracoeli.

The other group is made up of representations of Christ enthroned, rigidly frontal, His right hand raised in blessing and His left holding a book. An excellent example of this type [4.3] is found in the *duomo* at Sutri; other examples are in other churches of the vicinity between Viterbo and Rome. This type, too, goes back for its model to a much earlier venerated painting, one that is now in the treasury of relics, the Sancta Sanctorum, of the Vatican. This early icon, credited with being the portrait of Christ painted by St. Luke and "finished by the angels," is recorded as in the possession of the popes as

long ago as the eighth century, the icon itself being much older.* At times in the twelfth and thirteenth centuries this type of Christ appears as the central panel of a triptych with the Madonna Avvocata and St. John the Evangelist on the side panels.† This could be an adaptation of the iconography of the Deïsis usually found in Byzantine representations of the Last Judgment that consist of Christ enthroned as Judge flanked by the Virgin and St. John the *Baptist* as intercessors for the human souls.

It is interesting that the Last Judgment scene, more usually found as a monumental theme in mosaic or fresco decoration in medieval churches, should appear painted in detail on a circular panel with a rectangular base now in the Vatican museum. This panel may originally have been the back of a bishop's throne. In the seventeenth century it was on an altar in a convent chapel in Rome. The scene is painted in five rows. Of iconographic interest is the presence of the Holy Innocents standing beside the altar containing the instruments of Christ's Passion. (The relics of the Innocents were brought to Amalfi from Constantinople after the capture of that city by the crusaders in 1204.) An inscription in medieval Latin runs in bands between the rows of figures. In it appear the names of the two painters of the panel, *Nicolaus* and *Johannes,* otherwise unidentified. The style of the figures resembles that of the triptychs cited in the footnote, such as the one at Tivoli. Of added interest is the fact that this panel is a connecting link between earlier medieval representations of the Last Judgment and the monumental ones painted in fresco at the end of the thirteenth and in the early fourteenth centuries by Cavallini and Giotto.

Whether Cimabue the Florentine came to Rome to carry out a commission in the redecoration program ‡ or whether he came to learn the fresco technique is not known. Whichever the reason, on his return north he was able to rival his Roman colleagues and contemporaries at Assisi in the execution of frescoes. The young Florentine painter Giotto seems also to have gone to Rome to acquire knowledge in the handling of fresco; indeed, we shall find him on his first appearance at Assisi in the role of assistant to an anonymous Roman master. Rome assuredly was the font of fresco knowledge.

For examples of thirteenth-century frescoes, two localities near Rome furnish us with ample material: Anagni and Subiaco. Anagni was famous as the town from which Pope Alexander IV excommunicated Frederick Barbarossa and Pope Innocent III excommunicated Frederick II and where Pope

* This image in the Sancta Sanctorum is given credit for saving Rome miraculously on several occasions. It was enclosed in a covering of gold and jewels by various popes. When it was exposed during the twelfth century and then re-covered by Pope Innocent III, it is possible that it was copied, and that this copy became the model for the twelfth- and thirteenth-century panels.

† As, for example, the triptych in the *duomo* at Tivoli or the one in Santa Maria Assunta at Trevignano.

‡ Cimabue has at times been considered as the master of the vanished frescoes in the portico of the old St. Peter's. Sketch copies of these are to be found in a seventeenth-century manuscript in the Vatican.

4.4. ROMAN SCHOOL: Detail of Elders of the Apocalypse (13th cen.).
Fresco. Crypt, Cathedral; Anagni (Archivio Fotografico, Rome)

Boniface VIII, a member of the Caetani family, the lords of Anagni, suffered the humiliation of arrest at the hands of the agents of Philip le Bel of France. It was here too that the English barons responsible for the murder of St. Thomas à Becket came to make amends for their crime. In the crypt of the Anagni cathedral is a remarkable series of frescoes covering twenty-one cross vaults, three apses, and the walls of the crypt. The subjects represented include examples of contemporary scientific doctrine, stories of the Ark of the Covenant, and episodes from the Apocalypse [4.4] and from the lives of local saints. Christ enthroned among various saints appears in two lunettes, and the Virgin in bust form is to be found in one of the vaults. The crypt was dedicated in 1235, and the frescoes date in the second half of the thirteenth century.

Subiaco, in the valley behind Tivoli, is the spot to which St. Benedict retired to live after the foundation of Monte Cassino. Two monasteries there,

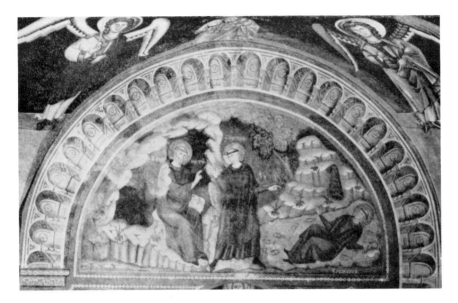

4.5. ROMAN SCHOOL: Episode from life of St. Benedict (13th cen.).
Fresco. Sacro Speco, Subiaco (Archivio Fotografico)

4.6 (*right*). ROMAN
SCHOOL: Prophet
roundel (late 13th
cen.). Fresco. Left
transept, church of
Santa Maria Mag-
giore, Rome (Foto-
gr. Gall. e Musei
Vaticani)

one dedicated to St. Benedict and the other to his sister St. Scolastica, contain many frescoes, the earliest being of the thirteenth century. The monastery of St. Benedict, built on the hillside over the Sacro Speco, the grotto in which St. Benedict lived, has a church on two levels. In the lower church are frescoes [4.5] of episodes from the life of St. Benedict; in the chapel of St. Gregory is the earliest known portrait of St. Francis of Assisi, in fresco, who appears here as "Brother Francis"—that is, before his canonization in 1228.

The importance of the Anagni and Subiaco frescoes, interesting as their style and subject matter is, lies primarily in the striking decorative borders painted around the scenes in the lunettes, or apses. These consist of architectural details, such as brackets (or consoles), billets, arched corbel tables with colonnettes, and even whole arches supported on twisted columns, all rendered illusionistically and in a perspective to give the effect of depth, thus breaking the flatness of the wall surface as well as affording an appropriate architectural framing of the painted episodes. Often there are inserts of imitated Cosmati work. As examples, we mention the corbels and arched areas between them filled with motifs of birds, vases, and hanging crowns in the central apse of the crypt at Anagni with its representation of the Elders of the Apocalypse [4.4]; the treatment of the lunette enclosing the Madonna in the nave of the cathedral above the crypt; and the lunette in the lower church of the Sacro Speco at Subiaco [4.5]. In this latter fresco note even the insertion illusionistically of small coffers on the under side of the painted arch to give the effect of even greater depth to the wall on which the stories are painted, a depth beyond that given by the prominent arched corbel table.

The twisted columns and corbels in perspective appear again in two frescoes in the left aisle of Santa Saba in Rome, one with the Madonna and Child, the other with a bishop saint. Other related examples in Rome appear in the shallow tunnel vaults in perspective supported on brackets that are backgrounds to the medallion busts of prophets in the triforium of the transepts of Santa Maria Maggiore [4.6]. Even in Rusuti's great mosaic in the open loggia above the entrance porch of the same church, huge hexagonal piers are represented as supporting an architrave on the under side of which are coffers in perspective, the piers separating the scenes in the story of the Miracle of the Snow associated with the origin of Santa Maria Maggiore.

Roman Fresco Painters at Assisi

It is precisely this type of illusionistic architectural painting that occurs in the upper church of St. Francis at Assisi. But at Assisi the illusionistic and the actual architectural details are blended and organized into an effective ensemble to act as a framework for the figurative frescoes, particularly those in the nave.

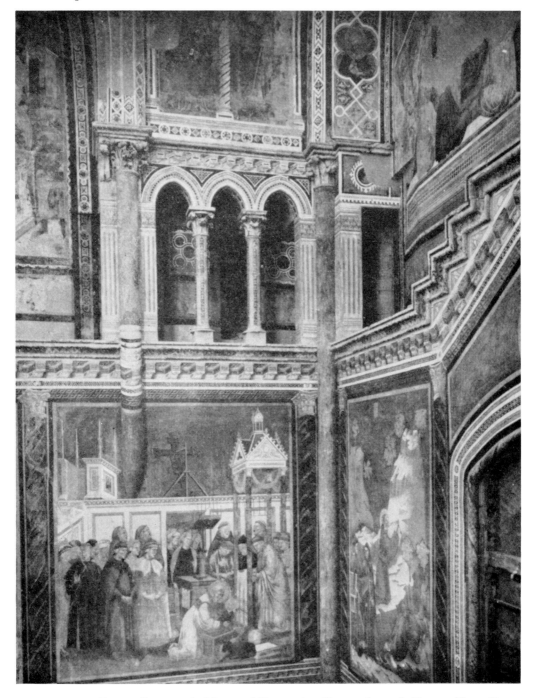

4.7. ROMAN SCHOOL: Architectural Decoration (late 13th cen.). Fresco. Nave, Upper Church, St. Francis, Assisi (Bencini e Sansoni)

The nave frescoes [4.7] are arranged as follows: A heavy molding running below the line of the clerestory windows divides the nave wall horizontally into two parts. The upper area between the windows is subdivided into two registers in which are painted scenes from the Old and the New Testaments. From the crossing, facing the entrance door, the Old Testament scenes are on the left and the New Testament ones on the right. The latter cycle continues around the entrance wall above the doorway with the two scenes of the Ascension and the Pentecost. Above these are medallions with bust portraits of SS. Peter and Paul and, in the space immediately above the entrance door, a large medallion with the Madonna and Child also in bust form.

The entire wall space of the nave and entrance walls below the heavy molding is filled with the great cycle of twenty-eight scenes from the life of St. Francis and their illusionistic architectural setting. These scenes appear to be painted on a wall slightly recessed behind a row of twisted columns that seem to stand on a continuous platform or floor supported on projecting brackets. The columns, in turn, seem to support a continuous architrave with Cosmati inlay. Two rows of coffers on the under side of this architrave indicate the recession of the wall surface on which the scenes are painted. Above the architrave larger brackets or consoles rendered in perspective carry illusionistically as a cornice molding the actual molding that divides the nave walls horizontally. The lower part of the walls below the columns is covered with simulated cloth or tapestry hangings.

This idea of a *stoa pictile,* an open-air picture gallery, in which painted scenes are seen as though in recessed spaces between columns or pilasters, goes back to Classic Roman times. We can see it in the famous Odyssey landscapes now in the Vatican Museum or in Pompeian wall painting. What is important for us at this point is the fact that a revival of illusionistic space-producers, such as columns, brackets, niches, and coffers in perspective, occurred during the last decades of the thirteenth century in Rome and its vicinity. This fact is strong evidence that the direction of the decoration of the nave of the upper church at Assisi was by a group of painters trained in the tradition of the contemporary Roman school and not by Cimabue, as claimed by Vasari, who attributed to that Florentine artist and his school all the Old and New Testament frescoes in the nave.

The effect of Cimabue's dramatic style in the frescoes of the sanctuary and transepts may have been felt by some of the painters of the Old and New Testament scenes, but those painters were trained in another tradition. The styles present in both sets of scenes in the first two bays nearest the transepts and in the figures of Christ, the Virgin, St. John the Baptist, and St. Francis in the cross vault over the second bay correspond closely to the styles of two Roman painter-mosaicists, Filippo Rusuti and Jacopo Torriti.*

* Rusuti signed the aforementioned mosaics in the open loggia of the façade of Santa Maria Maggiore, and Torriti signed those in the apse of the same church (1295) and in the apse of St. John Lateran (1291).

4.8. ROMAN SCHOOL: Esau before Isaac (late 13th cen.). Fresco. Left clerestory, Upper Church, St. Francis, Assisi (Alinari)

The remaining Old and New Testament frescoes in the last two bays and in the upper tier of the entrance wall are by still another master and his workshop. Although it has been suggested that this painter was the Florentine Gaddo Gaddi,* this third master remains anonymous and is generally known as the Isaac Master because two of the finest frescoes in that group [4.8] are concerned with the subject of the deception of Isaac by his wife Rebecca and her favorite son Jacob. Whoever he was, this master is on a par with Cimabue in importance at Assisi.† His style, however, is not Florentine, nor are there any Byzantinisms here. The powerful modeling of the heads and hands, as though made of bronze, and the fine-lined thin drapery clinging to the limbs to betray their forms reveal an intimate knowledge of Classical art that could have been acquired only in Rome. A similar style is seen in the colossal prophet heads [4.6] in medallions in the tribune gallery in Santa Maria Maggiore.

When we understand that the decoration of the upper church of St. Francis at Assisi was undertaken with the support of two popes of very dif-

* F. J. Mather, Jr., *The Isaac Master*, Princeton, Princeton University Press, 1932.
† See footnote on page 132.

ferent backgrounds—Nicholas III, a Roman Orsini, and Nicholas IV, himself a Franciscan—we need not be surprised to find Roman masters familiar with the tradition of fresco painting as well as the distinguished master from Florence who was known in Rome being asked to lend their services. The decoration of the church at Assisi, both in the thirteenth and fourteenth centuries, for which the most renowned artists of central Italy were employed, must have been an example for Pope Sixtus IV, because when in the fifteenth century he undertook to decorate the Sistine chapel in the Vatican he too called on a group of celebrated masters of central Italy.

The date for the beginning of the decoration of the basilica of St. Francis has been variously placed during the time of either Pope Nicholas III (1277–1280) or Pope Nicholas IV (1288–1292). The earlier dates seem likelier, for how can we explain the presence of the Orsini coat of arms in the fresco of St. Mark the Evangelist in the vault over the choir if the decoration was not at least begun during the reign of Nicholas III?

The Gothic Developments of Cavallini

It is rather extraordinary how long the Romanesque and Byzantine stylistic traditions persisted in the painting of Italy especially during the last half of the thirteenth century. The Cistercians from France had built cloisters and churches in the Gothic style in the first half of the century. By 1270 the French Angevins had driven out the German Hohenstaufens and had established a French court at Naples, bringing with them French culture and manners. Early in the last quarter of the century the Pisani and their followers were reflecting Gothic influences in their sculptures on pulpits and other monuments. And yet painting showed only sporadic manifestations of Gothic contacts. Margaritone had used the fleur-de-lis crown [3.30] and the lion-headed thrones. Coppo's Madonna at Orvieto [3.9] had worn a leafy crown, as had the Magi in various Guido-school panels in Siena, types of crowns to be found in Gothic miniatures and ivories. The St. Francis Master's and Cimabue's dramatic swing of Christ's body on the cross and Cimabue's emotionalism displayed by the figures at the foot of the cross in the Assisi Crucifixions manifested influences from Gothic sources, but the stylistic details were still those of the traditional Byzantine. In Rome the mosaics of Torriti and Rusuti showed similar adherences to Byzantine tradition, but the Isaac Master at Assisi had rendered heads and hands plastically and drapery functionally to bring out form in the fashion that he was able to observe from remnants of Classic sculpture in Rome.

Cavallini (c. 1250–c. 1330), however, was the first painter in Italy to use Gothic sculptural conventions as models to achieve for his figures that three-dimensional quality so sought after at the end of the thirteenth century. In the seven mosaic panels, dating about 1291, in the apse of Santa Maria in Trastevere in Rome—six scenes from the life of the Virgin plus a

panel [4.9] in which SS. Peter and Paul present the donor, Bertoldo Stefaneschi, to the Madonna and Child—Cavallini broke with the Byzantine tradition in his rendering of the forms and drapery. The heads are softer and rounder and they lack the harsh linear details. The drapery omits the stylizations rendering it flat and has instead broad areas of light and modeling shadows to give a sense of plastic form. The figures of SS. Peter and Paul illustrate this well. Their togaed forms are reminiscent of Classic orator or poet statues, such as the Sophocles in the Lateran Museum in Rome. But another element is present too. The drapery falling over the back and thigh of the kneeling Magus in the Adoration of the Magi panel has the baggy effect so common in French and Italian Gothic sculptures, such as those of the transept portals of Notre Dame in Paris or the sculptures of Giovanni Pisano. Hence, in order to achieve greater three-dimensionality of form, Cavallini first used Classical models and then Gothic ones. The colors of these mosaics, tending toward the light tones of pink, lavender, mauve, and green with occasional strong blues, red, orange, and white, help to give the modeled effect to the figures.

Shortly afterward, about 1295, Cavallini painted in fresco the great Last Judgment on the entrance wall of Santa Cecilia in Trastevere. A nun's choir built against the wall in the early sixteenth century fortunately protected a great portion of the fresco from destruction when Cardinal Acquaviva restored the interior of the church in 1727. Early in the twentieth century the protected frescoes were uncovered. Although much is missing, the central feature of the Last Judgment scene is well preserved—the large enthroned Christ showing His wounds, seven of the original ten angels surrounding Christ's aureole, the Virgin and St. John the Baptist, and the twelve enthroned apostles [4.10] flanking the Christ. The altar below Christ with the symbols of His Passion and the trumpeting angels and those herding the Blessed and the Damned to their respective Heaven and Hell have been cut off halfway down the composition. Other fragments are visible along the side walls of the church—a giant St. Christopher, an Annunciation, the scenes from Jacob's dream and his Deception of Isaac. But it is in the Christ and the row of enthroned apostles that we get our best material to study Cavallini's style.

Much has been said about the influence of Classical sculpture on Cavallini's naturalistic treatment of form and drapery. This is partially true so far as some of the figures in the mosaics in Santa Maria in Trastevere or the toga-clad *types* in the fresco [4.10] are concerned. But surely there is little indication of any Classic *style* here in the frescoes. No Classic statues are covered with woolen garments so heavy that they almost smother the form beneath and emphasize chiefly their own powerful plasticity and three-dimensionality by means of repeating, cascading loops falling down the sides or between the knees. Any comparison with contemporary Gothic figures of ivory or with the portal sculpture of the great French cathedrals, on the other hand, will immediately reveal a close connection. The work of the

4.9 (*above*). Pietro Cavallini: SS.
Peter and Paul recommending Bertoldo
Stefaneschi to the Virgin (1291). Mo-
saic. Apse wall, Santa Maria in Traste-
vere, Rome (Anderson)

4.10 (*right*). Pietro Cavallini: Apos-
tles, detail of Last Judgment (*c.* 1295).
Fresco. Entrance wall, Santa Cecilia in
Trastevere, Rome. (Vera)

Isaac Master, whose form-clinging folds of thin, almost wet, material and whose more structurally rendered heads echo the Classic tradition, also contrasts with Cavallini's heavy plastic drapery and puffy faces so characteristic of the Gothic style.

The Collaboration of Artists and the Development of Style

Naturally there were cross influences among the various masters working in Rome near the end of the thirteenth century. In the furniture in his mosaics and in the Last Judgment fresco, Cavallini used Cosmati designs. For example, the ciborium in the mosaic of the Presentation scene in Santa Maria in Trastevere is a simplified Cosmati type as is actually found in San Giorgio in Velabro, Rome. The thrones of the apostles of the Last Judgment fresco have grooved posts ready to receive varicolored cube decoration and unfinished knobs on the armrests and backs such as are common in Cosmati work. When he was restoring the Early Christian frescoes in the nave and decorating the façade with mosaics in St. Paul's outside the Walls, Cavallini had before him the work of the Cosmati in the cloister and on the famous ciborium with its Gothic architectural fòrms and its sculpture by Arnolfo di Cambio. Similarly, when Cavallini began work on the Last Judgment fresco in Santa Cecilia in Trastevere, Arnolfo had just completed a similar ciborium there.

Various artists often collaborated on the same monument. Arnolfo's ciborium in St. Paul's outside the Walls was done in collaboration with a certain Peter whom some have tried to identify as Cavallini. Again, when Arnolfo created the elaborately pinnacled tomb for Boniface VIII, finishing it in 1295 (eight years before Boniface's death), Torriti did the mosaic above the effigy. In its design he used SS. Peter and Paul flanking a medallion with the Madonna and Child, St. Peter presenting the kneeling Pope to the Holy Pair. (This is in reverse the design of Cavallini's mosaic in Santa Maria in Trastevere [4.9].) Another example of such collaboration is found in the Gothic tomb of Cardinal Acquasparta, who was both general of the Franciscan Order and legate of Pope Boniface VIII. The tomb is attributed to one of the Cosmati, Giovanni di Cosma, and the fresco in the lunette, depicting the enthroned Madonna flanked by St. John the Evangelist and St. Francis who is presenting the cardinal to the Virgin, is attributed to Cavallini.

This collaboration of painters and sculptors, often on the same monument, during the last quarter of the thirteenth century in Rome was bound to have an effect on the development of style. How could "cross fertilizations" be avoided? We have seen that French Gothic decorative architectural forms had appeared and blended with the regional Cosmatesque ornamentation in various types of church furniture and on tombs. Arnolfo and others, in carving figures for tombs and for other monuments, had used the

cascading folds of heavy drapery characteristic of Gothic sculpture in France. Would it not be natural, then, for painters, who at this time had already shown an interest in projection and three-dimensionality by decorating wall spaces with illusionistic architecture, to imitate sculpture as well in their desire to achieve plasticity of form? The models were at hand, even on the very monument for which they might be doing a mosaic or a fresco. Certainly it was this type of Gothic plastic drapery that was reproduced in Cavallini's frescoes even if the iconography of the scene was in a Romanesque-Byzantine tradition. The Isaac Master, on the other hand, chose to draw his models from Classic sculpture.

We might cite the frescoes in the upper church at Assisi as another example of the transfusion of styles resulting from various artists working on the same project. Here only painting is involved, but that the intermixture took place is patent from the vain attempts that have been made to unscramble the cross currents of style, especially in the frescoes of the upper registers of the nave walls. We have mentioned Cimabue, Torriti, Rusuti, and the Isaac Master as being at Assisi. There seems to be no stylistic evidence that would account for the presence of Cavallini. Attempts have been made to place him there, but these result from a confusion of the style of Cavallini with that of the Isaac Master. Cavallini was busy enough in Rome during the last fifteen years of the thirteenth century and, according to documents for the year 1308, he was in the service of the Angevins at Naples in the early fourteenth century. It is probable that he supervised in part the frescoes in the beautiful Neapolitan Gothic church of Santa Maria Donna Regina, which houses the tomb of Maria of Hungary, wife of Charles II of Anjou. The subjects of those frescoes are the Last Judgment and scenes from Christ's Passion and from the lives of SS. Agnes, Catherine, and Elizabeth.

Why did this new naturalism and plasticity in form appear first in the paintings of the Roman school rather than in those of Tuscany? The answer, I believe, lies in the fact that Rome had had a long tradition of fresco painting ever since Classic times. During medieval times churches naturally sprang up in numbers in the City of St. Peter, and churches needed fresco decoration. And painting in fresco makes possible much freer handling of form than does mosaic work or panel painting. Even in Rome, when the Romanesque-Benedictine style became most rigid under renewed Byzantine influences (as seen in the frescoes in the chapel of St. Sylvester in the church of Quattro Coronati), it rapidly softened and changed under local Cosmati and, possibly, imported French influences or even under the influence of contemporary Italian sculptors who had adopted the Gothic style. At any rate, a series of frescoes such as those in the portico of San Lorenzo outside the Walls in Rome, at Anagni and Subiaco, and at Santa Maria in Vescovio, Rome, make the transition to the frescoes of the Isaac Master and of Cavallini with their naturalism of form seem less sudden than it might seem if viewed in the light of Tuscan panel painting. That is, the stylistic development of

painting in Tuscany up to the end of the thirteenth century had been largely conditioned by the Western medieval and Byzantine traditions of two-dimensionalism and stylization that were difficult to shake; in the Roman school a fresco tradition with greater flexibility had been deeply rooted for centuries.

Unfortunately, the preoccupation of Roman masters of painting with naturalistic, three-dimensional representation came to a sudden end with the removal of the popes from Rome to Avignon in 1305. There they remained until 1377. But the accomplishments of the Isaac Master and of Cavallini were not lost. A young genius, who had come to Rome from Florence and who as we shall see had also been at Assisi in the last decade of the thirteenth century, was to turn his back on the Florentine traditions of Cimabue and develop his own style, at first under the influence of the two great Roman masters and then under that of the contemporary sculptor Giovanni Pisano. What Giotto started was to find its fulfillment in the work of Michelangelo.

BIBLIOGRAPHY

Kleinschmidt, B. *Die Basilika San Francesco in Assisi*, 3 vols. Berlin, Verlag für Kunstwissenschaft, 1915–1928. (This monumental publication by a Franciscan on St. Francis of Assisi is in German; Volume II discusses the frescoes.)

Nicholson, A. "The Roman School at Assisi," *Art Bulletin*, vol. 12, 1930, pp. 270–300.

Mather, F. J., Jr. *The Isaac Master*. Princeton, N. J., Princeton University Press, 1932.

Hutton, E. *The Cosmati—The Roman Marble-workers of the XIIth and XIIIth Centuries*. London, Routledge and Kegan Paul, 1950.

Toesca, P. *Pietro Cavallini*. Milano, Collezione Silvana, Pizzi, 1959.

PART II

The Fourteenth Century

✦ 5
Duccio of Siena

AS a contemporary of the Roman masters and of the Florentine Cimabue there appeared in Siena Duccio di Buoninsegna. Although he was somewhat older than Giotto, Duccio occupies almost the same position of importance in Siena as Giotto does in Florence. Each established a tradition of painting with many followers; each "turned the corner" leading into the Gothic style in Tuscany; but each did it in his own way. In the end, what Duccio and Giotto did was to characterize and differentiate fourteenth-century painting in Siena and in Florence.[*]

We can only conjecture the date of Duccio's birth, which may have been somewhere between 1255 and 1260. The first documented payment of his work was in 1278, when he was paid for painting twelve boxes, or small chests, to contain Sienese public civil documents. A year later he decorated one of the wooden covers of the treasury accounts of the city, a commission he was awarded several times during the next fifteen years and one that was given to anonymous as well as to well-known Sienese painters. In 1280 Duccio was fined the large sum of 100 livres for some unrecorded misconduct, the first of a series of fines and difficulties with the law. Duccio apparently was an independent individual. Once he refused to pay allegiance to the Capitano del Popolo, the imperial supervisor; later he failed to appear for military duty; and on various occasions he was fined for nonpayment of debts, for creating a public disturbance, and even for what appears

[*] Although the major accomplishments of these two artists date in the fourteenth century, it should be remembered that their earlier activities were still at the end of the thirteenth century.

to have been the suspicion of practicing magic. After his death in 1319, his widow and seven children refused his inheritance—which apparently consisted entirely of debts.

Duccio's reputation in his art, however, was such that he received an important commission in the rival city of Florence and in Siena was invited to serve on a commission with other artists (including Giovanni Pisano) that decided on the site of the Fonte Nuova, a fountain, to paint an altarpiece for the Palazzo Pubblico, and to undertake the painting of the great altarpiece for the main altar of the Siena cathedral.

The Rucellai Madonna

It was in 1285 that Duccio received the commission to paint in Florence a Madonna for the Compagnia di Maria Vergine of the important Dominican church of Santa Maria Novella. This organization was one of the companies of the *Laudesi*, referred to in Chapter 3, who were active in revitalizing the cult of the Virgin, especially after 1260. And the Madonna that Duccio produced for it [5.1] was the largest yet painted, which is some indication of the role the Madonna was to play in Italian painting and of the growth of the revived cult. When, in the middle of the fourteenth century, the chapel of the *Laudesi* was sold to the Bardi family, the Madonna was placed between it and the Rucellai chapel. In Vasari's time, a tomb was erected between the two chapels and apparently the Madonna was moved into the Rucellai chapel. Hence it became known as the Rucellai Madonna. During World War II it and many other priceless masterpieces were moved for safety to the Villa Montegufoni at Montespertoli. It is now in the Uffizi.

The Rucellai Madonna is remarkable for other reasons than its size. Its gabled top is borrowed from the tradition established by Duccio's Sienese predecessor Guido. The wide border around the whole panel is adorned with thirty medallions separated by delicate floral bands resembling enamel work. In these medallions are the bust figures of Christ, John the Baptist, Abraham the patriarch and ten prophets, the twelve apostles, and five saints, which are placed along the bottom border—two bishop saints, St. Dominic, St. Peter Martyr (founder of the Florentine *Laudesi* in 1243), and St. Catherine of Alexandria. The use of medallions with apostles, prophets, and saints about a central figure can be traced in Byzantine mosaic tradition. But Duccio had before his eyes the altarpiece, now in the Bardi chapel in Santa Croce, Florence, containing the full-length figure of St. Francis and scenes from his life [3.3]. Earlier we noted that in this altarpiece the central figure is surrounded by a series of bust-size figures in medallions.

The Madonna herself, the throne, and the six angels are worthy of special attention. Instead of covering the Madonna's mantle with an all-over hatchwork of gold as Guido and Coppo had done, Duccio presented a simple silhouette of blue with a gold border winding in curvilinear rhythms within the silhouette and at the base of the figure, which suggests that

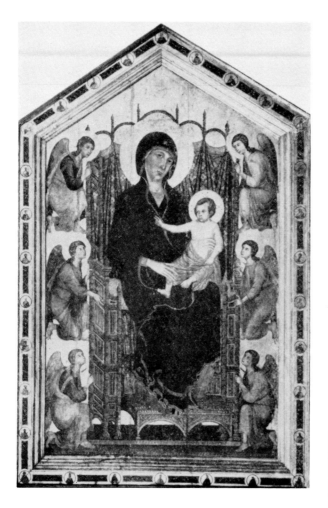

5.1. Duccio: The Rucellai Madonna (1285). Panel painting, 177⅞″ x 114⁵⁄₁₆″. Uffizi, Florence (Soprintendenza)

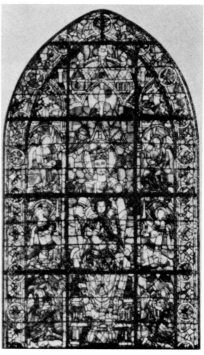

5.2. French Gothic: La Belle Verrière (13th cen.). Stained glass. Chartres Cathedral, France

Duccio had a knowledge of French Gothic illumination. In contrast to the metallic, angular, and stiff borders used by Guido and Coppo, Duccio's not only gives a delicate and subtle emotional effect but also leads the eye eventually to the Christ child whose diaphanous upper garment and gold-shot lower one make a striking contrast to the deep blue area of the Madonna's mantle. The elaborate brocade behind the Madonna and the intricate elegance of the woodwork of the throne help considerably to accent the simple silhouette of the Madonna.

Duccio's treatment of the throne is remarkable because of his attempt to get depth and break the front plane. First, as Guido had done, he set the throne at an angle. Then he added a number of devices, such as the consoles arranged in perspective, as we have seen them used by Roman artists, and the series of open arcades that show the drapery behind the throne. These arcades are for the most part made up of slender colonnettes and Gothic arches. The angels supporting the throne are also striking innovations. The softness of their thin garments is accentuated by the curvilinear rhythms of the drapery and by pastel shades of green, lavender, yellow, and blue. The kneeling postures, especially of the two upper pairs who seem to kneel in mid-air, would appear strange if we did not know that the same motif had been used in the famous Gothic stained-glass window of La Belle Verrière [5.2] in Chartres cathedral. Duccio must have known of this design—perhaps through his friend Giovanni Pisano the sculptor, who had traveled in France and visited cathedrals. In the Chartres window, the iron crossbars give visual support to the knees and feet of the upper pairs of angels. Duccio could not put in such horizontal supporting lines, but patently his kneeling angels were derived from ones that did have them. We shall see shortly that Duccio was also interested in designs for stained glass.

As early as the fifteenth century a confusion had arisen in the minds of Florentine writers whom Vasari followed in attributing this Madonna to Cimabue. Those writers, of course, were not aware of the documentation that was to be published in the nineteenth century,[*] and any such great accomplishment of the late thirteenth century, particularly in Florence, would inevitably be credited to Cimabue, who was supposed to have been the father of painting in Italy. We need not go into the confusion except to say that at the end of the nineteenth century the cause of Duccio as the painter of this Madonna was taken up and, although even a third master, the Rucellai Master, has been suggested, Duccio's authorship of this famous painting is generally accepted.

The Rucellai Madonna and Cimabue's Trinità Madonna [3.18] today hang in the same room in the Uffizi where they can be compared. In spite of certain strong similarities in the stylized features of the faces and the naturalistic moplike hair of the Christ child and the angels—Duccio and Cimabue must have been closely associated at this time—the fundamental

[*] Gaetano Milanesi: *Documenti per la Storia dell'Arte Senese*. Siena, 1854. Vol. I, p. 158.

differences are striking. Cimabue's Madonna emphasizes hieratic, dogmatic Byzantinisms in the all-over gold hatchwork of the mantles of the Madonna and Child and in the presence below the throne of the prophets who had foretold the coming of the Messiah. The contemporary search for more plastic form and any dramatic expressiveness drawn from Franciscan or Gothic sources is confined to the angels at the side of the throne. In the stepped and curved front of the throne Cimabue made some attempt at spatial effect, but the throne itself seems to be an effort to impose Duccio's wooden, spool-turned type on the more traditional leaf type that had been used by the Bigallo Master and went back at least to the throne of Christ in the eleventh-century frescoes in Sant' Angelo in Formis. Duccio, in his Rucellai Madonna, while parading the problem of space illusion in the elaborate craftsmanship of the throne, created an effect far from the dogmatic Byzantine one. The gentle adoration of the angels, their soft colors and veil-like garments, the fluid silhouette of the Madonna, and the general predominance of curvilinear rhythms reflect the qualities of style and feeling prevalent in Gothic France but reinterpreted in Tuscan Italy. The echo of the dogmatic Byzantine theology surviving in the medallioned prophets, apostles, and saints has been relegated to a decorative border. Consequently a more human concept of the Madonna emerges.

It is interesting to speculate why Duccio, from rival Siena, was commissioned to paint the great Rucellai Madonna in Santa Maria Novella in Florence, the native city of Cimabue. The answer may be that Cimabue was unavailable because he was at Assisi working on the frescoes. We can also speculate about the personal relationship of the two painters. Certainly a stylistic one exists as the hard facial features of the Rucellai Madonna show, a fact that caused many earlier writers to claim this Madonna for Cimabue. Professor Roberto Longhi, the distinguished Florentine art historian, has claimed that Duccio was at Assisi as an assistant to Cimabue before Giotto was, and that Duccio painted in fresco one of the angels in the left transept of the upper church and the Adam in the Creation scene as well as the Crucifixion in the upper tier of the nave. Although it is difficult to accept these attributions without other evidence of fresco painting by Duccio, evidence of another kind would seem to establish the fact that Duccio was present at Assisi and at least had seen the frescoes there.

I have pointed out the use by the Roman school of painters at Assisi of the traditional illusionistic architectural decoration, such as brackets, corbels, and consoles rendered in a quasi-perspective. In a Madonna and Child [5.3], now in the Stoclet Collection in Brussels, to be dated after the Rucellai Madonna and before the great altarpiece, the Maestà, in Siena, Duccio painted below the Madonna a ledge supported by a series of perspective consoles very similar to those that run along beneath the moldings of the St. Francis series in the upper church at Assisi. This use of perspective architectural detail will be further elaborated in Duccio's Maestà [5.5]. Even more convincing evidence appears in the Crucifixion scene [5.8] on the back

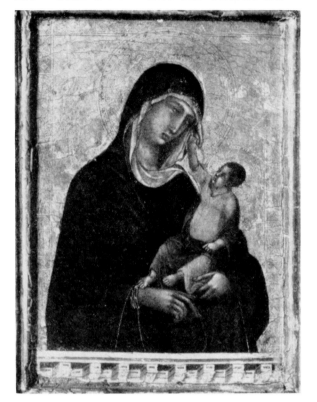

5.3. DUCCIO: Madonna and Child (13th cen., last decade). Panel painting, 10⅝″ x 8¼″. Stoclet Collection, Brussels (Courtesy, Ministry of Public Instruction, Brussels)

of the Maestà, which we will consider presently. Here the centurion to the right of the cross raises his arm outstretched pointing to the Christ. The head of a young man peers out at the spectator from beneath this outstretched arm. This identical group appears in Cimabue's fresco of the Crucifixion in the left transept of the upper church at Assisi, where the centurion is given a halo and stands in front of the group of Jews reviling Christ. Some of these bearded Jewish figures were also taken over by Duccio and adapted to his composition, as were the thirteen mourning angels fluttering about the cross. And, like Cimabue, Duccio enlarged the whole scene by adding many figures to give a more narrative and historical quality, which quality the fourteenth-century Florentine and Sienese painters developed even more highly.

By its size, its innovations, and its location in the important church of Santa Maria Novella, the Rucellai Madonna exerted great influence on the Madonnas of other artists. We have pointed out how it may have affected the Trinità Madonna of Cimabue. The other great Madonna issuing from Cimabue's workshop, formerly in San Francesco at Pisa and now in the Louvre [3.19], shows the Rucellai influence even more—in the throne, in the position of the Madonna's hands, and in the small medallion heads in the frame.

The Oculus of Siena Cathedral

A few years after the Rucellai Madonna, Duccio's interest in stained glass had a chance to manifest itself more specifically. Documents have recently come to light that concern the filling with stained glass of the oculus, or round window, in the wall above and behind the main altar of Siena cathedral [5.4]. They date in the year 1287 and 1288, which would make this window the earliest known stained-glass window in central Italy. Those in St. Francis at Assisi, previously considered to be the oldest, date from the last decade of the thirteenth century or later. For some reason the oculus at Siena had been held to belong to the second half of the fourteenth century, and documents for repairs from 1372 on are extant. But when the glass in the oculus was taken down for safekeeping during World War II, it became apparent that the style and designs were from the workshop of an artist who could only have been Duccio. The date of the newly discovered documents also confirmed this. The panels on vertical axis in the center of the window represent the scenes of the Resurrection of the Virgin, her As-

5.4. Duccio: Oculus window (1287–1288). Stained glass. Apse, Cathedral, Siena (Anderson)

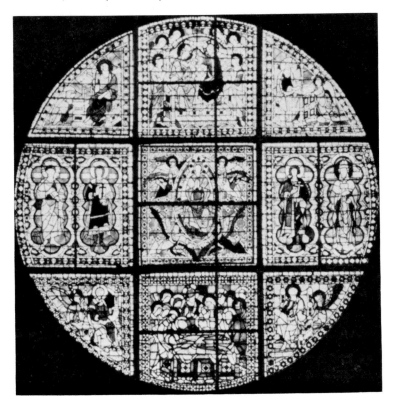

sumption, and her Coronation, reading from bottom to top. To left and right of the central panel of the Assumption the four protector saints of Siena (SS. Bartholomew, Ansano, Crescentius, and Savino) stand in peculiarly shaped aureoles. In the upper and lower corner panels the four evangelists are enthroned, accompanied by their respective symbols. Stylistically and iconographically the throne type in the Coronation panel is a simplification of the Rucellai throne, using Cosmati decoration instead of turned wood. The angels leaning over the back of the Virgin's throne in the same Coronation panel forecast the angels at the back of the throne in Duccio's great Maestà made for the same cathedral some twenty years later. Certain details also seem to show further connections with the basilica of St. Francis at Assisi, and the stance of the angels in the front row beside the throne of the Coronation panel resembles closely that of Cimabue's angels in the lower church at Assisi. It is interesting to observe that at the time this window was put up Giovanni Pisano was the supervising architect of the Siena cathedral, a position he had filled since 1285. We can hardly consider it a matter of chance, therefore, knowing that Giovanni had visited French cathedrals and was Duccio's friend, that the first stained-glass window in Tuscany was designed by Duccio and that Duccio had used as models for the angels of the Rucellai Madonna those of La Belle Verrière in Chartres.

The Maestà

Since Duccio's development during the next twenty years need not concern us here, we pass to his most momentous accomplishment, the Maestà [5.5] made for the main altar of the Siena cathedral. The contract was signed in October 1308 and the finished altarpiece was carried in triumph from Duccio's workshop to the cathedral in June 1311. It remained on the high altar until the beginning of the sixteenth century when it was supplanted by the great bronzes that are still there. It was then dismembered, sawed apart, and after various other vicissitudes finally placed—what was left of it—in the Opera del Duomo at Siena, where it is now.*

It is small wonder that the crowds witnessing the transportation of the altarpiece to the cathedral were struck with enthusiasm and awe, for nothing like it had been seen before. Here was a visual glorification of the Virgin to satisfy the most emotional of her worshipers. The sketch and the photographs will give some idea of its appearance. It was constructed architecturally with a predella as base, the large horizontal area containing the Madonna, angels, and saints as the main feature above the predella, and the pinnacles at the top. All this shows the strong Gothic elements affecting the form of the altarpiece—a form that was to become a prototype for most altarpieces that developed, with changes and variations, in the fourteenth and fifteenth centuries. In Duccio's Maestà, while the central rectangular

* It was recently cleaned at the Istituto del Ristauro in Rome.

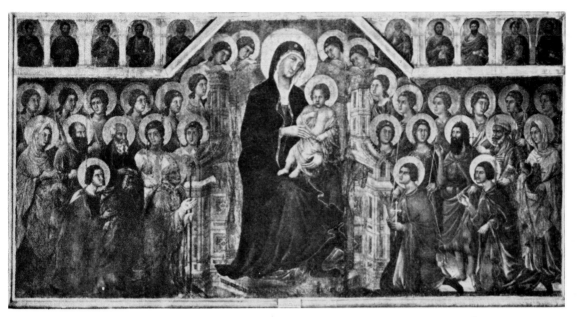

5.5. DUCCIO: Maestà (1308–1311). Panel painting, 82⁵⁄₁₆″ x 167⅝″. Opera del Duomo, Siena (Anderson)

panel still recalls the earlier ancona shape and the apostle busts under arches at the top are perhaps reminiscent of Byzantine enamels, the base and pinnacles and the way in which the Madonna is represented are Gothic. The use of the predella appears here for the first time, as far as surviving altarpieces are concerned. We do know from documents, however, that in 1301–1302 both Duccio and Cimabue received commissions to do altarpieces with a predella: Duccio for an altar in the Palazzo Pubblico at Siena, Cimabue for Santa Chiara at Pisa.

The entire central horizontal rectangle of the Maestà is occupied by the Madonna and Child enthroned in the midst of angels, saints, and apostles —that is, the Madonna is enthroned in the midst of her court like a liege queen, a completely new concept in Italian painting. Heretofore we have seen the Madonna represented with the Christ child, either as an unattended Majesty or with small-scale angels flanking the top of the throne or an occasional small saint at the bottom. Both Duccio and Cimabue had previously increased the scale and number of the angels and set them beside the throne. But the idea of representing the Madonna in the midst of a court is new and reflects both the influence of the feudal North and the growing tendency to interpret religious subject matter in a more secular fashion, probably the outgrowth of the Franciscan movement. In addition, the idea of intercession by the Virgin is introduced. In the front row, to the right and to the left of the throne, four patron saints of Siena * are kneeling in sup-

* Three, SS. Ansano, Savino, and Crescentius, are the same saints present in the Oculus of the cathedral. The fourth saint here is St. Victor.

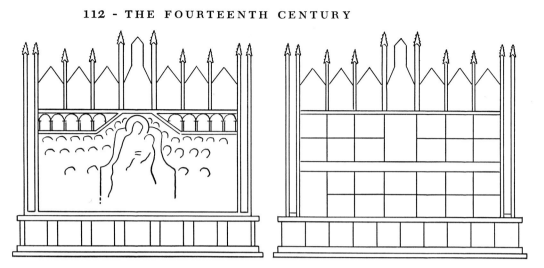

Restoration of Duccio's Maestà, front (*left*) and rear (*right*)

plication. We have already noted Duccio's connection with the *Laudesi*. The introduction in the Maestà of intercessory saints points also to some connection with, or influence of, these groups. In a moral laud written in Perugia for dramatic use in a church, there is, for example, a passage in which the Perugians, having been condemned by Christ for their sins, appeal to the Virgin to intercede for them. She, in turn, takes with her the patron saints of Perugia, and by joint appeals to Christ they receive His promise of pardon. These new features of the representation of the Madonna are the prototypes for the frescoes by Simone Martini in the Palazzo Pubblico in Siena [7.1] and by Lippo Memmi in the Town Hall of San Gimignano that we will consider in a later chapter. They also are to be found in the great altarpieces painted by Pietro and Ambrogio Lorenzetti [7.8, 7.14].

In the predella below are seven scenes from the early life of Christ, each separated from the other by an Old Testament prophet who foretold the scene. The pinnacle panels above the Madonna group contained the scenes of the Last Days of the Virgin, her Assumption and Coronation. Consequently the whole front of the altarpiece was dedicated to the Virgin, because she too was a participant in the scenes of Christ's early life.

The entire back of the altarpiece [5.6] is covered with panels illustrating scenes from the life of Christ. In the predella were those of His ministry and miracles; on the back of the main section containing the Madonna and court are the scenes of the Passion and Resurrection, from the Entry into Jerusalem to the Supper at Emmaus; and on the pinnacle panels above were the Resurrection, the scenes of His appearance to the apostles after the Resurrection, the Ascension, and the Pentecost.

Duccio's style reached its full development and splendor in this Maestà, fusing, as he had done in part in the Rucellai Madonna, Byzantine abstrac-

tions of form and patterned color, architectural space illusions observed in the Roman school, and Gothic elegance and emotion expressed in curvilinear outlines, in gestures, and in cascading draperies. Look, for example, at the Madonna, saints, and angels. The Madonna type is the Hodegetria observed in Byzantine and Romanesque art. Derived from the Byzantine too is the iconography of the angels, saints, and apostles. The throne with its pseudo-perspective of an open book reflects the space obsession of the Roman school. The Cosmati work on the throne also betrays this Roman connection. But the Madonna with her court, the broad area of her blue mantle with the wandering curvilinear gold border, and the cascading folds and rich brocading of the garments of the saints are Gothic adaptations. Some of these garments are edged with the gold-wire line present in the Madonna's robe. The whole effect is of richness and color, of gentleness of feeling and movement, which were to become the earmarks of the Sienese style.

In like manner, in the panels of the predellas, the pinnacles, and the entire back of the altarpiece on which the narrative scenes are painted, Duccio used the same three style factors to emphasize the emotional content of the stories or to render architectural space. In Byzantine art, backgrounds, whether landscape or architecture, had been reduced to stylized and patterned forms, just as had the human figure. To suggest an outdoor setting, conventionalized trees and rocks had been used; to suggest an architectural one, a parapet, turrets, small gabled structures, or doll-house interiors. In Duccio's panels such backgrounds are given a more specific purpose or function, both as decoration and as accents for the content expressed by the figures. One example will illustrate this. In the scenes of Christ's Betrayal [5.7], the composition is divided into two rectangles, a larger one at the left and a smaller one at the right. In the larger rectangle, Christ stands in the middle of a group of soldiers come to arrest Him. He is dressed in the traditional dark-blue robe edged with Duccio's gold line. The trees of the background standing out against the gold-leaf sky not only indicate the outdoor setting but also help in pointing out the chief episode of the scene: Judas kissing Christ. The dark accents of their silhouettes also call attention to the figure of Christ because it is the only dark accent in the lower half of the panel. In the right-hand rectangle, the apostles flee in terror from the scene of Christ's arrest. The shadows on the rocks of the mountain background with their fluid outlines help to emphasize the idea of flight. Hence the background functions both as decoration and as accent complementary to the action and emotion expressed in the figure groups.

In indoor scenes, such as those in which the various episodes of Christ's trial are represented, Duccio is more descriptive than a Byzantine artist would have been and also more space-conscious. He calls attention to all the carpentry—the doors, the paneling, the brackets, the rafters. He makes the latter heavy, and by setting them at sharp angles he attempts to give space to his little boxlike structures by carrying the observer's eye back into the room. In some cases he paints open or half-open doors leading into a

5.6. Duccio: Maestà, rear (1308–1312). Panel painting, 82⁵⁄₁₆″ x 167⅝″. Opera del Duomo, Siena (Anderson)

5.7 (*below*). Detail, Betrayal of Christ (Anderson)

5.8 (*opposite, top*). Detail, Crucifixion (Anderson)

5.9 (*opposite, below*). Pinnacle panel painting, Christ appearing to Disciples after the Resurrection (Anderson)

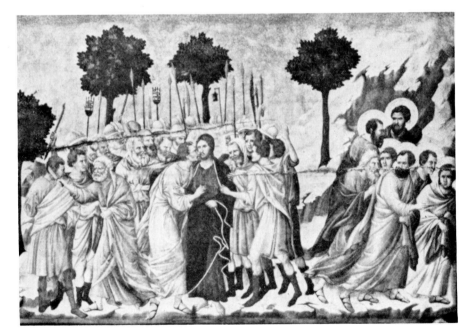

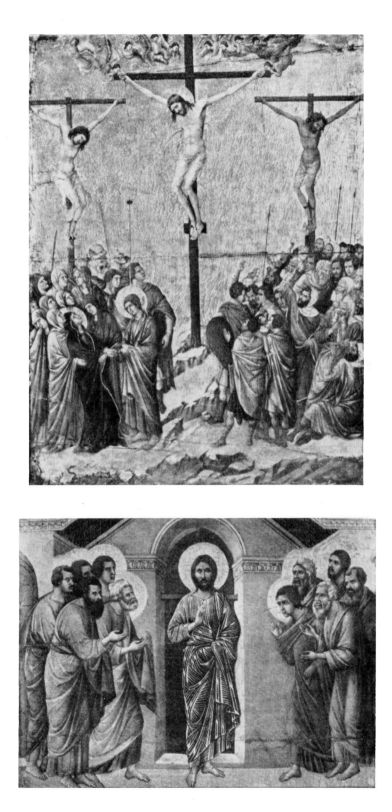

dark or even articulated space beyond the back wall. This is all in keeping with and a further development of the interest in architectural space illusion observed in the frescoes of the Roman painters of the late thirteenth century—possibly seen by Duccio at Assisi—and in the throne of the Rucellai Madonna.

Another point of interest in Duccio's treatment of these interiors is their variety. Instead of using one generalized setting for the indoor scenes, as was the custom in Byzantine painting, Duccio altered the setting with each change of locale. He used one interior when Christ is before Annas, another when He is before Herod, still another when He is brought before Pilate and is returned for sentence. In these "sets" with their boxlike carpentry, Duccio may well have been influenced by the stage sets of sacred dramas, which were becoming popular at that time. That certainly would seem to be the case in the two panels, one above the other, in which Christ appears in the Council Chamber before the throne of the high priest while Peter sits in the courtyard below, warming himself by a fire and denying that he ever knew Christ. The two levels are connected by a stairway in the background of the lower panel leading up to the second story shown in the upper panel.

In his figures, Duccio does not achieve this sense of space relationship. Although he shows the effects of Gothic sculptural conventions in the cascading draperies, his figures and groups still function essentially as silhouettes or two-dimensional patterns or as agent for some significant expression in the narrative. For example, in the scene of Peter's Denial just mentioned, the maid servant pointing out Peter to the others seated about the fire appears to be standing in the foreground, and yet the hand of her raised arm seems to be touching the rail of the stairway in the background. Duccio does this merely as a matter of design, since the stair rail continues the line of her arm. Another forceful instance of the violation of space relationship appears in one of the scenes of Christ before Pilate. Pilate, facing the left, stands beneath a portico supported by columns and yet his right arm is placed in front of the columns. Here the important thing to Duccio is not the space but the fact that nothing must interfere with Pilate's gesture during the remark, "Ecce Homo." But the figure is so two-dimensionally represented that the incongruity is not immediately noticed.

It is in the figures and in the interpretation of the narratives from the life of Christ and the Virgin that Duccio best shows his genius in blending the richness of Byzantine color and abstraction with the human expressiveness of the Gothic style. The harsh features of Guido's or Coppo's heads and hands Duccio softens to a more naturalistic modeling, and the drapery of the Madonna, the angels, and other figures, as we have already remarked, is either simplified to broad silhouette areas or else rendered with Gothic cascading folds. Emotions are concentrated in the faces and in the gestures of the hands, and drapery, as in Gothic sculpture, becomes the complement of the emotion expressed. How effectively Duccio used the drapery, particu-

larly in the figures of his principals, the Virgin and Christ, whom he clothed in flat blue robes edged with a gold line, can be illustrated in two examples.

In the Crucifixion scene [5.8] the Virgin, overcome by grief at the foot of the cross, is about to faint into the arms of her friends. The instability of the fainting figure is excellently rendered by the movement of the gold line along the edges of the mantle. In the Deposition scene, the Virgin reaches up in restrained agony to receive and caress the body of her dead Son being lowered from the cross. The definite upsweep of the gold line of the Virgin's robe emphasizes this reach and leads the eye to the emotional center of the scene around the heads of Christ and the Virgin.

Whenever Duccio represents scenes in which the human side of Christ is stressed, he clothes Him in a simple blue mantle with the decorative Gothic gold line. But whenever he shows Christ as a glorified Being, as in the Transfiguration, the Resurrection, and those scenes after His Resurrection [5.9] Duccio clothes Him in a robe covered with a hatchwork of gold line, like that found in Byzantine miniatures and mosaics. In other words, to Duccio a scene with dogmatic content was still to be expressed in the Byzantine style, while the more human ones called for the new style that lent itself more to personal emotional expressiveness. The colors, which cannot possibly be reproduced satisfactorily, add tremendously to the emotional effect. Just as the color contrast between the solid dark blue of the Madonna's robe and the pastel shades of the diaphanous garments of the angels in the Rucellai Madonna were so striking, so in the Maestà the solid blues of Christ and the Virgin and the softer shades of the apostles' garments set each other off with dramatic effect. The walls of the miniature interiors are in light greens or buff yellows or coral pinks.

The Maestà, as we have said, is now dismembered. While most of it is to be seen in the museum of the Opera del Duomo in Siena, the gabled pinnacles that once presumably contained half-length angels and several of the panels with scenes have disappeared. Some of the predella panels have found their way into museums and private collections—the Annunciation and the Transfiguration of Christ are in the National Gallery in London; the Nativity and the Calling of Peter and Andrew are in the National Gallery in Washington, D. C.; the Temptation of Christ is in the Frick Collection in New York; the Raising of Lazarus and the Christ and the Woman of Samaria are in the Rockefeller Collection in New York.

This Maestà proves Duccio to be one of the great masters of all times. He was not, as has been suggested, the apex and final flare of the Byzantine style in Italy. Rather, like Giotto, Duccio was an innovator who turned painting—and painting in Siena in particular—into new paths, paths leading from dogmatic formalism to a more naturalistic secularism. Keeping indeed certain Byzantinisms of abstract design, color, and iconography, he introduced the naturalisms of architectural space descriptively and borrowed concepts as well as forms from the Gothic, whether derived from France or from his

friend Giovanni Pisano. This was all in keeping with the trend and taste of the time. Giotto did more or less the same things but primarily from the standpoint of a sculptor. Hence Giotto's forms will seem much more plastic and will take on a kind of monumentality in contrast to the delicate quality of Duccio's forms, which have a closer affinity to the miniature traditions in illuminated manuscripts or to Gothic ivories.

BIBLIOGRAPHY

Weigelt, C. H. *Duccio di Buoninsegna.* Leipzig, Kunstgeschichtliche Monographien, vol. 15, 1911. (Sourcebook in German)
——— *Sienese Painting of the Trecento.* New York, Harcourt, Brace & Company, 1930.
Brandi, C. *La Maestà di Duccio.* Milan, Edizione d'Arte Sidera, 1954. (Short Italian text; 36 color plates)
DeWald, E. T. "Observations on Duccio's Maestà," in *Late Classical and Mediaeval Studies in Honor of Albert Mathias Friend, Jr.,* Princeton University Press, 1955.

✦ 6

Giotto of Florence

DUCCIO'S counterpart in the rival city of Florence was Giotto [1266 (or 1276)–1336].* Though both artists matured under the influence of the new Gothic culture appearing in Italy, each developed an essentially different style. As we have just seen, Duccio was concerned with the problems besetting a panel painter. Giotto is known to us primarily as a fresco painter, although no tradition of fresco painting existed in his native Florence.

The story has come down in tradition that Cimabue one day came across the young Giotto scratching figures of sheep on a rock and promptly offered to train him in the art of painting. Born in Florence when the Byzantine style was prevalent in painting, Giotto possibly did receive his earliest training from Cimabue, but evidence of any stylistic link between the two does not exist. When Giotto painted his earliest authenticated frescoes, his style was Gothic and his figure style, three-dimensional and sculpturesque, the very opposite of Florentine traditions as we have seen them in the late thirteenth century. Hence we must search elsewhere for the influences that made Giotto the great painter that he was. The frescoes in the Arena chapel at Padua are the earliest works by Giotto of which we can be sure, so let us examine them first to get our impression of Giotto's style at the beginning of the fourteenth century and of his capabilities as an artist. The frescoes were begun in 1305 when Giotto was thirty or forty years old, and when his style had reached maturity.

* The writer Antonio Billi (late fifteenth century) and Giorgio Vasari the biographer (sixteenth century) give Giotto's birth date as 1276. Antonio Pucci (second half of the fourteenth century) says Giotto died in 1336 at the age of seventy!

119

The Arena Chapel Frescoes

The Arena chapel in Padua was built by the Scrovegni family as a part of the palace they erected within the ruins of an ancient Roman arena—whence its name.*

The whole interior, consisting of a small rectangular nave, the sanctuary, and the covering vault, is decorated with frescoes by Giotto and his assistants. It is a jewel box of color held together by the intense light blue of the backgrounds pervading all. Writers from the fourteenth century on have said that Giotto had worked at Ravenna. If so, he must have been impressed by the blue of the mosaics in the little fifth-century shrine of Galla Placidia and wanted to reproduce a similar effect in the chapel he was decorating at Padua.

The subject matter of the wall paintings in the nave is an abbreviated version of the favorite medieval program of didactic church decoration depicting the Fall of Man and his Salvation, in scenes ranging from the Creation through the life of Christ to the Last Judgment. In French Gothic cathedrals this program was immensely elaborated in the portal sculptures, which included Man's physical activities throughout the year in the Labors of the Months, and which suggested his ethical life in the representations of Virtues and Vices. Here in the Arena chapel, the cycle of scenes [6.1] begins with the Annunciation to the Virgin. The scene is divided by placing Gabriel in the left spandrel of the arch opening into the sanctuary and the Virgin in the right one. These are the first figures that the spectator sees on entering the chapel. Scenes from the lives of the Virgin and Christ cover the three upper tiers of frescoes along the side walls and, in the fourth tier, the lowest, personified representations of Virtues and Vices face each other on opposite sides of the nave. Justice as a queen is seated on a Gothic throne and Injustice as a tyrant sits on a cracked and crenelated one. Small relief-like scenes illustrating the effects of Justice and Injustice in Government appear on the bottom of the thrones. Six Virtues flank the throne of Justice and six Vices that of Injustice. All these personifications are painted in a gray monochrome to simulate sculpture. In the wall space above the spandrels of the sanctuary arch containing the Annunciation is the scene that serves as a prelude to the whole cycle: God the Father, enthroned among His angels, is instructing Gabriel to descend to earth with His message to the Virgin.

The divided Annunciation scene appears in the spandrels of the arch into the choir in the mosaic decoration of Norman-Byzantine churches. But Giotto was not imitating. He had a very different reason for the special emphasis he gave here to the Annunciation and to the prelude scene. In 1278 the *podestà*, or governor, of Padua had ordered a special celebration of the

* During the aerial bombardment of Padua in World War II this shrine of early Italian painting narrowly escaped destruction. Bomb craters pockmarked all the surrounding area, but miraculously no bomb fell on the chapel.

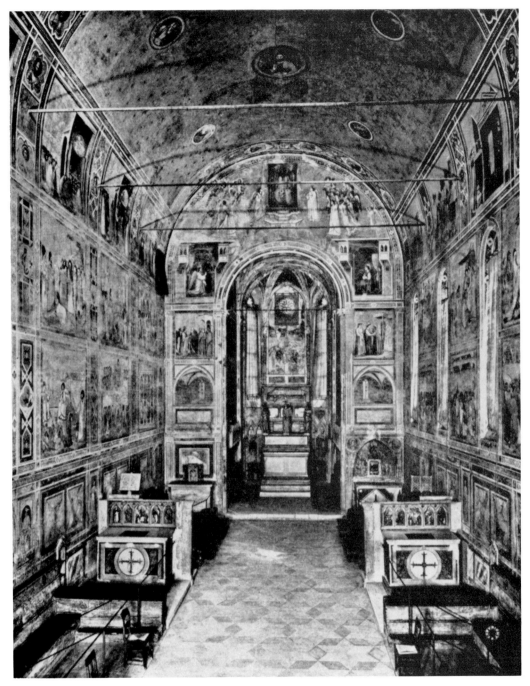

6.1. GIOTTO: Interior over-all decoration (1305–1306). Frescoes. Arena chapel, Padua (Anderson)

Feast of the Annunciation to be held with great pomp in the small chapel that then stood on the site of the present Arena chapel. Thereafter it was the custom on that feast day for the populace to gather at the cathedral and, together with the clerics, to escort two boys dressed as the Angel Gabriel and the Virgin to the Palazzo Communale where they were joined by the judges, lawyers, and others. All then proceeded to the arena where on a platform the two actors represented the Annunciation scene. During the building of the Arena chapel the celebration was temporarily interrupted, but a now-effaced inscription read that in March 1303 the ceremony was held at the chapel. The Arena chapel was consecrated in 1305, and Giotto must have begun the frescoes at that time. The performance of the mystery play before the chapel thus would explain not only the prelude scene with God the Father but also such "carpentry" stagelike settings of the Annunciation scene as the tabernacles with strongly projecting balconies beneath which the figures are set and the drawn curtains, the rods, and the small pillars around which the curtains are slung. In many of the other frescoes in the chapel the influence of stage sets of religious plays is also apparent.

Occupying the entire space of the wall above the entrance is a huge fresco of the Last Judgment [6.2], the most extensive one to have been painted up to that time. Although Giotto employed certain traditionally Byzantine features present in manuscripts, in icons, and in the mosaic at Torcello [1.12]—the angel hosts, the Christ seated on a rainbow within a mandorla flanked by the apostles on thrones like a jury, the stream of fire issuing from the base of Christ's mandorla—he varied and elaborated the theme. The huge figure of Christ dominating all is not Byzantine usage but is found in Last Judgments of western Europe both to the north and south of the Alps. In Italy striking examples are in the Baptistery mosaic in Florence [3.14], in the frescoes at Sant' Angelo in Formis, and in the Cavallini Last Judgment in Rome.* Un-Byzantine also is the large scale of the cross of Christ separating Hell from Heaven, the Damned from the Blessed. Heaven consists of rows of angels, of saints and citizens, the latter with naturalistic faces, beards, and headgear. Hell is luridly depicted as a series of fire-belching pits filled with demons, centaurs, and other creatures inflicting the most cruel tortures on the Damned. The iconography is a graphic elaboration on the Hell in the mosaic of the Baptistery in Florence with which Giotto was familiar. Certainly, even though Dante began his *Inferno* around 1300 and was present at Padua while Giotto was working in the Arena chapel, there is no indication that Giotto's representation of the tortures of Hell is based on Dante's poem.

Another significant variation from the Byzantine type is the absence of the Virgin and St. John the Baptist as intercessors for mankind. The Baptist

* Giotto in the Arena chapel Last Judgment also follows the iconographic tradition found in these and other examples in Italy of showing the Judging Christ with one hand turned to indicate the thumb-up and the other the thumb-down gesture of Salvation and Damnation.

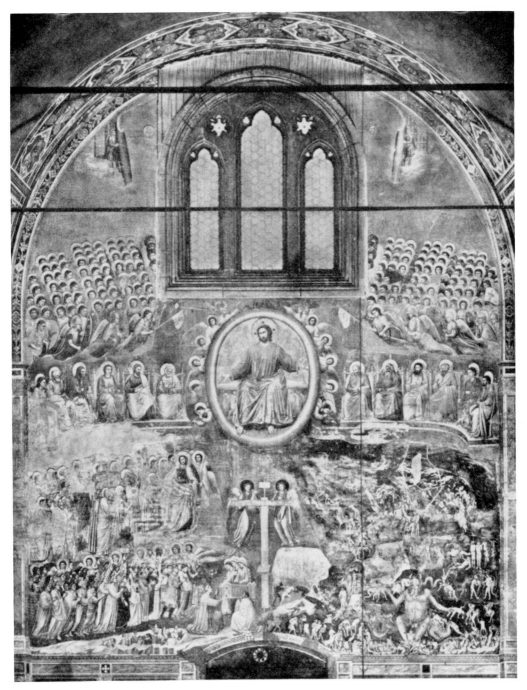

6.2. GIOTTO: Last Judgment (1305–1306). Fresco. Entrance wall, Arena chapel, Padua (Anderson)

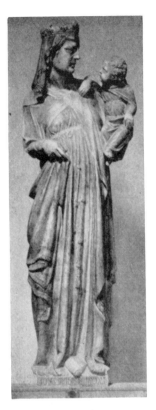

6.3 (*left*). GIOVANNI PISANO: Madonna and Child (*c.* 1303). Marble. Arena chapel, Padua (Alinari)

6.4 (*above*). GIOVANNI PISANO: Corner figure, detail (1301). Marble. Pulpit, Sant' Andrea, Pistoia (Alinari)

is nowhere in the fresco, but the Virgin in large scale appears to the left below Christ's mandorla in a gold-rayed aureole supported by angels, receiving the prayers of the saints who approach Her. This is also an indication of the special veneration accorded the Virgin in the Arena chapel. Below, to the left of the cross, a model of the chapel is being offered to three angels by Enrico Scrovegni, the donor of the chapel. (Dante, in the *Inferno*, consigned a member of this banking family to the seventh circle of Hell for usury.)

Giotto's figure style in the Arena chapel frescoes is certainly as far removed as can be imagined from any such Byzantined manner as prevailed in Florence in his youth. Instead his figure style shows his preoccupation with the human form and its drapery in three-dimensional terms in order to convey the religious content of the scenes in more human terms. His models were obviously Gothic sculpture of the kind found in the works of his friends Arnolfo di Cambio and Giovanni Pisano. The latter was the most accomplished of the Italian sculptors working in the Gothic tradition and for two decades had been chief architect and sculptor of Siena cathedral. Duccio, as we saw, had shown the effect of Giovanni Pisano's style in some of the figures of his great Maestà [5.5]. But Giotto's adoption of the Gothic sculpture style was more clear cut. Before his eyes was the Madonna and Child [6.3] that Pisano was making or had already made for the altar of the Arena chapel. When we compare Giotto's wonderful angel of the Annunciation

6.5 (*above*). GIOTTO: Annunciation (1305–1306). Fresco. Sanctuary arch, Arena chapel, Padua (Alinari)

6.6 (*right*). GIOVANNI PISANO: Annunciation, detail (1301). Marble. Pulpit, Sant' Andrea, Pistoia (Alinari)

[6.5] in the Arena chapel with one of the corner figures of Pisano's pulpit at Pistoia [6.4] we can see just how closely Giotto in paint imitated the parallel cascading folds of the drapery or stretched it tightly across the body to accentuate the bulkiness of the figure beneath.*

* Giotto must have had training in sculpture, for according to a contemporary writer he designed and even began some of the sculptures on the campanile in Florence. Ghiberti, the fifteenth-century sculptor, not only makes the same statements but also states that he himself owned some of Giotto's sculpture designs.

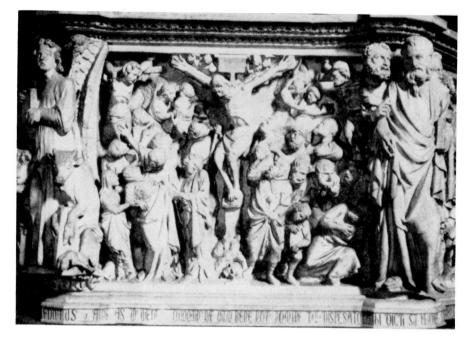

6.7. GIOVANNI PISANO: Crucifixion (1301). Marble. Pulpit, Sant' Andrea, Pistoia (Alinari)

Other stylistic elements reflecting the Gothic style are seen in Giotto's treatment of the eyes and the use of the rounded jaw line [6.5, 6.9]. The eyes are drawn with a sharp angle at the corners giving them a quasi-Mongolian squint. This characteristic of Gothic figures on such French cathedrals as Amiens and Rheims was passed on via Giovanni Pisano to Giotto.

But that is as far as Giotto went in his adoption of Giovanni Pisano's style. His use of figures to express the content of a scene differed widely. While Pisano's work reflects the typically Italian emotional qualities, Giotto's has a universal dignity and significance going beyond any expression of national temperament. A few examples will make this clear.

In the Annunciation scene [6.6] on Giovanni Pisano's pulpit at Pistoia, the Angel Gabriel rushes toward the Virgin in great excitement. She recoils, surprised and curious as though a neighbor were rushing in with some astonishing news. In Giotto's magnificent Annunciation [6.5] Gabriel kneels solidly on the ground and raises his hand calmly in a gesture of blessing and address, conveying by his dignity the importance of the mission. The Virgin, also in repose, submissively receives the message, fully conscious of the fact that she is to become the Mother of God. The religious as well as the human significance of the episode is dramatically rendered.

In Pisano's Crucifixion scene [6.7] from the same pulpit, the external manifestation of the emotions of grief and pain is emphasized. Christ's body

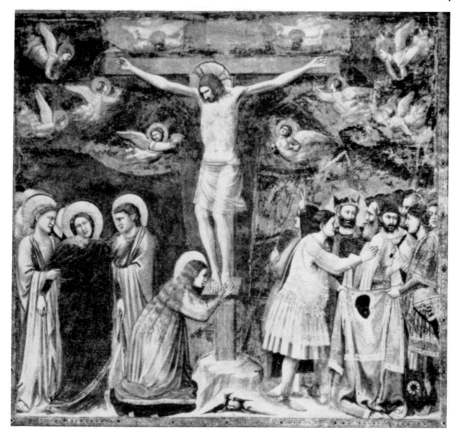

6.8. GIOTTO: Crucifixion (1305–1306). Fresco. Arena chapel, Padua (Anderson)

hangs twisting on the cross with arms stretched up at an angle to accentuate the last throes of His suffering. Below is a great commotion among those standing around the cross. The Virgin falls back in a faint into the arms of her attendants as though she had just uttered a cry of grief. In Giotto's Crucifixion fresco [6.8], on the nave wall, by contrast everything is still. The struggle is over for Christ's body hanging solidly on the cross, and the peace of death has prevailed. Beneath the cross the Virgin is about to faint, but when she does she will sink in a heap, a figure of pathos commanding sympathy. On the other side of the cross John stands in silent misery as he looks up at the dead Saviour. Here is none of Giovanni Pisano's pyrotechnics. The scene consequently has more dramatic significance than the melodramatic interpretation of Pisano. The latter plays all his scenes in a highly emotional key. Figures gesticulate and faces are contorted with emotional strain. Giotto prefers greater restraint and calm, using only the most significant gestures to achieve his dramatic effects.

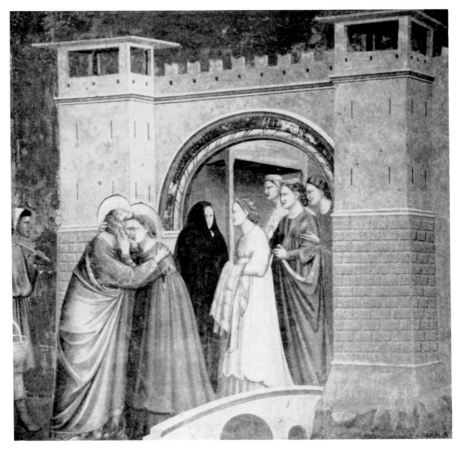

6.9. GIOTTO: Joachim and Anna meeting at the Golden Gate (1305–1306). Fresco. Arena chapel, Padua (Alinari)

This restrained emotion is found in other of the Arena frescoes. Deeply human and packed with tender feeling is Giotto's scene of the Meeting of Joachim and Anna, the Virgin's parents, at the Golden Gate [6.9]. According to the story, they were old and childless. Anna was far beyond the years for childbearing when she was informed in a vision that she would have a child. Joachim, off in the desert with his flocks, was told by an angel of the Lord of the coming event. Not believing, he returned to Jerusalem and was met at the Golden Gate by his pregnant wife. Giotto's fresco depicts this meeting with all the simple drama the story implies. Anna tenderly touches the cheek of Joachim as he kisses her. Anna is followed by a young attendant with happiness reflected in her face. In the shadow of the gate stands an older woman, her face half covered by a scarf so as not to appear to intrude inquisitively on the emotional intimacies of the old pair but at the same time observing all. A similarly simple and deep expressiveness is present in the

6.10. GIOTTO: Magdalen, from *Noli me Tangere* (1305–1306). Fresco. Arena chapel, Padua (Alinari)

Visitation scene in which the older St. Elizabeth, mother-to-be of the Baptist, greets the young Virgin Mary, both of them with child.

Another peerless example is the scene of Mary Magdalen meeting Christ in the Garden on the afternoon of the Resurrection, the *Noli me Tangere*. The figure of the Magdalen [6.10] kneeling before her Master and reaching out in frustration to touch Him has certainly never been surpassed. Giotto seems to have gotten the idea for the Magdalen from a similarly posed sculptured figure by Arnolfo di Cambio. The nearest approach in the Arena chapel to the representation of mixed emotions as present in the Magdalen is the figure of the Virgin in the Ascension scene in whom the emotions of love and adoration for her Son-God are mingled with the pain of physical separation in a remarkably simple and shorthand manner.

The emotional highpoint in the Arena chapel frescoes is the famous Pietà, the Lament over the body of Christ [6.11]. As in all Giotto's paintings, the background is chiefly functional and serves to emphasize the movement or the emotional theme in the picture as well as being a space factor. Thus the clay-cut mountain in the background toboggans down to the emotional center of the fresco where the Virgin, with face torn by grief, embraces the dead Saviour. The other Marys and the beloved disciple, St. John, are placed around this emotional center. Two of the women are huddled in the foreground with their backs to the spectator, but their hunched, sacklike forms emphasize the heavy muted quality of their grief. Each figure about the Christ and Mary registers a different kind of grief expressed by the carefully selected and varied gestures. One of the women has her hands raised slightly; another clasps her hands to her cheek; St. John throws out his arms in disconsolate desperation. By contrast, the two disciples standing at the extreme right are completely relaxed emotionally so as not to detract attention from the emotional center of the scene. They merely turn their heads in its direction. The tempo of the emotion is thus skillfully set by Giotto,

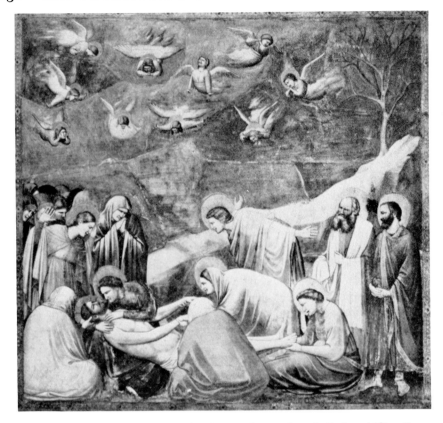

6.11. GIOTTO: Pietà (1305–1306). Fresco. Arena chapel, Padua (Alinari)

increasing in intensity as it approaches the head of Christ. There is no melo-dramatic explosion as might be found in the works of Giovanni Pisano. The only hysterical note is struck by the angels fluttering wildly in the sky above the scene, but they are light forms and are secondary accents of grief as they are also in the Crucifixion [6.8]. By their very excitement they accentuate the restrained drama around the head of Christ. The scene is a veritable orchestration of emotion.

Giotto rarely composed the scenes of the Arena chapel frescoes with symmetrical balance. The mathematical center is not necessarily the center of emotion or interest. To him the figures and their expressive content were the most important part of the picture. Backgrounds, as was said, served to reinforce the action or content of the figures and to deepen the space. At times the background is neutral, and figures move against this neutral background with a delicate rhythmic movement reminiscent of Classical relief sculpture [1.2]. That Giotto had imbibed some Classical spirit is also apparent in his simplifications and universalizations of essential human emotions.

Giotto's Earlier Style

At Padua we have found Giotto as a mature artist, the exponent of the Gothic style that was to prevail in fourteenth-century Italian painting, and the accomplished master of fresco painting. What then had been his style prior to Padua, for he must have been active for many years before that time? Where did he acquire training and experience in fresco painting? And where are any evidences of his earlier work to be found? These are the great enigmas about which many theories have been formed. What follows below must also be considered as hypotheses to answer these questions, the hypotheses, however, being based on indications present in literary references and in stylistic criteria.

We do know from the evidence of his work in Padua that one of Giotto's chief interests was to render form three-dimensionally in order to express most adequately the human content in the subject matter, that he found fresco painting most suitable for this expression, and that, for his work at Padua, contemporary Italian Gothic sculpture furnished the best models. But one thing is certain—Giotto's early style could not have been Gothic. Born in Florence c. 1266 or 1276, his earliest training must have been in the Byzantinized style still prevalent in painting at that time; and before his eyes was the great mosaic of the Baptistery dome still in the process of being finished. (We have seen how the impression of the Hell in this mosaic recurred when he painted his Last Judgment at Padua.) But this Florentine tradition was of no use to one interested in three-dimensional forms. It was in the work of the artists of the Roman school that such forms made their first dramatic appearance in the last quarter of the thirteenth century. Hence it must have been in Rome rather than in Florence that Giotto formed his early style by association with painters of the Roman school and with such sculptors as Arnolfo di Cambio. It was in Rome, too, that he must have received his training in the fresco technique in which he became so proficient. Florence had no such tradition. It is possible that Giotto was introduced to Rome by Cimabue, who had spent time there and who himself must also have acquired there (as we have suggested in the last chapter) whatever knowledge he had of fresco painting. Giotto must have established a sufficiently good reputation in Rome to be commissioned later at the end of the century by Cardinal Stefaneschi to execute the famous mosaic of the Navicella, Christ Walking on the Waters, for the basilica of St. Peter's. He also seems to have done some work for the Jubilee Year celebration of 1300.

In his chronicle, which ends with the year 1312–1313, Riccobaldo of Ferrara states for the year 1306 that Giotto was known for the work he did at Assisi, Rimini, and Padua. This passage, written so close in time to Giotto's work in the Arena chapel at Padua, would indicate that his work at Assisi preceded that at Padua. Giotto's presence at Assisi and the frescoes he might have produced there have been the subjects of much controversy. This book is not the place to go into the question of the validity of the arguments, but

we can consider some of the evidence that bears on our inquiry into Giotto's pre-Paduan style.

Granting Riccobaldo's assertion that Giotto worked at Assisi, the question remains, what was this work? One hundred years after Riccobaldo the fifteenth-century Florentine sculptor Lorenzo Ghiberti wrote that Giotto painted "quasi tutta la parte di sotto"—"almost all the lower portion"—in San Francesco at Assisi. This remark resulted in confusion. Some have claimed that Ghiberti meant all the lower church; others have maintained that he meant the lower registers of the upper church—that is, the St. Francis series. Since the style of most of the frescoes in the lower church is later than Giotto's style at Padua, we are left with the frescoes in the upper church among which to find possible evidence of his pre-Paduan style. As we have already noted, the sanctuary and transept frescoes are the work of Cimabue and his school from which Giotto must have disassociated himself by going to study and work in Rome. He must also then have arrived as Assisi in company with the painters of the Roman school whose work appears in the upper registers of the nave. It is among these frescoes, it would seem, that we should look for the first work of Giotto at Assisi.

The most significant master among those working on these frescoes in the upper registers of the nave is the so-called Isaac Master [4.8] who painted the well-known scenes of Isaac deceived by his wife Rebecca and by his son Jacob. Several art historians have claimed that the Isaac Master is Giotto.* It seems to me, however, that the related master of the Deposition scene on the upper south wall, of the Ascension and Pentecost frescoes on the entrance wall, and of the roundel with the Madonna and Child over the entrance doorway runs a better chance of being Giotto before he became a complete convert to the Gothic style. The serious expression of some of the faces in these scenes and the flat plane of light falling along the ridge of the nose giving the heads the effect of having been carved out of soft stone are met with again in a number of the frescoes in the lower register—in the scenes from the life of St. Francis. Without question, however, the masterpiece among these scenes of the upper register just mentioned is the Deposition or Pietà [6.12], the forerunner indeed of Giotto's great Pietà in the Arena chapel in Padua [6.11]. It contains a similar concentration of emotion about the head of the dead Christ, and the figure standing quietly with hands clasped in front of him anticipates the two figures of the apostles at the right of the Paduan fresco.

Vasari, after Ghiberti's often misinterpreted remark, was the first to claim the St. Francis series for Giotto. This claim has been attacked and defended ever since. Whatever the answer, a number of hands are distinguishable in this sequence of twenty-eight scenes. This fact and the intermingling of hands in a number of the frescoes suggests that a fairly large *bottega* was at work here. Occasionally the head types recall with their serious

* Professor Millard Meiss, in his recent publication *Giotto and Assisi*, New York University Press, 1960, champions this point of view, that the Isaac Master is Giotto.

6.12. GIOTTO(?): Pietà (1285–1295). Fresco. Upper Church, San Francesco, Assisi (Anderson)

mien those found in the frescoes of the upper register just mentioned, for example, in the Miracle of the Spring [6.13] or the Sermon to the Birds. These could be by the master of the group—by Giotto?—who by his success in the upper registers was entrusted with the supervision of the St. Francis scenes in the lower one.* A striking confirmation of this thesis that Giotto was the controlling spirit directing the work on these frescoes is found in the fresco representing the Verification of the Stigmata. On the iconostasis in this fresco is a crucifix that is practically identical with the large crucifix

* In two recent articles, "The St. Cecilia Master and His School at Assisi," I and II, in *Burlington Magazine*, CII (1960), p. 405ff. and 431ff., respectively, Mr. Alastair Smart presents the thesis that the St. Cecilia Master, the anonymous painter of the altarpiece in the Uffizi, Florence, representing St. Cecilia and eight scenes from her life, is the guiding genius in charge of the painting of the St. Francis series in the upper church at Assisi, assisted by a pupil—who seems to have done the work on the most important frescoes of the series—whom Mr. Smart calls the "St. Francis Master" (not to be confused with the follower of Giunta Pisano). He dates the series as practically contemporaneous with Giotto's Arena chapel frescoes at Padua.

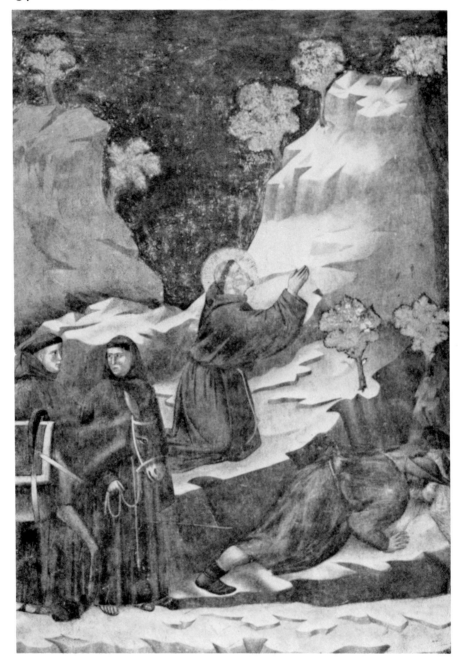

6.13. GIOTTO(?): Miracle of the Spring (c. 1290). Upper Church, San Francesco, Assisi (Alinari)

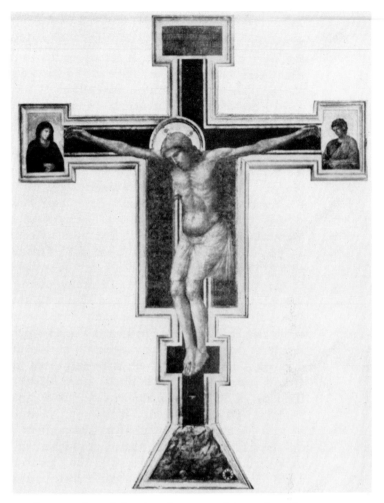

6.14. GIOTTO: Crucifix (1290–1300). Panel painting, 215″ x 159¾″. Santa Maria Novella, Florence (Anderson)

in Santa Maria Novella in Florence [6.14].* This last-named crucifix, the precursor of Giotto's figure of the Crucified in the Arena chapel at Padua, is mentioned as by Giotto in a will dated 1312 wherein provision is made to have a light burning perpetually before it. The shapes of the crucifix in the Assisi fresco and of the crucifix in Santa Maria Novella in Florence, with the rectangular terminations and the medallion at the top (cut off in the Santa Maria Novella cross), conform with the usual shape of thirteenth-century crosses. Fourteenth-century crucifixes, even the earliest ones, have Gothic terminations in the shape of a diamond intersecting a quatrefoil. It is interesting to note that although the frames of these crucifixes follow the thirteenth-century style, the Christ is the new Gothic type found in the sculpture of the Pisani and not the S-shaped tortured body present on Giunta and Cimabue crucifixes. The bust figures of the Virgin and St. John in the arm ends of the

* Mr. Smart, page 431 and figures 17 and 20 in the article cited on page 133, also has noticed the close correspondence between the crucifix in Santa Maria Novella and the one in the fresco of the Verification of the Stigmata in the upper church at Assisi.

Santa Maria Novella crucifix are remarkably close in style to the figures in the fresco of the Deposition in the upper tier at Assisi, enough to be by the same hand considering the differences in the techniques of fresco and panel painting. Therefore if Giotto's pre-Paduan style is to be found anywhere in Assisi it would seem to be first in the scenes that show their dependence on the style of the Isaac Master and then possibly in some of the scenes in the St. Francis series.

Attempts to date the St. Francis series in the third or fourth decade of the fourteenth century are futile for several reasons. In addition to the appearance of the late-thirteenth-century type of cross, just discussed, in the Verification of the Stigmata, we have these two facts, *first*, that the illusionistic architectural settings are characteristic of the last quarter of the thirteenth century, and, *second*, that an altarpiece of the Rimini school dated 1307 * contains a copy of the scene of St. Francis receiving the Stigmata as painted at Assisi. Further evidence can be gathered from the famous mosaic of the Navicella in St. Peter's, Rome, previously mentioned. Unfortunately this mosaic was moved about so much during the rebuilding of the basilica in the sixteenth century and so badly damaged and reworked that what remains has little practical value in telling us anything about Giotto's style at that time, that is, 1298. Two angel heads in medallions, however, one of which is in the Vatican Gallery, are sufficiently well preserved to show that this style is related to the circle of the Isaac Master at Assisi. The fragment in the nave of St. John Lateran in Rome of a large fresco representing Pope Boniface VIII appearing on a balcony to a multitude during the Jubilee Year of 1300 has since the seventeenth century been ascribed to Giotto. One of the three remaining heads, that of a deacon, has been cleaned recently and does show an affinity in style with the figures in the St. Francis series at Assisi. The date of this series would then be reasonably placed in the last decade of the thirteenth century.

At a time when the political and cultural scene in Italy was changing because of the collapse of the Holy Roman Empire (Romanesque) and the beginning of French domination (Gothic), it is reasonable to expect and to find a change in the style of the art of that period. The change had already been perceptible in architecture and sculpture. Now it was also taking place in painting, in no uncertain terms at the hands of a progressive and dynamic personality such as Giotto was. His early search for form had brought him in contact in Rome with painters influenced by Classical sculptural traditions. He had also met with sculptors in whose work both Gothic and Classic traditions were intermingled. On his return to the north from Rome and Assisi, Giotto came into closer contact with the new Gothic style in sculpture established in Tuscany by the Pisani. He must have known the great marble sculptured pulpit in Sant' Andrea at Pistoia, begun by Giovanni Pisano in 1301. He must also have known its creator whom he was to meet

* See J. White, "The Date of the Legend of St. Francis at Assisi," *Burlington Magazine*, XCVIII (1956), p. 344ff.

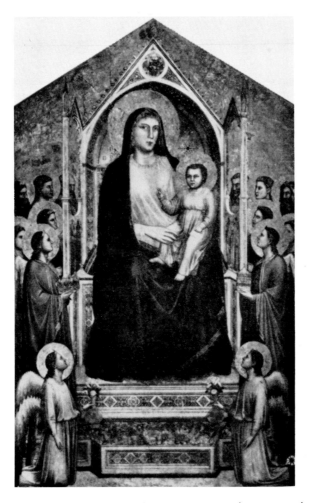

6.15. GIOTTO: Madonna from Ognissanti (1305–1310).
Panel painting, 128¾₁₆″ x 80⅜″. Uffizi, Florence (Anderson)

again a few years later at Padua: for Giotto's style at Padua, as we have
seen, was to be forcibly influenced by Pisano's sculpture. Giotto's work in the
Arena chapel represents the complete victory of the Gothic style in Italian
painting just as Giovanni Pisano's accomplishments represent the ultimate
triumph of the Gothic style in sculpture.

Some time during the first decade of the fourteenth century Giotto painted
for the church of the Ognissanti in Florence the huge enthroned Madonna
[6.15] that is now in the Uffizi Gallery. The large-scale proportions are in
line with those of the great late-thirteenth-century Madonnas already men-
tioned. From the indications of the angels' and saints' figures about the throne
we can presume that originally there were extensions to left and right. Giotto
represented the Madonna in terms of Gothic sculpture. The composition is

full of rectangular lines and few relieving curves, emphasizing the static bulk of the Virgin. The cubical silhouette contrasts sharply with the curvilinear one of Duccio's Madonnas and adds enormously to the effect of the physical thereness of the figure. The flimsy Gothic canopied throne on which the Madonna sits is scarcely adequate for the massive figure it supports. Giotto must surely have been familiar with the seated statues of Arnolfo di Cambio, such as that of Charles of Anjou now in the Museo de' Conservatori in Rome or those of Pope Boniface VIII and the Madonna and Child made for the Florence cathedral. These have the same rectangular bulk of form and similarly looped drapery between the knees that one sees in the Ognissanti Madonna. The angels kneeling with flower-filled vases at the foot of the throne are directly inspired by French Gothic ivory figures.

The Santa Croce Frescoes

Giotto's style reached its full development in the frescoes of the Bardi and Peruzzi chapels in Santa Croce, Florence. He had also decorated two other chapels here, the Tosinghi and the Giungi, but those frescoes have disappeared as the result of renovations. In the Bardi chapel the frescoes represent episodes from the life of St. Francis painted in three superimposed rows on the right and left walls. In a similar disposition of three levels in the Peruzzi chapel we see scenes from the life of St. John the Baptist on the left wall and from the life of St. John the Evangelist on the right wall. Santa Croce being the Franciscan church of Florence, it was fitting to commemorate St. Francis in the frescoes of the Bardi chapel. It was also fitting to choose stories from the life of John the Baptist in the Peruzzi chapel, John being the patron saint of Florence.

Although the frescoes of both chapels were gone over and retouched in the nineteenth century—most of this retouching has recently been removed from the Bardi chapel frescoes—enough is at hand from which to judge Giotto's late style. We note a much less rugged treatment of the human forms than had been the case at Padua. The proportions are more slender and incline toward elegance; and the emotions are more muted. Although the scene of St. Francis' death in the Bardi chapel [6.16] recalls the Pietà in Padua [6.11], these changes in form and emotion are patent. The figures in the Santa Croce frescoes in general are much more related to and contained by the architecture in which they are set. There is an obvious insistence on a symmetrically balanced architectural background even when the figure groups may be asymmetrically arranged. In the famous fresco in the Peruzzi chapel of the Feast of Herod [6.17], the architecture stretched across the background like a folding screen with re-entrant angles may suggest a sense of recession in space, a problem that was to be attacked with surprising results by Giotto's forward-looking pupils Maso and Taddeo Gaddi. But Giotto in this and other frescoes in Santa Croce maintains a compositional control between the forms and the architectural backgrounds.

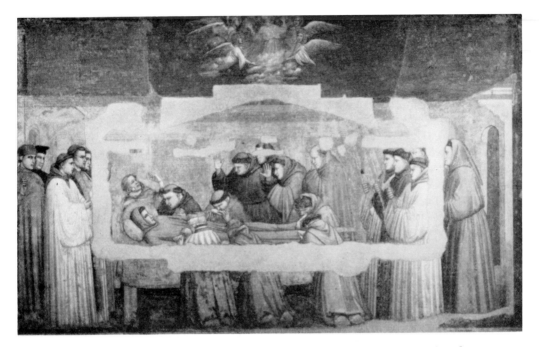

6.16 (*above*). GIOTTO: The Death of St. Francis (*c.* 1325). Fresco. Bardi chapel, Santa Croce, Florence (Alinari)

6.17 (*below*). GIOTTO: The Feast of Herod (*c.* 1325). Fresco. Peruzzi chapel, Santa Croce, Florence (Anderson)

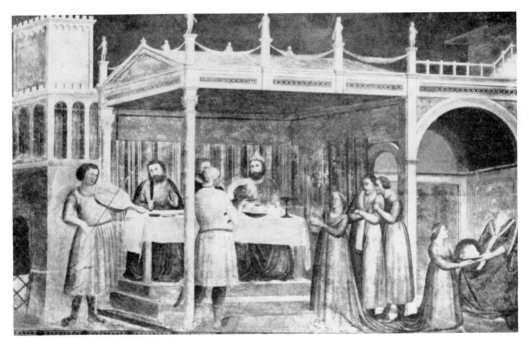

The close iconographic relationship between the Bardi chapel frescoes of St. Francis' life with those in the upper church at Assisi has obviously been remarked by everyone writing on Giotto. This connection is indeed true and is particularly close in the scenes of St. Francis refusing his Father's Goods, of the Franciscans before the Sultan of Morocco, of St. Francis appearing to the Brothers at Arles, and of the Granting of the Rule by Innocent III. The Vision of Bishop Guido of Assisi is a conflation of the same scene with the Dream of Pope Innocent, both at Assisi. All this we state here as a matter of interest since we obviously cannot demonstrate it photographically in this book. But it would argue either that Giotto indeed was the directing spirit thirty years previously for the Assisi St. Francis series or else that he was for some reason or other extremely familiar with these frescoes. The time lapse between the two cycles, however, had wrought notable changes particularly in the orderly organization and the centralized compositions as we find them in Santa Croce.

That Giotto was in contact with the French court at Naples and consequently directly with the French Gothic style is obvious from the fact that he was summoned by Robert of Anjou to that city in the early 1330's to carry out various commissions. Among these were frescoes of famous men for a hall in the Castelnuovo and of Old and New Testament scenes in the Franciscan church of Santa Chiara. Nothing of this has survived, yet during World War II when a conflagration following an incendiary bomb attack on Naples severely damaged Santa Chiara, beneath the calcined seventeenth-century frescoes in the choir of the Clarissan nuns emerged traces of earlier frescoes. One of these is a portion of a Pietà not unlike that in the Arena chapel at Padua. Hence we can assume that originally in this choir was a cycle of scenes that was connected with Giotto's workshop. The style of this Pietà is very close to Giotto's late style.

Giotto was called back to his native Florence in 1334 to take charge of the construction of the famous bell tower, or campanile, of the cathedral that he had designed and for which, it has been claimed, he had furnished some sculptural decoration. Under his direction too were painted the frescoes in the Magdalen chapel of the Palazzo del Podestà, or the Bargello, now almost completely faded. The scenes represented are a Last Judgment and an allegory of Good Government. Among the Blessed in the Last Judgment, tradition has recognized the head of Dante. This head has been restored on several occasions, most recently in the nineteenth century, so traces of Giotto's style are no longer visible. According to certain literary sources, Giotto may also have painted an elaborate civic allegory in the Palazzo del Ragione at Padua, thus anticipating Ambrogio Lorenzetti's great fresco in the Palazzo Pubblico in Siena (see page 157).

We have traced the development and reviewed the major achievements of the greatest figure in Florentine painting of the fourteenth century. We noted that the earliest evidences of Giotto's style are connected with the space-seek-

ing, sculptural traditions of the Roman school of fresco painters and mosa-icists; that he then followed the contemporary trend toward the Gothic style as manifested in the works of the sculptors Arnolfo di Cambio and Giovanni Pisano. These sculptural styles Giotto adopted in order better to express the human emotions latent in the religious episodes, discarding the earlier, more traditional flat and dogmatic Byzantine style. We also saw how Giotto passed from a simple narrative style at Assisi to one with greater dramatic accent-uation of the narrative in order to accomplish a psychological unity at Padua, and how finally at Santa Croce in Florence his additional concern seemed to have been to give a compositional unity to figures and background. Giotto was a master at portraying the simple fundamental human emotions, and in order to express these most effectively he embodied them in simple, bulky, earthy forms. In general he achieved for the episodes he was painting an expressive psychological unity far surpassing a mere color and pattern unity by blending with his subject content remnants of Byzantine abstraction, the Classical sense of the universal, and Gothic naturalism and movement. He gave Florentine art the direction it was to follow for several centuries—that is, the use of the human figure as the chief element in a pictorial composi-tion.

BIBLIOGRAPHY

Fry, R. "Before Giotto," "Giotto," *Monthly Review,* October, December, 1900, March, 1901.

De Sélincourt, B. *Giotto.* New York, Charles Scribner's Sons, 1905.

Sirén, O. *Giotto and Some of His Followers,* trans. by F. Schenck, 2 vols. Cam-bridge, Mass., Harvard University Press, 1917.

Toesca, P. *Florentine Painting of the Trecento.* New York, Harcourt, Brace & Com-pany, 1929.

Gnudi, C. *Giotto.* Milan, A. Martello, 1958. (In Italian; full of illustrative mate-rial and color plates)

Antal, F. *Florentine Painting and its Social Background.* London. Kegan Paul, 1947.

Meiss, M. *Giotto and Assisi.* New York University Press, 1960.

⬫7
Sienese Painting
after Duccio

⟨⟨⟨

SINCE the battle of Montaperti, Siena had been riding high—and would continue to do so until the tragedies of 1348. She had produced at least two great artists, Guido and Duccio, to match her ancient Tuscan rival Florence. Duccio's last monumental work, the great altarpiece for the Siena cathedral, was about contemporaneous with Giotto's frescoes at Padua, and it indicated Siena's preference for delicate emotional expression and the decorative elements of line and color. Now, in the face of the innovations of the great Florentine painter who, according to Dante, was "all the rage," what was being done by the younger generation contemporary with Giotto's later accomplishments? How Siena maintained her original preferences while keeping abreast of the times and trying to swallow Giotto's style is aptly illustrated in the accomplishments of three of Siena's greatest artists of the fourteenth century.

Simone Martini

Simone Martini (1285?–1344), although he had been trained in the workshop of Duccio, belonged to the younger generation that adopted completely the new fashion, the Gothic style. But Simone did not borrow this style from Giotto, who had based his work on thirteenth-century French characteristics transmitted to Italy by the sculptor Giovanni Pisano. More up-to-date, he was influenced instead by current fourteenth-century French mannerisms acquired at the court of Robert of Anjou at Naples and, later, at the papal court at Avignon. His facile technique and his Franco-Sienese charm gave

him a reputation second only to that of Giotto. Petrarch, Simone's devoted friend, writes in a letter that he knew of two talented painters: Giotto who enjoyed great fame among the "moderns," and Simone the Sienese. In two of his sonnets he praises Simone for the portrait he had painted of his (Petrarch's) lady-love Laura:

> Polyclitus together with the other famous sculptors by gazing a thousand years would never in the smallest degree have caught the beauty of her who has conquered my heart. But certainly my Simone must have been in Paradise, of which this lady forms a part; there he saw her and portrayed her on paper to give evidence here below of her beautiful face. The work was such as one could imagine in heaven, but not among us mortals where the body is a veil to the soul.

And in a manuscript of Vergil, now in the Ambrosian Library in Milan, formerly owned by Petrarch, there is the following couplet on one of the fly-leaves:

> Mantua gave birth to Vergil who composed these verses;
> Siena brought forth Simone who painted the illustrations for these verses.

The earliest important work by Simone for us to consider is the large fresco in the Palazzo Pubblico, the Town Hall of Siena [7.1]. It was painted in 1315 and represents the Virgin enthroned under a huge awning and surrounded by angels and saints. Occupying all the end wall, it gives the effect of a huge tapestry—which it apparently was meant to do. The Madonna, as in Duccio's great altarpiece, is thought of as liege queen, but Simone has brought the representation more up to date. The throne is completely Gothicized with gables and tracery. The Madonna and the saints wear brocades and ermine-lined mantles, a fashion of the period imported from France. The tented canopy supported on four poles is like the royal pavilion at a field of the Cloth of Gold. Kneeling angels offer bowls of flowers to the Madonna.* Siena, as a city, had dedicated itself to the Virgin, and she had effectively intervened at the battle of Montaperti. Now in the fresco, as truly liege queen, she addresses her subjects with the following words inscribed at the bottom of the painting:

> The angelic flowers, roses and lilies, with which the heavenly fields are adorned do not delight me more than the righteous council. But at times I observe some who for their own ends treat me and my territory with contempt. And the worse their words the more they are praised by those whom this rhyme condemns. My beloved, keep well in mind that your devout prayers will be answered according to your desires. But when the powerful attack the weak, oppressing them with shame and insult, your prayers will be of no avail to them nor to those who betray my territory.

* A very similar "cloth of gold" Madonna was painted in 1317 in the Town Hall at San Gimignano by Simone's brother-in-law, Lippo Memmi. Lippo was a fairly prolific painter of Madonnas close in style to those of Simone.

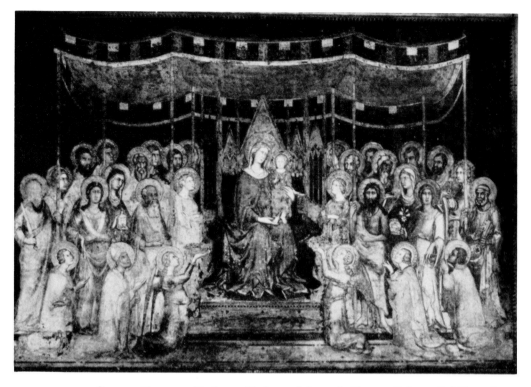

7.1. SIMONE MARTINI: Madonna Enthroned (1315). Fresco. Palazzo Pubblico, Siena (Istituto del Restauro, Rome)

Simone's style is quite in keeping with all this chivalric concept. Although there are still reflections of Duccio's types, Simone's tendency is to gloss them over with a surface of prettiness and naturalism and so to appeal to the susceptibilities of the spectator. The Madonna and the saints are all aristocrats and the Christ child a blond, curly-headed appealing princeling. How sudden this change is from Duccio's still-latent Byzantinisms to Simone's Frenchified style becomes apparent when we consider that this fresco was painted only three years after Duccio had completed his altarpiece for the cathedral.

A word about the fourteenth-century French Gothic style will help in understanding Simone's painting. For one thing, the French Gothic style of this century emphasized the decorative elements in preference to the plastic ones. In sculpture as well as in painting, drapery areas became flatter; the hems or folds were organized into curvilinear rhythms; and figures assumed an S-shaped pose. In the second place, the content expressed by figures or in scenes took on a secular, worldly quality. Mannerisms and sophistications of court life were reflected even in religious figures and scenes and produced an effect as elegant and charming as the content was vapid and superficial. The statue of the Madonna in the right transept of Notre Dame in

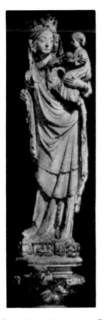

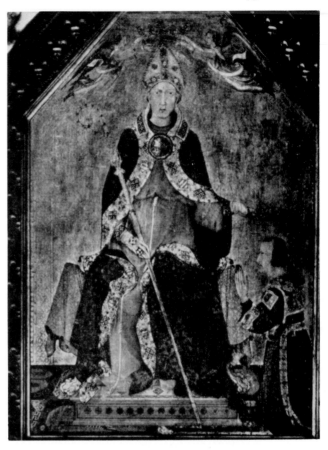

7.2 (*above*). FRENCH GOTHIC
SCULPTURE: Madonna and Child
(14th cen.). Marble. Interior of
North Transept, Notre Dame,
Paris (Alinari)

7.3 (*right*). SIMONE MARTINI:
St. Louis of Toulouse Enthroned
(1317). Panel painting, 78⅞″ x
51⅛″. Capodimonte Museum,
Naples (Anderson)

Paris [7.2], with arched and plucked eyebrows, decorative though she be,
takes on the air of a bored court lady. She has little interest in the Child
on her arm as she draws away from Him—a striking contrast in pose and
content to the thirteenth-century Virgin on the portal of the right transept
of the same cathedral or to the Vierge Dorée at Amiens [1.10].

This was the French style with which Simone came in contact when,
in 1317, he was called to the court of Robert of Anjou at Naples, a city that
already had numerous Gothic churches. In 1317 Simone painted for his ducal
patron the large altarpiece representing Robert's brother St. Louis of Tou-
louse [7.3], who had just been canonized. Robert himself is shown kneeling
at the foot of his brother's throne. The head of the saint has the long oblong
shape so characteristic of Simone's heads. The eyes are almond-shaped, the
lips are pursed, and the expression is one of aristocratic aloofness. The miter
and garments are elaborately decorated with French fleur-de-lis, and the folds
and hem of the mantle are rich with curvilinear rhythm. In the predella panels
Gothic architectural details abound. The altarpiece, originally set up in the
church of San Lorenzo, is now in the Capodimonte museum at Naples.

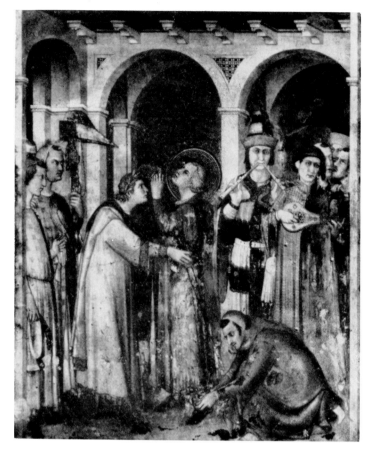

7.4. SIMONE MARTINI: Investiture of St. Martin (1322). Fresco. Chapel of St. Martin, Lower Church, San Francesco, Assisi (Soprintendenza)

On a commission from the same House of Anjou, Simone must have gone to Assisi in 1322 to decorate the chapel dedicated to the French St. Martin in the lower church of St. Francis. The beauty of Gothic stained glass is here recalled in the glowing reds and blues Simone used, while contemporary customs of knighthood and chivalry are reflected in the scenes from St. Martin's youth. Such is the case in the episode of the prayer of the saint the night before his investiture, and of the investiture itself [7.4].

In these Assisi frescoes, Simone shows himself a pioneer in the use of descriptive background that he had tentatively employed in the predella pieces at Naples. Backgrounds, heretofore, as we have seen in Giotto and Duccio, had been generalized rocks and trees or interiors with no indication of actual locale. Duccio, in his settings of the Passion scenes in the great altarpiece, based as they seem to be on contemporary mystery plays, may have been the first to show an interest in a specific setting, but it was Simone who developed the descriptive setting and prepared the way for his Sienese contemporaries, the brothers Lorenzetti. In such a scene as St. Martin before the Emperor Constantine, where the central position of the young saintly

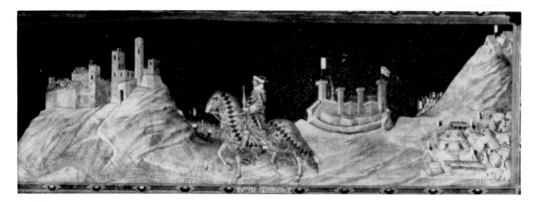

7.5. SIMONE MARTINI: Equestrian Portrait of Guidoriccio (1328). Fresco. Palazzo Pubblico, Siena (Anderson)

knight is accentuated by the traditional functional background of a diminutive conical mountain, the conical form is repeated rhythmically to right and left by actual tents to give a military flavor to the scene. Another instance is to be found in the Gothic architectural details of background in the scene of the requiem mass for St. Martin. This descriptive interest is carried even into the expression on the faces of the monks singing the mass.

The most extraordinary of Simone's frescoes is the equestrian portrait of the soldier of fortune Guidoriccio [7.5]. This portrait was painted in 1328 on the walls of the Palazzo Pubblico, opposite Simone's famous Madonna of 1315, as a kind of commemorative monument in recognition of Guidoriccio's military services to the city-state. In antiquity Marcus Aurelius had been represented in bronze on horseback. At Verona, in medieval days, the ruling Scaligers had themselves carved in stone mounted on their horses on top of their tombs. Here for the first time in painting an equestrian portrait serves as a commemorative monument. But, as we shall discover later, this portrait does not express the quality of the subject's personality, only certain characteristics of his profession. He is shown on a richly caparisoned charger as a portly knob-nosed knight of no particular physical charm, but he suggests force and authority. The entire background, in part generalized, in part descriptively particularized, accentuates the military nature of the soldier of fortune; in that sense the background is still functional. Fortified castles straddle the hills; pennants and pikes appear off stage on the right; and in the lower right-hand corner an entire encampment is shown in detail. Fences and entanglements wind across the middle distances. The whole atmosphere is military. But there is no visual or spatial unity for all these descriptive details. An interest in such a unity has yet to appear. This fresco is purely descriptive. The horse and rider, as the center of interest, are seen from a normal angle of vision, straight on. The castles are seen as from below, and the encampment in the right foreground is seen as from a bird's-eye view in order to show all the details.

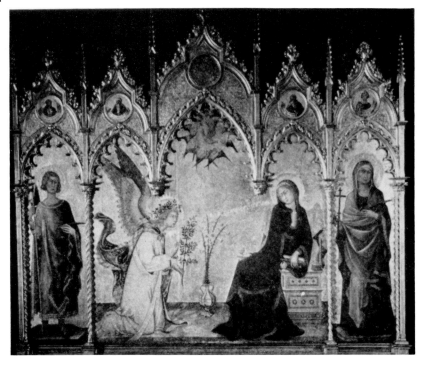

7.6. SIMONE MARTINI: Annunciation (1333). End saints by Lippo Memmi.
Panel painting, 42½″ x 43½″. Uffizi, Florence (Alinari)

Simone's best-known picture is the Annunciation in the Uffizi in Flor-
ence [7.6]. A masterpiece of color, pattern, and design, reminiscent of a fine
Japanese print, it ravishes the eye of the susceptible spectator. It is a triptych
in form but rigid in construction. The single figures of St. Ansano and St.
Mary Magdalen in the side panels of the triptych—done probably by Simone's
brother-in-law Lippo Memmi—are plastically rendered like statues from a
Gothic portal. They create a sharp contrast with the patternistic and two-
dimensional figures of the scene set between them. In spite of the decorative
and colorful beauty of the ensemble, the significance of the subject matter of
the Annunciation here falls far below that in Giotto's Annunciation at Padua
[6.5]. It is rendered in the spirit of contemporary French court manners.
The Angel Gabriel, clothed in a white robe gleaming with gold and pink
brocade, kneels in reverence like some court herald before the Virgin queen.
A vase of lilies is set between them. The Virgin, clad in a blue robe painted
in flat curvilinear silhouettes, recoils in bored annoyance at the interruption
of her reading. The superficial courtly content of the scene, however, is over-
shadowed by the emotional impact of the color, pattern, and vitality of the
design. It is dated 1333, and shows how impervious Simone was to the style
of Giotto.

7.7. SIMONE MARTINI: Return of the Holy Family from the Temple (1342). Panel painting, 19″ x 14″. Walker Art Museum, Liverpool (Walker Art Museum)

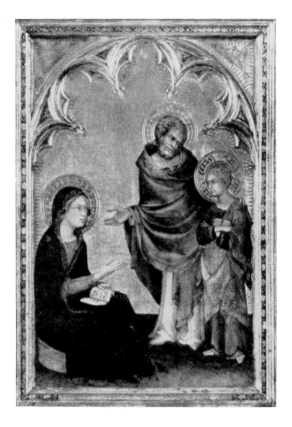

Simone's later style, when he had moved to the papal court at Avignon, displays an even more submissive adherence to the patternistic and trivially emotional art of contemporary France. The decorative diptych of the Annunciation, formerly in the Stroganoff Collection, is one example. Another is a panel, part of an altarpiece, now in the Walker Art Museum in Liverpool [7.7]. It represents the return home of the twelve-year-old Christ after His meeting with the elders of the Synagogue. According to the New Testament narrative, the young Christ had disappeared from home. When His parents later found Him discussing theological problems with the elders, they chided Him for the worry He had caused them. In this panel, although He stands with arms crossed in an attitude of respect before His parents, He frowns petulantly while they seem to be expostulating helplessly with their truculent offspring. The religious story is interpreted absolutely in secular terms.

Little remains of Simone's activities at Avignon. The badly faded fresco of the Madonna and Child and angels in the lunette of the main portal of Notre Dame des Doms seems to be by his hand. In the palace of the popes some follower frescoed the vaults of the chapel, and in a private apartment a series of secular wall decorations, imitating tapestries, with scenes of fishing, hunting, and other leisure pursuits of the contemporary nobility, are of particular interest.

Pietro Lorenzetti

The rise of secularism, the keynote of the fourteenth century, found its fullest expression in Sienese painting in the works of the Lorenzetti brothers * and their followers. The work of Pietro, the elder of the two, had none of the graces of Simone's style. Although also a pupil of Duccio, Pietro emancipated himself rapidly from the Byzantinizing elements left in his master's style and developed the more plastic ones that had been based on the sculpture of Giovanni Pisano.

Although notices of his activities are to be found as early as 1305–1306, Pietro's earliest documented work is the large altarpiece done in 1320 for the high altar of Santa Maria della Pieve at Arezzo. It is a curious mixture in style of Duccian reminiscences, particularly in the angels, and of the sculptural traditions of form derived from Giovanni Pisano. But it is overlaid with the decorative detail so dear to the heart of Sienese and painted in brilliant colors. The Madonna and Child in the central panel [7.8] are as close in pose and execution to Giovanni Pisano as one could wish in such details as the drapery drawn tightly over the shoulders of the Virgin or over the torso, arms, and thighs of the Christ child. Characteristic of both the Lorenzetti is the very human and playful Christ child present in almost all their Madonna compositions. He insistently demands attention from His mother.

A large altarpiece with a more hieratic Madonna surrounded by saints and angels was contracted for in 1329 with the monks of Santa Maria del Carmine at Siena. The interesting document still exists enumerating in detail the requirements for the altarpiece. The work itself has been dismembered and much of it lost, but the central panel with the Madonna and Child, the angels, and the patron saints of the Carmelite Order is now in the Pinacoteca at Siena, having previously been in the chapel of Sant' Ansano a Dofana outside Siena. The predella below the Madonna, repainted at a much later time, has recently been cleaned to reveal a beautifully rendered scene from the legend of the Carmelites. Four other predella panels are also in the same museum.

In the 1330's, Pietro was called to the basilica of St. Francis at Assisi to supervise the decoration of the vaults and walls of the left transept of the lower church. It would seem that every painter of note from Florence and Siena during this period of the revival of painting was to leave a record of his style at Assisi.

The subjects represented in this cycle were those of Christ's Passion, from the Entry into Jerusalem through the Crucifixion, and the later scenes of the Deposition [7.9], the Resurrection, and the Descent into Hell. Although most of the actual painting of these scenes was left to expert assistants from his workshop, Pietro's own hand is visible in portions of the Crucifixion and in the three later scenes. These last three in particular have

* Dates for the brothers are not ascertainable, but presumably both were victims of the Black Death in 1348.

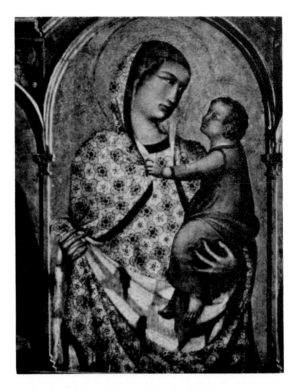

7.8 (*right*). Pietro Loren-
zetti: Detail of Madonna
and Child, altarpiece (1320).
Panel painting. Santa Maria
della Pieve, Arezzo (Brogi)

7.9 (*below*). Pietro Loren-
zetti: Deposition (*c.* 1330).
Fresco. Left Transept,
Lower Church, San Fran-
cesco, Assisi (Anderson)

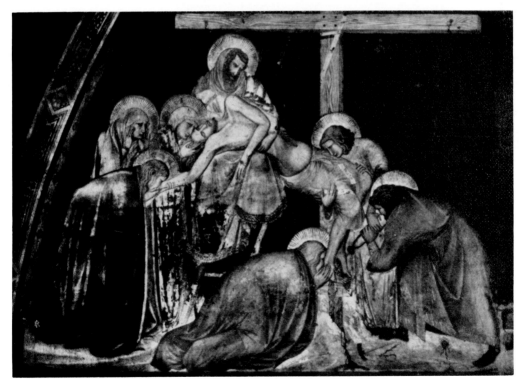

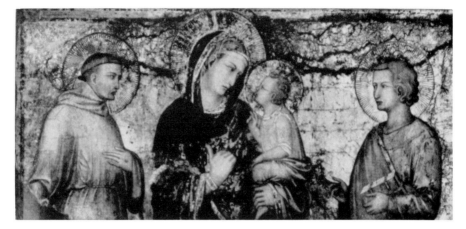

7.10. PIETRO LORENZETTI: Madonna and Child with St. Francis and St. John the Evangelist (*c.* 1330). Fresco. Left Transept, Lower Church, San Francesco, Assisi (Casa Ed. Francescana)

a greater monumentality and simplicity than appears in the earlier ones and show a definite influence of Giotto's style to which Pietro responded.

The fresco of the Madonna and Child with SS. Francis and John the Evangelist [7.10], set beneath the large scene of the Crucifixion, is noteworthy for the very human interpretation of a traditionally more formal presentation. The Madonna is doing her best to draw the Christ child's attention to the figure of St. Francis as the patron saint of the church with a gesture of her thumb reminiscent of modern hitchhikers. She looks reprovingly at the playful Child gazing pertly into her face while raising His hand in blessing toward the saint who otherwise receives no attention from Him. It is one of the most appealing of Madonna and Child compositions in the fourteenth century.

In the scenes leading up to and including the Crucifixion, the Sienese love of descriptive detail is developed to a high degree. In contrast to Giotto who emphasized only the essential action and content of each scene, Pietro picked out all the details of setting. For instance, in the Last Supper [7.11], the rafters of the ceiling, the dishes and food on the table are all put down with great care. As in Simone's portrait of Guidoriccio, we can see things from above and below at the same time with the strange perspective of one suspended from the middle of the columns of the room, or as though a hinged box were opened and we saw the contents of both lid and bottom. An additional bit of genre is added in the anteroom or kitchen at the left where a servant scrapes the dishes and feeds the cat and dog with the leftovers. Since the event of the Last Supper took place at night, stars and a crescent moon are set in the sky above the building shown in a vertical cross-section like a doll's house.

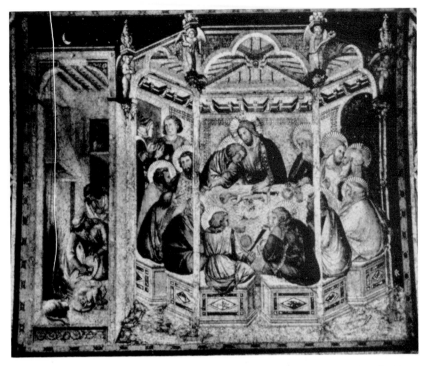

7.11. Pietro Lorenzetti shop: Last Supper (*c.* 1330). Fresco. Left Transept, Lower Church, San Francesco, Assisi (Anderson)

Giotto's influence on Pietro is also reflected in the remnants of a Crucifixion fresco now in one of the side chapels to the left of the sanctuary in San Francesco at Siena. Where Pietro chiefly differed from Giotto was in the added details of feature and emotion in the Christ, in the figures below the cross, and in the angels fluttering about Christ's head.

Love of descriptive detail is the hallmark of fourteenth-century Sienese painting, no matter how closely some Lorenzettian figures might approximate Giotto's style. Pietro's expressive Crucifixion panel in San Marco at Cortona, although full of Giottesque feeling, is differentiated, for example, from Giotto's Crucifixion at Padua [6.8] by such descriptive details as the fine strands of the hair, the half-open dead eyes, and the teeth showing behind the parted lips of the Saviour.

The epitome of Pietro's style is seen in his last important painting, the altarpiece of the Birth of the Virgin in the museum of the Opera del Duomo at Siena, bearing the date of 1342 [7.12]. It is, first of all, striking and significant that he chose as the central theme of an altarpiece not the traditional Madonna and Child or the figure of some other saint enthroned but a narrative scene from the life of the Virgin, such as would normally be found in the predella, and raised it to monumental importance.

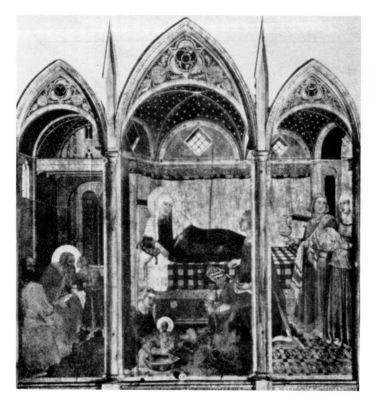

7.12. Pietro Lorenzetti: Birth of the Virgin (1342). Panel painting, 73¹¹⁄₁₆″ x 71¹¹⁄₁₆″. Opera del Duomo, Siena (Anderson)

It was in the telling of the story of the Virgin's birth that Pietro reached the height of his expressive powers. The scene is set in the vaulted room of a contemporary Sienese burgher. The old St. Anne who has just given birth to her child, the Virgin, lies hunched up on the bed. The lines of her face and the stretch of the garment against her tired loins and feet are marvelously expressive of the weariness of the aged saint after her trying ordeal. The midwives are busily washing the newborn child in a huge basin beside the bed, while a group of congratulatory friends approach with gifts for the mother, according to Italian custom. Another very human touch is added by the scene enacted in the adjoining antechamber at the left. St. Joachim sits on a bench, the "anxious seat," with a faithful friend who keeps him company during the moments of his anxiety. He cocks his head to hear the good news brought by the young messenger standing respectfully with folded arms. All the details of the interior are faithfully given: the ribs and the starry decorations of the vaults, the hangings around the bed, the details of the bedspread, the flaglike fan of the foremost of the female friends of St. Anne, and the tiles of the floor.

Another remarkable innovation is apparent in the handling of the space to create an illusion. The altarpiece was designed to look like a triptych, divided into its three sections by means of pointed arches supported on colonnettes. But these arches and colonnettes were made to become part of the architecture of the painted space behind them, the arches being the

front faces of the vaults and the colonnettes serving as the supports of the vaults. One of the figures is cut in half by the right colonnette as though she were behind it. Thus Pietro boldly attempted to break the flat plane of the panel to allow us to pass from the actual space outside the picture into the painted space created by his illusionistic architecture—as though we were looking into a small marionette theater. His brother Ambrogio went even further, as we shall see.

Ambrogio Lorenzetti

Although to the eyes of a casual spectator the styles of the two Lorenzetti brothers are not easily differentiated, Ambrogio's figures would seem to lack a certain ruggedness found in Pietro's. His Madonnas have a softer, prettier look, and the Christ child becomes an even more mischievous bambino than the one created by Pietro. The most intimate of all the Sienese Madonnas is Ambrogio's Madonna del Latte in the small chapel off the cloister of San Francesco in Siena [7.13]. Painted in bust length, the Madonna gazes with affection at the Child at her breast, Who while taking His sustenance turns His round eyes toward the spectator and kicks His feet with delight.

Even when Ambrogio painted a large altarpiece with many saints and angels surrounding the Virgin's throne, as in the magnificent Maestà from Massa Marittima [7.14], the intimacy of mother and child persists in spite of the more formal, courtly intention of the whole. Here is a decorative assemblage of gold, silver, and color equal to anything Simone ever did and surpassing him in the seriousness of its content. Seated on the steps of the throne are three female figures representing the theological virtues of Faith, Hope, and Charity.*

Ambrogio's most significant accomplishment was the series of frescoes in the Sala della Pace, the Hall of Peace, opening off the great hall in Siena's Palazzo Pubblico where the two great frescoes by Simone [7.1] are to be found. The work, commissioned in 1339, was destined to become an important milestone in the development of fresco painting in the latter half of the fourteenth century. The subject matter, an allegory of Good and Bad Government, was particularly fitting for a town hall, and the manner in which Ambrogio fused allegory and naturalism was remarkable for the time. Interest in allegory reaches far back into the medieval period when Virtues and Vices, Art and Crafts had been personified as female figures in both writings and the arts. In French cathedral sculpture, actuality was added to allegory by placing a historical personage representing a specific art beneath the personified figure of that art or by representing an actual act of vice as a contrast below a personified virtue. We have already seen how Giotto had used such virtues and vices in connection with an abbreviated

* The earliest known example of personified Virtues seated before the Madonna's throne is on a small panel in New York (dealer) and comes from Giotto's workshop, attributed to the master who painted the Stefaneschi altarpiece in the Vatican Gallery.

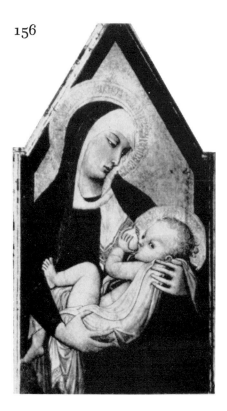

7.13 (*left*). AMBROGIO LORENZETTI: Madonna del Latte (*c.* 1340). Panel painting, 35½″ x 17¾″. Chapel off Cloister, San Francesco, Siena

7.14 (*below*). AMBROGIO LORENZETTI: Enthroned Madonna with Saints and Angels (*c.* 1340). Panel painting, 59¼″ x 80¾″. Town Hall, Massa Marittima (Alinari)

7.15. AMBROGIO LORENZETTI: Good Government Enthroned (1339). Fresco. Palazzo Pubblico, Siena (Anderson)

allegory of Good and Bad Government in the Arena chapel at Padua, a use particularly fitting for Italy with its city-states and their systems of government.

Ambrogio, with the Sienese love for detail, weaves allegory and reality into a program both decorative and didactic. Everyone in the Tuscany of that period had experienced the evil effects of internecine party strife, the recurrent changes in city government by means of violence, the brief periods of peace, and the longer periods of tyranny. What Ambrogio painted was therefore not a flight of fantasy; it was based on experience. The allegory [7.15] is presented in terms of the large-scale figure of a bearded ruler in ermine seated on a throne and bearing a scepter. Flanking him as counselors are seated the four cardinal Virtues of Fortitude, Temperance, Prudence, and Justice, and two other Virtues, Peace and Magnanimity. Above his head float the theological Virtues of Faith, Charity, and Hope. The figure of Peace is made prominent by placing her half-reclining at the left end of the counselor's bench. She wears a diaphanous white robe, supports her blond olive-crowned head with her right hand, and holds an olive branch in her left. Some Classic prototype might easily have inspired Ambrogio to paint this figure. In the lower register, allegory turns into actuality as the citizens of Siena approach in slow procession to pay their respects and to pledge their loyalty to Good Government and his advisers. Justice, inspired by Wisdom, is repeated to the left of Peace and metes out her virtue to other pairs of citizens and is assisted by Concord counseling them to live in harmony.

The more remarkable section of Ambrogio's fresco series is on the adjoining wall at the right where the effects of Good Government are in evi-

7.16 (*above*). AMBROGIO LORENZETTI: Good Government in the City (1339). Fresco. Palazzo Pubblico, Siena (Anderson)

7.17 (*left*). AMBROGIO LORENZETTI: Good Government in the Country (1339). Fresco. Palazzo Pubblico, Siena (Grassi)

dence. We are shown a part of the city of Siena itself set on the side of a hill, bustling with peaceful activities [7.16]. Peasants come in from the country and pass through the city gate with their produce on the backs of small donkeys characteristic of the Tuscan countryside. Citizens go about their business, and young girls dance and play in the square. A woman walks along carrying a basket on the top of her head, a familiar sight almost anywhere in Italy to this day. So truly had Ambrogio represented the scene that we can identify the section of the city. The fresco continues to the right with the portrayal of the effects of Good Government in the country [7.17]. A group of horsemen passes through one of the city gates. Before them spreads the peaceful hilly countryside of Siena, not symbolically represented but actually as it is. On the hillside are woods, well-tilled fields, lakes, and villas. In the distance are the barren hilltops of the arid lands such as surround Monte Oliveto. This is the first landscape painting since Roman times in which the main interest lies in the landscape itself. Only in the sketches of Leonardo or in the works of late-sixteenth-century and baroque painters shall we see this again, for during the Renaissance the human figure predominated as the subject for a picture.

Ambrogio's interest in the landscape was not an interest in space, as we are accustomed to think of landscape and see it done. It was a descriptive interest. In contrast to the earlier symbolic and functional landscapes that gave no indication of the place where the scene was set, Ambrogio wished to paint the countryside about Siena so that everyone could recognize it as such. To accomplish this he described all the topographical details distinguishing that countryside. And in order to make these details visible he had to show them, as in any topographical map or photograph, as though seen from above in a *panorama*. This panoramic, descriptive type of landscape is to be found for a long time in later Italian paintings even after the perspective type had come in.

The allegory continues along the opposite walls with the representation of Bad Government and its effects. These frescoes are considerably damaged so that many details are missing. But we can still see Bad Government, personified as a tyrant with fangs and horns, enthroned in the midst of his vicious counselors: Pride, Avarice, Vanity, Deceit, Treason, Cruelty, Fury, Discord, and War. In turn, the citizens present themselves in disorder before Bad Government to partake of the vices of Tyranny, and the city and country are shown once again, but this time suffering from the disastrous effects of anarchy, crime, and war.

In decorative medallions set in the borders around the Sala della Pace are representations of the Seasons, of the Sciences, of the Signs of the Zodiac, and of the Tyrants. These, too, show the strong effect of Gothic iconography and usage.

In the same year in which Pietro painted his famous altarpiece of the Nativity of the Virgin—1342—Ambrogio painted a similar one with the Presentation of the Christ child in the Temple for its subject [7.18], now in the

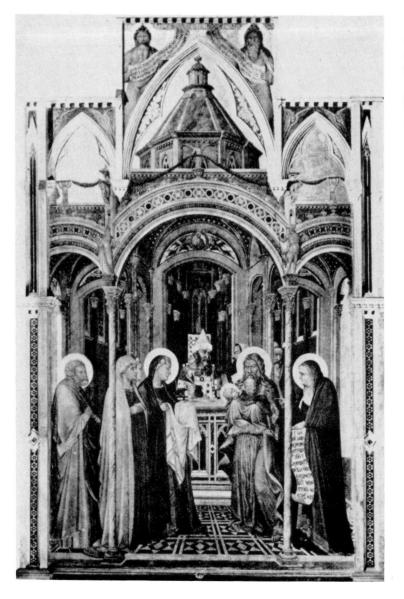

7.18. AMBROGIO LO-
RENZETTI: Presenta-
tion in the Temple
(1342). Panel paint-
ing, 101⁵⁄₁₆″ x 66³⁄₁₆″.
Uffizi, Florence (Ali-
nari)

Uffizi. It seems almost as if the two brothers had painted companion pieces
in some church or chapel. At this time both were at least experimenting with
the problem of representing architectural space *as seen*. Apparently that is
why the themes for these altarpieces are narrative episodes taking place in
an interior. Pietro, we observed, in his Birth of the Virgin [7.12] had super-
imposed the symmetrical triptych design on what was originally an asym-
metrically composed narrative panel. He had attempted to give the illusion
of architectural space by opening up a vista through rooms in the back of
the antechamber at the left. He had even undertaken to create the illusion
of passing from actual space into the space of the picture by giving the

7.19. AMBROGIO LO-
RENZETTI: Annuncia-
tion (1344). Panel
painting, 78½″ x
43⅜″. Pinacoteca,
Siena (Anderson)

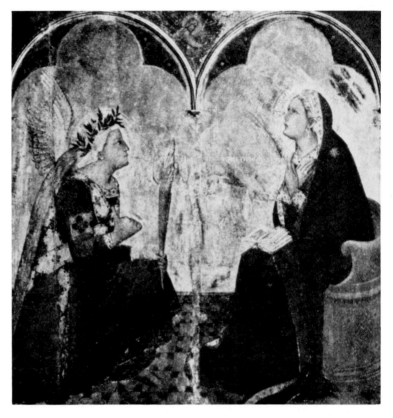

effect of a marionette theater to the altarpiece. This he achieved in part by
having the half-colonnettes that divide the panel into the three parts of the
triptych appear, at the same time, to be the supports of the vaults in the
picture.

Ambrogio, in the Presentation, used the interior of a church as his set-
ting, the nave and side aisles automatically giving the effect of a triptych
as well as a symmetrically balanced composition. But Ambrogio noticed, in
describing the interior space of the church, that the columns of the nave and
aisles at right angles to the field of vision seemed to grow smaller and to
converge on a point—that is, as early as the middle of the fourteenth cen-
tury the problem of perspective was posed by Ambrogio. He did not solve
it scientifically as the architect Brunelleschi was to do early in the fifteenth
century, for in Ambrogio's picture there are a series of vanishing points ly-
ing along a vertical line in the center of the picture. But he was well along
the way to discovering perspective as the result of his desire to describe in
paint what he saw. He also broached the problem of scale—that is, the rela-
tion of the figure to its architectural setting. There was more room for the
figures to move around the space provided for them in this picture than in
any other heretofore. But Ambrogio spoiled the effect somewhat and com-

pressed the space psychologically by showing the outside of the church as well as the inside in his endeavor to describe the setting completely, just as his brother had done in the Last Supper [7.11] at Assisi.*

In 1344 Ambrogio painted an Annunciation [7.19] now in the Pinacoteca in Siena that, together with those of Giotto and Simone, ranks as one of the most important representations of that subject in the fourteenth century. It has none of the glamor or the empty content of Simone's Annunciation [7.6] but approaches more closely the one by Giotto [6.5]. But whereas Giotto stresses the universal significance of the angel's message and the consciousness of the Virgin that she is to become the Mother of God, Ambrogio, in Sienese fashion, elaborates a specific moment. The angel has come into the room and with folded wings rests after the delivery of his message. The Virgin, holding the open book in her lap, no longer pays attention to the angel but raises her eager, obedient eyes toward the bust figure of the Almighty in heaven. With parted lips she utters the unforgettable words, inscribed on the panel: "Ecce ancilla dei"—"Behold the handmaiden of the Lord."

Despite Giotto's great accomplishments, the Sienese painters of the fourteenth century made numerous important contributions to the development of their art. They introduced via Simone Martini the contemporary French Gothic style; they popularized the intimate type of Madonna with the playful Christ child; they added to narrative religious scenes descriptive details of human forms and emotions, of environment, of contemporary settings and costumes, all the results of observation. They even used landscapes and secular pursuits, such as hunting and fishing, as subjects for their paintings. In fine, by the middle of the fourteenth century they had prepared the way for the more scientifically realistic painters of the fifteenth century.

BIBLIOGRAPHY

DeWald, E. T. *Pietro Lorenzetti*. Cambridge, Mass., Harvard University Press, 1930.

Weigelt, C. H. *Sienese Painting of the Trecento*. New York, Harcourt, Brace & Company, 1930.

Vavalà, E. Sandberg. *Sienese Studies*. Florence, Leo S. Olschki, 1953.

Paccagnini, G. *Simone Martini*. London, W. Heinemann, Ltd., 1957.

Brandi, C. *Pietro Lorenzetti*. Rome and Milan, Collana d'Art Sidera, 1958. (Color plates of the Assisi frescoes; short text in Italian)

Rowley, G. *Ambrogio Lorenzetti*. 2 vols. Princeton, N. J., Princeton University Press, 1958.

* Note again in this picture Ambrogio's interest in Classical sculpture as seen in the small figures along the tops of colonnettes and arches, some of them supporting leafy swags.

➤ 8

Tuscan Painting
after Giotto

DURING the remainder of the fourteenth century, Florence produced no painter of the monumental stature of Giotto and Siena had no successors to match in importance the significant achievements of Simone and the Lorenzetti.* Almost half a century was needed to assimilate what had been offered in the works of these four great painters. Instead, as we shall see, the increasing interest in contemporary secular surroundings, brought to expression by Sienese masters, became popular and was carried over into the art of Florence, while even among his followers Giotto's simplicity and ruggedness gave way to a descriptive multiplicity or a decorative elegance stemming from Siena.

The Followers of Giotto

That Giotto had an active workshop with accomplished assistants goes without saying. There are at least three pieces at hand bearing Giotto's signature *Opus Jocti Florentini* that seem to be the work of such top assistants.† One is the brilliant altarpiece of the Coronation of the Virgin in the Baroncelli chapel of Santa Croce in Florence; the second is St. Francis receiving the Stigmata in the Louvre in Paris; and the third is a polyptych of the Madonna with saints in the Museo Civico at Bologna.

* Such painters as Andrea Vanni, Luca di Tommé, and the anonymous Ovile Master, delightful as their works are, plodded along after Simone and the Lorenzetti without significant innovations of their own.
† As was the case with Rubens in the seventeenth century, the master made the design, let the assistants do most of the work, put on finishing touches, and then signed it.

Ghiberti, the early fifteenth-century sculptor, in his *Commentaries,* mentions the names of Maso, Stefano, and Taddeo [Gaddi] as among Giotto's followers. Ghiberti also listed the frescoes in the Sylvester chapel in Santa Croce, Florence, as works by Maso. Richard Offner * has offered evidence to identify this Maso with a Maso di Banco known in documents from 1320 to 1352. The Sylvester chapel frescoes themselves are a most significant step in fourteenth-century Florentine painting in the development of spatial relationships between figures and architecture, a development in which the Sienese painters, especially Ambrogio Lorenzetti, had excelled. In one of the most remarkable frescoes in the Sylvester series, in which the saint has subdued a dragon that had been spreading death and havoc and then turns to revive two magicians killed by the dragon [8.1], this influence from Siena is apparent. The effect in the architectural setting of a bombed-out area is astounding in itself, but the stepping back in space achieved by the overlapping architectural elements and the relation of the figures to this space go considerably beyond Giotto's own organization of figure and architecture as seen in his later style (see [6.17], for example).

Another close follower of Giotto is the painter known generally as Giottino, or the little Giotto. The style and feeling in the Deposition, now in the Uffizi, have all the delicacy and sensitivity of Giotto's figures in the Bardi chapel in Santa Croce. Whether Giottino can be the Stefano mentioned by Ghiberti is an open question.

Giotto's name has often been associated with many of the frescoes in the lower church of San Francesco at Assisi. Among these are the frescoes of the cross vaults over the crossing and those over the vault over the right transept. They are all by the same hand and by a follower but not by Giotto. The painter is known as the Master of the Right Transept or as the *Maestro delle Vele* (Master of the Vault Sections). Sparkling with bright colors and the gold of haloes, the cross-vault frescoes over the crossing contain allegorical paintings pertaining to St. Francis: the Marriage of St. Francis with Poverty; St. Francis assuming the Yoke of Obedience; Chastity in her Tower; and the Glorification of St. Francis. In the tunnel vault over the right transept are scenes from the early life of Christ plus a Crucifixion.

The style of this master is close enough to that of Giotto to have been confused with it in the past, but any close comparison brings out rather sharply the difference between the two. In Giotto's fresco in Padua of the Nativity of Christ [8.2] the scene is simply yet monumentally composed and presented. The heavy form of the Virgin, still exhausted from her labor, lies beneath a flimsy shed built against a rocky cliff. She turns to receive the Newborn from the hands of a midwife. The ox and the ass raise their heads in curiosity from the manger, while the isolated cubic figure of Joseph overcome with fatigue squats in the foreground. At the right, two shepherds with their flocks give solemn attention to the message of the angel from heaven

* See his article in *Burlington Magazine,* LIV (1929) cited in Bibliography, p. 176.

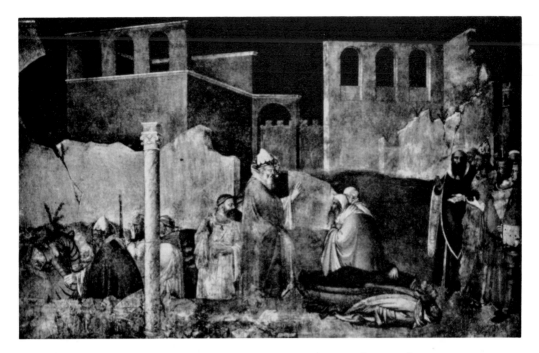

8.1. MASO DI BANCO: St. Sylvester reviving two Magicians (*c.* 1340). Fresco. Sylvester chapel, Santa Croce, Florence (Alinari)

and to his four winged companions hovering above the shed and praising God. In the same scene as painted by the Master of the Right Transept in the lower church at Assisi [8.3] the scale of the figures has been reduced and many of the details have been elaborated. As a result, while the addition of groups of angels with gold haloes, of the shooting star, and of the rays falling from heaven upon the Christ child may give a scintillating decorative effect, the essential content is lost. This crowding in of descriptive details and the emphasis on decorative effects per se are indicative of the infiltration of Sienese influences and taste. Indeed, as we saw in the preceding chapter, Simone Martini had been at work in the St. Martin chapel and Pietro Lorenzetti and assistants were decorating the left transept of the same lower church at Assisi.

Other frescoes in the lower church that have been associated with Giotto are those in the Magdalen chapel depicting episodes from the life of Mary Magdalen. Although there are reminiscences of Giotto's Paduan iconography in the scene of Christ meeting Magdalen in the Garden on Easter morning and of his style in the large-scale figure of the saint, the style in general of these frescoes has lost Giotto's forcefulness and must belong to some member of his workshop. The frescoes in the St. Nicholas chapel are still a puzzle. They seem earlier than the others we have mentioned. Their strange decorated architectural backgrounds recall architectural elements present in the St. Francis series in the upper church.

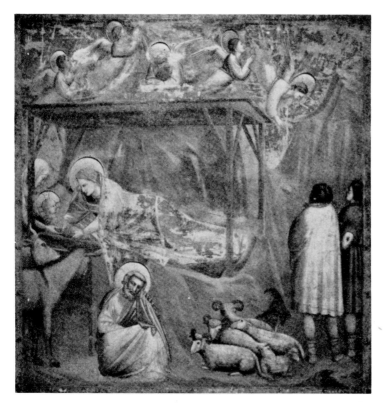

8.2 (*left*). GIOTTO: Nativity (1305–6). Fresco. Arena chapel, Padua (Alinari)

8.3 (*below*). MASTER OF THE RIGHT TRANSEPT: Nativity (1320–30). Fresco. Right Transept, Lower Church, San Francesco, Assisi (Alinari)

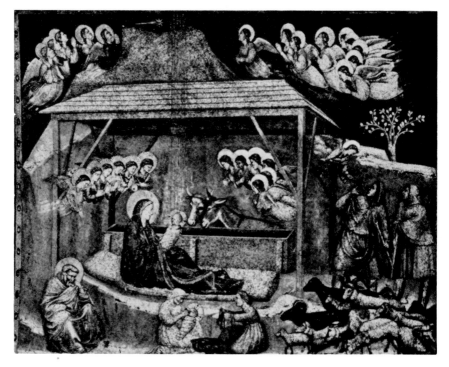

8.4. TADDEO GADDI: Presentation of the Virgin (1338). Fresco. Baroncelli chapel, Santa Croce, Florence (Alinari)

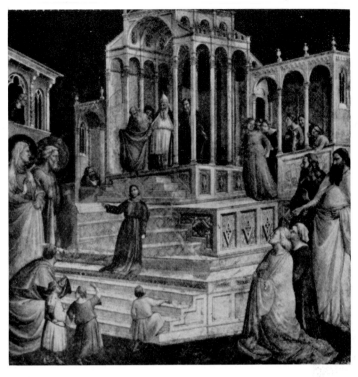

Giotto's pupil and godson Taddeo Gaddi (*c.* 1300–*c.* 1366) was a rather prolific painter of altarpieces. His major achievements, however, are to be found in the frescoes of the Baroncelli chapel off the right transept of Santa Croce in Florence. In these he shows himself somewhat at odds with the style and content of his great master's frescoes directly across the transept in the Bardi and Peruzzi chapels. In the extraordinary fresco of the Presentation of the Virgin in the Temple [8.4], Taddeo vividly proclaims his revolt against Giotto's "law and order" as applied to the scale of figures, to architectural backgrounds, and to space. Large and small figures are jumbled together; architectural structures jut in and out at angles to the front plane to achieve space in the background, and are connected with the foreground by a zig-zagging staircase resembling an accordion. In the scene of the Meeting of Joachim and Anna [8.5] as compared with Giotto's rendering of the same scene in the Arena chapel [6.9], Taddeo's elongation of the forms anticipates the style of the sixteenth-century Mannerists who revolted against the Classic form and order of the High Renaissance style (Chapter 30). This elongation of the figures and the curving lines of the architectural background create a sense of instability, emotional as well as physical. The figures tend to become bumptious, their expressions affected, and, in the case of the attendant shepherd to the left looking out of the picture, disturbed. These too are characteristics associated with the later Mannerists. In the

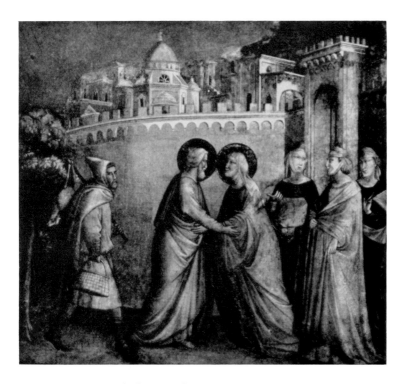

8.5 (left). TADDEO GADDI: Meeting of Joachim and Anna (1338). Fresco. Baroncelli chapel, Santa Croce, Florence (Alinari)

8.6 (opposite). BERNARDO DADDI: Triptych (1333). Panel painting, 35½" x 32¼". Bigallo Museum, Florence (Alinari)

scene of the angel announcing the news of Christ's birth to the shepherds, Taddeo's use of a phosphorescent light surrounding the angel in the darkness anticipates by almost a hundred years the experiment of Piero della Francesca (pp. 223–224).*

The most popular Giottesque painter in Florence before the middle of the fourteenth century seems to have been Bernardo Daddi. With the help of his assistants he turned out a large number of small altarpieces for which apparently there was a great demand. Almost every museum or private collection seems to contain some example of these mass-produced triptychs [8.6]. They are extremely decorative things, but they repeat the same subjects over and over with very slight variation. In general the central panel contains the Madonna and Child enthroned between angels and saints, the latter most frequently being SS. Peter and Paul and the two Johns. One wing of the triptych usually has the Nativity and the other the Crucifixion. In addition we may find the Angel Gabriel on the top of the left wing and the Virgin Annunciate on the top of the right one. Like the Master of the Right Transept, Bernardo Daddi seems to have been influenced by the decorative softer qualities of the Sienese masters, especially of Ambrogio Lorenzetti.

* In his late frescoes of the episodes from the life of Job in the Campo Santo at Pisa, Taddeo again uses as a background for one of the scenes a conglomeration of towers, domes, and other structures to indicate a distant city, such as he had used in the Joachim and Anna scene in the Baroncelli chapel in Santa Croce [8.5]. This idea could have been derived from Ambrogio Lorenzetti's Good Government frescoes in Siena together with a knowledge of Franco-Flemish miniatures. In another of the Job scenes, the landscape background certainly suggests Ambrogio.

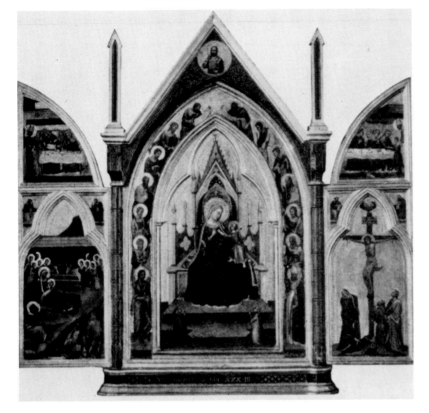

Barna of Siena and the Black Death Pessimism

In 1348 the Black Death spread over Europe. Italy was badly hit by the plague, and such cities as Florence and Siena lost more than half their populations. The effect on the people was tremendous. There were two general reactions, either a hysterical rushing into the arms of the Church or a materialistic attitude of "Let us eat, drink, and be merry, for tomorrow we die."

In painting, these two attitudes are neatly reflected. In altarpieces of the Florentine Andrea Orcagna (active 1344–1368) and his school appears the first, the more serious of these post-pestilence trends. As Millard Meiss points out,* a throwback to twelfth-century dogmatism can be detected, for example, in Orcagna's Strozzi chapel altarpiece in Santa Maria Novella in Florence [8.7]. Here Christ is given the central position usually occupied in altarpieces by the Madonna and Child and recalls the Christ as judge in a Last Judgment mosaic flanked as here too by the Virgin and St. John the Baptist.

* See Bibliography at the end of the chapter.

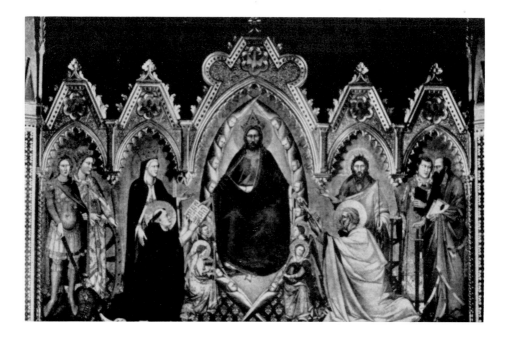

8.7 (*above*). AN-
DREA ORCAGNA: The
Strozzi Altarpiece
(1354–1357). Panel
painting. Strozzi
chapel, Santa Maria
Novella, Florence
(Alinari)

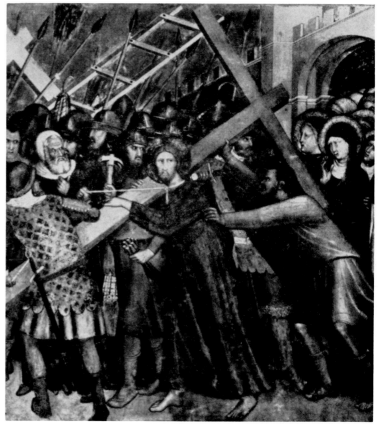

8.8 (*right*). BARNA
DA SIENA: Christ
carrying the Cross
(*c.* 1356). Fresco.
Collegiata, San Gim-
ignano (Alinari)

Death prefers a richer harvest. The allegory is obvious. The anchorites' choice of a life of sacrifice is contrasted with the worldly life of vain pleasure; and Death has its holiday.

These frescoes, as said in the note (p. 171), have been attributed to a local Pisan painter, Francesco Traini, trained in the Sienese tradition. He must have been acquainted with Boccaccio's recently written *Decameron,* for the fresco of the Triumph of Death graphically recalls Boccaccio's account of the group of young men and women who left the deadly atmosphere of Florence to go to a villa in the country where they tried to forget the horror of death by enjoying a lively houseparty, singing, dancing, and telling stories. Indeed the development of the narrative style in literature by Boccaccio is a neat parallel to the development of the narrative style in painting at this time.

This new narrative-allegorical style, actually begun on a grand scale by Ambrogio Lorenzetti in his Palazzo Pubblico frescoes of Good and Bad Government, also finds expression in Florence. Traces of a Triumph of Death, similar to the one at Pisa but painted by Orcagna, have been uncovered on the nave walls of Santa Croce in Florence. The fragment contains a group of the halt, the lame, and the blind. An accompanying scroll bears an inscription with an appeal to Death not to pass them by. Additional traces of the larger fresco came to light during World War II when various monuments were removed to safety leaving exposed wall areas.

The finest example of narrative-allegorical painting in Florence, dating *c.* 1366–1367, is by Andrea da Firenze in the Spanish chapel off the cloister of Santa Maria Novella, the great Dominican church. The frescoes over the altar on the wall facing you as you enter the chapel represent the Crucifixion, the Road to Calvary, and the Descent into Hell. Those of sections of the cross vault overhead contain the scenes of the Navicella, the Resurrection, the Ascension, and the Pentecost. Those of the remaining three wall surfaces, however, are given over to subject matter to glorify the Dominican Order. On the entrance wall are scenes from the life and activities of St. Peter Martyr, one of the first martyr saints of the Order. On the left wall is the great fresco glorifying St. Thomas Aquinas, the greatest of medieval theologians and a Dominican as well. He is represented as enthroned among the Doctors of the Church and the Old and New Testament figures of Moses and St. Paul respectively. At the foot of his throne are seated the archheretics Arius, Mahomet, and Averhoës. In the lower register the Liberal Arts personified as women are placed on Gothic thrones, each with a historical representative of the art she personifies at her feet.

The right wall is covered with an elaborate allegorical narrative exalting the Dominican Order as a Saver of Souls [8.10]. At the top the God-Christ is seated on an arc of rainbow within an almond-shaped glory in the midst of saints and angels in Paradise. A large-scale St. Peter stands at the gate of Paradise admitting a procession of souls recommended to him by a Dominican saint, presumably St. Dominic himself. Further down and at the

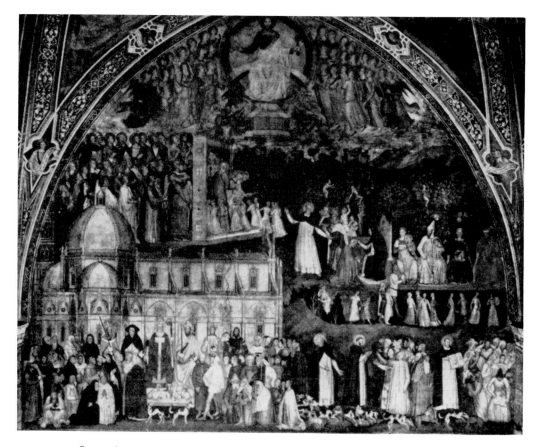

8.10. ANDREA DA FIRENZE: Dominican Allegory (1366–1368). Fresco. Spanish chapel, Santa Maria Novella, Florence (Alinari)

right are various representations of the worldly life. We recognize among these a group of people seated in an orange grove similar to the group in the Campo Santo fresco of the Triumph of Death. The dancing girls near by are obviously borrowed from Ambrogio Lorenzetti's fresco of Good Government at Siena. In the lowest register and at the left is the Church as the means of salvation, represented here in the form of a model of the cathedral of Florence, presumably, seen from the side. The pope is enthroned in the center before this side of the cathedral and is flanked by emperor, king, knight, bishop, and others as defenders of the Faith. Among these is also a knight of Malta. On a platform in front of the pope are sheep guarded by black and white dogs. From the early days of the Order on, the Dominicans have been called "the dogs of the Lord." This came about because the Latin word for Dominicans, *Dominicani* becomes *Domini canes*, or dogs of the Lord, by a simple change of ending. The inference therefore is apparent that the Dominicans as the watchdogs of the Church are guarding the souls of the faithful from danger. In fact at the right we see these dogs attacking

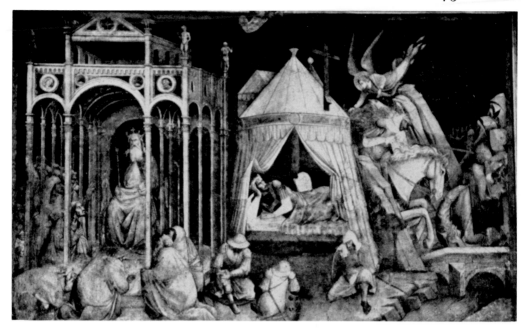

8.11. AGNOLO GADDI: Episodes from Legend of the Holy Cross (after 1374). Fresco. Choir, Santa Croce, Florence (Alinari)

wolves who obviously represent heretics, for immediately above them are the figures of three Dominican saints, among whom we recognize St. Peter Martyr and St. Thomas Aquinas, arguing with groups of heretics and non-believers. St. Thomas has succeeded in converting two Jews who kneel on the ground before him.

We have already mentioned the New Testament subjects that appear in the frescoes of the ceiling vault and of the wall above the altar. A few observations about some of them might be in order. The Navicella scene is obviously derived from Giotto's famous mosaic in St. Peter's and therefore is valuable for the study of the reconstruction of the original elements in that mosaic.

The large and populous Crucifixion on the wall above the altar shows how deeply Sienese traditions have penetrated Florentine painting: the lofty crosses, the crowd milling around beneath the crosses, the exaggerated display of emotion reflected even in the faces of some of the horses. This descriptive emotion is further elaborated in the scene of Christ's Descent into Hell, to the right below the Crucifixion. Christ majestically enters the nether regions treading over the broken gate beneath which lies the crushed figure of Hell personified. To the right four varicolored demons scream and spit at Christ in frustrated rage as the solemn and worshipful procession of patriarchs and other Old Testament personalities marches out to salvation.

All this indicates to what extent the allegorical, descriptive, and narrative tendencies observed before 1350 in Siena had been taken over by Florentine painters in the second half of the fourteenth century.

A final example will suffice to illustrate the popularity of the narrative-descriptive tendency in Florence toward the end of the century. This is the fresco decoration of the apse—or sanctuary—end of Santa Croce [8.11] painted by Agnolo Gaddi (c. 1350–1396), Taddeo's son. He was a direct artistic descendant of Giotto, and yet how cluttered with details in both foreground and background all these scenes from the story of the Holy Cross are. There is not much concern with composition or design, and gone is the simplicity of Giotto's style both as to emotion and composition.

Summing up the accomplishments of the fourteenth century, we have witnessed the following developments. *First,* painting became Gothicised both as to style and as to feeling. *Next,* in the wake of the Gothic, came a new interest in man, at first an interest in his emotional relation to religion so superbly expressed by Giotto with his universal forms and with his universal content and more secularly interpreted by Simone and the Lorenzetti. *Then* there developed an interest in man and his environment that manifested itself in the growth of secular themes with descriptive, naturalistic detail. This was often wedded to allegory, medieval didacticism still persisting. But this secular interest led *finally* in the Lorenzetti to observed realities of nature and produced the first attempts at landscape and at the visual experience of space—that is, perspective. But it took another half-century before new steps were to be taken and new discoveries made in the direction of visual reality. And during that half-century Florence had almost completely taken over from Siena that descriptive art which concerned itself primarily with allegory and narrative.

BIBLIOGRAPHY

Boccaccio, G. *The Decameron.* Various editions.

Sirén, O. *Giotto and Some of His Followers,* trans. by F. Schenck, 2 vols. Cambridge, Mass., Harvard University Press, 1917.

Offner, R. *Studies in Florentine Painting, the Fourteenth Century.* New York, F. F. Sherman, 1927.

—— "Four Panels, a Fresco, and a Problem." *Burlington Magazine,* LIV (1929), p. 224ff.

—— A Critical and Historical Corpus of Florentine Painting, Section III, Vols. III, IV, V, and VI. New York, 1930–1956.

Faison, S. L. *Barna and Bartolo di Fredi.* Chicago, reprint from *Art Bulletin* XIV, 1932, pp. 285–315.

Meiss, M. *Painting in Florence and Siena after the Black Death.* Princeton, N. J., Princeton University Press, 1951.

—— "A Madonna by Francesco Traini." *Gazette des Beaux Arts* (July 1960), p. 49ff.

An outstanding personality who also reflects the pessimism of the post-Black Death period is Barna of Siena. In his famous frescoes (*c.* 1356) in the Collegiata at San Gimignano, a grim intensity emerges from the scenes, especially those concerned with Christ's Passion. One of the most striking is the Christ carrying the Cross [8.8]. The diagonal accents of the design and the repeated rhythms of the metal helmets of the soldiers bring to mind modern abstract compositions. His descriptive details are wonderfully expressive in such figures as the Christ or the sleeping apostles in the Gethsemane scene or the boys casting lots for Christ's garments at the foot of the cross in the Crucifixion. Tragically this last-mentioned group was partially destroyed during World War II when shells crashed into the church during the German bombardment of the town. The damage to this and to other frescoes resulting from the shelling has since been repaired. Bartolo di Fredi probably assisted Barna in the decoration of the nave of the church. By Fredi's hand is the large Paradise on the entrance wall and also the frescoes on the north side of the nave.*

Campo Santo † and the Narrative Style

The most striking illustration of the emotional opposites of asceticism and materialism evoked by the Black Death is to be found in two frescoes flanking the Last Judgment and the Inferno on the south wall of the Campo Santo

* See the publication on Barna and Bartolo di Fredi by S. L. Faison cited in the Bibliography for this chapter.

† The cloister of the Campo Santo at Pisa, begun in 1277, was not completed until about 1350. The project to decorate the walls with frescoes was undertaken after 1360. A group of painters from Pisa, Florence, Siena, and Orvieto was active there until 1391. After an interruption, the project was continued by Benozzo Gozzoli, the pupil of Fra Angelico, in the latter half of the fifteenth century (p. 257). There were fifty-eight frescoes in all. Of the four on the short eastern entrance wall—the Crucifixion, the Resurrection, the Doubting Thomas, and the Ascension—the last three seem to be by the same master, presumably Francesco Traini of Pisa, who painted the four huge frescoes at the left end of the south wall: the Triumph of Death, the Last Judgment, the Inferno, and the Life of the Anchorite Hermits. Over the doorway between this group and the remaining eighteen frescoes on this wall was an Assumption of the Virgin by Lippo Memmi. Twelve of the eighteen frescoes contained stories from the lives of the local saints Raniero, Efisus, and Potitus. These were the work of the Florentine painters Andrea da Firenze, Antonio Veneziano, and Spinello Aretino. Taddeo Gaddi painted the remaining six on this wall with episodes from the life of Job. On the north wall, with the exception of the fresco of the Coronation of the Virgin over the easternmost doorway, the scenes represented were from the Old Testament. The first four at the left, a huge theological cosmography, Adam and Eve, Cain and Abel, and the Flood, are the work of a painter from Orvieto, Piero di Puccio. The remaining twenty-six frescoes, ranging in subject from the Drunkenness of Noah to the Meeting of Solomon and the Queen of Sheba, are the work of Benozzo Gozzoli.

Badly scorched and damaged during the battle along the Arno in 1944, when the roof of the Campo Santo burned and collapsed, many of these frescoes have been removed from the walls, reassembled, restored, and set up again in the cloisters of the Campo Santo, where they can be compared with the preparatory drawings, the *sinopia,* now visible on the walls where the frescoes once were.

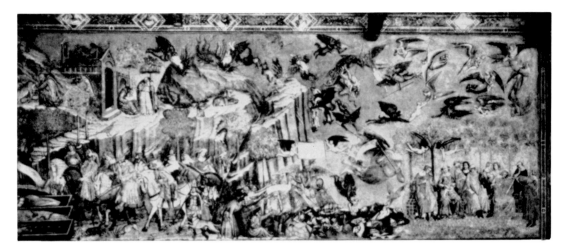

8.9. FRANCESCO TRAINI: Anchorite Hermits, and the Triumph of Death (*c.* 1350). Fresco. Campo Santo, Pisa (Alinari)

at Pisa—the Triumph of Death [8.9] to the left of the Last Judgment and the Life of the Anchorite Hermits to the right of the Inferno. At the left of the Triumph of Death fresco, three young bloods of the fourteenth century with falcons on their wrists emerge from the edge of a wood accompanied by their squires and dogs. They come upon three coffins, each containing a corpse in varying stages of decomposition. The young horsemen halt in astonishment at the sight. One of them holds his nose to keep out the stench. At the head end of the coffins and at the bottom of a rock-stepped slope a hermit holds an unfolded scroll with words of warning about the vanity of life and the ubiquity of death. This he extends admonishingly toward the young hunters. The stony path leads from the hermit to a rocky desert landscape in which small episodic scenes depict the life of the anchorite hermits who have chosen to spend their lives in prayer and contemplation in these arid areas. The wall space to the right of the Last Judgment fresco is covered with still other similar small scenes illustrating the life of the anchorite hermits. These scenes are in sharp contrast to the gay luxurious life of the wealthy worldlings shown at the extreme right side of the Triumph of Death fresco. There a group of young patrician men and women is seated in an orange grove. Some are playing musical instruments, others are fondling lapdogs. They are obviously indulging in pleasant pursuits in order to forget what is happening in the world around them, for, to their left the grim figure of Death, in the guise of a disheveled old witch, flies through the air swinging a huge scythe. Below her, the heap of the dead consists mostly of rich citizens and ecclesiastics whom she has cut down in the prime of life. Their souls, according to medieval belief, issue from their mouths in the forms of babes. Demons and angels struggle for the possession of these souls. To the left of the heap of the dead, maimed and blind wretches are huddled together beseeching Death to deliver them from their miseries, but

city-states to develop. The new interest in man and his emotions naturally carried with it an inquisitiveness about man's past and about his accomplishments in the past. The north Europeans had no particularly significant past to look back upon. Italy, on the other hand, had been the home territory of the last phase of Classic art and culture. This fact was to give to Italian art of the fifteenth and sixteenth centuries those characteristics that distinguish it from the art of northern Europe during the same period.

The Classical Revival and Humanism

The roots connecting medieval Italy with the Classic past had never been completely broken although at times they had become almost lifeless. The early Church had been none too keen for the survival of Classical literature. "Let us shun the lying fables of the poets," thundered Gregory of Tours, "and forgo the wisdom of the sages at enmity with God, lest we encur the doom of endless death by sentence of our Lord." In spite of such fulminations the works of Classic authors were kept alive, particularly those that were important for the transmission of learning and culture, including the writings of Aratus the astronomer, of Boethius the arithmetician, of Vergil the poet who presumably foretold the coming of the Messiah, of Cicero, and of Priscian. However, suspicion and prejudice on the one hand, and the desire for greater knowledge and learning on the other, created a conflict between the Church and those inquisitive natures whose pursuit of knowledge was often considered a certain proof that they had sold their souls to the devil. The legend of Dr. Faustus is an excellent illustration of this conflict. But this spirit of inquisitiveness was not restricted to scholars and philosophers. In the Dr. Faustus legend, the emperor as well as the students beg the great magician to show them Alexander the Great and Helen of Troy. Prohibition had merely stimulated the search for more knowledge about Classical characters. The resolution of the conflict was bound to come, and where more naturally than in Italy where individualism had long been thriving and where Classicism was very much at home?

Dante has, on occasion, been considered the initiator of the new movement toward humanism in Italy. In reality Dante (1265–1321) summed up the Middle Ages. He was still primarily concerned with Hell, Purgatory, and Paradise. It was Petrarch (1304–1374) who made the transition to humanism. Without abandoning his Christian background, Petrarch took up the cause for the study of the Classics with an enthusiasm that had telling effect on his followers. He also revived the study of Greek in Italy, and imported Greeks from Byzantium to teach men who, like Boccaccio (1313–1375), had taken fire from his enthusiasms. The interest in Classic learning thus engendered gained greater and greater momentum throughout the fifteenth century until at its end and in the early years of the following century even the occupants of St. Peter's throne had become such good pagans that a reformation within the Church was precipitated.

→ 9

Introduction to
the Renaissance

W̵ E have seen how the fourteenth-century painters in Italy, finding
the traditional Byzantine and Romanesque styles inadequate to express the
new content, had rather suddenly abandoned them in favor of the Gothic.
In this new content, in part owed to the Franciscan movement, the human
emotional situations latent in religious subject matter were at first stressed.
Secular elements then were introduced into the religious stories, and even-
tually an interest in secular details seemed almost to equal the interest in
religious narrative.

The Gothic style with its emphasis on emotional and three-dimensional
form was the perfect vehicle to express these new interests. In the course
of its development, the Gothic style passed through a decorative and super-
ficial phase, reflected in Italy in the paintings of Simone Martini. At the
same time the Gothic style became more descriptive of emotions, drapery,
forms, and backgrounds so that, toward the end of the fourteenth century
and at the beginning of the fifteenth, Gothic art in Europe generally was
headed toward a form of descriptive realism best exemplified by the art
produced in Burgundy and Germany. In Italy, Gothic art was headed that
way too. But in Italy something was present that turned this realism in an-
other direction and created the art and culture of the period we are ac-
customed to call the Renaissance.

During the medieval period, Italy had been a more fertile ground than
other regions of western Europe for the development of individualism be-
cause of the general economic and political conditions that had caused the

179

PART III

The Fifteenth Century

In the earlier days of this Renaissance, fired by the enthusiasm of Petrarch and Boccaccio, traveling scholars, like troubadours of learning, went from court to court extolling the beauties of their mistress. They often indulged in verbal polemics with one another, each jealous of the other's knowledge and wishing to gain the favor of princes. Gradually learning became the fashion and scholars became its missionaries. A delightful story of proselyting is told of the Florentine humanist Niccolò de' Niccoli (1363–1437). Passing one day through the Piazza della Signoria, he noticed a group of young men wasting their time at doing nothing, so he approached and gave them a stirring talk on the advantages of Classical learning. One of the group, a member of the Pazzi family, was converted on the spot and later became a prominent humanist himself.

Anything that shed light on the Classic past was assiduously studied. Ruins, such as those of the Roman forum hitherto considered the abodes of evil spirits, were now visited and studied. Manuscripts containing the writings of ancient authors were collected from libraries throughout Europe and brought to Italy to be copied. Scholars and writers, feverishly learning Latin and Greek, cast aside for the time being their own Italian idiom as a medium for expression in their efforts to orate like Cicero and Demosthenes or to write poetry like Vergil, Horace, Catullus, Ovid, and Homer. Even Dante was translated into Latin, and Italian verse was not revived until the end of the fifteenth century.

The success of the new cult for learning was assured when it was embraced by the noble families, the patricians, and the merchant-princes who lavished their patronage on scholars, writers, and artists, thus casting themselves in the roles of patrons established in antiquity by such a man as Mycenas, the friend of Horace. The Medici in Florence, the Gonzagas at Mantua, the Estes at Ferrara, the Montefeltres at Urbino, and the Viscontis and Sforzas at Milan are intimately associated with the humanistic accomplishments of their respective cities.

It was owing to the patronage of Cosimo de' Medici (1389–1464) that Florence took the lead in reviving the study of Classical culture. Other cities followed suit, but throughout the fifteenth century Florence maintained the initiative taken by Cosimo the Elder. It was he who bought many Classical manuscripts and had them copied. At one time he had forty-five copyists at work for twenty-two months producing 220 manuscripts. Niccolò de' Niccoli at his death left his great collection of manuscripts in charge of a group of trustees of whom Cosimo de' Medici was one. Cosimo bought the entire collection, and with 400 of these manuscripts in 1441 formed the first public library in Florence in the monastery of San Marco. The man who catalogued these manuscripts, Tommaso Parentucelli, later became the first humanist pope to occupy St. Peter's throne. Cosimo also founded a library for Fiesole. With the remaining half of de' Niccoli's manuscripts he started his own private library that became the nucleus for the present world-famous Biblioteca Laurentiana in the cloister of San Lorenzo in Florence.

Cosimo also sponsored the foundation of the Neoplatonic Academy in Florence—the most famous of Renaissance literary societies—which met in the Villa Medici at Careggi outside Florence to discuss the philosophy of Plato. Famous among its members were the architect Alberti, the philosopher Pico della Mirandola, the poet Politian, and the all-around genius Michelangelo.

In addition to all these activities to further humanism in Florence, Cosimo was the patron of many of the creative artists, such as the architect Brunelleschi, the sculptors Ghiberti, Donatello, and Luca della Robbia, and the painters Fra Angelico and Fra Filippo Lippi. This patronage of culture and the arts was maintained and surpassed by Cosimo's grandson Lorenzo the Magnificent (1449–1482) in whose town palace many a promising young talent was provided with quarters and the opportunity to learn and practice his art. Among these was Michelangelo.

After the death of Lorenzo and the succeeding political events Florence lost importance as the center of patronage for creative activity. The scene shifted to Rome where, amid the brilliant courts of popes and cardinals, the final phase of the Renaissance in central Italy was enacted. Venice was still another matter. But in Rome, where the humanist culture had become the necessary thing and taken for granted, there developed a sophisticated atmosphere quite the opposite of what had existed when the movement for learning began. It was the period when Macchiavelli wrote *The Prince*, when Baldassare Castiglione published *The Courtier*, mirroring the elegant deportment of the period, and when Raphael painted his Madonnas and portraits. It was an age of diplomacy, of flattery, of soft speech and elegance. The lengths to which affectations of correct Latin speech went are illustrated by anecdotes about two humanist churchmen. One is said to have rinsed out his mouth every time he finished saying Mass because he could not stand the taste of medieval Latin. The other is said to have suggested to his friends that they do not read the epistles of St. Paul if they wanted to keep their Latin style unpolluted. It was the period before the crash—the Reformation.

Out of all this renewed interest in Classical literature, art, and culture was bound to grow a contemporary art reflecting such concerns. Yet no art of any bygone period is ever re-created in later times; it will always bear the stamp of its own period. In this case, Classical elements and details did indeed appear in the art of the fifteenth and sixteenth centuries in Italy, while elsewhere in Europe the art of these centuries was still Gothic—and a highly realistic Gothic. Italy was no exception to the contemporary trend, but its realistic art was tempered by infusions of the new Classical ideas, details, and taste. The new style of the Renaissance was the result. Just as the Byzantine style had been transformed in the fourteenth century by the influx of Gothic elements, so, beginning with the fifteenth century, the Gothic style in Italy was intershot with Classical elements and the way was prepared for the great wave of Classicism that was to inundate Europe in the sixteenth and seventeenth centuries.

Brunelleschi and Donatello

These transformations can be clearly seen if we examine briefly examples of architecture and sculpture of the early fifteenth century chosen from the works of the two famous Florentine artists, Brunelleschi (1377–1446) and Donatello (1386–1466). Both men were pioneers in the new movement and influenced contemporary painters.

Italian fourteenth-century civil and ecclesiastical architecture had adopted many of the Gothic principles in structure and detail. In public palaces, such as the Palazzo Vecchio [9.1] and the Bargello in Florence and in the Palazzo Pubblico in Siena, and in private palaces, the exteriors were grim with such Gothic defensive details as towers, battlements, and small tracery-filled windows. The stone courses of the lower story were generally rough-hewn and the heavy entrance portals were studded with iron knobs. These all served to meet the emergencies of revolutions and streetfights. The inner courtyards [9.3] were equally somber with heavy polygonal piers supporting broad, weighty cross vaults. Wide staircases led from the ground floor to the upper stories. In Gothic churches, like Santa Croce [9.4] in Florence, tall slender piers and pointed arches accentuated the vertical lines of the interior.

In Brunelleschi's early Renaissance palaces, as for example the Quaratesi in Florence [9.2], the plans and the vaulting systems were still essentially medieval, but the details were changed as a result of his contact with ancient monuments at Rome. Horizontal lines were stressed instead of vertical ones. Cornices with Classical motifs replaced the open Gothic ones (machicolations) through which missiles could be hurled at enemies below. Window heads were round instead of pointed. Small round arches on colonettes were substituted for the Gothic tracery of pointed or trefoiled arches. The whole interior took on a simple, restful elegance. The lowest story still retained the heavy courses of rusticated stone and other precautions for defense of the palace, but it was separated from the smoother and more decorative upper stories by a prominent horizontal molding, the string course. The inner courtyard [9.6] underwent corresponding changes. Slender columns, capitals with Classical details, and light arches took the place of the heavy polygonal piers and widespreading cross vaults. In his churches of San Lorenzo and Santo Spirito [9.5] in Florence, Brunelleschi re-emphasized the horizontal effect of the Early Christian basilical plan that contrasts sharply with the verticality of a Gothic church like Santa Croce. Columns, capitals, arches, and molding were all studied from Classical architecture. The vault structure of the side aisles, however, was still medieval.

Donatello's development was equally striking. The sculptures of his early period—the two figures above the portal of the *duomo* in Florence and his prophets on the campanile—have all the characteristics of late Gothic sculpture in France, such as hip-shot poses and scythelike drapery. The figures of the prophets are carved in a style closely related to the realistic sculpture developed at the court of the dukes of Burgundy. The Habacuc [9.7]

9.1 (*left*). GOTHIC ARCHITECTURE: Palazzo Vecchio (14th cen.). Florence (Anderson)

9.2 (*above*). BRUNELLESCHI: Palazzo Quaratesi (15th cen.). Florence (Alinari)

9.3 (*below*). GOTHIC ARCHITECTURE: Inner court, The Bargello (Palazzo del Podestà) (13th cen.). Florence (Anderson)

9.4 (*above*). GOTHIC ARCHITECTURE: Interior, Santa Croce (13th–14th cen.). Florence (Alinari)

9.5 (*above, right*). BRUNELLESCHI: Interior, Santo Spirito (15th cen.). Florence (Alinari)

9.6. BRUNELLESCHI: Interior court, Palazzo Quaratesi (15th cen.). Florence (Alinari)

9.7 (left). DONATELLO: Prophet Haba-
cuc (1423–1426). Marble, 6' 8". Cam-
panile, Florence (Alinari)
 9.8 (above). DONATELLO: David (c.
1430). Bronze, 5' ½". Bargello, Florence
(Alinari)

in particular can be compared with the figure of the bald-headed prophet
on Claus Sluter's famous Well of Moses in the courtyard of the Chartreuse
at Dijon. It has realism of head and hands and achieves a more intensified
realism that is almost Roman. The influence of Classical sculpture on Dona-
tello is obvious in his revolutionary figure of the completely nude David
[9.8]. It is the structure of the human form rather than the content expressed
by it that interested Donatello. But the pose of this statue is still a Gothic
one. A few years earlier Donatello had carved another figure of the youth-
ful giant killer standing fully clothed in a hip-shot pose and with the usual
Gothic scythelike drapery, and it is this pose that persists in the nude David.

9.9. DONATELLO: Tomb of Pope John XXIII (1425–1427). Bronze and marble. Baptistery, Florence (Alinari)

Another example of this Classical overlay on Gothic form is the tomb of Pope John XXIII * in the Baptistery of Florence [9.9]. It is the same type of tomb we described for the thirteenth century, with curtains drawn back to reveal the corpse stretched out on the sarcophagus and with the personified figures of virtues below. But all the architectural and decorative details have been changed from Gothic to Classical. One such favorite Classical motif was the putto so frequently seen on ancient sarcophagi. Donatello used these little angel or cupid figures profusely. Those on the outdoor pulpit at Prato [9.10] and in the reliefs of his great bronze altarpiece in St. Anthony's in Padua are perhaps his most famous. In some of the other reliefs at Padua depicting the miracles of St. Anthony, Donatello made use of perspective, that science of the visual reality of space about which his friend Brunelleschi had written.

* One of the schismatic popes of the fifteenth century.

9.10. DONATELLO: Detail, Pulpit relief (1434–1438). Marble. Exterior, Cathedral, Prato (Alinari)

The Renaissance style in Italy, then, was to grow out of a background in which the interest in visual realism of the late Gothic period mingled with and was tempered by the intense local Italian interest in the rediscovery of the details of a bygone Classical culture once at home in Italy.

We have seen the result in a few examples of early Renaissance architecture and sculpture. We now turn our attention to painting.

BIBLIOGRAPHY

Pater, W. *The Renaissance; Studies in Art and Poetry.* New York, Modern Library, 1920; originally published London, 1873.

Burckhardt, J. *The Civilisation of the Renaissance in Italy.* Original German edition, Leipzig, 1885. Various English editions, *e.g.* Phaidon Press, London, 1944.

Symonds, J. A. *The Renaissance in Italy.* New York, Modern Library, 1935; originally published New York, 1887.

Wölfflin, H. *Classic Art, an Introduction to the Italian Renaissance,* 2d ed., trans. by P. and L. Murray. New York, Phaidon Press, 1953; originally translated into English by W. Armstrong, published New York, 1913.

Faure, E. *The Italian Renaissance.* New York, Studio, 1930.

Roeder, R. *The Man of the Renaissance.* New York, Viking Press, 1933.

Robb, N. A. *Neoplatonism of the Italian Renaissance.* New York, Macmillan Company, 1935.

Blunt, A. *Artistic Theory in Italy, 1450–1600.* Oxford, Clarendon Press, 1940, 1956.

The Conservative and Progressive Trends

A̲T the beginning of the fifteenth century two trends in Italian painting were to be distinguished. One we can call the conservative trend since it followed along with the contemporary Gothic style almost everywhere in Europe and produced what became known as the International Style. The other we can call the progressive trend since the painters who were a part of it made use, in their work, of the contemporary theories of Brunelleschi concerning perspective and foreshortening—that is, the visual experiences of space and forms. They also adopted the use of Classical architectural forms and details reintroduced by Brunelleschi and Donatello, and followed the latter's lead in the study of the human form in more Classical terms as an anatomical entity.

The Conservative Painters—The International Style

The characteristics of the International Style, the elements of which were drawn from a variety of sources—Burgundy, the Low Countries, Germany and Austria, and Italy—are (1) the abundant use of the Gothic curvilinear decorative rhythms in the S-shaped poses of the figures, in the scythelike swinging folds of the drapery with multiple calligraphic reverse-curved edges, and in the backgrounds; (2) the use of Italianate panoramic backgrounds, often with the conventional "cheese-cut" rocks; (3) the use of details observed in nature, such as grasses, flowers, rocks and pebbles, birds and animals—favorite motifs in France and the Low Countries; and (4) the patternistic use of brilliant colors.

10.1. The Brothers Limbourg: Labors of February from *Très Riches Heures* (c. 1415). Illuminated manuscript. Chantilly Museum (Archives Photographiques)

In the famous Book of Hours made for the Duc de Berry, now in the Musée Condé at Chantilly, three different elements of the International Style can be found. In one miniature, the Coronation of the Virgin, the French Gothic calligraphic elements predominate, although the crowded haloed heads of saints and angels at the sides recall those found on Italian altarpieces. In another, the Presentation of the Virgin, the design is taken almost directly from Taddeo Gaddi's rendering of the same scene in the Baroncelli chapel in Santa Croce in Florence. In a third miniature illustrating the Labors of the month of February [10.1] a realistic snow scene is depicted. It is unusual to find these elements separated out in this fashion, but here the separation seems to show that the more traditional decorative style was used for hieratic religious representations and that nature served as a model for the more secular ones.

Gentile da Fabriano

Gentile da Fabriano (c. 1360–1427), who was the outstanding painter in central Italy at the beginning of the fifteenth century, was also the most famous of the Italian Internationalists. Born about the year 1360, he had acquired a sufficient reputation by early fifteenth century to be asked to decorate some rooms in the Doges' Palace in Venice. One fresco that depicted a naval battle between the Venetians and Otto III attracted much attention for its realisms. Unfortunately it was destroyed by fire in the sixteenth century. It is possible that Gentile had contacts in Venice with paintings or painters from the north countries, which might account for the many

10.2. GENTILE DA FABRIANO: Adoration of the Magi (1423). Panel painting, 118⅝₁₆″ x 107⅝″. Uffizi, Florence (Anderson)

realisms that he introduced into his paintings. At any rate, by the time (1423) he painted the famous Adoration of the Magi [10.2] for Santa Trinità in Florence, now in the Uffizi, his style was thoroughly International. The subject of the Adoration of the Magi was a very popular one with the Internationalists, allowing for the introduction of many details. Gentile's picture is a brilliant achievement gleaming with gold crowns and brocades and enlivened with patches of deep blue, vermilion, and orange. All the eye-catching paraphernalia of Gothic taste are there plus the descriptive realistic details of nature painted along the borders of the frame, such as the flowers and grasses to be seen in springtime in Tuscany and Umbria. These are painted with exquisite detail, veritable forerunners of the achievements of Leonardo or Dürer. Interesting details within the picture itself include monkeys, camels, lions, and Oriental-looking retainers of the Magi. Ever since the fourteenth century circuses had been brought to Italy from the East arousing much public excitement with their strange animals and human beings. These circuses as well as the tales brought back by such globetrotters as Marco Polo unquestionably influenced the International Style artists to

10.3 (*left*). GENTILE DA FABRIANO: Madonna and Child (*c.* 1400). Panel painting, 37¾" x 22¼". National Gallery, Washington, D. C., Samuel H. Kress Collection.
10.4 (*right*). PISANELLO: Madonna and Child with St. Anthony the Hermit and St. George (1st half 15th cen.). Panel painting, 18⅛" x 11½". National Gallery, London

put these "curiosities" into their paintings as local color for the retinues of the Magi from the East.

In addition, Gentile painted a number of Madonnas seated on the ground in the midst of flowers and grasses. They all have a great deal of charm and seem to be a cross between the type of Madonna of the Humility found frequently in Umbria where Gentile was born and that of the Madonna in the Rose Garden so frequent in Germanic paintings north of the Alps.° Characteristic of Gentile's Madonnas are the maroon-colored robe with large brocade designs of gold and black, the reverse folds usually revealing a yellow lining. In a very handsome example in the National Gallery in Washington [10.3] the angels surrounding the Madonna and Child are not painted in but are incised in the gold background and appear only in a cross light.

° The Madonna of the Humility is a type first used by Simone Martini early in the thirteenth century and became very popular thereafter. The Madonna is seated on a cushion on the ground and is turned obliquely to the picture plane; the Christ child suckles her breast. (For a full discussion, see M. Meiss, *Painting in Florence and Siena after the Black Death*, Princeton University Press, 1951, pp. 132ff.) The transalpine Madonna of the Rose Garden is seated in a meadow full of grass and roses.

Pisanello and Stefano da Zevio

Affinities with the International Style as it developed across the Alps is best shown in the works of two Veronese artists, Pisanello (*c.* 1395–1455?) and Stefano da Zevio (*c.* 1393–1451). Pisanello was a follower of Gentile and also worked with him on the decorations of the Doges' Palace in Venice. A medallist as well as a painter, he was fond of bringing out the minutest details in his drawings and paintings. In the panel of St. Hubert and the Stag in the National Gallery in London, the interest in the details of the costume of the saint, in the horse, dog, and stag, and in the luxuriant forest background almost destroys the unity of the composition. And what fashion plates he turned out as, for example, the princess in the fresco in Sant' Anastasia at Verona, the young St. George with St. Anthony the Hermit [10.4] in the National Gallery in London, and a drawing at Chantilly of ladies dressed in costumes similar to those in the miniatures of the Chantilly Book of Hours of the Duc de Berry. His drawings of animals [10.5] and birds, gathered together in a sketchbook now in the Louvre, are astounding in their wealth of accurate realistic detail. They are interesting in comparison with the drawings of the thirteenth-century draughtsman Villard de Honnecourt. Many of the same animals and birds appear in these earlier sketches, but they are still quite generalized in outline and stylized in detail as you might expect in the thirteenth century. Pisanello's sketches show how great the advance had been toward naturalistic descriptive detail observed from nature.

10.5. PISANELLO: Sketch of a Mule (15th century). Drawing. Louvre, Paris

10.6. STEFANO DA ZEVIO: Madonna in Rose Garden (15th cen.). Panel painting, 24⅞″ x 18¾₆″. Worcester Art Museum (Worcester Art Museum)

Stefano da Zevio (or da Verona), in a small painting in the Worcester Museum of the Madonna seated in the midst of a rose garden [10.6], borrows a theme common in Austria and Germany. It is an arabesque of beautiful detail and color.

Lorenzo Monaco

In Florence the leading proponent of the conservative International Style was Lorenzo Monaco (c. 1370–1425?), a Camaldolese monk. He was a prolific painter of intimate Madonnas who are usually seated on the ground and surrounded by musical angels, a type very commonly used by the Internationalists. His colors are kept very blond and delicate and the drapery lines are full of calligraphic curves. In his larger compositions, such as the Coronation of the Virgin [10.7] in the Uffizi, straight lines are at a premium. Everything is made to conform to the curvilinear rhythms that sweep across the panels and are carried up into the framework of the altarpiece terminating in elaborate Gothic architectural details. In meticulously balanced compositions, such as the Crucifixion in the Yale Art Museum, and in the figure

10.7. LORENZO MONACO: Coronation of the Virgin (1413). Panel painting, 97⅜″ x 147¹⁄₁₆″. Uffizi, Florence (Anderson)

style generally the influence of the sculptor Ghiberti is perceptible. Ghiberti used similar scythelike folds in his figures on Orsanmichele,* and in the doors of the Baptistery in Florence. Ghiberti was the counterpart in sculpture of the International Style painters who used late Gothic swirling draperies and also naturalistic floral and bird motifs as border decorations.

Masolino

Another Florentine who painted in the International Style was Masolino da Panicale (1383–1440). This is clearly evident in such works as the Madonna in the Kunsthalle at Bremen, a symphony of calligraphic drapery, or in

* Orsanmichele (Or San Michele in English) was originally a Lombard church. It became a loggia in which grain was sold but was reconverted to a chapel because of the presence of a miraculous Madonna fresco. The upper floor housed the religious guild, the Compagnia di Orsanmichele. Fifteenth-century sculptures on the exterior include works by Ghiberti, Donatello, and Verrocchio.

10.8 (*left*). MASOLINO: Assumption of the Virgin (1425–1428). Panel painting
54″ x 30″. Capodimonte Museum, Naples (Anderson)

10.9 (*right*). MASOLINO: Annunciation (before 1435). Panel painting, 58¼″ x
45¼″. National Gallery of Art, Washington, D. C., Mellon Collection (Courtesy,
National Gallery of Art)

the Assumption of the Virgin [10.8] in Naples in which the Virgin is sur-
rounded by a group of flatly silhouetted angels making a colorful Gothic
pattern. In the frescoes in the Baptistery of Castiglione d'Olona north of
Milan, done in 1435, Masolino still adheres largely to the International Style
of his earlier pictures in spite of his association in the 1420's with the young
progressive painter Masaccio. What this association was we shall speak of
shortly.

In the handsome panel of the Annunciation [10.9], formerly in the Gold-
man collection and now in the Mellon collection of the National Gallery in
Washington, Masolino reflects somewhat more Masaccio's influence on his
style. There is a perspective unity to the design; the interior of the room
is made up of details of contemporary Renaissance architecture; and the
faces and hands have a soft modeling. The drapery, the poses, and the color,
however, are still Gothic. The large brocade designs on Gabriel's robe are
very colorful and resemble those found in the works of Gentile da Fabriano
and of Pisanello.

This conservative International Style, with its roots in the late four-teenth century, was to extend its influence well into the mid-fifteenth century and after, mingling often as we shall see with the style of the more progressive artists.

The Progressive Painters and Visual Experience —First Generation

The artists whose work is characteristic of the progressive trends in the development of fifteenth-century painting were concerned with setting down certain facts of visual experience. Such an interest was the logical outcome of the secularism that had sprung up in the fourteenth century. Giotto had re-established man as a three-dimensional entity experiencing emotions, even though the scenes and episodes in which man was experiencing them were still religious. The Lorenzetti in turn had set down detailed observations of man's environment, but in actuality these descriptive details cannot all be seen at one glance. In normal vision we do not see the inside and outside of a building at one and the same time nor do we distinguish with equal clearness objects in the foreground and those in the background. It was, therefore, with the actual visual experience of both man and his surroundings— that is, of form and background—that the progressive painters of Florence in the first half of the fifteenth century were concerned. The way had been prepared for them by Brunelleschi and Donatello.

Masaccio

The spearhead of this new movement in painting was a rugged young personality best known by the name of Masaccio. He was born, according to the testimony of a younger brother, on December 21, St. Thomas' day, 1401. He died unaccountably in Rome in 1428. During that short lifetime Masaccio accomplished so much in the painting of visual reality that his work inspired many later artists, among them the young Michelangelo.

Masaccio must have been in close contact with Brunelleschi and Donatello, the two leaders of the new direction in architecture and sculpture at the beginning of the fifteenth century, in spite of the fact that they were twenty-four and fifteen years older, respectively, than he. Brunelleschi, according to an early fifteenth-century source, was said to have been very fond of Masaccio, and Vasari reported that Brunelleschi taught Masaccio the essentials of perspective and architecture and at Masaccio's untimely death stated "we have suffered a great loss." The famous contemporary fifteenth-century architect Alberti, in his *Treatise on Painting*, included Masaccio's name with those of Brunelleschi, Donatello, Ghiberti, and Luca della Robbia as the men whom he considered the initiators of a renaissance in art in Florence in the early decades of that century.

There can be no doubt, as we shall see, that Masaccio's style was influenced by the studies in perspective and by the architecture of Brunelleschi as well as by the sculpture of Donatello, but who was his master in painting? Masolino has been accepted generally as such, yet it is strange that Masolino, who was almost eighteen years older than Masaccio, matriculated in the painters' guild in 1423, one year *after* Masaccio. Whatever the answer, there was a close relationship between the two men and they worked together on several projects.° In a lost fresco in the cloister of the Carmine in Florence of the dedication ceremonies of that church in 1422, Masaccio, according to Vasari, included the portraits of Brunelleschi, Donatello, and Masolino among other celebrities present.

Masaccio's most important accomplishments are found in the frescoes of the Brancacci chapel in the church of Santa Maria del Carmine in Florence. This chapel, rectangular in shape, opens from the right transept of the church. It is covered with a cross vault and has pilasterlike projections below the entrance arch. Masolino had received the commission to decorate the chapel, and the scheme of decoration called for the painting of the four evangelists in the cross vault (a traditional subject for medieval and Renaissance cross-vault decoration) and episodes from the life of St. Peter on the remaining wall surfaces. An exception was made of the upper tier frescoes of the pilaster projections at the entrance which were to represent the Temptation of Adam and Eve and their Expulsion from the Garden of Eden.

Masolino must have associated Masaccio with him rather soon in the undertaking. Then when Masolino was summoned to Hungary in 1426 he turned over the remainder of the job to Masaccio. Consequently both men had been at work on the frescoes of the upper tier of the side walls. Masolino had finished the frescoes in the vault and those in the lunettes of the walls beneath three of the vault arches, the fourth being the top of the entrance arch. Vasari claims that one of the two frescoes on either side of the window in the lunette above the altar was painted by Masaccio. This cannot be verified because later all the surface of the vault and of the lunettes was repainted with decorations of the baroque period. At the time of his sudden death, Masaccio left some of the work on the lower tier of the wall and the two lower frescoes on the projections in an unfinished state. These were completed nearly sixty years later, in 1484, by Filippino Lippi.

Because of the collaboration of the two men and Masolino's departure when the work was in progress, the problem of distinguishing between their styles and of deciding which scene Masolino painted and which Masaccio did has preoccupied art historians for the last century. The solution might have been less difficult had the vault and lunette frescoes not been covered over. But we do have paintings elsewhere from which to appraise Masolino's style. There are the panel paintings in the International Style mentioned previously. And to judge his fresco style, there are the paintings and

° The Madonna and St. Anne in the Uffizi and the Pietà in the museum of the *duomo* at Empoli.

10.10. MASOLINO: The Feast of Herod (1435). Fresco. Baptistery, Castiglione d'Olona (Anderson)

the inscription *Masolinus de Florentia pinxit* uncovered in 1843 in the Collegiate church * at Castiglione d'Olona in Lombardy and those in the adjoining baptistery bearing the repainted date 1435. These were all done after Masolino's association with Masaccio but still show the smoothly modeled technique and decorative quality of the late Gothic International Style. But at the same time they include such details as the putto frieze and the perspective of the architecture in the scene of Herod's Feast [10.10] that show a knowledge of Donatello's sculpture and of Brunelleschi's treatise on perspective.

With all this in mind, let us examine some of the frescoes in the Brancacci chapel, looking first at the two scenes in the upper tier of the projections at the entrance into the chapel, the Temptation and the Expulsion.

In the Temptation [10.11], Adam and Eve appear as a pair of rather bland though elegant figures. They are smoothly modeled in light and shade as though they were standing before a soft spotlight. There is no attempt at a psychological interpretation of the event. Neither Adam nor Eve show

* Begun 1421, dedicated 1425.

10.11 (*left*). Masolino: Temptation (1423–1426). Fresco. Brancacci chapel, Carmine, Florence (Anderson)

10.12 (*right*). Masaccio: Expulsion (1424–1428). Fresco. Brancacci chapel, Carmine, Florence (Anderson)

any emotional reaction to the situation nor is there any guile in the human-headed serpent, the supposed tempter. In contrast to this fresco, the Expulsion from the Garden of Eden [10.12] is overwhelming in its effect. Adam's reaction of shame and remorse and Eve's howling grief are put over with an astounding effect. The great splashes of light falling on the nude forms create in conjunction with the shadows their physical thereness in striking contrast to the smooth modeling noted in the Temptation. The tragic facial features of Eve, as though hewn out of a block of stone, are poles removed from the rather vapidly delineated features of Eve in the Temptation. The movement of the legs of Adam and Eve is also an extraordinary indication of the tragedy of the situation. And if Eve's gestures

as she covers her shame recalls the Classical gestures of the Medici Venus, the whole content of the scene too is redolent with Classical tragedy. There can be no doubt here as to who painted which fresco. The basic contrast is apparent between the dynamic style of the young innovator Masaccio and the gentler, softer style of his older associate Masolino who is trying to adapt himself to the newer method of rendering form.

Heretofore, as in Giotto's work, the form was first designated by means of a bounding line. This created a silhouette that became part of the design pattern of the picture, and three-dimensionality was achieved by the three-tone modeling within the silhouette. But Masaccio observed that in actual visual experience lines do not exist, that forms appear as contrasts of light and shade and color. Lines are merely a painter's abstraction of what in nature are seen as the edges between such contrasts. But Masaccio was no Vermeer understanding all the subtleties of light and color values. He was at the beginning and stated the new problem in the simplest terms of light and shade contrasts. Form is visible only when there is light, and those details of form nearest the light come out most clearly. Therefore Masaccio's forms appear to emerge from the background as though a spotlight had been turned on them in the dark. The anatomy of the forms is expressed in its simplest volumes with the muscles, hands, and feet generalized.

The contrast is also very telling between the two scenes in the top tier on either side of the altar: St. Peter Preaching [10.13] and St. Peter Baptizing [10.14]. In the former, the figure of St. Peter is wooden and his eyes are fixed in a stare. His audience is stiffly attentive and have similarly staring eyes. In the baptism scene, however, St. Peter is a vital, dedicated being carrying out the most important function of his mission, and the neophytes receiving or waiting to receive baptism are among the most extraordinary nude forms in Italian painting psychologically as well as physically. The dignity and humility of the figure kneeling in the water is moving beyond words. The shivering youth behind him waiting his turn is marvelously characterized as well as rendered. This is also true of the figure to the left, half-covered by his mantle, awesomely preparing for the significant event. In all these forms Masaccio uses the same technique of splashes of highlights and contrasting shadows noted in the Expulsion. The heavy, hanging folds of St. Peter's mantle in both frescoes are very similar to those Donatello used on his prophet figures for the campanile in Florence.

It is in the fresco of the Tribute Money [10.15] in the center of the upper tier of the left wall that Masaccio makes use of his knowledge of perspective acquired from Brunelleschi. The principles of both the linear and optical (atmospheric) perspective are used in the scene. The steps and the portico on the right-hand side of the fresco and the trees in the middle distance and background are rendered in linear perspective according to the laws of which objects at an angle to the picture plane seem to the eye to diminish in size as they recede into the distance toward the horizon line. In optical or atmospheric perspective as objects recede into the distance,

10.13. MASOLINO: St. Peter Preaching (1423–1426). Fresco. Brancacci chapel, Carmine, Florence (Anderson)

they appear to the eye to lose in definition and clarity of detail. Masaccio used this type of perspective in painting the landscape background of mountains and trees and even in the rendering of some of the figures, for example the figures of the disciples in the back row of the central group and the figure of St. Peter at the left taking the coin out of the mouth of the fish. The landscape backgrounds of the Baptism and the Preaching frescoes had been similarly rendered in optical perspective. Note also that the scale of these landscape backgrounds now is in proper relation to the figures in the foreground—in sharp contrast to the traditional symbolic or descriptive landscape backgrounds of the Byzantine or Gothic traditions. Compare, for instance, an International Style background, such as appears in Gentile's Adoration in the Uffizi [10.2] with that of the Tribute Money [10.15].

In the Tribute Money fresco the figures are again fashioned in light and shade, the light coming from a single source, the window in the end wall, apparently. This single source of light helps also to unify the elliptical composition of the central group: it creates the proper space relationships between the figures and emphasizes their expressions, their gestures, and

10.14. MASACCIO: St. Peter Baptizing (1424–1428). Fresco. Brancacci chapel, Carmine, Florence (Anderson)

10.15. MASACCIO: Tribute Money (1424–1428). Fresco. Brancacci chapel, Carmine, Florence (Anderson)

10.16. MASOLINO AND MASACCIO: The Raising of Tabitha (1424–1428). Fresco. Brancacci chapel, Carmine, Florence (Anderson)

their individual appearances. We note, for example, the dignity of Christ, His authoritive gesture, Peter's stern but trustful reaction to the command of Christ, the suppressed indignation of some of the disciples, and the stubborn insistence of the amazed tax collector whom Masaccio painted with his back to the spectator. Other notable details are: the extraordinary foreshortening of St. Peter's left hand; the idealized heads of St. John and of the other young disciple (Philip?) more to the right, both so obviously borrowed from some Classical sculptural prototype; and the short curly hair of St. Peter clinging tightly to his head (as he pays the tax gatherer) that recalls the hair treatment on so many imperial Roman portraits.

It is worth remarking that Masaccio rather cleverly composes the scene of the Tribute Money with its three episodes in the form of an open-air triptych, the main episode occupying the central space with the minor ones of St. Peter drawing the coin from the fish's mouth and of his paying the tax gatherer relegated to the shallower areas to left and right.

A similar division of the wall space into a triptychlike composition [10.16] is found on the opposite wall on the right. Here, however, the triptych arrangement is a much more self-conscious one, and, strangely, the two miracle scenes, as the right and left wings of the triptych, carry the greater subject interest, not the center space as would be customary. The interesting, and possibly true, suggestion has been offered that a pilaster formerly separating the two miracle scenes was removed for some reason during the decoration of the chapel and that the two elegantly clad strollers were added as a connecting link. A building in the background closes off the far end of the piazza. Masolino was to repeat this composition in its major elements later in the fresco of Herod's Feast [10.10] in the Baptistery at Castiglione d'Olona.

That this fresco in the Brancacci chapel is by Masolino is apparent not only by the fact that its general composition was repeated at Castiglione d'Olona but also by the fact that the figure types are similar to those in the Temptation [10.11] and Preaching [10.13] scenes, the beady, staring eyes of St. Peter, the wooden expressions and the flaccid emotional reactions of the bystanders. Compare also for similarity in type the bearded old man raising his hands above the figure of Tabitha and the old man in the front row of the St. Peter Preaching fresco, or the heads of the two young dandies strolling across the square and the heads of Adam and Eve in the Temptation. The optical perspective, however, used in the painting of the building and street scene in the background suggests that Masaccio might have had a hand in this after the departure of Masolino.

Another innovation that Masaccio made in Florentine painting was the insertion of contemporary portraits into his pictures. We have mentioned Vasari's statement that Masaccio had painted the figures of Brunelleschi, Donatello, and Masolino among other celebrities in the lost fresco in the cloister of the Carmine. That was a contemporary ceremonial scene. But in the scene of St. Peter reviving the son of a Roman governor and in that of the Enthronement of St. Peter, in the lower tier of the left wall of the Brancacci chapel, the portraits of several contemporary Florentines are to be found among the spectators. Masaccio's own portrait is at the right of St. Peter's throne. This insertion of portraits became a popular custom among painters of the fifteenth and sixteenth centuries.

During his short lifetime Masaccio made astounding advances in directing the art of painting once more toward naturalism. These consisted of setting down in paint man's fundamental visual experiences with regard to form and background—that is, (1) that form as we *see* it is a contrast of light and shade, and is most simply realized by having the light come from one source; (2) that form related to background is an experience in scale; and (3) that objects (buildings, trees, and figures) in the background are subject to the laws of perspective, both linear and optical. His use on occasion of the contemporary group portraits on the side lines of religious scenes might well be an extension of the donor portraits of medieval times, with or without family, or a further development of Giotto's idea of portraying Dante and other Florentines among the Blessed in Paradise.

Masaccio's wonderful fresco of the Trinity [10.17] in the left aisle of the Dominican church of Santa Maria Novella in Florence incorporates all these achievements. The light from one source together with the shadows establish the nude form of Christ on the cross and the draped figures of God the Father, the Virgin, St. John, and the kneeling donors; a scale-relationship is established between the figures and the painted architecture; both types of perspective are present; and the donor portraits are of contemporary Florentines, man and wife. In a bold experiment Masaccio painted these kneeling donors as though they were in the spectators' space outside the entrance to a chapel containing the group of the Trinity. This is a sur-

10.17. MASACCIO: The Trinity (c. 1428). Fresco. Left aisle, Santa Maria Novella, Florence (Soprintendenza)

prising anticipation of Mantegna's illusionistic experiments some forty years later of attempting to break the visual barrier between real space and painted space.* The design of the Trinity is an impressive ensemble of simple geometric forms in keeping with the dignity of the scene: the great triangle of God the Father and the donors within which the smaller inverted triangle of Christ's body on the cross is inscribed; the strong verticals of the columns, of the Virgin and St. John, and of the tall striated pilasters, the latter being part of the great enclosing rectangle relieved only by the curves of the tondi in the spandrils, the entrance arch, and tunnel vault in perspective. It is as though Masaccio in the architecture of this fresco were paying tribute to Brunelleschi and in the sculpturesque forms to Donatello, his two friends and the sources of his inspiration.

Uccello

Paolo Uccello (1397–1475) qualifies as a visual or scientific realist only on the basis of his studies in foreshortening—that is, in perspective applied to objects. Otherwise, his work with its imaginative and decorative inventiveness indicates that his style is still deeply rooted in the International tradition. The fact that his work often shows sculpturesque qualities need not come as a surprise since Uccello began his career as an assistant to the International Style sculptor Ghiberti. And when he went to Venice in 1425 where he presumably worked on a mosaic, he was in the company of Gentile da Fabriano and two Florentine sculptors. Ghiberti's influence is perceptible in the frescoes Uccello did in the Green Cloister of Santa Maria Novella on his return to Florence six years later. These frescoes were done in green monochrome, which accounts for the name then given to the cloister. The scenes of the Creation of Adam and Eve [10.18] are practically identical with those that Ghiberti did in relief on the doors of the Baptistery in Florence.†

In 1436 Uccello was commissioned to paint on the interior wall of the cathedral of Florence the equestrian portrait of Sir John Hawkwood [10.19], the English soldier of fortune who had been in the service of that city. Hawkwood had died in 1394, and many attempts had been made to erect some commemorative monument to him but without previous success. The horse on which the English knight is seated is definitely inspired by the

* On the wall space beneath the donor figures there has recently been uncovered a fresco representing a stone tomb on the top of which lies a skeleton. The tomb is included in the architectural design and structure of the whole Trinity fresco. In addition to being another *memento mori*, a reminder of eventual death, this fresco further demonstrates Masaccio's interest in visual experiments. Just as the Crucified is painted as seen from the level of the donors, who are on the same eye level with the spectator, so the tomb and the skeleton appear as they would were the spectator or the donors looking down on them.

† Uccello was to return to these cloisters about fifteen years later to work on scenes of Noah and the Flood. All his frescoes there have suffered badly with time. Some have been removed to the Belvedere Museum in Florence.

10.18. PAOLO UCCELLO: Creation of Adam (*c.* 1431). Fresco. Formerly in Green Cloister, Santa Maria Novella, Florence (Alinari)

Hellenistic bronze horses on the façade of St. Mark's in Venice that make such an impression on everyone who sees them—and Uccello had been to Venice and seen them. Set on a beautiful substructure with Classical motifs, the whole group is painted to simulate sculpture.

The four prophet heads Uccello painted as though they were emerging from roundels in the corners of the rectangle framing the great clock in the cathedral of Florence also give the effect of sculpture. They resemble in type the bronze heads in the borders about Ghiberti's famous doors of the Baptistery in Florence.

It is Uccello's interest in foreshortening, however, that gives him a place among the visual realists. According to Vasari, this interest was an obsession with Uccello, whose wife was very jealous and resented the fact that her husband spent so much time in his studio tower. One night as she called to him to come to bed she heard him muttering, "Oh, what a beautiful thing perspective is," and consequently was certain that she had a serious rival!

Uccello's experiments in foreshortening are most apparent in three battle pictures, commissioned about 1456 by Cosimo de' Medici and later part of the decoration of Lorenzo de' Medici's bedroom in the present Riccardi

10.19. PAOLO UCCELLO: Equestrian portrait of Sir John Hawkwood (1436). Fresco. Duomo, Florence (Alinari)

palace. One of the three is now in the Louvre, Paris, a second in the National Gallery, London, and the third in the Uffizi, Florence. All three have to do with the Battle of San Romano in which the Florentine general, Niccolò da Tolentino, in 1432, with a handful of knights held off the Sienese forces until aid arrived to defeat the Sienese. This hero's equestrian portrait was painted in 1456 by Andrea del Castagno as a companion piece to Uccello's portrait of Sir John Hawkwood. As a similar commemoration of Tolentino's feat the Medici presumably had these battlepieces painted at the same time.

10.20. PAOLO UCCELLO: Battle of San Romano (c. 1456). Panel painting, 71¾" x 125".
National Gallery, London (National Gallery, London)

In the foreground of these pictures spears and bits of armor are strewn about in all conceivable positions. Horses and riders are seen from the front, from the sides, and from the rear. Yet in spite of this overemphasis on foreshortening, Uccello achieves a very beautiful decorative effect in these pictures. The panel in the National Gallery in London [10.20] resembles a colorful tapestry: the horseman wearing the hat of vermilion and gold brocade, the golden-blond hair of the boy knight, the light-blue trappings of the horses' harnesses decorated with gold bosses that repeat the color and shape of the oranges on the trees in the middle distance. All the rhythmic elements in the picture are so organized that a feeling of action is imparted to the ensemble in spite of the statically posed figures of the horses and men and of the foreshortened armor. The eye is caught and moved about the picture by means of a series of curves, such as the fanlike arrangement of the lances sweeping down from vertical to horizontal to emphasize the impact of the battle, or by the rumps and necks of the chargers, or the lines of the fields and hills in the background. As the *leitmotif* for the design of the whole picture, Uccello seems to have taken the double curve of the mane and rump of the horse in the center of the picture on which the knight with the red hat is mounted. We see it repeated not only in the other horses in the composition—sometimes even in reverse—or in the lines of the fields and rocks in the background but also in the broad curve that sweeps diagonally across the entire picture from the lower left corner to

10.21. PAOLO UCCELLO: The Hunt, detail (*c.* 1460). Panel painting, 25⅝″ x 65″. Ashmolean Museum, Oxford (Reproduced by Courtesy of the Visitors of The Ashmolean Museum)

the upper right. Uccello did not give unity to the figures and background by means of light or perspective as Masaccio had done. The light is present in the foreground where the foreshortened objects and figures are and extends only to the orange hedge—that is, in the space in which these objects and forms operate—giving this space the appearance of a stage platform. The background has neutral lighting and looks in fact like a backdrop. But, as we have pointed out, the foreground and background are held together by means of the design.

In the late and remarkable picture of the Hunt [10.21] in the Ashmolean Museum at Oxford, Uccello again displays his love of foreshortening and of motion achieved by repeated rhythms of forms in action. The confused effect of a chase is extraordinarily produced by the shouting horsemen, the running pages, and the dogs and stags zigzagging back and forth among the vertical tree trunks. The trees are rendered in perspective to give a sense of depth to the forest, yet the tufted tree tops in bloom, the patches of flowers and grasses scattered along the ground, and the patterned figures of men and animals produce the effect of a *millefleurs* tapestry.

Uccello thus presents himself to us as an artist of mixed loyalties and of great decorative fantasy. Trained in the International Style of Ghiberti, he became fascinated by the novelties introduced by Brunelleschi, Donatello, and Masaccio. And, while he was himself obsessed by the problem of foreshortening, he tried at the same time to amalgamate the new methods of painting with the older Gothic principles of abstract design.

Domenico Veneziano

Belonging to the same generation as Masaccio and Uccello was a third painter, Domenico Veneziano (*c.* 1400–1461), who in his own work and in that of his pupils had additional contributions to make to the painting of visual reality. As his name indicates, he came from Venice where he must have received his early training and where there could be available to him works by painters to the north of the Alps. He arrived in Florence ten years after the death of Masaccio, having written to Cosimo de' Medici in 1438 for some commission. He was at work in 1439 on frescoes in the church of Sant Egidio, adjoining the hospital of Santa Maria Nuova, and had as an assistant the young Umbrian painter Piero della Francesca, about whom we shall learn more in the next chapter.

Very few of Domenico's works are extant, but what does remain indicates that his style, like Uccello's, had some of its roots in the International Style. The most important of his accomplishments still in existence is the St. Lucy altarpiece of which the central portion with the Madonna and Child with the four saints (Francis, John the Baptist, Zenobius, and Lucy) is now in the Uffizi gallery [10.22]. The lunette that was above the central panel and that contained the Annunciation is in the Fitzwilliam Museum in Cambridge, England, and the predella panels, each with a scene from the life of one of the saints flanking the Madonna, are distributed among the National Gallery in Washington, the Fitzwilliam Museum, and the former Kaiser Friedrich Museum in Berlin.

The style of the altarpiece shows the mixture of late Gothic and early Renaissance elements so usual in many late International Style paintings. The drapery has the heavy quality characteristic of Burgundian sculpture already seen in Donatello's work, and the Madonna is enthroned beneath vaults that are still Gothic, although the capitals of the supports and the shell niche behind the Madonna are details found in Classical and early Renaissance architecture. Similar transitional elements are present in the Annunciation panel in Cambridge where the blond Gabriel and the Madonna clad in Gothic draperies are set against a Renaissance colonnade drawn in Brunelleschian perspective.

In the two predella panels in the National Gallery in Washington representing St. Francis receiving the Stigmata and the Youthful Baptist in the Desert [10.23], the backgrounds show an adherence to the older fourteenth-century tradition in the formalized structure of the rocks. But in the St. John panel the figure of the young saint casting aside his garments seems to have been adapted from some small and delicate Classical bronze.

Domenico's innovation, however, was the attempt to portray outdoor light. The lightness of the colors throughout is one indication of this. The effect is also perceptible in the small predella panel in the former Kaiser Friedrich Museum representing the decapitation of St. Lucy. There seems to be a glare of sunlight in the courtyard where the martyrdom is taking place.

10.22 (*above*). DOMENICO VENEZIANO: St. Lucy altarpiece, center (*c.* 1445). Panel painting, 82⅜″ x 84″. Uffizi, Florence (Anderson)

10.23 (*right*): DOMENICO VENEZIANO: St. John in the Desert (*c.* 1445). Panel painting, 11⅛″ x 12¾″. National Gallery of Art, Washington, D. C., Samuel H. Kress Collection (Courtesy of National Gallery of Art)

10.24 (above). DOMENICO VENEZI-
ANO(?): Portrait of a Young Girl
(c. 1450). Panel painting, 20" x
13¾". Former Kaiser Friedrich
Museum, Berlin (Photographische
Gesellschaft, Berlin)

10.25 (right). ALESSO BALDOVI-
NETTI: Madonna and Child (c.
1465). Panel painting, 41" x 30".
Louvre, Paris (Alinari)

A number of profile portraits of Florentine ladies and gentlemen have
been attributed to Domenico and to his followers. Among these is the beau-
tiful portrait of a young girl [10.24] in the former Kaiser Friedrich Museum
in Berlin. The head of St. Lucy in the altarpiece we have just been dis-
cussing is also in profile. Certain it is that this type of portrait had become
very popular and was painted by Masaccio, Uccello, and other contempo-
rary Florentine painters. This vogue can undoubtedly be connected with the
interest at that time in ancient Roman cameos, medallions, and coins on
which profile heads so often appear.

The tradition to use as background a river valley flanked by mountains
and seen from a bird's-eye view, so common in fifteenth-century Florentine
painting and lasting well up to the time of Leonardo da Vinci, apparently
began in Veneziano's workshop. It appears very prominently in the work of
Domenico's most famous pupils: in the Madonna [10.25] by Alesso Baldo-
vinetti (1425–1499) in the Louvre and in several paintings by Piero della
Francesca as we shall see. This motif of viewing a distant river valley as

though from a platform was used by Jan van Eyck in Flanders, and Domenico could have been familiar with it.

Vasari also credits Domenico with being the first Florentine artist to use oil as a medium for painting. If that is so, the new medium was certainly not what we now call oil paint. Domenico and his followers still painted with tempera, but in his attempt to represent outdoor light he may have used an oil glaze such as was used in northern Europe to give colors greater transparency. This would also be further evidence that Domenico was familiar with north European painting.

These three painters, then—Masaccio, Paolo Uccello, and Domenico Veneziano—constitute a pioneer generation in the fifteenth century that set down in paint certain essential visual experiences and the principles related to them. These were the fundamental truths about perspective, foreshortening, and light on which following generations were to build and elaborate. Of the three painters, Masaccio was the most revolutionary in his break with the medieval traditions of style. Uccello and Veneziano, as we have noted, still clung in part to the conservative tradition and used it as a backdrop against which they set their own researches and inventions.

BIBLIOGRAPHY

Hill, G. F. *Drawings by Pisanello*. Brussels, G. Van Oest, 1929.

Lipman, J. H. "The Florentine Profile Portraits in the Quattrocento," *The Art Bulletin*, vol. XVIII, 1936, pp. 54ff.

Kennedy, Mrs. R. W. *Alesso Baldovinetti, A Critical and Historical Study*. New Haven, Yale University Press, 1938.

Pope-Hennessy, J. *Paolo Uccello: The Rout of San Romano*. London, P. Lund, Humphries, 1944.

Toesca, P. *Masolino a Castiglione Olona*. Milan, A. Pizzi, 1946. (Color plates with Italian text)

Pope-Hennessy, J. *The Complete Work of Paolo Uccello*. London, Phaidon Press, 1950.

Hendy, P. *Masaccio, Frescoes in Florence*. Greenwich, Conn., New York Graphic Society, 1956.

Michelletti, E. *Masolino da Panicale*. Milan, Istituto Editore Italiano, 1959. (Plates, many in color)

Progressive Painters- Second Generation

〰〰

Piero della Francesca

Up the Tiber valley from Arezzo lies the town of Borgo San Sepolcro, the birthplace of two famous fifteenth-century Italians: Luca Pacioli the mathematician and Piero della Francesca (c. 1415–1492) the painter. Besides being a painter, Piero was one of the first artist-humanists of the century, for he was learned in Latin and mathematics, was a poet and cosmographer, wrote books on perspective and form, and dabbled in architecture.

In 1439 he was present in Florence as an assistant of Domenico Veneziano when the latter was working on the frescoes in the choir of San Egidio. At that time Brunelleschi, Donatello, Uccello, and the architect Alberti were also on hand in Florence. From these, as well as from his friend Pacioli and from his master Domenico Veneziano, Piero must have acquired much inspiration to shape his own interest in the problems of form, architecture, and painting, and in mathematical theories of perspective. He seems to have been attracted especially to Domenico Veneziano's experiments with outdoor-light effects, for we shall see that one of his own major problems was the creation of *form in light*, both indoors and outdoors. Another problem certainly was to stress the *architectonic* relationship between animate and inanimate form. A third was the problem of *color*.

The earliest work of importance by Piero is the altarpiece of the Madonna della Misericordia [11.1], commissioned in 1445 shortly after his return to Borgo San Sepolcro. The central panel of the altarpiece is one of great dignity. The Madonna stands very erect and sweeps her mantle in

216

protection about a group of men and women kneeling at her feet. One man at the left wears a black, peaked hood with slits for his eyes, much like a Ku Klux Klan hood except for the color. He was a member of the Brotherhood of Mercy (Confraternità della Misericordia) who commissioned the altarpiece. Members of this brotherhood were obliged to attend the sick whom no one else would approach, particularly in times of epidemics and pestilence, and to transport them to the hospitals. Their hoods were meant to protect them from infection. The brothers carried bells with which to warn the timid or fearful of their approach. One can see them today in certain Italian towns, wearing the same costume and going about with litter and bell.

The design in this panel is very simple, one that Piero was to use over and over again: a cylindrical upright in the center of a circle drawn around its base. The upright is repeated in the vertical accents of the kneeling figures and in the folds of the robe and in the edges of the mantle, and the circle in the curvilinear sweeps of the Madonna's shoulders and of her parted mantle, giving the whole composition a tentlike effect. Piero was thinking in terms of architecture. The Madonna has taken on the form of a column, with the vertical folds of her garment recalling its flutings. The egg-shaped head rests solidly on the long but sturdy cylinder of the neck. There is no detailing of emotion in the features of the face. It is the ensemble that creates the effect. There stands the Madonna like some pillar of strength to give protection to her suppliants.

In 1447, Sigismond, tyrant of Rimini, commissioned the famous architect Alberti to remodel the Gothic church of San Francesco at Rimini. This new structure, in addition to being a church, was also to be a temple immortalizing Sigismond's love for his mistress Isotta whom he eventually married some thirty years later. A jewel of early Renaissance architecture, this building is known as the Tempio Malatestiano, or the Malatesta Temple. It was actually begun in 1450. The design of the façade was inspired by a Roman triumphal arch. In the interior the intertwined initials of the two lovers are present everywhere among the charming angels and saints carved in relief and in the round by the delightful sculptor Agostino di Duccio.

In the chapel of the Relics, next to the chapel of St. Sigismond of Hungary, Piero della Francesca was commissioned to paint in fresco the figure of the tyrant kneeling in homage before his patron saint [11.2]. The fresco bears Piero's name and the date 1451. Although the landscape background had almost completely faded even before the vicissitudes suffered by the fresco during World War II when the Tempio was severely damaged and before its recent cleaning, the essential decorative beauty of the fresco still remains. How subtly Piero accents the rectangular elements of the architectural setting in the diagonal grouping of the figures and animals. The patron saint seated at the left repeats the vertical accent. The kneeling tyrant stresses both the vertical and horizontal directions, and the lighter colored of the two elegant hounds reposing at the right continues the horizontal and

11.1 *(left)*. PIERO DELLA FRANCESCA: Madonna della Misericordia, detail of altarpiece (1445). Panel painting, 107½″ x 127¼″. Town Hall, Borgo San Sepolcro (Anderson)

11.2 *(below)*. PIERO DELLA FRANCESCA: Sigismond Malatesta kneeling before St. Sigismond of Hungary (1451). Fresco. Chapel of the Relics, Tempio Malatestiano, Rimini (Soprintendenza)

completes the diagonal with the line running from head to haunch. But at the same time Piero intermingles curvilinear elements everywhere to relieve the rectilinear, such as the fruit swags at the top, the roundel between the pilasters at the right, the orb in the saint's hand, the head of the tyrant, and the elegantly curved neck of the hounds that repeat in patterned contrast of light and dark the curves of the swags above. And how successfully Piero maintains Sigismond as the predominant figure in spite of his position at a lower level than the saint, as was proper! No accessories or unnecessary details mar the simple beauty of the fresco. The colors too are telling. The architecture is a whitish-gray; the figures are accented in purple and green.

It is not certain when Piero visited the Este court at Ferrara as Vasari relates. It is possible that this visit took place before he went to Rimini. But that some work by him existed at Ferrara is evident from the strong traces of his style in the works of certain Ferrarese painters, as we shall see later. Of his work in the Vatican in Rome nothing exists either, except notices in documents of the year 1459. His frescoes there had to make way for the masterpieces of Raphael.

It was on the walls of the choir of San Francesco at Arezzo that Piero painted one of the most beautiful and important series of all times. Other artists may have painted subjects with greater didactic, religious, or philosophic content—which did not concern Piero very much—or may have created designs of greater virtuosity, but no one has ever achieved such breathtaking effects of subtle color.

The decoration of this choir had originally been entrusted to the Florentine painter Bicci di Lorenzo in 1445. Bicci died in 1452 without having finished the project and not until later in the 1450's did Piero undertake to finish it. The frescoes must have been finished by 1466 because a document of that year mentions Piero as the one who had finished them. The subject matter for the frescoes had been taken from the Legend of the Holy Cross as related in the thirteenth-century *Golden Legend* by Jacopo da Voragine.[*] Briefly the story is that Seth, Adam's son, presented himself at the gate of Paradise to ask for oil from the Tree of Mercy with which to anoint his aged father and extend his life. Seth was refused the oil but was given the branch of a tree to plant, which branch when grown into a tree would save his father Adam. But Adam died before Seth's return. The branch, planted however, grew into a huge tree destined later to furnish the wood for the Saviour's cross. When Solomon decided to build the temple at Jerusalem, a search was made for large trees. Adam's tree was cut down and transported to the Holy City. Because it was too big for use, it was discarded and thrown across a pond as a bridge. When the Queen of Sheba made her historic visit to Solomon's court she passed by the discarded tree and with foreknowledge of its future destiny knelt to worship it. On her return she wrote Solomon

[*] *The Golden Legend* of Jacobus de Voragine, translated and adapted from the Latin by Granger Ryan and Helmut Ripparger. Part I, pp. 269ff. under May 3, the Invention of the Holy Cross. London—New York—Toronto, 1941.

220

PIERO DELLA FRANCESCA: Frescoes (*c.* 1458–1466) on Choir walls, San Francesco, Arezzo

 11.3 (*opposite*). Over-all view of the left wall (Soprintendenza)
 11.4 (*above*). Detail from The Last Days of Adam (Anderson)
 11.5 (*below, left*). Annunciation (Anderson)
 11.6 (*below, right*). Hiding of the Wood (Anderson)

221

that the man who was to be hanged from this tree would some day bring the kingdom of the Jews to an end. Solomon then had the wood hidden away. At the time of Christ's Crucifixion the wood was found floating on top of a pond, was taken by the Jews and shaped into Christ's cross. After the Crucifixion the location of the true cross was lost. In the fourth century St. Helena, a devout Christian, attempted to convert her son the Emperor Constantine to her faith. He finally adopted the new religion but only after the successful battle against his rival Maxentius. The night before the battle an angel of the Lord had appeared in a dream to Constantine, showing him the cross and telling him that he would win if he adopted the cross as his standard. Later Queen Helena made a pilgrimage to the Holy Land in search of the cross. She was informed that a certain Judas at Jerusalem knew the secret of its location. He refused to divulge the information until after he had been shut up in a dry well for days. But three crosses were found: the true cross and the two on which the thieves had been crucified. To establish which was the cross of Christ, a cadaver was brought in and resuscitated when the true cross was held over him. St. Helena took some relics of the cross with her for her son the emperor, but left the cross itself at Jerusalem. Later, in the seventh century, the Holy City was captured by the Persian king Chosroës II, who carried off the cross. The Byzantine emperor Heraclius pursued him, defeated him in battle, and undertook to return the cross to Jerusalem in a great triumphal procession. As Heraclius approached the walls of the city an angel appeared on the battlements to remind him that the Saviour Himself had entered the Holy City humbly and without pomp. So Heraclius dismounted and entered Jerusalem on foot accompanied by a few companions.

Piero took the major episodes of this legend as the basis of his decoration of the choir walls, but he arranged them to fit the decorative scheme he had planned. The right and left walls of the sanctuary of the church are each subdivided into two horizontal bands topped by a lunette. On the right side, from top to bottom, are: the Last Days of Adam (lunette) [11.4], the Meeting of Solomon and the Queen of Sheba, and the Battle of Maxentius and Constantine. On the left side [11.3] in corresponding order are: Heraclius with the Cross before the Walls of Jerusalem (lunette), the Finding and Identification of the True Cross, and the Battle of Heraclius and Chosroës. The same banded subdivision continues along the end wall on either side of the long window and the six spaces thus formed are also frescoed. The two part-lunette spaces contain each a figure of a saint or prophet. The upper space to the right of the window and adjoining the Solomon and Sheba fresco has the scene of the Hiding of the Wood [11.6]. Below it, next to the Battle scene of Constantine and Maxentius, is the Dream of Constantine. On the left side of the window and adjoining the fresco of the Identification of the Cross is the scene of the Jew Judas hauled up out of the Dry Well: and below this is the Annunciation to the Virgin [11.5] next to the Battle between Heraclius and Chosroës.

In each of these ten scenes Piero states clearly, singly or collectively, his interest in the problems of form, light, design, and color that obsessed him. In the Annunciation [11.5] he shows again, as he had in the Madonna of the Misericordia, how he thought of the human form in architectonic terms. Here he makes it even more striking by placing the Madonna beside an actual column, two vertical cylindrical repeats—the one inanimate, the other animate—stressing the essential solidity of form. The same is true in a detail of the scene in which the Queen of Sheba meets Solomon. The fluted column of the portico is repeated in the form and drapery of the queen. In a group around Adam [11.4], we meet Piero's favorite design of upright and circle. (In the group itself are beautiful contrasts of nude and draped forms.) The same design, varied somewhat, appears in the scene of Helena and her attendants kneeling before the True Cross and is repeated two-dimensionally in the paneled decoration of the background. Piero achieves in wonderful fashion the atmosphere of reverent awe by means of the grouping and by the gestures of his static forms. In the fresco of the Hiding of the Wood [11.6], his mastery of diagonal design is apparent in the simple but effective organization of the elements at hand and anticipates by a hundred years Tintoretto's design of the Road to Calvary in the Scuola di San Rocco, Venice [27.9].

The Problem of Form in Light

As a realist, Piero was interested in a specific problem concerning form: the creation of *form in light*. Masaccio had taken the initial step toward solution of this problem, but in order to make his thesis clear Masaccio had resorted to the artificiality of showing the form emerging from a dark background into a spotlight, the shadow side of the form merging into the background. As a true pupil of Domenico Veneziano, Piero wanted the form to exist in light—that is, in daylight—a much more difficult problem to solve, because light has a tendency to silhouette or to blur form (as the nineteenth-century impressionists were to discover). But since form was still the major element in fifteenth-century Italian composition, Piero wanted both form and light. And he solved his problem by observing, and then putting down in paint, that a form in light has a line of *reflected light* * on the shadow side, since the light surrounds the figure, and that the shadow moves more toward the center of the modeled form. In this way Piero detached the form from the background and made it exist solidly and three-dimensionally in a lighted space. The column in the Annunciation scene [11.5] is one excellent example of this interest of Piero, but there are many others throughout the San Francesco frescoes, such as the heads and hands of the kneeling women in the scene of the Finding of the True Cross or the horses and men in the battle scenes. Even when he uses a dark background, as for

* Perhaps observed from Castagno's initial use of reflected light, for example, the figures in the Last Supper [11.12] at Sant' Apollonia, Florence.

example the wall behind the figure of a prophet, Piero makes the figure appear surrounded by light and detached from the background by the use of reflected lights. A tour de force of this kind is seen in the altarpiece that Piero did later for the monastery of San Bernardino at Urbino, now in the Brera Gallery at Milan, in which he suspends an egg on a thin string from the shell niche above the Madonna's head and makes it appear to be hanging free in space.

The Problem of Light

The whole problem of light was a major concern for Piero. His paintings, like those of his master Domenico, have none of the murkiness of other contemporaries but are filled with a pearly luminosity suggesting the daylight. The two battle pictures in San Francesco at Arezzo are striking examples of this. We have seen how Uccello in his battle pictures [10.20] used a strong light only in the foreground where the objects he wished to paint in foreshortened positions were placed, and how the light in the background was dull, giving it the effect of a backdrop. There was a unity of design but not of light. In Piero's battle scenes the background as well as foreground is full of light. It brightens the far-distant horizon and edges of the small clouds in the blue sky. It filters through the forest of horses' legs accentuating the weighty bulk of chargers and riders.

Another tour de force in light effects is present in the scene of Constantine's Dream. It is night, and the angel of the Lord flies down from heaven bearing a gleaming cross that spotlights the figure of the emperor reclining behind the open curtains of his tent. Piero here experiments with the problem of having the source of light *inside* the picture. Hence the figures in the foreground between the spectator and the source of light must be in shadow. This was a favorite theme much later with Mannerist and Baroque painters, who frequently represented a figure holding a lighted candle or lamp in a dark room.

The Problem of Color

The problem of light brought with it the problem of color—not color as hitherto used conventionally and arbitrarily but color as the observed counterpart of light. Piero's accomplishments in the field of color are unique in all Renaissance painting. Not until the time of Vermeer or until the nineteenth-century impressionists would color be studied in its relation to nature.

Piero was the first realist in color. He did not have the advantages of more modern inventions, such as the spectroscope, and consequently he did not paint color in the modern realistic manner, but he did observe and set down general truths about color. For example, in his panel painting of the Baptism of Christ [11.7] in the National Gallery in London, the most intense red and blue are found on the figures nearest the left-hand foreground.

11.7. PIERO DELLA FRAN-
CESCA: Baptism of Christ
(*c.* 1440–1445). Panel
painting, 65½″ x 45½″.
National Gallery, London
(Bruckmann)

Farther back the figures are painted in a lighter blue and pink. That is,
Piero had observed that color in nature is more intense the nearer you are
to it and that it loses its intensity as it approaches the horizon. This was, of
course, a general observation. It is similar to the observation Masaccio made
as to the loss of detail with distance. What Piero did not realize, as we now
do, is that red and blue are most intense in different places of the color-
value scale.

But he did observe that color in light is what we call "warm" and color
in the shadow is "cool." In the late panel of the Nativity in the National
Gallery in London, the lighted section of the wall of the manger is painted
in a warm gray and the shadow in a bluish gray. In fact, Piero's color
schemes throughout all his paintings are based on this general principle.
He starts with a basic gray and builds up the colors in alternating values
of blue and red to their intensities. For contrast he also uses white and
black as the extremes of noncolor values—that is, he uses black, white, and
gray and then builds up the warm and cool blues and reds from neutral
gray to their intensities. This was almost a convention with him. And then
in good Italian fashion he turned his observed realisms into a decorative

PIERO DELLA FRANCESCA: 11.8 (left). Madonna del Parto (c. 1460). Fresco, life size. Cemetery chapel, Monterchi (Anderson). 11.9 (above). Detail from Resurrection of Christ (c. 1460). Fresco. Town Hall, Borgo San Sepolcro (Anderson)

scheme that added so immeasurably to his final effects. It was this use of warm and cool grays that gives such pearly luminosity to his pictures and simulates the effects of daylight. His realisms of form and color wedded to his architectonic designs and his subtle decorative sense created the overwhelming effects experienced in the frescoes of San Francesco.

During the period when Piero was at work on the Arezzo frescoes he apparently undertook other commissions. Among these, judging by the style, must have been the Madonna del Parto at Monterchi [11.8], perhaps Piero's finest Madonna. After being in the Palazzo Communale at Borgo San Sepolcro for a considerable time, the fresco has now been restored to the small cemetery chapel at Monterchi, his mother's native village. Once again Piero reveals his mastery of simple form and design to create an effect of dignity and serenity. Two angels in green have swept aside the ermine curtains of an enclosure to reveal the Madonna clad in a heavy purple robe presenting herself to the public in her pregnant condition. In simple stateliness she points to the opening part in her garment covering the womb in which lies concealed the coming Saviour of the world. Like some contemporary princess who through established custom showed herself in the condition of expected motherhood to assure her subjects of an heir to the throne, the Vir-

gin here presents herself to the audience of the faithful. The effect is simple, dramatic, electric, achieved by another variant of Piero's favorite tent-like composition.

One of Piero's most breath-taking performances in paint also belongs to this period. It is the fresco of the Resurrection of Christ [11.9] in the Palazzo Communale at Borgo San Sepolcro. In the background the trees are both bare and in full foliage, symbolizing death and life. In the foreground the impressive gray figure of Christ rises vertically out of the tomb like a ghostly apparition, materializing before your eyes and hypnotizing you with the intensity of His stare. Never before or since has the significance of the "resurrection of the body" been so powerfully represented. The effect is all the more startling because of the rich rose-pink mantle thrown over Christ's left shoulder accentuating the marble pallor of His flesh. In front of the sarcophagus four guards lie huddled in a comatose sleep; the head of the second one from the left is remarkably foreshortened. Their dark-purple, burnt-orange, and green garments contrast sharply with the gleaming form and mantle of the Risen One.

The court of the humanistic Duke of Urbino, Federigo da Montefeltro, attracted a number of creative artistic personalities from northern Europe as well as from Italy. Piero had apparently been there on several occasions and later in life lived in Urbino for a while. Very few of the pictures cited by Vasari as painted at Urbino have survived. A beautifully painted small Flagellation in the Urbino gallery has been variously dated in the 1440's and late 1450's. Both the architecture represented in the panel and the color scheme used seem to point to the later date; the architecture in the background reflects the style of Alberti, and the colors build up from neutral grays toward warm and cool intensities.

The portraits of the Duke and the Duchess of Urbino [11.10, 11.11], now in the Uffizi, are the most important paintings surviving from Piero's sojourn at Urbino. They are small panels forming a diptych. They can be dated with reasonable certainty in 1465 on the basis of a poem written in that year praising the portraits. On the front of each panel is the profile portrait fashionable in the early Renaissance. A far-distant landscape fills the background as though the sitter were placed at a window of a castle high on a mountain. This far-distant background—which, in mentioning Baldovinetti's Madonna in the Louvre [10.25], we suggested as possibly derived from Flemish paintings—gives emphasis to the profiled head in the foreground. In both portraits every detail of the physiognomy has been set down with accuracy, with no attempt to beautify the subject. Duke Federigo was an ardent jouster. In one of the tournaments he had sustained a broken nose and the loss of his right eye when struck by his opponent's lance. Piero shows the profile with the good eye but delineates the notch of the broken nose. Battista, the duchess, looks much older than she actually was. She died in 1472 after giving birth to her son Guidobaldo. She was twenty-six years of age, but in her short married life had borne many children.

PIERO DELLA FRANCESCA: 11.10 (*left*). Duchess of Urbino (1465). 11.11 (*right*). Duke of Urbino (1465). Panel paintings, each 18½″ x 13″. Uffizi (Anderson)

The lack of physical beauty in the sitters, however, is heavily compensated for by the beauty of the color, the sparkle of the jewels, the sheen of the brocade, and other meticulous rendering of details. How effective is the contrast between the swarthy dark-haired duke clad in red hat and jacket, his face covered with blemishes, and the blond, delicately complexioned duchess bedecked with jewels and brocade! Piero's decorative talent is also apparent in the subtle linking of the portraits in the foreground with the distant backgrounds. The latter are filled with criss-crossed fields, dotted trees, cone-shaped hills and mountains, winding roads and streams, all of which are rhythmic repeats of shapes and lines present in the silhouettes, physiognomies, clothes, and adornments of the two sitters. The multiplicity of parts in the background also emphasize the quiet dignity of the duke and the duchess. On the reverse of each panel Piero indulges in allegorical representations. Again we find the distant backgrounds far below the elevated plateau of the foreground on which the duke and duchess in small scale are riding on triumphal chariots, each on the reverse side of his respective portrait. Fame and the four cardinal virtues personified accompany the duke in his chariot drawn by white horses. Unicorns, the symbols of chastity, draw

the chariot of the duchess who has Faith, Hope, and Charity in her entourage.

The Duke of Urbino appears again in the altarpiece, now in the Brera, which was presumably painted at the time of the birth of his son Guidobaldo and the death of his wife for the church of San Bernardino at Urbino in 1472. The duke appears as the donor kneeling at the foot of the Madonna's throne. It is rather a lifeless painting in which assistants evidently collaborated. It does contain, however, as previously mentioned, the representation of the egg that seems to be suspended in space by a thread above the Madonna's head.

Toward the end of his life, Piero seems to have been primarily interested in his art theories and in architecture and thus gave less attention to painting. What we have left of his work, however, clearly demonstrates his assimilation of and interest in the new progressive art and architecture of the fifteenth century as propounded and practiced by Brunelleschi, Masaccio, Uccello, and Domenico Veneziano. Especially out of his association with Veneziano and with the architect Alberti did he form his own art in which, as we have stated, he represented both animate and inanimate form as something fundamentally geometric and static in order to emphasize its architectonic quality. Then he represented that solid form in full light, and from his study of outdoor light was able to approach the fundamental problems of realistic color. Through his architectonic figures and groups he was also able to convey an emotional dignity and power that at times is almost overpowering.

Andrea del Castagno

It has been traditional to consider Andrea del Castagno as belonging to the same generation as Masaccio, Uccello, and Domenico Veneziano. Recent research, however, has brought to light the fact that he was born in 1421, if not earlier, and hence was a contemporary of Piero della Francesca. His work during his comparatively short lifetime—he died in 1457 at the age of about thirty-six—is therefore interesting in relation to that of Piero. Both men were interested in the problems of form and the effect of light on form. Both had connections with Domenico Veneziano from whom they presumably derived their interests in light. Yet in spite of certain resemblances in style at times, the results Piero and Andrea achieved were essentially different. As we have seen, Piero's generalized forms had something static, something architectonic about them. Andrea's forms, on the other hand, showed the impact of contemporary sculpture on his style, in particular of the sculpture of Donatello both in the use of the heavy Burgundian-Gothic drapery and in the surface musculature of the bodies. To Andrea animate form was capable of action and movement and of emotion. A certain harshness pervades much of his work, although at times, as in his Entombment of Christ, to be mentioned shortly, he achieves an amazing tenderness of emotion.

As a talented country boy, he came to Florence in his teens from his native village of Castagno. At the age of nineteen he had sufficiently proved his ability in painting to be given the commission—although a disagreeable one—of painting in effigy on the exterior walls of the Bargello the figures of certain conspirators against the Florentine government who had been defeated at the battle of Anghiari but had escaped capture. He painted them as hanged by their feet. For this he had annexed the nickname of "Andreino degli Impiccati," Andrew of the Hanged Men. Perhaps it was on account of his unpopularity in certain quarters resulting from these frescoes that he decided to leave Florence for a time. At any rate in 1442 he signed and dated together with a Francesco da Faenza the frescoes that adorn the vaulted sections of the apse of the chapel of San Tarasio in San Zaccaria in Venice. These are adorned with figures of God the Father, the four standing evangelists with their symbols, St. John the Baptist, and St. Zacharias. The underside of the apse arch is decorated with an arabesque of prophet busts in medallions supported by putti. These frescoes have recently been cleaned through the efforts of Professor Muraro,* who in the process discovered that the head and hands of St. John the Evangelist were the work of Domenico Veneziano whose presence in Venice at that time with Castagno had not previously been known. That a close relationship could have existed between the older and the younger painter, perhaps a rivalry, seems quite possible. Vasari suggests a rivalry existed between them when both later worked on the frescoes, no longer extant, in San Egidio, Florence. Antonio Billi a late-fifteenth- and early-sixteenth-century biographer of artists states in his life of Castagno that he, Castagno, in a fit of jealousy killed Veneziano by hitting him over the head with an iron bar. Vasari, characteristically, later elaborated on this reported episode. That it was a piece of slander is clear from the fact that Veneziano actually died four years after Castagno.

The frescoes in the chapel of San Tarasio show, in the heavy drapery of the figures and in the use of the putto arabesques, the influence of Donatello's sculpture on Castagno even at this early date. There are also echoes in the draperies of the style of Masaccio and Masolino; and the head of St. Luke, as Professor Muraro has pointed out, is very Masaccian.†

Returning to Florence, Castagno made cartoons in 1444 for stained glass windows in the cathedral—the Pietà and the Coronation of the Virgin—and set to work on his now-famous frescoes in the refectory of Sant' Apollonia in Florence: the Last Supper [11.12], the Crucifixion, the Entombment [11.13], and the Resurrection.

The Last Supper [11.12] is the first of a series of noteworthy Renaissance paintings of that subject of which the most famous is by Leonardo da Vinci. Castagno's version is a very simple and powerful one. He follows

* Michelangelo Muraro: "Domenico Veneziano at San Tarasio," *The Art Bulletin*, 1959, vol. XLI, pp. 151–158.

† For a discussion of Castagno's earlier work in Florence before going to Venice, see Frederick Hartt: "The Earliest Works of Andrea del Castagno," *The Art Bulletin*, 1959, vol. XLI, pp. 159ff.

11.12. ANDREA DEL CASTAGNO: The Last Supper (1445–1450). Fresco. Sant' Apollonia, Florence (Alinari)

the old traditions of choosing the moment when Christ announces that one of the disciples will betray Him,* and of placing Judas on the opposite side of the long table from Christ. The scene is set in a rectangular room decorated with panels of marble revetment that reflect the architectural taste of the period and at the same time give the artist an opportunity to play with the problem of interior perspective. The design is a simple organization of vertical, horizontal, and diagonal elements with very few curvilinear details to relieve the predominatingly rectangular effect. The horizontal line of the table, the panels on the walls, the placing of the figures—all contribute to this effect. In part the setting is an excellent foil for the rugged simplicity of the content Castagno has given the scene, expressed most powerfully in the heads and hands of Christ and His disciples. The restrained richness of the architectural details and the handsome sphinxes at the ends of the marble bench create a subtle contrast with the heavy plebeian figures set around the table like so many pieces of bronze sculpture. Their awkward rigidity calls to mind the venerated figure in bronze of the Prince of the Apostles in St. Peter's in Rome.

In the wall space above the red-tiled roof of the room in which the Last Supper takes place are the three scenes, from left to right, of the Resurrection, the Crucifixion, and the Entombment [11.13], separated by the two shuttered windows but held together into a unified composition by the flying angels above each turning in toward the Crucifixion. Each of the three scenes is powerfully rendered. Christ is a beardless young athlete in all of them, rising starkly from the grave in the Resurrection scene almost in the manner of Piero della Francesca's Resurrecting Christ [11.9], hanging in lone

* As related in John 13:21ff where John is described as "leaning on Jesus' bosom."

11.13 (*above*). ANDREA DEL CASTAGNO: Detail from Entombment (1445–1450). Fresco. Sant' Apollonia, Florence (Soprintendenza)

11.14 (*right*). ANDREA DEL CASTAGNO: Pippo Spano (1450–1457). Fresco. Sant' Apollonia, Florence, from Villa Pandolfini (Anderson)

dignity on the cross, and being lowered into His grave by the solicitous young St. John, touchingly rendered, and the elderly Joseph of Arimathea.

A beautiful example of Castagno's art, more fluid in design and more delicate than usual in color, is the young David with Goliath's head that is painted on the front of a leather ceremonial shield. Formerly in the Widener Collection in Philadelphia, it is now in the National Gallery in Washington. Veneziano's influence is surely perceptible in the colors.

Since Giotto's time, there had been a number of instances when famous personalities, past and present, had been used as subjects for wall decorations in a "hall of famous men" of some château or palace. Castagno used

11.15. ANDREA DEL CASTAGNO: Crucifixion (c. 1450). Fresco. Sant' Apollonia, Florence, from Santa Maria Nuova (Alinari)

such an idea for the decoration of a room in the Pandolfini Villa at Legnaia. He chose as his subject three famous women of ancient times (the Cumean Sibyl, Queen Esther, and Queen Tomyris), three great Italian writers (Dante, Petrarch, and Boccaccio), and three contemporary warriors of note (Farinata degli Uberti, Niccolò Acciaiuoli, and Pippo Spano [11.14]). They form an imposing array, set as they are in a continuous series like statues against the dark paneled background of the wall. A putto frieze reminiscent of Donatello runs along the top of the wall. The marblelike beauty of the Sibyl contrasts strikingly with the swaggering swarthiness of Pippo Spano. These frescoes were later transferred to the Castagno museum at Sant' Apollonia.

In the fresco of the Crucifixion with the Virgin and St. John and with SS. Romuald and Benedict [11.15] from Santa Maria Nuova, now also in the Castagno museum in Sant' Apollonia, the figure of Christ is very close in feeling and in execution to Donatello's bronze crucifix in Santa Croce. The muscular details of Christ's chest, His fingers and toes are carefully articulated. The figures at the foot of the cross are clad in heavy Burgundianlike draperies as are the figures of Donatello's prophets on the campanile.

In 1456, the year before his death, Castagno was commissioned to do in fresco the equestrian portrait of the *condottiere* Niccolò da Tolentino [11.16] in the cathedral of Florence as a counterpart to Uccello's portrait of Sir John

11.16. ANDREA DEL CASTAGNO:
Equestrian portrait of Niccolò
da Tolentino (1456). Fresco.
Cathedral, Florence (Alinari)

Hawkwood [10.19]. A marble monument to Tolentino, who had died in 1435
and was buried in the cathedral, had long been under consideration. In
Castagno's fresco portrait, in contrast to Uccello's of Sir John Hawkwood,
there is a greater sense of movement and more muscular detail. The influ-
ence of Donatello's sculpture is once more apparent. Donatello had worked
a great deal in bronze, and bronze (in contrast to marble) reflects light,
sharply causing bright thin lines to appear along the edges of forms and
drapery. Details look harder and more brittle than they do when sculptured
in marble. These thin wiry lines of light seen on bronze sculpture appear
frequently in Castagno's painting. The base for the equestrian statue por-
trait, however, is painted in imitation of marble. It is a simple and power-
ful design, the base being supported by a huge shell and two heavy con-
soles, the severity of the main rectangular section being relieved by the light
anthemion molding that tops it and by the delightful small nude shield-
bearers wearing plumed hats who are set at the two corners of the plat-
form.

Antonio Pollaiuolo

In the paintings of Antonio Pollaiuolo (c. 1432–1498) we can recognize certain characteristics that were present in the works of his master Andrea del Castagno, but which Pollaiuolo as a specialist developed to a very high degree. These were, form in action—at times violent action—and line. At his best he combined the two, expressing form in action by means of line. His inborn sensitivity to line was fostered and developed by his training and professional activity in sculpture, particularly in sculpture of the most delicate kind in gold, silver, and bronze. This creation of small sculpture also gave his style a certain elegance that is almost always present in his work.

The small panel in the former Kaiser Friedrich Museum in Berlin of the young David [11.17] straddling the head of Goliath reflects his training as a goldsmith in the hard brittle outlines of the silhouette, in the features, and in the hands. A certain tense nervousness and restlessness is apparent in the style plus an elegant sophistication in the attitude and in the pose of the hands and head of the slim, young contemporary dandy.

11.17. ANTONIO POLLAIUOLO: David (c. 1470). Panel painting, 18⅛″ x 13⅜″. Former Kaiser Friedrich Museum, Berlin (Bruckmann)

11.18 (*left*). Antonio Pollaiuolo: Hercules and Antaeus (*c.* 1470). Panel, 6¼″ x 3½″. Formerly in Uffizi, Florence, now lost (Alinari)

11.19. Antonio Pollaiuolo: Battle of the Ten Nudes (*c.* 1470). Engraving, 15¾″ x 23″ (Alinari)

In the two small panels formerly in the Uffizi, each representing one of the Labors of Hercules—the Strangling of Antaeus [11.18] and the Slaying of the Hydra—this nervous intensity is combined with an attempt to portray muscular form in action. This leads to an exaggeration of form and expression. Hercules grits his teeth as he puts everything he has into the lethal squeeze that keeps Antaeus' feet off the ground from which the giant might gather strength. Antaeus howls as arms and legs flail the air in his vain death struggle. Remarkable is the right angle in Hercules' back, like an angle iron, that accentuates the sense of strain to which Hercules is put to support the giant's weight. In the Slaying of the Hydra the long necks of the monster and the tail of Hercules' lion's skin supply curvilinear whiplike rhythms to give action to the scene. The far-distant landscapes in the panels show the influence of Pollaiuolo's second master Baldovinetti,* the pupil of Domenico Veneziano. The two panels were lost during World War II while the Germans were transferring them from a villa near Florence where the Italians had placed them for safekeeping to a depot in the Italian Tyrol.

In a slightly larger panel with another of Hercules' Labors—the Slaying of the centaur Nessus who is carrying off the maiden Danaira—now in the Yale University Art Gallery—Pollaiuolo had difficulty relating the distant river valley to the figures in the foreground. The latter are made to stand in the waters of the river that seems to be rushing far below them because of the bird's-eye view of the panoramic landscape background.

It was in the drawing of figures in outline that Antonio excelled. Unquestionably he had seen examples of Greek red-figured vase-painting in the Medici collection in which the figures of athletes, heroes, and others are delicately outlined against a dark neutral background. In the frescoes uncovered in the Villa Gallina near Florence, Pollaiuolo painted such figures in a frieze of nude youths performing a bacchanalian dance. One of these figures assumes the identical pose of a dancing satyr on an existing Greek vase.

In two bistre drawings now in the National Gallery in London, Pollaiuolo again imitates the method of drawing found on Greek vases. What is represented in the London drawings is an enthroned figure before whom bound captives are brought, and all the figures are nude. It is in such creations in line that Pollaiuolo excels. He captures in the outline of the forms the easy natural rhythms of movement.

His famous engraving of the Battle of the Ten Nudes [11.19] suffers by contrast, because Pollaiuolo has undertaken to cover the surface of the forms with many small muscles. These details were intended to emphasize the effect of strain and action, but instead they tend to make the forms rigid. Pollaiuolo had not observed that a form in action does not have all its mus-

* With whom Antonio and his younger brother Piero also collaborated in the decoration of the Portogallo chapel in San Miniato, Florence. Piero, a weaker painter than Antonio, was commissioned to do the figures of the personified Virtues for the Mercatanzia, Florence, now in the Uffizi.

11.20. ANTONIO POLLAIUOLO: Martyrdom of St. Sebastian (*c.* 1475). Panel painting, 114″ x 79½″. National Gallery, London (Anderson)

cles tensed; some are flexed, others relaxed. But in his print it is the design and not the details that gives the sense of action. This is accomplished by the swing of the circle at the top formed by the brandished swords and by the revolving oval compositions of the figures to right and left below. These latter act as buttresses for the angular, top-heavy, V-shaped design of the two central figures, who by themselves are completely off balance. How much more successful and satisfying Pollaiuolo's results are without the use of all this descriptive surface detail is apparent in a fragment of a drawing now in the Fogg Art Museum of Harvard University, a study for the upper left corner of the print.

His style is nicely summed up in the late painting in the National Gallery in London, the Martyrdom of St. Sebastian [11.20]. Here are beauty of linear expression, interest in the nude in action, Classic motifs, and far-distant landscape. A close examination of the details is well worth while—for example, the head of the archer at the left raising his bow, the Roman triumphal arch with the relief of a battle scene, and the details of the background.

It is worth noting that Pollaiuolo was the first artist in the fifteenth century to use Classical mythological subjects as the main themes in his paintings. This is good evidence of the inroads of Classical art and culture on the art and culture of Italy, even to the extent of imitating and monumentalizing the Classical technique of drawing found on Greek vases.

We began this chapter with the work of an artist—Piero della Francesca—who insisted on establishing form by means of light and shade and on keeping it solid even in an outdoor light. The result was an essentially static form. We end the chapter with another genius—Antonio Pollaiuolo—who is equally interested in establishing form but, in his case, by means of a fluid line with which he can set that form in motion. The work of Andrea del Castagno, apart from other things, bridges the apparent gap between these two extremes. Piero della Francesca's later fellow Umbrians will demonstrate what can be done further with solid forms; Pollaiuolo's Florentine successor and compatriot Botticelli, and eventually Leonardo da Vinci, will perform miracles with forms by the use of line.

BIBLIOGRAPHY

Berenson, B. *The Drawings of the Florentine Painters*, amplified edition, 3 vols. Chicago, University of Chicago Press, 1938; originally published 1903.

Cruttwell, M. *Antonio Pollaiuolo*. New York, Charles Scribner's Sons, 1907.

Colacicchi, G. *Antonio del Pollaiuolo*. Florence, Chessa Editore, 1943. (Color plates)

Richter, G. M. *Andrea del Castagno*. Chicago, University of Chicago Press, 1943.

Clark, K. McK. *Piero della Francesca*. New York, Phaidon Press, 1951.

Russoli, F. *Andrea del Castagno*. Milan, A. Pizzi, 1957. (Color plates)

Hartt, F. "The Earliest Work of Andrea del Castagno, Part One," *The Art Bulletin* XLI, 1959, pp. 159–181.

Muraro, M. "Domenico Veneziano at San Tarasio," *The Art Bulletin* XLI, 1959, pp. 151–158.

◂ 12

Fra Angelico and His Pupil Benozzo Gozzoli

Painting had for centuries been the "handmaiden" of religion, so we need not be surprised to find it in the fifteenth century still playing the same role and providing the progressive painters with subject matter for working out their new technical problems relating to forms and background. Masaccio used Adam and Eve or figures in baptismal scenes for his studies of the nude form; Piero della Francesca used battle scenes from religious legends for his experiments with outdoor light. Naturally there were exceptions reflecting the growing interest in secular and in Classical mythological subjects, such as the battle pictures of Uccello, the Labors of Hercules by Pollaiuolo, and the profile portraits by various painters.

To gather an impression of how and to what extent the progressive trend affected contemporary painters whose primary interest was religious expression, we will examine in this and the next chapter the work of two painters, Fra Angelico and Fra Filippo Lippi, each a member of a religious community. They are two radically different personalities, Angelico representing the medieval mystic type of monk, Lippi representing the type that also loved the material things of this world. Much ink, both facetious and sentimental, has been spilled about these two painters by writers of the nineteenth century and later and has produced false impressions about their accomplishments and the meaning of their art. Let us therefore examine their work without prejudgments, if possible, and enjoy their actual significance in the light of the time in which they lived and labored.

240

Fra Angelico

Fra Angelico, whose real name was Guido da Vicchio, was born in 1387 and died in 1455. As a youth in his teens he had probably studied painting with the Camaldolese monk Don Lorenzo Monaco and had been trained in miniature painting and in the Gothicisms of the International Style. When he was about eighteen, a certain Giovanni Domenici came to Florence to preach against existing "pagan" luxuries. Fired by his eloquence, the young Guido together with several friends left the worldly life to become Dominicans. He made his novitiate at San Domenico at Cortona and took orders in 1408 at Fiesole, outside Florence.

At that time the religious world was in a state of confusion and the Church was torn apart by the Great Schism, with rival popes at Rome and Avignon claiming the right to St. Peter's throne. The Council of Pisa in 1409 deposed both Gregory XII and Benedict XIII and elected Alexander V. But the deposed popes refused to abdicate and for a time authority was claimed by three popes, each with his supporting factions. Since the Dominicans at Fiesole had been loyal to Gregory XII they had to flee, first to Cortona and then to Foligno. The schism was finally healed in 1418 under Martin V, and, with Fra Angelico among them, the Fiesole monks returned to their monastery at San Domenico.

From 1418 until about 1435 Fra Angelico painted in the style most usually associated with his name. This style was completely Gothic in the good International tradition. As examples, we have a number of paintings on small reliquary shrines commissioned for the church of Santa Maria Novella in Florence. One of these reliquary panels is the little standing Madonna delle Stelle. She and the Christ child are set against a gold background incised with lines to give the effect of a sunburst. The frame is Gothic and surrounded by stars. Another panel [12.1], now in the San Marco Museum, Florence, has the double representation of the Annunciation and the Adoration of the Magi. These are set against diapered drapery backgrounds common in French Gothic miniatures. The Assumption of the Virgin [12.2] in the Isabella Stewart Gardner Museum, Boston, was also part of a painted shrine. In all three panels the colors are blond, the backgrounds gold and decorative, and the drapery calligraphic and Gothic. The emotional content is very simple and childlike. In the Gardner Assumption, the girlish-looking Madonna raises her eyes in ecstacy to the rayed, golden heaven to which she is being wafted by the joyful, blissful angels. Each of two small panels in the Turin Museum, parts of some larger composition, also contain an enraptured angel seated on a cloud floating through the golden void. Incised rays sparkle at the base of the clouds.

As the result of the writings of the romantic nineteenth century mentioned above about these naïve, childlike, blissful creations, Fra Angelico is often judged, or passed by, as a delightful, charming painter, secluded in his cell with no experience of life and consequently painting a series of nice

12.1. FRA ANGELICO: Annunciation and Adoration of Magi (c. 1425–1430). Panel painting on reliquary, 33″ high. San Marco Museum, Florence (Alinari)

12.2. FRA ANGELICO: Assumption of the Virgin (c. 1425). Panel painting, 21″ x 15″. Isabella Stewart Gardner Museum, Boston (Marr)

colorful paper dolls. How very wide of the mark that judgment is! As we shall see, these pictures reflect the mystical religious attitude widely current in medieval days and assumed today throughout the world—a mystic being one who has intense desire to experience the Ultimate Real, God. Two types of mystics were and are prevalent: the *negative* mystic who achieves his objective by way of contemplation and visions; the *positive* mystic who reaches heaven by patterning his life on the life of Christ *in this world*.

The Greek Neoplatonic philosopher Plotinus postulated God as a source of light from which everything emanated. The farther removed from the source of light the more material these emanations became. But once having issued from the light, they strive continually to be reabsorbed into the source from which they came. St. Augustine pointed out to his contemporaries that this source was the Christian God and that the abiding place of light was Heaven. His teachings became the foundation for medieval and later mysticism. Dante's writings, particularly the Paradiso in the *Divine Comedy*, are shot through with this negative mysticism and mystical symbolism. In Canto XXIII of the Paradiso * he writes:

> As in the calm full moons Trivia smileth among the eternal nymphs who paint the heaven in each recess, I saw, above a thousand lamps, *one sun* which all and each enkindled, as doth our own the things we see above; and *through the living light outglowed the shining substance so bright* upon my vision that it endured it not.

Early in Canto XXX he sums up the whole mystical idea:

> We have issued forth from the greatest body into the *heaven which is pure light*, light intellectual full-charged with *love*, love of true good full-charged with gladness, gladness that transendeth every *sweetness*. Here shalt thou see the one and the other soldiery of Paradise, and the one in those aspects which thou shalt see at the Last Judgment.

Surely Fra Angelico had read his Dante as every learned ecclesiastic and secular person did, and surely he had these lines in mind when he painted his famous Last Judgment in San Marco, Florence [12.3]. Christ is seated in a halo completely surrounded by incised gold lines that give the appearance of unearthly light emanating from His person. The apostles and saints about Him are all seated in the heaven of golden light. In the representation of Paradise at the left, groups of happy, childlike souls dance in a meadow of flowers or embrace with joy, each having little golden rays at their heads or feet as emanations from the great source of light in the center. In fact, this image of Paradise is in Canto XXIII of Dante's *Paradiso:*

> Wherefore doth my face so enamour thee that thou turnest thee not to *the fair garden which flowereth beneath the rays of Christ?* . . . [and] As under the sun's ray, which issueth through a broken cloud, ere now mine eyes have seen a *meadow full of flowers,* when themselves covered by the shade; so beheld I many a *throng of splendors, glowed on from above by ardent rays,* beholding not the source whence came the glowings.

* Wicksteed and Oelsner translation, Temple Classics ed., 1936. Italics are mine. *Au.*

12.3. FRA ANGELICO: Last Judgment (*c.* 1430). Panel painting, 41½″ x 83″. San Marco Museum, Florence (Anderson)

12.4 (*right*). FRA ANGELICO: Corona-tion of the Virgin (*c.* 1430). Panel paint-ing, 44⅛″ x 45″. Uf-fizi, Florence (Ali-nari)

12.5. Fra Angelico: Madonna of the Linaiuoli (1433). Panel painting, 102½" x 52½". San Marco Museum, Florence (Alinari)

Another famous painting now in the Uffizi illustrates all this with equal effectiveness, the Coronation of the Virgin [12.4]. A tremendous sheaf of golden light appears to emanate from behind the group of Christ and the Virgin. The rays spread to the outer confines of heaven and, like goodness, envelop the saints and angels present at the ceremony. The angels float joyously in this immaterial golden atmosphere, their swirling garments giving them the effect of creatures without weight.

In all the pictures we have mentioned, the childlike, naïve appearance of the angels and of the saints and the blessed are the natural consequence of that concept that with God and in heaven the human soul sloughs off the searing marks of physical experience and returns to the innocent state in which he emanated from God. "Except ye become as little children," said Christ, "ye shall not enter into the Kingdom of Heaven." (Matthew 18:3)

I am quite aware that most of the panels mentioned here as examples of negative mystical painting have in recent years been attributed by a distinguished authority * to Zanobi Strozzi, a pupil of Fra Angelico. We can-

* See bibliography at end of this chapter. John Pope-Hennessy: *Fra Angelico*.

not in this book enter into a discussion on attribution. But I cannot concur that a weak miniaturist, such as we know Strozzi to have been, should have produced such brilliant creations as, for example, the Last Judgment in San Marco and the Coronation in the Uffizi. Recognition of the existence of this question of authorship does not in any way affect what has been written in the text, because, in either case, the pictures are the products of Angelico's workshop and as such reflect the master's ideas and interpretations. These panels, by Angelico or from his workshop, have nothing whatsoever to do with nineteenth-century sentimentality but are the deep and sincere expression of the negative mystical attitude prevalent in medieval times.

The well-known Madonna of the Linaiuoli (the linen weaver's guild) [12.5], painted in 1433, belongs to the end of this early period. She is the central panel of a large triptych with the two St. Johns represented on the shutters. The blond Madonna wearing a powder-blue robe is enthroned beneath a tentlike Gothic canopy. Along the beveled golden border of this central panel Angelico painted a series of angels each carrying a musical instrument. For generations these blythe spirits have furnished material for Christmas cards. The predella panels with scenes from the lives of the two saints are beautifully painted.

An important change took place in Angelico's approach to his religious subject matter about the middle of the 1430's. We may note it first in the large Coronation of the Virgin [12.6], at present in the Louvre. Here the scene takes place on earth and not in a golden heaven as in the Coronation in Florence. A Gothic throne is set at the top of a high, stepped platform, and saints and angels are grouped around the steps.

Another similar painting is the remarkable Deposition of Christ [12.7] from the cross in the Angelico Museum in San Marco, Florence. Again the scene takes place in an earthly setting. This time it is a landscape with flowers and grasses in the foreground and a valley view in the distance. The body of Christ and the figures grouped around Him are painted three-dimensionally to give them the reality of existence in this world. The colors of the garments are light and like pastels.

This change of setting in Angelico's paintings at this time, from the abstract immaterial world to the earthly material one, was due to the fact that he was now thinking in terms of positive mysticism. The positive mystic is not content to achieve heaven and experience the Ultimate Reality by mere contemplation. He feels himself part of the material world and wishes to achieve his salvation, his union with the Ultimate Real in heaven by some action on this earth. Christ had said, "I am the way." Consequently the positive mystic seeks salvation by *imitating* the life of Christ that had taken place in the Here and the Now and not in a golden heaven. This is the key to Angelico's later style from about 1435 to 1445. It is best illustrated by his frescoes in the Dominican monastery of San Marco in Florence.

12.6 (*right*). FRA ANGELICO: Coronation of the Virgin (*c.* 1435). Panel painting, 84″ x 83¼″. Louvre, Paris (Alinari)

12.7 (*below*). FRA ANGELICO: Deposition of Christ (*c.* 1435). Panel painting, 108¾″ x 112¼″. San Marco Museum, Florence (Alinari)

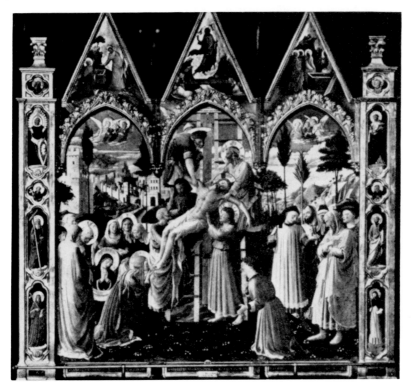

When Cosimo de' Medici decided in 1437 to restore this monastery that had fallen into disrepair, he commissioned the architect Michelozzo, a pupil of Donatello, to supervise the reconstruction and Fra Angelico to carry out the fresco decoration. Angelico himself was to live in this reconstructed monastery, and later Savonarola and the painter Fra Bartolomeo. And Cosimo de' Medici originally deposited his great library here. At present the monastery is a veritable museum of the works of Angelico, for in addition to the frescoes we are now to discuss, most of his panel paintings from in and around Florence have been collected here and are shown in a series of rooms off the cloister.

The frescoes Angelico painted in San Marco are in the ground-floor cloister, in the small refectory, and in the corridors and cells of the dormitory upstairs. The latter were decorated with the help of assistants. In the cloister there are the three lunette frescoes of Christ received as a pilgrim by St. Dominic and another monk, St. Peter Martyr enjoining silence by placing his finger to his lips, and the half-figure of the dead Christ erect in a sarcophagus. On the wall at the end of the cloister as you enter the monastery is a fresco of St. Dominic kneeling at the feet of the Crucified.

In the small refectory, the long wall opposite the entrance is entirely covered with the painting of the Mystical Crucifixion [12.8]. The three crosses with the bodies of Christ and the two thieves are silhouetted against a dark-red sky. The effect is startling. Groups of figures, standing and kneeling, are strung across the foreground beneath the crosses. But only the group at the foot of Christ's cross—St. John and the Marys—belong to the historical event of the Crucifixion. The remainder, to left and right, such as Moses, St. Paul, St. Augustine, St. Jerome and other doctors of the Church, St. Francis, St. Bruno, St. Peter Martyr, and St. Dominic, are all persons who prefigured (e.g. Moses), preached or wrote about the Crucifixion, or else had mystical experiences of the event. In this last group the key to the interpretation of the fresco is found. The figures kneel or stand as in a trance; their eyeballs turn inward as they lift their heads to the cross or stare at the ground. Before their eyes, the Crucifixion has become an actuality, and Angelico emphasizes the reality of their experience by painting the whole scene, at which all these people living at different periods of time could not have participated, as taking place at one time and at one place. A simpler version in the same vein is the Crucifixion in the cloister, mentioned above, in which St. Dominic kneels at the foot of the cross. The body of Christ is just as real as the figure of Dominic. The two are represented together in the same time and in the same space, yet Dominic obviously never knelt at the feet of the actual Christ. He, however, experiences the Christ's Crucifixion through the intensity of his contemplation. A third similar Crucifixion with St. Dominic kneeling at the foot of the cross is to be seen in the corridor of the dormitory on the upper floor.

The frescoes in the cells of the dormitory have similar mystical significance. Present in each are Dominican saints standing to one side as though

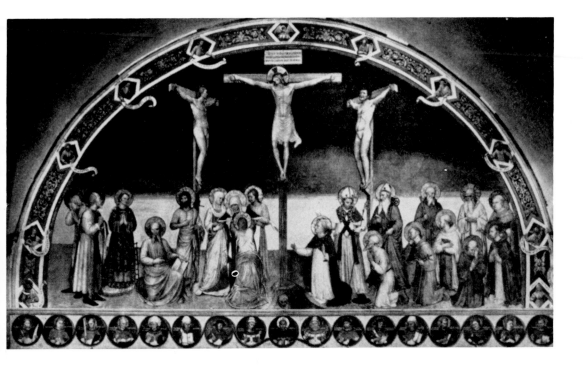

12.8 (*above*). FRA ANGELICO:
Mystical Crucifixion (1437–
1445). Fresco. Refectory, Mon-
astery of San Marco, Florence
(Alinari)

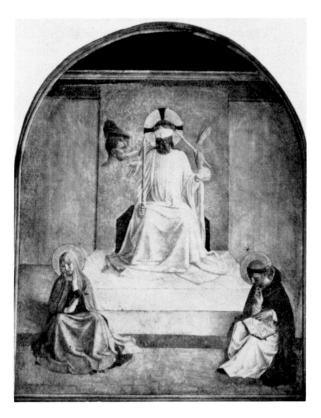

12.9 (*right*). FRA ANGELICO:
Buffeting of Christ (1437–
1445). Fresco. Cell no. 7, Mon-
astery of San Marco, Florence
(Alinari)

participating in the scene. The Annunciation to the Virgin seems to have been a favorite choice, for it is repeated in many cells. One of Angelico's most impressive frescoes in these cells is the Transfiguration of Christ. The statuesque figure of the Saviour with arms outstretched in the form of a cross dominates the composition, and the three apostles cower at His feet because of the brilliance of the apparition. A Dominican mystically experiencing this event stands at one side. The most extraordinary of all these frescoes is the scene of the Buffeting of Christ [12.9]. Clad in a white robe and blindfolded, He is seated on a slightly elevated platform. Around about His head appear a face that spits, a hand that holds a reed, another hand making a gesture of derision, and still another hand that pulls His hair—like materializations at a spiritualistic seance. The explanation of this very strange scene is found in the two figures seated on a lower step of the platform to right and left of the Christ: St. Dominic and a female saint of the Dominican order. St. Dominic is reading a book and the female saint gazes in detachment into space. They are reading about and contemplating that episode in Christ's Passion in which He was reviled by his tormentors. The Saviour materializes as the result of their concentration—but only those parts of the bodies of the tormentors that are the agents of the abusive acts.

On the corridor walls outside the cells of the dormitory are three interesting frescoes. One has already been mentioned, the Crucified with St. Dominic kneeling at the foot of the cross. The others are a beautiful and famous Annunciation set in an elegant early Renaissance vaulted portico and a Madonna and Child enthroned among eight saints.

This Madonna is one of a group of four executed between the years 1430–1445—one a fresco, the other three altarpieces—all of which have contemporary Renaissance architectural backgrounds. Each of these four Madonnas deserves mention. Now in the monastery of San Marco, one formerly was on the high altar of the church of San Marco; another was in the Dominican convent of St. Vincent d'Annalena and has long been known as the Annalena altarpiece [12.10]. The third is the fresco we have just mentioned in the corridor of the dormitory of San Marco; and the fourth was in the Franciscan monastery of Bosco ai Frati in the Mugello near the Medici villa of Caffagiolo. All four paintings must have been commissioned by the Medici, because in each there appear the two Medici patron saints, Cosma and Damian, the doctor saints. It has been pointed out by others that the architectural details in the backgrounds of the Annalena altarpiece, of the painting formerly on the high altar of San Marco, and of the fresco in the dormitory corridor reflect the influence of the architecture of Fra Angelico's friend, Michelozzo, who had been in charge of the restoration of the monastery of San Marco. An interesting detail in the San Marco altarpiece is the Oriental rug spread before the throne of the Madonna, a reflection of the influx of luxury articles from the eastern Mediterranean. The landscape-garden backgrounds of this altarpiece and of the one from Mugello are further evidence of the elegant settings of fifteenth-century Florentine patrician life.

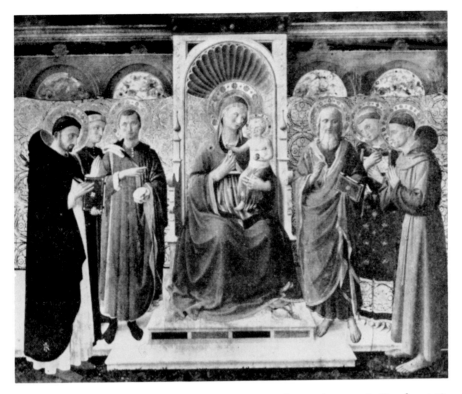

12.10 (*above*). FRA ANGELICO: The Annalena Madonna (*c.* 1435). Panel painting, 71″ x 79⅝″. San Marco Museum, Florence (Alinari)

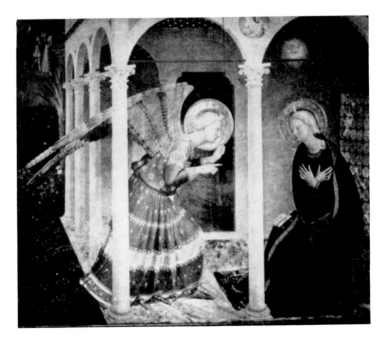

12.11. FRA ANGELICO: Annunciation (*c.* 1435). Panel painting, 63⅛″ x 71″. Museum, Cortona (Alinari)

A transition from the Gothic Linaiuoli Madonna to these four Madonnas is the altarpiece from San Domenico at Cortona with the Madonna and Child flanked by angels and the two St. Johns, St. Mark, and St. Mary Magdalen. While its framework is still Gothic with pointed arches above the Madonna and the saints, in the tabernacle behind the Madonna, Angelico has used the moldings, the shell niche, and the colonnettes of the early Renaissance style. This altarpiece, hidden and walled up in a dank chamber to protect it from air raids during World War II, was almost destroyed by the heavy mold that ate into the panel and gesso on which it was painted. Fortunately the paint surface was expertly removed and remounted by the conservation personnel of the Uffizi Gallery in Florence.

Another Fra Angelico masterpiece from the San Marco period is the Annunciation altarpiece [12.11], now in the museum at Cortona. Related in form and setting to the fresco of the same subject in the dormitory corridor at San Marco, the action and attitudes of the angel and the Madonna are more vivid and tense in the wonderful wide spread of the angel's wings, his gesture of pointing, and the Madonna's eager and submissive attitude toward the will of God. The fenced-in garden of flowers and grasses with trees beyond is similar to that in the Annunciation in San Marco and to the garden in the *Noli me tangere* fresco in one of the cells. In the Cortona Annunciation, however, Adam and Eve driven from Paradise by the angel are visible in the background, giving the painting a typological meaning—that is, with the Coming of Christ, Man was to be redeemed from the evil incurred by Adam's fall. The enamellike treatment of the painted surfaces is a source of wonder, and the iridescence of the wings, the strong pinks and blues, and the gold are a delight to the eye. The little predella scenes sparkle like miniatures in an illuminated manuscript.

In 1445 Angelico was called to Rome by Pope Eugene IV to work in the Vatican. Eugenius died early in 1447 and his successor Nicholas V kept Angelico in his service and had him complete the frescoes in the chapel that bear Nicholas' name. In the same year, 1447, Angelico during the summer months undertook an additional commission to paint frescoes of the Last Judgment in the chapel of San Brixio in the cathedral of Orvieto. He seems, however, only to have laid out the designs of the vault sections of the cross vaults and with the assistance of his pupil Benozzo Gozzoli to have completed only two of these. In one of these vault-section frescoes is Christ enthroned among the Angels and pronouncing Judgment and in the other, a group of prophets. For some reason Angelico gave up the Orvieto project to give his entire attention to the frescoes of the Nicholas chapel in the Vatican. Not until some fifty years later did Signorelli undertake to complete the Last Judgment in the Orvieto chapel with his overpowering frescoes [16.12, 16.13, and 16.14].

The frescoes in the Nicholas chapel depict scenes from the lives of the protomartyrs SS. Stephen and Lawrence especially venerated in Rome. On

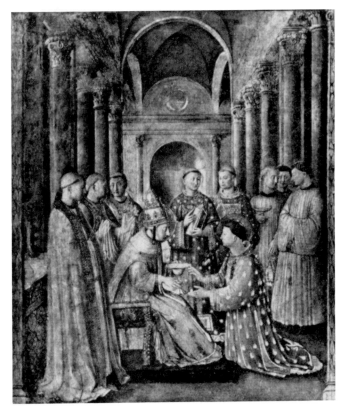

the underside of the entrance arches are the figures of the four Western and
the four Eastern Doctors of the Church, perhaps reminiscent of that council
in Florence in 1439 which attempted to achieve a union of the Eastern and
Western churches. The figures of these saintly doctors are set beneath ar-
chitectural baldachins recalling similar usages on French Gothic cathedrals.
Only here the architecture of the baldachins is made up of Renaissance as
well as Gothic details.

In the scenes from the lives of the two saints, Angelico demonstrates
his knowledge of the new science of perspective. For instance, in the fres-
coes of St. Lawrence consecrated as a deacon [12.12] and of the same saint
distributing alms a one-point perspective is presented by means of the rows
of receding columns in the center of each scene. In the lunette with the
two scenes of St. Stephen preaching to the people and before the High Coun-
cil, a two-point perspective is presented by the buildings in the background
of both scenes seen at an angle to the picture plane. In the lunette in which
St. Stephen is led to his execution and martyred, the sweeping curve of the
Aurelian Wall from the far distance to the front plane of the fresco is a bold
invention not only to separate the two scenes but also to contrast the linear
type of perspective on the left with the more optical one on the right. And,

finally, in the Martyrdom of St. Lawrence the foreshortening in the figure of the executioner at the left anticipates the problem that was to fascinate Mantegna a decade later. In fact in the above-mentioned scene of St. Stephen preaching, the view up the street and the buildings seen at an angle also anticipates Mantegna in the fresco of St. James led to his Execution [23.3].

Fra Angelico was by nature a profound medieval Christian who, for the most part, executed altarpieces and frescoes with mystical content, embellished either with jewellike colors or glittering gold and set in contemporary surroundings. Yet we must conclude that when he was called to decorate the walls of a chapel for a humanist pope, Fra Angelico was capable of using all the up-to-date paraphernalia of perspective, foreshortened figures, distant backgrounds, and Classical details of decoration popular at that time.

He died in 1455 while at work on these frescoes for Pope Nicholas V. The tomb slab with his effigy in relief lies in the pavement of the left transept of Santa Maria sopra Minerva in Rome.

Benozzo Gozzoli

The most accomplished of Angelico's pupils was Benozzo Gozzoli (1420–1497) whose hand can be distinguished in some of the figures in the vault frescoes of the chapel of San Brixio at Orvieto cathedral. Although following the designs of his master, the faces of Benozzo's figures have a harder, more matter-of-fact look and their drapery is stringier.

In 1452 Gozzoli was working independently on the frescoes for the apse of San Francesco at Montefalco. This delightful Umbrian hill-town, across the valley from Assisi, had been visited by St. Francis on various occasions. A church and monastery were erected there after his death. The church is now a museum for Umbrian paintings. The frescoes in the tall apse relate, as is fitting, stories from the life of the saint [12.13]. They are presented with much naïve charm, but the style is rather dry, and the design emphasizes the rectangular, the vertical elements. The landscapes with their distance and detail recall the International tradition, but verticals, not curves, predominate. The colors give a surprising effect with light greens and coral pinks predominating. The scenes look as though they ought to be in the predella of some altarpiece rather than on the walls of a church, such is their delicacy and complete lack of monumentality.

But in later frescoes Benozzo rapidly emancipated himself from the restrictions of panel painting. His masterpiece of decoration is the renowned and popular Journey of the Magi painted on the walls of the tiny chapel of the Medici palace, known now as the Riccardi Palace. He expanded this favorite theme of the International Style painters to cover the four walls of the chapel with a pageantry of rare beauty. Over the altar, Fra Filippo Lippi had painted the altarpiece with the scene of the Nativity, now in the

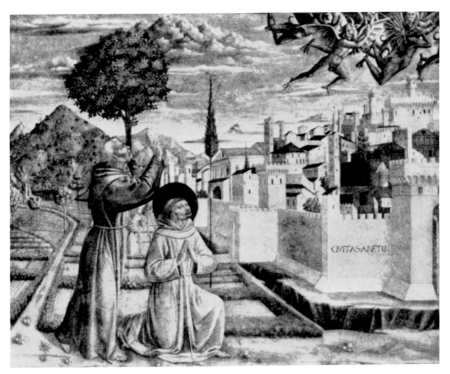

12.13. BENOZZO GOZZOLI: St. Francis before Arezzo (c. 1452). Fresco. Museum of San Francesco, Montefalco (Alinari)

former Kaiser Friedrich Museum in Berlin. Benozzo's frescoes were designed so as to have the manger of the Christ child as the focal center. He painted groups of angels, some kneeling in adoration, others standing about in choirs singing, to right and left of the Nativity panel on the end wall. Over the entrance doorway opposite he painted the Annunciation to the Shepherds. The remaining space on that wall and on the two side walls is occupied by the three figures of the Magi, each arriving with a huge retinue stretching off into the far distance [12.14]. The Magi are given prominent positions in the foreground, riding on magnificently caparisoned steeds. Each is the portrait of a contemporary notable. From the middle of the century on it became the fashion to introduce the portraits of contemporary Florentines into paintings, either as onlookers at some event in holy story or, as here, as one of the Magi in the Adoration scene. The youthful magus in a handsome white and gold brocaded jacket on the white charger is a portrait of the young Lorenzo de' Medici. The Byzantine emperor John Palaeologus is represented as the magus with short black beard and spiked crown astride the black steed. The third is Cosimo de' Medici, head of the famous merchant-prince family. Many other personalities appear among the retainers.

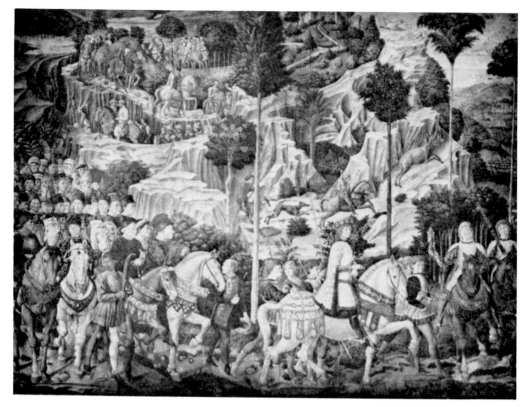

12.14. BENOZZO GOZZOLI: Detail of Procession of the Magi (1459–1461). Fresco. Medici chapel, Riccardi Palace, Florence (Alinari)

We can find many archaisms in Gozzoli's treatment of the landscape background. The love of detail, the "cheese-cut" rocks, and the high skyline are all remnants of the International Style. Yet, as at Montefalco, Benozzo emphasizes verticality in the design. Not only is this true in the folds of the draperies but in the accents created by the trees so characteristic of the Tuscan landscape around Florence. These lofty pines with umbrella tops can be seen to this day on the rocky hillsides along the Arno between Florence and Pisa.

Benozzo did everything in his power to make the frescoes as brilliant as possible. The only light in the windowless chapel would come from candles and torches, so he used much gold, not only in the haloes but also on the garments and in the landscape. This would catch the artificial light and by reflection create a sparkling surface all over the wall. The stunning pinks, light blues, and yellows set against the darker green of the background add immeasurably to the whole and give the frescoes the presumably intended effect of being tapestries.

Had Benozzo painted nothing more, his fame would have been established by the creation of this jewel box of decoration. However two other fresco cycles remain to give evidence of his later style: one in the apse of the church of Sant' Agostino at San Gimignano, the other in the Campo Santo at Pisa. The former, painted in 1465, with scenes from the life of St. Augustine, is a more mature version of the type of decoration he painted at Montefalco. Everything is larger in scale and more adapted to fresco technique, but the severe angularity of the design still persists. The arabesque of putti in the border about the frescoes is full of delightful elements and shows Benozzo's knowledge and adaptation of the motifs borrowed from Classical art and so popular at this time. A fresco of St. Sebastian stuck full of arrows is to be found on the entrance wall of the Collegiata at San Gimignano and dates from the same time. Gozzoli also restored some figures at the end of Lippo Memmi's fourteenth-century fresco of the Madonna in Majesty in the Town Hall of this city.

The Campo Santo frescoes were executed between 1468 and 1484 and cover the wall opposite the fourteenth-century Triumph of Death frescoes by Traini (see p. 171). The subject matter is taken from the first books of the Old Testament. In contrast to the San Gimignano frescoes, these were full of lush decorative details resembling more Benozzo's work in the Medici chapel in Florence. Delicate Renaissance architecture and well-trimmed garden landscape with peacocks and other birds were the settings for the stories. In 1944 when an incendiary bomb caused the destruction and collapse of the roof of the Campo Santo these precious frescoes were for the most part calcined and dropped off the walls. The only consolation for this tragedy is that Benozzo's red preparatory sketches beneath the frescoes came to light.

His panel pictures of Madonnas and saints, such as those in the Museo Communale at San Gimignano and the one in the Kress collection in the National Gallery of Art, Washington, are drier and less interesting variants of Fra Angelico's Madonnas of the 1530's and early 1540's.

BIBLIOGRAPHY

Douglas, R. L. *Fra Angelico*. London, G. Bell & Sons, 1900.

Stokes, H. *Benozzo Gozzoli*. London, G. Newnes, ltd., 1904.

Pope-Hennessy, J. *Fra Angelico*. New York, Phaidon Publishers, 1952.

Hausenstein, M. *Fra Angelico*. Trans. by Agnes Blake. London, Methuen & Co., 1928.

Boccabianca, G. M. *Gli Affreschi di Benozzo Gozzoli nella Capella del Palazzo Medici-Riccardi a Firenze*. Milan, Istituto Editoriale Italiano, 1957. (Color plates of the Medici chapel frescoes)

← 13

Fra Filippo Lippi

THE circumstances that led Filippo Lippi (c.1406–1469) to become a monk were totally different from those that had decided Fra Angelico. The son of a humble butcher, Tommaso Lippi, Fra Filippo had been orphaned at an early age and placed under the care of the Carmelite brothers whose monastery was in the same section of Florence in which he was born. At the age of fifteen he had the choice of staying in the monastery as a brother or of going out into the world. He chose the former, possibly as a gesture of appreciation for the benefits he had received. There he was, then, in the monastery of the Carmine when, at the age of eighteen, he witnessed the creation of Masaccio's revolutionary frescoes in the Brancacci chapel of the church adjoining his monastery. We do not know when his own talent manifested itself or from whom he received his earliest instruction in painting. He must have become acquainted with both Masolino and Masaccio during the years these painters were at work in the Carmine, and he could not have failed to be aroused by their creations, if indeed he did not assist them. He was, after all, only five years younger than Masaccio.

The earliest evidence of Fra Filippo Lippi's style is, in fact, to be found in the same cloister of his monastery in which Masaccio, according to the previously mentioned account of Vasari, had painted a fresco commemorating the consecration of the church of the Carmine in 1422. Only a fragment of Fra Filippo's fresco remains, but, interestingly, it too commemorated an event of importance to the Carmelites. In 1432 Pope Eugene IV had approved a reform ameliorating the strict rules to which the Carmelites had previously been held. Fra Filippo's fresco certainly is related to this event

258

13.1. FRA FILIPPO LIPPI: Detail from Reform of the Carmelite Order (*c.* 1432). Fresco. Cloister, Santa Maria del Carmine, Florence (Soprintendenza)

for it shows the Carmelite brothers freely communicating with each other in conversation while walking, standing in groups, or sitting as though enjoying the new privilege granted them by the reform. Perhaps that is why in one of the fresco fragments [13.1] there is a happy smile on the rotund face of one of the monks before whom a younger brother is kneeling. The pose of the latter anticipates that of the Angel Gabriel in the Annunciation scene painted so many times by Fra Filippo in the years that followed. The style in the fresco with the soft heavy drapery, the areas of light and shade to create form, and the lighting and softened details of the background are essentially derived from Masaccio. Another early work similar in style to the fresco with reminiscences of Masaccio is the panel of the Madonna of Humility surrounded by angels and saints, now in the Castello Sforzesco in Milan. The face of the old St. Anne at the left strongly recalls Masaccio's St. Anne in the altarpiece in the Uffizi.* In the angels behind the Madonna with the inquisitive expressions of Florentine choir- or altar-boys we already get a hint of his later use of local types, both male and female, to represent saints and angels.

* See footnote, page 198.

Strangely, the influence of Masaccio does not appear in Fra Filippo's panel paintings after this time. Only later in one of the frescoes in the duomo at Prato does it momentarily appear again. The stylistic connections in his panel pictures seem rather to be with Fra Angelico, Domenico Veneziano, and even with the north of Europe.

Fra Filippo had left the monastery in 1431 and had gone to live in the palace of the Medici who as patrons of promising young artists had recognized Fra Filippo's ability as a painter and were to give him commissions to perform. In 1433–1434 he was working in Padua, and there perhaps could have seen some northern paintings. At any rate when he painted that rather extraordinary Madonna and Child [13.2], dated 1437, now in the Galleria Nazionale in Rome,* the window at the left with a view of the outside, the details in the background picked out by a sharp light, and the book on the right arm of the throne recall similar details in Flemish paintings, as Robert Oertel † has pointed out. The broken angular folds about the feet of the Virgin also have a northern look in contrast to the more swirling, calligraphic drapery common to the International Style in Italy at this time. The overchubby Christ child is rather startling!

The Annunciation to the Virgin was a favorite subject with Fra Filippo. He painted it many times in the period between the late 1430's and early 1450's, both as the central motif of an altarpiece and as predella and lunette compositions. The earliest one of importance is now over the altar of the Martelli chapel in San Lorenzo, Florence [13.3]. It had previously been in the SS. Annunziata. The composition of the right half with Gabriel and the Virgin appears in all his later monumental Annunciations, such as the one now also in the Galleria Nazionale in Rome or the one in the gallery in Munich. In the San Lorenzo Annunciation, dating around 1437, the perspective background still gives evidence of Masaccio's principles of perspective, although Fra Filippo's own preference for rectangular architectural space-enclosures in the foreground is more insistent. In the left half of the panel are two attending angels. The one at the left turns his head to look out of the picture, a gesture much used by Fra Filippo to draw the spectator into the picture. He had used it in his early fresco and will repeat its use right up to his latest panel paintings.

In 1437 too, Fra Filippo contracted to paint the altarpiece of the Madonna with angels and saints for the Barbadori chapel in Santo Spirito in Florence [13.4]. It is now in the Louvre, Paris. The W-shaped design created by the foremost angels to right and left, the two kneeling saints, and the standing Madonna seem to anticipate one of Botticelli's favorite designs as we shall have occasion to observe. The detached introspective look on all the faces in the painting—except for the face of the black-haired young monk gazing out at the spectator at the extreme left, supposed to be a self-portrait—will be found frequently in Fra Filippo's pictures and also carry

* Formerly in the Museum at Tarquinia.
† Robert Oertel: *Fra Filippo Lippi* (in German), Vienna, 1942.

13.2 (*right*). FRA FILIPPO LIPPI: Madonna and Child (1437). Panel painting, 45″ x 25½″. Galleria Nazionale, Rome

13.3 (*below*). FRA FILIPPO LIPPI: Annunciation (*c.* 1437). Panel painting, 69″ x 71⅛″. Martelli chapel, Church of San Lorenzo, Florence

over into the work of his pupil Botticelli. The head of the standing angel at the extreme right seems to be a small copy in reverse of Masaccio's St. John in the Tribute Money fresco [10.15] in the Brancacci chapel.

The famous altarpiece of the Coronation of the Virgin in the Uffizi [13.5] was ordered originally in 1441 by a canon of San Lorenzo, Francesco Maringhi, for the high altar of the church of the Benedictine monastery of Sant' Ambrogio, of which he was prior. It was not completed until about 1447. Maringhi died the same year the altarpiece had been commissioned, and Fra Filippo placed his portrait, as donor, in the lower right-hand corner of the picture. This portrait has at times been falsely identified as a self-portrait of the artist. Not only does the gray hair on the head of the old man deny this—Fra Filippo was thirty-five years of age at the time—but also the prayerful attitude of the figure traditional for donor portraits. The inscription on the band held by the angel also reads in Latin: *This man had the work done.* If there is a self-portrait in the picture it is most likely to be the younger of two kneeling monks at the left who supports his chin on the right hand and looks out at the audience. He can easily be the same person as the one we noted in the Barbadori altarpiece.

The long-stemmed lilies, associated both with the Virgin and with Florence, and the garlanded, towheaded angels modeled after local youngsters have evoked much admiration as reflecting the holiday spirit of the Tuscan city. The colorful effect indeed is there as befits the celebration of a major event in the life of the Virgin; but where in the figures themselves, except for their external attractiveness, is there any holiday spirit? They all—the angels, the two standing saints, and those kneeling in the foreground—wear serious introspective expressions very much like Angelico's figures in his version of the same scene, now in the Louvre [12.4], with which Fra Filippo must have been acquainted. He introduces in his Uffizi Coronation similar mystical attitudes—note the upturned eyeballs of several of the angels so frequently found in Angelico's paintings.

It was during the decade of the 1450's that Fra Filippo went through a number of emotional experiences about which so much has been made by Vasari and other later writers. The spotlight turned on these human transgressions has unfortunately obscured in the minds of many the significance of Fra Filippo's work. A brief account of these experiences therefore seems necessary to evaluate properly some of his work at this time.

Previously in 1442 Fra Filippo had been appointed rector and perpetual abbot of San Quirico a Legnaia, and in 1450 was also chaplain to the nuns of San Niccolo de' Fieri at Florence. But that year he became involved in his first public scandal. He had taken on an assistant by the name of Giovanni da Rovezzano and had agreed to pay him forty florins at the end of a certain time. When the young man asked for his pay Fra Filippo claimed that he had already paid him. The matter went to court and Fra Filippo produced a signed receipt. The youth, however, protested so vigorously and so earnestly that the judge, convinced of his innocence, had Fra Filippo put

13.4 (*above*). FRA FILIPPO LIPPI: Barbadori altarpiece (1437). Panel painting, 85½″ x 96¼″. Louvre, Paris (Archives Photographiques)

13.5 (*below*). FRA FILIPPO LIPPI: Coronation of the Virgin (1441–1447). Panel painting, 78⅞″ x 113⅛″. Uffizi, Florence (Alinari)

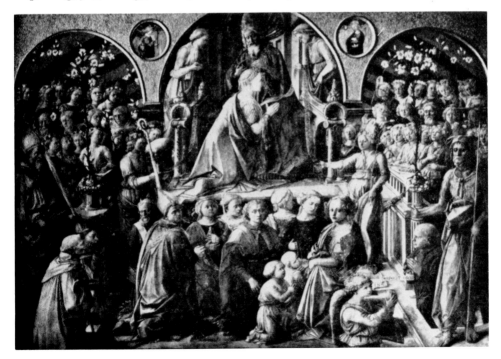

to the torture, producing the confession that he had forged the receipt. The ensuing scandal, as might be imagined, had a devastating effect on Fra Filippo's position as a priest. In addition, his parishioners complained that he was neglecting them and the services of the Church. The cry against him rose so high that the matter was taken to Rome. In 1454 he was deprived of his rectorship, and the pope issued a bull against him. All this should have finished his religious career, but his connections with the Medici family were such that their intervention at the papal court produced more favorable results and Fra Filippo was sent off to Prato where, of all things, he was made the chaplain to the nuns at the convent of Santa Margarita.

The story then goes that the abbess of the convent commissioned him to paint for the high altar of the chapel an Assumption of the Virgin representing the moment when the Virgin dropped her girdle (now the great relic in Prato cathedral) into the hands of St. Thomas. Fra Filippo requested and received permission to use as the model of the Virgin in this picture a young nun who had caught his attention. Her name was Lucretia Buti, one of three Buti sisters. As was the custom then, a family provided an adequate dowry for its eldest daughter. If nothing was left for other daughters, these unfortunates often were sent to a nunnery to be amply provided for during the remainder of their earthly existence. Such had happened to Lucretia Buti and her sister, who were placed in the convent at Prato. The inevitable followed: a love affair between Lucretia and Fra Filippo that was to be the second major scandal in Fra Filippo's life. On the feast day of the Assumption of the Virgin, 1456, during the noisy celebration in which both populace and clergy participated, Fra Filippo abducted the pretty nun. Consternation reigned in Prato. The abbess did her best to induce the erring nun to return to the convent, but not until 1458 did Lucretia return penitently to the community of nuns. Fra Filippo was so sincerely in love with her that he convinced the abbess to release Lucretia in order that she might become his wife. Apparently they lived happily together thereafter until Fra Filippo's death in 1469. The result of their union was another painter, Filippino Lippi, of whom we shall have something to say in another chapter.

Despite his emotional vicissitudes during this period Fra Filippo was busy with a number of important commissions. A project to adorn the choir of the cathedral at Prato with frescoes had been considered as early as 1440, but the project did not get under way until 1452. Fra Angelico was approached to do the work but he declined. It is possible that he suggested Fra Filippo for the job, for in a document of that same year Fra Filippo is mentioned as the painter commissioned to do the job. Between 1452, then, and the time he left for Spoleto in 1466 Fra Filippo worked sporadically at the cathedral. In the cross vault over the choir are the four evangelists with their symbols. On the left and right walls respectively are scenes in three tiers from the lives of St. Stephen and St. John the Baptist. On the end wall flanking the window are SS. Giovanni Gualberto and Albert represented

as standing in front of semicircular niches adorned with early Renaissance architectural details.

The vault tiers, or zones, containing the birth scenes of St. Stephen and St. John were the first to be done in the years immediately following 1452. According to a notice of payment of 1456, the middle zone seems to have been done then. It contained on the left wall episodes from St. Stephen's life, and on the right St. John the Baptist's departure for the desert and his sojourn there [13.7]. The Funeral scene of St. Stephen [13.8] that is in the lowest zone on the left bears the date 1460, and the Feast of Herod [13.9] on the opposite wall was probably painted about 1464. In that year Prato authorities desired Carlo de' Medici to exert his influence on Fra Filippo to finish the Prato project.

The composition of these scenes is essentially the same in all except in the lowest zone. A large, rectangular, space-enclosing architectural feature is flanked on the right or left by a smaller rectangular unit. This becomes almost stereotyped in Fra Filippo's work. Actually it harks back to fourteenth-century usage. But Fra Filippo inserts a third area between these two rectangular ones in the form of a twisting curvilinear pathway or road as an exit or escape area leading off into a hidden background. In the two corresponding scenes of the Birth of St. Stephen and of St. John the Baptist [13.6] in the top vault tiers, this compositional scheme is clearly stated, the larger rectangle being at the left. In the middle zone or tier on either side the scheme is reversed with the larger rectangle at the right. On the wall with the scenes of St. John's departure for the desert and his sojourn there [13.7], the rocky arid desert landscape takes the place of architectural elements as seen on the opposite side but the fundamental composition is the same in both cases. To relieve the rectangularity of the larger areas a semicircular opening is introduced. In the lowest tier the smaller rectangle is almost completely pushed aside by the importance and size of the larger one, which is moved into an almost central position in each fresco. The architectural perspective in both the scenes of the Funeral of St. Stephen and the Feast of Herod adds to the effect given these scenes of being the balanced supports of the compositions in the upper tiers. Note how in both frescoes the rectangle is emphasized both two-dimensionally and three-dimensionally. In the Funeral scene [13.8], for example, the horizontals are repeated in the bier, the heads of the figures flanking it, the platforms on which they stand, the pavement, the altar, the cornice molding above it, and the cross beams of the coffered ceiling. The verticals in turn are picked up by the figures, the striations of the pilasters, and the columns; and the diagonals appear in the lines of the pavement, the perspective lines of the capitals and the cornice moldings above them as well as in the converging lines of the ceiling coffers. All these rectangular elements are gently relieved by the curvilinear accents of the nave arcade and of the arches over the sanctuary and apse. In this fresco, which itself exerted an influence on later painters, are several reminiscences of the past: the perspective principles of

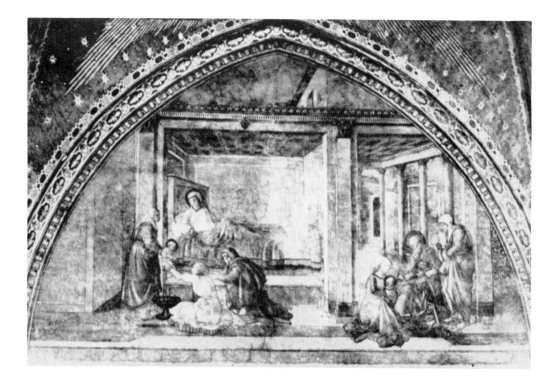

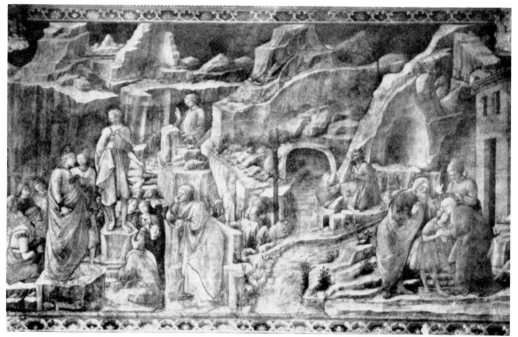

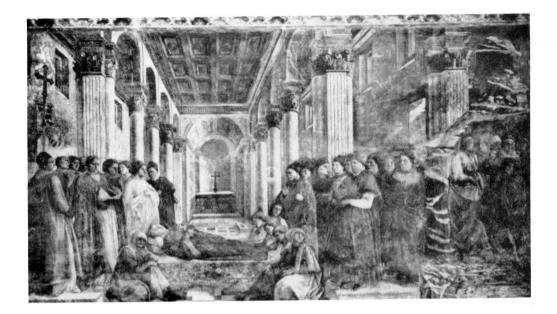

FRA FILIPPO LIPPI: Choir frescoes, Prato Cathederal

 13.6 (*opposite, above*). Birth of St. John the Baptist (1452–1454). (Alinari)
 13.7 (*opposite, below*). St. John the Baptist in the Desert (*c.* 1456). (Soprintendenza)
 13.8 (*above*). Funeral of St. Stephen (*c.* 1460). (Alinari)
 13.9 (*below*). Feast of Herod (*c.* 1464). (Soprintendenza)

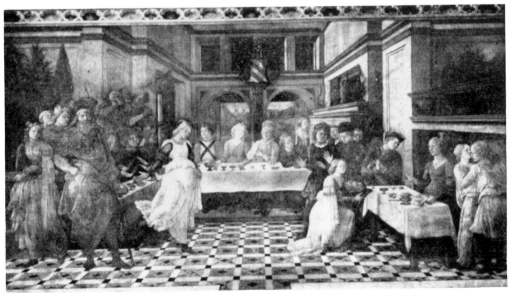

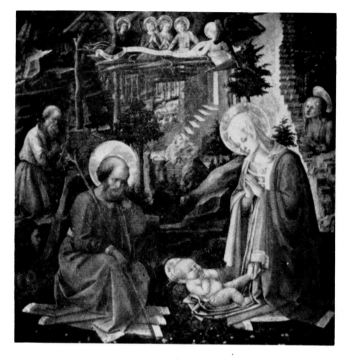

13.10. FRA FILIPPO LIPPI: Madonna Adoring Child (c. 1453). Panel painting, 53″ x 52¾″. Uffizi, Florence (Alinari)

Brunelleschi, the light and shade and the portrait groups of Masaccio. In the fresco on the opposite wall, the Feast of Herod [13.9], Fra Filippo attempts in the dancing Salome to portray a figure in motion. To achieve this effect he envelops the figure with many lightly swirling draperies. It is a delightful creation in the midst of much somber emotion on these walls and is found in many varied versions in the works of Botticelli, Ghirlandaio, Filippino Lippi, and other painters.

During the period when he worked intermittently at Prato, Fra Filippo painted many panel pictures, several of which have enjoyed much popularity up to the present day. Among these are the three versions of the Madonna kneeling on the ground in adoration before the Christ child. Of these three, two are now in the Uffizi gallery, one having formerly been in the convent of Annalena [13.10], the same convent in which an altarpiece by Angelico had been, the other had been donated to the hermit monastery at Camaldoli by Lucretia Tornabuoni about 1463. The third, now in the former Kaiser Friedrich Museum in Berlin, was formerly on the altar of the Medici chapel in the Riccardi palace decorated by Benozzo Gozzoli. It has been replaced with a copy by an anonymous follower of Fra Filippo known by the preposterous name of the Pseudo Pier Francesco Fiorentino! This type of Madonna had been used occasionally in the fourteenth century, but Fra Filippo revived it and it became very popular in the fifteenth and sixteenth centuries. In all three the rocky landscape backgrounds with parallel horizontal striations, the twisting paths, and the hollow depressions recall the

13.11. FRA FILIPPO LIPPI: Madonna, tondo (1452). Panel painting, 53⅞" dia. Palazzo Pitti, Florence (Anderson)

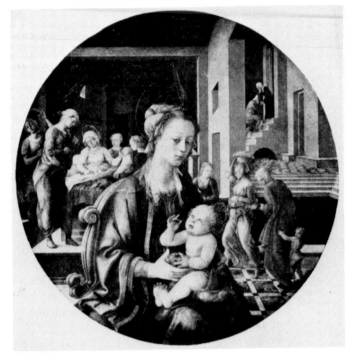

fresco at Prato with the scenes of St. John the Baptist in the desert. They are rendered more attractive, however, by the introduction of trees, grasses, and flowers scattered throughout the settings. All this charm that has been introduced by means of these evidences of springtime in Tuscany and by the coy, chubby Christ child cannot hide the expressions of wistful sadness and daydreaming on the faces of all the other figures in the pictures—the Madonna, St. Joseph, and the young Baptist as well as the hermit saints on the sidelines who are experiencing mystically the scene before them. This wistfulness is present in almost all Fra Filippo's pictures and increases, if anything, toward the end of his life. In fact, in these creations he seems to have wished to compensate and do penance for the weaknesses of the flesh that beset him. For him, salvation was a serious business. He never portrays God, the Virgin, or the saints facetiously.

Two other important panel pictures date from this period. They are circular in shape. Hitherto the rectangular form had been traditional for religious pictures. The circular panel, known as a *tondo,* had been used as a tray on which presents were brought to the mother of a newborn child. Hence it was a *desco da parte,* that is "birth disk." One side of it was generally decorated with a mythological or secular scene. Fra Filippo now introduces this tondo form * on which he paints religious birth scenes. In the tondo scene in the Pitti gallery [13.11] in Florence, the Madonna is seated

* Domenico Veneziano painted an Adoration of the Magi in a tondo (now in former Kaiser Friedrich Museum in Berlin). The question of its date, however, has not been settled.

in the foreground in an elaborate chair set at a slight angle to the picture plane. In the background middle distance is the event of her birth. Among the women coming in with presents for the aged St. Anne sitting up wearily in the bed is a young matron whose posture, movement, and rippling draperies we shall see again in the works of Ghirlandaio. In the background to the right the Meeting of Joachim and Anna is shown. The connection between this tondo scene and the two birth scenes in the uppermost zones of the Prato frescoes is very close. The presence of a birth scene is one link; the general compositional scheme of the large space-enclosing rectangle and the smaller òne at the right is another; and the presence and postures of the group at the extreme right in every case is a third connection.

By using the tondo form Fra Filippo introduced a new problem of fitting the subject matter into a circular field. There were to be many experiments and solutions in the time to come. Botticelli and other later painters took it up, and Michelangelo and Raphael gave it its most monumental solutions in the Doni Madonna [20.2] of the former and the Madonna of the Chair of the latter [21.16]. Fra Filippo himself in the Pitti tondo, in which the rectangular-triangular design predominates, makes various adjustments to the circle in such details as the figure bending toward St. Anne, the curve of the back of the Madonna's chair, the curve of the back of the woman at the right, repeated in the figure of the St. Anne on the steps above, the low arch supporting the stairway in the background, and the haloes.

In the other large tondo with the Adoration of the Magi, formerly in the collection of Sir Herbert Cook in England and now in the National Gallery of Art in Washington [13.12], Fra Filippo follows the International Style tradition: he depicts all the processional pageantry accompanying the Magi as well as the detailed interest in animals, birds and flowers to which also a Classical and secular touch has been added in the figures of the nude youths who presumably have climbed up on the wall from their swim in order to see the procession. In adjusting all this to the circular field, he has used a horseshoelike design open at the top that certainly recalls the winding escape areas he used in the St. John scenes in the middle tier of frescoes at Prato. Robert Oertel, in the work already cited, points out the similarity between the young kneeling Magus here and the kneeling figure at the left in the Preaching of St. John at Prato; both have a thick braid of blond hair falling down the back. The strange perspective of the manger shed and of the surrounding buildings is pitched toward a point at the extreme left edge of the tondo. It has been suggested that the hand of Fra Angelico is also to be seen in this panel, but that is questionable.

To the latter part of his Prato period, possibly shortly before his departure for Spoleto, are two more Madonna types we should mention. The one is represented by the so-called "Madonna of the Niche" in the museum of the Riccardi palace in Florence. A similar one was formerly in the former Kaiser Friedrich Museum in Berlin and is now in the Kress collection in the National Gallery of Art, Washington. In both, the Madonna, in half length,

13.12. FRA FILIPPO LIPPI AND
FRA ANGELICO(?): Adoration
of the Magi (*c.* 1455). Panel
painting, 53″ dia. National Gal-
lery of Art, Washington, D. C.,
S. H. Kress Collection (Cour-
tesy of the National Gallery of
Art)

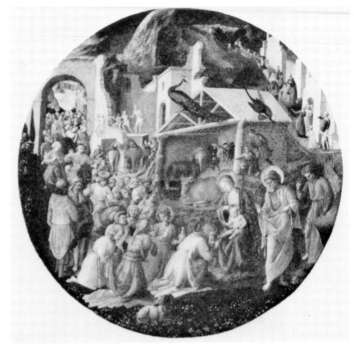

is placed in front of a shell niche and caresses the Christ child who is placed
on a parapet in front of her, a theme to be at home in Padua and Venice,
but one that could have been acquired from Domenico Veneziano or the
reliefs of Donatello and the della Robbias. The hyperwistfulness of the Ma-
donnas' expressions presages that of Botticelli's later Madonnas.

In the late Madonna in the Uffizi [13.13], of which there is a variant
in the gallery in Munich, we can again note elements of surprise and in-
vention. The Madonna is seated in profile, both palms of her hands joined
in a gesture of adoration. The misshapened Christ child, recalling somewhat
the one at Rome [13.2], is not supported by her or on her lap but is held up
in front of her by the popular urchinlike putto who looks out of the pic-
ture at the spectator as though seeking applause for his feat. Another angel,
almost completely hidden except for a portion of his head and hands, helps
support the heavy Christ child. What is additionally remarkable is the fact
that Fra Filippo has painted the Madonna and the other figures, together
with the elegant armrest of her chair, as though they projected out of the
frame, a bit of space illusion sufficiently common in sculpture but rather
unusual in painting up to this time. We have seen examples of it in Uccello's
prophet heads in the cathedral in Florence and in Masaccio's Trinity in Santa
Maria Novella in that city. But it will be Mantegna in Padua and Mantua
who will really bring up that problem. The landscape background in Fra
Filippo's Uffizi panel differs from his usual type and seems to be a preview
of the type Leonardo da Vinci is to use.

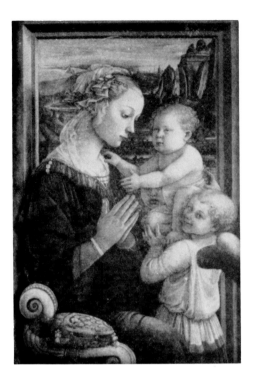

13.13. Fra Filippo Lippi: Madonna and Child (*c.* 1465). Panel painting, 36¼" x 25". Uffizi, Florence (Alinari)

Fra Filippo's last project of importance was the decoration of the apse of the cathedral at Spoleto. This was begun in 1466. The best known of these frescoes is the Coronation of the Virgin in the half-dome of the apse, a composition that was to be reflected in the panel of the same subject by Botticelli. On the walls below are the scenes of the Annunciation, the Birth of Christ, the Death of the Virgin, and the Handing of her girdle to St. Thomas at the moment of the Assumption. The effect of these frescoes is extremely impressive—in the scale of the figures and in the soft effect of the colors in which the pink, green, and gray predominate. Much of the work was done by assistants, particularly by Fra Diamante and perhaps by Botticelli too, for Fra Filippo apparently was feeling the effects of the internal injuries received at the time he was subjected to the torture. Indeed he died in 1469 while at work on this project.

It may surprise those cognizant of Fra Filippo's worldly vagaries to learn that no evidence of these appears in his paintings. His intimate contact with the world about him is brought out in the contemporary local types used in his pictures and in the emotional reactions of some of his figures, such as the jollity of the Carmelite monk and of the urchinlike angel in the late Madonna panel in the Uffizi, or the brutal hatred of St. Stephen's executioners in the Prato fresco, or the wrapped attention of the Baptist's audience in the desert, also at Prato. Otherwise, especially in his panel pictures as we have had occasion to mention, an atmosphere of solemnity reigns.

Apart from this, Fra Filippo's importance in the development of Tuscan painting is great. He bridges the gap between Masaccio and such later Florentines as Botticelli and Ghirlandaio, and he also carries forward into the middle of the century traditions from the International Style, such as the realistic representation of rocks, flora, and fauna that will find their apogee in the works of Leonardo da Vinci. We have remarked how he made popular the kneeling Madonna type as well as the new tondo form, both of which were taken up extensively by later painters. His unorthodox use of perspective at times (tondo in the Pitti), his exaggeration of forms (such as the Christ child in the Madonna panel at Rome [13.2] or the giant figure to the left in Herod's Feast), and his attenuation of form (as in the Madonna of the Annunciation in Munich) suggest that he had certain qualities in common with the Mannerist movement of a century later. Small wonder, then, that Vasari was to say of him: ". . . in his early as well as in his mature years he produced such admirable works that he was a miracle." And, "Indeed, such was his excellence that no one surpassed him in his day, and but few in our own, while Michelangelo has never tired of singing his praises and has frequently imitated him."

Appendix: Francesco Pesellino

Closely associated with both Fra Angelico and Fra Filippo Lippi was the delightful painter Francesco Pesellino (1422–1457), who died at the early age of thirty-five. Not quite attaining the stature of his masters he was, however, a painter of sensitive feeling and great charm. We associate him primarily with small predella and cassone panels in which the blond color effects achieved by the use of pinks, light blues, and grays recall those of Fra Angelico. At work at times on predella panels for Fra Filippo Lippi's altarpieces, he also absorbed some of that painter's elegance of style. We cite as an excellent example of his work a predella panel in the Worcester (Mass.) Art Museum representing the miracle of St. Sylvester reviving the Bull before the Emperor Constantine and his mother Helena. Two companion pieces are in the Doria Gallery in Rome.

BIBLIOGRAPHY

Strutt, E. C. *Fra Filippo Lippi*. London, G. Bell & Sons, 1906.
Carmichael, M. "Fra Filippo Lippi's Portrait," *Burlington Magazine* XXI, 1912, p. 194.
Pudelko, G. "The Early Work of Fra Filippo Lippi," *Art Bulletin* XVIII, 1936, pp. 104ff.
Oertel, R. *Fra Filippo Lippi*. Vienna, A. Schroll, 1942. (A basic study in German)
Salmi, M. *Fra Filippo Lippi, Gli Affreschi nel Duomo di Prato*. Bergamo, Istituto Italiano d'Arte Grafiche, 1944.

ᐧ14
Botticelli

I
T should be evident by now that, with exception of Piero della Francesca the Umbrian (who after all received his training in Florence), the artists who brought painting in Italy during the Renaissance to its high moment were Florentines. And that it was the patronage of the Medici that made possible this flowering of art in the city on the Arno. We have noted the advance made by the progressive painters of the fifteenth century in Florence toward a realism based on visual experience, and we have also seen the contemporary reactions to and interpretations of religious ideas and subject matter, both by a more traditional monastic painter—Fra Angelico—and by a painter-monk with essentially more secular tendencies—Fra Filippo Lippi. We have also noticed the gradual infiltration of Classic taste in decoration and the introduction of mythological or pagan subject matter. Christian and pagan ideas were to meet head on, and the attempt was to be made to reconcile and even to fuse them. The formation by Cosimo de' Medici of a Platonic Academy in and about Florence is a case in point. How it was to appear in the painting of the period we can see first of all in the art of Alessandro dei Filipepi, better known as Botticelli (1444–1510).

As a pupil of Fra Filippo Lippi, whom he had accompanied to Prato and Spoleto, Botticelli reflects the older painter's style in his early Madonnas, for example, those in the Uffizi and the Louvre [14.1]. The slender, sharp-featured Madonna and the chubby Christ child are plainly derived from his master's work. But Botticelli also came under the influence of other Florentine masters and, as a sensitive, impressionable, and emotional man, absorbed their styles as well.

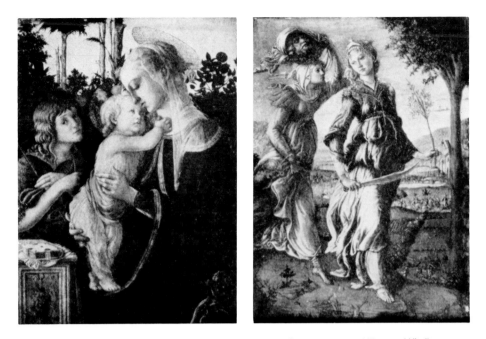

14.1 (*left*). BOTTICELLI: Madonna (*c*. 1470). Panel painting, 36½″ x 27⅛″. Louvre, Paris (Alinari)

14.2 (*right*). BOTTICELLI: Judith with Head of Holofernes (*c*. 1470). Panel painting, 11″ x 8¼″. Uffizi, Florence (Anderson)

When the Pollaiuolo brothers were commissioned to paint the personifications of the cardinal and theological Virtues for the Mercatanzia in Florence in 1470, Botticelli was allowed to do the figure of Fortitude. From the brothers, who were masters of line and detail, he acquired added impetus for his predilection for line as a major means of expression. Their interest in forms in motion and in strange, affected poses and gestures was also incorporated in his style. From the painter-sculptor Andrea Verrocchio, who had the most important shop in Florence for training young artists and who was the master of Leonardo, Botticelli acquired a third source of influence. It is Verrocchio's Madonna type, with the broad forehead, heavy-lidded eyes, and small round nose and chin, that we find in several early Botticellis, such as the Madonna in the Louvre and the Madonna in the Gardner Museum in Boston. The most delightful little panel of Judith with the head of Holofernes [14.2], in the Uffizi, shows the same type, although the tripping stances of the figures recall the Pollaiuoli and the swirling drapery of the Judith calls to mind the dancing Salome in Fra Filippo's fresco at Prato.

After 1474, Botticelli was active fulfilling commissions for the Medici family. He painted a banner for the famous tournament of 1475 in which Giuliano de' Medici was the victor, receiving the champion's crown from the hands of the celebrated beauty Simonetta Vespucci. A number of his Medici portraits date from this period, among them the Giuliano in the

former Kaiser Friedrich Museum in Berlin and the two versions in reverse, one in the former Otto Kahn collection, the other in the Kress collection in the National Gallery, Washington.

His Adoration of the Magi [14.3] in the Uffizi, painted in 1478, was a handsome compliment to his Medici patrons. The Holy Family is placed in the middle distance with the ruined manger as a background. Glimpses of the far horizon are visible to right and left of the manger. The foreground is filled with entourage of the Magi converging in a triangular design with the Holy Family as the apex of the triangle. The faces of the Magi are portraits of members of the Medici family: Piero il Gottoso, Cosimo, and Giovanni. On the sidelines to right and left are the young Lorenzo and Giuliano in the midst of their companions and other Florentines. The figure in yellow at the right looking out at the spectators has often been identified as Botticelli himself, although this identification has been doubted. In these portrait figures Botticelli displays a realism rarely found again in his work. To emphasize this realism his forms are solid and the lines of the composition are essentially vertical. The altarpiece had been commissioned by the Florentine Giovanni Lami for the church of Santa Maria Novella and was a handsome gesture in the direction of the Medici by placing them, as it were, in the front of the receiving line of the Holy Family.

Some years later Botticelli painted another version of this subject [14.4]. Now in the National Gallery in Washington and one of the many jewels of that collection, it was one of several paintings formerly in the Hermitage Museum in Leningrad bought from the Russian government by Andrew Mellon. The figures are smaller than those in the Uffizi Adoration. The design is an interesting exercise on the theme of the W motif, which occurs both two- and three-dimensionally throughout the picture. Light blues, pinks, yellows, and whites give a ravishing color effect.

Allegorical Paintings

In the same year in which he painted the Uffizi Adoration, 1478, Botticelli began the first of a series of allegorical poesies based on Classic subjects. He had come under the influence of the group of Neoplatonic humanists centering about the Medici who met for their discussions at various private villas outside the city.

It was for the Villa Castello that he painted the celebrated Primavera, or Spring [14.5], borrowing the theme from a poem by Poliziano, one of the humanist group. In the center stands the pregnant figure of Spring. To the left are the three Graces and Mercury, and at the right the beautiful Flora and a nymph pursued by the North Wind. Flowers and grasses spring up about the figures in the foreground, shut in by a row of orange trees in the background. These trees with their vertical repeats give stability to the design that in the foreground is full of movement and curvilinear rhythms. The figures in themselves are still quite heavy, but by using light draperies

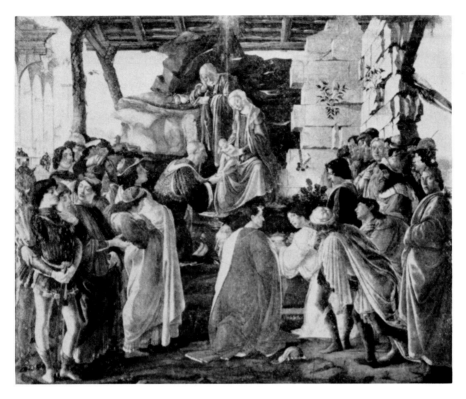

14.3 (*above*). BOTTICELLI: Adoration of the Magi (1476–1478). Panel painting, 43¾" x 52¾". Uffizi, Florence (Anderson)

14.4 (*below*). BOTTICELLI: Adoration of the Magi (*c.* 1482). Panel painting, 27⅝" x 41". National Gallery of Art, Washington, D. C., Mellon Collection (Courtesy, National Gallery of Art)

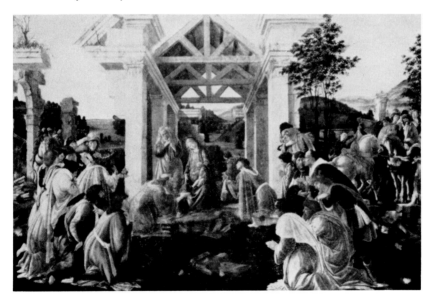

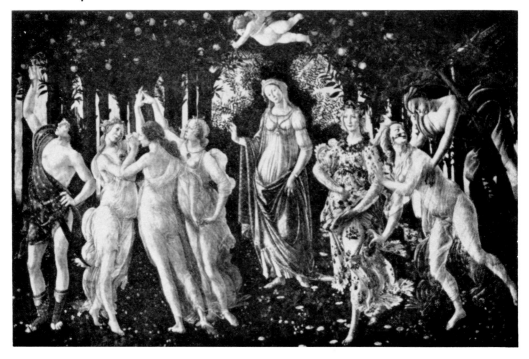

14.5 (*above*). BOTTICELLI: Primavera (*c.* 1478). Panel painting, 80″ x 123¼″. Uffizi, Florence (Anderson)

14.6 (*below*). BOTTICELLI: The Birth of Venus (*c.* 1485). Panel painting, 68¼″ x 107¼″. Uffizi, Florence (Anderson)

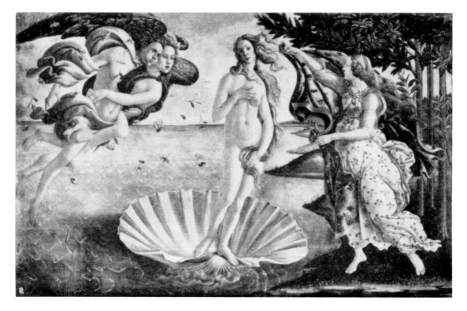

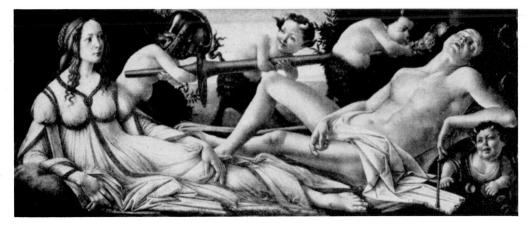

14.7. BOTTICELLI: Venus and Mars (1476–1478). Panel painting, 27¼" x 67⅞". National Gallery, London (Courtesy, National Gallery, London)

swirling about the forms, Botticelli creates an impression of lightness and imparts to the scene itself a lyric, a poetic flavor. We are now in the realm of fantasy.

The well-known Birth of Venus [14.6] is the counterpart of the Primavera, although it was painted several years later. The goddess of Love comes floating to shore on a cockleshell propelled by the gusts of Zephyr behind her. Tiny wavelets whipped up by the wind sparkle on the sea about her. A nymph clad in a flowing pink and white brocaded robe approaches from the grove at the right to receive the goddess and to cover her with a mantle. Botticelli had obviously seen the Classic marble of Venus in the Medici collection, now in the Uffizi, for he copied the pose rather faithfully, in reverse. But in place of the completely self-assured courtesanlike attitude of Venus, Botticelli creates a vision of shy modest virginity gazing with nostalgic sadness at the beholder. It is the same expression that he painted on the faces of his later Madonnas, as though the Christian Botticelli could not allow himself to stray further in the pagan direction than the representation of the sheer beauty of the form itself. Every line has an unsurpassed lyric beauty. The gentle rhythm of the swirling strands of the taffy-blond hair is carried across the picture by the wind-blown drapery of the nymph and stabilized by the vertical trees at the right.

The panel representing Venus and Mars [14.7] in the National Gallery, London, was apparently painted to commemorate the famous tournament referred to above in which Giuliano de' Medici and Simonetta Vespucci were the romantic principals and received popular acclaim. The panel is long and narrow, being much wider than it is high. The nude form of young Mars is stretched out at the right, his limbs relaxed, his head thrown back, in deep sleep after the exhaustion of the joust. Venus, clothed, reclines at the

left and smiles at the lassitude of her lover. A group of baby satyrs glee-fully start to carry off the lance and armor of the unconscious god of War. Botticelli's sureness and beauty of line is ably demonstrated, especially in the rendering of the figure of the young god.

The popular romance came to a sudden end when Simonetta died of tuberculosis in 1476. Two years later Giuliano was assassinated in a plot against the Medici. A rival family, the Pazzi, jealous of the power of the Medici, had planned to liquidate Lorenzo and his brother Giuliano in dra-matic circumstances. The date was April 26, 1478. The place was the ca-thedral of Florence. The signal for the assassination was the elevation of the Host during the Mass. The Pazzi hoped to seize the power during the resulting confusion. Though Giuliano was killed, Lorenzo was rushed by friends into the sacristy of the cathedral, and eventually the plotters were seized and the rebellion put down. The perpetrators were hanged from the walls of Florence.

A picture which in all probability commemorates this event is Botti-celli's Minerva and the Centaur, now in the Pitti Palace, Florence. Minerva, the goddess of Wisdom, stands holding the Centaur, who symbolizes fool-ishness, by his hair as a sign of her domination over him. Since the Medici used the figure of Minerva frequently as a device, and since the Italian word for fools or crazy individuals is *pazzi*, the picture seems to be a fitting al-legorical epilogue to the abortive attempt of the Pazzi rebellion. Botticelli had also been commissioned to paint the figures of the executed rebels on the outer faces of the walls of Florence.

An important social event in Florence in 1486 was the marriage of the patricians Lorenzo Tornabuoni and Giovanna degli Albizzi, which Botticelli was commissioned to commemorate in two frescoes in the Villa Lemmi. He chose as his theme allegorical portraits of the bride and bridegroom. In the one Lorenzo Tornabuoni is being received by the seven Liberal Arts, in the other Giovanna degli Albizzi is being presented to Venus by the Three Graces. We have previously noted that these Arts and Graces had been used by Piero della Francesca on the reverse of the portraits of the Duke and Duchess of Urbino. Apparently it was a form of flattery acceptable to noble and patrician patrons to have the husband represented as a man of culture and learning and the wife as a paragon of beauty and love.

The Villa Lemmi frescoes, considerably damaged, are now in the Louvre, but Botticelli's ability with line is still amply evident, particularly in the heads and forms of the three Graces and of Giovanna.

Religious Paintings

When, in 1481, Pope Sixtus IV summoned to the Vatican the outstanding painters from Florence and Umbria to decorate the walls of the Sistine chapel, newly built and bearing his name, Botticelli was placed in charge of the project. His Sistine frescoes will be considered in a later chapter.

14.8. BOTTICELLI: Illustration for Dante's *Inferno*, Canto XIV (1485–1495). Ink drawing. Kupferstichkabinett, Berlin

What is important to us here is that as the result of his preoccupation with religious subject matter for the decoration of the Sistine chapel, Botticelli again interested himself in painting Christian subjects.

As we have seen in the Birth of Venus, Botticelli's conscience had not been entirely at ease when he was painting pagan subjects. Perhaps he reread his Dante with the graphic descriptions of Hell, Purgatory, and Paradise. At any rate he undertook to illustrate the *Divine Comedy*.

These illustrations of the Dante classic are without question among the finest accomplishments in line of all times. In them Botticelli achieves remarkable effects of texture, movement, and form found in the vivid descriptions of Dante's poem, for example the impassable and poisonous tangle of thorny bushes mentioned in Canto XIII of the *Inferno*, or the flinty, jumbled rocks descending into one of the circles of Hell, and the slither of the snakes as they attack their victims, described in Canto XIV [14.8]. Most remarkable of all is the effect of the complete dematerialization of the forms of Dante and Beatrice as they are drawn through space into the Seventh Heaven (Canto I of the *Paradiso*) like rays of sunshine passing through water without disturbing it [14.9].

Two of Botticelli's most famous Madonnas are the Madonna of the Magnificat and the Madonna of the Pomegranate, both in the Uffizi and

14.9. BOTTICELLI: Illustration for Dante's *Paradiso*, Canto I (1485–1495). Ink drawing. Kupferstichkabinett, Berlin

both painted after he began his work in the Sistine chapel. For both, he chose the tondo form but adapted his designs to the round frame differently. In the Madonna of the Magnificat [14.10], the bend of the Madonna's head and the positions of the Christ child and attendant angels given curvilinear accents that for the most part are parallel to the circumference of the circular frame. In the case of the Madonna of the Pomegranate [14.11] the grouping is such as to produce a conical design, with the head of the Madonna at the apex and the angels forming a circle at right angles to the frame. Both compositions are justly famous for the beauty of the faces, for the hands, and for the hair created by Botticelli's expressive line. Both Madonnas have extremely sensitive faces conveying a hyperwistfulness noted previously in the face of the Venus. It is as though the Madonna had foreknowledge of the fact that her Son would one day suffer death upon the cross. Or is it that Botticelli is worrying about his own soul as well?

There is in the Uffizi another, more monumental Madonna. She is enthroned and attended by four angels and six saints. The beginnings of despair are even more sharply etched in her face than in the two Madonnas just mentioned, but what beauty of line in the faces and hands of the angels holding the curtains of the canopy!

14.13. BOTTICELLI: Pietà (c. 1496). Panel painting, 55¼″ x 81⅝″. Alte Pinacothek, Munich

The most emotionally disturbed of all these late religious pictures is the Pietà [14.13], or Lament over the Body of Christ, in the Alte Pinacothek Museum at Munich. The rigid form of a youthful, beardless, and Adonis-like Christ lies across the lap of the Madonna gone limp in a faint against the shoulder of St. John who supports her and the cloth beneath Christ's body. Two of the three other Marys bend hysterically over the head and feet of the dead Saviour. The third, holding the three nails of the Passion, leans solicitously toward the Madonna and, together with the St. John, form a parenthesis in design enclosing the figure of the suffering Mother of God. St. Peter stands in silent withdrawal to the right, while to the left St. Jerome as an anchorite and St. Paul with his sword mystically become part of the mourning group. The effect, however, is rather the opposite of the mysticism found in Fra Angelico's paintings, where unity with God and the state of happiness and bliss are postulated. Here, beginning with the design that suggests the falling apart of the petals of a rose, the effect is one of desperation and hopelessness, the reflection of Botticelli's own fear of damnation. Remarkable in this picture in spite of its hectic Christian content is the survival of Botticelli's Neoplatonism in the representation of the ideal, youth-

14.12. BOTTICELLI. Coronation of the Virgin (*c.* 1490). Panel painting, 149″ x 101¾″. Uffizi, Florence (Anderson)

are many beautiful details in the picture, particularly in the groups of the angels. One angel face seen behind the golden rays of heaven has extraordinary appeal in its beauty.

In a panel in the Metropolitan Museum in New York, representing the Last Communion of St. Jerome, the exaggerated poses seen in the Coronation of the Virgin are repeated. The aged and dying saint reaches almost desperately for the holy wafer that will assure him of salvation.

The Allegory of the Cross in the Fogg Museum at Cambridge, Mass., was also painted under the influence of Savonarola. It seems almost the direct result of the famous sermon of 1491, for in the background is the city of Florence. A storm is approaching from the right and a fork of lightning strikes at the dome of the cathedral. In the foreground is the Crucified. A female figure, like a Magdalen, has thrown herself to her knees and desperately clutches the feet of Christ while an angel with a sword points to Christ and to the happenings in the background.

In the year 1489 the monk Savonarola appeared on the scene in Florence. He began his sermons in 1491, attacking the luxuries and vanities of life and prophesying doom to come, in the church of the monastery of San Marco where he dwelt as a member of the Dominican community. His attacks were directed against the Neoplatonic humanists who included Lorenzo de' Medici and the most brilliant minds and artists of Florence. The effect of his preaching was tremendous. The crowds could not be handled at San Marco so he moved to the pulpit of the *duomo*. Eventually there was formed a group of adherents to his cause who were known as *piagnoni* (snivelers) because they went about with long faces predicting and fearing destruction and hell.

In 1492 Savonarola preached a startling sermon, beginning with the words, "Behold the sword of the Lord that soon and swiftly will descend upon Florence." Shortly after, the *duomo* in Florence was struck by lightning, and in the same year the great Lorenzo de' Medici died. (Lorenzo had been interested in the sermons of Savonarola and had had him called to his deathbed.) About the same time French armies invaded Italy and brought with them the confusion that was to reign in Italy for many years. As for Florence, the glorious reign of the Medici was momentarily brought to an end. Savonarola had gained great prestige from the fulfillment of his prophetic utterances and from Lorenzo's last act. In 1496 he took political control of the city and staged the famous Bonfire of the Vanities in which many works of art were destroyed as the result of the fanaticism of the mobs. His reign, however, was short-lived. Charges were brought against him; he was deserted by the Church, and finally met his death at the stake in 1498.

The sensitive and temperamental Botticelli, always emotionally unstable, had been an ardent adherent of the cause of Savonarola. The neopagan movement had appealed to him because of its restatement of the ideal of physical beauty and its general appeal to the imagination. We have seen how he indulged in the representation of ideal beauty poetically expressed. But he had never abandoned his Christian belief—perhaps like many another Neoplatonic Christian (such as the philosopher Ficino) he hoped that Platonism and Christianity might be blended—and his emotional insecurity at this time has been noted in the expression painted into the face of Venus and the contemporary Madonnas. Then came Savonarola with his thunderings against the pagan taste and his threats of damnation and hell-fire. Botticelli was sent into an emotional tailspin.

His state of mind is reflected in a number of paintings done while under Savonarola's influence. In the large Coronation of the Virgin [14.12] in the Uffizi, the Virgin in the upper part of the picture bends over to receive the crown from Christ's hands in an exaggerated movement of submission. The angels whirl about them in an excited circle. In the lower register are Saints John the Evangelist, Augustine, Jerome, and Eligius. At the left St. John is pointing dramatically to the Coronation, like an apocalyptic counterpart of the preaching friar. In spite of the disturbed emotional undercurrent, there

14.10 (*right*). BOTTICELLI: Madonna of the Magnificat (*c.* 1485). Panel painting, 44″ dia. Uffizi, Florence (Anderson)

14.11 (*below*). BOTTICELLI: Madonna of the Pomegranate (*c.* 1487). Panel painting, 56¾″ dia. Uffizi, Florence (Anderson)

14.14. BOTTICELLI: Nativity (1500). Panel painting, 42½" x 28⅜". National Gallery, London (Anderson)

ful, and beardless form of Christ that goes counter to the traditional representations of the Saviour. Castagno, however, had used a youthful representation of Christ in the frescoes of the Crucifixion, Deposition, and Resurrection in Sant' Apollonia in Florence (see page 231).

We can only imagine the further shock to Botticelli's emotions at the public execution of Savonarola as a heretic and a fraud. But we have direct evidence of his state of mind in the year 1500 after a certain Doffo Spini had confessed to him that the charges against Savonarola had been concocted and that the monk had been sincere to the end, whereupon, Botticelli painted the Nativity [14.14], now in the National Gallery, London, that is full of excitement and joy. The Madonna, set in the middle distance, kneels in rapture before the Christ child lying in the straw of the manger. A ring of angels, resembling those of Fra Filippo at Spoleto or Botticelli's own angels in the Coronation of the Virgin, dance in the sky above the shed in which Christ was born. In the immediate foreground, angels are embracing several *piagnoni* who apparently have arrived in Paradise. At the right the devil lies bound in chains. Botticelli adds a long inscription at the bottom of the picture:

> This picture I, Alessandro, painted at the end of the year 1500 during the trouble in Italy in the half-time after the time which was prophesied in the 11th of John and the second woe of the Apocalypse when the devil was loosed upon the earth for three years and a half. Afterward he shall be put in chains according to the 12th woe, and we shall see him trodden under foot as in this picture.

Interestingly the joy apparent in this picture is not the simple childlike bliss encountered in Fra Angelico's heavenly creatures but has a hectic emotional flavor resembling that present in the reunion of persons who had given each other up as lost forever.

So we see in Botticelli the example of a fifteenth-century Christian trying to adjust himself to the Neoplatonic culture of the day but forced by his own conscience to return to the Christian fold through fear of losing his soul. Botticelli was, however, the first Italian artist of that century to paint an ideal of beauty according to Classic concepts.

BIBLIOGRAPHY

Ady (Cartwright), J. M. *The Life and Art of Sandro Botticelli.* New York, E. P. Dutton & Company, 1903, also Rand, McNally & Co. ed., New York, 1915.

Horne, H. P. *Alessandro Filipepi, Commonly Called Sandro Botticelli, Painter of Florence.* London, G. Bell & Sons, 1908.

Bode, W. *Sandro Botticelli,* trans. by F. Renfield and F. L. Rudston Brown. New York, Charles Scribner's Sons, 1925.

Yashiro, Y. *Sandro Botticelli,* 3 vols., text and plates. London, Medici Society, 1925; one-volume edition, *Sandro Botticelli and the Florentine Renaissance,* Boston, Hale, Cushman and Flinth, 1929.

Venturi, L. *Botticelli.* New York, Oxford University Press, 1937.

Batard, Y. *Les Dessins de Sandro Botticelli: La Divine Comédie.* Paris, O. Perrin, 1952. (For illustrations of Botticelli's drawings for Dante's *Divine Comedy*)

Chastel, A. *Botticelli.* Greenwich, Conn., New York Graphic Society, 1958. (Color plates)

◆ 15

Ghirlandaio and Filippino Lippi

~~~~~~~~~~~~~~~~~~~~~~~~~~~~~~~~~~~~~~~~~~~~~~~~~~~~~~~~~~~~~~~~~~~~~~~~~~~

## Domenico Ghirlandaio

Of all his contemporaries, Domenico Ghirlandaio (1449–1494) gives us the best picture of Florentine society at the high moment of its culture in the last quarter of the fifteenth century. He depicts with great fidelity the luxury of patrician palaces and the refinement and good breeding of the people who lived in them. His portraits are the most elegant of the period. His religious paintings, set in contemporary Florentine surroundings and filled with contemporary personalities, are rendered with such technical excellence and beauty of design that their religious content becomes a matter of secondary interest. Often his figures are aware only of themselves, their fine surroundings, and their social importance; and their calm dignity is not disturbed by any flights of fancy or expressions of emotion by the artist. An excellent example is the fresco panel of St. Jerome [15.2] in the Ognissanti, which we shall consider shortly. Yet Ghirlandaio's developed style has a definite charm and a delightful quality in its cool emotional aloofness.

The two frescoes in the small chapel of Santa Fina in the Collegiata at San Gimignano, painted about the year 1475, have never failed to captivate those who take the trouble to pay them a visit. According to the story, the beautiful young saint from San Gimignano had been warned by her mother never to pay any attention to the advances of young men whom she might meet in public. One day as she was strolling across the square accompanied by her duenna, a handsome youth, impressed by her beauty, presented her

15.1. DOMENICO
GHIRLANDAIO: The
Funeral of Santa
Fina (*c.* 1475).
Fresco. Chapel of
Santa Fina, Collegi-
ata, San Gimignano
(Alinari)

with a pomegranate. She accepted it, but on the way home repented of her act of disobedience. Shortly after she was stricken with paralysis and had to lie stretched out on a plank unable to move, enduring the gnawing of rats and mice on her body. To add to her misery her mother died suddenly and left her to the tender mercies of her nurse and a kindly neighbor.

The first of the two frescoes in the handsome small chapel, whose altar is adorned by the delicate sculpture of Benedetto da Majano, shows the saint, prone on her plank, attended by her two faithful friends. She perceives in a vision the figure of Pope Gregory the Great who urges her to have patience in her suffering, reminds her that he too had submitted to physical trials, and promises her a speedy release in death. Her companions seem conscious that something strange is happening. She died on Gregory's feast day, and in the second fresco on the opposite wall is her funeral ceremony [15.1], at which a small blind boy is miraculously cured by touching his eyes to Santa Fina's feet. The problem of designing the lunette is beautifully solved by horizontal accent of the bier, by the vertical lines of the attendant figures, of pilasters of the apse and of the towers, and by the semicircular curve of the apse itself. The varying heights of the towers in the background, for which San Gimignano is still famous, make an effective transition from the vertical accents to the curvilinear ones by their festooned rhythm. The figures in the foreground around the recumbent saint recall Fra Filippo Lippi's composition in the Funeral of St. Stephen [13.8] at Prato.

Ghirlandaio's dependence on Fra Filippo's style in his early paintings is also observable in other works, such as the fresco of the Madonna of Pity in the church of the Ognissanti, made for the Vespucci family. One of

15.2 (*left*). Domenico Ghirlandaio: St. Jerome in his Study (1480). Fresco. Ognissanti, Florence (Alinari)

15.3 (*right*). Sandro Botticelli: St. Augustine in his Study (1480). Fresco. Ognissanti, Florence (Alinari)

the younger members of this family represented in the fresco may well be Amerigo Vespucci after whom the continents of North and South America were named. The Deposition below it, added somewhat later, however, shows a style that in its harshness resembles the work of Andrea del Castagno. A third influence in Ghirlandaio's style, as was true also of Botticelli's, came from the master Verrocchio whose shop at that time was one of the most important in Florence. The heavy-lidded eyes, the domed forehead, the small chin of the Virgin present in a series of Madonnas at this time (of which one in Sant' Andrea at Brozzi is an example), the heavily modeled terracottalike body of the Christ child, and the elegantly posed hands of the saints —all are found in the works of Verrocchio and his school.

After working at San Gimignano, Ghirlandaio made his first trip to Rome in order to undertake some decorations for Pope Sixtus IV in the Sala Latina of the Vatican library. These consisted chiefly of bust figures of pagan philosophers and Church fathers.

Back in Florence, Ghirlandaio was again painting for the Vespucci family in the church of the Ognissanti in 1480. Here he painted in fresco the Early Christian Church father St. Jerome [15.2] in the guise of

15.4. DOMENICO GHIRLANDAIO: The Last Supper (1480). Fresco. Ognissanti, Florence (Alinari)

a Florentine patrician humanist seated in the midst of his elegantly furnished library-study writing his translations of the Bible with calm concentration. The details of the Oriental rug on the table, the manuscripts on the shelves, the eyeglasses, the scissors, and other paraphernalia are rendered in the meticulous manner of a Flemish artist. As a companion piece, but also in competition with Ghirlandaio, Botticelli had painted the figure of another Church father, St. Augustine [15.3]. The contrast is striking. Botticelli is not concerned at all with the minutiae of setting but depicts St. Augustine as an inspired mystic filled with emotional fire.

At the same time (1480) Ghirlandaio was busy with the fresco of the Last Supper [15.4] in the refectory of the Ognissanti. It is an interesting and important transitional painting of this subject between the earlier composition by Castagno [11.12] and the later one by Leonardo da Vinci [19.10]. Although the figures of the apostles still retain some of Castagno's rigidity, their emotional reaction to Christ's words anticipates Leonardo's psychological organization of the situation. Peter has even drawn a knife as if to threaten Judas on the other side of the table. Ghirlandaio also anticipates Leonardo in painting the scene as though it were taking place on a raised open loggia at the end of the refectory. The setting has a patrician richness

in its tiled floor, fine damask tablecloth, the glassware on the table, and the view through the open arches into the tops of trees of a landscaped garden among which falcons and other birds are flying.

In 1481–1482 Ghirlandaio was among those artists called to Rome to decorate the walls of the Sistine chapel. He was to paint several of the popes' portraits in the window zone, and also the scene of Christ Calling the Apostles [17.3] in the main series of the life of Christ. This scene will be mentioned again when we consider the whole cycle of the decorations of the Sistine chapel walls. Here we call attention to Ghirlandaio's use of the river valley and the stream flowing down from the background to the foreground directly behind the central figure of Christ. This background device is characteristic of Ghirlandaio and was inherited from the tradition stretching back through Antonio Pollaiuolo and Baldovinetti to Domenico Veneziano.

Ghirlandaio's most monumental achievements in fresco painting were those in Santa Trinità and in Santa Maria Novella in Florence after his second return from Rome.

Francesco Sassetti, a Florentine banker and representative of the Medici interests in Avignon and Lyon, and whose family had long been associated with the Dominican church of Santa Maria Novella, wished to have frescoes painted there with scenes from the life of his patron saint, Francis. This idea was met with strenuous objections from the Dominicans, the rival order of the Franciscans. The up-shot was that Sassetti transferred his interest to the church of the Trinità and commissioned Ghirlandaio to decorate the small chapel to the right of the crossing with scenes from St. Francis' life [15.5]. All but one of the six episodes represented, two to each of the three walls, had been used earlier by Giotto at Santa Croce: Francis renouncing his father's Wealth; the Granting of the Rule by Pope Honorius III; the Trial by Fire before the Sultan of Morocco; St. Francis Receiving the Stigmata; and the Funeral of the Saint. The sixth was one of the miracles ascribed to him, the reviving of the Spini child. In all these scenes, with the exception of the Stigmata, the major episode is almost lost in the midst of all the local contemporary personalities brought in on the sidelines. Most of the backgrounds too are local. In the Granting of the Rule, the Piazza della Signoria acts as the background, while Lorenzo de' Medici, his young sons and their tutor Poliziano, and other friends occupy the foreground. In the Miracle of the Spini Child, the present Via Tornabuoni with the church of the Trinità and the bridge of the Trinità make up the background. In the vaults above are the four Classical sibyls as prophetesses of the coming of Christ.

For the altar of the chapel Ghirlandaio was commissioned to paint the panel with the Adoration of the Shepherds [15.6]. To right and left of the altar the portraits of the kneeling donor and his wife are painted in fresco. Below them is the dedication date, December 25, 1485. The altarpiece, which also bears the date 1485, calls for attention because of a number of interesting features: the Virgin kneeling in adoration before the Child after the

15.5. Domenico Ghirlandaio: Over-all view of the Sassetti chapel frescoes (1485). Santa Trinità, Florence (Soprintendenza). Above the altarpiece is the Miracle of the Spini Child and at the top, the Granting of the Rule

15.6. DOMENICO GHIRLANDAIO: Adoration of the Shepherds (1485). Panel painting, 65¾" x 65¾". Sassetti chapel, Santa Trinità, Florence (Alinari)

fashion set by Fra Filippo; the troop of the Magi recalling the winding processions of the International Style; the Classical sarcophagus as manger—surely a reminiscence of Ghirlandaio's stay in Rome; and, finally, the shepherds at the right. These shepherds with their gnarled hands and realistic faces were definitely influenced by those appearing in the altarpiece of the Adoration of the Christ child by the Flemish painter Hugo van der Goes that had been set up in the chapel of the hospital of Santa Maria Nuova in Florence in the late 1470's. It had been commissioned about 1475 by the Medici agent in Bruges, Tommaso Portinari, who had it sent to his native city where it caused a great stir among local painters.

The second great fresco commission undertaken by Ghirlandaio in the 1480's was the decoration of the choir of Santa Maria Novella. The contract with the donor, Giovanni Tornabuoni, was signed in the fall of 1485 and the work finished by May 1490. Leaks in the roof over the choir had ruined the earlier frescoes of the Life of the Virgin by the fourteenth-century artist Orcagna (p. 169), and after much dickering the great Florentine patrician finally arranged for the restoration of the choir and for its redecoration.

The wall areas to right and left were divided by Ghirlandaio into six rectangular sections in three tiers of two's and surmounted by a pointed

15.7. DOMENICO GHIRLANDAIO: The Birth of the Virgin (1486–1490). Fresco. Choir, Santa Maria Novella, Florence (Alinari)

lunette. One section was separated from the next by a painted pilaster. On the left wall were the scenes from the life of the Virgin: her Birth [15.7], her Presentation in the Temple, the Betrothal, the Adoration of the Magi, the Massacre of the Innocents, and, in the lunette, her Death and Assumption. Balancing these on the right wall were the scenes from the life of St. John the Baptist, the patron saint of Florence: the Appearance of the Angel to Zaccharias; the Visitation; the Birth of St. John; St. John Preaching in the Desert; the Baptism of Christ; and, in the lunette, the Feast of Herod and Salome's Dance. In the cross vaults over the choir are the usual four evangelists seated on clouds with their symbols.

Into these frescoes Ghirlandaio crowded as much of Florentine patrician elegance as possible. In almost every scene, along the sidelines, Florentine contemporaries are present. In the scene of the Angel appearing to Zaccharias there are so many bystanders that the event from the New Testament story is practically smothered—although, according to the story, Zaccharias and the angel were alone in the temple. Even the Florentine patrician ladies make their appearance for the first time here in the birth scenes of the Virgin and St. John the Baptist (where the ladies come in as the congratulating friends) and also in the Visitation scene. Each group is headed by an important lady of the Tornabuoni family, as, for example, Giovanna Tornabuoni in the Visitation scene. This profile is also known from the portrait formerly in the Morgan Library in New York and now in the Thyssen collection, Lugano.

15.8. DOMENICO GHIRLANDAIO: The Adoration of the Magi (1488). Panel painting, 112⅜" x 94¼". Innocenti, Florence (Alinari)

The elegance of the interior of Florentine palaces is reflected in the birth scenes, especially in the Birth of the Virgin [15.7] where the room is decorated with delicate intarsia panels and stone carving. Fragments of Classical sarcophagi with playful putti are set in the frieze, the one on the back wall serving as a repeat in the middle distance for the processional group in the foreground. The outdoor scenes are mostly set against arcades or loggias through which vistas of streets and squares are afforded. In the Massacre of the Innocents and in the Adoration of the Magi are reminiscences of Classical architecture recalling Ghirlandaio's visits to Rome.

During the period when he was at work on these frescoes, Ghirlandaio was also active with panel painting. It will suffice to mention one of his most famous accomplishments: the altarpiece of the Adoration of the Magi [15.8], painted for the Hospital of the Innocenti (the Foundlings) in Florence. The characteristic river-valley background is seen through the openings and at the sides of the manger with elegantly curved pilasters. Shepherds, in Flemish fashion, look in at the main scene from across the manger wall. The Virgin and Child, well-centered between the ox and the ass and small groups of Florentines, receive the gifts and homage of the Magi. The two Sts. John

15.9. DOMENICO GHIRLANDAIO: Portrait of Old Man and Boy (*c.* 1490). Panel painting, 24⅜″ x 18⅛″. Louvre, Paris (Alinari)

in the foreground each present to the Holy Family the tiny figure of a martyred Innocent with glowing rayed haloes about their heads. The picture is dated 1488.

To this period also belong several of Ghirlandaio's best-known portraits, the one of Giovanna Tornabuoni already mentioned, the one of Francesco Sassetti and his son in the Bache Collection in New York, and the charming portrait in the Louvre of the Old Man [15.9] whose large nose is covered with "rum blossoms" and who is receiving an eager greeting from his very young grandson or pupil.

## Filippino Lippi

The career of Filippino Lippi, the son of Fra Filippo and Lucretia Buti, can be followed rather easily both from documents and from dated monuments. Born at Prato in 1457/8, he apparently went to Spoleto with his father, who worked on the cathedral frescoes there from 1466 until he died in 1469. Consequently, at a very tender age, Filippino received his grounding in the art of painting from his famous father. He must then have attached himself to Botticelli, for in the records of the Guild of St. Luke in Florence for the year 1472 Filippino is mentioned as painter with Sandro Botticelli. Although there are no dated paintings by his hand extant before 1483, it seems possible that some of the works given by Berenson * to the anonymous *Amico*

---

* Bernhard Berenson: *Italian Pictures of the Renaissance.* Oxford, 1932.

15.10. FILIPPINO LIPPI: The Angel of the Annunciation (1483–1484). Panel painting, 43½″ dia. Museum, Town Hall, San Gimignano (Anderson)

*di Sandro,* "Friend of Sandro," are by Filippino. The Tobias and the Three Angels in Turin and a small group of Madonnas (for example, the one in the Hermitage at Leningrad) in which the walled-in garden used by his father appears seem to belong to this early period.

When in 1481 Botticelli, together with other artists including Ghirlandaio and Perugino, was summoned to Rome to decorate the walls of the Sistine chapel, Filippino must have stayed behind in Florence to carry on the work on frescoes begun by Perugino in the Palazzo della Signoria. In 1483 he was at San Gimignano, where he painted the charming Annunciation in two tondi, one containing the Angel Gabriel [15.10] and the other the figure of the Virgin. It is interesting to note that Filippino has split the scene of the Annunciation into two separate tondi to adorn the wall. The splitting of this scene is frequently found in gables, pinnacles, or even in small roundels of fourteenth- and fifteenth-century triptychs and altarpieces, but its use in more monumental tondi, as here, seems to be an innovation. The bits of still life and the view out the window in these tondi indicate Filippino's acquaintance with Flemish paintings.

In 1484 he returned to Florence to finish the frescoes in the Brancacci chapel of the Carmine that the death of Masaccio in 1428 had left uncompleted. In the meantime, the Brancacci family had suffered political difficulties. Francesco was exiled in 1434, and the ban was not lifted until 1474. Masaccio had been working on the lower tier of frescoes on the left wall of the chapel at the time he died. He had finished the St. Peter Enthroned

15.11 (*left*). FILIPPINO LIPPI: St. Peter delivered from Prison (*c.* 1485). Fresco. Brancacci chapel, Carmine, Florence (Anderson)

15.12 (*above*). FILIPPINO LIPPI: The Vision of St. Bernard (*c.* 1486). Panel painting. Badia, Florence (Alinari)

and a portion of the contiguous scene of St. Peter and St. Paul raising the son of Theophilus. This scene Filippino now finished, as well as the scenes of SS. Peter and Paul before the Proconsul and the Crucifixion of St. Peter along the lower tier of the opposite right wall. He also filled in the space below the Temptation and the Expulsion [10.11, 10.12] with the episodes of St. Peter in Prison and St. Peter delivered by the Angels [15.11]. The subjects must all have been part of Masaccio's original scheme of decoration.

One of Filippino's most popular paintings of this period is the Vision of St. Bernard [15.12], now in the Badia in Florence. In this panel the Virgin, accompanied by a group of charming angels, appears to St. Bernard to give him strength to carry on his labors in writing. In addition to the appealing angel types that take such a lively interest in what is going on, the sensitive interrelation of the hands of the Virgin and the saint in the center of the picture is worth special attention. The landscape background again suggests Filippino's knowledge of contemporary Flemish pictures.

Another altarpiece [15.13] painted at this time is the one made for the Nerli family for their chapel in Santo Spirito, Florence, in which the donor and his wife are presented to the Madonna and Child and baby St. John the Baptist by SS. Martin and Catherine of Alexandria. The Madonna is enthroned in an open loggia with arabesque pilasters surmounted by putti. Through the open arches one glimpses a street scene in Florence with the Palazzo Neri at the right and a distant mountain at the left. Once more we seem to have a reflection of Flemish usage in the treatment of this background.

During the late 1480's and early 1490's Filippino was occupied with two important fresco projects. One was the decoration of the Caraffa chapel in Santa Maria sopra Minerva in Rome; the other was the frescoes in the Strozzi chapel in Santa Maria Novella in Florence.

In the frescoes in the Caraffa chapel, Filippino gives ample evidence of his creative ability and produces an emotionalized style that is present in most of his later works. In the cross vault over the chapel he painted the four sibyls instead of the more usual four evangelists so frequently used by other painters in similar cross vaults. The treatment of these sibyls was most unusual. Only one of them is placed frontally. The other three are in twisted, sidewise, reclining postures and are attended by angels and putti, forecasting the sibyls as represented later by Michelangelo in the Sistine ceiling or by Raphael in Santa Maria della Pace in Rome. It seems also possible that Filippino was influenced, as others have suggested, by the figures in bronze of the Liberal Arts on the tomb of Pope Sixtus IV, on which Antonio Pollaiuolo was working at about this time.

Over the altar of the Caraffa chapel Filippino painted an Annunciation, giving it the appearance of a panel-altarpiece. Flanking it are two groups of apostles as part of the scene of the Assumption of the Virgin in the lunette, above which is the main feature of the chapel frescoes. In this Assumption the Virgin is encircled by jubilant angels recalling Fra Filippo's fresco at Spoleto or Botticelli's Coronation of the Virgin [14.12] in the Uffizi. But the foreshortening of these angels, their musical instruments, and the illusionistic architectural features seem to indicate that Filippino was also familiar with Melozzo da Forli's fresco of the Ascension with its musical angels [16.19] painted in the church of the SS. Apostoli in Rome a short time before. The puffy swirling draperies used by Filippino in both the cross-vault sibyls and in the Assumption scene add considerably to the emotional excitement that pervades these frescoes.

The east wall of the Caraffa chapel contained a Triumph of the Virtues over the Vices, but this fresco was destroyed to make room for the tomb of Pope Paul IV in the sixteenth century.

The two west-wall frescoes were dedicated to St. Thomas Aquinas. The upper one illustrates the Miracle of the Crucifix [15.14] in which St. Thomas, kneeling before the crucifix, heard the voice of the Crucified commend him for his labors on behalf of the faith. The left-hand section of this fresco, in which the kneeling saint is shown accompanied by angels, is one of Filippino's most effective emotional passages in painting. The lower fresco is the scene of St. Thomas' triumph over the heretics. One thinks back to the earlier treatment of this subject in the fourteenth-century Spanish chapel in Santa Maria Novella in Florence (p. 173). But what a difference in the treatment of space elements since that earlier time. Filippino's treatment of space anticipates Raphael's performance in the *Disputà* fresco [21.8] in the Vatican Stanze. There are other rather startling details in this lower fresco, such as the figures on the balconies at the right of the St. Thomas fresco which are all the world like those to be used by Paolo Veronese a century later.

All through these frescoes in the Caraffa chapel Filippino's style shows the effect of Rome and its monuments—in the profuse use of the "grotesque" arabesques in the decoration of the painted pilasters throughout (so much in fashion with the Umbrian painters, see pages 306–324) and also in the views of the houses of Rome through the loggias in the St. Thomas frescoes. In the one to the left in the Triumph fresco can be seen the equestrian statue of Marcus Aurelius when it was still in the Lateran area.

Filippino's second fresco project was the decoration of the Strozzi chapel in Santa Maria Novella, Florence. He had contracted for this work with Filippo Strozzi before he went to Rome, and Strozzi graciously allowed the many interruptions caused by the Roman project. The first contract was in 1487. Work, however, was not begun until 1489 but was interrupted almost immediately. Filippo Strozzi died in 1491. After further delays the chapel was finally consecrated in 1493, but payments to Filippino continued in 1494 and 1500. An inscription gives the date of completion as 1502.

15.14 (*above*). FILIPPINO LIPPI: The Miracle of the Crucifix (1488–1493). Fresco. Caraffa chapel, Santa Maria sopra Minerva, Rome (Anderson)

15.15 (*below*). FILIPPINO LIPPI: St. Philip exorcising Dragon (1489–1502). Fresco. Strozzi chapel, Santa Maria Novella, Florence (Anderson)

15.16. FILIPPINO LIPPI: Tabernacle with Madonna and Saints (1498). Fresco. Formerly on Strada Santa Margherita and now in the Museo Communale, Prato (Soprintendenza)

Filippino's frescoes in the Strozzi chapel are even more extraordinary than those in Santa Maria sopra Minerva in Rome, both as to the details of the decoration and as to the emotional restlessness of the figures. In the four-part vault he placed four patriarchs of the Old Testament: Adam, Noah, Abraham, and Jacob, each surrounded by putto heads and associated attributes. Classical decorative grotesques abound in borders and moldings.

On the north and south walls are two scenes each from the lives of St. John the Evangelist and of St. Philip, one scene depicting a miracle and the other the martyrdom of the respective saint. On the north wall the episode of St. John resuscitating Drusiana is shown. In the lunette above, the saint is being boiled in oil at the command of the Roman emperor Domitian. On the south wall St. Philip exorcises the dragon sacred to Mars in front of the statue of the god [15.15]. According to the legend the son of the king of Hierapolis had been killed by the noxious fumes issuing from the dragon's mouth and the saint had determined to put an end to the beast. The priests of Mars, however, used Philip's action as a pretext to have him crucified. In the lunette above this scene of exorcism, the cross bearing the saint is about to be lowered into the hole prepared for it by the executioners. On the entrance wall of the chapel, on either side of the window in the center, Filippino painted illusionistic architecture with personified virtues, angels, and other figures below the bases of the columns.

These frescoes in the Strozzi chapel show to what extent Filippino's imagination and fantasy were stimulated by the remains of Classical antiquity he had seen. But what he produced is not Classical. It is a strange mixture of Classical motifs and almost Savonarolian religious sentiment, and the decorative effect of something like the miracle of St. Philip [15.15] is almost rococo.

Three other works by Filippino should be mentioned. One is the rather turbulent Adoration of the Magi, contracted for in 1494 with the monks at Scopeto. This was to take the place of the Adoration that Leonardo da Vinci had contracted to paint in 1481 but had never finished (which now hangs in the Uffizi in its unfinished condition). Although Filippino's picture is in part influenced by Leonardo's design in the triangular composition of the Madonna and the kings in the foreground, the rough shelter of tree trunks all askew behind the Madonna, the almost northern landscape background, and the emotional excitement of the crowd about the Holy Family are quite at variance with Leonardo's mathematical order and serenity. In Filippino's Adoration, now in the Uffizi too, the figures and general atmosphere approximate what we saw in the two frescoed chapels in Rome and Florence.

A second work of this period is the famous frescoed tabernacle that stood at the corner of the Strada Margherita in Prato [15.16]. In this work Filippino returned to a more placid emotional form of expression. Here the Madonna stands erect and turns slightly toward the right in front of a festooned marble altar. The Christ child on her arm turns toward the spectator to bless with His right hand while fondling the small crystal orb of the world resting on His mother's right hand. Cherubs, hands folded in adoration, appear in a circle of clouds behind the Madonna's head. Two side panels, giving the tabernacle the form of a triptych, contain the figures of SS. Stephen and Catherine to the right and SS. Anthony the Abbot and Margaret at the left, the female saints kneeling in front of the male saints. This impressive work was broken to bits during an air raid on Prato during World War II. The pieces were carefully assembled by a local artist, reset in plaster, and now is to be seen in the Museo Communale at Prato.

Finally, mention should be made of Filippino's last work, the Descent from the Cross, commissioned for the church of the SS. Annunziata, Florence, in 1504. Filippino died suddenly of a throat infection that very year and the picture was finished later by Perugino. The portion finished by Filippino shows the same type of excited emotionalism we noted in his other late works. It is now in the Uffizi in Florence.

## BIBLIOGRAPHY

Davies, G. S. *Ghirlandaio*. New York, Charles Scribner's Sons, 1909.
Neilson, K. B. *Filippino Lippi*. Cambridge, Mass., Harvard University Press, 1938.
Scharf, A. *Filippino Lippi*. Vienna, A. Schroll, 1935, and 1950. (Plates, German text)
Lauts, J. *Domenico Ghirlandaio*. Vienna, A. Schroll, 1943. (Plates, German text)

# ⊸ 16

# The Umbrians

BEFORE the end of the fifteenth century, the region of Umbria, lying to the southeast of Tuscany, produced a number of painters, some of whom were outstanding figures in the development of Italian painting. We have already considered Gentile da Fabriano, the International Style artist whose influence was far-flung throughout Umbria, the Abruzzi, and the Marches. Of less importance at this time was Ottaviano Nelli, a native of Gubbio. His Madonna with angels and saints in Santa Maria Nuova at Gubbio has great charm both in composition and color. Otherwise his style is rather provincial and harsh.

An amazing series of frescoes was painted by an unknown artist of the International Style in the Palazzo Trinci at Foligno. Two rooms, a corridor, and the Hall of the Giants are covered with scenes from the legend of Romulus and Remus, personifications of the Liberal Arts and the Planets, the Seven Ages of Man, and huge figures of Classical, Old Testament, and Christian heroes. They constitute a rare document of early fifteenth-century secular painting. Many of the figures hold banderoles bearing inscriptions in French. Some areas of the frescoed plaster have fallen from the walls to reveal the preparatory sketches underneath. These have great vitality and freshness in the drawing of the figures and in the details of the naturalistic backgrounds.

In the third quarter of the century a delightful painter by the name of Benedetto Bonfigli (died 1496) was active in Perugia and vicinity. He painted banners and altarpieces in a style reflecting both Benozzo Gozzoli and Fra Filippo Lippi. Most characteristic are the Adoration of the Magi, the An-

306

nunciation [16.1], and the banner with the figures of Christ and St. Bernardino in the gallery at Perugia, and the frescoes of St. Louis in the Palazzo Pubblico of the same city. His angels with carefully coiffured blond ringlets and rose garlands set rakishly on their heads have great charm.

In the gallery at Perugia are also eight panels with scenes of miracles performed by San Bernardino [16.2]. They are the decorations of a cupboard in which the banners of the saints were stored. Who the artists were who painted them is not known, but they bear the date of 1473 and are productions of great elegance and distinction. The beautiful architectural settings of some hint at the influence of Piero della Francesca. It has been suggested that Fiorenzo di Lorenzo is the guiding spirit in these compositions assisted by his young pupils Perugino and Pintoricchio. The distinct landscapes with feathery trees resemble those we shall meet in the work of Perugino and Pintoricchio. The bystanders are for the most part young dandies dressed in the height of fashion and strike poses of sophisticated elegance, such as we have seen in the David by Pollaiuolo [11.17].

## Perugino

Certainly the most important Umbrian painter at the end of the fifteenth century was Pietro Vanucci (1445–1523), better known to us as Perugino. Although he lived and worked chiefly at Perugia except for his sojourn in Rome in the early 1480's, his influence was widespread. His most famous pupil was Raphael.

We have noticed how the compositions of paintings were becoming more and more crowded as the fifteenth century advanced, a phenomenon similar to that which had happened at the end of the preceding century. But in the fifteenth century this crowding was largely owed to a desire to put into the picture as many donors, prospective donors, and friends as possible. Perugino was aware of the compositional problems thus created and attempted to relieve the congestion, first, by eliminating all but the most essential figures and, second, by creating a far-distant background against which his figures were set. The figures themselves are usually brought well forward in the foreground and are rather monumental in scale. Behind them, an architectural feature, such as an archway or vault, leads the eye into a distant landscape, or else he has a landscape without architecture, flanked and dotted with feathery trees. Thus he made the backgrounds of his pictures act as a resonator, or loud-speaker, for the figures in the foreground. We can observe this in his well-known fresco of the Handing of the Keys to Peter on the walls of the Sistine chapel [17.4] (which we shall discuss in the next chapter), in the Pietà [16.3], and in the Madonna and Saints in the Uffizi and in the St. Sebastian in the Louvre. The most famous example is the Crucifixion [16.4] in the tiny chapel of Santa Maria Maddalena dei Pazzi in Florence, where the foreground is painted as an open loggia of three arches, as a part of the room itself, through which the Crucifixion and the

16.1 (*above*). BENEDETTO BONFIGLI: Annunciation (*c.* 1460). Panel painting, 90½″ x 78⅞″. Perugia Gallery (Anderson)

16.2 (*right*). SAN BERNARDINO MASTER: A Miracle of San Bernardino (*c.* 1473). Panel painting, 30½″ x 22½″. Perugia Gallery (Alinari)

distant landscape are seen. The number of figures in the composition is held to six: two to each of the three arches. Set well forward, they attain an extraordinary monumentality and simplicity that is accentuated by the stillness of the broad landscape behind them. The vertical, diagonal, and horizontal accents in the composition are subtly and delicately balanced.

In all his paintings Perugino established rather self-conscious rhythms by means of the poses of the figures—their tilted heads, the hands, legs, and feet—that carry the eye across and around the picture. We become progressively aware of the geometry of his designs, whether it is the simple verticals with a connecting festoon, as in the Uffizi Pietà [16.3], the pyramid in the Madonna of the Archangels in the National Gallery in London, or the cube set within a circle in the tondo with the Madonna and Saints

16.3 *(right)*. PIETRO PERUGINO: Pietà (1493–1494). Panel painting, 66¼″ x 67¾″. Uffizi, Florence (Alinari)

16.4 *(below)*. PIETRO PERUGINO: Crucifixion (1493–1496). Fresco. Santa Maria Maddalena dei Pazzi, Florence (Alinari)

16.5. PIETRO PERUGINO: Madonna and Saints (*c.* 1490). Tondo, panel painting, 59½″ dia. Louvre, Paris (Alinari)

[16.5] in the Louvre. He was very fond of using a double-decked and even a triple-decked composition, such as in the Resurrection of Christ in the Vatican Gallery or in the Assumption of the Virgin in the Uffizi. Other characteristics in these two pictures are the flying angels in curvelike posture carrying twisting banderoles floating from one level to another.

Perugino's frescoes on the walls and vaults of the Cambio (the bank) in Perugia are famous not only as predecessors in a small scale of Raphael's decoration of the Vatican Stanze, but also as results of a cooperation between a learned humanist and an accomplished painter. The subject matter for these frescoes was apparently suggested by Francesco Maturanzio, a professor of rhetoric and of Classical literature in the University of Perugia. In each of two wall lunettes beneath the vaults a pair of cardinal virtues, represented as personified, are placed in the upper level of the fresco. The figures of Classical "heroes" wearing fantastic helmets and headdresses are set beneath them and are examples, in antiquity, of the virtues in the upper level [16.6]. In a third lunette, God the Father surrounded by angels in the upper level is placed above the figures of six prophets of the Old Testament and six sibyls of antiquity. In two other lunettes the Adoration of the Shepherds and the Transfiguration are represented. In the ceiling vaults medallions with representations of the seven planets and the signs of the zodiac are surrounded with delicate arabesque ornaments composed of tritons, satyrs, centaurs, sirens, and other fantastic Classical creatures. Amid the arabesques on the wall we find the self-portrait of Perugino, illusionistically painted as though it were in a frame hanging by a chain from the wall. The date 1498 is above it. The decoration of the whole Cambio is an excellent reflection of the attempt so frequently made by Renaissance

16.6 (above). PIETRO PERUGINO: Fortitude and Temperance with Classical Representatives (1498–1500). Fresco. Cambio, Perugia (Alinari)

16.7 (right). PIETRO PERUGINO: Entombment (1495). Panel painting, 85⅛" x 76½". Pitti Gallery, Florence (Alinari)

humanists to blend the ideas and imagery of ancient culture with those of Christianity. Thus here the virtues of antiquity, the prophets and sibyls of the Old Testament and of the Classic past prefigure and foretell what is to come with Christianity.

Raphael, as we shall see, was also to use Perugino's beautiful Entombment of Christ [16.7], now in the Pitti Gallery in Florence, as the basis for the first designs for his own famous painting of the same subject [21.7] in the Borghese Gallery in Rome. In Perugino's picture in the Pitti the gestures and poses of the figures again give a special accent to the emotional content of the episode and the whole group is set off and emphasized by the typical far-distant Umbrian landscape. It is interesting to remark that the figures in Perugino's paintings with their long bodies, their heads with broad brows and small features are local Umbrian types still to be seen on the streets of Perugia.

Perugino lived to a ripe old age and was eventually eclipsed by the artistic giants active in Rome—Raphael and Michelangelo. But he continued working in Perugia in his established manner and even undertook to finish a fresco of the Trinity in San Severo in that city that had been begun and left unfinished by his pupil Raphael in the days of Raphael's high renown.

## Pintoricchio

Another pupil of Perugino, but much less gifted than Raphael, was Bernardino di Betto (c. 1454–1513), better known as Pintoricchio.* Perugino must have thought sufficiently highly of his talents, since Perugino took Pintoricchio to Rome on the Sistine chapel project and allowed him to paint several of the frescoes, as we shall have occasion to note in the next chapter. These were the episodes from the early life of Moses and the Baptism of Christ.

Pintoricchio's pleasing style brought him other commissions in Rome, the first being the frescoes in the church of the Aracoeli with episodes from the life of San Bernardino. His most important work in Rome, however, was the decoration of the apartment of Pope Alexander (VI) Borgia in the Vatican, where he frescoed five rooms. One contains the Assumption of the Virgin, scenes from the life of Christ, and the four evangelists. The second, the Room of Saints, has episodes from the lives of Susanna, Barbara, Anthony the Abbot, Paul the Hermit, and Catherine. Isis and Osiris appear in the ceiling fresco. In the third room, that of the Arts and Sciences, geometry, arithmetic, music, rhetoric, and grammar are represented as female figures enthroned and flanked by historical personalities active in these arts. The fourth room of Creeds contains the figures of prophets, and the fifth has representations of the sibyls and consequently is known as the Room of the

---

* The name is also spelled Pinturicchio and Pintorricchio.

16.8. Bernardino Pinto-
ricchio: Resurrection,
with Pope (1492–1495).
Fresco. Borgia apartments,
Vatican, Rome (Alinari)

Sibyls. In the first room, in the fresco of the Resurrection of Christ [16.8],
Pope Alexander VI is portrayed kneeling to the left of the sarcophagus from
which Christ has risen.

All these Vatican frescoes are painted in brilliant colors. Details of cos-
tumes, armor, the flowers and rocks in the background, haloes, and some-
times even the entire sky are embossed with dots of raised stucco covered
with gold leaf. The effect of the colors and the gold as eye-catchers com-
pensate for the softness and weakness of some of the figures. These frescoes
were begun in 1492.

Nine years later we find Pintoricchio decorating a chapel in the church
of Santa Maria Maggiore at Spello, which lies in the same valley as and
not far from Assisi. A member of the ruling family in Perugia, the Baglioni,
had recently been appointed bishop of Spello and consequently had the
popular painter from his home town decorate the chapel in question. The
three walls contain the Annunciation, the Nativity of Christ, and His Dis-
pute with the Doctors in the Temple. In the vaults of the ceiling are the
four sibyls on thrones similar to those in the Borgia apartments.

Pintoricchio's major accomplishment next in importance to the Borgia
decorations is in Siena. Francesco Piccolomini of the famous noble house of
Siena, who had been made a cardinal by his uncle Pope Pius II (Aeneas
Sylvius Piccolomini), commissioned Pintoricchio in 1502 to decorate the
walls of a newly constructed building adjacent to the chapel of St. John in
Siena cathedral. This building was to house the library of Pius II. The next
year, in September, the cardinal Francesco became Pope Pius III, but he

16.9 (*left*). BERNARDINO PINTORIC-CHIO: Aeneas Sylvius received by James I of Scotland (1503–1508). Fresco. Piccolomini Library, Cathedral, Siena (Alinari)

16.10 (*right*). BERNARDINO PINTORICCHIO: Madonna, enthroned, with Saints (1509). Panel painting. Sant' Andrea, Spello (Anderson)

died three months later. By that time Pintoricchio had completed only the ceiling decoration, but, according to his contract with Pius III, the latter's heirs had him continue to decorate the walls of the library. This consisted of a series of frescoes elaborating certain episodes from the life of Pius II [16.9]. These are seen through large arched openings painted illusionistically to resemble a loggia with marble revetment and arabesque decoration. All the action in the scenes is set against the typical Umbrian, or rather Peruginesque, distant backgrounds. The whole effect is quite stunning and is an excellent example of monumental wall decoration of the period.

In 1505, Pintoricchio returned to Rome to paint the ceiling of a chapel in Santa Maria del Popolo with figures of the evangelists, sibyls, and the four doctors of the Church. This was his last work in the Eternal City.

Of his panel pictures, a number of sweet Madonnas have survived, reflecting the charm already noted in his fresco figures. The enthroned Madonna in the Perugia Gallery and the Madonna in Sant' Andrea at Spello [16.10] are characteristic with their arabesque details on the throne and the glimpses of background in the distance. A Madonna and Child in the National Gallery, London, is representative of the more intimate type of half-length Madonnas. There is, as usual, a variety of detail, such as in the Oriental rug on the balustrade, in the flowers in the Madonna's hand, and in the trees and rocks of the distant landscape.

## Signorelli

A more rugged Umbrian painter, whose primary interest, like that of the great Florentines, was in the human form, was Luca Signorelli (1441–1523) of Cortona.

Piero della Francesca would appear to be the first master on whom Signorelli depended and from whom he got his interest in the heavy forms that he adopted. Later he was associated with the bottega of the Pollaiuoli in Florence. The Flagellation of Christ, now in the Brera Gallery in Milan, reflects these two sources of his early style.

We shall concern ourselves mainly with Signorelli's fresco painting. The earliest evidence of his activity in this medium is the scene of the Testament of Moses [16.11] on the left wall of the Sistine chapel. This will be discussed in the next chapter.

In the sacristy of the Santa Casa at Loreto Signorelli decorated the eight-part vault with seated figures of the evangelists and the four doctors of the Church. In the level above each of these is a standing angel. On the walls below are paired figures of the apostles, clad in the heavy drapery so characteristic of Signorelli, and the scene of St. Paul's conversion.

In 1479 Signorelli was at work on frescoes in the cloister of the monastery of Monteoliveto near Siena. There he painted scenes from the life of St. Benedict in which groups of monks clad in their white habits are placed in the foreground against a rocky, far-distant background. The moss-topped

16.11. LUCA SIGNORELLI AND BARTOLOMEO DELLA GATTA: Testament and Last Days of Moses (1482–1483). Fresco. Sistine chapel, Vatican, Rome (Alinari)

rocks appearing in some of these backgrounds are similar to those found in the works of other Umbrian masters, such as Pintoricchio and Fiorenzo di Lorenzo, the master of Perugino.

The most significant series of frescoes executed by Signorelli, however, is that of the Last Judgment in the chapel of San Brixio in Orvieto cathedral during the years 1499–1502. Fra Angelico had originally been commissioned in 1445 to do this work, but, as we have already pointed out, he was called to Rome to decorate the chapel of Pope Nicholas V in the Vatican after only three months' work at Orvieto. Fra Angelico had completed only two sections of the cross vault at the altar end of the chapel with the aid of his pupil Benozzo Gozzoli. These represented Christ coming as Judge surrounded by angels, and a group of prophets. A few years before Signorelli was asked, Perugino had contracted to do the work, but he never came to Orvieto because of his commitments in Rome. Consequently, a period of over fifty years elapsed before the frescoes were resumed by Signorelli.

Signorelli completed the work in the remaining two sections of the vault over the altar according to Angelico's designs. One section contains a group of the apostles, the other angels holding the symbols of the Passion. The four sections of the second cross vault of the chapel he filled with figures

16.12. Luca Signorelli: The Blessed (1499–1502). Fresco. San Brixio chapel, Cathedral, Orvieto (Alinari)

of patriarchs, martyrs, doctors, and virgin saints respectively. Then began the drama of the Last Judgment painted in the upper half of the walls of the chapel in the lunettes described by the vault arches. In the lunette over the entrance, partly cut into by the entrance doorway, is represented the fulfillment of the prophecy concerning the Last Days when all sorts of portents and unusual celestial phenomena are to take place. The first lunette to the left of the entrance has the preaching of the Antichrist that takes place in a wide, spacious piazza reminiscent of Perugino. Signorelli's portrait and that of Fra Angelico appear in the left foreground.

On the opposite right wall of the chapel and in the corresponding position is the scene of the Resurrection of the Dead. Stalwart, athletic archangels are vigorously blowing trumpets in the heavens above as the dead are pushing their way up out of their graves. The second scene on the left wall and next to the altar shows the assemblage of the Blessed [16.12] with angels hovering in the sky above. In this scene Signorelli exhibits his preoccupation with the nude human form. Male and female, he paints them all as perfect athletic specimens and emphasizes their muscular structure.

16.13. LUCA SIGNORELLI: The Damned (1499–1502). Fresco. San Brixio chapel, Cathedral, Orvieto (Alinari)

There is not an ounce of extra fat on any of them. Their skin is like a transparent sheet of rubber stretched over the muscles. Their poses are calm and relaxed. As counterpart to this scene the Damned [16.13] are represented on the right wall. Here all is struggle and turmoil as the demons fly among the fighting mass of forms to bear them off to Hell.* There is scarcely any posture of the human form in action that Signorelli has not rendered here. On the wall over the altar and opposite the entrance wall are the two remaining scenes, separated by a window. To the left of the window the Blessed are receiving their reward, and to the right the Damned are entering Hell. These overpowering frescoes had a great effect on Michelangelo —and on many artists who have since visited and studied them.

* In this fresco Signorelli paints the skin of the muscular demons in changing colors of blue, green, orange, red, and purple. This extraordinary performance seems to anticipate the use by Pontormo and other of his Mannerist contemporaries of figures clothed in tinted skin-tight garments. Colored demons, however, had appeared previously in the fourteenth-century fresco of the Descent into Hell in the Spanish chapel in Santa Maria Novella, Florence.

16.14. LUCA SIGNORELLI: Dante (1499–1502). Fresco. San Brixio chapel, Cathedral, Orvieto (Alinari)

To relieve this titanic work in human forms, Signorelli decorated the lower half of the chapel walls with panels of delicate arabesque forms against a golden-yellow background, one large panel beneath each of the Last Judgment frescoes above. In the center of each panel he placed the portrait of a famous poet or philosopher—Dante [16.14], Vergil, Horace, Ovid, Lucian, and Empedocles—and around these, in small tondi in grisaille, he represented scenes from their writings which he set in the arabesque backgrounds. Remarkably handsome arabesques of intertwined human and animal grotesques also decorate the bands and pseudo-pilasters separating the panels.*

In the various panel paintings that have survived, Signorelli's love of monumental athletic form, both nude and draped, is manifest. Examples are to be found in the Crucifixion [16.15] in the Uffizi, Florence, the majestic Madonna Enthroned in the town hall at Volterra, the Virgin in Glory in the museum at Arezzo, and the Deposition in Cortona cathedral. His colors too are striking, the deep red, the blues and greens and the aubergine purples.

The tondo in the Uffizi with the Holy Family pushed far up against the front plane of the picture and adapted monumentally to the curve of the frame anticipates the problem of design Raphael set for himself in the Madonna of the Chair [21.16]. Another Madonna and Child in the Uffizi within a circular frame [16.16], which itself is within a rectangular panel, is re-

---

* A small but very touching Pietà, frescoed on the wall of an arched recess in the right wall as you enter the chapel, is apt to be overlooked in the midst of these overpowering forms.

16.15 (*left*). LUCA SIGNORELLI: Cru-
cifixion (1500–1505). Panel paint-
ing, 98¼″ x 65½″. Uffizi, Florence
(Anderson)

16.16 (*right*). LUCA SI-
GNORELLI: Madonna and
Child (1490–1495). Tondo
detail within rectangular
panel, 66¹⁄₁₆″ x 45⁵⁄₁₆″. Uffizi,
Florence (Anderson)

16.17. LUCA SIGNO-
RELLI: Pan (*c.* 1488).
Panel painting, 76½"
x 101¼". Formerly in
Kaiser Friedrich Mu-
seum, Berlin, now de-
stroyed.     (Hanf-
staengl)

lated if not the forerunner of Michelangelo's Doni Madonna [20.2]. In the middle distance of this Signorelli picture is a group of nude shepherds paralleling the nude youths in the same place within the Michelangelo tondo. Signorelli's background, however, is in the fifteenth-century tradition and is much more detailed than Michelangelo's vague one.

An extraordinary accomplishment, finally, was Signorelli's famous picture of the god Pan [16.17] enthroned among a group of nudes, male and female. The composition resembled startlingly that employed by some modern academic cubist painter, for example, André Lhôte. Unfortunately this picture, in the former Kaiser Friedrich Museum, was lost during the early days of the Russian occupation of Berlin when the depot in which it and other works of art were placed for safety was gutted by fire.

## Melozzo da Forlì

In the fifteenth century, the city of Forlì together with the remainder of the region of the Marches was a part of Umbria. For this reason as well as for certain stylistic ones we consider Melozzo da Forlì (1438–1518) among the Umbrian painters. Although his early activities are still shrouded in mist, we do know that he was at the court of the Duke of Urbino between 1465 and 1470 and there came in contact with the Spanish painter Pedro Berruguete and the Flemish artist Justus van Ghent. The styles of these three artists has often been confused. But while Melozzo was at Urbino he must also have met Piero della Francesca and become acquainted with his work. It is possible that Melozzo also visited Padua and Mantua and saw the works of the painter Mantegna—whom we shall study later—and the sculpture of Dona-

16.18. MELOZZO DA FORLÌ: Pope Sixtus IV holding audience (1475–1477). Fresco. Vatican Gallery, Rome (Alinari)

tello. In Melozzo's small Annunciation in the Uffizi the drapery of the Angel Gabriel has the crinkly, clinging, bronzelike quality of Donatello's sculpture.

In the fresco painted by Melozzo between 1475–1477 of Pope Sixtus IV giving the famous librarian Platina the order to reorganize the Vatican Library [16.18] various influences appear. The parallel planes of the architecture receding in perspective resemble those found in Donatello's relief sculptures in Padua and Florence. The figures have a stolidity associable with Piero della Francesca, and the effect of seeing the figures and the room slightly from below recall Mantegna's experiments in "worm's-eye" perspective at Padua. In the group we see the pope enthroned at the right. Platina kneels before him. In the second row are the pope's four nephews, the tallest one almost in the center of the fresco being Cardinal Giuliano della Rovere who later became the formidable Pope Julius II. The oak branches rising from the small vases, which decorate the front surface of the outer pilasters in the fresco, are the device of the della Rovere family to which the pope belonged, oak leaves and acorns appearing in its coat of arms.

During the next two years—1478 to 1480—Melozzo was busy with the decoration of the apse of the church of the SS. Apostoli in Rome which Pope

# The Frescoes on the
# Side Walls of the
# Sistine Chapel

I N 1480 the building of the papal chapel in the Vatican, undertaken by
Pope Sixtus IV, was completed. The next step was to have it decorated.
This took place between the fall of 1481, October 27 to be exact, when a
contract was signed between the architect Giovannino de' Dolci and the
four painters Rosselli, Ghirlandaio, Botticelli, and Perugino, and May 15,
1483, the feast day of the Assumption of the Virgin, when the chapel was
dedicated. A certain number of the frescoes were apparently finished by
mid-January in 1482. In August and December of that year Rosselli and
Botticelli were again at work and in August Signorelli had come to partici-
pate in the project after his release from civic responsibilities in his native
city of Cortona. In addition to these painters there were present Pintoric-
chio (as assistant of Perugino), Piero di Cosimo (as pupil of Rosselli), Bar-
tolomeo della Gatta (from the workshop of Signorelli), and Fra Diamante
(who had assisted Fra Filippo Lippi at Spoleto).

Most fresco projects start at the top of the surface to be decorated and
work downward. In the case of the Sistine chapel, the ceiling was painted
a simple blue with gold stars to simulate the heavens. It was only twenty-
six to twenty-seven years later that the stupendous project of decorating that
space was undertaken by Michelangelo at the behest of Pope Julius II. Hence
during the period of 1481–1483 the decoration was a matter of the walls.
In the spaces of the top tier between the windows were painted portraits
of popes, a feature to be found in paint and mosaic in numerous churches
since Early Christian times. In the Sistine chapel they are represented as
standing in front of shell niches. Of the twenty-four still to be seen, seven

have been identified as by Fra Diamante, eight as by Ghirlandaio, seven as by Botticelli, and two as by Rosselli. It was the decoration of the uninterrupted areas below, however, that was the most interesting and important.

As had been the case, too, in earlier church decorations, subjects were chosen from the Old and New Testaments that had typological significance. By typological, of course, we mean that certain Old Testament scenes would be considered as parallel to or forecasting others in the New Testament. For the Sistine chapel walls, it was decided to represent scenes from the life of Moses on the left as you face the altar, and scenes from the life of Christ on the right, Moses being considered an Old Testament prototype of Christ.

The series began on the end wall over the altar where now is the Last Judgment by Michelangelo [20.12]. Since the chapel was dedicated to the Virgin of the Assumption, the subject of her Assumption was represented in the upper central portion of the end wall together with the portrait of Pope Sixtus IV and members of his (the della Rovere) family. Below, on either side, were the Finding of Moses (left) and the Birth of Christ (right). These frescoes on the end wall were assigned to Perugino who, together with his pupil Pintoricchio, painted them. Unfortunately when Michelangelo undertook to paint the Last Judgment on that wall, the Perugino frescoes were destroyed, although drawings for the Assumption exist, for example, those in the Albertina Museum in Vienna. According to Vasari, Michelangelo did not think much of Perugino.

In the series of scenes from the life of Moses and of Christ, the first fresco on the left wall contains the Circumcision of Moses and episodes of his later travels. The corresponding fresco on the right is the Baptism of Christ [17.1]. Both, although possibly under the supervision of Perugino, are the work of Pintoricchio. The landscape backgrounds have the openness and feathery trees used so frequently in the Umbrian tradition. But the medieval practice of representing in the same picture several episodes related to the main one and the addition of contemporary portraits render the space rather crowded. This crowding is characteristic of most of these Sistine frescoes—with perhaps two important exceptions, as we shall see.

The second pair of frescoes was painted by Botticelli, the one on the left wall being the wanderings of Moses with the central theme of Moses and the Daughters of Jethro [17.2], and the one on the right wall being the Temptation of Christ and the cleansing rite of the Leper. The Daughters of Jethro fresco is one of Botticelli's very fine accomplishments, the lovely heavy blond tresses of the daughters reminiscent of the Venus in his Birth of that goddess [14.6]. His favorite landscape conventions are present too, particularly the vertical tree trunks to stabilize the action in the picture, and also present are the high constructions in the center and at the sides of the picture, which create curvilinear rhythms in the movements of the figures making their entrances and exits on to or out of the scene.

In the Temptation of Christ on the right wall Botticelli has made the three episodes of Christ's Temptation and the angels ministering unto Him

play a secondary role in the fresco by placing them in the background of the picture, but he has elevated them on the tops of the rocks and at the sides of the temple in the center. The chief emphasis is placed on the scene of the Leper presenting himself to the High Priest to be cleaned at the altar in front of the temple. A number of contemporary personalities appear to right and left across the foreground as the retinue of the High Priest. The reason for the prominence given to this scene, which according to the gospel of St. Matthew took place after the Sermon on the Mount, is owed to the fact that the pope's throne in the Sistine chapel was set against the opposite wall. The pope would therefore have before him a New Testament example of a High Priest officiating at the altar, a prototype, as it were, of his own priestly duties.

The third scene on the left wall was the Destruction of Pharaoh and his army in the Red Sea after Moses had led the Children of Israel dry-shod through the sea. Generally attributed to the painter Cosimo Rosselli, critics have tended to see the hand of his pupil Piero di Cosimo in the handling of the landscape. In fact, many consider the whole fresco to be Piero's work. The white horse of the foremost rider certainly resembles others by this artist, particularly the horse in the allegorical painting in the Kress collection in the National Gallery in Washington. Whoever he was, the artist had difficulty in properly relating the foreground, middle distance, and background to each other. The composition is also very crowded, what with Moses and the Israelites on the left and the Egyptian hosts on the right.

In the corresponding position on the right wall is Ghirlandaio's fresco of Christ Calling the Apostles [17.3]. The sense of space and room to move about in it is more satisfactorily achieved here than in the other frescoes we have mentioned. Ghirlandaio uses his favorite background of a river valley with the river flowing from the background to the foreground of the picture with the perspective of a railroad track. Although he inserts several episodes in the background, such as the Calling of Peter and Andrew and the Calling of the Sons of Zebedee, and although he has many portraits of contemporary figures mingling with the apostles in the main scene of the foreground, the effect is less crowded than in the frescoes previously considered. The calmness of the action of the figures, so characteristic of Ghirlandaio, adds to the clarity and dignity of the composition.

The next pair of scenes, the Moses receiving the Tables of the Law on the left wall, showing also the Children of Israel worshiping the Golden Calf, and Christ's Sermon on the Mount on the right wall, are both by Cosimo Rosselli. They are crowded with figures and rather weak in invention and technique. There is this, however, to be said about the crowded compositions on the Sistine chapel walls: they are meant to function as tapestries, which indeed they do, and contemporary and earlier tapestry traditions required an area covered with details, figures, and episodes.

There follows, on the left wall, the Destruction of Korah and his band of insurrectionists by Moses. It is by Botticelli and illustrates again Botti-

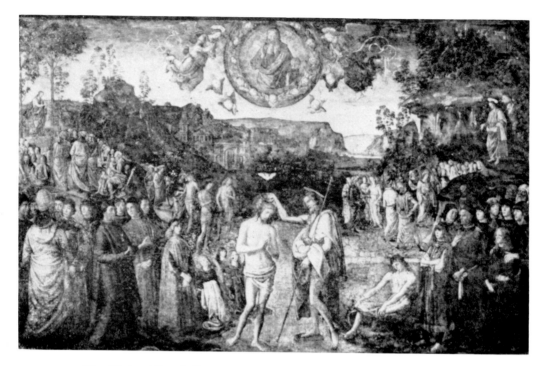

The Sistine Chapel Frescoes:

17.1 (*above*). PINTORICCHIO: Baptism of Christ (1481–1482). (Alinari)

17.2 (*below*). BOTTICELLI: Moses and the Daughters of Jethro (1482–1483). (Alinari)

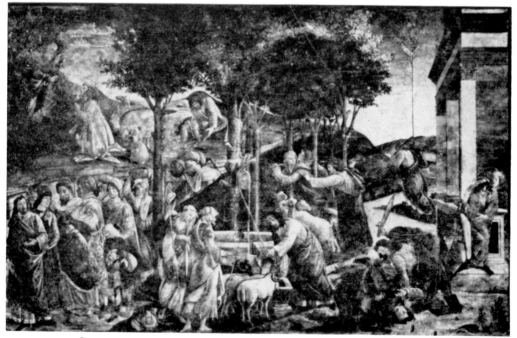

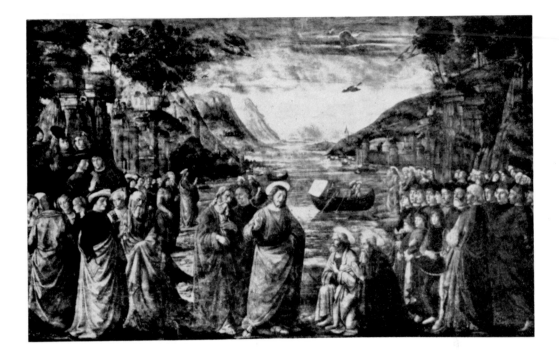

The Sistine Chapel Frescoes:

17.3 (*above*). GHIRLANDAIO: The Calling of the Apostles (1481–1483). (Anderson)

17.4 (*below*). PERUGINO: The Handing of the Keys to Peter (1481–1483). (Anderson)

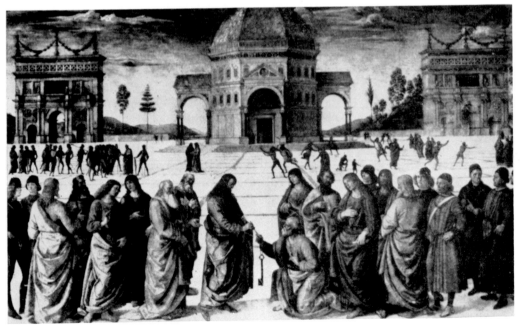

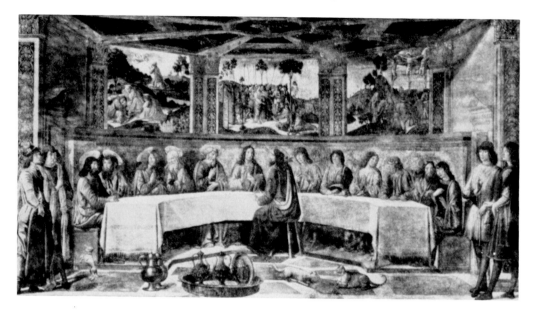

17.5. Cosimo Rosselli: The Last Supper (1482–1483). Fresco. Sistine chapel, Vatican, Rome (Anderson)

celli's favorite type of composition, with the movement of the figures in the foreground held down by the verticals in the background and middle distance. Here the triumphal arch acts like a huge clasp holding together the action of the foreground. The balancing fresco on the right wall is the Handing of the Keys to Peter [17.4]. It is by Perugino, and it enjoys great fame for its arrangement and composition. By means of the great piazza and the small figures in the middle distance contrasting with the large-scale figures of Christ and the apostles in the foreground, Perugino achieves a sense of breathing space and room for movement absent in most of the other frescoes on these walls. His favorite method of emphasizing the figures in the foreground by throwing them against a vast resonating spatial background succeeds here in spotlighting the major episode as if it were the only one in the fresco and relegating the two minor ones of the Arrest of Christ and the Stoning of Christ to the far middle distance with tiny figures. The effect of spaciousness is increased by the domical structure in the center of the far end of the piazza flanked by two festooned triumphal arches inspired by the arch of Constantine in Rome. Behind these buildings stretches a wide, open Umbrian landscape with hills and a few feathery trees. The composition of the central portion of this fresco with the domed structure as the background is repeated by Perugino in a beautiful panel painting now in the museum at Caen, France. The subject of this picture, however, is the Sposalizio, or Marriage of the Virgin. Perugino's young pupil Raphael painted the same composition which is now in the Borghese Gallery in Rome.

The series on the side walls end on the left with Moses reading his Last

Will [16.11] and on the right with the Last Supper [17.5]. Vasari claimed that Signorelli, the great Umbrian painter, painted the Last Will of Moses, but most of the execution of this fresco is attributed to Signorelli's assistant, Bartolomeo della Gatta. Signorelli obviously influenced the design. Possibly he painted some of the figures, which resemble those he painted elsewhere, particularly the youth seated in the center of the foreground who seems to anticipate Michelangelo's nudes in the ceiling. The Last Supper on the right wall was painted by Rosselli. Through the windowlike opening in the room in which the Last Supper takes place can be seen subsequent scenes of Christ's Passion: the Agony in Gethsemane, the Arrest of Christ, and the Crucifixion.

On the end wall opposite the altar wall the two concluding frescoes represented the Burial of Moses on Mt. Nebo and the Resurrection of Christ. The former was by Signorelli; the latter was by Ghirlandaio. Both were destroyed by an accident in the sixteenth century and repainted so that nothing remains to attest to the quality of the originals.

Vasari, in his life of Cosimo Rosselli, tells the following anecdote: *

> Being summoned with other painters to the work carried on by Sixtus IV, in the chapel of the palace, he worked in conjunction with Sandro Botticelli, Domenico Ghirlandaio, the abbot of San Clemente [Bartolomeo della Gatta], Luca da Cortona [Signorelli], and Piero Perugino, painting three scenes, namely the drowning of Pharaoh in the Red Sea, the Preaching of Christ to the people by the Sea of Tiberius, and the Last Supper. In the last of these he represented an octagonal table in perspective, the roof above likewise being octagonal, the whole very well foreshortened and showing that he understood this art as well as others did. It is said that the Pope had offered a prize to the painter who in his judgment should acquit himself the best. When the scenes were finished His Holiness went to see them and judge how far the painters had striven to earn the reward and the honor. Conscious of his weakness in invention and design, Cosimo had endeavored to cover these defects by using the finest ultramarine and other bright colors, illuminating the whole with a quantity of gold, so that there was not a tree, a blade, a garment, or a cloud which was not illuminated, in order that the Pope, who knew very little of art, might be convinced that he ought to award the prize to him. When the day came for uncovering all the works, the artists laughed at Cosimo and chaffed him, making jokes at his expense instead of pitying him. But the event proved that they were deceived, for, as Cosimo had expected, the Pope, being ignorant of such matters, though he took great delight in them, judged that Cosimo had done much better than all the rest. Accordingly he received the prize, while the Pope directed the others to cover their pictures with the best ultramarine they could find, and touch them up with gold so as to make them resemble that of Cosimo in richness and coloring. The poor painters, in despair of trying to please so foolish a pope, set themselves to spoil their own good work. Cosimo, however, had the laugh of those who had been laughing at him shortly before.

* Giorgio Vasari: *The Lives of the Painters, Sculptors and Architects,* translated by A. D. Hinds (New York, Dent), Vol. II, p. 54 (1950 ed.).

# Appendix: Piero di Cosimo

One significant painter among the artists active in Florence at the end of the fifteenth and early in the sixteenth century is often passed by because he does not fit into the general scheme of things. Piero di Cosimo (1462–1521) did not follow the contemporary conventional range of subject matter but instead was highly individualistic in his choice of subject and his technique, evidencing, like Leonardo, an avid interest in nature rather than in Madonnas and Holy Families. In his peculiar way he was a descendant of such earlier fifteenth-century Internationalists as Pisanello and Jacopo Bellini the Venetian who were fascinated by the study of birds, insects, and animals as well as landscape, the ensemble of nature.

Piero di Cosimo became the pupil of the weakest of the Florentine painters of that period, Cosimo Rosselli. In 1481–1482, when he was twenty-one, he apparently accompanied his master to Rome as an assistant when Cosimo participated in the decoration of the walls of the newly built Sistine chapel in the Vatican, because in the landscape details in two of the scenes Rosselli painted—the Crossing of the Red Sea and the Sermon on the Mount —we find evidences of Piero's style. It must also have been in the Sistine chapel that Piero made his first contacts with the styles of Botticelli, Ghirlandaio, and Signorelli, the influences of which are often perceptible in his later paintings.

Apart from this work in Rome, Piero spent most of his time in Florence. Although he painted quite a number of Madonnas, his major interest seems to have been in primitive and mythological subject matter in which he could display his preoccupation with human, animal, and hybrid forms. A pair of his earliest known pictures, now in the Capetown [South Africa] Museum, were done for the wedding that in 1486 united two wealthy Florentine wool-trading families, the Tornabuoni and the Albizzi. They are cassone panels and represent, appropriately, the story of Jason and Jason and Medea.

In the same year (1486) Francesco del Pugliese, a friend and patron, and a wealthy wool merchant as well, finished his palace in the section of Santo Spirito in Florence and employed Piero to paint several panels to be set above the wainscoting in one of the rooms known as the *studiolo*. Piero by then had become popular in Florence as the fanciful designer of triumphs and floats that passed along the city streets at carnival time, so in the Pugliese Palace panels he let his imagination run on themes involving mythology and primitive man during the Stone Age. Five of these panels from the Pugliese *studiolo*, and possibly a sixth, have survived and can be found in the following museums: the Hunt, and the Return from the Hunt, in the Metropolitan Museum in New York; Hylas and the Nymphs, in the Wadsworth Athenaeum in Hartford; Vulcan and Aeolus, in the Ottawa (Canada) Museum; and the Forest Fire, in the Ashmolean Museum, Oxford. The possible sixth that has been questioned as belonging to this group is the Battle of the Centaurs and the Lapiths, in the National Gallery in London.

17.6. PIERO DI COSIMO: The Discovery of Honey (c. 1500). Panel painting, 31¼" x 50¾". Worcester (Mass.) Art Museum (Courtesy, Worcester Art Museum)

Piero apparently believed that during the Stone Age humans and animal interbred, for many strange creatures appear in the two Hunt panels in the Metropolitan Museum. His style in these two panels is somewhat influenced by Luca Signorelli, who had just painted the famous Pan [16.17], formerly in Berlin, and the Madonna and Child in the Uffizi [16.16] with the wild creatures (shepherds?) clothed in skins in the middle distance. In the Forest Fire at Oxford, the air is filled with winged creatures flying to safety, and the foreground is crowded with quadrupeds moving out of the burning woods in Noah's Ark-like order. Many of the animals have human faces. The bear family in the center is marvelously done. The title of the picture in the Wadsworth Athenaeum, Hartford, is disputed; whether it is Hylas and the Nymphs or Vulcan falling from heaven among the women of Lemnos is the question, but it is probably the former since the people in the picture are elegant and belong to a civilization to which the use of fire and metals has already been introduced (for example the necklaces of the women). The Vulcan and Aeolus in the National Gallery in Ottawa seems to be a companion piece to the Hartford panel. Vulcan with hammer and forge is demonstrating how to fashion beautiful objects of metal, and one of the workmen on the building to the right is using a hammer and nails in place of the more primitive club being used by another of the men.

Piero's preoccupation with the activities of primitive man appears also in the Discovery of Honey [17.6] a wonderfully painted picture in the Worcester (Mass.) Art Museum and in the Discovery of Wine in the Fogg Museum

17.7. PIERO DI COSIMO: Death of Procris (1490–1500). Panel painting, 25½″ x 72¼″. National Gallery, London (Anderson)

in Cambridge, Massachusetts. In the Worcester picture Piero uses oil paint and achieves beautiful soft modeling in the bodies of the figures and a limpid space effect. The color areas and the light and shade spotting anticipate their decorative use in sixteenth- and eighteenth-century Venetian painting. In fact, the small village landscape at the left resembles the later work of Giovanni Bellini.

More strictly mythological subjects appear in the Death of Procris [17.7], in the National Gallery, London, in the Rescue of Andromeda by Perseus [17.8] and the Marriage of Andromeda and Perseus in the Uffizi Gallery, and also in the two versions of the Story of Prometheus in Strasbourg and in Munich. The Prometheus pictures with the episodes of bringing of fire to man illustrate again Piero's interest in the element of fire.

The Death of Procris [17.7] with the long rectangular shape of the panel and the figure of Procris lying across the foreground recalls Botticelli's Venus and Mars [14.7], which presumably inspired it. The Mars, Venus, and Cupid in the Berlin Gallery show the same source of inspiration. But the Procris has an unusual beauty and pathos in the twisted figure of Procris, in the solicitous figure of the satyr at the left, and in the head of her dog Laelaps gazing in on Procris' corpse from the right. The three other desolate-looking dogs on the beach of a sea or inlet in the middle distance add to the depression of the scene, and the sense of loneliness is increased by the background with the river issuing from between its banks on the left to lose itself in the wide emptiness of the sea at the right. The lone sparsely foliated tree and the cranes on the beach and in the air add to the bizarre effect of the picture.

In the Rescue of Andromeda [17.8] Piero's use of the Leonardesque light and shade to give a *sfumato* (smoky) effect adds to the drama of the situation and makes the huge monster approaching the victim bound to the rock all the more frightening to behold.

17.8 (*above*). Piero di Cosimo: Rescue of Andromeda
(*c.* 1515). Panel painting, 27¾″ x 48⅜″. Uffizi, Florence (Alinari)

17.9 (*right*). Piero di Cosimo: Simonetta Vespucci
(*c.* 1498). Panel painting, 22½″ x 16½″. Musée Condé,
Chantilly (Alinari)

Several exceptional portraits were painted by Piero during his later period. One of the most striking is that of the famous Florentine beauty Simonetta Vespucci [17.9], whom we mentioned when discussing the work of Botticelli, the lady whose romantic connections with Giuliano de' Medici were the talk of Florence around 1475. The portrait is bust size, profile, and nude except for a variegated scarf thrown around the shoulders and enclosing the bust. A simple gold necklace has a dark serpent coiled about it, possibly symbolic of the dread consumption that caused her death. Her blond tresses are braided and interwoven with pearls and other jewels. The sky is filled with clouds, with a huge black one placed directly behind Simonetta's head to accentuate her profile. The landscape background is arid, relieved only by a small group of buildings among the trees of the background and a river flowing across the landscape in the distance. Another bit of symbolism of death and life appears in the leafless trees at the left and those in full foliage at the right. At the bottom of the portrait, in capital letters, runs the inscription: SIMONETTA JANUENSIS VESPUCCIA.

Piero uses practically the same Simonetta profile in the portrait bust of the youthful St. John the Baptist, now in the Metropolitan Museum in New York. The background is completely dark. The bit of furry camel's skin showing on St. John's chest repeats the tousled hair of the young saint. His rough-cut cross is placed at the left.

The pair of portraits in The Hague of the architect Giuliano da San Gallo and his father Francesco di Bartolo Giamberti seem to be companion pieces. Both have lyric landscape backgrounds with village or pastoral scenes, and both have similarly decorated parapets behind which the bust portraits

of the husky sitters are set. Each has attributes of his profession set on the parapet: the one his architectural instruments, the other a sheet with musical notations. Giamberti's rugged, alert head is extraordinarily effective.

The Young Warrior in Armor in the National Gallery, London, is another of Piero's fine portraits. Through an opening in the wall of the rooms one glimpses the Palazzo della Signoria, with the Marzocco and Michelangelo's David flanking the entrance, and a portion of the Loggia de' Lanzi in the famous Piazza della Signoria. Piero must have known well the frescoes by Ghirlandaio in the Sassetti chapel in Santa Trinità. In one of these frescoes from the life of St. Francis the background depicts a wider view of the famous piazza [15.5]. This portrait seems almost to be the artistic grandfather of Pontormo's well-known Halberdier [30.11].

The variety in the types of landscape backgrounds used by Piero di Cosimo is most interesting. As in his figure style he does not hesitate in his landscapes to adapt formulas from other contemporary painters. For instance, in the Hunt in the Metropolitan Museum, he uses Botticelli's device of vertical tree trunks to stabilize or balance action. In the Forest Fire in the Ashmolean Museum, he makes use of the exit passages between mounds or barriers placed in the center and to right and left in the picture that we found in the works of Botticelli and of others of the Sistine chapel painters. In a tondo of the Madonna by Piero in the Strasbourg Museum, Filippino Lippi's built-up landscape—as seen in Filippino's Vision of St. Bernard [15.12]—appears. We have just mentioned Piero's adaptation in the portrait of the Young Warrior in London of Ghirlandaio's piazza background. There are also reflections in Piero's paintings of the wide Umbrian landscapes or of the pastoral, idyllic ones of northern Italy that we shall discover shortly. And certainly he had seen the landscape backgrounds of Flemish paintings imported to Florence by the business agents of the Medici and of other banking houses. Rather peculiar to himself are the widestretching distant backgrounds, for example, in the Death of Procris [17.7] in which inlets and bodies of water running horizontally to the picture plane lead into an infinity of sky. In keeping with the subject of the picture he often introduces grotesque, bizarre, and exotic forms of trees, such as in the Discovery of Honey [17.6].

Such are some of the works of this extraordinary artist whose introverted imagination, whose individualism, led him beyond the usual range of subjects to be painted to the activities of primitive man and into the realm of the fantastic.

## BIBLIOGRAPHY

Steinmann, E. *Die Sixtinische Kapelle*, 2 vols. and portfolio of plates. Munich, Verlagsanstalt F. Bruckmann A.-G., 1901–1905. (Sourcebook in German)

Douglas, R. L. *Piero di Cosimo*. Chicago, University of Chicago Press, 1946.

# ◂ 18

# Fifteenth-century
# Sienese Painting

T HE great enthusiasm for naturalistic representation manifested in Florence was not shared by the rival city of Siena. Hence the Sienese painters of the fifteenth century contributed practically nothing to the development that came to a climax in Raphael and Michelangelo. By contrast, they preferred to look back on the accomplishments of Siena in the fourteenth century and to keep alive the love for color, decorative charm, and gold backgrounds for which their predecessors were so famous. Not that they were unaware of what was going on in Florence and elsewhere, for reflections of style from these sources are apparent from time to time, but they were content to remain fundamentally true to their own local traditions.

## Early Fifteenth-century Painters

This is most certainly true of the work of two painters active in the earlier half of the fifteenth century: Sassetta and Giovanni di Paolo.

### Sassetta

Sassetta (active 1423–1450), as the follower of Paolo di Giovanni Fei, an International Style artist, retained the naïve charm of medievalism in color, line, and expression. An example of this is the fine Madonna of the Snow in a private collection in Florence. The treatment here of the drapery with calligraphic lines, the brocaded cloth behind the Madonna, the gold background, and the Gothic arches of the frame indicate the presence of the

337

18.1 (*left*). Sassetta: Meeting of St. Anthony and St. Paul the Hermit (1430–1432). Panel painting, 18¾″ x 13⅝″. National Gallery of Art, Washington, D. C., Samuel H. Kress Collection (Courtesy, National Gallery of Art)

18.2 (*below*). Sassetta: Journey of the Magi (1432–1436). Panel painting, 9″ x 12″. Metropolitan Museum of Art (Courtesy of The Metropolitan Museum of Art, Bequest of Maitland F. Griggs, 1943)

International Style. In the small panels depicting episodes from the life of St. Anthony the Abbot in the Jarvis Collection at Yale and in the National Gallery, Washington, and those from the life of St. Francis in the National Gallery in London and in the Musée Condé at Chantilly the descriptive elements of the landscape are organized into rhythmic curves and diagonals that, together with the color effects, compensate for the disregard for naturalistic representations of space. How effectively, in the Meeting of St. Anthony and St. Paul the Hermit [18.1], the conical silhouette of the two figures embracing is repeated in the cave immediately behind them and in the hills in the middle and distant backgrounds. The beauty and delight of the Journey of the Magi [18.2] in the Metropolitan Museum in New York are owed primarily to similar uses of linear rhythms and color.

## Giovanni di Paolo and Sano di Pietro

At first glance, the work of Giovanni di Paolo (1403–1482) is in a style rather close to Sassetta's—both had worked with the same master. But actually Giovanni's style is much crisper, his figures are more active, and his backgrounds are even more geometric than Sassetta's. The zigzag layout of the roads and paths in the Youthful St. John going into the Desert [18.3] and of the *Ecce Agnus Dei*, both in the Art Institute of Chicago, gives the effect of flashes of lightning. His use of drapery too is definitely in the tradition of the International Style and recalls that of the Florentine master Lorenzo Monaco. We can also see certain resemblances to Fra Angelico in Giovanni's Paradise panel [18.4] in the Metropolitan Museum of Art in New York.

18.3. GIOVANNI DI PAOLO: St. John the Baptist in the Wilderness (*c.* 1455). Panel painting, 27″ x 14¼″. The Art Institute, Chicago (Courtesy of The Art Institute of Chicago, Mr. & Mrs. Martin A. Ryerson Collection)

18.4. GIOVANNI DI PAOLO: Paradise (1445). Panel painting, 17⅞" x 15¹³⁄₁₆". The Metropolitan Museum of Art. (Courtesy of The Metropolitan Museum of Art, Rogers Fund, 1906)

A contemporary of Giovanni di Paolo and a pupil of Sassetta was Sano di Pietro (1406–1481). He has none of the sprightliness of Giovanni nor the quality of his master. He was an extremely prolific painter of sweet Madonnas [18.5] that were very popular in his time, but he repeats the same types over and over again and consequently becomes rather monotonous. He bases much of his subject matter on iconography established by the Lorenzetti in the previous century.

18.5. SANO DI PIETRO: Madonna and Child (c. 1480). Panel painting, 21¼" x 17". The Art Institute, Chicago (Courtesy of The Art Institute)

18.6. DOMENICO DI
BARTOLO: Distribu-
tion of Alms (1441–
1444). Fresco. Siena
Hospital (Anderson)

## Domenico di Bartolo

Of the early fifteenth-century Sienese painters, Domenico di Bartolo (1400–
1449) was the only one who seems to have been interested in and affected
by the naturalist movement in Florence and Umbria. His most important
work illustrating this is in the hospital at Siena, the Spedale della Scala.
There in his frescoes of the Care and Marriage of the Foundlings and in
the Distribution of Alms to the Poor [18.6] he uses architectural perspective
in both, and, in the latter fresco, in the nude figure who has removed his
garments, he shows that he was aware of the figures in Masaccio's St. Peter
Baptising [10.14] in the Carmine in Florence. One of his early Madonnas
in the Siena Gallery seems to reflect in the drapery and in the gentle feel-
ing of the whole the influence of the great Sienese sculptor Jacopo della
Quercia who was Domenico's friend.

18.7. VECCHIETTA: Adam and Eve (1446–1449). Fresco. Chapel of Siena Hospital (Anderson)

## Vecchietta

Vecchietta (1412–1480) seems to have combined the styles of Sassetta and of Domenico di Bartolo, for he fuses the narrative style, at home in Siena, with the new naturalism of form and background. His frescoes—for example, the Adam and Eve [18.7] in the chapel of the Spedale della Scala at Siena—are very beautiful and display a knowledge of the works of the Florentines Domenico Veneziano and Masolino in the softness of the forms and in the use of pinks and greens. His frescoes in the baptistery at Siena, dating in the middle of the century, are more harsh in feeling and take on a dryness that is further perceptible in his large fresco figure of St. Catherine of Siena painted in the great hall of the Palazzo Pubblico at Siena. This latter figure assumes some of the qualities of his bronze sculptures done for the cathedral and the baptistery in Siena. Like Antonio Pollaiuolo, Vecchietta was both a painter and a sculptor, and his sculpture has a similar dry linear quality with emphasis on meticulous rendering of anatomical detail.

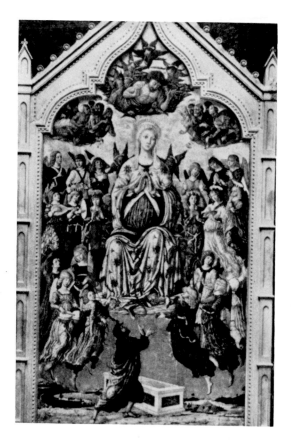

18.8. MATTEO DI GIOVANNI: Assumption of the Virgin (1474). Panel painting, 130½″ x 68½″. National Gallery, London (Anderson)

# Later Fifteenth-century Painters

In the work of the Sienese painters active during the second half of the fifteenth century we can note a greater reliance on Renaissance style than before. Although at times the background for a Madonna still is gold, the figure types and the backgrounds for the scenes fall in line with Renaissance discoveries in the realm of visual representation. But to the Sienese, visual realism seems to have been secondary to their inherent love of rhythmic, decorative charm and narrative or emotional detail.

## *Matteo di Giovanni, Cozzarelli, and Benvenuto di Giovanni*

Matteo di Giovanni (*c.* 1435–1495) is characteristic of this later Sienese style. He painted many half-length Madonnas, flanked to right and left behind each shoulder by bust-sized angels or saints, that have much simple appeal and charm. The influence of the style of other non-Sienese artists is apparent in various of Matteo's pictures. For example, the St. Michael to the right behind the Madonna in the Barber Institute picture at Birmingham, England, shows his early connection with Piero della Francesca. In the Assumption of the Virgin [18.8] in the National Gallery in London the St.

18.9 (*left*). MATTEO DI GIO-
VANNI: Massacre of the Inno-
cents (1482). Panel painting.
St. Agostino, Siena (Ander-
son)

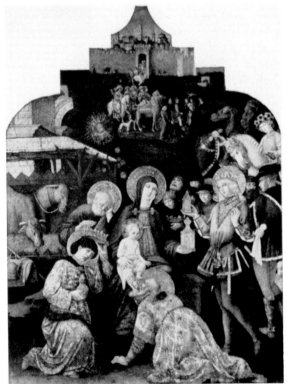

18.10 (*right*). BENVENUTO
DI GIOVANNI: Adoration of
the Magi (*c.* 1490). Panel
painting, 71¾″ x 54⅛″. Na-
tional Gallery of Art, Wash-
ington, D. C. (Courtesy of
The National Gallery of Art,
Mellon Collection, 1937)

Thomas below and the Christ above the figure of the Ascending Virgin have marked resemblances in style to that of Pollaiuolo. The angel playing the viol immediately to the left of St. Thomas is a cousin, in style, of Fra Filippo Lippi's urchinlike putto in the Uffizi Madonna [13.13].

Matteo's narrative and emotional expressiveness is best seen in the three versions of the Massacre of the Innocents, now in St. Agostino, Siena [18.9], in the Servi, Siena, and in the Capodimonte Museum in Naples. The fierce executioners and the screaming mothers are in sharp emotional contrast with the placid onlookers in the background, especially with the two youngsters peering with glee from behind the balusters of the staircase within the Renaissance building in the background. The turbans worn by Herod and by several of the executioners are presumably a reflection of the sack of Otranto in 1480 by the Turks.

The style of Guido Cozzarelli (1450–1516), as seen in the panel of the Annunciation in the National Gallery, Washington, is rather closely related to that of Matteo di Giovanni. It is less fluid, however, the figures are coarser, and the drapery that is supposed to express the form and give lightness of movement becomes heavy and leaden.

A more pleasing and facile painter was Benvenuto di Giovanni (1436–c. 1518). A year younger than Matteo, he was apprenticed with Vecchietta, which fact apparently accounts for his greater control of form than Cozzarelli had displayed. Echoes of the International Style appear in the handsome Adoration of the Magi [18.10] in the National Gallery in Washington, with the rich costumes of the Magi and followers and with the winding procession in the background reminiscent partly of Bartolo di Fredi. The calligraphic drapery about the feet of the Madonna in the altarpiece in the National Gallery in London is also a hold-over from the International Style. The musical angels behind the Madonna's throne, however, as well as the Madonna herself are more closely related to Vecchietta and Matteo di Giovanni, the angels also to Francesco di Giorgio and Neroccio, both pupils of Vecchietta.

## Francesco di Giorgio

In Francesco di Giorgio (1439–1502), Siena possessed an artist of varied accomplishments, such as Piero della Francesca had been or as Leonardo da Vinci on a much grander scale was becoming. He was a sculptor and architect of note as well as a painter. Some of his early Madonnas, such as the one in the Cook collection, Richmond, England, presuppose a knowledge of Fra Filippo Lippi's Madonnas kneeling in adoration before the Child on the ground. This motif reappears in his more elaborate creations, such as the Adoration of the Christ child, in the Siena Gallery, in which SS. Bernard and Thomas Aquinas and two angels take part and in the Adoration of the Shepherds [18.11], in San Domenico, Siena. In these two large compositions Francesco's interest in Renaissance architecture is evident, with the archi-

tecture set in the middle distance before a far-distant landscape. The ideal
figures of the angels in the San Domenico Adoration, the fluttering move-
ment of their draperies, and the triumphal arch set in the center of the mid-
dle distance are reminiscent of Botticelli's style as seen particularly in the
fresco of the Daughters of Jethro [17.2] in the Sistine chapel in Rome. The
blond, tousle-haired angels in all of Francesco's pictures are extremely at-
tractive.

Francesco di Giorgio also painted a number of cassone panels that are
full of gold, color, and charm. They are spread throughout various public
and private collections. One fine example is in the Louvre, representing the
story of the Rape of Europa, and another is in the Nelson Gallery, Kansas
City, Missouri.

As for Francesco's achievements in other media we might cite among
his drawings the fine figure of the Atlas supporting the Heavens in the print
room of the museum at Brunswick, Germany. Here again the swirling drapery
and the wind-blown mop of hair of Atlas serve both as a complementary
action to the circular universe Atlas is supporting and as an expression of the
emotional strain he is undergoing. Of his sculpture we should mention the
group of bronze, almost life-size, candle-bearing angels made for the Siena
cathedral. Handsome pieces they are. Their crinkled and wind-tossed draperies
and their curly mops of hair resemble those we have seen in his paintings.
A very apt comparsion would be with the figure of Fidelity formerly in the
Otto Kahn collection now in the Mogmar Art Foundation collection, New York.

The domed church of Santa Maria delle Grazie al Calcinaio below
Cortona is an example of Francesco's architecture. It shows the effect of
Brunelleschi's style, even to the use of light- and dark-gray stone in the
interior.

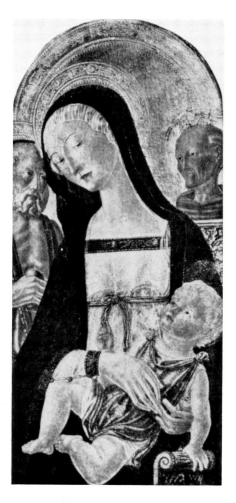

18.12. NEROCCIO DE' LANDI: Madonna with Child and Saints (*c.* 1475). Panel painting, 39¾″ x 20½″. Pinacoteca, Siena (Anderson)

## Neroccio de' Landi

Neroccio de' Landi (1447–1500) and Francesco di Giorgio, pupils of the same master, were also for a time associated artistically. Neroccio was the younger by eight years. To the untutored eye, the work of the one is difficult to distinguish from the other. Neroccio too uses the formulas for the half-length Madonna with angels or saints [18.12] so characteristic of Matteo di Giovanni. Other examples are to be seen in the Louvre and at Cracow. But always in Neroccio's work—whether it be a Madonna composition, a cassone panel, or a painting, such as the Annunciation lunette in the Jarvis collection at Yale University—there is a certain relaxed freshness and smoothness of execution lacking in the works of Francesco di Giorgio. The pose of the figures is easier, and their movement unhampered by cumbersome drapery. Yet interestingly—in the Yale Annunciation, for instance—we can see that the

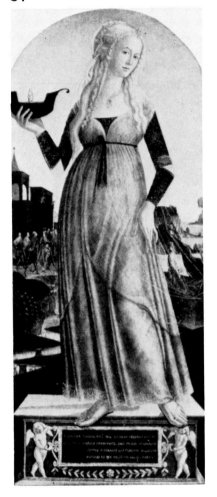

18.13. NEROCCIO DE' LANDI: Claudia
Quinta (end of 15th cen.). Panel paint-
ing, 41¼" x 18³⁄₁₆". National Gallery of
Art, Washington, D. C. (Courtesy of the
National Gallery of Art)

tradition of Simone Martini's treatment of that subject is still in the mind
of the late fifteenth-century artist.

Neroccio's Portrait of a Girl now in the National Gallery in Washington,
with her mass of fluffy platinum-blond hair and her necklaces of pearl-shaped
crystals is the epitome of Sienese charm and elegance. What could make the
contrast between Sienese and Florentine taste and purpose in painting more
apparent than a comparison of this portrait with that of the Mona Lisa [19.11]
some twenty years later!

As a fitting conclusion to this chapter on fifteenth-century Sienese paint-
ing we call attention to a delightful painting [18.13] by Neroccio in the
National Gallery of Art in Washington, D. C. The subject is Claudia Quinta, a
Roman lady of noble lineage about whom the poet Ovid in his Fasti (iv:11,
247ff.) tells the following story. The goddess Cybele desired to leave her
home in Phrygia and take up her abode in Rome, a place worthy of any

god. The Phrygian king Attalus at first refused to let her go, but after a series of disastrous earthquakes he yielded to the goddess' wishes. It had been foretold that when she should come to Rome she must be received by chaste hands.

A ship was fitted out in haste and the goddess began her journey westward passing by the islands of Tenedos, Lesbos, Crete, Cythera, and Sardinia and finally arrived at Ostia at the mouth of the Tiber. A crowd of Roman nobles with their ladies were gathered on the shore to greet the goddess and draw her ship up the Tiber to Rome. But when the men began to tug at the ropes the ship refused to budge. It was stuck on a mudbank in the river made shallow by a long drought.

Among the noble ladies on the shore was Claudia Quinta, famed for her beauty as well as for her ancestry. Although she was chaste, evil, jealous tongues had spread false rumors about her lack of virtue, about her vanity because of her elaborate hair-do and clothes worn in public, and about her sharp tongue to her elders. But now Claudia stepped forward from the crowd, knelt on the shore of the river, doused her head three times with water—to the amazement of the others who thought she was crazy—and besought the goddess either to kill her if she, Claudia, was unchaste or else to vindicate her by some sign. Claudia then took hold of one of the ropes and drew the ship easily off the mudbank, whence it was taken in triumph up the Tiber to Rome.

In Neroccio's charming picture, Claudia Quinta stands in all her finery and intricate coiffure on a low platform. She holds a model of the ship containing the cult statue of the goddess in her right hand. In the inscription, in Latin, on the plaque supported by two putti on the front face of the platform, Claudia states that she was chaste, that while the people did not believe it the ship proved her innocence, and that the goddess pleased the people and vindicated her.

Sienese painters of the fifteenth century indeed may not have wished to compete with the forward-looking trends of their Florentine counterparts. They showed instead a preference for the elegant and the imaginative in painting as their predecessors of the previous century had too. But they demonstrated, as we have just seen, that they were equally interested in humanism and in the Classic authors available to them.

## BIBLIOGRAPHY

Berenson, B. *A Sienese Painter of the Franciscan Legend*. London, J. M. Dent & Sons, 1909.

McComb, A. "A Life and Works of Francesco di Giorgio," *Art Studies* II, 1924, pp. 3–32.

Edgell, G. H. *A History of Sienese Painting*. New York, MacVeagh, Dial, 1932.

Pope-Hennessy, J. *Giovanni di Paolo, 1403–1483*. London, Chatto and Windus, 1937.
——— *Sassetta*. London, Chatto & Windus, 1939. (Also for bibliography)
Weller, A. S. *Francesco di Giorgio*. Chicago, University of Chicago Press, 1943. (Comprehensive bibliographies)
Pope-Hennessy, J. *Sienese Quattrocento Painting*. Oxford and London, Phaidon Press, 1947.
Coor, G. *Neroccio de' Landi*. Princeton, Princeton University Press, forthcoming 1961.

# Three Great Masters of the High Renaissance

# ► 19

# Leonardo da Vinci

I
~~~~~~~~~~~~~~~~~~~~~~~~~~~~~~~~~~~~~~~~~~~~~~~~~~~~~~~~~~~~~~~~

F we had to choose one painter who in his work represents the best in the field of scientific discovery developed in the fifteenth century and who at the same time was a forerunner of the new directions of the sixteenth century, unquestionably that artist would be Leonardo da Vinci. Sculptor, painter, architect, engineer, writer, musician, naturalist, and inventor— Leonardo reflected in his personality and in his career that diversity of interest in art, nature, and culture present in the fifteenth century. He was an artist-scientist if there ever was one, and he had in his make-up all the characteristics those two words imply. He was a temperamental and imaginative being, equipped with an analytical and extremely inquisitive mind. Nothing escaped his observation. He had to know the answer to everything. Difficulties merely stimulated his imagination the more. But, although endowed by nature with all the qualifications of genius, Leonardo's interest in scientific minutiae forever interfered with his art, and his temperament injected a restlessness into his scientific observations, with the result that he seldom arrived at definite conclusions. His life is a record of things left undone. He collected reams upon reams of scientific data, but only on rare occasions was he able to get very definite results therefrom. The same is true in the arts. He experimented so much with sketches, drawings, studies, and models that he left to posterity very few finished products in painting, sculpture, and architecture.

353

Leonardo the Man

The milestones in Leonardo's life are these. He was born at Vinci, near Florence, in 1452 as the natural son of a bourgeois father and a peasant mother. Showing his capabilities in the arts at an early age, Leonardo was sent to the studio of Andrea Verrocchio (1435–1488), where many another young artist was trained. Verrocchio was primarily a sculptor, famous for his David (now in the Bargello), his group of Christ and the Doubting Thomas on the exterior of the guild house at Orsanmichele, and his equestrian portrait of Colleone in the square of San Giovanni e Paolo, Venice. Under the direction of this man, Leonardo attained his artistic majority in both sculpture and painting and set forth on his own in 1476. He went to Milan in 1483 in the service of the powerful Sforza family and remained there as engineer, architect, sculptor, and painter until the city was taken by the French armies in 1500. He then joined Caesar Borgia in the capacity of military engineer. Between 1503 and 1506 he revisited Florence, and then returned to Milan, this time in the service of the French. A short visit in 1513 to Rome, the Mecca for artists under papal patronage, netted Leonardo nothing, and he returned in disappointment to the north. In 1516, Francis I called the disillusioned old man to his court at Amboise in France, and here in the small château at Cloux Leonardo spent the remaining three years of his life.

The varied capabilities of Leonardo are strikingly set forth in a letter he wrote about 1482 to Ludovico Sforza while applying for service with that duke in Milan. It is worth reading. He writes: *

Most Illustrious Lord,
 Having now sufficiently considered the specimens of all those who proclaim themselves skilled contrivers of instruments of war, and that the invention and operation of said instruments are nothing different to those in common use; I shall endeavor without prejudice to anyone else, to explain myself to your Excellency, showing your Lordship my secrets, and then offering them to your best pleasure and approbation to work with effect at opportune moments as well as all those things which in part shall be briefly noted below.
 1) I have a sort of extremely light and strong bridges, adapted to be most easily carried, and with them you may pursue, and at any time flee the enemy; and others secure and indestructible by fire and battle, easy and convenient to lift and place. Also methods of burning and destroying those of the enemy.
 2) I know how, when a place is besieged to take water out of the trenches and make endless variety of bridges and covered ways and ladders, and other machines pertaining to such expeditions.
 3) Likewise, if, by reason of the height of the banks or the strength of the place and its position, it is impossible when besieging a place to avail

* Jean Paul Richter: *The Literary Remains of Leonardo da Vinci*, second edition by Jean Paul Richter and Irma A. Richter (London–New York–Toronto, 1950), Vol. II, pp. 325–327. [Paragraph 9 is out of order in the original publication. *Author*]

oneself of the plan of bombardment, I have methods of destroying every rock or other fortress, even if it were founded on a rock.

4) Again, I have kinds of mortars most convenient and easy to carry, and with these can fling small stones almost resembling a storm, and with the smoke of these causing real terror to the enemy to his great detriment and confusion.

9) And when the fight should be at sea, I have kinds of many machines most efficient for offense and defense, and vessels which will resist attack of the largest guns and powder and fumes.

5) Likewise, I have means by secret and tortuous and ways made without noise to reach a designated [spot] even if it were needed to pass under a trench or a river.

6) Likewise, I will make covered chariots, safe and unattackable, which entering among the enemy with their artillery, there is no body of men so great but they would break them. And behind these the infantry could follow quite unhurt and without hindrance.

7) Likewise, in case of need I will make big guns, mortars and light ordnance of fine and useful forms, out of the common type.

8) Where the operation of bombardment should fail, I would contrive catapults, mangonels, trabocchi and other machines of marvelous efficacy and not in common use. And, in short, according to the variety of cases, I can contrive various and endless means of offense and defense.

10) In time of peace I believe I can give perfect satisfaction and to the equal of any other in architecture and the composition of buildings public and private, and in guiding water from one place to another. Likewise, I can carry out sculpture in marble, bronze or clay, also in painting whatever may be done and as well as any other be he who he may.

Again, the bronze horse may be taken in hand which is to be to the immortal glory and eternal honor of the prince your father of happy memory, and of the illustrious house of Sforza.

And, if any of the above-named things seem to anyone to be impossible or not feasible, I am ready to make the experiment in your park or in whatever place may please your Excellency, to whom I commend myself with the utmost humility.

<div align="right">LEONARDO</div>

There you have the picture of the man drawn by himself, ready to apply his inventive genius to any problems of engineering, military ordnance, or art. This is also borne out by his sketchbooks, in which we find his ideas set down in visible form, such as fortifications and moats, cannon, barrages, and armored chariots (the first tanks), and studies for flying machines.

Leonardo's versatility and his interest to acquire knowledge of every manifestation in nature is copiously apparent in these same sketchbooks— whether it be rocks, clouds, a storm [19.1], plants, trees, insects, animals, or men. He collected specimens of all kinds, studied them, dissected them, and made notes about them with the fervor of a confirmed naturalist and anatomist. Abnormalities and curiosities in nature were a part of his research too. Anything complicated fascinated him. He had to know all about it; he had to become its master.

19.1. LEONARDO DA VINCI: Storm in the Alps (c. 1503). Sketch. Royal Collection, Windsor Castle, copyright reserved

Leonardo the Renaissance Artist

So also in the field of art. He mastered the techniques of drawing, light and shade, fresco, painting, modeling, bronze-casting, carving, and architectural drawing and made experiments of his own along various technical lines. Unfortunately, as already indicated, little remains beyond his sketches and notes: a handful of paintings, a few attributed pieces of sculpture in relief, and no building that can be ascribed with certainty to his design.

Yet these few existing paintings and the sketches and drawings made for them and for others now lost or never begun give us sufficient evidence of Leonardo da Vinci's technical wizardry, his invention in design that influenced Raphael and other sixteenth-century painters so powerfully, and his insight into the human psyche.

The list of Leonardo's paintings is this.

Three small items of the period when he was in Verrocchio's studio: the sensitive, kneeling angel in the lower left corner of his master's picture of the Baptism of Christ [19.2], now in the Uffizi; an Annunciation to the Virgin, also in the Uffizi; and another panel of the same subject in the Louvre, part of an altarpiece on which his fellow pupil Lorenzo di Credi also worked.

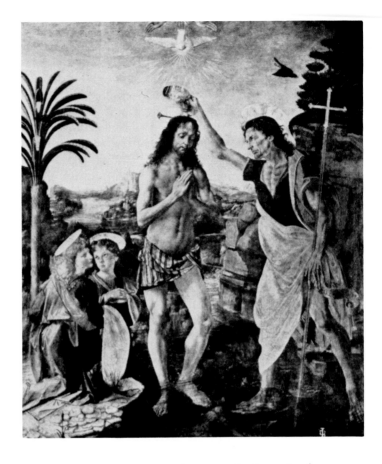

19.2. ANDREA VERROCCHIO: The Baptism of Christ (*c.* 1472). Angel at left by Leonardo. Panel painting, 69¾″ x 59½″. Uffizi, Florence (Alinari)

Three paintings dating from the years after he left Verrocchio's studio and before he went to Milan in 1483 to be in the service of Ludovico Sforza: the small Madonna in the Hermitage at Leningrad; the unfinished Adoration of the Magi [19.3], painted for the monks at Scopeto and now in the Uffizi; and the unfinished panel of St. Jerome in the Desert [19.4] in the Vatican Gallery in Rome.

From his first Milanese period of seventeen years, all that remains are: the Madonna of the Rocks [19.5] in the Louvre; the portraits of the Woman with the Ermine and of the Belle Ferronière, both also in the Louvre; some trellislike decorations in the Castello Sforesco in Milan; and the fresco of the Last Supper [19.10] in the refectory of Santa Maria delle Grazie in Milan.

During his visit to Florence, 1503–1506, he painted the portrait of the Mona Lisa [19.11] and worked on the drawings [19.15] and cartoons of the fresco for one side of the great hall of the Palazzo Vecchio, representing the Battle of Anghiari. This fresco, however, was never painted.

During his second stay in Milan under the French occupation, he painted the second version of the Madonna of the Rocks (now in the National Gallery in London), assisted by his pupil Ambrogio da Predis. He also began at long last the painting of St. Anne and the Virgin with the Christ child and the

youthful St. John the Baptist. He made his first designs for this composition during his earlier stay in Milan, and at the time he was painting the Mona Lisa he put another, famous design of the composition on exhibition in Florence where it attracted considerable attention. A very fine cartoon of the subject [19.7] is at present in Burlington House, London. His final design [19.13] in the painting does not follow any existing drawing and is a compact and intricate interweaving of the four figures represented. But once again Leonardo did not finish the painting. It was the compositional problem that absorbed him most, and once that was solved to his satisfaction the painting did not really matter. That perhaps could be left to a pupil to finish.

Other subjects that Leonardo painted are: the Leda with the Swan; Bacchus; and the seated figure of St. John the Baptist. The painting of the last named [19.14] in the Louvre is presumably by Leonardo. The other two we know only from copies.

This list of Leonardo's paintings is meager, but it is fuller than the list of his sculptures. Various attributions of relief sculpture have been made to him, but the most likely one is the helmeted profile of a young man, now in the Louvre. The notorious bust of Flora acquired in the last generation for the former Kaiser Friedrich Museum in Berlin has been discredited as a forgery. His most monumental undertakings were the equestrian statues to have been made for the Trivulzio and the Sforza families, but neither was ever cast or set up. Leonardo worked for seventeen years on the Sforza monument and succeeded in setting up the clay model in the courtyard of the Sforza castle in Milan only to see it shot to pieces by archers of the French army who used it as a practice target. Various sketches exist of it and for the casting process.

The Physiological Aspect of Man

A careful study of Leonardo's drawings and paintings will reveal that, in spite of all his scientific interest in the phenomena of nature (rocks, insects, clouds, flowers, trees, landscape) and in mechanics, his major preoccupation was with man. In that respect Leonardo was a true product of the Renaissance. But he turned his scientific searchlight on man in much the same way he turned it on other objects of nature. For Leonardo, man became a "specimen" too. And first of all a physical specimen. He drew heads, arms, legs, torsi, hands, and feet; he sketched skulls, skeletons, muscles, tendons, viscera, and everything that gave him more knowledge of the human being as a physical apparatus. In both drawings and paintings he found the head to be the most difficult and challenging part of the human anatomy to render because of the complication of planes, highlights, and shadows. And complications and difficulties always fascinated Leonardo.

Take, for instance, the unfinished picture of the Adoration of the Magi [19.3] in the Uffizi. The most finished portions of the picture, with the exception of the tree behind the Virgin, are the heads of the Magi and their

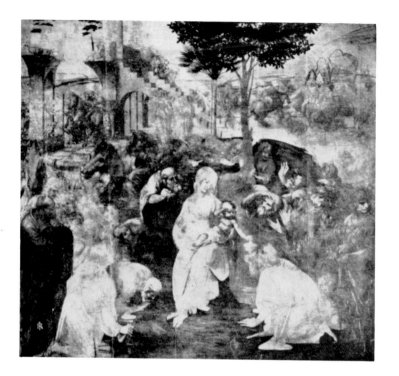

19.3 (*above*). LEONARDO DA VINCI: Adoration of the Magi (1481–1482). Panel painting, 97⅛″ x 95¾″. Uffizi, Florence (Anderson)

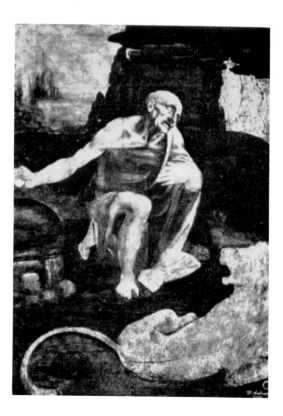

19.4 (*right*). LEONARDO DA VINCI: St. Jerome (*c*. 1483). Panel painting, 40⅝″ x 29 3/16″. Vatican Gallery, Rome (Anderson)

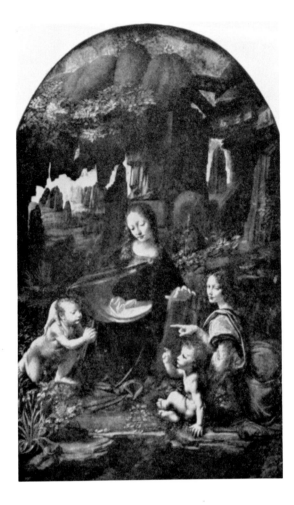

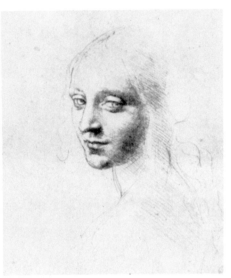

19.5 (*left*). LEONARDO DA VINCI: Madonna of the Rocks (1483–1490). Panel painting, 78″ x 48½″. Louvre, Paris (Alinari)

19.6 (*below*): Drawing of Angel for the Madonna of the Rocks. Silver point. Library, Turin (Alinari)

followers to right and left of the Madonna and Child. If we examine the heads of the group at the right, it becomes clear what Leonardo's major interest is. It is not the expression of adoration common to them all but the physical differentiation that distinguishes one as a youth, another as a middle-aged man, a third as an old man, and finally one who is so old that his head is a skull with skin stretched across it. That is, Leonardo has observed that to the eye age differences are apparent in the skull structure. In youth the skull is covered with cushions of flesh, but with advancing age the hollows of the bony structure underneath manifest themselves. In drawing or painting, the old man is the most difficult for the artist to realize because of the complications of the highlights and the shadows. So, in this picture, once he had mastered these complications he lost interest. A similar striking example is the unfinished panel of St. Jerome [19.4] in the Vatican Gallery. Leonardo worked out in detail all the technical difficulties of rendering the shrunken neck and hollow-eyed head of the ascetic saint and then left the rest of the picture unfinished. The most difficult technical problem had been solved.

19.7. LEONARDO DA VINCI: Cartoon of St. Anne and the Virgin (*c.* 1499). Charcoal heightened with white, 54¹³⁄₁₆″ x 39¹³⁄₁₆″. Burlington House, London (Anderson)

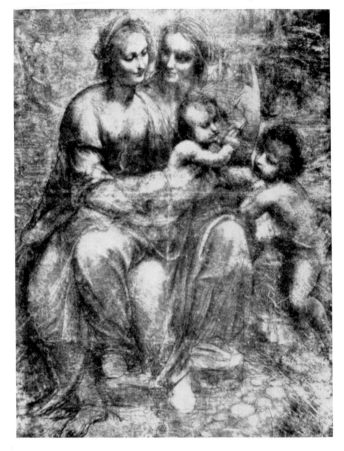

Yet Leonardo was not content just to put down these observations of the physical as it appears to the eye, and, following the tradition of Classical artists, he experimented with the relation of parts to the whole, such as features to the head or legs and arms to the torso. Can a general proportion or a set of proportions be established to create a type, an ideal type? The Greeks had done it and several of Leonardo's predecessors and contemporaries in the fifteenth century had attempted it. So we find in his notebooks drawings of heads in profile or full face, with lines marking the sizes of eyes, nose, mouth, and chin in numerical relation to the head. And in his finished drawings and in his paintings we find heads conforming to a mathematical proportion creating his ideal type of physical beauty, just as the Greek types of physical beauty conformed to mathematical proportions. Examples of this ideal head type are: the Virgin and the angel in the Madonna of the Rocks [19.5] and the drawings made for them [19.6]; the Madonna and the St. Anne in the cartoon in Burlington House [19.7] and in the painting in the Louvre [19.13]; and the drawing of St. Philip for the Last Supper.

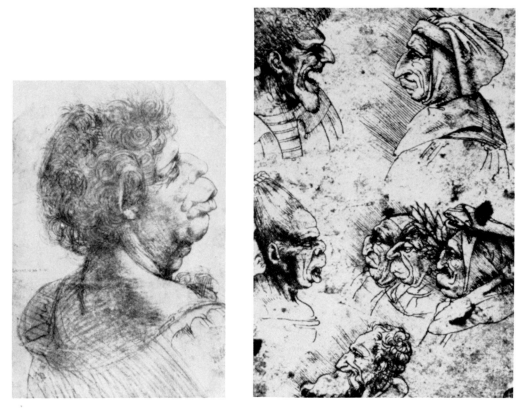

LEONARDO DA VINCI: 19.8 (*left*). Drawing of man with deformed lip (*c.* 1490). Christ Church Library, Oxford (By permission of the Governing Body of Christ Church, Oxford). 19.9 (*right*). Sketches of abnormalities (*c.* 1490). Accademia, Venice

While setting down these actual, normal appearances of human heads or the ideal ones, Leonardo—true scientist that he was—studied and recorded the abnormal physical appearances of people he saw. Consequently we have many extraordinary sketches that he made of facial or cephalic abnormalities. They have often been wrongly called "caricatures." But a caricature is a conscious distortion of certain physical peculiarities in order to achieve a humorous effect or in order to be satirical. A look at the remarkable sketch of the man with the abnormally large and thick lips [19.8] shows that it is neither humorous nor satirical. It is a statement of what Leonardo saw, and it calls forth pathos rather than humor. In like manner the sketch of the so-called "Duchess of Carinthia" evokes a feeling of horror and revulsion but not of amusement. It was Teniell who took this unfortunate creature as the model for his illustration of Lewis Carroll's Duchess and made her a figure to be laughed at. Another sketch contains the heads of three men with fatuous expressions [19.9]. Laurel-wreaths crown their heads. They are the fifteenth-century counterparts of what one can see in any institution for the

mentally unbalanced suffering from a Napoleon complex. They are thinking of themselves as Roman emperors or as poets of fame. Leonardo drew pages filled with these human unfortunates because they fascinated him and because they were "specimens" found in nature. In the days when, in a congested city like Milan or in the backwoods of Tuscany or Lombardy, no adequate provisions were made for the care of cretins, the insane, or the physically abnormal, Leonardo had ample opportunity to carry out his investigations "for the record." In his instructions to young artists he says: *

> When you have well learnt perspective and have by heart the parts and forms of objects, you must go about, and constantly, as you go, observe, note, and consider the circumstances and behaviour of men in talking, quarrelling or laughing or fighting together: the action of the men themselves and the actions of the bystanders, who separate them or who look on. And take a note of them thus, in a little book which you should always carry with you . . . for the forms, and positions of objects are so infinite that the memory is incapable of retaining them, wherefore keep these as your guides and masters.

This was indeed what he did himself, and these sketches are some of the results he gathered together.

The Psychological Aspect of Man

It is obvious that a keen observer like Leonardo could not study the external appearance of so many heads without also becoming aware of what went on inside them. Men's faces best reflect their emotions and their character. So we find Leonardo giving more attention to the study of human personality than did any other artist in Italy before his time. And as the result of his study he shows us in his paintings and drawings three types of personality corresponding to the three types of objective physical appearances—that is, the average or normal, the ideal, and the abnormal.

Leonardo was the first artist to paint the Last Supper [19.10] as a study in psychology. The traditional way of painting that event had been to place Christ and eleven of the apostles on one side of the table and Judas the Betrayer on the other, so that there would be no doubt as to Judas' identity. But Leonardo placed all the figures on the same side of the table and isolated Judas *emotionally* from the rest. It is as though he were posing the following problem: The Master has with Him at the Last Supper the twelve men—most of them from the simpler walks of life—who have given up their all to follow Him. He announces that one of them is to betray Him and cause Him to be executed. What would the effect be (1) on the eleven to whom this was incredible news, and (2) on the one who is guilty?

There might be several solutions, but Leonardo chose a specific one. The eleven to whom the announcement is a shocked surprise react very emotionally as a group and, at the same time, each apostle reacts according to his

* Richter, J. P. *op. cit.* 1939 ed., Vol. I, p. 338.

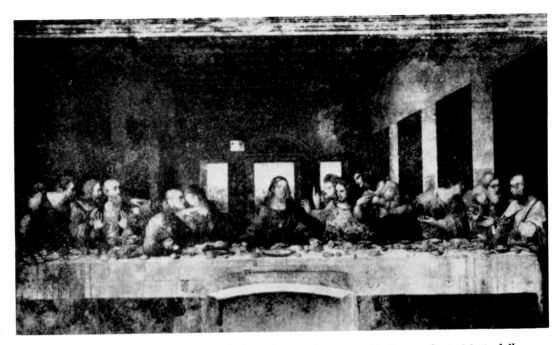

19.10. LEONARDO DA VINCI: The Last Supper (1495–1498). Fresco. Santa Maria delle Grazie, Milan (Soprintendenza)

personality as we know it from the Gospels. Thomas the Doubter raises a challenging finger at Christ demanding proof that it is he; Andrew draws back in horror at the idea; the gentle Philip leans forward, arms folded across his chest, to ask if Christ could possibly think it were he; Peter's jaw juts out aggressively as he demands whether Christ has him in mind. The groups of three at either end of the table excitedly discuss among themselves the implication of Christ's words. John leans away from Christ, completely stunned and overcome by His words. Traditionally John is represented as falling over on Christ's bosom, but here Leonardo uses the diagonal line of John's form retreating from Christ in order to separate sharply the group at the left containing Judas from Christ and the group at the right. This diagonal of John is repeated in the figure of Judas set as a defiant triangle in the midst of all the emotional turbulence about him. Except for the Christ, Judas is the only figure who is still. As he clutches his moneybag and turns to see the reaction of Christ's words on the others, he has been emotionally isolated by Leonardo. There has been no need to place Judas on the opposite side of the table. Quite apart from the compositional virtuosity displayed here by Leonardo, the Last Supper is primarily a great psychological picture. It is not a religious picture in the sense that a painting by Angelico is. It becomes so only as the situation concerns Christ and His apostles. We could substitute for the Christ any other great leader in a similar situation and the effect would be the same. Leonardo's problem was to depict personality under the stress of emotion.

After his studies in group psychology in the Last Supper, that took many years in Milan to achieve, Leonardo was ready for his supreme achievement, the representation of a specific personality, the Mona Lisa [19.11], painted during his stay in Florence in 1503–1506.

Portrait painting—that is, the representation of the human individual—had been revived only recently in Italy as elsewhere in western Europe. It developed naturally in the wake of the wave of secularism and interest in the individual at the end of the Middle Ages. In the fourteenth century the portrait was still merely a variation of a type. For example, Giotto's figure of Enrico Scrovegni presenting the Arena chapel to the angels in the Last Judgment fresco [6.2] at Padua is scarcely to be distinguished from any of the other figures in the fresco. Essentially it is Scrovegni's act of presentation and a few details of costume, perhaps, that set him apart from the rest. Giotto still followed the older medieval tradition of placing the donor portrait to one side, so frequently found in sculpture and painting. It was merely incidental to the main theme, and often an inscription was necessary to give the donor his contemporary status. Simone Martini followed the same tradition in the Naples Museum panel of St. Louis of Toulouse [7.3] by painting the small figure of Robert of Anjou kneeling at the foot of the throne of his sainted brother. Simone painted Robert's head with certain particular descriptive details, such as the long black hair and the hooked nose, but these are "pasted on," as it were, to the general Simone type. His fresco portrait of the warrior Guidoriccio [7.5] in the Palazzo Pubblico at Siena, however, can claim to be the first portrait in the truer sense, since the portrait is the main feature of the painting. Yet Simone had to resort to descriptive details, such as costume, the caparisoned charger, the fortified castles on the hilltops, the encampment and the soldiers with pikes and banners, to give the spectator a notion of the warlike character of the general. He made no attempt to portray personality.

In the fifteenth century, when painters were more concerned with putting down what they saw, the portrait took on greater importance. What established one individual as different from any other *visually* were such details as the shape of the head, the brow, the nose, the mouth, the chin. The profile portraits painted by Masaccio, Uccello, or Veneziano were best suited to show these varied characteristics of head and face. Excellent examples of this type are the portraits of the Duke and Duchess of Urbino painted by Piero della Francesca [11.10, 11.11]. Every detail of facial anatomy is brought out with maplike precision, even facial blemishes. Yet in these portraits the individual is not established because of his or her personality but because of the idiosyncrasies of physical appearance. The expressive features of the Duke and the Duchess are frozen; the eyes are fishy and dead; they are like waxworks at Mme. Tussaud's museum.

Botticelli realized this when in the full-face portrait he began to use all the mobile features of the face, such as the eyebrows, eyes, nostrils, and lips, to reflect the emotions and character of a living individual. The full-face

19.11 (*left*). LEONARDO DA VINCI: Mona Lisa (1503). Panel painting, 30½″ x 20⅞″. Louvre, Paris (Alinari)

19.12 (*right*). SANDRO BOTTICELLI: Portrait of a Young Man (*c.* 1482). Panel painting, 14¾″ x 11⅛″. National Gallery, London (Anderson)

portrait has an added advantage. If you sit at a football game or ride on a public conveyance and observe the variety of human specimens about you, you note first of all the details of their appearance, their physiognomies, the color of their hair, or other physical details. But should one of these "specimens" turn and direct his or her gaze toward you, you immediately become aware of a personality. So in a full-face portrait the artist has a greater chance to display the personality of the sitter. Take Botticelli's portrait of the young man [19.12] in the National Gallery, London. What emerges and is important are not all the physical details of the head but the personality of an eager, intelligent youth, sensitive and somewhat petulant—and a bit spoiled perhaps.

In this type of portrait the question often arises as to whose personality actually is shown. Perhaps it is that of the artist himself, or at least partly so. Perhaps the artist chose the sitter because he saw something of himself reflected in the face of the sitter. Certainly in the portrait just described we note many of the characteristics of Botticelli himself.

Much has been written about Leonardo's portrait of the Mona Lisa. She has been called the great enigma. Is she smiling, or is she sad? And the story

19.15 (*left*). LEO-
NARDO DA VINCI:
Sketch for Battle
of Anghiari (*c.*
1503). Pen and
ink. Accademia,
Venice (Ander-
son)

19.16 (*below*). LEONARDO DA VINCI: Sketch of Galloping Horse
(*c.* 1504). Red chalk. Royal Collection, Windsor Castle, copyright re-
served

nitely the one or the other sex. It is a Renaissance hermaphrodite. The same avoidance is true emotionally: here is no focused personality, but a strange schizophrenic being leering out of the picture at the spectator.

The remarkable thing is, of course, that all three personality types—the normal, the ideal, and the abnormal—as represented by the Mona Lisa, the St. Anne, and St. John the Baptist, bear a general family resemblance and wear the same smile. Yet in the Mona Lisa we are aware of a definite, focused, individual personality, in the St. Anne we recognize a generalized ideal, and in the St. John we look upon a distracted, Ophelia-like personality such as one meets in institutions for the mentally ill.

Form in Action

Leonardo's keen observation, his inventiveness, and his draughtsmanship led him to the solution of another very important problem, that of form in action. In the fourteenth century this problem really had not been posed. Episodes were generally presented as tableaux. If movement or action were required, abstract elements of design, such as interacting diagonals or curves, sufficed for the purpose. Late Sienese paintings and those in the International Style used winding curvilinear designs to give the effect of movement.

With and after Masaccio, when forms were rendered according to the laws of visual experience, the problem of representing action became more difficult. The first problems concerning form were naturally those of static form (Masaccio, Castagno, della Francesca), but what about the representation of forms in action? The difficulty presented by this problem was that in visual experience motion occurs during a change of time and place, whereas in a painting or drawing action has to be presented at one time and in one place. Hence the artist depicting forms in motion must give at one time and in one place (the picture) the experience of a change in time and place.

Uccello was the first Renaissance artist really to tackle the problem in his battle scenes [10.20] where action is actually the theme of the picture. But examination of any separate figure or horse in Uccello's pictures does not reveal a solution of the essential problem. His individual horses, painted with a generalized light and shade to create form but without any muscular reactions to movement, are frozen, wooden hobbyhorses. Yet, when we examined Uccello's paintings, we noticed that the sense of action was produced solely by the abstract curvilinear organization of elements in the picture into a flowing design that catches the eye and moves it around the picture.

Antonio Pollaiuolo was certainly interested in form in action. He had observed the strained postures and the flexed muscles of figures undergoing physical exertion. So in his Labors of Hercules [11.18] and in the engraving of the Battle of the Ten Nudes [11.19], he covers the bodies of the nude figures with all the details of flexed muscles, not realizing that in action some muscles of the body are flexed while others are relaxed. So it happens that any single figure in the Battle of the Ten Nudes by itself looks rigid, tense,

19.13 (*left*). LEONARDO DA VINCI: St. Anne and the Virgin (1508–1510). Panel painting, 67″ x 50⅞″. Louvre, Paris (Alinari)

19.14 (*right*). LEONARDO DA VINCI: St. John the Baptist (1509–1512). Panel painting, 27¼″ x 22⁷⁄₁₆″. Louvre, Paris (Alinari)

is repeated over and over again that Leonardo had to have music played while he painted her in order to keep her mind off the sad events of her life.

Despite the fact that the Mona Lisa is one of the most famous pictures in the world, most people doubtless would not care to have it around all the time as they might some portrait by Titian or Raphael. The reason is simply that the Mona Lisa gives her viewers an inferiority complex. She, so to speak, "has their number." As she looks out at them she knows all about *them*, but they know very little about her and cannot fathom her.

What all this means is that Leonardo, as we have seen, through his studies of the objective appearance of the human head became interested in what goes on inside it—that is, in the personality. In the Last Supper he showed us the psychological reactions of a group of people. In the Mona Lisa he wanted to, and did, depict a definite personality. He pointed out to the spectator, using the Mona Lisa as the subject, that the human individual personality is, or can be, one of the subtlest things in creation, that personality is something that cannot be pinned down and pigeon-holed, because the moment you say it is one thing it can turn around and be another. That is the so-called "enigma" of the Mona Lisa, and that was Leonardo's supreme problem, the subtlety of individual personality. The sheer difficulty of the problem fascinated Leonardo. With what genius he solved it is seen in the portrait itself. Never has there been such subtle treatment of light and shade in the modeling of form. Highlights deepen into shadows, and shadows resolve into highlights with almost magic transitions. Definition of either defies pinning down, just as the specific qualities of the personality do. As we have suggested before, perhaps there is a reflection of Leonardo's own subtle personality in the Mona Lisa for which the sitter has become a foil. The portrait apparently was his favorite painting. He did not leave it unfinished, and he carried it about with him until he died. Hence it was in the château at Cloux when he died, then passed into the possession of Francis I and into the royal collection of France; it is now in the Louvre. The same is true of the unfinished picture of St. Anne and the Virgin [19.13] and of the St. John the Baptist hanging in the same museum.

The second problem in personality was that of the generalized or ideal personality. Which of the human emotions would be the best counterpart for his ideal head type expressive of beauty? Obviously the gentler ones of kindness, tenderness, love. Hence to his ideal head type as seen in the Virgin, the St. Anne, the angels, and others Leonardo imparted that soft, gentle smile to indicate mother love or adoration. In all these there is no sense of a concrete individual as we feel it in the Mona Lisa, but only the generalized beauty of form and emotion.

In this study of personality Leonardo had also observed the abnormal. This is strikingly evident in his later pictures, particularly in the St. John the Baptist [19.14] in the Louvre. It is difficult to say whether the figure is male or female. Leonardo avoids, apparently intentionally, making the form defi-

and incapable of movement. But since Pollaiuolo has arranged the forms in a design in which curves and ellipses predominate, an effect of movement is achieved for the whole design that is transferred psychologically to the figures.

But when we look at Leonardo's drawings of horses or his studies of the figures for the Battle of Anghiari [19.15], the individual horses or men really move. His solution of the problem was this. Let us say that he had observed a galloping horse [19.16]. He caught the essentials of the details of the action —the flying mane, the stretch of the body, the galloping legs that in actuality are a series of actions—and incorporated them into one figure and one action. It is as though someone had taken a moving picture of a galloping horse and then had cut the filmstrip into the separate frames, placed one on top of the other, and eliminated all but those details most effectively conveying the impression of the gallop. In each such figure Leonardo then organized these details into a rhythmic design that keeps the eye moving around the drawing or picture.

When it came to representing the human form in action Leonardo arrived at the same solution that Michelangelo did. Having studied anatomy and having observed figures in action (as he advised others to do), he noticed not only that there were alternations of muscular tension and relaxation but also that the source of power in a human form was in the twist at the waist whereby leverage is obtained for any action, as in a coiled spring. By representing a body in this counterpoised position and by organizing rhythmically the details resulting from it, he gave the effect of action to the form.

In spite of the interest in perspective resulting from the studies of the architect Brunelleschi and of its use by fifteenth-century painters since Masaccio, rarely in paintings had there been any actual space relation of the foreground figures to the background. The effect in fifteenth-century paintings was usually one of a foreground space in which the figures could move and a background that was little more than a backdrop. We have seen how this was the case in Uccello's paintings and how the two parts of the picture were held together by the design. The same was true of the Funeral of St. Stephen [13.8] by Fra Filippo Lippi in Prato cathedral or of the Funeral of Santa Fina [15.1] in the Collegiata at San Gemignano by Ghirlandaio. The figures in the foreground are not *in* the space created by the perspective but in front of it. The river valleys in the paintings by Pollaiuolo and Ghirlandaio give the same effect. It was Leonardo, however, who studied the problem of forms in relation to the space created by perspective and who really set his figures *in* the space. His perspective sketches for the Uffizi Adoration of the Magi plainly show this. In the Last Supper [19.10] in Milan the table and the figures of Christ and the apostles are *in* the space of the room, and the background is not a backdrop. In fact, as the result of Leonardo's painting of the perspective, the room appears to be a part of the refectory, as though it were an elevated space at the end of the room.

Group Composition

Leonardo, then, as artist-scientist found the solution to many problems in painting that resulted from the contemporary fifteenth-century interest in representing what the eye sees. Three of these we have discussed—the human being as an individual, form in motion, and the relation of form to perspective space. But Leonardo was also fascinated by the problems posed in the arrangement of form groups.

We have remarked that Leonardo was an artist who still had one foot in the fifteenth century but had the other in the sixteenth. That is rather nicely illustrated in his compositional studies of these form groups as they appear in pictures at three different periods of his work. For example, in his sketch, dating about 1474, for the Adoration of the Magi, the unfinished picture in the Uffizi, Leonardo in general followed the traditional design found in paintings by Botticelli and Ghirlandaio. In these the manger was placed in the center of the middle distance behind the Madonna and Child group to form the apex of the central triangle of a W design in perspective. Leonardo, however, moved the manger and the Madonna group into the foreground and straightened up the W design, which he made up only of the figures in the immediate vicinity of the Madonna. By itself, the Madonna group was beginning to take on a pyramidal design. In the unfinished picture [19.3], the manger was omitted, freeing the Madonna group of the rectangular "lid" that pinned it down in the drawing and allowing the pyramidal design to assume more monumentality in space. Looked at two-dimensionally as a triangle, the Madonna group takes up about one quarter of the picture area.

In the Madonna of the Rocks [19.5] in the Louvre, Leonardo built up the group into an even more apparent pyramid. The camera, so to speak, had moved closer to the Madonna group, which now takes up half the picture area and, as a result, has become more monumental. And the number of figures has been restricted to four. This is indeed an anticipation of the sixteenth-century use of form monumentally to the exclusion of the background. But in the Madonna of the Rocks Leonardo still clung to the fifteenth-century love of depicting details of nature in the foreground and background: the rocks, the flowers, the grasses. On the other hand, his preoccupation with the group and its geometric organization was the springboard for not only his own later studies but also those of the great artists of the sixteenth century, such as Raphael, Fra Bartolommeo, and Andrea del Sarto.

Leonardo's preoccupation with interrelated figures in complicated geometric organizations is most apparent in his studies over many years of the theme of St. Anne and the Virgin with the Christ child and the infant St. John the Baptist. We have mentioned earlier the famous cartoon of this subject [19.7] in Burlington House, London, and the cartoon (now lost) exhibited by Leonardo in Florence about 1505–1506 that called forth so much admiration and must have made a deep impression on Raphael. Leonardo

finally got the group down in paint [19.13], although as we now see it in the Louvre, it is unfinished. But in the painting we can see how completely Leonardo shed the fifteenth-century manner and became a leader in the sixteenth-century use of monumental form. The group occupies almost all the picture area, and the background and details of nature have been subdued so as not to interfere with the importance of the figure group. It was not only the problem of the use of form groups for monumental effect that interested Leonardo but the variety of designs possible when using interrelated human forms in a compact pyramidal composition. This again was to fascinate him and to stimulate his imagination to look for and find brilliant solutions to the problem.

All these accomplishments of Leonardo are adequate evidence of the versatility of his genius. It would be difficult at any time, before or after, to find his equal in the universality of his knowledge, in his inventive brilliance, or in the perfection of his technique in the arts.

BIBLIOGRAPHY

Pater, W. *The Renaissance; Studies in Art and Poetry.* New York, Modern Library, 1920; originally published London, 1873. (Essay on Leonardo)

Berenson, B. *The Study and Criticism of Italian Art,* 3d series. London, G. Bell and Sons, 1916. (See pp. 1–37)

McCurdy, E. *The Mind of Leonardo da Vinci.* New York, Dodd, Mead & Co., 1928.

—— *Leonardo da Vinci: the Artist.* London, Jonathan Cape, 1933.

—— *The Notebooks of Leonardo da Vinci,* arranged and translated with numerous introductory notes, 2 vols. New York, Reynal & Hitchcock, 1938.

Clark, K. McK. *A Catalogue of the Drawings of Leonardo da Vinci in the Collection of His Majesty the King at Windsor Castle.* Cambridge, Cambridge University Press, 1935.

—— *Leonardo da Vinci. An Account of His Development as an Artist.* Cambridge, Cambridge University Press, 1939; revised, Harmondsworth, Penguin, 1958.

Goldscheider, L. *Leonardo da Vinci.* London, Phaidon Press, 1943.

Popham, A. E. *The Drawings of Leonardo da Vinci.* New York, Reynal & Hitchcock, 1945.

Richter, J. P., and Richter, I. A. *The Literary Works of Leonardo da Vinci,* compiled and edited from the original manuscripts, 2d ed. New York, Oxford University Press, 1939, 1950.

Heydenreich, L. H. *Leonardo da Vinci,* 2 vols. New York, Macmillan Company, 1954.

Leonardo da Vinci. New York, Reynal & Company, 1956. (A huge publication resulting from the memorial exposition just before World War II. Many contributors of articles; large quantity of illustrative material practically inaccessible elsewhere)

⋆ 20

Michelangelo

I‌T was at Rome and at Venice that the masterpieces of the High Renaissance were produced. By an irony of fate, Florence, after so much preparation, was succeeded by Rome where their great wealth and temporal power made the popes the obvious successors of the Medici as dispensers of patronage. There were other reasons, of course, but the death of Lorenzo the Magnificent in 1492 put a temporary stop to the patronage of the Medici in Florence, and the confusion that followed there was not helped by the French invasion of Italy in 1500. Meanwhile, Nicholas V (1447–1455), who had spent his earlier years in the company of humanists surrounding Cosimo de' Medici, had undertaken as pope to beautify the Eternal City, and each of the succeeding humanist popes apparently had tried to outdo his predecessors in magnificence. Nicholas himself had brought Fra Angelico to the Vatican to paint frescoes in his chapel, and Sixtus IV (1471–1484) had summoned the outstanding painters to decorate his Sistine chapel. Accordingly, when Lorenzo de' Medici died, Rome was ready to take over from Florence the leadership in art, and it was the popes who became the great patrons of art and distributors of privilege—the Borgia Alexander VI (1492–1503), the della Rovere Julius II (1503–1513), the Medici Leo X (1513–1521), Lorenzo's son, and Clement VII (1523–1534), and the Farnese Paul III (1534–1549), churchmen from families already known as patrons of art. And it was in the atmosphere of intrigue, nepotism, and neopaganism that flourished in Rome during these years that Michelangelo Buonarroti was constrained to spend the greater part of his life and create the majority of his masterpieces.

374

20.1. MICHELANGELO: Pietà
(1498–1500). Marble
sculpture. St. Peter's, Rome
(Alinari)

Like Leonardo, Michelangelo did not confine his creative genius to one art. Although he was primarily a sculptor, he was equally capable as a painter, an architect, and a poet. It is essentially his accomplishments in the field of painting that will interest us here.

Born at Caprese in 1475, Michelangelo was taken to Florence in his early teens to study with Domenico Ghirlandaio. His talent in drawing developed so rapidly that when Lorenzo de' Medici requested Ghirlandaio to send him his most promising pupils to be trained as sculptors in the Medici gardens and to live at the palace, Michelangelo was one of those chosen. Among other things he studied and sketched the frescoes of Giotto at Santa Croce and of Masaccio at the Carmine, was impressed by the preachings of Savonarola whose star was in the ascendant at that time, and also sat in on the Medicean Neoplatonic Academy at Careggi. Michelangelo was only seventeen years old when Lorenzo the Magnificent died in 1492, and yet he had already distinguished himself in sculpture, as the Battle of the Lapiths and the Centaurs in the Casa Buonarroti in Florence shows. After Lorenzo's death, he visited Bologna for a short time and at the age of twenty-one made his first trip to Rome. There he rapidly established his reputation as a sculptor with, for example, his tipsy Bacchus, and was commissioned to carve the Pietà [20.1], now in St. Peter's.

The Sistine Chapel Ceiling

Pope Julius II wanted Michelangelo in Rome to discuss the erection of a monumental tomb that was eventually to house the pope's bones. Once the commission was given, the pope temporarily lost interest, because of another great project, the rebuilding of St. Peter's, that he was discussing with the architect Bramante, and Michelangelo, humiliated, left Rome. One account has it that he left because his life had been threatened in a feud with Bramante, a relative and friend of Raphael. Be that fact or fiction, the pope, with commands and threats, tried to get Michelangelo back, but stubbornly the sculptor stayed away until he received a papal guarantee of personal safety.

Julius II now was anxious to have Michelangelo back in Rome because of a third major project, the decoration of the ceiling of the Sistine chapel. Vasari claims that Bramante, envious of the pope's interest in Michelangelo, had suggested to Julius II that the decoration of the Sistine ceiling be entrusted to Michelangelo. Bramante thereby hoped to discredit the great sculptor, whose ability as a painter he believed to be inferior. Michelangelo did in fact recoil from the undertaking, stating that he was a sculptor and no painter and suggesting that Raphael be given the job. But Julius insisted, and Michelangelo gave in.

The preparations for the decoration of the Sistine chapel ceiling were begun May 10, 1508. It took the remainder of the year to settle on the subject matter, make the initial drawings and cartoons, and erect the huge scaffolds necessary for the work. Assistants were brought from Florence, presumably experts in the fresco technique, but Michelangelo ran into so many difficulties with them that eventually he dismissed them all and undertook to do the job singlehanded. The painting probably was begun in January 1509. On November 1 of that year, about half completed, the work was uncovered and shown to the public. The effect was such that Bramante again started intrigues: this time he suggested that Raphael be allowed to finish the work since Michelangelo had established his renown with what he had already done. Michelangelo naturally was infuriated and insisted on finishing the ceiling himself. Fortunately Pope Julius stood behind him.

The scaffolding had now to be rebuilt and Michelangelo set to work on the remaining half. Goaded by the pope, who would climb the scaffolding to watch him work, and constantly badgered by his family with demands for financial help, Michelangelo led a hectic existence. The impatient pope is supposed finally to have threatened to have him thrown down from the scaffolding if he did not hurry to complete the ceiling. That decided Michelangelo, who then had the wooden structures taken down and left the frescoes as they were without the final touches of gold intended for them.

Michelangelo stopped the work on October 12, 1512, and the frescoes were uncovered on New Year's Day 1513. All Rome was amazed at the stupendous performance. About 10,000 square feet of surface had been cov-

ered with some 343 figures. How Michelangelo himself felt after this grueling experience he related in a sonnet: *

> I've grown a goitre by living in this den—
> As cats from stagnant streams in Lombardy
> Or in what other land they hap to be—
> Which drives the belly close beneath the chin;
> My beard turns up to heaven; my nape falls in,
> Fixed on my spine; my breast-bone visibly
> Grows like a harp; a rich embroidery
> Bedews my face from brush-drops thick and thin.
> My loins into my paunch like levers grind;
> My buttock like a crupper bears my weight;
> My feet unguided wander to and fro;
> In front my skin grows loose and long; behind
> By bending it becomes more taut and strait;
> Crosswise I strain me like a Syrian bow;
> Whence false and quaint, I know,
> Must be the fruit of squinting brain and eye;
> For ill can aim the gun that bends awry.
> Come then, Giovanni, try
> To succour my dead pictures and my fame,
> Since foul I fare and painting is my shame.

The design of the ceiling decoration is an amazing performance in itself. The actual ceiling is a flat tunnel, or barrel, vault, interpenetrated at regular intervals by windowheads that form incipient cross-vault sections. The narrow ends of the tunnel vault terminate in halfdomes broken into at the corners by triangular vaults. So the shape of the space to be decorated was rather complicated. Michelangelo had the choice of either emphasizing that shape or masking it with some superimposed design. He chose the latter solution [20.4]. He began by establishing a large continuous rectangle along the central area of the tunnel vault where there were no interruptions from the cross-vault sections and from the triangular vaults. This rectangle he painted as though it were the terminal cornice of the side and end walls and made it appear to be supported by rectangular pilasters breaking out from the walls at regular intervals, thus creating rectangular, boxlike niches. His intention was to paint out the effect of the curved vault and to make this space seem to be a continuation of the vertical walls below, giving the chapel the appearance of greater height. Consequently, on top of each of these illusionistic pilasters he painted block pedestals on which sculpturesque nude figures were seated, and in each of the rectangular niches below he created a simple bench-throne on which the single figures of prophets and sibyls were set. So each niche contained a gigantic seated figure flanked by two sculpturesque nudes facing inward and placed on top of the enclosing

* John Addington Symonds: *The Life of Michelangelo Buonarroti*, 3d ed. (New York, Scribner's Sons, 1899), Vol. I, pp. 234–235.

20.4. MICHELANGELO: The Sistine Ceiling (1508–1513). Fresco. Sistine chapel, Vatican, Rome (Anderson)

pilasters. This created an inverted triangle composition of figures for each niche, drawing the eye of the spectator to the large prophet and sibyl figures. And since these seemingly rectangular niches were painted in the curved spaces of the vaults between the windowheads, the effect was both to destroy the curves of the vaults and to make an easy transition from the pseudo-vertical painted wall space to the actual side walls. Then from behind each seated nude along one side of the cornice he painted what appears to be a broad arch spanning the space across the ceiling to the corresponding nude on the opposite side. The rectangular spaces thus produced by these arches at the top of the ceiling became the frames for the scenes from the Old Testament furnishing the main subject matter of the ceiling. Thus by means of this extraordinary use of pseudo-architecture and pseudo-sculpture, Michelangelo created a magnificent setting for the equally extraordinary theme of the ceiling.

When Pope Sixtus IV had the painters from Florence and Umbria decorate the walls of the Sistine chapel (1481–1483), as we have seen, he chose

as the theme of the decoration the contrast between the Old and the New Testaments exemplified by parallel episodes from the life of Moses and from the life of Christ. That, of course, was in keeping with medieval tradition. The subject matter of Michelangelo's ceiling was to link up with that of the side walls. And later, when the Last Judgment was added to one of the end walls, the Sistine chapel was to present a unified Christian program from the beginnings of Creation to the Last Days, resembling that found on French Gothic cathedral portals or in Giotto's frescoes in the Arena chapel at Padua. But Michelangelo's interpretation had its own Renaissance flavor as we shall point out.

The ten scenes he painted in the nine panels along the top of the ceiling emphasize effectively two of the major tenets of the Hebrew and Christian religions: the One God, and the hopelessness of Man when left to himself. In the first scene of the Separation of Light from Darkness, Michelangelo represents God as a gigantic figure with human aspects (for, "God made Man in His own image"). No details are emphasized, except the beard, for God is a tremendous generalized dynamic force, the All-Powerful, who by his very action is able to separate the Light from the Dark. The sweeping curves of the design accomplish the effect. As for the representation of

God as an old man with a white beard, that goes back to the early texts in which God is referred to as the Ancient of Days. But Michelangelo indicates His indestructible, eternal quality by giving Him a powerful athletic body.

In the second scene in which the creation of the sun, the planets, and plants are represented, dynamic action is still an attribute of Michelangelo's God. He appears twice, as in a medieval painting or mosaic, both coming and going. But this double representation adds to the sense of onrushing power, similar to the experience of a railroad train sweeping by. The small attendant figures, like emanations or sparks from a fireball, add to the sense of speed in the figure of God. But in addition, the interesting thing is that Michelangelo has particularized certain features of God more than in the first picture, and thereby shows us *how* God created. His eyes and furrowed brow indicate the intense concentration of the Supreme Being during the act of creation, and the gesture of His right hand adds the idea of command. God is *willing* that things be and they *are*. All through early Genesis we come across the expression: "And God said, 'Let there be . . . , and there was'" God is the Supreme Will. And the material creations that result from His acts of Will, such as the stars and the planets, inanimate though they be, take on the dynamic quality of their Creator as they begin their orbits through space.

In the next scene Michelangelo offers a third attribute of God. No more benign figure was ever painted than this God raising His hands in blessing as His imposing figure floats in the space between heaven and earth [20.5]. "And the Spirit of God hovered over the waters." The effect is achieved by the simplest of means. The sense of the extension of the figure of God in space is produced by a cornucopialike design in foreshortening, the hands and arms of God expressing the widest opening. The simple band at the bottom of the fresco representing the sea adds immeasurably to the total effect.

According to Genesis, only one more thing was now lacking, and that was Man. In the next scene, that is generally called the Creation of Adam, Michelangelo begins the first act of the drama he is to lay before us. The preceding scenes have been preludes. It is not just the creation of Adam that Michelangelo stresses. Adam has been created as a perfect physical specimen. But he lies there with a bland expression on his face and raises his hand listlessly toward God. The latter, by contrast, is shown with all His dynamic energy intent on endowing Adam with that power that will make him function as a human being. He is about to transfer to Adam a part of Himself, the Will. The contrast between Adam's relaxed hand and God's expressively dynamic one is most striking [20.6]. The moment God touches Adam, Adam will become a responsible being free to choose his own actions. How Adam does this and what the consequences are follow later.

In the Creation of Eve, Michelangelo's God does not put forth the same effort He displayed when He gave Adam will power. Standing firmly on the

ground, He calls Eve forth from Adam's side with a benevolent gesture that at the same time seems to be admonishing her to be obedient to her mate. Eve seems almost to be begging for the privilege to be alive.

The distinction Michelangelo has drawn between the male and the female as represented by Adam and Eve is further expressed in the scenes of the Temptation and the Expulsion that follow in the next fresco panel. In the Temptation [20.7] at the left, Eve sits beneath the Tree of Life like some statuesque Hellenistic Juno, absolutely unruffled by the fact that she is about to break God's special command. Adam, on the other hand, is psychologically one of Michelangelo's great creations. The unsteady silhouette line of his leg and torso reflects his initial uncertainty. The tousled hair of his head, the face in shadow, and his parted lips indicate the emotional strain under which Adam labors. But his final determination to break God's command is effectively indicated by the line of his right arm that reaches straight for the fruit as he hooks it with his index finger. It is an extraordinary representation of Man, given the power to choose between good and evil and deciding to act against the will of God. Incidentally, in the design, Michelangelo gives a simple demonstration of his favorite contraposto composition in the direction of the body of Adam, the counterdirection of that of Eve and then in the spiral twist of the serpent about the core of the tree trunk.

In the Expulsion from the Garden of Eden [20.7] at the right, the emotional contrast is continued as between the sexes. The beautiful goddesslike Eve of the Temptation now looks like a whipped animal as she crouches behind the body of Adam in physical fear of the angel's sword. But to Adam the point of the sword is like some annoying insect to be brushed off, and the emotion reflected in his face is the result of the remorse he is experiencing at having done wrong. The legs and the shuffling feet of the pair are remarkably expressive of the emotional situation. It is also interesting to compare Adam's face in this scene with his face before he had received from God the will to decide his own fate [20.6]. In spite of his wrong choice, Adam at least has acquired character and is no longer the bland creature first created.

And so Michelangelo terminates the first act of his drama in which he points out Man's abuse of the will power with which God endowed him.

According to the Book of Genesis, the descendants of Adam followed in the same footsteps of disobedience and became so hopeless that God practically decided to put an end to the human race. There was one man, however, who still looked to God and paid Him homage by means of sacrifice. For this reason Michelangelo inserted the scene of Noah performing a sacrifice at this point in the ceiling rather than at the moment after the Flood (as a thanksgiving for survival) as it appears in the Biblical text. The scene itself has no particular emotional content. It seems inspired from ancient sacrificial scenes, and in it Michelangelo uses varied and interesting repeated rhythms of forms to make a handsome design.

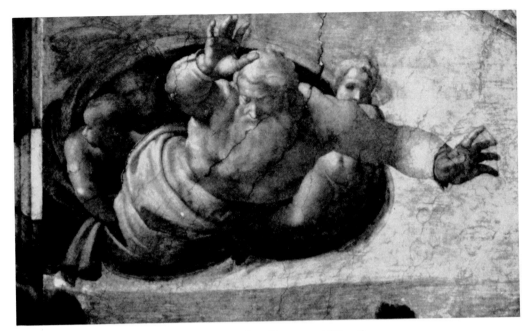

MICHELANGELO: The Sistine Ceiling Frescoes (Alinari)
 20.5 (*above*). God hovering over the Waters (1510)
 20.6 (*below*). Adam receiving the Will (1509–1510)
 20.7 (*opposite, above*). Temptation and Expulsion (1508–1509)
 20.8 (*opposite, below*). Detail from the Flood (1508–1509)

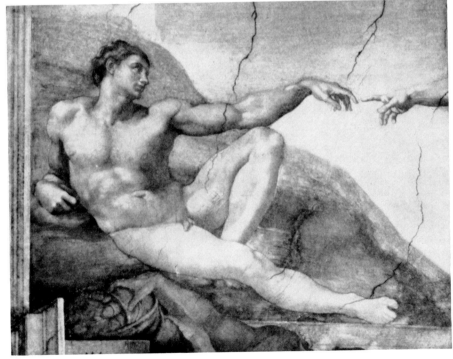

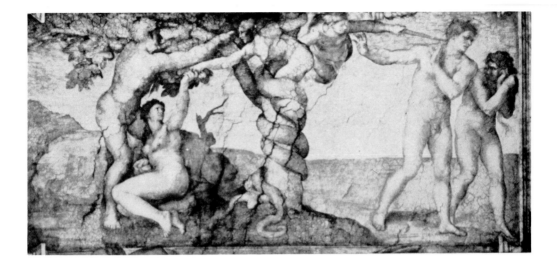

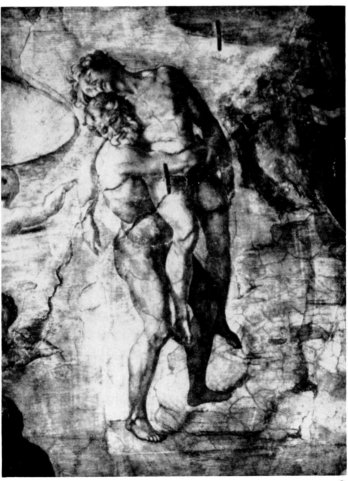

385

The same is more or less true in the scene of the Flood * which fol-
lows, although the effect of the storm and the emotional reactions of indi-
vidual groups and figures are superlatively rendered—such groups as the
mother trying to protect her young or the powerful young man straining
to carry his old father to safety [20.8]. This latter group is certainly the high
moment in the composition of two interrelated forms as initiated by Pol-
laiuolo in his Hercules strangling the giant Antaeus [11.18]. The whole com-
position marks the triumph of form as the most important element in de-
sign, for, Michelangelo uses forms here in groups alternating from right to
left to give the effect of distance, or of going back into the picture, instead
of using a perspective of architecture or landscape. It is a type of design
to be used frequently by later artists.

As the last scene at the top of the ceiling Michelangelo chose the
Drunkenness of Noah. In the background Noah is busy cultivating the vine,
but the major accent is on the episode in the foreground. The old man is
stretched out naked in his drunkenness, and the one son who has uncovered
him is calling to the other two to witness their father's shame. The question
might arise why this scene was chosen to conclude the second act of the
drama. It was simply that Michelangelo wished to bring out the fact that
even the one man whom God had chosen to carry on the human race did
not have enough self-control to keep from getting drunk, to say nothing of
the dastardly action of his son. That is, Man is hopelessly prone to choose
to do the wrong thing, not only as concerns the commands of God, as was
the case with Adam, but even in matters of personal behavior, as with Noah.
Thus Michelangelo graphically asserts the major tenet of Hebraic-Christian
religion that Man is a hopeless being when left to himself, and that Man is
therefore in need of salvation, deliverance.

Michelangelo then takes up this theme of deliverance. On each of the
four triangular vault areas in the corners of the ceiling he painted a scene
from the Old Testament in which the children of Israel were delivered from
impending disaster: David slaying Goliath (deliverance from the Philistines);
Judith decapitating Holofernes (deliverance from the Assyrians); Moses rais-
ing the Bronze Serpent in the Wilderness (deliverance from mass hysteria
resulting from snake bites); and the Execution of Haman (deliverance from
Antiochus).

In what form this deliverance was to come was announced in the Old
Testament by the prophets. Hence Michelangelo chose seven prophets who
had foretold the coming of the Messiah and placed them in the rectangular
painted niches along the base of the vault. Magnificently imposing figures,
they are the cousins in paint of the statue of Moses Michelangelo made for
the tomb of Pope Julius II: Jeremiah, with his hand in his long beard, deep

* This was the first of the Genesis scenes to be painted by Michelangelo. The fig-
ures are in smaller scale than those in the other scenes. The scale of the latter was in-
creased after the uncovering of the half-finished frescoes in November 1509—probably
because Michelangelo then saw the effect from the floor below.

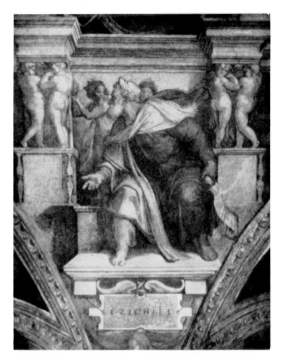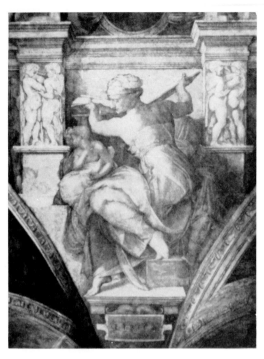

MICHELANGELO: The Sistine Ceiling Frescoes (Alinari)
 20.9 (*left*). Ezekiel (1509)
 20.10 (*right*). Libyan Sibyl (1510)

in meditation; Ezechiel [20.9] aggressive visionary, turning his head in rugged profile to listen to the words of an angel; Joel reading a scroll; Zaccariah, in profile with his nose in a book; Isaiah, deep in thought; the proud Daniel writing; and a young Jonah, painted by Michelangelo as a tour de force in foreshortening as though seated precariously on the throne and leaning back into space, his body at right angles to the actual curve of the vault. Alternating with the prophets, Michelangelo placed the figures of five sibyls, the seeresses of antiquity: the Persic, the Eritrean, the Delphic, the Cumean, and the Libyan [20.10]. They appear in Michelangelo's scheme partly because in Vergil's ninth Eclogue the Cumean Sibyl gives forth an utterance that has been interpreted as a prophecy of the coming of Christ. So Michelangelo was able to introduce her and the other sibyls as female Classical counterparts to the male Hebrew prophets.

Who the Messiah is to be is indicated by the groups of figures used to fill the spaces of the windowheads and of the triangular vaults above them. Among these we find the ancestors of Christ in the Old Testament. Christ Himself appears nowhere in the ceiling decoration which, as we have now seen, is a prelude to the events from His life depicted along one of the side walls of the chapel. And then later there will be the Last Judgment as the end of all things to complete the cycle of events for mankind.

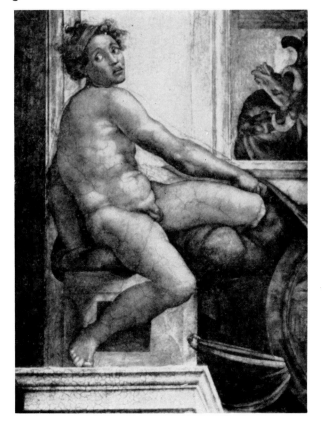

20.11. MICHELANGELO: Nude Youth (1508–1509). Fresco. Ceiling, Sistine chapel, Vatican, Rome (Alinari)

We have still to consider another important element of decoration that has bearing on the content of the ceiling as presented by Michelangelo: the series of twenty nude youths [20.11] so placed that there are four at the corners of each scene along the pseudo-cornice of the ceiling.* Pseudo-sculptural arabesques though they may be if considered as decoration, they are, however, a definite part of the content of the ceiling as conceived by Michelangelo. It will be remembered that Michelangelo was a member of the group that met in the Medici villa at Carreggi to discuss the philosophy of the Neoplatonists and that tried to develop a Renaissance Neoplatonism of its own. That is, being at the same time both lovers of the pagan past with its Platonic ideals of physical beauty and Christians, they wanted to fuse this pagan idealism with Christian doctrine. Marsilio Ficino, the philosopher in this Florentine Neoplatonist group, tried to achieve this fusion in his writings. Michelangelo attempted to paint it in the Sistine ceiling.

* Note that most of the swags supported by these nude figures are composed of oak leaves and acorns, the armorial devices of the della Rovere family of which Pope Julius II was a member.

The Hellenistic Neoplatonists postulated God or the Ultimate Real as Light from which all material things emanated, and this had been incorporated into medieval Christian mysticism (as we saw it illustrated in the works of Fra Angelico). The Renaissance Neoplatonists, however, substituted Beauty for Light. God was the source of all Beauty. God's image is Man. Therefore the ideally beautiful Man is the closest approximation of God on this earth. The fallacies of this argument are patent, but still that is what this Renaissance group tried to establish. In his sonnets Michelangelo gives abundant evidence of his adherence to this philosophy: *

> Mine eyes that are enamoured of things fair
> and this my soul that for salvation cries
> may never heavenward rise
> Unless the sight of beauty lift them there.
>
> * * *
>
> For every beauty that we look on here
> brings, to wise souls, in recollection clear
> the merciable fount whence all things flow;
> Nor other pledge nor other fruit have we
> of heaven on earth. Who loves thee faithfully
> To God ascends, and makes death precious so.
>
> * * *
>
> The immortal soul aspiring to that height
> It stooped from, to your earthly prison came
> An angel of compassion infinite
> To heal all hearts and bring our earth good fame.
> By it alone, not by your face serene
> Am I enflamed and enamoured so
> For never love of passing thing could lean
> On hope so sure, or equal virtue show.
> So comes it when to crown her toils intent
> Nature brings forth new works and excellent;
> The heavens themselves such spacious births prepare.
> And God, by His own grace, I chiefly see
> In some fair vestige of humanity
> Which I love only for His image there.

Michelangelo presents these ideas in the ceiling not only in the physically ideal bodies but also in the restlessness of their attitudes and expressions whereby he attempts to show that as emanations from the Supreme Source of Beauty they are unhappy in their material existence and long to return to the source from which they came.

Thus in the Sistine ceiling we have the most extraordinary document in paint of the attempted fusion of a pagan Neoplatonic philosophy with Hebraic-Christian religious ideas.

* Nesca Robb: *Neoplatonism of the Italian Renaissance* (London, Allen, 1935), pp. 262, 264, and 268.

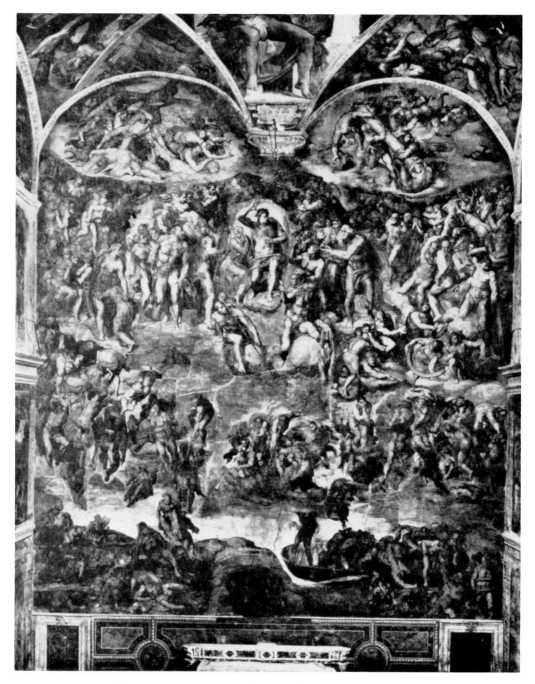

20.12. MICHELANGELO: Last Judgment (1536–1541). Fresco. Altar (west) wall, Sistine chapel, Vatican, Rome (Anderson)

20.13. MICHELANGELO: Detail of St. Sebastian from Last Judgment (1536–1541). Fresco. Sistine chapel, Vatican, Rome (Anderson)

The Last Judgment

The next twenty years of Michelangelo's life were chiefly occupied with sculptural and architectural projects that were required of him by Leo X and Clement VII. But when Paul III ascended St. Peter's throne in 1534 the project of finishing the grand decorative scheme for the Sistine chapel was taken up. The intention was to cover both end walls, the one with the Fall of the Rebel Angels as the prelude to the ceiling and the other with the Last Judgment [20.12] as the consummation of the whole subject-cycle. For some reason the fresco of the Rebel Angels was abandoned, although sketches for it apparently were made. But studies for the Last Judgment were begun around 1536 and the fresco completed in 1541. In order to do this the three earlier frescoes on that wall—the Nativity of Christ, the Birth of Moses, and the Assumption of the Virgin—had to be covered up (p. 326).

In the time between the completion of the ceiling frescoes and the beginning of the Last Judgment, much had happened in the religious life of Europe. The Protestant Reformation under Luther had broken out in 1520, and Rome had been sacked in 1525 by a horde of Protestants and free-booters from the north. The Reformation had a disturbing effect on many Catholics who had been anxious about the pagan and overworldly practices of the princes of the Church and who were sympathetic to a reform within the Church. Many intellectuals, among them Michelangelo and his friend Vittoria Colonna, were part of a circle influenced by the Spaniard Valdes who advanced the idea of justification by faith alone apart from works and religious practices. Later when this group came under the displeasure of the Inquisition, Vittoria Colonna took fright and left, but Michelangelo apparently stuck by the group and remained a liberal Catholic. Despite his Neoplatonic leanings, his youthful memories of Savonarola's preachings and activities had been deeply imbedded. Hence it should be no surprise to find Michelangelo on the side of the more serious-minded, puritan elements in the Church.

The Last Judgment [20.12], full as it still is of Michelangelo's ideal athletic forms, is in content a powerful expression of the Christian pessimism that was abroad in Italy as the result of the Reformation. A beardless, bemuscled, stern Christ appears in the attitude of a Zeus brandishing a thunderbolt. The Virgin at His side shrinks into herself at the evidence of His wrath. Martyr saints [20.13] glower and brood as counterparts to the symbols of His Passion carried aloft by angels as they present the evidence and attributes of their passion. Michelangelo's own dejected face appears as part of the flayed hide held by St. Bartholomew. Expressions of hysterical joy among the blessed as they embrace or of stark terror on the part of the damned as they are dragged down to Hell add to the general emotional restlessness of this monumentally composed fresco.

One of the stories told about the painting of the Last Judgment concerns the pope's chamberlain who had made disdainful remarks about the number of nude figures in the fresco while Michelangelo was at work. Later when the entire painting was uncovered the chamberlain found himself represented in the lower right side of the fresco in Hell as Minos with asses' ears and with a serpent coiled about his body. He rushed to the pope to protest this offense against his dignity. But Paul III, amused, told him that he, Paul, was powerless to get him out of Hell. If Michelangelo had put him in Purgatory, that would have been a different matter!

Another famous episode in connection with this fresco concerns the correspondence between Michelangelo and Pietro Aretino, the notorious Venetian publicist and friend of the painter Titian. Aretino prided himself that he knew and could command favors from the most prominent personalities of his time who feared the power of his glib pen. He wrote Michelangelo a flattering letter on hearing that he was to paint the Last Judgment for the Sistine chapel, made suggestions about its design, and requested some sketches as gifts. Michelangelo apparently ignored these approaches. Then, after the fresco was finished and Aretino had seen a print or copy of it, he flew into a rage and wrote Michelangelo a scurrilously clever letter. In it he rubbed salt into all Michelangelo's personal and professional wounds and assumed in addition a hypocritical attitude of false modesty that was becoming fashionable in sophisticated circles after the Reformation. The letter is worth quoting as an example not only of the refined poison issuing from Aretino's pen but also of the overdressed elaborate style used by writers of the High Renaissance: *

Sir, when I inspected the complete sketch of the whole of your Last Judgment, I arrived at recognising the eminent graciousness of Raffaelo in its agreeable beauty of invention.

Meanwhile as a baptised Christian, I blush before the license so forbidden to man's intellect, which you have used in expressing ideas connected with the highest aims and final ends to which our faith aspires. So, then, that Michelangelo stupendous in his fame, that Michelangelo renowned for pru-

* John Addington Symonds: *op. cit.*, Vol. II, pp. 51ff.

dence, that Michelangelo whom all admire, has chosen to display to the whole world an impiety of irreligion only equalled by the perfection of his painting! Is it possible that you, who, since you are divine, do not consent to consort with human beings, have done this in the greatest temple built to God, upon the highest altar raised to Christ, in the most sacred chapel upon earth, where the mighty hinges of the church, the venerable priests of our religion, the Vicar of Christ, with solemn ceremonies and holy prayers, confess, contemplate, and adore his body, his blood and his flesh?

If it were not infamous to introduce the comparison, I would plume myself upon my virtue when I wrote La Nanna. I would demonstrate the superiority of my reserve to your indiscretion, seeing that I, while handling themes lascivious and immodest, use language comely and decorous, speak in terms beyond reproach and inoffensive to chaste ears. You, on the contrary, presenting so awful a subject, exhibit saints and angels, these without earthly decency, and those without celestial honors.

The pagans when they modelled a Diana gave her clothes; when they make a naked Venus, hid the parts which are not shown with the hand of modesty. And here there comes a Christian, who, because he rates Art higher than the faith, deems it a royal spectacle to portray martyrs and virgins in improper attitudes, to show men dragged down by their shame, before which things houses of ill-fame would shut the eyes in order not to see them. Your art would be at home in some voluptuous bagnio, certainly not in the highest chapel in the world. Less criminal were it if you were an infidel, than, being a believer, thus to sap the faith of others. Up to the present time the splendour of such audacious marvels hath not gone unpunished; for their very superexcellence is the death of your good name. Restore them to repute by turning the indecent parts of the damned to the flames, and those of the Blessed to sunbeams; or imitate the modesty of Florence who hides your David's shame beneath some gilded leaves. And yet that statue is exposed upon a public square, not in a consecrated chapel.

As I wish that God may pardon you, I do not write this out of any resentment for the things I begged of you. In truth, if you had sent me what you promised, you would only have been doing what you ought to have desired most eagerly to do in your own interest; for this act of courtesy would silence the envious tongues which say that only certain Gerards and Thomasses dispose of them.

Well, if the treasure bequeathed you by Pope Julius, in order that you deposit his ashes in an urn of your own carving, was not enough to make you keep your plighted word, what can I expect from you? It is not your ingratitude, your avarice, great painter, but the grace and merit of the Supreme Shepherd, which decides his fame. God wills that Julius should live renowned forever in a simple tomb, inurned in his own merits, and not in some proud monument dependent upon your genius. Meantime, your failure to discharge your obligations is reckoned to you as an act of thieving.

Our souls need the tranquil emotions of piety more than the lively impressions of plastic art. May God, then, inspire his Holiness Paul with the same thoughts as he instilled into Gregory of Blessed memory, who rather chose to despoil Rome of the proud statues of the pagan deities than to let their magnificence deprive the humbler images of the saints of the devotion of the people.

Lastly, when you set about composing your picture of the universe and hell and heaven, if you had steeped your heart with those suggestions of glory, honor, and of terror proper to the theme, which I sketched out and offered to you in the letter I wrote you and the whole world reads, I venture to assert that not only would nature and all kind influences cease to regret the illustrious talents they endowed you with, and which today render you, by virtue of your art, an image of the marvellous: but Providence, who sees all things, would herself continue to watch over such a masterpiece, so long as order lasts in the government of the hemispheres.

your servant,
THE ARETINE

Now that I have blown off some of the rage I feel against you for the cruelty you used to my devotion, and have taught you to see that, while you may be divine, I am not made of water, I bid you to tear up this letter, for I have done the like, and do not forget that I am one to whose epistles kings and emperors reply.

Other Work

In the year following the completion of the Last Judgment, in 1542, Pope Paul III commissioned Michelangelo to do two frescoes for the walls of the small private chapel in the Vatican, between the Sistine chapel and the Sala Regia, known as the Pauline chapel. The subjects chosen were the Conversion of St. Paul [20.14], on the one side, and the Martyrdom of St. Peter, on the other. These frescoes have not been easily available to the public. After the imposing spectacle of the Last Judgment they come as something of an anticlimax. But the main figures wear the same expressions of emotional insecurity and sullen vindictiveness of many of the martyrs in the Sistine fresco. We shall recall these frescoes in the Sistine and Pauline chapels when we discuss the so-called "Mannerist" painters (Chapter 30).

No other paintings by the hand of Michelangelo remain. The lost Leda and the Swan, painted for the Duke of Ferrara, is known only from copies and drawings and adds nothing to our knowledge of his technical or emotional development. There are, however, a number of interesting drawings and a piece of sculpture that give us a clear-enough indication of how his religious emotional problems were finally resolved. During the period of his friendship with Tommasso Cavalieri the influence of Neoplatonism is still apparent in such drawings as the Ganymede and the Fall of Phaeton. But as the result of the jolt administered by the Reformation, and of his association and friendship with Vittoria Colonna and her circle, Michelangelo's mind turned more toward the essential Christian problems of salvation. How disturbed he was at first we saw in the emotional outbursts of the Last Judgment and in the Pauline chapel frescoes. Perhaps the death of Vittoria Colonna in 1547 accentuated this, since the Martyrdom of St. Peter on which he was at work at that time is the more disturbed of the two Pauline chapel paintings. But a wonderful emotional control and calm reappears in the two

20.14 (*above*). MICHELANGELO: Conversion of St. Paul (1542–1550). Fresco. Pauline chapel, Vatican, Rome (Anderson)

20.15 (*right*). MICHELANGELO: Pietà (1548–1555). Marble sculpture. Cathedral, Florence (Brogi)

drawings of the Crucifixion (one at Oxford, the other in the British museum) dated by Charles de Tolnay between 1550 and 1556. And his final statement of faith is certainly to be seen in his sculptured Pietà [20.15] in the *duomo* at Florence. Here the body of Christ, still athletic, no longer emphasizes the beauty of human form. It is a figure evoking pathos in the broken angles of its design and in the collapsing spiral of the twisted arm. But there is no despair. The angel, the Virgin, and the Joseph of Arimathea, in whose face we recognize the features of Michelangelo himself, form a solid triangle around the collapsing form of Christ, the Virgin grieving, the angel reassuring and serene, and the Joseph (Michelangelo) gazing at the Saviour in sorrow, love, and faith. He has renounced the error of his earlier Neoplatonism and has accepted only the simple Christian doctrine. In his own words: "Neither painting nor sculpture avail me aught . . . but only the body of Christ Who for us upon the cross was slain."

We have thus arrived at the end of that road along which Giotto started when he first created his simple bulky human forms. After Giotto, the growth of naturalism through the visual observation of nature, and the study of anatomy and of Classical sculpture, gave fifteenth-century painters a greater control over the use of those forms. In the hands of Michelangelo they were raised to such monumentality and given such dynamic force that they dominated the entire compositional layout. They achieved once more the heroic proportions of Classical sculpture. But in contrast to the Classical sculptor, Michelangelo uses these forms not merely to express their own material form and beauty. They become the means through which he expresses his own indomitable personality and the depth of his Christian faith even though it was colored at times with Renaissance Neoplatonism.

BIBLIOGRAPHY

Steinmann, E. *Die Sixtinische Kapelle*, 2 vols. and portfolio of plates. Munich, Verlagsanstalt F. Bruckmann A.-G., 1901–1905. (Sourcebook in German, basic for Sistine chapel)

Davies, G. S. *Life of Michelangelo*. London, Methuen & Company, 1909, 1924.

Symonds, J. A. *The Life of Michelangelo Buonarroti*, 3d ed., 2 vols. New York, Scribner's Sons, 1899.

Venturi, A. *Michelangelo*, trans. by Joan Redfern. London and New York, F. Warner and Co., Ltd., 1928.

Goldscheider, L. *The Paintings of Michelangelo*. London, Phaidon, 1939.

de Tolnay, C. *Michelangelo*, 5 vols. Princeton, N. J., Princeton University Press, 1943–1960.

Goldscheider, L. *Michelangelo's Drawings*. London, Phaidon Press, *c.* 1951.

—— *The Paintings, Sculptures, and Architecture of Michelangelo*. New York, Phaidon Publishers, 1953.

Michelangelo. *The Complete Poems of Michelangelo*, trans. by J. Tusiani. New York, Noonday Press, 1960.

Morgan, C. H. *The Life of Michelangelo*. New York, Reynal & Company, 1960.

◄ 2 I

Raphael

TOTALLY different from Michelangelo was the precocious genius of the High Renaissance, Raphael Sanzio. His gentle and suave personality was in sharp contrast to the rugged and brooding temperament of the great sculptor. Michelangelo's life was made difficult by the demands of his family, by the intrigues of those jealous of his tremendous abilities, and by the insatiable demands of the popes who wished to profit from his genius. He avoided society, relying on the loyalty of a few close and devoted friends. Raphael's pathway through life was a pleasant and placid one. His friends saw to it that he had all the opportunities to develop his natural genius, and he basked in the sunshine of the brilliant society in Rome whose sophisticated esthetic tastes he aimed to please and which he reflected in his paintings. Even the lifespans of the two men are in sharp contrast; although eight years older (Raphael was born in 1483), Michelangelo lived to be eighty-nine and Raphael died when he was thirty-seven.

Only rarely does the work of these two High Renaissance masters run along parallel lines. Raphael was a painter par excellence of Madonnas and of portraits, but when he was entrusted with the decoration of the papal apartments in the Vatican he proved himself one of the greatest masters of design that ever lived. We have, therefore, no reason to compare these two giants of art except in those instances when Raphael undertook to absorb Michelangelo's style—for, sensitive genius that he was, Raphael had a chameleonlike tendency to affect and then to elaborate on the styles of several of his great contemporaries once he had come in contact with their works.

397

21.1 *(left)*. Raphael: Vision of the Young Knight *(c.* 1502). Panel painting, 7" x 7". National Gallery, London (Anderson)

21.2 *(right)*. Raphael: The Three Graces *(c.* 1502). Panel painting, 7" x 7". Musée Condé, Chantilly (Alinari)

The Young Genius

Raphael's first master was his own father, who was a painter and poet at the court of the dukes of Montefeltro at Urbino. When Raphael was only eight years old, his father died and Timoteo Viti undertook to develop the latent talents of the young genius. Although Viti was a painter of meager accomplishments, he acquainted the young Raphael with the elements of Umbrian style as developed by Perugino, with whom Raphael was soon to study. There is a sensitive self-portrait in silver-point in the Ashmolean Museum in Oxford that gives us an idea of the gentle and intelligent young genius at this period of his life.

The earliest paintings by Raphael of which we know, done before he went to study with Perugino, include the Vision of the Young Knight [21.1] in the National Gallery in London and the Three Graces [21.2] at Chantilly. Both are tiny compositions, yet already they display Raphael's preoccupation with problems of design, which was to characterize all his later work. In the little picture in the National Gallery, the design is made up of two vertical elements, to right and left, bound together by the horizontal festoonlike figure of the knight in the foreground. We shall see this design over and over again in Raphael's paintings, either simply stated as here or elaborated to monumental proportions. In the Three Graces, the design problem is one of interlocked forms. This Raphael again solved simply by establishing a rhythm of alternating three's and six's of round and angular forms moving from the top to the bottom of the composition: the three heads, the

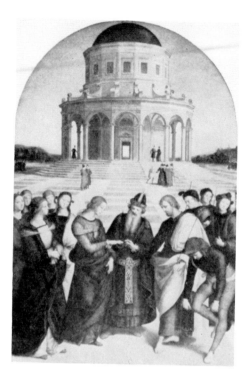

21.3. RAPHAEL: The Marriage of the Virgin (1504). Panel painting, 67" x 46½". Brera, Milan (Anderson)

six bent arms, the golden apples, the three torsos, the buttocks, the six legs. We shall notice throughout Raphael's work—and as characteristic of sixteenth-century painters in general—the tendency toward more self-conscious designs. It is another indication of the sophistication of the High Renaissance period.

In 1500, at the age of seventeen, Raphael went to Perugia to study with the great Umbrian master Perugino until 1504. Having previously been trained by Viti in the traditions established by this master (as the Vision of the Young Knight showed), Raphael now adopted and followed so closely the style of Perugino that at a casual glance many of his paintings at this time are with difficulty distinguished from those of Perugino. The Crucifixion, formerly in the Mond collection and at present in the National Gallery in London, with the small-headed figures of the Virgin and St. John, the angels with curlicued ribbons, and the far-distant landscape is a good example, and so is the Coronation, in the Vatican Gallery, with its double-decked composition. Another striking example of the similarity in style is the large panel with the Marriage of the Virgin [21.3] in the Brera in Milan. Here the composition is a simplified adaptation of Perugino's Handing of the Keys to St. Peter [17.4] in the Sistine chapel.* Raphael used the same arrange-

* Since Raphael had not yet been to Rome, he could have known Perugino's Handing of the Keys to Peter only from sketches. More likely he adapted his design from sketches and the actual picture of the Marriage of the Virgin (now in the museum at Caen, France) on which Perugino was working and which he finished in 1504, the year in which Raphael's picture is also dated. In both paintings, the central group of the priest, Joseph, and the Virgin is identical, and the piazza and building behind the group are very similar.

ment of figures along the front plane of the picture and a similar wide piazza with perspective squares converging on the background. But in Raphael's picture the design is expertly fitted to the shape of the frame with its semi-circular top. The vertical uprights and the half circles are repeated in various sizes in the arcades of the building in the background (three-dimensionally in the form of the building itself surmounted by the half dome) and in the group in the foreground, the semicircle being indicated in the bend of the heads of the Virgin and St. Joseph.

But Perugia was not the place where a young genius of Raphael's caliber would linger long. Creative activities and opportunities to see the works of great masters, both past and present, were greater in Florence even though the Medici were no longer patrons of art. So Raphael procured letters of introduction from the ducal court at Urbino and for the next four years, from 1504 to 1508, came under the influence of several outstanding Florentine painters whose works were to kindle his imagination and affect his style perceptibly. The foremost of these was Leonardo da Vinci, then at work on the Mona Lisa, whose cartoon of St. Anne and the Virgin was causing such excitement.

Angelo Doni, a Florentine patrician, for whom Michelangelo was painting the Madonna [20.2], commissioned Raphael to do portraits of his wife and himself. In Maddalena Doni's portrait [21.4], Raphael obviously followed Leonardo's composition of the Mona Lisa [19.11] in the three-quarter position of the sitter and in the position of the hands, but the landscape with its distant background and small feathery trees was still Umbrian. It is in a series of intimate Madonnas that the Leonardesque influence is most obvious. In the Granduca Madonna in the Pitti Gallery in Florence, the background is dark, the modeling has Leonardo's softness, and the Madonna and Christ child show the effect of Leonardo's idealized prettified types in the proportions of their heads and faces that no longer are those of Perugino. The same is more or less true of the Tempi Madonna at Munich and the two Cowper Madonnas, one of which [21.5] is in the National Gallery in Washington, but in these Raphael still uses the clear Umbrian background.

How rapidly Raphael responded to whatever artistic environment he found himself in is further illustrated by his reversion to Peruginesque types of figures when, during his Florentine period, he returned for a short time to Perugia to finish work on the San Severo frescoes and to paint the Ansidei Madonna (National Gallery, London) and the Morgan Madonna (Metropolitan Museum, New York). Then, back again in Florence, he did a series of paintings of the Madonna seated in the foreground with the Christ child and the infant St. John the Baptist that includes the Belle Jardinière in the Louvre, the Madonna of the Goldfinch [21.6] in the Uffizi, and the Madonna of the Meadows in Vienna. In all these paintings Raphael experimented with the pyramidal designs of closely knit figure groups that Leonardo had used in his sketches for St. Anne and the Virgin. Again the influence of the Leonardo head type is to be noted, and in the Vienna Madonna in particular Raphael

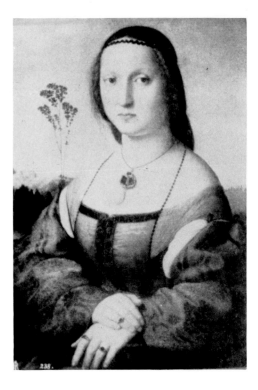

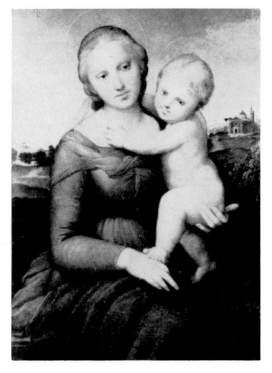

21.4 (above). RAPHAEL: Maddalena Doni
(1506). Panel painting, 24⅜″ x 17⅜″. Pitti
gallery, Florence (Alinari)

21.5 (above, right). RAPHAEL: Small
Cowper Madonna (c. 1505). Panel painting,
23⁷⁄₁₆″ x 17⅜″. National Gallery of Art,
Washington, D. C. (Courtesy of the Na-
tional Gallery of Art, Widener Collection)

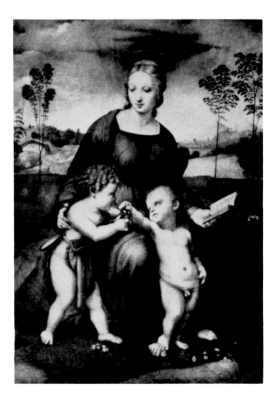

21.6. RAPHAEL: Madonna of the Gold-
finch (1505). Panel painting, 42″ x 29½″.
Uffizi, Florence (Anderson)

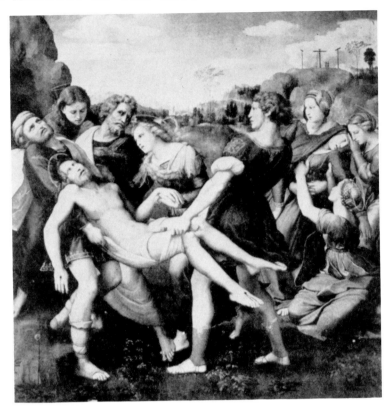

21.7. RAPHAEL: Entombment (1507). Panel painting, 72½″ x 69⅛″. Borghese Gallery, Rome (Alinari)

used the knobby light-and-shade accents in the treatment of the knees and breasts of the Virgin that Leonardo had used in his earlier sketch for St. Anne and the Virgin in Burlington House [19.7].

Another artist from whose work Raphael drew ideas for his own compositions was his friend Fra Bartolommeo, a member of the Dominican community in the monastery of San Marco, where both Fra Angelico and Savonarola had lived. Fra Bartolommeo had been to Venice, had seen there the monumental compositions of Giovanni Bellini in which the Madonna was enthroned against an apsidal background, and had introduced this in some of his paintings in Florence. Raphael's Madonna of the Baldacchino in the Pitti Gallery in Florence is closely related to Fra Bartolommeo's Marriage of St. Catherine [29.2] in the Uffizi in the use of flying angels supporting the ends of the baldacchino, in the position of the saints at the sides of the throne, and in the musical putti seated on the steps of the throne. Raphael began this Madonna four years before Fra Bartolommeo did his Marriage of St. Catherine but left the painting to be finished later.

When he received the commission to paint an Entombment of Christ for Atalante Baglione of Perugia, whose violent offspring had caused so many bloody tragedies in that city, Raphael for the first time tried to introduce Michelangelesque elements into his style. His first sketch of the subject shows that he intended to follow the design used by his master Perugino in the Entombment now in the Pitti [16.7], and in his sketch the body of Christ is lying on the ground surrounded by a group of mourners. In later sketches, however, and in the painting [21.7], Raphael has the body of Christ off the ground and lying in the shroud supported at its ends by two athletic male figures. The posture of Christ's body is almost an exact copy of Michelangelo's Christ in the famous Pietà in St. Peter's [20.1]. And the group of the fainting Virgin and the young girl to the right in the middle distance is an obvious appropriation of Michelangelo's design for the Doni Madonna [20.2]. In this Entombment, now in the Borghese Gallery in Rome, Raphael overreached himself in trying to achieve the effects of Michelangelo's dramatic style that is so totally different from his own very lyric one. The two chunky male figures exert entirely too much effort and emotion in carrying the fairly light body of Christ. And whereas in Michelangelo's Madonna the athletic Virgin is quite capable of handling the young Hercules of a Christ child whom St. Joseph is handing to her over her right shoulder, one wonders what will happen to the young girl in Raphael's picture, seated in the same twisted position as the Doni Madonna, who is trying to catch the swooning Virgin collapsing over her right shoulder.

The Mature Artist

It was the highest ambition of every successful painter of the High Renaissance period to be called to Rome, and Raphael was no exception. Through the efforts of his relative, the architect Bramante, Raphael was commissioned in 1508 by Pope Julius II to decorate the pope's apartments in the Vatican, known more generally as the Stanze. And it was during the next twelve years of his life at Rome—he died in 1520—that Raphael achieved his greatest triumphs and astounded the world with his virtuosity as a decorator and designer and as a portrait painter.

The decoration of the pope's apartments was a huge project, covering the walls and ceilings of three vaulted rooms known as the Stanza della Segnatura (the room in which the pope set his seal to official documents), the Stanza d'Eliodoro, and the Stanza dell'Incendio, and it took approximately ten years to accomplish. For our purposes we shall examine only a few of the frescoes. The most important ones are in the Stanza della Segnatura. In the stuccoed vault of the ceiling are four large medallions with the enthroned personifications of Theology, Philosophy, Justice, and Poetry, and in the corners of the vault are the Temptation, the Judgment of Solomon, Astronomy, and the Flaying of Marsyas. On the side walls, beneath each of the large ceiling medallions, are the main frescoes. Beneath Theology is

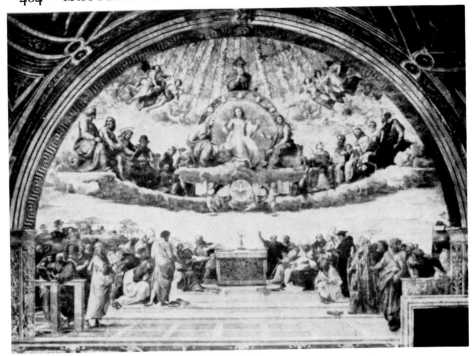

21.8. RAPHAEL: The Glorification of the Sacrament (1509–1510). Fresco. Stanza della Segnatura, Vatican, Rome (Alinari)

the *Disputà*, or the Glorification of the Sacrament [21.8]; opposite it, beneath Philosophy, is the School of Athens [21.9]. The other two frescoes are smaller because of the space occupied by windows: Parnassus is beneath the medallion of Poetry, and the double subject of Temporal Justice and Spiritual Justice is beneath the personification of Justice.

In the fresco of the Disputà [21.8], Raphael carried out in monumental fashion the combination of the rectangle and the half circle inherent in the shape of the wall space he had to decorate. His earlier, simpler treatment of these elements of design we have seen in the Marriage of the Virgin [21.3] in the Brera Gallery. In the Vatican fresco he takes the rectangle and its component parts—the horizontal, vertical, and diagonal—and together with the half circle and circle composes a sweeping harmony of design. In the lower part of the fresco, a shallow rectangle is established by placing the horizon line at the spring of the arch. The balustrades to right and left in the foreground and the altar in the middle distance repeat the rectangle in smaller sizes but at the same time establish a foreshortened triangle in space leading from one balustrade to the altar and then back to the other balustrade. The steps leading to the altar repeat the horizontal accents of the balustrades and altar; the figures repeat the vertical accents; and the pavement lines repeat

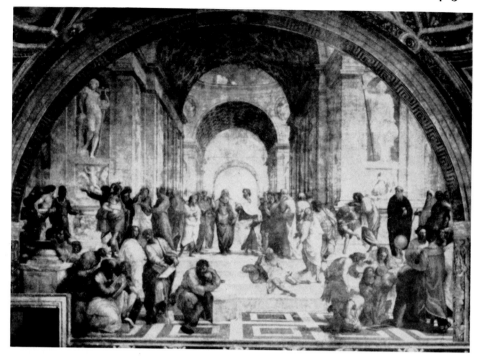

21.9. RAPHAEL: The School of Athens (1510–1511). Fresco. Stanza della Segnatura, Vatican, Rome (Alinari)

both the horizontal and the diagonal accents. Very cleverly, by means of the balustrades, Raphael masks the fact that the rectangular space of the fresco is broken into, at the lower right, by a corner of the door. In the upper semi-circular space the main accents of the design are curvilinear. The bank of clouds on which the saints sit is drawn in a perspective half circle to establish the sense of a half dome. Two-dimensionally the circles of the Host, the medallion enclosing the dove of the Holy Spirit, and the aureole about Christ lead in expanding sizes from the horizon line to the top of the enclosing half circle of the arch. Then Raphael binds the upper and lower designs together by repeating rectangular elements in the upper field, and curvilinear elements in the lower. For example, the ends of the cloud bank repeat the horizontals of the balustrades below, the figures of the saints repeat verticals and horizontals, and the rays from God the Father at the top of the fresco repeat the diagonals of the pavement, while the postures and gestures of the figures in the lower composition and the wavy horizon line create curvilinear accents tying in with those in the upper field of the fresco. Thus Raphael achieves a cleverly worked-out design with nothing left to accident or chance.

The School of Athens fresco [21.9] on the opposite wall displays an equally great genius for design. Here Raphael uses a different interrelation

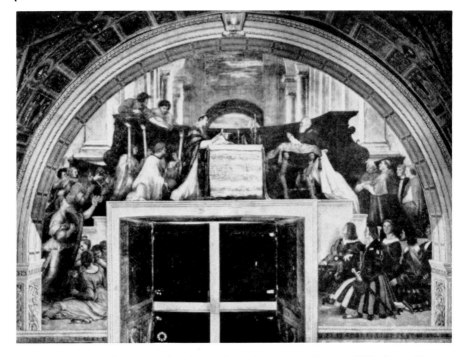

21.10. RAPHAEL: The Mass of Bolsena (1512). Fresco. Stanza d'Eliodoro, Vatican, Rome (Anderson)

between rectangle and circle by cutting the upper semicircular field into three parts by the monumental verticals of the architecture and then leading the eye back into a tunneled space by means of the decreasing half circles of the vaults. In the lower field the horizontal and vertical elements again predominate but are broken up by the curvilinear accents of the groups of figures scattered over the area of the steps. The whole is a monumentalization of the "goal-post" type of design used very simply by Perugino in several of his paintings, for example, the Pietà [16.3] in the Uffizi in Florence. The problems of scale and space are solved in grand fashion.

In these two frescoes of the Disputà and the School of Athens Raphael also uses with monumental effect the portrait groups first used by Masaccio and Fra Filippo Lippi. In the Disputà, among others, St. Thomas Aquinas, St. Bonaventura, Pope Sixtus IV, Dante, and Fra Angelico have been identified. In the School of Athens we recognize, for example, Leonardo da Vinci's portrait as Plato in the center of the fresco and Bramante's as Euclid. Raphael, with a companion believed by some to be the Sienese painter Sodoma, can be found in the lower righthand corner as though in conversation with Zoroaster and Ptolemy; the latter is wearing a spiked crown and has his back turned.

Another expert design is that of the Mass of Bolsena [21.10] in the Stanza d'Eliodoro. Here again Raphael was presented with the problem of

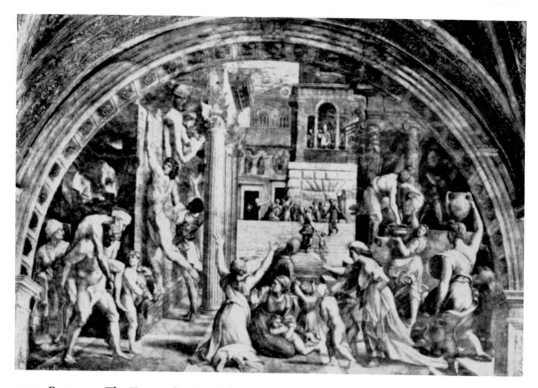

21.11. RAPHAEL: The Fire in the Borgo (1514). Fresco. Stanza dell' Incendio, Vatican, Rome (Alinari)

decorating an irregular area of wall that is broken by a door not centered. This he overcame most cleverly by leading the eye out of the narrower space by the spiral movement of the forms in it that point up to the altar at which the miracle is taking place. The eye then comes to rest on the priest or on the portrait of Pope Julius kneeling on the side of the altar opposite the priest, or the eye is caught by the colorful costumes of the pope's attendants in the larger, right-hand area below. So, the spectator is scarcely conscious of the unbalanced wall space.

While Raphael was at work on the frescoes of the Stanze, Michelangelo was decorating the ceiling of the Sistine chapel, and in due course it had been unveiled. Even Raphael could not resist the power of these frescoes. In the Fire in the Borgo [21.11], in the Stanza dell' Incendio, his composition is full of athletic forms that reflect Michelangelo's style: the figure climbing the wall; the group of the son carrying the father to safety (obviously inspired by Michelangelo's group of father carrying son in the flood [20.8]); and the beautiful figure of the girl with back turned and carrying a jug on her head.

Henceforth Michelangelo's style was to be in evidence in all Raphael's later frescoes, the most striking being the four sibyls on the wall right of the entrance in the church of Santa Maria della Pace and the Galatea [21.12] and

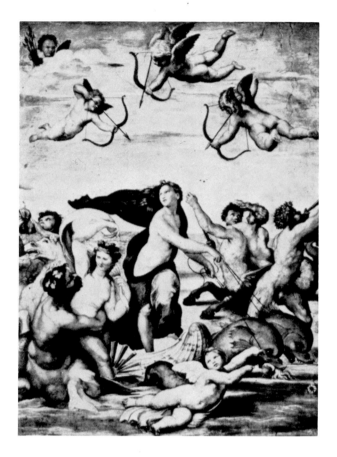

21.12. RAPHAEL: Galatea (1514). Fresco. Villa Farnesina. Rome (Anderson)

the vault frescoes with Cupid and Psyche in the Villa Farnesina. The Cupid and Psyche frescoes were painted in 1518, four years after the Galatea.

The last great project of fresco decoration assigned to Raphael was the Loggie of the Vatican, the architecture of which Bramante had designed and Raphael had finished. These Loggie consist of thirteen arcades, with vaults. In each vault four scenes were painted. They were mostly Old Testament scenes, one vault only having subjects from the New Testament. They have been called Raphael's Bible, although Raphael himself probably executed only the designs, most of the work being done by nine of his followers. It may be that Michelangelo's great achievement in the Sistine chapel had roused Raphael to attempt something similar. Certain it is that the scenes in the first vault are the same episodes that Michelangelo chose for the beginning of his Sistine series. And it is equally certain that it was another vain attempt on the part of Raphael to emulate Michelangelo. Raphael's God hovering over the Waters looks like a paper doll, and in the scene of God separating Light from Darkness the Almighty's strenuous effort gives Him the appearance of leaping over a hurdle. Dramatic rendering of action simply was not Raphael's forte.

21.13 (*left*). RAPHAEL: Pope Leo X (1517–1519). Panel painting, 61″ x 46⅞″. Pitti, Florence (Alinari)

21.14 (*right*). RAPHAEL: Baldassare Castiglione (*c.* 1514). Panel painting, 30¼″ x 26⅜″. Louvre, Paris (Alinari)

But as a portrait painter Raphael has had few peers. All his really great portraits date from his Roman period. All are personalities from the sophisticated early-sixteenth-century society in which he moved: the grim, determined Pope Julius II * and the well-fed voluptuary Leo X [21.13], in the Pitti; the sharp-featured, proud, intellectual cardinal in his stiff scarlet robe, in the Prado Museum at Madrid; his friend Baldassare Castiglione [21.14], the author of the contemporary book of manners *Il Cortigiano* (*The Courtier*) elegant in furs and velvets, in the Louvre; and Raphael's sleek, black-haired, large-eyed mistress whose smooth skin is accentuated by the contrast with rippling folds of the magnificent, varicolored sleeve. All are in a three-quarter pose of bust length made fashionable by Leonardo's Mona Lisa. In the portraits of two popes, Raphael again uses the composition of two vertical uprights with a festoon motif to tie them together: the ends of the chair in the Pope Julius and the heads of the two attendant cardinals in the Leo X.

* Known only in three copies: one in the National Gallery, London, one in the Uffizi, Florence, and the copy by Titian in the Pitti Gallery.

PART V

The Fourteenth, Fifteenth,
and Sixteenth Centuries
in Northern Italy

★ 22

Early Venetian

Painting

UNIQUE among Italian cities in its location, Venice was destined to develop a culture and an art that also distinguished the city from the rest of Italy. Situated amid the lagoons to which its settlers had fled for safety from northern invaders of the mainland, Venice by the ninth century had developed commercial projects of sufficient importance to achieve recognition in treaties with the Carolingian emperors to the west. But its destiny was linked with the sea, and the resulting trade was primarily with the eastern Mediterranean, particularly with Constantinople, the capital of the Byzantine Empire. Its political ambitions also were focused primarily on regions to the east, from the coasts of Dalmatia to the Greek island of Rhodes, where in time the lion of St. Mark appeared on columns and over city portals as the symbol of the empire of the Queen of the Seas.

It is not surprising, therefore, that the early art of Venice should show close affinities with the art of the Byzantine east, whence came so much of its imports. The architecture of the cathedral of St. Mark and its scintillating mosaic decoration [1.5] are the most striking examples. And with the capture of Constantinople in 1204 by crusaders from the West, who included Venetians, loot from the Byzantine capital was brought back to the city of the lagoons—including the four bronze horses now on the façade of St. Mark's, the numerous sculptural details that decorate the exterior walls, the famous *pala d'oro* on the altar, and various precious objects in the treasury of the cathedral.

Thirteenth- and Fourteenth-century Painting

These affinities with eastern Mediterranean art do not mean that there were no other sources for the painting that began to manifest itself in Venice during the fourteenth century. Venice, naturally, carried on her trade and her political relations with other Italian cities and with the regions to the north and west of the Alps. Hence we can expect to find evidence of the Gothic style, either as transmitted directly from northern sources or via Italian adaptations.

Stylistically, the situation that existed in Venetian painting at the beginning of the fourteenth century was almost the same as that in Tuscany —that is, Gothic elements had begun to mix with the more traditional Byzantine ones. But at first these Byzantine stylistic elements in Venetian painting seem closer to original models—not unnatural in the presence of the mosaics of St. Mark's. Two panels representing the half figures of St. Andrew [22.1] and St. John the Baptist, once the right and left wings of a triptych, now in the Museo Correr in Venice, are excellent examples of an almost pure Byzantine style. Among the many painted panels of the fourteenth century that have survived, we shall consider only the works of painters whose names are known from signatures or documents.

Paolo Veneziano and His Followers

The first important personality was Paolo Veneziano, known from signatures on paintings ranging from 1324 to 1362. The earliest dated piece, 1324, is the Coronation of the Virgin [22.2] in the Kress collection at the National Gallery of Art in Washington, D. C. Although the facial types and the gold-shot draperies of the figures betray the close connection with the Byzantine style, the enthroned figures of Christ and the Virgin are set beneath a molding in the shape of a Gothic arch.

The same mixture of stylistic traditions is present in Paolo Veneziano's large altarpiece in the Accademia in Venice, in which the same subject is the theme of the central panel, flanked to right and left by eight scenes from the life of Christ arranged in two rows. These scenes are set beneath round arches supported on colonnettes reminiscent of the arrangement of the enamel scenes in the *pala d'oro* in St. Mark's, yet the scenes of the life of St. Francis in the third or top row of the altarpiece, although similarly enclosed, are topped with Gothic gables floridly decorated with leaf ornaments. A large Gothic gable enclosing a circular motif resembling the wheel windows on Gothic church façades is the central feature of the frame above the scene of the Coronation of the Virgin. Here the robes of the Virgin and of Christ no longer have the gold-shot Byzantine webbing ornament but are decorated with curvilinear fine-lined gold brocade designs on dark-blue and pink backgrounds so characteristic of Venetian fourteenth-century painters. The edges of the draperies also are rendered with curvilinear rhythms.

22.1 *(right)*. VENETIAN–BYZANTINE: St. Andrew (mid-14th cen.). Panel painting, 28½″ x 20⅝″. Correr Museum, Venice (Böhm)

22.2 *(below, left)*. PAOLO VENEZIANO: Coronation of the Virgin (1329). Panel painting, 39″ x 30½″. National Gallery of Art, Washington, D. C. (Courtesy of National Gallery of Art, Samuel H. Kress Collection). 22.3 *(below, right)*. LORENZO VENEZIANO: Mystic Marriage of St. Catherine (1359). Panel painting, 37⅜″ x 23³⁄₁₆″. Accademia, Venice (Anderson)

These inroads made by the Gothic style on Venetian painting during the fourteenth century are even more strikingly apparent in the works of Lorenzo Veneziano, a follower of Paolo, who was active from 1356 to 1372. The polyptych in the Accademia in Venice with the Annunciation as its central panel, flanked by four saints on either side, and signed and dated 1357 is an excellent example of his style. The Madonna's light-blue mantle is covered with large and small gold snowflake and floral brocade motifs. The reverse of the mantle is light green, the tunic a lavender pink. Gabriel wears a vermilion mantle over a blue tunic. All the colors are highlighted with white. Gabriel's wings are of tooled gold with blue and vermilion added. The drapery folds of the Virgin and Gabriel and particularly of the saints at the sides fall in heavy plastic and calligraphic folds characteristic of Gothic sculpture.

In another panel by Lorenzo [22.3] in the Accademia, signed and dated 1359 and representing the mystic marriage of St. Catherine with the Christ child, the saint and some of the angels stand about with arms folded, an attitude of respect current in Gothic times.

A painter who followed the same artistic tendencies as Lorenzo Veneziano is Caterino Veneziano. He signed an altarpiece that is now in the Walters Art Gallery in Baltimore and also a Madonna of Humility in the Art Museum in Worcester, Mass. Stefano di Sant' Agnese, whose work is found in the Accademia and in the Correr Museum in Venice, is another close follower of Lorenzo.

Thus, briefly, we have evidence of the gradual superimposing of Gothic stylistic elements on those that had been inherited from Constantinople, the Balkans, and Dalmatia.

Fifteenth-century Painting

By the close of the fourteenth and at the beginning of the fifteenth century these Gothic stylistic elements completely supplanted Byzantine ones in Venice as elsewhere in Italy. It was the taste of the times, and they seem to have come from two general sources. The one apparently was at home on the other side of the Alps and was Germanic. The sweetness of the Madonna and Child and the sprightly childlike angels in the panel of the Madonna enthroned among music-making angels [22.4], signed by Niccolò di Pietro and dated 1394, and now in the Accademia in Venice, recall the works of some of the masters of the school of Cologne. On the other hand, a number of the most prominent Venetian painters of this period followed in the tradition of the International Style, represented elsewhere in Italy by such painters as Pisanello, Masolino, and Gentile da Fabriano. The essential characteristics of this style as we have seen earlier are the extremely calligraphic edges of very full drapery, these edges drawn in double S-shaped curves; the use of detailed flowers and grasses in the foreground; and the application of gilt raised gesso for crowns, armor, and other details of costume.

22.4 (*right*). NICCOLÒ DI PIETRO: Madonna enthroned (1394). Panel painting, 42⅛" x 25⁹⁄₁₆". Accademia, Venice (Fiorentini)

The International Style Artists

Of the International Style artists in Venice Jacobello del Fiore was outstanding. He was active from 1394 to 1439. One of his most famous productions is the giant triptych [22.5] now hanging in the first large hall at the top of the entrance staircase of the Accademia in Venice, the same hall in which many of the works of the earlier Venetian artists mentioned so far are to be found. The center panel of Jacobello's triptych represents Justice, personified and enthroned between two lions—the symbols of St. Mark and therefore of Venice. Justice is crowned and holds a sword in one hand and a pair of scales in the other. In the left wing of the triptych the Archangel Michael, with raised sword, treads on a dragon. He too holds a pair of scales, indicating his office of weighing the souls on the day of the Last Judgment. The Archangel Gabriel occupies the right wing. About to alight on the ground, he bears the lily wand in his left hand and stretches out his right arm with the gesture of the Annunciation. All three figures are set against a dark-blue background. The scales, the sword handles, Michael's armor, and the cuffs and the plastrons of the two other figures are done in gilt raised gesso giving a remarkable richness to the whole effect further enhanced by the elaborately carved and gilt Gothic arches under which the figures are placed. All this emphasis on eye-catching color and decorative detail as well as the extremely calligraphic drapery on the figures of Justice and of Gabriel show the derivation of Jacobello's style from that of the Internationalists. He was also influenced by the Paduan artist Guariento.

22.5. Jacobello del Fiore: Justice triptych (1421). Panel painting, 193⅛″ x 82″. Accademia, Venice (Anderson)

22.6 (right). Giam-bono: St. Crisogono (1420–1462). Panel painting. San Tro-vaso, Venice (Ali-nari)

Jacobello's follower Giambono carried on this elegant late Gothic style with all its courtliness, as seen in the charming St. Michael in the Berenson collection at Settignano and in the *preux chevalier* St. Crisogono on horseback with shield and bannered spear in San Trovaso, Venice [22.6]. Giambono's activity came in the years between 1420 and 1462 and shows the effect on contemporary Venetians made by Gentile da Fabriano and Pisanello, both of whom were imported to work on the decorations (now gone) of the Doges' Palace.

A less well-known Venetian painter was Francesco de' Franceschi, active from 1447 to 1467. Apart from being a follower of Giambono, he furnishes further evidence in his work of influences on Venetian painting from elsewhere in Italy. In a triptych, listed by Berenson as "homeless" and still unaccounted for, Francesco's debt to Masolino of Florence is quite apparent.*

The Vivarini

With Antonio Vivarini and Jacopo Bellini we come to the famous dynasties of painters established in Venice. Both men began as adherents of the International Style and, as many another Italian Internationalist, both gradually admitted certain Renaissance elements into their style. Actually the Vivarini came from the island of Murano near Venice but they did most of their work in and about Venice. They also established a workshop in Padua between 1447 and 1450 where the local painter Squarcione, the master of Mantegna and Crivelli, was active. Jacopo Bellini and his sons were also in Padua at that time. Padua's magnet, of course, was the Florentine sculptor Donatello, who was at work on the decoration of the altar of the church of Sant' Antonio and whose work influenced most of these painters.

The Adoration of the Magi by Antonio Vivarini in the former Kaiser Friedrich Museum in Berlin shows his closeness in style to Gentile da Fabriano's famous version of that subject in the Uffizi [10.2]. (Gentile da Fabriano was active in Venice in the early fifteenth century.) The embossed trappings and costumes, the colorful retinues of the Magi, the animals and flowers in the foreground, and the treatment of the panoramic background are all earmarks of the International Style.

Antonio was assisted in this picture by his brother-in-law Giovanni d'Alemagna, with whom he collaborated in a number of works until Giovanni's death in 1450. In the chapel of St. Tarasio in San Zaccaria, Venice —the same chapel that contains the Castagno frescoes (p. 230)—are three altarpieces signed by these two artists and dated in the years 1443 and 1444. All three are excellent examples of the elaborate structures in which north Italian paintings of the late Gothic period were often assembled. The simpler triptychs and polyptychs of Tuscany are completely outclassed by these brilliantly gilded architectural creations laden with intricately carved Gothic

* See Bernhard Berenson, *Italian Pictures of the Renaissance, Venetian School,* New York. Phaidon Press, 1957, Vol. I, pl. 57.

22.7. ANTONIO VIVARINI AND GIOVANNI D'ALEMAGNA: Altarpiece with Madonna and saints (1443–1444). Panel paintings. Chapel of St. Tarasio, San Zaccaria, Venice (Böhm)

motifs and figures. The front face, for example, of the altarpiece [22.7] on the main altar of the old chapel of St. Tarasio, although recomposed, gives the effect of a cross section of some five-aisled cathedral with buttresses, gables, pinnacles, and flèche reminiscent of Milan cathedral. It is only in the lowest tier that the painted panels of the Madonna and four saints have been inserted. The Madonna and the two nearest flanking saints are the work of a follower of Lorenzo Veneziano. The two saints at the ends are

by the Vivarini–d'Alemagna combination. The back of the altarpiece has been kept plain and is covered with painted panels by these two artists, the subjects being an episode of the story of the Holy Blood at the top, below which is the figure of God the Father enthroned between twelve saints and two angels standing under Gothic-arched niches in two rows. In the bottom row, at the ends, are two bambino martyrs; inserted between them is a predella piece on which the bust figure of St. Tarasio and six small scenes from his life are represented.

The altarpiece on the right wall features the youthful St. Sabina holding her martyr's palm and standing in a garden of roses over which four angels hover [22.8]. She is flanked by St. Jerome and a handsomely attired youthful saint. In the upper tier above St. Sabina is the half figure of an angel holding a scroll. To right and left are the half figures of SS. Catherine and Margaret, the one holding the martyr's palm and a book, the other bearing a cross-staff which she has plunged into the jaws of a dragon. On the right wall opposite is another small tabernacle altarpiece of which the major portion is made up of carved decoration and sculptured groups representing in three tiers on the central axis: the dead body of Christ upright in the tomb, the mourning Virgin surrounded by her friends present at the Crucifixion, and the Resurrection of Christ. Flanking the lower groups are two pairs of saints, Nereus and Achilleus to the right and Gaius and Ignatius to the left. These are painted panels.

In the same year, 1444, in which the large altarpiece in the chapel of St. Tarasio was painted, Antonio Vivarini and Giovanni d'Alemagna signed and dated the large painting in the church of St. Pantaleone in Venice. It is a very elaborate rendering of the Coronation of the Virgin [22.9]. The throne on which Christ and the Virgin attended by God the Father and the Dove of the Holy Spirit are seated is raised high upon columns set on a podium. A group of babes, the Holy Innocents, bearing the symbols of Christ's Passion move about in the space between the columns. The four evangelists with their symbols are seated at the foot of the throne, while in eight tiers saints, martyrs, patriarchs, prophets, and angels are set in the apselike space behind the throne.

The figure-style of this Vivarini–d'Alemagna brother-in-law pair, despite its relation to the International Style and its presence in elaborately Gothic frames, does not display the overcalligraphic drapery so common with the Internationalists. The style seems closer to such late Gothic developments of the fifteenth century as we found in the works of the Florentines Masolino, Domenico Veneziano, Fra Angelico, or even Fra Filippo Lippi. Uccello and Lippi had actually worked in north Italy and at one time were present in Venice, and Castagno did the frescoes of the apse vault in the chapel of St. Tarasio above the great altarpiece by the Vivarini–d'Alemagna pair. We previously noted a similar Florentine influence in the style of Francesco de' Franceschi to whose figures some of the Vivarini saints (such as the St. Sabina in the St. Tarasio chapel) seem to be related. The Holy Innocents

22.8 (*left*). Antonio Vivarini and Giovanni d'Alemagna: Detail from St. Sabina altarpiece (1443). Panel painting, 47⁵⁄₁₆″ x 20⅞″. Chapel of St. Tarasio, San Zaccaria, Venice (Alinari)

22.9 (*below*). Antonio Vivarini and Giovanni d'Alemagna: Coronation of the Virgin (1444). Panel painting, 84¾″ x 66⅝″. St. Pantaleone, Venice (Anderson)

in the St. Pantaleone altarpiece also appear Florentine and in the tradition to be established by Donatello in the north by his sculptures at Padua. In fact, later work of Antonio Vivarini, such as the altarpiece in the Vatican Gallery, signed and dated in 1464, reflects in the more sculpturesque style of the figures the influence of the great Florentine sculptor.

Other members of the Vivarini family who were painters are Bartolomeo, Antonio's brother and later collaborator, whose signed works date from between 1450 and 1491, and Alvise (1445–1503), who was influenced by both his father Antonio and his uncle Bartolomeo but also by Antonello da Messina and Giovanni Bellini whom we shall consider shortly.

Jacopo Bellini

Jacopo Bellini (1424–1470) developed his style under similar auspices. As a pupil or close friend of Gentile da Fabriano, Jacopo absorbed the elements of the International Style, but while at Padua in the 1440's he felt the impact of Donatello's style as did the other painters present at that time in Padua.

In the altarpiece with the scene of the Annunciation in St. Alessandro at Brescia [22.10] and in the five scenes from the life of the Virgin in the predella the International Style predominates—in the florid Gothic arches of the frame under which the Annunciation is set and in the rich brocades worn by the Virgin and by Gabriel. However, in the Madonna and Child [22.11] in the Accademia in Venice, the background is filled with small cherub heads that had become so popular under Donatello's influence. Similar half-length Madonnas but without the cherubs are to be found in the museum at San Diego and in the Louvre, but in another Madonna in the collection

22.10. JACOPO BELLINI: Annunciation (1445). Panel painting, 118½″ x 77³⁄₁₆″. St. Alessandro, Brescia (Alinari)

22.11. JACOPO BELLINI: Madonna and Child (*c.* 1448). Panel painting, 28" x 20½". Accademia, Venice (Böhm)

of Mrs. Walter Burns at North Mimms, England, the cherubs are again present, some of them holding the symbols of Christ's Passion.

In the Louvre and in the British Museum are portions of Jacopo's notebooks in which the sketches abound with the realistic representations of animals, birds, grasses, and flowers, the favorite subject materials of International Style artists. But here and there in the same sketches the rendering of space by means of piazzas and squares and the Renaissance architectural details [22.12] betray the influence of Donatello. These sketchbooks of Jacopo Bellini must be equated with that of Pisanello (p. 193) who himself belonged to the group of International Style artists.

We turn now to the activities at Padua and leave for a later chapter the works of Jacopo Bellini's sons Gentile and Giovanni.

BIBLIOGRAPHY

Golubev, V. *Die Skizzenbücher Jacopo Bellinis,* 2 vols. Brussels, G. van Oest & Cie, 1912. (Facsimile edition of Jacopo Bellini's sketchbooks in the Louvre and the British Museum)

Berenson, B. *Venetian Painting in America; the Fifteenth Century.* New York, F. F. Sherman, 1916.

Marle, R. v. *The Development of the Italian Schools of Painting,* 19 vols. The Hague, Nijhoff, 1923–1938, vol. 17.

Moschini, V. *Disegni di Jacopo Bellini.* Bergamo, Istituto Italiano d'Arti Grafiche, 1943. (Plates of selected drawings)

Berenson, B. *Italian Pictures of the Renaissance. Venetian School,* 2 vols. New York, Phaidon Press, 1957. (Many plates)

22.12. Jacopo Bellini: St. John the Baptist Preaching (*c.* 1438). Drawing, 16½″ x 11⅞16″, from the sketchbook in the Louvre, Paris (Alinari)

← 23
The School of Padua

CLOSE to Venice and not too deeply involved in the political and military difficulties that beset so many of the Italian city-states, Padua became a fruitful area for the growth of the new humanism. Beginning in 1222, Padua had been a university town to which students flocked from all over Europe. Albertus Magnus had been a student there. The importance of the university is indicated by the fact that in 1363 it acquired the right to confer the degree in theology, a privilege hitherto enjoyed only by the Sorbonne in Paris.

The interest in the Classical humanities had been fostered in the north at a very early date. In 1315, Musato received the poet's laurel for an opus entitled *Eccerino*, based on the exploits of the young tyrant and bastard son of Frederick II and patterned on a Classic tragedy. The gravitation of interest toward the Classics was stimulated by the finding of the bones (supposedly) of the Roman historian Livy, a Paduan by birth. Of a certain Guarino da Verona, who was in direct humanistic descent from Petrarch through Giovanni da Ravenna, his biographer states that he made more men eloquent and learned than all the other men of his profession put together. "More scholars came out of his school than warriors out of the Trojan horse." And when Pala Strozzi, the Florentine patron of the Classics, was exiled from his native city, he chose Padua as the city in which to spend the remainder of his days. In all probability it was Strozzi's influence that brought Donatello to Padua to execute his sculptures for the high altar of the church of St. Anthony, known as the Santo. Donatello also cast the great equestrian statue of Gattamelata in front of the Santo.

Prior to Donatello's arrival, Padua's artistic connections naturally had been with Venice. The two great families of artists, the Vivarini and the

430

23.1. FRANCESCO SQUARCIONE: Madonna and Child (*c.* 1450). Panel painting, 31½" x 26". Former Kaiser Friedrich Museum, Berlin (Photographische Gesellschaft)

Bellini had, for a short time, established workshops in Padua bringing with them late Gothic, Germanic, and International Style influences. But previously elements of Florentine art had been injected into the art of the north. In the early fourteenth century Giotto had decorated the Arena chapel at Padua, and in the fifteenth century Uccello and Castagno had worked in Venice and Uccello also in Padua. Two Veronese painters, Altichiero and Avanzo, had painted frescoes in the Santo and elsewhere in Padua at the end of the fourteenth century. The local painter Guariento, a Byzantine-Giottesque of the later fourteenth century, also did frescoes in the Eremitani at Padua and in the Doge's palace, Venice.

Squarcione's Workshop

The most famous painter in Padua when Donatello arrived was Francesco Squarcione (1394–1474). Only two works by his hand are in existence, the small Madonna and Child [23.1] in the former Kaiser Friedrich Museum, Berlin, bearing his signature and the documented (1449) altarpiece of St. Jerome with four saints in the Museo Civico at Padua. Very little is known about Squarcione beyond what the biographer Vasari and others have transmitted. He is said to have had his pupils draw from ancient statues in his workshop. With his love for the antique, it is therefore not surprising that Squarcione should take an interest in the work of Donatello. On examination, his Madonna in Berlin is found to be very Donatellesque in its relief-like quality, in the type of the Christ child, in the fruit swag at the top, and in the use of the Classical candelabrum.

23.2. CARLO CRIVELLI: Madonna and Child (c. 1472). Panel painting, 35″ x 23″. Metropolitan Museum, New York (Courtesy of Duveen and Co.)

Squarcione's fame, however, rests primarily on the fact that he was the master of numerous painters and of two in particular: Carlo Crivelli (c. 1430–1495), a lesser luminary, and Andrea Mantegna, the greatest painter of the fifteenth century in northern Italy outside Venice. Crivelli's brittle, porcelainlike figures with small heads and slender bony extremities create an exotic effect [23.2]. A wealth of details covers his panels, all done with meticulous care, such as fruit swags, individual fruits and vegetables, gold and brilliantly colored brocades. His exaggerated gestures and expressions of emotion have a northern, Germanic quality. There is also a suggestion of Antonio Pollaiuolo's style in the way Crivelli's hands and fingers are done—Squarcione, in fact, possessed a drawing of Pollaiuolo among the objects in his workshop. Crivelli's art is in a category more or less by itself and contributed little to future developments.

Mantegna

Andrea Mantegna (1431–1506) was a master of outstanding accomplishments. He was the foster son as well as the pupil of Squarcione, from whom he must have acquired his taste for the Classic art he studied with so much enthusiasm. And then when Donatello came to Padua, Mantegna was impressed by his sculpture and by his studies in perspective.

23.3. ANDREA MANTEGNA: St. James led to his Execution (1451). Fresco. Formerly in Ovetari chapel, Eremitani, Padua, now destroyed (Alinari)

Perspective and Illusion

Mantegna's first monumental performance was the frescoes of the Ovetari chapel in the right transept of the church of the Eremitani at Padua. In these frescoes, depicting episodes from the life of St. James and of St. Christopher, he posed a new problem in visual reality: that of perspective as applied to a whole block of space. Here were his first experiments in illusionistic space that he later brought to such a triumphant climax in the Camera degli Sposi of the Castello at Mantua.

In the scene of St. James led to his execution [23.3], Mantegna wished to reproduce the effect the spectator would see if he were looking at the episode from the level of the ground line—that is, from a worm's-eye perspective. To make this impression, the ground line of the fresco is just about at the height of the spectator's eye. Masaccio and other Florentine and Umbrian realists had used a one-point perspective: the buildings were parallel or at right angle to the picture plane and the forms receding into the distance converged on one point on the horizon line. A two-point perspective is called for when the spectator is to see two sides of a building at one

23.4. ANDREA MANTEGNA:
Beheading of St. James
(1452). Fresco. Formerly
in Ovetari chapel, Eremi-
tani, Padua, now destroyed
(Anderson)

and the same time (for example, when you look at the corner of a build-
ing of which only the edges are parallel to the picture plane)—that is, there
are two vanishing points. But when the spectator looks at a building or
figure from below or from above, neither the planes nor edges but only
points are parallel to the plane of vision. Therefore three vanishing points
are present. This experience Mantegna wished to incorporate in his frescoes.

In the St. James scene just mentioned, the lines of the triumphal arch
in the foreground and those of the building at the right are drawn in one-
point perspective. The building in the distance to the right, being seen from
an angle, is rendered in a two-point perspective. But since the entire scene
is viewed from below there should also be a three-point perspective. Here,
however, Mantegna came up against a difficulty of design. If he drew the
buildings in three-point perspective, he would disturb the rectangular or-
ganization of his fresco. So he resorted to certain optical illusions to give
space the appearance of tilting back. The figures in the foreground are in-
deed drawn in the proper perspective and do lean away from the front
plane. But to make the buildings seem to do the same thing, particularly
the tower in the background, Mantegna created a wide, obtuse angle in the

right foreground formed by the figure of the soldier and the long shaft of the banner. This angle thrown against the vertical parallel lines of the tower make the tower appear to bulge and lean. And the buildings in the foreground, by the very fact that they are drawn with parallel vertical lines contrasting with the converging lines of the leaning figures, appear to be bulging out at the top, as indeed they should if the spectator were looking up at them. The vault of the triumphal arch as seen from below was obviously inspired by Donatello's relief in the Santo of the ass kneeling before St. Anthony, but Donatello did not attempt to foreshorten the space or the figures in the foreground.

Mantegna created another bit of illusion in the fresco of the Beheading of St. James [23.4]. The execution takes place in the foreground along a horizontal bar extending across the fresco. This bar is painted in such a way that its right end disappears behind the molding framing the fresco but its left end comes out over the molding and is attached to it by a leather thong. (The molding is painted so realistically that it seems to be an actual architectural feature.) Then as his eyes move along the bar, the spectator sees St. James' head and the arm of one of the soldiers projecting across the bar into his space. That is, Mantegna wished to break the surface of the wall and give the illusion that there is no break between the spectator's space and that of the picture.

These Ovetari chapel frescoes are filled with many Classical details, such as triumphal arches, architectural fragments, the costumes and armor of the Roman soldiers. The most striking examples are in the scene of St. James before the Roman judge. In contrast to the Classical fantasies often created by the Florentine realists, Mantegna's details were those he had observed on actual Classical monuments. He was the president of an archeological society at Padua that went out into the surrounding country to dig up and study Classical remains. Details from these he would then incorporate into his paintings. We shall see other examples of this.

On the night of March 11, 1944, a bomb from an Allied plane struck the Ovetari chapel and demolished it completely—the most tragic loss in the field of Renaissance art in Italy during World War II. The tiny fragments of the demolished frescoes, however, were gathered together, and for years patient experts have been attempting to reassemble what was salvaged from rubble. The chapel itself has been rebuilt, and, ghosts though they be, photo murals of the destroyed frescoes have been installed to give an idea of the glory of the original decoration.

The influence of Donatello's bronze sculpture appears in the figure style of the Ovetari frescoes. The sharp highlights running around the heads and the drapery of Mantegna's figures are the result of observing the effect of light on metallic surfaces. Mantegna's intimate Madonnas painted about this time also recall Donatello's reliefs of the same subject, yet their thin brittle execution are in the tradition of his master Squarcione from which he had not yet completely emancipated himself.

23.5. ANDREA MANTEGNA: Center detail from Madonna enthroned (1456–1459). Panel painting, 86¾″ x 46⁵⁄₁₆″. San Zeno, Verona (Anderson)

In Mantegna's large altarpiece of St. Luke, now in the Brera at Milan, tradition still rears its head in the use of the Gothic, Vivarinesque frame. But the foreshortened figures of the saints in the upper register lean back realistically in space as though they were standing in upper balconies and create a strange contrast with the frame. Such "balcony" figures without the foreshortening, however, are also found in the altarpieces of Antonio Vivarini that Mantegna must have known.

Mantegna breaks completely with this tradition in the altarpiece done for San Zeno at Verona [23.5]. The architecture of the frame is completely Classic and is made to blend and be part of the architecture of the painted space, giving the illusion of a marionette theater such as was first attempted in the fourteenth century by Pietro Lorenzetti [7.12]. But Mantegna opens out the space even more. He is not content just to create the space of the room; he opens up the background by letting you glimpse the clouds and sky of the far distance through the pilasters at the end of the room. It is very characteristic of him to create a middle distance with openings through which the far distance can be seen. The composition is full of the usual Donatellesque reminiscences, such as the putti, the fruit swags, and the sculpturesque treatment of the figures and drapery.

The predella panels of this altarpiece are now in the Louvre and in the museum at Tours. The most significant one is the Crucifixion in the Louvre [23.6]. The lone figure of Christ is set at the apex of a triangular design rendered in perspective with the two crosses of the thieves converging toward it. A flinty formation of rock rears up vertically at the left as a harsh accent to the cross of Christ. The vertical is repeated again in the slender

23.6. ANDREA MANTEGNA: Crucifixion, predella panel from San Zeno altarpiece (1456–1459). Panel painting, 26″ x 35⅞″. Louvre, Paris (Alinari)

shaft held by the soldiers below. At the foot of the cross the witnesses of the event are grouped like actors in some Classic tragedy, with those who are for Him at the left and those who are against Him at the right. The Virgin collapses into the arms of her friends. St. John, slightly detached from the group, wrings his hands in bitter grief as he gazes up at the Christ. On the other side the handsome figure of the centurion stands silently and in wonder at the scene before him. A far-distant landscape winds off gently at the left and relieves somewhat the stark tragedy enacted in the foreground. The delicacy of Mantegna's drawing and the slenderness of the forms add considerably to the total effect.

In the landscape backgrounds in general, the echo of the International Style is still perceptible in the swinging curves and in the minute details of the round hills dotted with trees, the striated rocks, and the pebbles. But anyone traveling in the region between Verona and Padua will see in the landscape many of the specific elements found in Mantegna's backgrounds, especially the great hill facing the traveler approaching Padua from Vicenza.

The two other predella pieces, the Gethsemane and the Ascension, beautiful in detail and brilliant in color, are in the Tours Museum. A larger and varied version of the Gethsemane scene [23.7] now hangs in the National Gallery, London. In this panel Christ kneels in prayer on the side of a rocky incline at the left. Below, the three apostles lie stretched out in deep sleep and in various foreshortened positions. St. Peter's mouth is open as though he were snoring. The spiral, winding repeats of the road and of the background in general furnish a marvellous accompaniment to the drowsy unconsciousness of the apostles.

In 1459 Mantegna accepted an invitation to go to the court of the Gonzagas at Mantua and remained in the service of that family, off and on, for the rest of his life.

A famous altarpiece painted by Mantegna while in the service of the Gonzagas is the triptych now in the Uffizi. Its central feature is the scene of the Adoration of the Magi. The Presentation in the Temple and the As-

23.7. ANDREA MANTEGNA: Gethsemane (*c.* 1464). Panel painting, 24⅝" x 31½". National Gallery, London (Anderson)

cension are in the right and left panels. Mantegna painted the Adoration on a panel with concave surface, as though again to break any barrier between the picture space and the spectator. He leads the eye immediately on to the rock-paved road along which the Magi have traveled and which flows like a great river from the distant and elevated background straight down to the foreground. There it curves slightly to the right to pass out of the picture space and into the spectator's space from which the figure at the extreme right has come to approach the cave in which the Madonna and Child are receiving the homage of the Magi. The Madonna is surrounded by an aureole of winged, Donatellesque angel heads.

The Presentation of Christ [23.8] on the right wing of the triptych is one of Mantegna's finest achievements. The slender figures participating in the rite of the circumcision are painted with the greatest delicacy of detail. The small angellike assistant holding the bowl of instruments resembles a miniature masterpiece in sculpture, with drapery and hair masterfully rendered. The setting for the scene is a lofty colonnaded hall covered with variegated slabs of marble revetment and with relief sculpture. The effect

23.8 (*left*). ANDREA MANTEGNA: Presentation detail from Adoration of the Magi (1463–1464). Panel painting, 37⅞" x 16¾". Uffizi, Florence (Alinari)

23.9 (*right*). ANDREA MANTEGNA: St. George (*c.* 1462). Panel painting, 26" x 12⁹⁄₁₆". Accademia, Venice (Alinari)

is rich without seeming overloaded with detail. This highly decorative background furnishes a radiant arabesque of form and color. A drawing for the group of apostles to the right in the Ascension panel is to be found in the Fogg Museum at Cambridge.

Close in time to this triptych is the Madonna of the Quarries in the Uffizi. It is a remarkable performance and worthy of special attention. The Madonna, frontal and with the nude Christ child on her lap, is seated on a rocky ledge in the foreground. Behind her the ground drops off hundreds of feet to the bottom of a valley in which miniscule figures walk along a highway and roads lead to a far-distant city on the horizon. Other figures on the right quarry stone and carve columns at the base of a huge mountain with jagged projections rising up from the valley below. The mountain fills up almost the entire middle distance except for the small open area to the left through which the spectator glimpses the distant hill and the city perched

23.10. ANDREA MAN-
TEGNA: The Dead Christ
(c. 1501). Panel paint-
ing, 26″ x 31⅞″. Brera,
Milan (Alinari)

on the top of it. The mountain itself gives the effect of a great sunburst or
crystallized explosion behind the Madonna. A connection between the com-
position of this picture by Mantegna and that of the St. Barbara by Jan
van Eyck has been suggested.

Another much-admired painting by Mantegna is the small panel with
St. George and the Dragon [23.9] in the Accademia in Venice. The aris-
tocratic young saint stands bareheaded and in full armor within an open-
ing framed by pilasters. The ever-present fruit swag is suspended above his
head. A distant landscape fills in the background. It is as though the so-
phisticated young knight had stepped to the front of the stage to receive
the plaudits of an admiring audience for his skill in disposing of the dragon
that lies sprawling at his feet. But his dignity does not allow him to ac-
knowledge the approbation of his public. He fixes his haughty gaze to one
side beyond them. The exploit has gone slightly to his head!

Mantegna himself was rather conscious of his own ability to conquer
difficulties. Certainly the Dead Christ [23.10] in the Brera is a tour de force
of foreshortening. Christ lies on the ground, His feet projecting toward the
spectator. He is seen slightly from above to give the full effect of the fore-
shortening. His loins are covered with a cloth, so used that in truly Classic
manner it brings out the form beneath. The folds are drawn in a series of
receding ovals like cross sections of the limbs they conceal. The grimacing
faces of the Virgin and St. John at the left introduce a strident note of grief
and give the painting its proper identification as a Pietà; otherwise it might
have been just a study of a cadaver seen in perspective.

The climax of Mantegna's experiments with perspective and space il-
lusion is reached in the frescoes of the Camera degli Sposi, the marriage

chamber, in the Gonzaga palace at Mantua. It is a small room, but with the decoration of the walls and ceiling Mantegna opened up the confined space in a manner worthy of the Baroque artists of the seventeenth century, whose predecessor he was indeed.

Mantegna begins the illusion by painting in a loggia on the wall over the fireplace, the floor of this illusionistic loggia being on a level with the top of the fireplace. The space of the loggia is limited by a marble parapet painted across the middle distance. Beyond the parapet, through drawn curtains, trees and the sky are visible. In this newly created space of the loggia the Duke and Duchess of Mantua are seated in the midst of their family. Mantegna makes this painted space more convincing as part of the actual space of the room by painting in a cross vault over the loggia. The ribs of this cross vault are supported on slender square piers that are also painted in but appear to support the actual vaults of the room. The capitals of these painted piers, however, are actual brackets. In this manner he breaks the wall space completely and deceives the eye further by painting one of the figures as though it were in front of the pier at the right and in the act of descending a stairway from the loggia into the actual room. On the left wall, additional piers with vistas between them of the outdoors have been painted in. Between two of these piers the Duke is shown again conversing with his cardinal-son Francesco.

The boldest bit of illusionistic painting is on the ceiling [23.11]. Mantegna painted out the low vault of the room to make it appear like a domical vault pierced by a round opening, an oculus, through which the open sky can be seen. The oculus itself is surrounded by a marble balustrade over which women and children look down into the room, and marble putti are painted in foreshortened positions on the inner side of the balustrade. The effectiveness of the entire illusionistic decoration is owed to the fact that the actual architecture and the simulated architecture are so skillfully blended.

Early in the 1480's, at the behest of Pope Innocent VIII, Mantegna made a trip to Rome where his archeological interest in ancient sculpture must have received additional impetus, evidenced in the famous series of tapestries of the Triumph of Caesar that he finished after his return to Mantua. Made originally for the Gonzagas, these tapestries were sold in the seventeenth century to the agent of Charles I of England and are now in Hampton Court Palace. Mantegna also painted at this time various Classical and Old Testament subjects in grisaille to simulate Classical relief sculpture, for example, the Triumph of Scipio in the National Gallery in London, Tarquin and the Sibyl in the Cincinnati Museum [23.12], and the Judith in Dublin.

To carry out a vow made at the Battle of Fornovo in 1495 when Charles VIII was defeated by the Italian forces, Gianfrancesco Gonzaga, the husband of Isabella d'Este, built a church in honor of the Virgin and had Mantegna paint as its altarpiece the Madonna of the Victory [23.13] now in the

23.11. ANDREA MANTEGNA: Ceiling fresco (1469–1470). Camera degli Sposi, Castello, Mantua (Anderson)

Louvre in Paris. The inventiveness of the artist again manifests itself in his treatment of the apse behind the high throne of the Madonna as an open trellis wound about with ropes of laurel. Strings of pearls and a fragment of luck-bringing coral are looped and suspended from the center of the trellis above the Madonna's head. Through the openings the sky is visible and gives greater space to the composition. Gianfrancesco in armor kneels in prayerful contemplation at the foot of the throne.

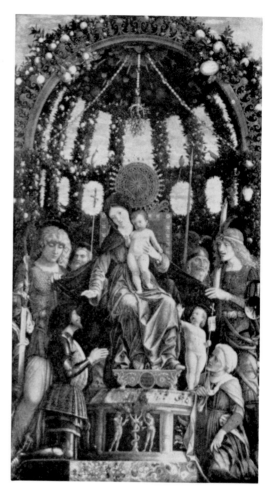

23.12 (*above*). ANDREA MANTEGNA: Sibyl and Prophet (*c.* 1495). Canvas, 22¹³⁄₁₆″ x 18¹⁵⁄₁₆″. Cincinnati Art Museum (Courtesy of Cincinnati Art Museum)

23.13 (*right*). ANDREA MANTEGNA: Madonna of the Victory (1495–1496). Canvas, 110⅜″ x 63¹⁄₁₆″. Louvre, Paris (Alinari)

For Isabella d'Este, the great patroness of the arts and wife of Gian-francesco, Mantegna painted two large allegorical pictures to be placed in her studio. In one of these Mercury and the Three Graces [23.14] are grouped together on the top of Mount Parnassus in the center of the middle distance while the Liberal Arts, personified, execute a circular dance in the foreground. In the other, a Triumph of Virtue over Vice, the fully armed goddess Minerva in the vanguard of the Virtues is putting the Vices to rout. In both these compositions Mantegna used his favorite device of an enclosed foreground with openings in a barrier in the middle distance through which glimpses of the far distance appear.

At Mantegna's death in 1506, Isabella d'Este wrote in a letter:

> The death of our master Andrea causes me great sorrow for, in truth, in him an excellent man and a second Apelles have passed away. I do believe that the Lord God wishes to employ him for the creation of some beautiful work. As for me, I can never hope to meet a finer draughtsman or a more original artist.

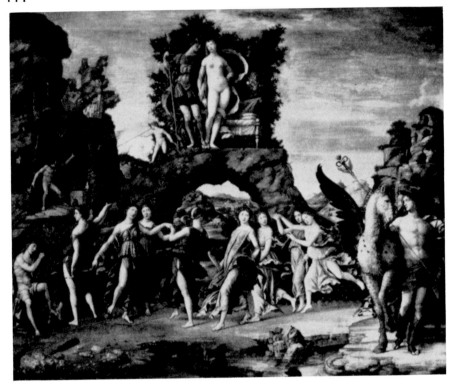

23.14. ANDREA MANTEGNA: Parnassus (1497). Canvas, 63¹⁄₁₆″ x 75⅝″. Louvre, Paris (Alinari)

Looking back over these pages, we find these influences on the development of Mantegna's style: early dependence on Squarcione; assimilation of Donatello's Classic decorative details as well as the influence of Donatello's reliefs and bronze sculpture; interest in archeology; love of decorative arabesque; and obsession with foreshortened form and illusionistic space. The influence of Mantegna's style was tremendous in northern Italy. How it affected the work of his brothers-in-law, Gentile and Giovanni Bellini, we shall see in the following chapter.

BIBLIOGRAPHY

Rushforth, G. M. Carlo Crivelli. London, G. Bell & Sons, 1900.

Kristeller, P. Andrea Mantegna, trans. by S. A. Strong. London, Longmans, Green & Company, 1901. (Still a sourcebook for Mantegna)

Marle, R. v. The Development of the Italian Schools of Painting, 19 vols. The Hague, Nijhoff, 1923–1938, vol. 18.

◄ 24

The Bellini Brothers
and
Antonello da Messina

I̲N the second half of the fifteenth century, Jacopo Bellini's two sons, Gentile and Giovanni, succeeded their father as the outstanding painters of Venice. A third painter, Antonello da Messina, made a lasting impression on Venetian painting although he resided in Venice little more than a year.

Gentile Bellini

Gentile Bellini (1429–1507) apparently accompanied his father to Padua in the 1440's and there assisted him in the work on an altarpiece. While the Bellini family was at Padua the young painter Mantegna made acquaintance with its members, and in 1453 married the daughter of the house, thus becoming the brother-in-law of Gentile and Giovanni. This close connection was manifested in their paintings, and for a time Mantegna exerted a definite influence on the style of the younger Bellinis.

Among the earliest known works of Gentile is the portrait banner of the Blessed Lorenzo Giustiniani [24.1], dating in 1465, in the Accademia in Venice. The hard, brittle outline of the figure as well as the distant landscape betray Mantegna's stylistic formula found in the Eremitani frescoes in Padua. So do the organ shutters from St. Mark's, Venice, now in that cathedral's museum, on which the standing figures of SS. Mark, Theodore, Jerome, and Francis are painted quite in the style of Mantegna and are set under coffered barrel vaults seen from below, resembling similar architecture in Mantegna's Eremitani frescoes.

24.1. GENTILE BELLINI: Detail from Banner of Blessed Lorenzo Giustiniani (1465). Canvas, 87⅜″ x 61⅟₁₆″. Accademia, Venice (Alinari)

In 1466 Gentile worked for the School of St. Mark, but whatever he did there was later lost in a fire. The *Scuole,* or schools, in Venice actually were guild societies or clubs, ranging downward in social importance from the School of St. Mark, named after the city's patron saint. Each was housed in an elegant building, which generally had a chapel on the ground floor and meeting and banqueting halls on the upper floor. We shall have occasion to mention other such schools in the course of considering Venetian painting since they commissioned the outstanding artists to decorate their halls and chapels.

In 1469 Gentile was made a Count Palatinate by Emperor Frederick III. Five years later we find him restoring the frescoes painted by Pisanello in the Doge's Palace and also offering his services to the city while asking to be appointed to the Fondaco dei Tedeschi (the German Merchants' Guild), which appointment would carry with it a special stipend and the duty to paint the portrait of a newly elected doge.

When in 1479 Sultan Mohammed II invited the doge of Venice to his daughter's wedding, he requested that a good painter be sent to help with the decorations for the occasion. So Gentile went to Constantinople in the fall of that year. Mohammed II was the first humanist sultan of Turkey. He was interested in Western culture, in the Greek and Latin poets and philosophers, had the Classics translated into Turkish, and founded the first library in Constantinople. He admired Alexander the Great and Caesar. Despite the prohibitions in the Koran against figure representation, Mohammed earlier had had himself portrayed by an Italian medalist sent to him by Sigismondo Malatesta of Rimini.

Gentile's experiences at the court of the sultan in part have been related by Vasari, with tradition enlarging on some of the episodes. Others

24.2. GENTILE BELLINI: Portrait of Mohammed II (*c.* 1480). Panel painting, 27½″ x 20½″. National Gallery, London (Anderson)

are told by a certain Giovanni Maria Angiolello who at the time was a slave to the sultan's son and who subsequently wrote a history of Turkey. These sources indicate that Gentile and the sultan got along amiably. Among other things, the sultan had Gentile decorate the walls of his harem with a series of panels that later were removed by the sultan's son and sold in the bazaars of the city.

Gentile left Constantinople after about a year's stay, his departure supposedly precipitated by an episode that has come down in story. The sultan, who was a frequent visitor to Gentile's studio, complained one day that the blood dripping from a severed head of John the Baptist on which Gentile was working was not true to actuality. To prove his point, he summoned a slave and had him beheaded in front of Gentile. After that experience the latter supposedly decided that Venice was safer than Constantinople and departed. When he left the Turkish capital Gentile was presented with the Order of the Golden Knights by the sultan.

Very little has survived of the works Gentile did at Constantinople. One of the finest is the extraordinary portrait of Mohammed II [24.2] in the National Gallery, London, in which Gentile has keenly portrayed the mixture of intelligence and sensuality in the sharp profile of this humanistic sultan. A miniature portrait of Mohammed II is in the Seraglio Library in Constantinople; a delightful miniature portrait of a Turkish youth is in the Gardner Museum, Boston. The heads of two turbaned Turks, fragments of a larger panel, in the Art Institute, Chicago, apparently come from Gentile's studio at this time. The effect of Near Eastern miniatures on Gentile's style is perceptible in some of the panels he executed after his return, as, for example, in the portrait of Doge Giovanni Mocenigo in the Correr Museum, Venice.

The paintings that we associate with Gentile Bellini as most characteristic, however, are those in which he depicted contemporary Venice and started the tradition that we will see recurring in Carpaccio's work (Chapter 25) and eventually in that of Canaletto and Guardi. In Gentile's paintings these views of Venice were connected with some religious procession or event. We have in mind, of course, those four large pictures he painted for the schools of San Giovanni Evangelista and of St. Mark.

The School of San Giovanni Evangelista was one of the six great *Scuole* and one of the oldest. It possessed a relic of the Holy Cross, and this relic became the subject for three of the four great decorations undertaken by Gentile. The best known painting [24.3] is that done in 1496 in which the relic is being carried in a huge procession around St. Mark's square on that saint's feast day in 1444 when a miracle of healing was attributed to the relic. The commemoration of the miracle, however, is lost, for Gentile meticulously detailed a description of the elaborate procession in which all official Venice partook and of the square itself. Among the spectators Gentile painted many portraits, including one of himself, and in the careful rendering of the cathedral façade he gave us a record of the scenes represented in the mosaics, now lost except for the one over the portal at the extreme left. But the sense of the vastness of the space in the square is not lost in the presence of all the detail. The restrained dignity of the scene is accentuated by the repetition of verticals throughout the composition, relieved somewhat by the curves of the domes and arches of the cathedral in the background and of the arcades flanking the square and on the Doge's Palace.

The second panel of this series [24.4] records the episode when, during a procession, the relic fell into one of the canals and was salvaged only when the guardian of the Scuola went in after it himself. Here we have a scene of everyday Venetian life, with the crowds along the narrow streets beside a canal watching with interest some exciting event. Much local color exists in the presence of the gondolas and gondoliers and in such a detail as the nude Negro youth at the right getting ready to jump into the canal to help in rescuing the relic. At the same time we have a ceremonious and semiofficial atmosphere introduced by the group on the left bank of the canal and by the portrait groups along the parapet in the foreground. Among these, at the left, is the figure of the young patrician Caterina Cornaro who was made queen of Cyprus, a role in life distasteful to her and which she soon abandoned to retire to Venice to a social life more to her taste. A portrait of her in later life by Gentile is in the National Gallery in Budapest.

The third panel (all three are now in the Accademia, the famous picture gallery in Venice) depicts another miracle accredited to the relic in which a certain Piero di Ludovico was cured of undulant fever by approaching a candle to the relic. The chief interest in this picture lies in the beauty of the interior space of the chapel in which the relic reposes as the sunlight falls on the marble revetment of the walls and the mosaic inlay of the floor. Again the foreground is replete with portraits.

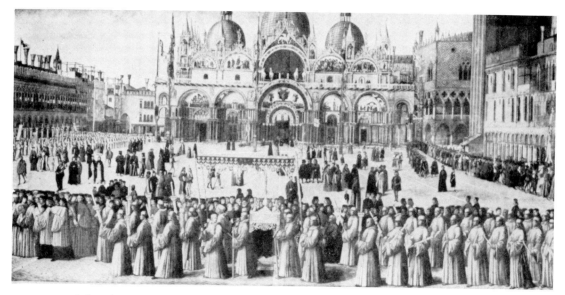

24.3 (*above*). GENTILE BELLINI: Procession in St. Mark's Square (1496). Panel painting, 144$^{11}/_{16}$" x 293$^{13}/_{16}$". Accademia, Venice (Anderson)

24.4 (*below*). GENTILE BELLINI: Recovery of the Relic of the Holy Cross (1500). Panel painting, 127$^{3}/_{8}$" x 169$^{1}/_{2}$". Accademia, Venice (Anderson)

24.5. GENTILE AND GIOVANNI BELLINI: St. Mark Preaching in Alexandria (1493–1507). Panel painting, 137″ x 304″. Brera, Milan (Anderson)

The fourth panel is the Preaching of St. Mark in Alexandria [24.5], now in the Brera Gallery in Milan. Gentile offered in 1492 to paint it for the School of St. Mark in memory of his father Jacopo, if that organization would just pay for the materials and add a small sum for whatever they thought it was worth. For some reason his offer was not taken up until 1504. Gentile began the painting then, but progress was slow and early in 1507 he became desperately ill. In his will, made a few days before his death in February of that year, he stipulated that if Giovanni, his brother, would finish the picture he would leave Giovanni their father's sketchbook and whatever money was to be paid for the picture, otherwise Gentile's widow was to receive these items. Giovanni undertook to finish it.

The design for this panel must have been completed by Gentile. It is very much like that of the procession of the Holy Cross relic in St. Mark's square in Venice with the same spaciousness, the same vertical accents, and the placing of a domed religious structure with many arches at the farther end of the square. But, this being the square in Alexandria, Gentile fills the picture with observations of his own made while in the Near East. The structure at the end of the square is a mosque. Minarets, an obelisk, and a Roman triumphal column fill the background. A giraffe stalks across the square in front of the mosques and humped camels are in evidence. Most of the men in St. Mark's audience, except for a group of Venetians at the left, wear turbans or fezlike hats bound to their heads; the women are hooded and veiled. The lighting on the figures in the foreground, however, gives evidence of Giovanni's hand. Throughout the picture, in fact, in contrast to Gentile's earlier panel of the procession in St. Mark's square, the soft light and shade accentuating the rectangular forms of the buildings recalls, as we

shall see, the work of Giovanni during this same first decade of the sixteenth century.

Gentile was buried in the cemetery of San Giovanni e Paolo very near the School of St. Mark for which his last picture was intended.

Giovanni Bellini

Younger by a year than his brother Gentile, and possibly a natural son of Jacopo Bellini, Giovanni Bellini (c. 1430–1516) was to become the most significant painter of fifteenth-century Venice. During his long lifetime he brought Venetian painting from a dependence on the late Gothic International style to a fully developed Renaissance style of its own in which color, textures, and space filled with light were to give Venetian painting its particular richness and beauty. Then, as master of other painters, Titian in particular, Giovanni also laid the foundations for modern painting.

Of the numerous paintings surviving from his long period of activity a restricted number of key pictures have been chosen to illustrate his development and to communicate the quiet beauty of his work.

Giovanni naturally received his early training in his father's workshop and through his brother-in-law Mantegna was subjected to the style current in Padua. As we remarked when discussing Mantegna, Paduan painters had been strongly influenced by the works of the Florentine sculptor Donatello in the basilica of Sant' Antonio. All these various style elements appear in the earliest known paintings by Giovanni Bellini. Most representative of the Mantegna influence are panels, such as the Transfiguration and the Crucifixion of Christ in the Correr Gallery in Venice. In the Transfiguration [24.6], the flinty, quarrylike rocks are reminiscent of the rock formations in various Mantegna pictures, such as the central panel of the Adoration triptych in the Uffizi. The background of the Crucifixion has the winding roads and figure groups seen in Mantegna's Eremitani fresco of the Beheading of St. James [23.4]. In both the Crucifixion and the Transfiguration the figures have the slender height, the hard outlines, and the brittle clinging drapery we observed in the side panels [23.8] of the Mantegna altarpiece just mentioned, and eventually derived from Donatello.

Giovanni, like Raphael, was a painter par excellence of Madonnas. He painted them throughout all periods of his life. They were for the most part the intimate half-length type with the Christ child standing, lying, or sitting on a ledge in the foreground. In his earlier Madonnas, apples and other fruit are often placed on the ledge in the manner of the Paduan usage. The monumental Madonna compositions date in the 1480's and later. In the early Madonnas the style derivations to be noted are the same as those in the panels mentioned above, primarily Mantegna and Donatello. One of the earliest, now in the Johnson Collection of the Philadelphia Museum of Art [24.7], is like an elegant creation in porcelain with smooth features and thin brittle fingers. The Christ child with His finger in the mouth is an adaptation of

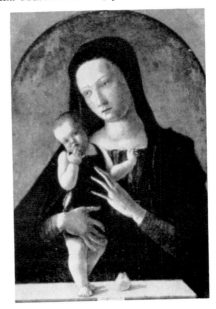

24.6 (*left*). GIOVANNI BELLINI: Transfiguration (*c.* 1460). Panel painting, 52¾″ x 34½″. Correr Museum, Venice (Alinari). 24.7 (*below*). GIOVANNI BELLINI: Madonna and Child (*c.* 1460). Panel painting, 24⅜″ x 16½″. Philadelphia Museum of Art, Johnson Collection

24.8 (*below*). GIOVANNI BELLINI: Christ in Gethsemane (1465–1470). Panel painting, 32″ x 50″. National Gallery, London

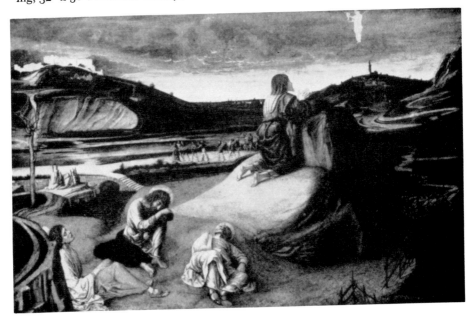

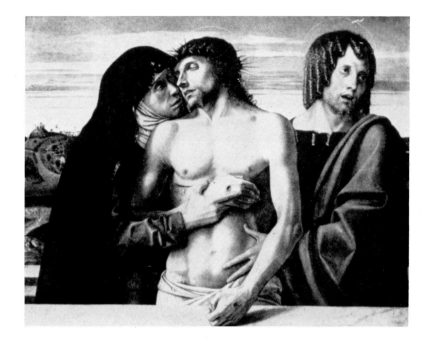

24.9. GIOVANNI
BELLINI: Pietà
(c. 1470). Panel
painting, 34" x
42⅛". Brera, Mi-
lan (Alinari)

the child clinging to the skirts of his mother in the Presentation in the Tem-
ple panel [23.8]. Another Bellini Madonna of the earlier period is in the
Lehman Collection in New York. Here a Paduan or Donatellian fruit swag
is suspended above the Madonna's head. The landscape background and the
glimmering horizon are also derived from Mantegna.

With the famous picture of Christ in Gethsemane [24.8], hanging as it
does in the same room in the National Gallery in London with Mantegna's
equally famous rendering of the same subject [23.7], a spectator can make
an interesting on-the-spot comparison. Both compositions are related to the
drawing of the same subject by Jacopo Bellini, and both have obviously re-
lated elements, such as the winding roads and the central position of the
Christ. The strong pinks and blues in both are very exciting, as are also the
lemon yellows of the glowing horizons. But in spite of similarities, we note
in Giovanni's picture a softening of Mantegna's harsh linear effect, particularly
in the rocks and landscape generally. Certain elegancies also appear in the
Bellini picture, such as the carefully coiffured and oiled locks on the head
of Christ and on the heads of the apostles John and James (although the
hair on the heads of the apostles is slightly rumpled as the result of their
sleeping).

Another magnificent example of this oiled-ringlet coiffure appears in the
head of St. John in the deeply stirring Pietà in the Brera in Milan [24.9].*

* Is it possible that Dürer, who visited Venice several times and was befriended by
Giovanni Bellini, could have seen this picture and as a result painted his self-portrait as
Christ with similar very long, oiled locks? Perhaps this was a hair style of the times since
these locks appear, although less prominently, in other pictures of Giovanni's early period,
such as the Transfiguration [24.6], and persist well into the 1480's.

453

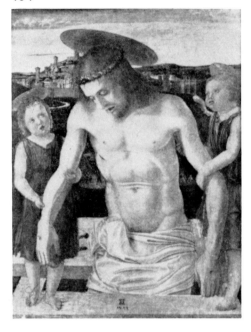

24.10. GIOVANNI BELLINI: Pietà (c. 1458). Panel painting, 25¼″ x 19¾″. Correr Museum, Venice (Alinari)

Note the contrast between the rugged intensity of the Madonna's grief as she presses her head close to that of Christ as if to kiss it—so like the effect of a German wood-carving—and the elegant lament of St. John. The cleft in the design between the heads of Christ and St. John emphasizes this contrast as does also the position of the two heads turning away from each other. And yet the three figures of the group are linked together by St. John's gesture of touching Christ's body, and the cleft in design between the heads of Christ and St. John is sensitively bridged by the golden-blond color of the tresses and beards of the two figures. This painting too represents a transitional phase in a series of Pietàs, ranging from the dry Mantegnesque type [24.10] in the Correr Museum in Venice (derived from Donatello's bronze relief of this subject in the basilica of St. Anthony at Padua) and the more softly modeled versions, such as that in the Museo Civico in Rimini.

In the Transfiguration [24.11] in the Capodimonte Museum in Naples Giovanni has emancipated himself almost completely from the Mantegna type of landscape and sets the pattern for his future development in that field. A wonderful luminous effect pervades the scene as the hidden sun lights up clouds banked along the horizon. And in the light accenting the mountains and buildings and in the cowherd leading his drove off to the left are the elements of Giovanni's future idyllic landscapes. A softer treatment is also perceptible in the draperies of Christ and the prophets flanking Him. They are cast in fuller and broader folds than heretofore, although echoes of Donatello's sculptural style are still apparent.

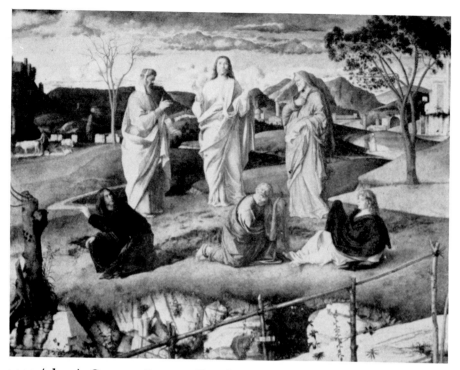

24.11 (*above*). GIOVANNI BELLINI: Transfiguration (*c.* 1480). Panel painting, 45″ x 59″. Capodimonte Museum, Naples (Alinari). 24.12 (*below*). GIOVANNI BELLINI: St. Francis receiving the Stigmata (*c.* 1480). Panel painting, 48¾″ x 54″. Frick Collection, New York

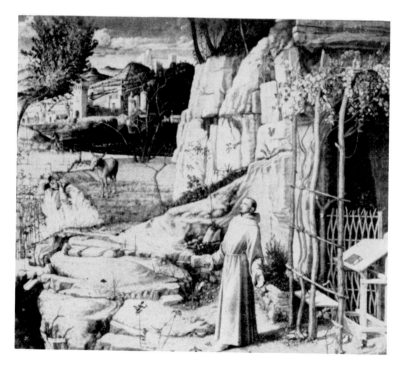

The landscape with St. Francis receiving the Stigmata [24.12], now in the Frick Collection in New York, is painted in similar manner. The foreground has reminiscences of Mantegna's quarrylike rocks. All the descriptive details in the foreground—such as the book, the skull, the jug, the flowers, vines and grasses—even the wonderful donkey and the birds in the middle distance are descendants of the International Style's love of details of nature as seen in the drawings and notebooks of Pisanello and Jacopo Bellini. But the mountain landscape in the distance with its brilliantly lighted walls and buildings and with its shepherd, flocks, and other barnyard accessories belong to Giovanni's new interpretations of nature.

A group of half-length Madonnas with the Christ child belong to this transitional period. They are placed against various types of background, either a neutral one or a landscape or a piece of brocade. In these panels the modeling of the Madonna and Child has lost much of its earlier hardness. The Madonna dell' Orto in the Accademia in Venice is set against a strip of brocade on either side of which can be seen the Greek-letter abbreviations for the Mother of God and of Jesus Christ used in Byzantine icons. Giovanni thus links his painting with the traditional Byzantine art out of which Venetian painting grew. In another Madonna, also in the Accademia in Venice, he paints a landscape background of his latest type.

In the latter half of the 1480's Giovanni painted a series of monumental Madonnas that must be considered as among his most important. Possibly in the early years of that decade he completed the Madonna painted for the church of SS. Giovanni e Paolo. The Madonna was elevated on a high throne beneath the cross vault of a loggia. Three angels singing lustily from a music book stood at the foot of the throne. Ten saints, five very symmetrically placed on either side, flanked the throne. Unfortunately this picture was destroyed in a fire in the church in 1867. A print and a poor water-color copy are all that remain to give us an idea of its composition and appearance. A very similar composition is found in the famous altarpiece [24.13] painted for the church of San Giobbe and now in the Accademia at Venice. Here too the Madonna is set on a high throne but beneath an apse covered with gold mosaics, and the three angels playing on musical instruments are seated on the steps of the throne. The six saints present are less mechanically arranged than were the ten saints in the SS. Giovanni e Paolo altarpiece. Here Giovanni paid much attention to light, color, and texture effects: the glow of the gold mosaics, the soft light across all the figures, and the contrasts between the old body of Job and the youthful one of St. Sebastian and between the homespun cloth of St. Francis' habit and the satin of the angels' garments. This type of monumentally enthroned Madonna with musical angels on the steps of the throne became popular elsewhere in Italy. Fra Bartolommeo, for instance, after a visit to Venice introduced it to the Florentines in several of his paintings (see Chapter 29).

Another Madonna of great beauty, painted in 1488, is in the sacristy of the church of the Frari, in Venice [24.14]. In spite of the fact that its

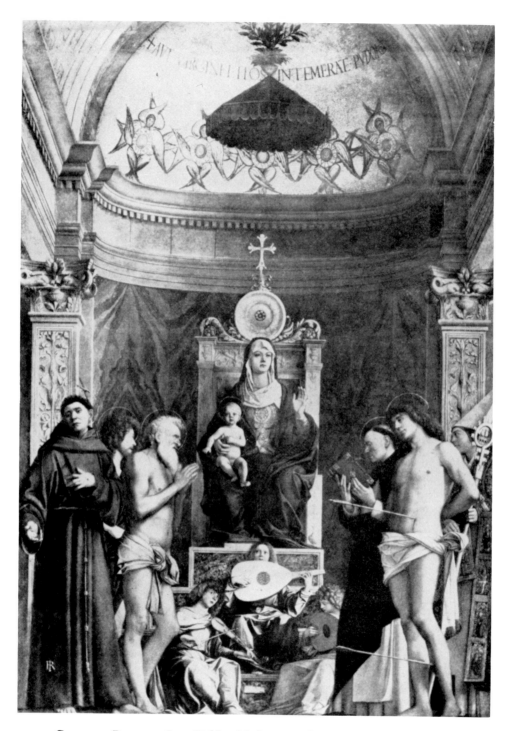

24.13. Giovanni Bellini: San Giobbe Madonna enthroned (1480–1485). Panel painting, 184″ x 101″. Accademia, Venice (Anderson)

24.14. GIOVANNI BELLINI: Madonna and Saints (1488). Panel painting, center panel 73″ x 31″. Sacristy, Frari, Venice (Zago)

24.15. GIOVANNI BELLINI: Madonna of the Trees (1487). Panel painting, 29⅛″ x 22½″. Accademia, Venice (Alinari)

size is only about one third that of the San Giobbe Madonna (which is about 15 feet high), the effect of the Frari altarpiece is very impressive. Its construction is certainly adapted from Mantegna's San Zeno altarpiece [23.5] —that is, it is a triptych the frame of which appears to be part of the architectural space within the picture. Bellini's composition is much simpler than Mantegna's. In the central panel an interesting interrelation of two triangles occurs: one triangle includes the Madonna and the pedestal on which she rests, and the other includes the Christ child and the two angels. Dürer on his visit to Venice must have seen this altarpiece, for the four rather dour saints in the side panels surely served as the inspiration for his Four Evangelists now in Munich.

A lovely porcelain quality is still apparent in the Frari Madonna and Child and in a number of the more intimate Madonnas of this decade. This was soon to give way to the more pronounced use of shadow in the modeling of the faces in keeping with Giovanni's more dreamy and poetic interpretations of the Madonna in his later period.

In his many Madonnas of the half-length, intimate type of the 1480's we notice that Giovanni used landscape backgrounds more frequently, sometimes in combination with the strip of brocade on either side of which a vista of landscape appears. A handsome example of this combination is in the Accademia at Bergamo, in which the vista at the left with its river, town, and grove of trees recalls similar details in Madonna paintings of the north, for example in Memling's work. The Madonna of the Trees [24.15] in the Accademia in Venice is a popular and fine variant of this combination. The wide strip of green satin behind the Madonna allows for very little vista space, but this Giovanni has filled cleverly with a tall, slender tree on either side of the brocade beyond which the distant landscape can be glimpsed.

Finally, a Madonna of this period having special interest is in the Metropolitan Museum in New York. In this picture the red cloth behind the Madonna and Child takes up two thirds of the background space at the right and leaves the remaining third at the left to the landscape. In other words, Giovanni posed here the problem of an asymmetrical composition of solids and space, a problem he was to pose frequently in his last paintings and which his pupil Titian was to use and solve with such success and *élan*.

That Giovanni Bellini was a pious soul not only is attested to by Dürer in his notes but also is apparent in his preoccupation with representations of the Madonna and of the Pietà theme and with the sincere and deep-felt emotion with which he endowed his figures. His Madonnas have nothing self-conscious about them; almost always they are preoccupied with some thought, perhaps the foreknowledge of the suffering and sacrifice awaiting the Christ child. Consequently, it is not surprising to find Giovanni interested in allegory. As an illustration we have the five small panels (decorative parts of a mirror case perhaps), now in the Accademia in Venice, that are allegorical representations of Virtue and Vice, Fortune, Temperance and Jus-

24.16. GIOVANNI BELLINI: Allegory (1490–1495). Panel painting, 28¾″ x 47¾″. Uffizi, Florence (Anderson)

tice, Falsehood and Truth. Fickle Fortune, for instance, is represented as a young woman surrounded by sportive putti while balancing a large pearl-colored sphere on her knee and riding in a small unstable bark.

In a picture in the Uffizi [24.16], Bellini paints a landscape of rocks, wooded areas, houses, and water as a setting for a more ambitious allegory that takes place on a balustraded area in the foreground. For the most part, the allegory is based on a fourteenth-century poem "The Pilgrimage of the Soul" (*Le Pélerinage de l'Âme*) by a French Cistercian monk. In the poem the soul of the monk-author is taken on a journey through Hell, Purgatory, and Paradise by his guardian angel who explains the sights. They arrive, at the entrance to Purgatory, at a hedged-in enclosure with its doors wide open —a garden of Paradise—in the center of which is a green tree. About this tree souls of the departed in Purgatory are gathered anxious to partake of the fruit of the tree. The guardian angel explains what is happening, and in this explanation lies the key to the representations in the Bellini picture. In consequence of Adam's eating of its fruit contrary to God's command, the Tree of Knowledge lost its leaves and its fruit became sour. It became the *dry* tree. All its descendants henceforth became *dry* trees. The original tree ap-peals to God for justice and restitution. God then grafts a new branch onto a descendant of the *dry* tree. This becomes the *green* tree that produces a flower (the Virgin) and a fruit (Christ). Whoever partakes of the fruit therefore partakes of Christ and is assured of Salvation. But Justice, as queen among the Virtues, demands more. She argues with the Virgin and convinces her

that her Son must die upon the cross to make restitution for Adam's fall. Since the cross of Christ, according to the legend, was made from the wood of the Tree of Knowledge, the *dry* tree rejected by the builders of Solomon's temple, the circle is now complete and what Man lost by Adam's act has been redeemed by Christ's sacrifice on the cross. Hence by prayers and the intercessions of saints the souls of the living and of those in Purgatory can receive the benefits of this redemption.

In Bellini's picture the Virgin is set on a lofty throne beneath a canopy from which a vine and a cluster of grapes, symbols of Christ's blood, are suspended. At her feet sits the personified figure of Justice wearing a crown, pressing her request upon the Virgin. A female attendant of the Virgin stands by. SS. Peter and Paul, the advocates of human souls outside Paradise, stand near at hand outside the balustrade and near the open gate of Paradise. The local Venetian saints, Job and Sebastian, identical with those in the San Giobbe altarpiece mentioned earlier, stand at the right within the enclosure and as martyrs make their prayers of intercession to the Virgin and to the golden-haired Christ child standing under the green tree in the center of the enclosure. He is shaking down the fruit of the tree that is picked up and consumed by the babes playing about the tree who, in the medieval tradition, represent souls of the departed. On the bluff on the opposite side of the stream rises the empty cross destined for the Christ child.

In the poem the guardian angel also explains that less dispensation is required for souls in Purgatory who led ascetic lives renouncing the world during their earthly existence. This we see illustrated in Bellini's painting in the area below the cross where St. Anthony the Hermit descends the rock-cut stairs in the desert and meets the centaur who points out to him the cave in which Paul the Hermit is living.

Quite apart from these "program notes," which we need to follow what goes on in this picture but which presumably were not needed by Giovanni and his friends, the painting is a triumph of poetic color and light and is a worthy predecessor of later allegorical and idyllic paintings by Giovanni himself and especially by his pupils Giorgione and Titian.

As time went on, Giovanni Bellini more often used landscapes, beautifully graded in soft color effects of light and shade, as background for his many religious pictures. An outstanding and moving example is the Madonna with the Christ child in her lap seated behind a parapet and flanked by the half-length figures of St. John the Baptist and a female saint, now in the Accademia, Venice. The background is a semidistant landscape of trees, a river, and the buildings of a city with mountains in the far distance, all seen as from a height. During this late period, he painted many other Madonnas alone with the Christ child in similar idyllic settings. Sometimes the landscape is partly obscured by a piece of the traditional brocade behind the Madonna, restating his earlier interest in asymmetrical composition. But in all the mood reflected in the Madonna's face or the faces of accompanying saints (if present) became increasingly introspective and daydreamy.

24.17. GIOVANNI BEL-
LINI: Baptism of Christ
(c. 1502). Panel paint-
ing, 162″ x 104½″. Santa
Corona, Vicenza (Ali-
nari)

One of the masterpieces of this period is the Baptism of Christ [24.17] in the church of Santa Corona in Vicenza. The Baptism takes place in the foreground set against the wide mountain valley of the Jordan. The path on the left leads up to a turreted castle, that on the right to a rocky hermit cell. The whole space of the background shimmers with delicate tones of blue, green, gray, and purple and sets off the beautifully modeled body of Christ standing with crossed arms in the center foreground. He gazes intro- spectively out of the picture, while at the right St. John, moved, respect- fully performs the rite of baptism to the astonishment, wonder, and adora- tion of the three angels on the bank at the left.

24.18. GIOVANNI BELLINI: Madonna enthroned with Saints (1505). Panel painting, 197½" x 92¾". San Zaccaria, Venice (Alinari)

Giovanni's monumental Madonna, the Madonna with Saints [24.18] in San Zaccaria, Venice, was painted in 1505, eleven years before his death when he was about seventy-five years old. In construction and design it is very close to the San Giobbe Madonna [24.13] painted twenty years before. The apse with its gold mosaic is set back farther in space than in the ear-

24.19. GIOVANNI BELLINI: Pietà (*c.* 1502). Panel painting, 25½″ x 35½″. Accademia, Venice (Alinari)

lier Madonna, showing an area of pavement in the foreground and slight glimpses of outside space with slender trees to right and left. There is but one angel at the foot of the throne, and the saints flanking the throne are more introspective. This is accentuated by the almost translucent but deep shadows that fall across the faces of the forward saints and bathe the draperies of all the figures. The effect is most similar to that achieved by Giovanni's pupil Giorgione, and it is a problem to decide who influenced whom. But since Giovanni in his earlier Madonnas already had this tendency toward the contemplative mood, we may assume that Giorgione took it over from his master and developed it in the manner that we shall see later.

We have noted elsewhere that Dürer had visited Venice. He had been cordially received, and his work had been admired by Giovanni Bellini. We have also suggested that Dürer borrowed certain motifs from Giovanni for his own creations. That Giovanni, in turn, was affected at times by art from beyond the Alps we pointed out while discussing the famous Pietà in the Brera in Milan. This seems again to be true in the late Madonna with the dead body of Christ lying across her lap [24.19] in the Accademia in Venice. There can be little doubt that this motif was borrowed from one of the many Pietàs or *Vesperbilder* found in Gothic wood and stone sculpture of Germany and Austria. In Bellini's painting of the Murder of St. Peter Martyr, in the National Gallery in London, the background of the woods (in which peasants are chopping down trees) as well as the winding road passing by a village also indicate a knowledge of prints from the north that were being circulated in Italy at this time.

24.20. GIOVANNI BELLINI (with Titian): Feast of the Gods (1514). Canvas, 67″ x 74″. National Gallery of Art, Washington, D. C. (Courtesy of the National Gallery of Art, Widener Collection)

We have observed that Giovanni's paintings were concerned primarily with Christian and other Biblical subjects. Pagan material was conspicuously absent until it appeared in several pictures painted at the end of his career. Whether this was owed to the growing taste and demand for pagan subjects in sophisticated and cultivated circles at that time or whether it was the result of an attempt to keep up with his pupil Titian whose love for pagan subject matter was already apparent is open to question. At any rate, in 1515, the year before his death, Giovanni painted the sensuously handsome figure now in the Kunsthistorisches Museum in Vienna of the nude woman, sometimes called Venus, looking into a hand mirror while doing her hair.

A more significant painting he signed in 1514. This is the famous Feast of the Gods [24.20], now in the Widener Collection of the National Gallery in Washington. It was painted for the studio or private apartment of Alfonso d'Este in the palace at Ferrara, to be one of five pictures with pagan subjects. Of the other four, Dosso Dossi, the Ferrarese artist, painted one

and Titian painted the remaining three. After Giovanni's death Titian undertook to repaint a large section of the Feast of the Gods, apparently to make it fit in with his own and Dosso's more dynamic and dramatic styles. We have noticed how Giovanni's style, affected by his quietistic religious feelings, had a calm introspective beauty about it. It is difficult to think of him as painting a bacchanalian revel. When he did undertake to do this in the Feast of the Gods, the result was rather in the nature of a static tableau. This effect was accentuated by the background screen of trees which he had originally painted across the entire picture. This Titian decided to change by repainting the landscape in the left half of the picture to represent a romantically lighted mountain height with a castle perched on top and with an equally romantic tangle of trees at the base, making a sharp contrast with the orderly rhythm of the tree trunks on the right. The contrast between these two landscape backgrounds is emphasized by the deep wedge of sky that Titian painted in to separate them. Titian also touched up some of the figures to give them more abandon, changing some of the gestures and revealing more nude portions of the female forms than Giovanni had done.[*] In spite of these changes, Titian was not able to transform the essential calm and dignity of Bellini's picture.

In various paintings by Giovanni in the late 1470's and after, we have called attention to the greater softness and translucency of his colors. This is usually explained as the result of Antonello da Messina's visit to Venice. This artist, whose accomplishments we shall mention almost immediately, came from Sicily and Naples to Venice in 1475. He had been trained in the technique of oil varnishes used by Flemish painters and observable in paintings by these artists in southern Italy and Sicily. By means of this technique softer color effect could be achieved.

The influence of this Sicilian painter is also apparent in many of Giovanni Bellini's portraits, most of which date from the middle 1470's to the end of his life. The earliest portrait in existence is the delightful Boy in Purple in a private collection in London. It is full of casual charm and shows what Giovanni's portrait style must have been like before the advent of Antonello. The more rugged portrait of Joerg Fugger, scion of the famous Augsburg banking family, dated 1474, in the collection of Count Bonacossi in Florence, is another example of this pre-Antonello style. After the Sicilian's arrival in Venice, Giovanni was perceptibly influenced by the oil-varnish technique that enabled him to model the heads and faces of his sitters more subtly and more plastically. But always a certain poetic quality comes through, a quality so characteristic also of his religious pictures. Some of the portraits, such as the Youth in Black from the Bache Collection in the Metropolitan Museum in New York, are set against dark neutral backgrounds; others, for example the Young Man with the Long Black Hair in the

[*] These changes by Titian and the original designs of Bellini were revealed by a series of X rays. The results and the discussion of them are published in John Walker's fascinating volume: *Bellini and Titian at Ferrara* (see bibliography).

24.21. GIOVANNI BELLINI: Portrait of Doge Loredan (*c.* 1501). Panel painting, 24″ x 17½″. National Gallery, London

Louvre, are painted against a cloudy sky, thus introducing a space contrast. According to Vasari there was scarcely a palace in Venice in those days that did not possess portraits by Bellini, so popular had they become. To-day very few remain. Among the most famous still in existence is the marvelous portrait of the Doge Leonardo Loredan [24.21], now in the National Gallery in London. Serious and authoritative in mien, it is an eye-filler in its beauty of color—the light blue of the background, the gold and silver and white of the brocaded cape, the brown buttons, and the reddish balustrade behind which the bust of the Doge is set like a precious piece of glazed polychrome porcelain. All Bellini's portraits are comparatively small in size, all are bust length and face the left, except for the earliest one of the Boy in Purple, who turns his head to the right.

We have been considering some of the highlights in Giovanni's long career as a painter. These cause us to marvel at the tremendous accomplishment of this artistic giant who during his lifetime prepared Venice to take over from Florence and Rome the leadership in painting that those cities had held for so long a time. Thus Giovanni also laid the foundations for modern painting.

Antonello da Messina

Although Antonello da Messina arrived in Venice in 1475 and stayed only one year and a half, his sojourn was of such importance that a brief account of his work is postulated at this point.

Antonello was born about 1430 in the Sicilian city of Messina, as his name indicates. His father was a stonecutter. He seems to have been sent

24.22 (left). ANTONELLO DA MESSINA: Crucifixion (1475). Panel painting, 23½" x 16¾". National Gallery, London (Anderson)

24.23 (above). ANTONELLO DA MESSINA: St. Jerome in his Study (1450–1455). Panel painting, 17¹¹⁄₁₆" x 10½". National Gallery, London (Hanfstaengl)

to Naples to study painting with Colantonio, the ranking painter of that city. During the brief reign of René d'Anjou and later of Alfonso of Aragon, both of whom were admirers and collectors of Flemish paintings, the technique of Flemish painters was imitated in Naples by the local masters. Colantonio, according to sixteenth-century accounts, was able to paint in the northern manner so well that his work was taken to be Flemish. No wonder then that Antonello's technique and style are reminiscent of those of the northern painters. Like theirs, his colors were brilliant, owing to the use of oil varnishes, and his painting of jewels and objects of still-life were meticulous in detail after the Flemish fashion. Domenico Veneziano and his pupil Piero della Francesca were probably the only Italians up to that time to have had knowledge—and used it—of these northern methods of painting.

How close to the Flemings his style could be is apparent in the three Crucifixion scenes that Antonello painted. Let the one in the National Gal-

24.24 (*above*). ANTONELLO DA MESSINA: Portrait of a Condottiere (1475). Panel painting, 13½″ x 11″. Louvre, Paris (Alinari)

24.25 (*right*). ANTONELLO DA MESSINA: St. Sebastian (*c.* 1476). Panel painting, 67⅜″ x 33½″. Gemaeldegalerie, Dresden (Alinari)

lery in London [24.22] suffice as illustration, or the well-known St. Jerome in his Study [24.23] in the same gallery. The latter is laden with still-life subjects.

A number of heads of Christ wearing the crown of thorns show how expertly Antonello could render the human being, both as a physical as well as a psychological subject. It was but a step from these to the portraits that he painted with great simplicity and effectiveness. Examples of these are to be found in the Metropolitan Museum and in the Johnson Collection in the Philadelphia Museum of Art. In all, the head emerges from a dark background as an object of extreme plasticity.

When Antonello arrived in Venice for his short stay, he attracted so much attention with his technique and his portraits that a lasting impression

was made on his Venetian contemporaries. The story goes that Giovanni Bellini, anxious to know Antonello's technical secrets, went to have his portrait painted by the Sicilian master, and then while sitting observed what Antonello did. Whether true or not, the fact remains that in the late 1470's Giovanni Bellini's portraits show the influence of Antonello's technique, although in the majority of the portraits assigned to Giovanni after Antonello's visit to Venice the background is an open, clouded sky. In the portrait of Pietro Bembo in Hampton Court Palace, England, the background is a landscape.

While in Venice, Antonello painted a large altarpiece with the enthroned Madonna and six saints for the church of San Cassiano. This has subsequently been sawed up and the pieces that remain are in the Kunsthistorisches Museum in Vienna. Without question Giovanni Bellini had this masterpiece in mind when he designed the San Giobbe Madonna and the other monumental ones he painted in the 1480's.

Several of Antonello's finest portraits were painted while he was in northern Italy, as for example the forceful Condottiere [24.24] in the Louvre and the male portrait in the National Gallery in London that might well be a self-portrait. In these he continued to use the convention of a dark background from which the head emerges. In one of his latest, however, that is in the former Kaiser Friedrich Museum in Berlin, he used a sky and landscape background that set the head more in space, as we noticed Giovanni Bellini doing.

In his final masterpiece, the St. Sebastian [24.25] in the Dresden Gemaeldegalerie, Antonello displays his acquaintance with the work of Piero della Francesca. This is evident not only in the figure of St. Sebastian but also in the grouped figures in the background at the right, which suggest that Antonello had been in Urbino and seen Piero's Flagellation of Christ.

Antonello left Venice in 1476 to return to Sicily where he died in 1479.

BIBLIOGRAPHY

Fry, R. Giovanni Bellini. London, At the Sign of the Unicorn, 1899.
Hendy, P., and Goldscheider, L. Giovanni Bellini. New York, Oxford University Press, 1945.
Wind, E. Bellini's Feast of the Gods, a Study in Venetian Humanism. Cambridge, Mass., Harvard University Press, 1948.
Bottari, S. Antonello da Messina, trans. by G. Scaglia. Greenwich, Conn., New York Graphic Society, 1955. (Large, color-plate edition)
Walker, J. Bellini and Titian at Ferrara. London, Phaidon Press, 1956.
Berenson, B. Italian Pictures of the Renaissance. Venetian School, 2 vols. New York, Phaidon Press, 1957. (Many plates)

~ 25
Carpaccio and
Giorgione

COMPARATIVELY safe amid its lagoons, the great city of Venice scorned the grim fortresslike appearance of Florence and other cities in Italy that hid their palaces behind bristling walls and towers. Venice boasted no walls but the sea, and its public buildings and palaces combined with the sky and the sea to produce a scene of beautifully arcaded façades and ravishing color, ever changing in appearance. The splendor and the wealth that Venice had amassed through widespread commerce was always on display when local festivals were celebrated or when the gilded and colorful barges and gondolas, draped with brocades and Oriental rugs, went out to meet some important visitor. It is this richness and glamour, at its height in the late fifteenth and during the sixteenth century, that is reflected in the works of contemporary Venetian painters.

Vittore Carpaccio

The most distinguished reporter of the life in Venice is Vittore Carpaccio (c. 1455–c. 1526), one of the most delightful painters of all times. As a pupil of Gentile Bellini, he continued his master's narrative style, adding, however, his own dry humor to the episodes he illustrated. Although most of his paintings have religious subject matter, he set his scenes and events mostly in Venice.

This is apparent in the delightful series of paintings that Carpaccio did for the chapel of the School of St. Ursula, a small structure now incorporated into the great museum of painting in Venice, the Accademia. Here a series

471

of large paintings on canvas tell the fairy-tale story of St. Ursula. (Fresco painting was rare in Venice because of the dampness of the walls. Hence large canvases were used instead.) In the first three canvases relating to the Arrival of the Ambassadors from England to sue for the hand of Ursula, their Departure from the King of Britain, and their Return to England, Carpaccio has undertaken to show the spectator some of the magnificence of official receptions in Venice, the outdoor pavilions, the curiosity of the crowds along the shore, and the costumes worn. In the Departure of the Ambassadors [25.1] the scene takes place in a throne room beautifully decorated with marble revetment similar to that described in the Miracle of the Relic of the Holy Cross (p. 448) by Gentile Bellini. Alongside the throne a bit of local color is shown in the blond young scribe writing out a letter or contract for a client. The fourth canvas shows the Meeting of the young Prince of Britain and the Princess Ursula [25.2] and their Departures. Ursula had made it a condition in accepting the proposal of the young prince that he become a Christian and that they make a pilgrimage to Rome. The youthful charm of this fairy-tale pair is accentuated. All along the shore again are crowds of onlookers and in the harbor are ships like the great carriers of Venice's wealth. Then comes their Arrival in Rome for the setting of which Carpaccio must have used some print showing the Castel Sant' Angelo, which he reproduces here. The pope and his cardinals receive the royal lady, who is accompanied by the ten thousand virgins Ursula had taken along on the trip. Next we see the Dream of St. Ursula in which an angel informs her of her impending martyrdom. For anyone interested in period furniture, this painting is an excellent document at the turn of the fifteenth century in Venice. On the floor at the foot of the bed lies the small white dog whom we shall meet again in Carpaccio's work. The Arrival at Cologne follows. The setting here too seems inspired from some print of the north country known to the artist. While in Cologne the son of the king of the Huns wishes to marry Ursula and threatens to kill her if she does not comply. Obviously she does not, for in the last episode in the story this Hunnish prince with his archers dispatch Ursula and her ten thousand virgins. In the right half of the picture members of the clergy are carrying the corpse of the saint into a church. (The relics of Ursula and her maidens are kept in Cologne.) On the end wall of the chapel as an additional picture is the Apotheosis of St. Ursula, who is raised on a column of palm branches at the foot of which kneel as many of her ten thousand fellow martyrs as Carpaccio could crowd into the composition.

It is necessary to emphasize that in spite of the narrative and descriptive quality of these paintings Carpaccio composed them beautifully as to color and as to the distributed patterns of light and shade. This is especially true of the detail of the transportation of the saint's body into the church at Cologne.

Two other sets of paintings that cannot be passed over in presenting Carpaccio are those in the chapel of the School of San Giorgio dei Schiavoni.

25.1 (*left*). CARPAC-
CIO: Departure of
the Ambassadors
(after 1495). Can-
vas, 110½″ x 99½″.
Accademia, Venice
(Anderson)

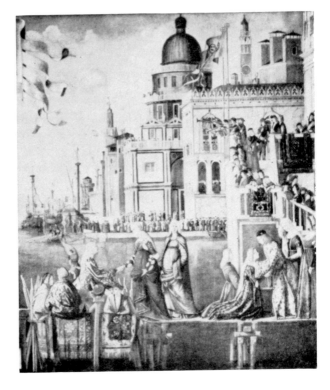

25.2 (*right*). CARPACCIO: Meet-
ing of the Young Pair (1495).
Canvas, 110½″ x 236⅝″. Ac-
cademia, Venice (Anderson)

25.3. CARPACCIO: St. George bringing in the Dragon (1502–1507). Canvas, 56¼" x 139". San Giorgio degli Schiavoni, Venice (Anderson)

Venice, as any great modern commercial city, had its foreign quarters. The Fondaco dei Tedeschi, for example, was the merchants' guildhouse in the German quarter and San Giorgio dei Schiavoni was the guildhouse in the Slavic section, an area reaching from near San Zaccaria down to the Grand Canal where then, as now, it was known as the Riva dei Schiavoni—the bank or shore of the Slaves. In this chapel of St. George, along the top of the paneled side walls, are scenes from the life of St. George and the life of St. Jerome. The same sense of a romantic fairy tale humorously related is present in these as in the stories of St. Ursula. In one the youthful St. George charges at the fierce dragon in a barren desert, the sands of which are scattered with the blanched bones of victims. In another [25.3], the saint drags in the body of the wounded beast to deliver the *coup de grâce* in front of the applauding public to the music of an Oriental brass band. On the opposite wall St. Jerome seated in his Study * is a kind of counterpart to Ghirlandaio's famous fresco of the same subject in the Ognissanti in Florence. The saint is in his spacious study furnished with all the accoutrements belonging to a humanistic scholar of the Renaissance. The little white dog is present here too, gazing up pertly at the saint. In another of the episodes from the life of St. Jerome, the saint, like a Christian Androcles, returns to the cenobite community followed by a meek lion from whose paw the saint had extracted a thorn [25.4]. A group of monks, who had been talking, is scattering in all directions at the approach of the wild beast. The action of the monks is accentuated by the pinwheel design Carpaccio employs to produce a centrifugal effect. Finally, in the scene of the death of St. Jerome the rigidity of the corpse is emphasized by the use of horizontal

* This scene has recently been interpreted as St. Augustine in his study hearing the voice of St. Jerome who had just died in Bethlehem. See Helen I. Roberts in *The Art Bulletin*, Vol. XLI (1959), pp. 283–301.

25.4. CARPACCIO: St. Jerome and the Lion (1502–1507). Canvas, 54¼″ x 81″. San Giorgio degli Schiavoni, Venice (Alinari)

and vertical lines everywhere to the practical exclusion of any curves in the design.*

A more monumental phase of Carpaccio's style is to be seen in the large canvas with the Presentation of the Christ child in the Temple, now in the Accademia in Venice. He sets the scene against an apse in the background gleaming with gold mosaics in the manner of Giovanni Bellini's various large-scale Madonnas.

In keeping with his interest in secular detail, Carpaccio painted a rather surprising portrait characterization of two Venetian prostitutes [25.5] as they are seated, bedizened and weary, along the arcades. One of them is playing with a dog; various birds complete the setting. The whole picture is painted with a dry humor so characteristic of this master. It is now in the Correr Museum, Venice. Not until the eighteenth century, with painters like Canaletto and Guardi, do we have Venice again so intimately portrayed.

Carpaccio, however, had another side that he revealed only rarely: the mystical one. The Metropolitan Museum in New York possesses a picture [25.6] in which the dead Christ is propped against a stelelike stone. On

* In addition to the St. George and St. Jerome scenes, there are: a Miracle of St. Tryphonius, to the right of the altar, and the Calling of Matthew and Christ's Agony in the Garden (the latter dated 1502), which precede at the altar end of the right wall the scenes in which St. Jerome figures.

25.7. GIORGIONE:
The Judgment of
Solomon (before
1500). Panel paint-
ing, 35″ x 28″. Uf-
fizi, Florence (An-
derson)

Madonna [25.8] made in 1504 for the church in his home town of Castel-
franco, where it has remained. But here the mood is also caught by the
figures of the Madonna and Child and of St. Liberale and St. Francis, whose
daydreaming attitudes betray the romantic nostalgia so ever-present in Gior-
gione's paintings. The mood is heightened by the stunning colors, the mar-
velous pinks, greens, and blues.

As of this period too we might consider the beautiful Adoration of the
Shepherds [25.9] in the Kress collection of the National Gallery in Wash-
ington. It still reflects much of the style of Giovanni Bellini, in particular
the beautiful distant landscape at the left. But the humble shepherds and
the Madonna and St. Joseph have a detachment similar to that we just
noted in the Castelfranco Madonna.

Of Giorgione's romantically poetic subjects, the so-called "Soldier and
the Gypsy" (sometimes called "The Tempest") [25.10] is perhaps the ear-
liest that has survived. The group consists of a semi-nude woman seated
to the right nursing her child while a youth leaning on a staff at the left
gazes in a daydream in her direction. The ruins in the landscape and the

25.8 (*right*). GIORGIONE: Madonna enthroned (*c.* 1500). Panel painting, 78¾″ x 59⅞″. Cathedral of St. Liberale, Castelfranco (Alinari)

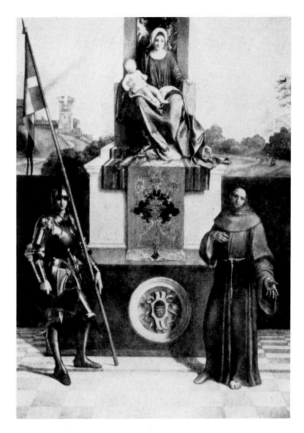

25.9 (*below*). GIORGIONE: Adoration of the Shepherds (*c.* 1503). Panel painting, 35¾″ x 43½″. National Gallery, Washington, D. C. (Courtesy, National Gallery of Art, Samuel H. Kress Collection)

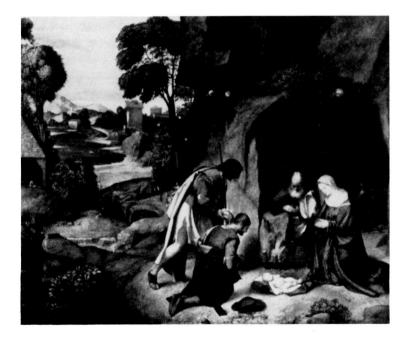

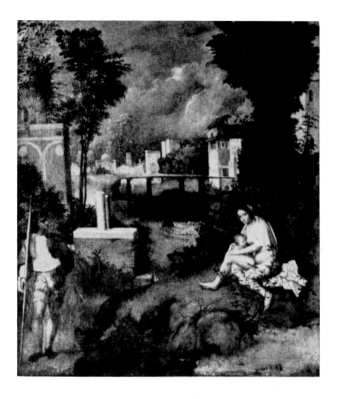

25.10. GIORGIONE: The Soldier and the Gypsy (*c*. 1505). Canvas, 30″ x 28½″. Accademia, Venice (Alinari)

thunderclouds and lightning in the sky suggest the emotional situation in the picture, which seems to be concerned with a sylvan love affair.

A number of smaller panels with mythological subject matter, particularly of episodes from the life of Paris, have survived. But the most significant of these Arcadian pictures is the one bearing the misnomer "La Fête Champêtre" [25.11] in the Louvre. In the background, in an idyllic landscape, a shepherd with his flock is passing along the wooded edge of a road. In the foreground are two nude female figures, one of them seated and holding a flute, the other at the left pouring water into a wellhead shaped like a sarcophagus. Between them, and slightly set back, are two youths gazing wistfully at one another, one of them playing a lute. Far from being a *fête champêtre*, this is another of Giorgione's romantic poesies. There is no actual relation between the goddesses and youths, who pay no attention to the female figures. Presumably what is happening is that the two youths are singing to each other, and the subject of their poetry or song is the pair of goddesses whom the artist has materialized in his picture. What a difference in feeling and intention from the famous realistic nineteenth-century *fête champêtre* * painted by Manet, probably with this picture, misunderstood, in mind. It is possible that the young Titian had a part in the painting of this picture as he did in other creations of Giorgione. So perhaps we have here an allusion to the close friendship that existed between these two youthful artists. The Knight of Malta in the Uffizi and

* The Déjeuner sur l'Herbe.

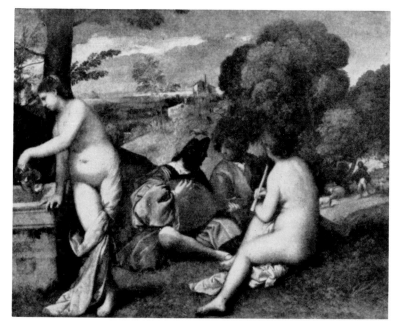

25.11 (*above*). GIORGIONE: The "Fête Champêtre" (*c.* 1508). Canvas, 43½″ x 54¼″. Louvre, Paris (Archives Photographiques)

25.12 (*below*). GIORGIONE: Sleeping Venus (*c.* 1505). Canvas, 42½″ x 68¾″. Gemaeldegalerie, Dresden (Alinari)

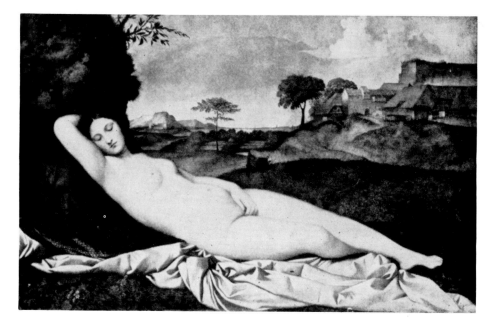

the Concert in the Pitti are two other pictures in which the former fellow students in the Bellini studio collaborated. (If Titian did not collaborate in the Concert, he at least finished the head of the monk after Giorgione's death.)

The high moment of Giorgione's idyllic painting is the Sleeping Venus [25.12] in the Gemaeldegalerie in Dresden. Despite its first impression of rather startling reality, the painting is, after all, primarily a poetic adaption of the female form to the landscape, the curves of which repeat the curves of the body. There is a complete absence of self-consciousness about the figure; it has none of the brashness of some of Titian's later nudes. Left unfinished by Giorgione's untimely death, Titian undertook to complete it and removed the Cupid that originally was to the right of Venus' feet. From this picture Titian certainly took the inspiration for many of his own nudes, especially the Venus Urbino now in the Uffizi.

In Giorgione's few portraits we can recognize the same wistfulness that exists in his other work. This wistfulness is evident in the portrait of the Young Man in the former Kaiser Friedrich Museum in Berlin and most certainly appears in the portrait of the bearded young person in the Altman collection of the Metropolitan Museum of Art. Although the latter portrait may be a studio piece, it nevertheless reflects the feeling of Giorgione and is an excellent example of his use of an almost transparent and golden chiaroscuro to achieve the emotional effect.

Giorgione's Arcadian art, stemming as it does from his master Giovanni Bellini's own poetic awareness of nature, serves as an interlude between the more factual, narrative storytelling of Gentile Bellini and Carpaccio and the creations of Titian that glorify the sensuous beauties inherent in material things. The effect of this Arcadianism was strong on many contemporary painters, but it was rather short-lived. We shall see next how Titian, affected as he was in his earlier style by the poesies of his friend Giorgione, passed on from this quasi-adolescent phase to the glorious achievements of his long and productive life.

BIBLIOGRAPHY

Cook, H. *Giorgione*. London, G. Bell & Sons, 1900.

Ludwig, G., and Molmenti, P. *The Life and Works of Vittore Carpaccio,* trans. by R. H. H. Cust. London, John Murray, 1907.

Conway, W. M. *Giorgione*. London, Ernest Benn, 1929.

Phillips, D. *The Leadership of Giorgione*. Washington, D. C., The American Federation of Arts, 1937.

Richter, G. M. *Giorgio da Castelfranco*. Chicago, University of Chicago Press, 1937. (Full bibliography)

della Pergola, P. *Giorgione*. Milan, A. Martello, 1955. (Plates)

Muraro, M. *Victor Carpaccio*. Milan, Edizione d'Arte Sidera, 1956. (Color plates)

Pignatti, T. *Carpaccio*. New York, Skira, 1958.

← 26

Titian

S TRANGE it is that two great geniuses of the Italian Renaissance, each the climax in painting in his region of Italy, should have been born at almost the same time and have lived for almost a century. Titian (1477–1576) was born two years after Michelangelo, in the township of Pieve di Cadore in the foothills of the Alps north of Venice. He came to Venice at the age of eleven and eventually studied painting with the Bellini, although his first master seems to have been a minor painter named Sebastian Zuccato.

Early Influences and Developments

It was in the studio of Giovanni Bellini that Titian got his best training and received the impulse for many of his earlier works. While Giovanni Bellini, as a rule, used a symmetrical composition for his Madonnas, with equally balanced bits of landscape to right and left of the Madonna figure, he had begun to use an asymmetrical arrangement by the time Titian became his pupil. Titian was to take up this problem of asymmetrical balance and, as we shall see shortly, develop it to monumental proportions.

One of Titian's earliest known works, the so-called "Gypsy Madonna" [26.1], painted about 1505, now in the Kunsthistorisches Museum in Vienna, starts out like the well-known Giovanni Bellini type of half-length Madonna with the Christ child on a parapet set against a panel of brocade and with vistas of landscape in the background. But in this painting Titian stated the problem of asymmetrical balance very simply as a problem of interrelation of

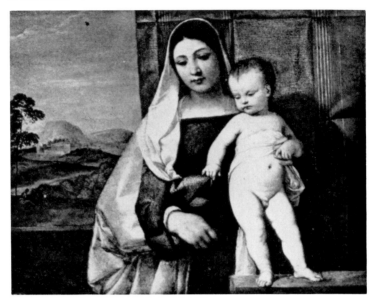

26.1. Titian: The Gypsy Madonna (*c.* 1505). Panel painting, 26⅜″ x 33¹⁄₁₆″.
Kunsthistorisches Museum, Vienna (Kunsthistorisches Museum photo)

mass and space: how much space will balance how much mass? The green
satin hanging behind the Madonna and Child shuts out space at the right
and makes the eye move vertically, horizontally, diagonally, or along the
curves of the form and drapery. But, after passing the edge of this hanging
or the right sleeve of the Madonna, the eye plunges into the depth of the
painted space, and a psychological sense of balance is achieved between the
forms and the space, even though the painted space occupies only about
three eighths of the area of the canvas. The tree in the middle distance at
the left edge of the picture catches the eye and turns it back into the deeper
background space to follow the zigzag road that leads into the mountains.
The diagonal pitch into space had, however, already been prepared for in
the right-hand side of the composition by the position of the Christ child
on the short ledge tight against the front plane of the picture and by the
position of the Madonna, especially her right sleeve, set in the plane behind.

Another early asymmetrical composition by Titian is the Pesaro St. Peter
[26.2] in the Royal Museum in Antwerp. It is also of historical interest,
since it commemorates the victory of the Venetian armada under Jacopo
Pesaro over the Turks. In the picture the admiral is being presented by the
Borgian Pope Alexander VI to St. Peter, enthroned at the left.

It was also in the studio of Giovanni Bellini that Titian met the young
genius Giorgione from Castelfranco with whom he was to be closely asso-
ciated for a time and by whom he was deeply influenced. This influence can
be seen in the altarpiece of St. Mark enthroned, in Santa Maria della Salute

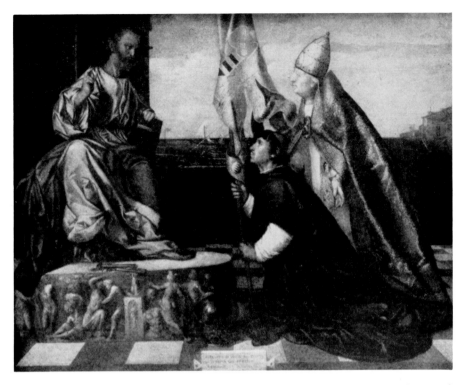

26.2. TITIAN: Jacopo Pesaro presented by Pope Alexander VI to St. Peter (*c.* 1506). Canvas, 57⅛″ x 72⅛″. Musée Royal, Antwerp (Fiorentini)

in Venice, which was painted at the time of one of the plagues that so frequently beset Venice. While the figure of St. Mark set high above the heads of the four saints recalls in its drapery and posture the rigid brittleness of an early Giovanni Bellini, the soft, daydreamy heads of SS. Sebastian and Rocco (who always were invoked against the plague) at the right definitely reflect Giorgione's style. The two saints at the left are Cosma and Damian, the doctor saints. Not long after, Titian escaped to Padua from one of these plagues and there painted frescoes from the life of St. Anthony in the Scuola di San Antonio. Giorgione stayed behind in Venice and succumbed to the plague.

The close association between these two painters, which has already been mentioned (page 480), gave Titian's work at this time a certain idyllic quality. He even adopted his friend's soft chiaroscuro, so much so that some critics have claimed that the portrait of the Knight of Malta in the Uffizi is by Titian rather than by Giorgione.

After Giorgione's death, Titian still painted poetic and idyllic subject matter, but his actual technique in painting and his types, particularly his women, seem to have been influenced by another contemporary painter, Palma Vecchio. This is apparent in the Three Ages of Man in the collection at Bridgewater House, London, and in his early masterpiece, Sacred

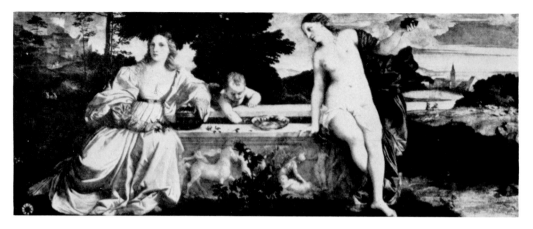

26.3. TITIAN: Sacred and Profane Love (*c.* 1515). Canvas, 42⁹⁄₁₆″ x 100⅞″. Borghese Gallery, Rome (Anderson)

and Profane Love [26.3], in the Borghese Gallery in Rome. In the Three Ages of Man, Titian focuses attention on the nude young shepherd and the garlanded maiden holding the shepherd's pipes, who represent the age of Youth. He calls attention to the texture of the girl's blond hair, of the satin of her dress, of the brown body of the shepherd. In heightened fashion this is also true of the Sacred and Profane Love. Here too the emphasis is on a nude and a clothed figure. The voluptuous softness of the nude figure at the right is set off against the deep pink satin of the cloak behind her and is in sharp contrast with the figure at the left clad in a heavy white satin dress with pink sleeves. The picture is full of the beauty of material things and the differentiation between their textures: the hair, the flesh, the satins, the metal of the bowl, the cherries, the marble of the relief on the fountain, the blue of the sky. And the glimpses of landscape to right and left give the idyllic, poetic setting still reminiscent of Giorgione.

The Dynamic Genius

Titian was never meant to be a daydreamer, and between 1515 and 1530 his style became completely independent and blossomed forth in all its virile and dynamic power. Although following the Bellini formula, the Madonna of the Cherries [26.4], now in the Kunsthistorisches Museum in Vienna, has a physical vitality surpassing that of his master. In the Tribute Money, now at Dresden, the hair and beards of Christ and the tax collector may still be fused into the dark background in the manner of Giorgione, but the faces and hands and even the drapery create an impression of the ruggedness of character in each of the two figures that is no longer Giorgionesque. The tremendous canvas of the Assumption of the Virgin [26.5] over the high altar of the church of the Frari in Venice, completed in 1518, is bursting with jubilation as the Mother of God is wafted aloft "as with a shout" by

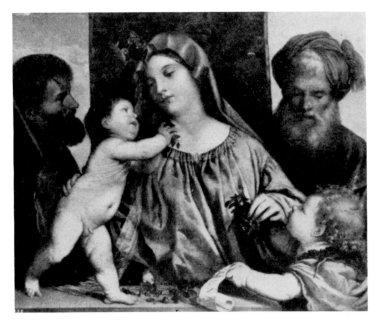

26.4. TITIAN: Madonna of the Cherries (1516–1518). Panel, 31⅞" x 39".
Kunsthistorisches Museum, Vienna (Kunsthistorisches Museum photo)

the circle of putti about her and by the apostles below. The equally huge composition of the Pesaro Madonna [26.6] in the same church is a bold experiment in asymmetrical design. Although the Madonna and Child are set off to the right side, perfect balance is achieved by the dynamic handling of all the other elements in the picture by a retreating zigzag that becomes progressively more narrow as it approaches the center of the picture and establishes the center of the balance. Forms are so placed to right and left as to keep the balance of weight moving until the point of rest or release is reached in the space between the columns of the background. Thus the eye of the spectator passes from the kneeling form of Jacopo Pesaro in the right foreground to the kneeling figure on the opposite side, which, however, is set further into the space of the picture and does not establish an actual equilibrium. Then the eye passes, via St. Peter, to the Madonna and Child placed on a high podium, and the balance is thrown off again. By setting the Madonna against the background of a column, painted in proper scale, Titian is able to restore the balance by placing another column on the left side, but set back in space. St. Francis, with his position and gesture, keeps the eye from going out of the picture at the right; the standard points it back in at the left; the clouds and the putti "put a lid" on the top. So the only escape is into the space between the columns in the center of the picture. In these two canvases of heroic scale in the Frari we find the seeds for many designs developed by later artists of the Baroque period.

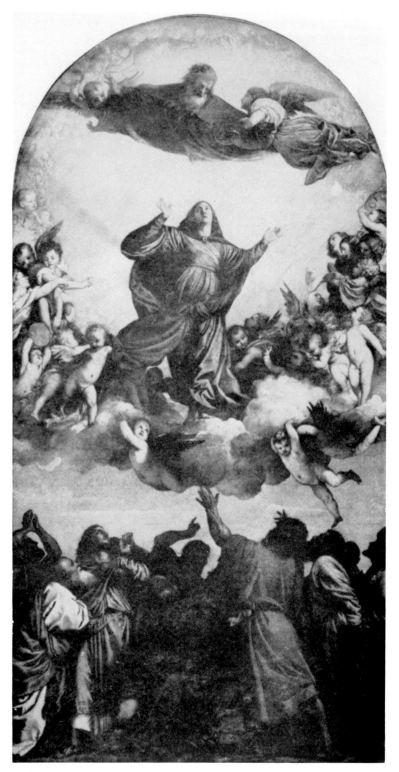

488

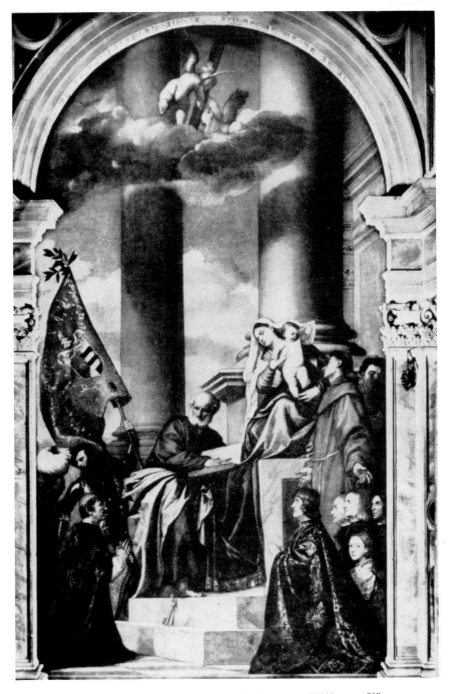

26.6. TITIAN: Pesaro Madonna (1519–1526). Canvas, 188½″ x 105⅝″.
Santa Maria dei Frari, Venice (Anderson)

(*Opposite*) 26.5. TITIAN: Assumption of the Virgin (1516–1518).
Canvas, 271″ x 142″. Santa Maria dei Frari, Venice (Alinari)

Another religious picture of this period before 1530 remarkable for its design is the Entombment of Christ, in the Louvre [26.14]. Two later versions exist in the Kunsthistorisches Museum, Vienna, and in the Prado, Madrid [26.13]. The three figures carrying the body of the Saviour form, together with it, a design like a compressed figure 8 in perspective and on its side that enhances the effect of solicitous care on the part of the three. The colors, too, are effective, especially the cold, light slate-blue of the Madonna's cloak and the silvery peach of the garment of the figure at the extreme right. In the heads of the St. John and the Christ we still have an echo of Giorgione's feeling, but the whole is a superb example of Titian's mastery of color, design, and controlled emotion.

During the years from 1516 to 1523 Titian frequently received commissions from the Duke Alfonso d'Este at Ferrara. The above-mentioned Tribute Money was presumably done for him. But the most significant pictures Titian painted for this Renaissance prince were not religious ones. For Alfonso's personal quarters in the palace at Ferrara, Titian furnished three paintings full of pagan vitality: the Worship of Venus, the Bacchanale, both at present in the Prado in Madrid, and the Bacchus and Ariadne [26.7] in the National Gallery in London. In the Worship of Venus a swarm of putti, the pagan counterparts of the angels circling about the Assunta in the Frari Assumption, mill around the statue of the goddess of Love while a frenzied bacchante shaking a tambourine rushes in from the right. In the Bacchanale, a drinking bout is at its height and gives Titian the opportunity to display his ability in representing the texture of nude forms. The beautiful figure of the maiden in the lower right-hand corner who has succumbed to the effects of the wine takes her place as one of the finest among Titian's many representations of the female nude. A cartello in the center of the foreground bears an inscription in French: "he who drinks and doesn't drink again, doesn't know what drinking is."

The third, and perhaps the most beautiful of the series, is the Bacchus and Ariadne [26.7]. Here again we find Titian using his favorite asymmetrical composition of balanced form and space. The whole troupe at the right following the chariot of Bacchus is balanced by the single figure of Ariadne and the far-distant space toward which she directs the eye by her gesture. The figure of Bacchus leaping from the chariot is a tour de force of action and an object of breath-taking beauty as Titian has painted it, ivory colored against the pink rose-madder satin cloak that flutters behind it. A century later Rubens was to be much affected by these pictures. In fact a copy that he made of the Worship of Venus is to be seen in the Prado, the same museum in which the Titian picture now hangs.

Another masterpiece of this period is the half-figure of the Flora in the Uffizi, Florence, in which Titian ravishes the eye by his skill in contrasting the textures of the auburn hair, the velvet-skinned bosom, the thin woolen chemise, and the peach-colored brocade of the cloak of the model. Similar effects are achieved in the picture of the Lady with the Mirror and her

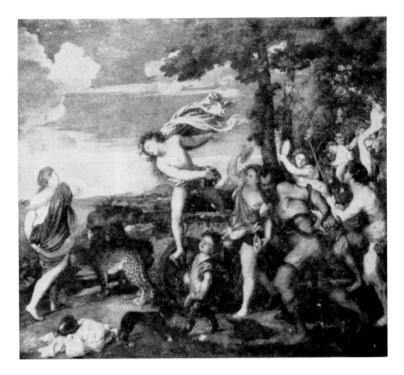

26.7. TITIAN: Bacchus and Ariadne (1523). Canvas, 67 13/16″ x 72⅞″. National Gallery, London (Anderson)

Lover, presumably Laura Diante and Alfonso d'Este. A variant of this picture showing the lady completely nude apparently was also painted by Titian. One version, presumably done in Titian's studio, is in the Goldman collection in the Metropolitan Museum of Art, New York. This pair of pictures would seem to have started the tradition extending to the present day of representing the model clothed in one picture and nude in the other. Goya's Maja, clothed and nude, are perhaps the most famous examples. Of course Titian himself had contrasted the nude and clothed forms in one and the same picture, his earlier Sacred and Profane Love [26.3]. The Venus Anadyomene in the Bridgewater House collection, London, showing the goddess, three-quarter length, rising from the sea and wringing out her hair, belongs to this 1516–1523 period.

To what heights Titian was to rise as a portrait painter is forecast in his portrait of the Ariosto in the National Gallery, London, with its Giorgionesque treatment of the head and the startling color effect of the quilted green satin sleeve of the sitter. Certainly one of Titian's greatest portraits is the Man with the Glove [26.8] done about 1519 and now in the Louvre. The seriousness and calm of the young sitter is rendered in the simple effective design of the triangular accent of head and hands and the repeat of the curves of the bang, the chin, and the ruffs at the neck and wrists. The color, too, is kept black, white, and gray to bring out the flesh-color of head and hand, and is relieved only by the momentary flash of the gold chain and the locket with its deep-blue sapphire cabochon.

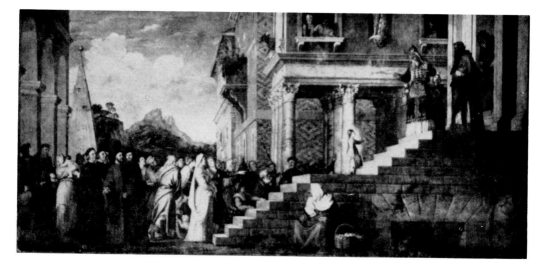

26.10. TITIAN: Presentation of the Virgin (1534–1538). Canvas, 136$\frac{1}{16}$" x 303$\frac{5}{8}$". Accademia, Venice (Alinari)

on the right and furnishes a counterrhythm toward the left in opposition to the major movement toward the right, thus preparing the spectator for the position of the high priest at the head of the stairs.

The Christ before Pilate, or "Ecce Homo," in the Kunsthistorisches Museum at Vienna, is a more bold and dynamic treatment of the same compositional problem. The center of subject interest, Christ and Pilate, is set far to the left at the top of the stairs. But the eye of the spectator is caught by the opening with the blue sky and is drawn toward the right. In front of this space opening Titian has placed the figure of a young girl in white, flanked at the right by a high priest in a brilliant red robe. The colors of these figures as well as the space opening in the composition continually draws the attention to the right, although the gestures of the figures moving from right to left on the stairs and the attitude of the soldiers below the figure of Christ are in their turn directing all attention to the main figures at the left. By these means Titian keeps the eye swinging across and back the picture in pendulum fashion and establishes a sense of balance in what is essentially an asymmetrical design.

While at Naples, Titian had also undertaken to paint a pagan subject for one of the Farnese. It was the picture of Danaë [26.11] relaxed against the pillows at the right and receiving Zeus in a shower of gold from heaven. Cupid exits to the right, feeling himself a supernumerary. It is one of Titian's most beautifully rendered nudes, and apparently became sufficiently famous for him to receive commissions to repeat the theme. One of these repetitions was once in the collection of the Estes at Ferrara. A variation in which an old maidservant replaces the Cupid was painted later for the Hapsburgs and is now in the Prado at Madrid. Another is in the Hermitage

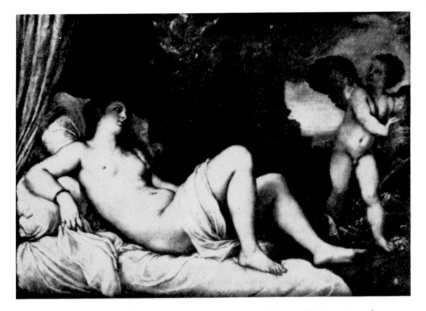

26.11. TITIAN: Danaë (*c.* 1545). Canvas, 47⁵⁄₁₆″ x 67¾″. Capodimonte Museum, Naples (Anderson)

at Leningrad. The Naples Danaë was one of the pictures taken from the deposit at Montecassino during World War II by the Hermann Goering Division and sent, together with other objects, to the Feldmarschall as a birthday present. It was later sent to the famous salt mines at Alt-Aussee in Austria for safekeeping and recovered there by American troops. It is now back in Naples in the Capodimonte Museum.

Titian's fame was such that not only the Italian dukes and princes vied for his services but foreign grandees as well, even imperial families. The expressive portraits of Francis I of France in the Louvre, and of the Elector of Saxony, at Vienna, were done at this time. The Hapsburgs apparently had sought Titian as early as the mid-1530's, but it was not until late in the 1540's and in the 1550's that the artist finally undertook to paint portraits of Charles V and his son Philip II. He portrayed Charles in armor on horseback, as at the Battle of Mühlberg (Prado), in hunting costume with his great dog (Prado), and seated and dressed in black velvet (Munich). He painted an official full-length portrait of Philip II that was to be sent to England to the Princess Mary, later Mary I, whose hand was sought for Philip. All these royal portraits became models for later portrait painters, such as Velásquez, other Spanish court painters, Rubens, and van Dyck.

During the last twenty to twenty-five years of his life, Titian's technique became even broader and looser, his color more tonal, and his use of light more dramatic than ever. A series of mythological scenes he painted for Philip II in the 1550's and early 1560's show the contrast between this

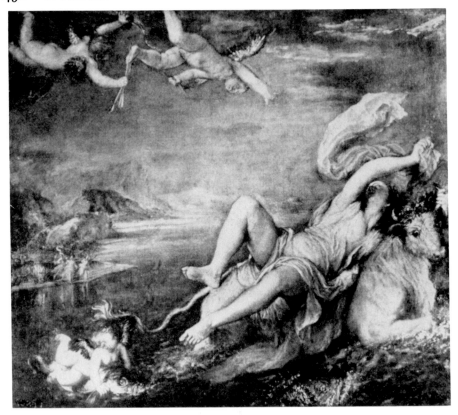

26.12. Titian: The Rape of Europa (c. 1559–1562). Canvas, 70″ x 80½″. Isabella Stewart Gardner Museum, Boston

later style and that in the 1520's and 1530's. The spectator is made so much more conscious of the brush stroke that conveys such vibrant vitality to the figures and to the composition. Among the mythological pictures painted for Philip are the Venus and Adonis in the Bache collection of the Metropolitan Museum, the Diana and Actaeon in the collection at Bridgewater House, London, and the magnificent Rape of Europa [26.12] in the Isabella Stewart Gardner Museum, Boston—remarkable performances for a man in his late seventies and early eighties. The popular Venus punishing Cupid, in the Borghese Gallery in Rome, belongs to this late period.

In his religious pictures at this time, Titian considerably heightened the dramatic content of the theme chosen by his use of bursts of light, made so effective by his particular technique that we shall discuss shortly. That is why his third version of the Entombment of Christ [26.13], in the Prado, while retaining the pathos of the earlier one in the Louvre [26.14] as well as the slow torsion in the composition, is stepped up dramatically by the

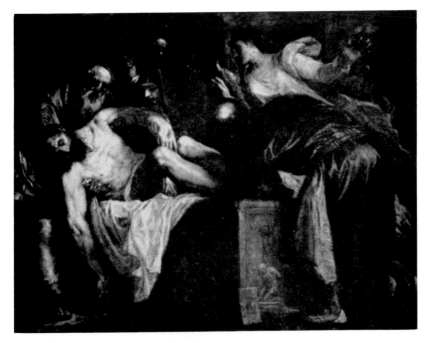

26.13. TITIAN: Entombment (1559). Canvas, 54″ x 69″. Prado, Madrid (Anderson)

26.14. TITIAN: Entombment (c. 1525). Canvas, 58⁵⁄₁₆″ x 84⁵⁄₈″. Louvre, Paris (Alinari)

26.15. TITIAN: Transfiguration (c. 1560). Canvas, 96⁹⁄₁₆″ x 116¼″. San Salvatore, Venice (Alinari)

knobs of glowing color throughout. The same is true of the Crowning of Thorns in Munich as against the earlier version in the Louvre. The flaming candelabrum in the upper right of the picture shed its sinister gleams on the staves, arms, and faces of Christ's tormentors and on His own pathetic acceptance of the torture and indignity He suffers. In the Gethsemane in the Prado, the light is even more concentrated to accentuate the bitterness of Christ's struggle with Himself. And in the Transfiguration, in the church of San Salvatore in Venice [26.15], a veritable sunburst surrounds the glorified body of Christ from whom the light emanates to blind the three who had followed Him to the mount.

The last picture Titian painted was a Pietà [26.16] that was to be placed over his tomb in the Frari in Venice. It is now in the Accademia. Unfinished at the time of his death, it was completed by Palma Giovane. But in it is all the dramatic vitality of Titian's last period. A greenish-golden glow pervades the whole with the contrasts in the black-green of the shadows and the gleaming gold of the mosaic apse. The effect of the Moses and of the Sibyl ° on their lion-faced pedestals flanking the pedimented niche to left and right and of the putto with flaming torch at the right give a theatrical and

° The Hellespontine Sibyl.

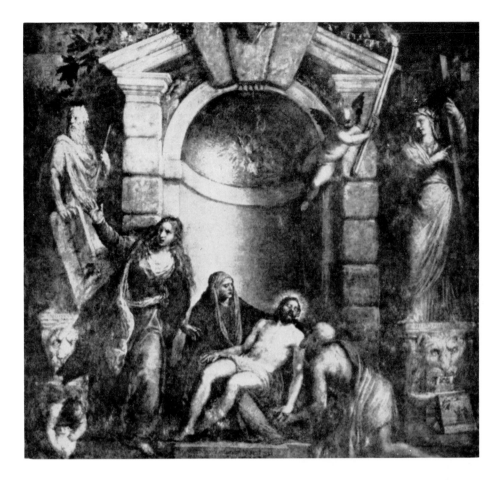

26.16 (*above*). TITIAN (with Palma Giovane): Pietà (1573–1576). Canvas, 138⅜″ x 153⁵⁄₁₆″. Accademia, Venice (Anderson)

26.17 (*right*). TITIAN: Self-portrait (*c.* 1565–1570). Canvas, 33⅞″ x 25⁹⁄₁₆″. Prado, Madrid (Anderson)

almost baroque setting to the main group of the Pietà. The Magdalen's emotional outburst links her with this setting but at the same time throws into contrast the stillness of the body of the dead Christ, the quiet grief of the mature Virgin, and the solicitous adoration of the kneeling old man who might be traditionally identified as Joseph of Arimathea but who actually is Titian himself.

The remarkable self-portrait [26.17] in the Prado, Madrid, executed when Titian was ninety years or more old, reflects the extraordinary vitality both physical and intellectual and the clear eye that he still possessed at that advanced age. Once more he achieves a masterly result with the simplest compositional accents. At the age of ninety-nine he was finally carried off by the pest that some sixty-six years earlier had put an end to the promising career of his friend Giorgione.

The Forerunner of Modern Painting

Throughout this long lifetime Titian produced, as one might imagine, a great number of pictures and had a workshop that turned out a great many more. Of much that has not survived we have knowledge either from accounts or from prints and copies. His influence on later painters throughout Europe was tremendous, and in his work we can find the seeds of many later technical developments in painting, for Titian, more than any other Italian painter prior to his time, gave his chief attention to problems that were basically painters' problems. The central Italian painters, for example, were so completely tied up with the ideas of the human form that they gave most of their attention to the three-dimensional establishment of that form. That is what gives their painting primarily a sculpturesque quality, as we saw in the climax of this type of painting in the work of Michelangelo. But Titian, as a Venetian, was more interested in color, its harmonies, and in the texture of things, whether hair, flesh, velvets, satins, the sky, and nature, and how to achieve these textures by his colors and his medium. That is why Michelangelo unjustly accused the Venetians of not being able to draw. They were interested in the lush qualities of the material world and were not held down by the Classical obsession for the beauty of the human form to the exclusion of other beauties.

Titian, for instance, finding the technical methods current at his time inadequate to achieve the subtle differences in the textures of materials, began to develop the use of impasto in such a way that he could control the amount and quality of light more easily and so procure the effect he was after. By the earlier method a monochrome underpainting in tempera would be glazed over with a transparent varnish in which color was suspended, resulting in an effect very much like that of a colored piece of mica held over a charcoal drawing. But the successive glazings needed to give depth to the color would diminish the contrasts between light and shade. With Titian's new method, an opaque white medium (the impasto) could be in-

serted between any of a series of transparent color glazes, making possible the building up of various gradations of shades and lights if necessary between the shadow and the highlight. And so by controlling the light Titian was able to create the differences in texture between velvet, satin, wool, or the human skin. The most subtle of these textures, of course, is that of the human body with many small muscles rippling beneath the skin. Heretofore that texture had never actually been achieved in paint. Most painted nude forms had looked like stone or marble. But Titian caught the vibrant live quality of the human form by painting its subtly dimpled surface—something that could be done only by his new impasto technique. He was also aware that the contrast of warm colors with cool ones give an effect of depth. So, if you examine a Titian body surface, you will notice it covered with patches of opaque white impasto glazed over with yellow and pink tones (which represent the highlights of the dimpled skin) set alongside transparent gray, blue, or greenish glazes placed over the shadows of the underpainting (representing the hollows of the dimples).

In his earlier period, Titian's use of impasto on drapery and the human form gave the surface of the paint a somewhat granular appearance, for example in the details of the Assumption [26.5] or the Pesaro Madonna [26.6]. As time went on his use of impasto became looser and more fluid in effect, giving an impressionistic effect, calling attention to the brush strokes (the Danaë [26.11] or the small Virgin in the Presentation [26.10]). In his late period Titian seems practically to have modeled with the impasto, putting it on thick, and to have painted solely with it. It is then that he achieved those extraordinary results of dramatic lighting. How boldly he modeled with the impasto can be seen in the details of the head of Christ in his last picture, the Pietà [26.16]. It seems almost as though it were done impressionistically in clay. Tintoretto, as we shall see, was to develop the fluid use of impasto to a high degree. It was this technique that was the forerunner of later and more modern "brushwork," and it was the medium of impasto that became the "ancestor" of our tube paints.

It was natural for the Venetian painters, with their interest in textures and the beauties of nature, to give special attention to color. But color in Italian painting was never used naturalistically, as for instance Vermeer or other color realists might use it. Ever since the medieval period with its stained glass, its enamels, and illuminated manuscripts, color was used in an abstract manner to give esthetic pleasure or to express emotion. This carried over into fifteenth-century painting in Italy, but Piero della Francesca was the only artist who really paid much attention to color as it is in nature, and even he generalized his observations into an almost set palette of black and white, warm and cool grays, and warm and cool intensities. Some painters began to experiment with color harmonies—that is, to use the triads of blue, red, yellow and orange, green, violet. Mantegna, in the Eremitani frescoes, now destroyed, emphasized the so-called "minor triad" of orange, green, violet. In one of the frescoes, the Beheading of St. James

[23.4], each of the three figures on the bridge in the middle distance was painted in one of these colors.

It was this problem of color harmony that the Venetians attacked, Titian in particular. Almost always he uses the major triad of blue, red, yellow but with these variations: the red is most usually his favorite pink or crimson lake; the yellow may be the hair or areas of ivory complexion or body color, and often an area of white replaces or accompanies these. For example, in the Tribute Money, in Dresden, the most prominent colors are the red, blue, and white color blocks set alongside each other. In the Feast of Venus in the Prado, three colored cloths of red, blue, and white are placed on the ground in the middle foreground, as if to make the spectator aware of the color scheme of the picture; then the whole picture is built up on these colors broken into small bits to heighten the effect of the activity of the putti and the bacchante. Here again the ivory body color of the small figures is really the third color. The green of the background in most Titians, being much reduced in intensity in comparison to the major colors, functions really as a neutral color against which the others are thrown. We see the same combination in the Sacred and Profane Love [26.3]. In the Assumption of the Virgin [26.5], in addition to the use of the major triad of blue, red, yellow, Titian employs a triangle of reds to help hold together the two levels in the huge canvas: the figure of the Virgin above, and the two figures to right and left in the lower level. The red of the figure to the right is very warm and a bit toward a vermilion when compared to the cooler, more bluish crimson-pink of the Virgin and of the figure below to the left. In the Presentation of the Virgin [26.10], Titian demonstrates the effectiveness of the use of complementary colors by painting the main figure —that of the tiny Virgin ascending the steps of the temple—in a brilliant light blue set against the orange-yellow of the aureole surrounding her. We have already pointed out how he used blue, white, and red in the "Ecce Homo" at Vienna to keep the eye moving to right and left in that picture. But in addition to the major triad, he has orange, green, and violet in this picture, as though he were experimenting with the problem of using the colors of both triads together and still achieving a harmony, as Matisse did in modern times. In this picture, too, the red of the high priest's robe is almost a strong Flemish red. The green and orange on the garments of the soldier to the left below Christ are mixed tones, the orange really being a beautiful peach color. The use of the minor triad by itself is rather rare with Titian, but in the portrait of La Bella in the Pitti at Florence the velvets of the lady's dress are green and violet, and her hair and the chain about her neck are auburn and gold. In his last period Titian often avoided the problems arising from the use of too many colors by painting tonally. That is, for example, a purplish tone pervades the Education of Cupid in the Borghese at Rome and the Venus at the Mirror in the National Gallery in Washington, and a greenish-gold tone the Pietà [26.16]. Within the tone the various triads still emerge, but the harmony is secured primarily by the tone.

Thus Titian anticipates the solution of color problems that were taken up in the seventeenth century by Rubens, who more self-consciously worked in color harmonies, or by Hals and Rembrandt, who in their later periods appreciated the value of tonal painting. A remarkable anticipation by Titian of nineteenth-century divisionism or impressionism is found in the picture of Mary Magdalen in Leningrad. To give more life to the highlight on the vase of ointment at the left Titian painted, in addition to the white, a series of broken colors.

BIBLIOGRAPHY

Phillips, C. *The Earlier Works of Titian.* New York, Macmillan Company, 1897.

––– *The Later Works of Titian.* New York, Macmillan Company, 1898.

Gronau, G. *Titian,* trans. by A. M. Todd. New York, Charles Scribner's Sons, 1904.

Ricketts, C. S. *Titian.* London, Methuen & Company, 1910.

Fischel, O. *The Work of Titian, in 284 illustrations.* Classics in Art series. New York, Brentano's, 1921.

Hadeln, D. *Titian's Drawings.* London, MacMillan, 1927.

Tietze, H. *Titian's Paintings and Drawings.* New York, Oxford University Press, 1950.

Tietze, H., and Tietze-Konrat, E. *The Drawings of the Venetian Painters in the 15th and 16th Centuries.* New York, J. J. Augustin, 1944.

Acqua, G. A. dell'. *Tiziano.* Milan, A. Martello, 1955. (Many plates in color and black and white; full bibliography)

⊸ 27
Tintoretto and
Veronese

ALTHOUGH they were born about a half-century after Titian, two other giants in painting, contemporaries of Titian's later years, made their appearance in Venetian art.

Tintoretto

Second in importance only to Titian as a painter of sixteenth-century Venice was Jacopo Robusti (1518–1594), better known as Tintoretto. His father was a "tintor" or dyer of woolen cloth, hence the diminutive form of the word applied to the son. According to tradition, Tintoretto's two heroes in the field of painting were Michelangelo and Titian. He is said to have placed a sign over his studio door which read "The drawing of Michelangelo and the color of Titian." That he was a fast worker is patent in his paintings and also in the appellation *"il furioso."* His dynamic brushwork must have been startling to his contemporaries and apparently was looked at askance, because at first he had difficulty in securing commissions.

Venice happened to have, however, a poor ecclesiastical community, Santa Maria dell' Orto, whose church was in serious need of repair and decoration. Tintoretto offered to furnish some of the latter. This comprised two huge paintings for the entrance into the sanctuary, the Children of Israel worshiping the Golden Calf [27.1] and the Last Judgment. In these paintings we sense at once the fiery temperament of the artist. All the dramatic elements inherent in the subjects are heightened by his swinging brushstrokes and by the lightning-and-thunderlike treatment of the lights and

27.1. TINTORETTO: Worship of the Golden Calf (c. 1561). Canvas, 50' high. Santa Maria dell' Orto, Venice (Anderson)

shades. Tintoretto took Titian's impasto and swirled it about his canvases almost in the manner of the modern technique of direct brushwork. In the Last Judgment in particular, we note his use of intersecting curves to give impetus to the movement and to the emotion. These intersecting curves were to appear over and over again in his later compositions.

In a third picture in Santa Maria dell' Orto, the Presentation of the Virgin in the Temple [27.2], Tintoretto displays his ability as an innovator in iconography. The more usual design for this subject, as we found it from Giotto through Titian, was to have the young Virgin climbing the steps to the temple in a movement that is parallel to the picture plane. Tintoretto has the movement go into the picture at an angle to the picture plane. (We shall see other instances of his revision of traditional interpretations of religious scenes.)

In 1547–1548 Tintoretto was commissioned by the School of St. Mark to paint a series of scenes from the life of Venice's patron saint. The first

27.2. TINTORETTO: Presentation of the Virgin (c. 1551–1556). Canvas, 168⅛"
x 189¼". Santa Maria dell' Orto, Venice (Alinari)

of these [27.3], in which St. Mark catapults from heaven to smash miracu-
lously the hammer in the hands of the executioner who was about to dis-
patch a Christian slave, was at first rejected by the members of the School.
Later they took it back (it is now in the Accademia) and ordered three
more canvases. One of these has for its subject the Rescue by St. Mark of a
Saracen from shipwreck (in the Accademia). Here again the use of the in-
tersecting curves suspends the saint in mid-air and emphasizes the move-
ment of the storm-tossed bark. In the second picture, the Finding of St.
Mark's Body [27.4], painted between 1562 and 1566, now in the Brera in
Milan, Tintoretto by means of the receding arches of the tunnel vault of
the church and the strong light at the far end creates a sense of vast diag-
onal space and emphasizes once more the excitement of the event in which
a corpse is revived by the presence of the body of the saint. No less excit-
ing is the scene of the transport of the body of St. Mark from the city of
Alexandria during a thunderstorm (in the Accademia).

In the Adam and Eve and in the Cain and Abel, now in the Accademia
in Venice, Tintoretto furnishes examples of his interest in Michelangelesque

27.3. TINTORETTO: Miracle of the Slave (1548). Canvas, 164″ x 215″. Accademia, Venice (Anderson)

27.4. TINTORETTO: Finding of St. Mark's Body (1562–1566). Canvas, 169½″ x 169½″. Brera, Milan (Alinari)

27.5. TINTORETTO: Cana Wedding (1561). Canvas, 192″ x 252″. Santa Maria della Salute, Venice (Alinari)

nudes in contraposto. The movement and the color, however, are more in accord with the Venetian tradition and Tintoretto's own development than with Michelangelo's.

An extraordinary accomplishment, foreshadowing his later Last Supper in San Giorgio Maggiore, is the Cana Wedding [27.5] in Santa Maria della Salute. Once again we have the tunnellike perspective noted in the Finding of St. Mark's Body. But here the entire area from foreground to background is filled with figures and the focal center of the episode, Christ, is set in the middle distance at the end of a long table. Much still-life material is at hand in the amphorae, the tableware, and the chandeliers.

In 1560 a competition was held for the decoration of the School of San Rocco in which a number of artists took part. Tintoretto forestalled the others by secretly mounting his contribution in the ceiling of the refectory and then at the appointed time having it unveiled in place—much to the surprise and discomfiture of the other artists. Having thus won the competition, he was busy with the project for the next twenty years. The areas to be decorated were the spaces between the windows in the ground-floor chapel (1583–1587), the stairway, and the ceilings and the wallspaces of the refectory (1564–1566) and of the ballroom or grand hall (1576–1581) on the second floor.

The ground-floor paintings consist of events in the early life of Christ: the Annunciation [27.6], the Adoration of the Magi, the Flight into Egypt, and the Massacre of the Innocents. In addition there are two paintings opposite each other and flanking the altar: St. Mary Magdalen [27.7] and St. Mary of Egypt, each in the wilderness. Both paintings are quite remarkable, with the palms of the wilderness appearing to be painted with phosphorescent paint. The Annunciation scene is most dramatically represented and in an unorthodox manner: the Angel Gabriel flies into the Virgin's presence over a ruined wall, with startling effect. The Flight into Egypt is much more idyllic and gives the effect almost of a tapestry.

For the stairway, Tintoretto painted the Visitation that is now on the platform in the great hall on the second floor.

The refectory, at the left end of the second floor, was the earliest area to be decorated in the School. Over the entire width of the end wall Tintoretto painted the Crucifixion, an almost overpowering composition. A very athletic Christ on the central cross dominates the scene [27.8]. There are many fine details in the composition—the lad tugging at the rope that steadies Christ's cross, the group of the Virgin and John at the foot of the cross, the horsemen charging off at the left. The scene not only creates the atmosphere of the confusion that must have been present in the historical event but also brings out the significance of the Crucifixion as a religious experience.

On the opposite wall, to right and left of the doorway leading into the great hall, are Christ before Pilate and the Carrying of the Cross [27.9]. In the former Tintoretto sets off the incandescent Christ by placing Him somewhat back toward the middle distance; in the latter he emphasizes the cross by repeats not only in the shape of the other crosses but also in the diagonal lines of the road leading to Calvary, reminiscent of Piero della Francesca's Hiding of the Wood [11.6] in San Francesco at Arezzo. The strain of lugging the cross up the hill and the resulting weariness is powerfully rendered.

In the great hall both ceiling and side walls are decorated with many scenes from the Old and New Testaments. It would be of no avail here to describe them all, but we must mention the remarkable scene of Moses striking the Rock in which the water spurts like phosphorescent fire to quench the thirst of the Israelites in the desert. And certainly the scene of Christ's prayer in Gethsemane [27.10] is one of Tintoretto's masterpieces: the agony of Christ as he leans toward the angel offering the bitter cup, the group of drowsy apostles, and the ghostly procession approaching in the distance with staves and torches to arrest the Christ. From this, El Greco took his inspiration for the various versions of that scene he painted. After a visit to these paintings no one can leave the School of San Rocco without the impression of having lived through an unforgettable emotional experience.

In the years of 1577–1578 we find Tintoretto busy with decorations for the Doge's Palace in Venice. It was here that he painted those delightful

TINTORETTO: School of San Rocco, Venice

27.6 (*above*). Annunciation (1583–1587). Canvas, 166⅜″ x 214⅞″. Ground floor (Alinari)

27.7 (*left*). St. Mary Magdalen (1583–1587). Canvas, 167⅝″ x 82″. Ground floor (Anderson)

27.8 (*below*). Detail of Crucifixion (1565). Entire canvas, 211⅚₆″ x 482¾″. Refectory (Anderson)

27.14. TINTORETTO: Last Supper (1594). Canvas, 143⅞″ x 224″. San Giorgio Maggiore, Venice (Anderson)

the figure on the left, the gray-blue of St. Mark, and the mustard-yellow on the other figures in the foreground make a startling contrast with the silver-gray of the background.*

The Last Supper [27.14] in San Giorgio Maggiore in Venice is the high moment in Tintoretto's use of dramatic lighting. The scene is set as though it were taking place in a murky cavern. Light flashes from the lamp suspended from the ceiling at the left. But this is almost dimmed by the strong light emanating from the head and being of Christ as He stands at the upper end of the table, set at an angle to the picture plane, and distributes the bread and wine to His disciples. The head of each disciple is surrounded by a lesser gleam of light in place of the conventional halo. The ghostly outlines of attending angels appear in the air to the right of Christ. Servants are busy in the foreground preparing the details of the supper, and dishes, glasses, and utensils gleam on the table. Tintoretto has chosen to represent the moment in the Last Supper when Christ instituted the sacrament of the partaking of bread and wine—that is, when He was saying "This is My Body," "This is My Blood," "Do this in remembrance of Me." It is not the moment usually shown in earlier Italian paintings of the Last Supper of which that by Leonardo da Vinci [19.10] is the most famous, the moment when Christ announces (or has announced) that one of the twelve

* Tintoretto may have been assisted in this picture by his son Domenico.

27.12 (*above*). TINTORETTO: Crucifixion (*c.* 1568). Canvas, 96″ x 81″. San Cassiano, Venice (Fiorentini)

27.13 (*below*). TINTORETTO: Martyrdom of St. Catherine (*c.* 1584). Canvas, 63″ x 89⅛″. Accademia, Venice (Fiorentini)

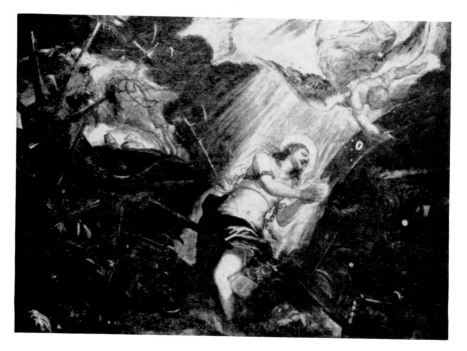

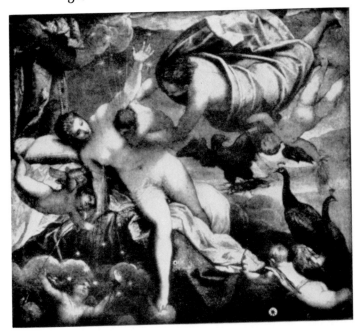

27.11. TINTORETTO: Origin of the Milky Way (1477–1478). Canvas, 58″ x 65½″. National Gallery, London (Anderson)

allegories and subjects from ancient mythology, such as the Triumph of Venice, Bacchus and Ariadne, and the Origin of the Milky Way [27.11], the last of which is now in the National Gallery in London.

Never tiring of innovation, Tintoretto painted a number of remarkable canvases in his later years. The St. George and the Dragon, now in the National Gallery, London, is one example. Here he reverses the usual arrangement of this theme and relegates St. George to the background, while the startled princess, attired in a gleaming ensemble of deep pink and steel-blue satin, rushes into the foreground of the picture. Another variant from the usual is the Crucifixion [27.12] in San Cassiano, Venice. In this picture the three crosses are set in a diagonal perspective on the right side. Two figures climb a ladder leaning against Christ's cross to nail to the top the placard with the I.N.R.I. At the bottom of the picture Mary and John are huddled at the foot of the cross, while across the middle distance and parallel to the picture plane is a row of lances held by a group of half-hidden soldiers. This is a picture Velásquez must have seen on his visit to Italy, and it must have given him the idea of using the lances in his Surrender of Breda.

Two very exciting late pieces are the Martyrdom of St. Catherine [27.13] and the Dream of St. Mark, both in the Accademia in Venice. The former is composed of a series of broken angles and shafts of light, giving the whole an extremely dramatic effect. The Dream of St. Mark is another breath-taker. The light behind the Saviour in the sky bursts like a skyrocket above the bark in which St. Mark lies dreaming, and flashes fitfully over the figures of the saint and his companions in the boat. The deep red of the robe of

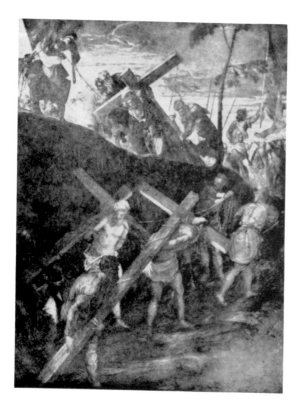

27.9 (*left*). Carrying of the Cross (1564–1566). Canvas, 205⅞" x 169½". Refectory (Alinari)

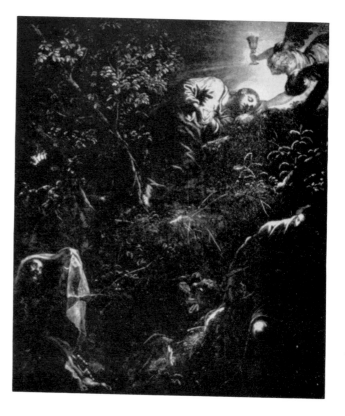

27.10 (*right*). Gethsemane (1576–1581). Canvas, 210⅛" x 181⅜". Great Hall (Fiorentini)

27.15. TINTORETTO: Portrait of Jacopo Sansovino (1566). Canvas, 25⅝″ x 29⁹⁄₁₆″. Uffizi, Florence (Alinari)

will betray Him. This stressing of the sacramental element in the Last Supper became common in the Baroque period and is a throwback to the Byzantine use of the theme. The Counterreformation probably also had something to do with the stressing of the sacramental phase of the Supper, particularly as the Protestants were denying the literal interpretation of Christ's words.

Tintoretto's last great decorative undertaking was the painting of the Coronation of the Virgin for the audience chamber of the Doge's Palace. It occupies the entire width of the wall at the end of the chamber. Christ and the Virgin are placed in the center of a host of saints and angels. Each wears a phosphorescent halo, so that the effect of the whole with the curvilinear groupings of the figures about the central pair is that of a throbbing mass of glowworms.

In his portraits, too, Tintoretto uses knobs of light to emphasize the structure of the heads as well as to accent the design. This is to be seen in the portrait of his friend the architect Jacopo Sansovino [27.15], in the Uffizi, and in his self-portrait, now in the Louvre. This technique also appears in a number of his drawings that are quite unorthodox according to more traditional usage. In these, instead of lines, Tintoretto uses blobs of light and dark wash or impasto to indicate only the essentials of form and of the distribution of light and shade. Small wonder that Titian is said to have expelled Tintoretto as a pupil from his studio because he was unable to draw.

Together with Titian, then, Tintoretto takes his place at the top of the list of sixteenth-century Venetian painters. In evaluating the two, we can say

that Tintoretto captures the imagination with his dynamic compositions and his dramatic effects of spotlighting and movement. He is breath-taking. Titian reflects and records the various facets of human experience, the healthy voluptuousness and joy in the material beauties of this existence as well as the deeply felt values of religious experience. The interpretation of character in Titian's portraits is also an outstanding performance.

Paolo Veronese

The third Venetian giant of the sixteenth century is the man, born in the city of Verona and baptized Paolo Cagliari, who most generally is known as Paolo Veronese (1528–1588). Coming to Venice at the age of twenty-seven, he quickly became an active member of the painting community.

Veronese was fascinated by the luxurious life and the pageantry of Venice, and although he painted religious and mythological subject matter, he preferred to set these in contemporary villas and palaces. Consequently Veronese chose New Testament episodes in which a feast is taking place, such as the Feast in the House of Simon [27.18] or of Levi or the Cana Wedding [27.16]. Many of these are huge canvases, painted for the refectory of some wealthy monastery. Christ in the House of Levi, which now hangs in the Accademia in Venice, is a prime example of Veronese's love of display and splendor. A long table stretches across the open loggia of a magnificent Renaissance palazzo with a view of other buildings similar to a view we might have on the Grand Canal in Venice. The tablecloth is a fine damask; the dishes and utensils are costly. Major domos, servants, dwarfs, and dogs make up the ménage to serve and give pleasure to the guests at the table, of whom Christ is the central one. The Cana Wedding [27.16], now in the Louvre, is an even more elaborate feast. Again the open loggia, the table laden with food and expensive dishes, and servants everywhere to attend to the wants and wishes of the guests. Christ, although centrally placed, is practically lost in the crowd present at the banquet. Of greater interest is the trio of musicians placed in front of Christ's table—Titian, Tintoretto, and Veronese himself furnish the music!

Even when the New Testament episode calls for a simple setting, such as the Supper at Emmaus [27.17], Veronese has it take place, in his picture in the Louvre, in a Venetian patrician's home with all the well-fed and well-dressed members of the family standing about so that Christ and the two ragged travelers are almost hidden from view. Never has the lavishness of Venice and its luxury-loving population been on such parade as in Veronese's pictures. Whether the scene is that of the Finding of Moses or the Rape of Europa, the female participants in the scene are clad in rich brocades and bedecked with pearls and other precious jewels.

Veronese had a wonderful sense of color and decoration that lent elegance to what otherwise might have seemed vulgar display. Pinks, light greens, orchid shades, lemon-yellows and light blues, all of them half shades

27.16 (*above*). PAOLO VERONESE: Cana Wedding (1562–1563). Canvas, 262⁹⁄₁₆″ x 390⅜″. Louvre, Paris (Alinari)

27.17 (*below*). PAOLO VERONESE: Supper at Emmaus (1560). Canvas, 114⁵⁄₁₆″ x 177⅝″. Louvre, Paris (Alinari)

27.18 (*above*). PAOLO VERONESE: Feast in the House of Simon (1573). Canvas, 179″ x 384⅛″. Louvre, Paris (Alinari)

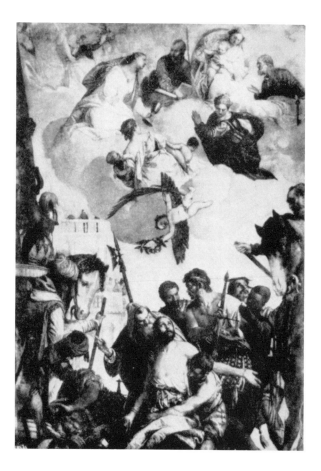

27.19. PAOLO VERO-NESE: Martyrdom of St. George (*c.* 1565). Canvas, ceiling. San Giorgio in Braida, Verona (Brogi)

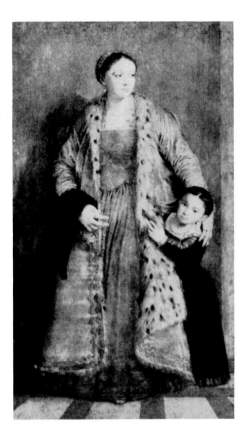

27.20. PAOLO VERONESE: Portrait of Lucia Thiene and daughter Porzia (*c*. 1556). Canvas, 81″ x 47½″. The Walters Art Gallery, Baltimore (Courtesy of The Walters Art Gallery, Baltimore)

of the more usual solid colors, make his canvases scintillate. In his later period too he anticipated what Giovanni Battista Tiepolo and the rococo artists were to emphasize—that is, he used the irregular shapes and silhouettes of light, shade, and color to create an all-over pattern in the picture. This is already apparent in the Feast in the House of Simon [27.18], in the Louvre, where the shapes of the light and darks of the curtains, of the putto's wings, of the columns and of the groups at the tables create a consciously decorative pattern. This is even more perceptible in the Marriage of St. Catherine in the church of that saint in Venice and reaches its fullest expression in the Martyrdom of St. George [27.19] in San Giorgio in Braida, Verona.

With all his fine taste Veronese produced some very elegant portraits, such as that of Pasio Guarienti in his red and gold striped armor. This is in the Gallery at Verona. The portrait of Daniele Barbaro, in the Pitti Gallery in Florence, wearing a fur-trimmed coat is another example, as is the appealing full-length portrait in the Walters Art Gallery in Baltimore of Lucia Thiene and her small daughter Porzia [27.20], the latter peeking out shyly from behind the folds of her mother's dress.

For his mythological subject matter, Veronese chose primarily episodes in which the ancient goddesses were involved, Venus in particular, which gave him the opportunity of displaying the soft white bodies of Venetian

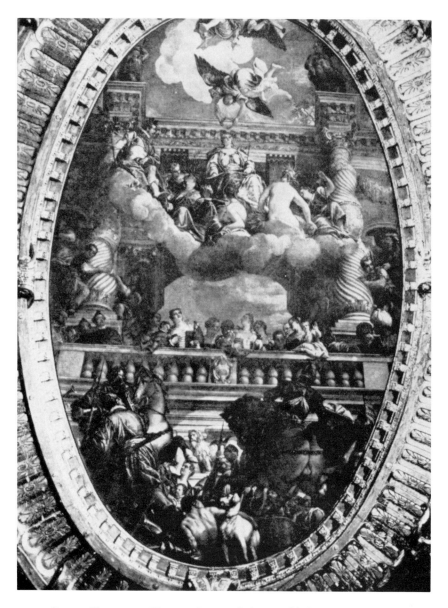

27.21. PAOLO VERONESE: Venice, Queen of the World (*c.* 1585). Canvas, ceiling oval. Doges' Palace, Venice (Alinari)

beauties—for example, the Venus and Mars in the Metropolitan Museum in New York.

It was only natural that he would be employed by the State of Venice to paint some of the ceiling decorations in the Doge's Palace. The Venice as Queen of the World [27.21] with its rolling clouds and its huge twisted columns extending into the sky is almost a Baroque conception, but its pyramidal composition is still well contained within the frame of the picture.

Appendix: Other Contemporary Venetian Painters

There were, of course, many other Venetian painters of note in the sixteenth century whose works would have to be considered in a more extensive history of painting in Venice.* These are painters whose creations reflect the influences of various of the great masters previously mentioned—that is, of the Vivarini, the Bellini, Giorgione, and Titian. Their names are familiar, and their works are to be found in many of the important galleries and private collections of Europe and America. We mention briefly a few of these artists.

Cima da Conegliano (1459–1517) was a follower of Alvise Vivarini. His style at times was very close to that of Antonello da Messina and that of Giovanni Bellini. This is very evident when you compare his painting of St. Jerome in the Desert in the National Gallery in Washington with that of the same subject by Giovanni Bellini in the same gallery.

Palma Vecchio (1480–1528) was another well-known and popular painter of sixteenth-century Venice. His style is related to that of Giovanni Bellini's later works. His female figures, however, are inclined to be more plump and have taffy-colored, blond hair of a cottony texture. Titian, at the time he was painting the Three Ages of Man and the Sacred and Profane Love, seems to have absorbed some of Palma's stylistic features. The heroic figure of St. Helena, the central feature of a handsome altarpiece in Santa Maria Formosa in Venice is one of Palma's best known works. One of his favorite subjects was the Sacred Conversation, an intimate group of the Madonna and Child with saints.

Lorenzo Lotto (1480–1556) was a pupil of Alvise Vivarini and a follower for a time of Giovanni Bellini. He was influenced by Giorgione and Titian, and even drew some inspiration from the works of Raphael. Exciting as a painter, his emotional tensions are often evident in restless or explosive compositions or in colors that at times are quite startling. He was also an excellent portraitist.

Finally we mention Sebastiano del Piombo (c. 1485–1547), a remarkable and powerful painter. Born in Venice and trained in the traditions of Giovanni Bellini, Cima da Conegliano, and Giorgione, he left his native city while still in his twenties to go to Rome. There he fell under the thrall of Michelangelo and stayed in the papal city until his death. His works all bear the mark of a sober and serious disposition. The Pietà in the Viterbo Museum is a magnificent work full of tragic emotion. The athletic figure of Christ is stretched rigidly horizontal at the feet of His equally athletic mother squatting in anguish on the ground. The brooding, misty background through which the darkened sun peers like a sinister eye heightens the tragic effect of the painting.

* For these, see Berenson, *Italian Pictures of the Renaissance. Venetian School,* cited in bibliography on page 470.

BIBLIOGRAPHY

Holborn, J. B. Stoughton. *Jacopo Robusti, called Tintoretto*. London, G. Bell & Sons, 1903.

Bell, N. R. E. *Paolo Veronese*. London, George Newnes, 1905.

Phillipps, E. M. *Tintoretto*. London, Methuen & Company, 1911.

Osmaston, F. P. B. *The Art and Genius of Tintoretto*, 2 vols. London, G. Bell & Sons, 1915.

Fiocco, G. *Paolo Veronese, 1528–1588*. Bologna, Casa Editrice Apollo, 1928. (Italian text, but many plates, and authoritative)

Orliac, A. *Véronèse*. Paris, Hyperion, 1939. (Color plates)

Newton, E. *Tintoretto*. London, Longmans Green, 1948.

Delogu, G. *Veronese; the Supper in the House of Levi*. Milan, Pizzi, 1948.

La Mostra del Tintoretto, 1937, and *La Mostra di Paolo Veronese*, 1939. These catalogues of exhibitions held in Venice are important for illustration, bibliography, biography, and so forth.

☙ 28

The Painters of

Ferrara

BEYOND the Appenines the court of the age-old Este family at Ferrara was one of the most important centers of culture in Italy throughout the fifteenth and sixteenth centuries. At times during this period, the cities of Modena, Reggio, and Parma were also under the control of the Estes. Since the dukes and duchesses of Ferrara * were avid patrons of the arts, it is small wonder that the city of their residence became a center where the arts flourished.

The earliest paintings of any note in Ferrara seem to have been done by foreign artists, but at the end of the fourteenth and at the beginning of the fifteenth centuries artists native to Ferrara made their appearance. Their Madonnas in calligraphic drapery, seated on cushions in the midst of flowery meadows recall the International Style of Gentile da Fabriano. Indeed two other Internationalists, Pisanello and Jacopo Bellini, left evidences of their work at Ferrara: Pisanello, the St. Jerome now in the National Gallery in

* Nicholas III (1384–1441) was the first of the distinguished fifteenth-century Estes. He was succeeded, each in his turn, by the three brothers: Lionello (1404–1450), Borso (1413–1471), and Ercole I (1431–1505). Three of Ercole's children were distinguished personalities: Alfonso I (1486–1534) was married to Lucrezia Borgia and succeeded his father; Isabella, Alfonso's sister, married Francesco Gonzaga, Duke of Mantua, and became a famous patroness of art; Beatrice, another sister became the wife of Ludovico Sforza, Duke of Milan, and was also renowned for her interest in and patronage of the arts. Ercole II (1508–1559) succeeded his father Alfonso I. His brother Ippolito, the cardinal, was responsible for the building of the famous Villa d'Este, at Tivoli, with its garden filled with fountains. (See D. R. Coffin, *The Villa d'Este at Tivoli*. Princeton University Press, 1960.) The direct line came to an end with Ercole II's son Alfonso II (1533–1597), who was a patron of the poet Tasso.

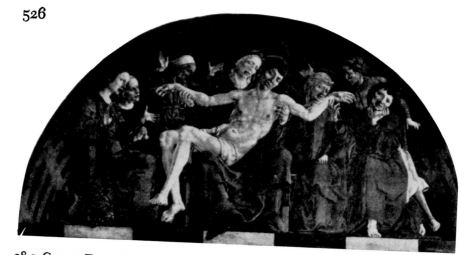

28.3. COSIMO TURA: Pietà, from Roverella Altarpiece (*c.* 1473–1474). Panel painting, 52″ x 105″. Louvre, Paris (Alinari)

Colonna in Rome. The lunette [28.3] formerly at the top of the altarpiece above the Madonna is in the Louvre. Of the three roundels that remain of the original seven in the predella, the Adoration of the Magi is in the Fogg Museum at Cambridge, Massachusetts, the Circumcision is in the Gardner Museum in Boston, and the Flight into Egypt is in the Metropolitan Museum in New York as part of the Bache bequest.

In the central panel of the Madonna the stylistic elements that we observed in the Primavera are again in evidence: the shell at the top of the Madonna's throne garlanded with crystals and jewels, the large heads of the figures and the U-shaped loops in the metallic drapery. Present also in other works by Tura and the Ferrarese painters of this period is the airiness of the space behind the Madonna's throne. The lunette with the Pietà [28.3] in the Louvre is worth special attention because of the beauty of its rich colors of green, purple, and dark blue and the rhythm of the hands accenting the emotional content of the picture.

The Schifanoia Palace Frescoes—Francesco del Cossa

In 1466, presumably, Borso d'Este undertook additions to the Schifanoia Palace in Ferrara, which were completed in 1470. One of the large new halls was called the Hall of the Months because of its painted decorations. A series of painted pilasters divided the walls into vertical panels in each of which was represented, in the top band, an ancient deity drawn in triumph in a cart or chariot. In the central band was the sign of the zodiac associated with the respective month, and each sign was flanked by figures representing the "decades" of each month. In the lowest band the equivalent of the Labors of the Months as they appeared in medieval manuscripts and

portal sculptures were represented but brought more up to date for the fifteenth century. In these scenes of the Labors, Borso d'Este appeared repeatedly as hunting or dispensing justice while accompanied by his favorites at court. These twelve panels were distributed around the walls of the hall as follows: two on the south wall (January, February), three on the east wall (March, April, May), four on the north wall (June, July, August, September), and three on the west wall (October, November, December). At the end of the sixteenth century the palace passed out of the hands of the Este family, was owned in succession by three other families, and ended up as a tobacco factory and granary, during which time the walls of the Hall of the Months were covered with whitewash. When in time all the whitewash was removed, only the frescoes on the north and east walls were in a condition to be salvaged. Between 1950 and 1954 the cleaning and restoration of these frescoes was sponsored by various local bodies in Ferrara and carried out by Professor Arturo Raffaldini.

That Cosimo Tura had had some hand in these fresco decorations in the fifteenth century was more or less assumed by various nineteenth-century writers, but the general present-day consensus holds that what still remains on the walls is the work primarily of Francesco del Cossa, Ercole de' Roberti, and some anonymous artist. Indeed, there has been unearthed a letter written by Cossa (*c.* 1435–*c.* 1477) to Borso d'Este reading in part:

> And I humbly beg to remind Your Lordship that I am Francesco del Cossa, the one who has painted all by himself the three panels by the entrance [east wall], so that if Your Lordship should not want to give me more than ten bolognini del pede, although I were to lose forty or fifty ducats and although I live only by the work of my hands, I would be content and at peace; but as there are other circumstances attached I feel sorry and sad in my heart, especially when I consider that I, who have begun to win a name for myself, am treated on a par with the worst dauber in Ferrara, and that my having studied all the time, and my continuing to do so, may not receive, this time, some consideration, especially from Your Lordship, outside what is reserved to those who do not practice such studies.

As others have pointed out, Cossa is telling only part of the truth in claiming to have painted the three panels on the east wall with his own hand. The panels of March and April display the same hand, which is Cossa's, but the May panel is certainly by a weaker assistant so far as the style goes. Cossa's style, as one can see from the group of ladies around the loom in the upper row of the March panel [28.4] owes a good deal to Piero della Francesca. A comparison with the Queen of Sheba group in San Francesco at Arezzo is striking. Cossa's head types are very characteristic with the rather sharply receding domed foreheads, the projecting, almost horsey noses, the heavy-lidded eyes, and the short chins. The female figure at the left in the central band of the April panel [28.5] repeats this style so well. His heads are considerably smaller in proportion to the bodies than those of Tura. His use of drapery, too, varies from that of Tura in that it breaks into more

The Schifanoia Palace fresco panels, Ferrara (1469–1470)

FRANCESCO DEL COSSA: 28.4 (*above, left*), March panel, upper zone right (Anderson). 28.5 (*above, right*), April panel, upper zone right (Anderson)

ERCOLE DE' ROBERTI: 28.6 (*right*), Cyclops at the Forge of Vulcan, September panel (Anderson)

voluminous and metallic folds where it touches the body closely and omits the typical U-shaped forms so frequent in Tura.

Other excellent examples of Cossa's drapery style are to be found in the SS. Petronius and John the Baptist flanking the Madonna in the altarpiece made for the Palazzo della Mercanzia in Bologna, now in the picture gallery of that city. To these we should also add the imposing figures of St. Peter and St. John the Baptist, both now in the Brera in Milan but formerly parts of another altarpiece, made for San Petronio in Bologna. The vermilion robe of the Baptist is unusually effective as is also the simple festoon of crystals and corals behind the saint so frequently found in the works of the pupils of the Paduan Squarcione.

Ercole de' Roberti

An anonymous artist, presumably a follower of Cossa carried out the June panel and portions of the July and August panels. But in the central band of the July panel with the zodiac sign, in the lower two thirds of the August panel, and throughout the entire September panel [28.6] the hand of Ercole de' Roberti (c. 1450–1496) is perceptible. This artist is perhaps the most accomplished of his time among the painters of Ferrara. We note the great vitality of his figures in these Schifanoia frescoes, for example, the Cyclops working at the forge of Vulcan [28.6] and the lightninglike crispness of his drapery folds, which distinguishes Ercole from the other artists at work here. These characteristics are also discernible in the panels depicting miracles of St. Vincent Ferrer in the Vatican Gallery.

Two of his monumental Madonnas, one in the former Kaiser Friedrich Museum in Berlin [28.7] the other in the Brera in Milan, are further evidences of Roberti's accomplished talents. Unusual is the form of the elevated throne on which the Madonnas are seated. They are raised from the ground as it were on giant jacks allowing the far-distant landscape to be glimpsed in the spaces between the "jacks." Scenes from the Old and New Testament appear in simulated relief on the paneled surfaces at the bottom of both thrones and on the back behind the Madonna on the one in the Brera. The decorative details are multiplied in the Berlin Madonna by the addition of putti and putto heads about the top of the throne and by the sculpturesque figures of David and Solomon set under the lunettes behind the throne. The eagle and the lion as symbols of St. John the Evangelist and St. Mark are rendered with extraordinary vitality. David with Goliath's head and Samson with the jaw bone of an ass appear in the spandrils of the arch in the foreground of the Brera Madonna.

The painting in the Cook collection at Richmond, England, that has been called both the wife of Hasdrubel and Medea and her children illustrates well the elegance of Roberti's work and also the effect on it of Donatello's sculpture and Mantegna's painting. In the striding pose of the woman, the turn of her head, and the pose of the child at the right whom she grasps

28.7. ERCOLE DE' ROBERTI: Madonna enthroned (1476–1478). Panel painting, 122" x 92". Former Kaiser Friedrich Museum, Berlin (Hanfstaengl)

by the hand, the painter repeats a group that he included in the scene of Christ carrying the Cross (or Road to Calvary) [28.8], now in the Dresden gallery.

The influence of Flemish paintings, in addition to the influences coming from Padua, is apparent in fifteenth-century Ferrarese painting not only in the presence of the distant landscape or in the detailed rendering of crystals, jewels, and metalwork but also in the iconography of such a paint-

28.8. ERCOLE DE' ROBERTI: Christ carrying Cross (c. 1485). Panel painting, 35″ x 117″. Gemaeldegalerie, Dresden (Alinari)

ing as Christ carrying the Cross [28.8]. Here, in the left half of the picture, we see two naked thieves with hands bound behind their backs trudging on at the head of the procession, the brutal guards manhandling Christ, and the aged dignitaries on horseback behind Christ quite as we see these elements in representations of this scene in the north by artists from the Van Eycks to Henri met de Bles.

Lorenzo Costa and Aspertini

Lorenzo Costa (1460–1535) is the first to be considered of another group of Ferrarese painters whose activities span the period from the end of the fifteenth century to the middle of the sixteenth. Among these we can also number briefly Mazzolino, Ortolano, Niccolò Pisano, and Dosso Dossi (p. 534). In general, the style of these artists moves away from the thrall of the Donatello-Squarcione-Mantegna tradition and reflects relationships established with the Bolognese, Peruginesque, and Venetian schools of painting. Costa illustrates the transition from the one direction to the other. In the Crucifixion in the Altenberg Museum the crisp detailed style of Mantegna or early Giovanni Bellini is still patent. But his close association with the Bolognese painter Francia softened his style considerably and turned it in the direction of the Peruginesque styles. The Ghedini altarpiece [28.9] in the church of San Giovanni in Monte, Bologna, is a curious mixture of Ferrara and Perugia in style. The lofty, elevated throne through the bottom of which one glimpses a distant landscape and the historiated capital of the pilasters of the loggia recall what we saw in the monumental Madonnas of Ercole Roberti. The softly rendered heads with gentle expression and the receding cross vaults of the loggia behind the throne of the Madonna recall similar renderings in the works of Perugino.

Another Ferrarese contemporary named Aspertini fell even more deeply for a time under the spell of Perugino, for example, in his St. Sebastian in

28.9. Lorenzo Costa: Ghedini altarpiece (1497). Panel painting. San Giovanni in Monte, Bologna (Anderson)

a private collection in Milan. It was a wave that then passed on to make way for the oncoming tide of Venetian influence.

The Venetian Influence—Dosso Dossi

It was during the reign (1505–1534) of Alfonso I d'Este that this Venetian influence became very manifest. Titian had been commissioned in 1523 to paint the bacchanalian pictures for Alfonso. Certainly the effect of his Worship of Venus with the putti milling about the statue of the Goddess, and also of the figures in the Bacchanale, is apparent in the mass of struggling figures of women, babies and soldiers in the Massacre of the Innocents [28.10] by Ludovico Mazzolino (c. 1478–1528), now in the Doria Gallery in Rome. In its landscape the Flight into Egypt (in the upper right

28.10. Ludovico Mazzolino: Massacre of the Innocents (*c.* 1520). Panel painting, 53¾₁₆″ x 44⅛″. Doria Gallery, Rome (Anderson)

28.11. Dosso Dossi: Circe (*c.* 1512–1520). Canvas, 69⅜″ x 68⅝″. Borghese Gallery, Rome (Anderson)

section of the Massacre picture) betrays its debt to the pastoral landscape backgrounds of Giorgione and Titian.

The artist who most consistently shows in his style the influence of Venice is Dosso Dossi (c. 1479–1542). At one time he seems touched by Giorgione, as in the Glasgow Madonna and Saints; at another, by late Bellini or Titian, as in the Bacchanalia in the Castel Sant' Angelo in Rome, very reminiscent of the Bellini-Titian Feast of the Gods [24.20] in the National Gallery in Washington. Then again in the famous Circe [28.11] in the Borghese Gallery in Rome, Dosso Dossi uses the wooly trees of Palma Vecchio and the phosphorescent technique of Tintoretto. The same is true in the fine Departure of the Argonauts in the National Gallery in Washington. This style is also found in some of the paintings by his brother Battista and by the extraordinary painter from Modena known as Niccolò dell' Abbate.

The two painters mentioned on page 531 as belonging to the later Ferrarese group—Ortolano (1488–1525) and Niccolò Pisano (active 1484–1530) —used the more monumental and clearly articulated forms that are to be found in late Raphael and his school, but the landscape backgrounds ° are lighted much in the manner of the later style of Giovanni Bellini. The head types, too, bear mixed resemblances to both Bellini and the sixteenth-century Florentines.

This sketch must suffice to acquaint the reader with the major artists and their stylistic tendencies in and around Ferrara during the reign of the house of Este that produced so many patrons of the humanities and the fine arts. These painters have too long escaped the attention of the general art public, but their works are most rewarding for their color as well as for their content and for the experience of seeing how they used contemporary stylistic elements, from the International Style to those of central Italy and of Venice in the High Renaissance, to forge their own masterpieces both great and small.

BIBLIOGRAPHY

Gardner, E. G. *The Painters of the School of Ferrara*. New York, Charles Scribner's Sons, 1911.

Longhi, R. *Officina Ferrarese*. Rome, Le Edizioni d'Italia, 1934; expanded edition, Florence, Sansoni, 1956. (In Italian, but *the* reference book for the Ferrarese school)

Nicolson, B. *The Painters of Ferrara, Cosme Tura, Francesco del Cossa, Ercole de' Roberti and Others*. London, Elek, 1950.

Ancona, P. d'. *The Schifanoia Months at Ferrara*, with a critical notice on the recent restoration, by C. Gnudi. Milan, Edizione de Milione, 1954. (Color plates)

Ruhmer, E. *Tura: Paintings and Drawings*. London, Phaidon Press, 1958.

° A study on the use of landscape in sixteenth-century Italian painting is being prepared for publication by A. R. Turner as a further development of his doctor's thesis at Princeton University.

PART VI

The Sixteenth Century
Elsewhere in Italy

⭐ 29

Painting in Florence
and Parma

A PART from the accomplishments of the great artists whom we have discussed, the sixteenth century saw a development of Italian painting that was varied and uneven.

Florence, as we have said, suffered a period of political confusion following the expulsion of the Medici, during which invading French troops occupied the city, Savonarola's reforms ended in his execution, and the Medici were re-established only to be exiled again. Not until Cosimo de' Medici, of another branch of that illustrious family, succeeded to power in 1537 did calm return to Florence, which during the next forty years and under Cosimo's somewhat ruthless hand reached its peak of political importance. Following the Protestant revolt, Rome was sacked in 1527 by an army of freebooters and Protestant sympathizers, and the Catholic Church, some twenty years before Michelangelo's death, relinquished humanism and politics to begin the redirection that was to be called the Counter Reformation. It was at this time that the center of art activity shifted from Rome to Venice.

The emotional disturbances occasioned by these and other events were reflected in the works of a number of painters whom we shall consider in this and the next chapter. Before the sixteenth century had ended, the Renaissance was over and Mannerism and the reaction against it was preparing the way for the Baroque.

Florence

In the first thirty years of the sixteenth century, two men were active in strife-torn Florence, and their accomplishments would have received top ranking had they not been overshadowed by the contemporary achievements of Leonardo, Michelangelo, and Raphael. These artists were Fra Bartolommeo and Andrea del Sarto.

Fra Bartolommeo

Although his first master was Cosimo Rosselli, Baccio della Porta (1475–1517), better known as Fra Bartolommeo, preferred to develop his own style out of elements observed in such great masters as Perugino, Leonardo, Giovanni Bellini, and even Michelangelo.

An early painting, the Vision of St. Bernard, now in the Accademia in Florence, shows certain affinities to Filippino Lippi's famous version of that subject [15.12], but when Fra Bartolommeo undertook the Last Judgment for the hospital of Santa Maria Nuovo in 1494 (finished by his friend Mariotto Albertinelli), he employed Perugino's well-known doubledecked composition. The group of apostles seated on banks of clouds in the upper half of the picture obviously gave Raphael the idea for his treatment of the upper half of the Disputà [21.8] in the Vatican Stanza. (Raphael visited Florence in 1506 and the two artists became friends.) In God the Father with St. Catherine and Mary Magdalen [29.1], painted at Lucca in 1509, Fra Bartolommeo turned the Peruginesque formula into a triangular composition of monumental simplicity. It too caught the eye of Raphael, and in it we see the prototype of the Sistine Madonna [21.17]. Even the position of the kneeling saints—the one facing in, the other facing out of the picture—anticipates the St. Barbara and St. Sixtus in Raphael's masterpiece. Fra Bartolommeo had already learned much from Leonardo's use of chiaroscuro to enhance the soft and gentle effect of his picture.

Having become a Dominican monk in 1500, Fra Bartolommeo had temporarily abandoned painting. But in 1508 he made a trip to Venice, where he was greatly impressed by the altarpieces of Giovanni Bellini with the Madonna monumentally enthroned against an apsidal background and with musical angels seated at the base of the throne. On his return to Florence, he used this Bellini scheme in some of his large paintings, such as the St. Anne and the Virgin (in monochrome) in the refectory of the Dominican church of San Marco, the Mystic Marriage of St. Catherine [29.2], now in the Uffizi, and the Madonna della Misericordia at Lucca.

No contemporary artist was able to escape the impact of Michelangelo's style after the painting of the Sistine ceiling, and Fra Bartolommeo was no exception. In the colossal figures of St. Mark [29.3], Jonah, and Isaiah, now in the Uffizi but originally painted for San Marco, he too pays tribute to the titan in Rome. But the huge, scowling form of the evangelist-saint, com-

29.1 *(left)*. FRA BARTOLOMMEO: God the Father with SS. Catherine and Mary Magdalen (1509). Canvas, transferred from panel, 142″ x 92½″. Picture gallery, Lucca (Alinari)

29.2 *(right)*. FRA BARTOLOMMEO: Mystic Marriage of St. Catherine (1512). Panel painting, 138⅟₁₆″ x 105¼″. Uffizi, Florence (Alinari)

by del Sarto: the Arrival of the Magi, and the Birth of the Virgin [29.6]; the others were painted by his friends Franciabigio and Rosso Fiorentino and by his pupil Pontormo. The Birth of the Virgin is certainly the most imposing work by del Sarto in this narthex. Painted in 1514, it shows the progress he has achieved in composition. There is a wonderful sense of the semicircular processional movement from the doorway at the left around to the figure of St. Anne stretched out on the bed, achieved by the alternating rhythms of heads, arms, legs, and torsi. The circular hangings beneath the canopy of the bed accentuate it, and the rectangular motifs of canopy and fireplaces set it off. Andrea's head and face types seem now definitely influenced by Fra Bartolommeo and by Leonardo. We also note his use of smiling-faced putti as auxiliary accents to the emotional tone of the picture. These happy infants are frequently to be found in his pictures and carry over into those of his pupil Pontormo.

Andrea probably did not start to work on the frescoes in the tiny cloister of the Scalzo until 1514 and then interrupted his work in 1518 to go to France. This trip was made at the behest of Francis I, to whose court other Italian painters were to emigrate after the Protestant sack of Rome in 1527. Del Sarto, however, infuriated the French monarch by returning to Florence after two years in response to his wife's persistent urgings. During his two-year absence his friend Franciabigio worked on two of the Scalzo frescoes, but on his return Andrea took over and finished the project in the course of

the next seven years. The frescoes are scenes from the life of St. John the Baptist plus four personified virtues: Faith, Hope, Charity, and Justice. Each is painted in a greenish-gold monochrome that is very effective and brings out all the plastic qualities of del Sarto's style at this time.

Among Andrea's friends in Florence were two well-known sculptors, Sansovino and Rustici, each of whom had done a group in bronze over the entrance doors of the Baptistery, Sansovino the Baptism of Christ, and Rustici St. John Preaching. All three were members of the group, which, according to Vasari, met at Rustici's house in Florence for exotic dinner parties to which everyone present contributed some fantasy in food. Certain it is that del Sarto's style when he painted in the Scalzo cloister was definitely affected by that of Sansovino's sculpture. His earliest fresco there, the figure of Justice, done before he went to France, closely resembles Sansovino's sculpture of the same subject in Santa Maria del Popolo in Rome. And the later Charity, done in 1520, so extremely like a group in sculpture, has all the firmness and roundness of a Sansovino masterpiece. A reminiscence of Andrea's first master's style can still be seen in the child at the left, whose grinning mask is the counterpart of those to the right in Piero di Cosimo's Andromeda panel in the Uffizi. In the Baptism of Christ, one of the earliest of the cloister scenes, the figures of Christ and St. John are obviously inspired by Sansovino's bronze group over the east door of the Baptistery. The kneeling angels are also very much in the manner of Sansovino.

543

In contrast to the simple diagonal composition of this scene is the later St. John Preaching, in which del Sarto uses the formula of a central elevated figure surrounded by figures in a circle. This formula is used in a number of his panel pictures at this time and later. The Madonna of the Harpies [29.8] is a simpler version of this scheme, and the Madonna with Six Saints, now in the Pitti, is a more compact one. Critics have pointed out that del Sarto had studied certain Dürer prints and incorporated details from them in his paintings. One such Dürer detail is the cloaked man at the right of the St. John Preaching, an almost direct copy of the Baptist in Dürer's Christ in Limbo in the woodcuts of the Little Passion.

In another of the Scalzo frescoes, the St. John Baptising [29.7], painted in 1517, some Michelangelesque elements appear in the slight contraposto of some of the figures and in the predilection for nude forms. The man at the left pulling off his clothes seems to indicate that Andrea had seen Michelangelo's cartoon of the Battle of Cascina [20.3] and observed particularly the figure putting on his clothes in great haste. The tousle-haired child at the right anticipates Pontormo's happy creations in the frescoes at Poggio a Cajano, both in looks and in posture. The remainder of the Scalzo frescoes, done after del Sarto's return from France, were scenes of Herod's feast and the Decapitation of St. John. In these, Andrea displayed the serene assurance of his mature style, both in technique and in composition.

In 1517 del Sarto also painted the Madonna of the Harpies [29.8], so called because of the figures of the harpies perched at the corners of the painted pedestal. With Fra Bartolommeo's God the Father [29.1] at Lucca and Raphael's Sistine Madonna [21.17], this picture represents the peak of that quality of monumental simplicity in composition that characterized art in the first quarter of the sixteenth century. The proportions of the figures and their contraposto are now definite evidence of Michelangelo's influence on del Sarto, but the emotional content is that of his own placid self. The head types are his own too, but everywhere is evidence of Leonardo's chiaroscuro. As also in the Sistine Madonna, there is a touch of the theatrical about the whole of the Madonna of the Harpies. The Madonna is a model posed on a stand, and the two saints have both been carefully placed in alternating contraposto positions, and, as in the Sistine Madonna, we have a tableau. Del Sarto, however, cleverly but consciously relieves the effect of almost too much drapery in the large triangle of the Madonna and the two saints by creating a smaller triangle within it of the nude forms of the Christ child and the putti at the base of the pedestal. At the same time he alleviates the sober seriousness of the three main figures by the vivacity of the smaller ones. In the treatment, color, and lighting of the drapery are early evidences of that fluidity, characteristic of his later style, that will lead eventually to the style of the Mannerists (Chapter 30).

If in the Scalzo frescoes del Sarto demonstrated his ability to create plastic, sculpturesque forms in monochrome, in his panel paintings from about 1520 until his death in 1531 he uses color in a manner that suggests

29.7 (*above*). ANDREA DEL SARTO: St. John Baptising (1517). Fresco. Scalzo, Florence (Alinari)

29.8 (*right*). ANDREA DEL SARTO: Madonna of the Harpies (1517). Panel painting, 82″ x 70$\frac{1}{16}$″. Uffizi, Florence (Brogi)

Venice rather than Florence. For example, in the two late Assumptions of the Virgin, in the Pitti Gallery, he holds the double-decked composition together by a triangle of rose-pink formed by the Madonna's dress and the cloaks of the two figures to right and left below. This is very similar to Titian's use of red in his famous Assumption of the Virgin [26.5], in the Frari at Venice, dating also in the early 1520's. Del Sarto at this period liked to use a series of light color tones, such as rose- and lavender-pinks, light blues, greens, and yellows and then throw against them stronger, darker reds, vermilions, blues, greens, purples and gold-yellows. In each of the two Assumptions just mentioned, the central accent in the lower tier is a figure in dark blue and red. In the beautiful late Pietà, in the same gallery, a series of pink and lavender tones are in contrast with dark blue and vermilion. A bold assemblage of colors is found in the Four Saints, in the Uffizi. The St. Michael at the left has a gold-yellow cloak over his shoulder. The light blue skirt has red shadows; the tights are a brilliant red; and a tab of blue cloth is draped out over the golden border of the lavender-gray leaves—all this on one figure against the sweep of the rich green mass of the cloak with gold-embroidered borders of the St. Bernard on the opposite side of the panel, and the crimson-lake mantle of the Baptist concealing most of his hair shirt. The fourth figure, St. Giovanni Gualberto, paired with the St. Michael wears a neutral gray-brown habit. (The grouping of four monumental figures in pairs recalls Giovanni Bellini, an early Titian, or a Dürer.)

Characteristic of this last period too is the persistent use of a soft chiaroscuro, either to fill the entire background or else to spot between areas of colors, softening and even blurring their outlines and forcing the eye to their *surfaces*. Here contrasting or blending halflights and highlights create fluid rhythms that impart to the statically posed figures an undercurrent of emotional restlessness. The heads, however, smile blandly, are introspective, or stare vacantly out into space. These are characteristics we shall find strikingly present in the works of the earlier Mannerists Pontormo and Rosso Fiorentino. The two putti, and the strange picture of St. James with the two altar boys, both in the Uffizi, betray the same emotional repression.

In the so-called "Cloister of the Dead" on the north side of the Annunziata in Florence, del Sarto painted one of his masterpieces in fresco in the lunette over the door leading into the north transept of the church. The space to be decorated was a shallow semicircle. Yet within this limited space he designed a Holy Family [29.9]—the Madonna and Child and St. Joseph—that displays his inventiveness in the composition of space. (The fresco is known as the Madonna of the Sack, because of the sack in the background against which St. Joseph is leaning as he reads his book.) The architectural setting for the group is very simple. He has painted a low step in the foreground from which, to right and left, rise the ends of molded rectangular projections drawn in perspective to create a shallow recessed platform. The lower ends of flat pilasters appear on the wall behind immediately above these projections. Within this artificially created rectangular space he has

29.9. ANDREA DEL SARTO: Madonna of the Sack (1525). Fresco. Cloister, Annunziata, Florence (Alinari)

placed the Holy Family. The Virgin with the Christ child on her lap is seated on the top step, her feet resting on the step below. She is placed off center to the right. The spread of the drapery on the step and floor and the extension of her left leg form the base of the pyramid into which she and the Christ child are composed; the back of the Child and the right edge of St. Joseph's book designate the sides of the pyramid. To compensate for the asymmetry created by the off-center position of the Madonna, St. Joseph is set back into the space at the left. Seated on the floor, he leans against a white sack, the end of which projects over the top step. The lower portion of St. Joseph's body disappears behind the Madonna's back. This is a very ingenious composition of interrelated rectangular and curvilinear forms, the curves beginning within the pyramidal group of the Madonna and Child by means of the drapery swinging over her knees, then being picked up and made more definitely circular by the end of the sack, thus preparing the spectator for the terminating curve of the wallspace.

The use of an asymmetrically balanced composition was not usual in central Italy. It suggests again that del Sarto had been acquainted with the design from Venice. And we note once more the serenity of the poses and of the composition as opposed to the movement of the surfaces of the drapery.

Parma

Early in the sixteenth century, Pope Julius II, that great patron of the arts, had added the once-free city of Parma to the papal territory, and Parma for a little while could bask in the reflected High Renaissance glows from Rome.

It was at Parma that one Italian artist, who lived but forty years, produced the paintings that were to have such important effects on later artists and later art movements, those of the Baroque period in particular.

Correggio

Antonio Allegri (1494–1534), known as Correggio, was born in the small town of Correggio in Emilia but spent most of his short creative life in Parma, although he also had connections with Ferrara and with the Gonzagas at Mantua.

Although during his lifetime Michelangelo and Raphael were creating some of their great masterpieces, Correggio seems aware of them only rarely. His early works have certain stylistic relations with the Ferrarese school, with Lorenzo Costa, and with Dosso Dossi. There is a certain stiffness in these early compositions, to be seen in such paintings as Christ Parting from His Mother, in the Benson collection, London, and even in the Madonna with St. Francis [29.10], in the Dresden Gallery. But there is also a sentimental sweetness of expression and content that pervades all Correggio's work. Even in his later and more mature style, he never shakes off this and creates an effect of emotional immaturity characteristic of one who has refused to grow up. Furthermore, he superimposes a childlike innocence of a strip-tease form of sensuality, although the Io, in the Vienna Gallery, achieves this sensuality more frankly. Tragic emotions are quite beyond Correggio, and when he attempts them they become ludicrous, as in the Martyrdom of SS. Placidus and Flavia, in the Parma Gallery.

Correggio's great achievement was his ceiling frescoes in Parma. The earliest of these (1518) is in the vaulted chamber [29.11] of the abbess of the convent of San Paolo, Donna Giovanna Piacenza. Her coat of arms bore three crescents. These being in antiquity associated with the huntress-goddess Diana, this deity was chosen to adorn, in fresco, the chimneyhead of the fireplace and then the sixteen sections of the ribbed handkerchief dome over the room were treated by Correggio in the manner of a garlanded trellis with oval openings in each section, quite in the manner of the trellis behind the Madonna of the Victory [23.13] by Mantegna painted for the Gonzagas in Mantua. Behind these openings there appear groups of putti romping and holding various attributes reminiscent of the chase: spears, bows and arrows, dogs and deer. The sixteen lunettes at the base of the sixteen vault sections contain gray relieflike figures and personifications from ancient mythology, most of which are variously identified. The whole is a charming and delightful performance.

29.10 (*right*). CORREGGIO: Madonna enthroned, with St. Francis (1515). Panel painting, 117⅞″ x 96¾″. Gemaeldegalerie, Dresden (Alinari)

29.11 (*below*). CORREGGIO: Detail from vault decoration (1518). Fresco. Convent of San Paolo, Parma (Alinari)

29.12. CORREGGIO: Glorification of Christ (1520–1524). Fresco. Dome, San Giovanni Evangelista, Parma (Alinari)

Correggio's second important ceiling decoration was in the dome and apse of the church of San Giovanni Evangelista (1520–1524). The apse fresco representing the Coronation of the Virgin was largely destroyed or damaged when the apse was moved to widen the tribune in 1587, but fragments of the fresco are now in the Parma library and in the National Gallery, London. Copies of the angels by Annibale Carracci are in the museum at Parma.

In the dome over the crossing in San Giovanni, Correggio represented in fresco an Ascension or Glorification of Christ [29.12]. The apostles, grouped in pairs, are seated in a circle of banked clouds that open at the top to allow the form of the Saviour to float up into the lighted sky. Putti in numbers mingle about the figures of the apostles and crowd around the ascending form of Christ. Correggio must surely have seen Mantegna's ceiling [23.11] in the Camera degli Sposi at Mantua, but he transformed Man-

29.13. Correggio: Assumption (1526–1530). Fresco. Dome, Parma cathedral (Alinari)

tegna's rigid circular balustrade into the human forms of the apostles and thus gave greater potentiality for movement to the composition of concentric circles. He must also have seen, in actuality or in copy, the Sistine ceiling [20.4], because the unusual representation of the apostles as nude forms and their contrapostal positions in the San Giovanni dome reflect the nudes in Michelangelo's famous ceiling. This fresco is indeed the next step after Mantegna's illusionistic space and before that of the Baroque ceiling painters.

Correggio's third great fresco project was in the Parma cathedral (1526–1530) and represented the Assumption of the Virgin [29.13]. The tremendous whirlpool design of clouds and figures within the large octagonal dome has most of the elements of the Baroque in it. The jubilant activity of the figures swirling about in the clouds and leaping over the balustrade apparently into the space of the dome and the clouds themselves pushing out into that same space are akin to similar elements in Baroque frescoes. The design here at Parma, however, is still contained within the octagonal form of the dome or the triangles of the spandrils, and the figures, though active to a degree, are kept within a spiral design of concentric circles. The clouds still contain the space, whereas in Baroque frescoes diagonal lines of force are accentuated and either the figures and clouds move out into space suggested as *not* contained by the architectural forms or else they overlap the architectural forms and seem to project into the space in which the spectator is moving.

These frescoes at Parma were Correggio's most significant accomplishments. Together with Michelangelo's great ceiling and the decorations in the Doge's palace in Venice by Tintoretto and Veronese they prepared the way for the Baroque ceiling painters of the seventeenth century.

BIBLIOGRAPHY

Baxter, L. E. *Fra Bartolommeo; Andrea d'Agnolo called Andrea del Sarto.* New York, Scribner and Welford, 1881.

von der Gabelentz, H. *Fra Bartolommeo und die Florentiner Renaissance.* Leipzig, Hiersemann, 1922, 2 vols. (in German, but a sourcebook)

Guiness, H. *Andrea del Sarto.* Great Masters of Painting and Sculpture series. London, G. Bell and Sons, 1901.

Berenson, B. *Florentine Painters of the Renaissance.* New York–London, G. P. Putnam's Sons, 1899.

Woelfflin, H. *The Art of the Italian Renaissance.* New York, G. P. Putnam's Sons, 1903, pp. 143–182.

Ricci, C. *Antonio Allegri da Correggio, his Life, his Friends, his Time,* trans. from the Italian by Florence Simmonds. New York, Charles Scribner's Sons, 1896.

Brinton, S. *Correggio.* Great Masters of Painting and Sculpture series. London, G. Bell and Sons, 1903.

Moore, T. S. *Correggio.* New York, Charles Scribner's Sons, 1906.

Gronau, G. *Correggio.* Classics in Art series. New York, Brentano's, 1921.

Popham, A. E. *Correggio's Drawings.* London, Oxford University Press, 1959.

~ 30

Mannerism

WITH the death of Raphael in 1520 the high moment of the Renaissance had been reached. Perhaps it had even passed, for Raphael's last picture, the Transfiguration [21.18], which was left unfinished at his death and was completed by his pupils, is filled with exaggerated expressions of emotions rather at odds with the more controlled feelings and actions of his earlier works.

During the period of about 1520 to some time in the last quarter of the sixteenth century, a style of art developed in Florence that is known as Mannerism or, as some would have it, anti-Classicism. Instead of the well-ordered compositions, the ideal forms, and the controlled emotional content in the High Renaissance tradition of Raphael, Fra Bartolommeo, and del Sarto, in the earlier phase or works of the first generation of painters of this new style we find restless though decorative areas of light and shade and color, forms elongated to the point of distortion, and hollow-eyed haunted expressions externalizing some inner fear or anxiety. We find, too, that the sense of space is almost entirely blocked by shadowy and abstract backgrounds; figure groups are crowded into the front plane; verticality and two-dimensionality are stressed.

The First Generation of Mannerists (c. 1520–c. 1550)

In Florence the principal exponents of the earlier phase of Mannerism were Pontormo and Rosso Fiorentino.

553

Rosso Fiorentino

Rosso Fiorentino (1494–1540) also painted a fresco, the Assumption of the Virgin, in the narthex series in the Annunziata, but already at this early stage his fresco was strangely emotionalized. He further defied the tradition of the High Renaissance by having a portion of the robe of the central figure in the lower tier appear to project over the frame.

His most astounding picture is the Descent from the Cross [30.3], in the museum at Volterra. Possibly taking his cue from the Deposition by Filippino Lippi in the Uffizi, Rosso painted one of the most astoundingly emotional Crucifixions ever done. The major accents are the disciple John at the right in blue and whitish-pink, who turns his back on the cross to bend over and hide his face in his hands in utter despair; the female figure in gold-yellow and whitish-pink at the extreme left, peering like a haunted soul out of the picture; and the almost prone figure of the Magdalen in a strong vermilion at the foot of the cross, who acts as a connecting diagonal between the other two figures. The dramatic excitement is heightened by the figure of the man on the left ladder grasping the knees of Christ, by the figure above him pointing to the body as he gives directions, and by

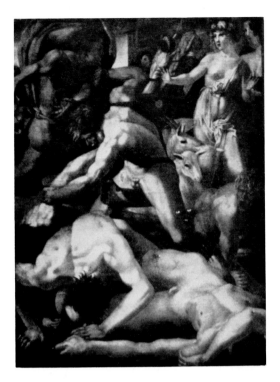

30.4. ROSSO FIORENTINO: Moses and the Daughters of Jethro (1528). Canvas, 63″ x 46⅛″. Uffizi, Florence (Alinari)

the old man in a blue turban and a pink robe who, with beard flying, leans over the top of the cross and stares down on the scene. The design of the ladders, the cross, and the figures is all of verticals and zigzags.

Another picture by Rosso, not to be missed by the visitor to the Uffizi, depicts the episode of Moses rescuing the daughters of Jethro [30.4]. It is full of wild excitement as the blond Moses in the center swings his fists at three of the assaulting shepherds lying sprawled and howling on the ground, while another wild-haired shepherd charges in at the left behind Moses toward a girl, petrified with fear, at the right. The color effect of the light-colored nude bodies with their blond and brown patches of hair, the dark blue of Moses' scrap of drapery, and the light blue, green, purple, lavender, and yellow of other garments is highly effective.

Rosso had been in Rome and must have seen the paintings on the Sistine ceiling, a slight reflection of which is discernible in the Moses and the daughters of Jethro. But when Rome was sacked in 1527, together with many other artists, he left that city and finally ended at the court of Francis I at Fontainebleau. There, with Primaticcio and other Italian Mannerists, he undertook the decoration of that famous French palace and helped to found the French school of painting known as the Fontainebleau School. Niccolò dell' Abbate (c. 1512–1571), mentioned in passing in connection with the school of Ferrara, was also active in this group in France, where he painted many of his luminous landscapes and intimate groups of courtiers in their contemporary plumed hats.

Beccafumi and Parmigianino

A third member of the early Mannerist group in Tuscany was Domenico Beccafumi (1485–1551), who was active primarily in Siena. He had studied there with Sodoma and became very popular as a painter, although he was also a sculptor and an architect. He produced very fine drawings for some of the pavement mosaics in Siena cathedral.

Beccafumi's connection with the Mannerists is apparent in his elongated forms, his use of offshades of pink, green, blue, and yellow highlighted with white and with occasional accents of dark blue and vermilion, and in the eroticism of the nudes in many of his larger pictures. In such pictures as the Descent of Christ into Hell and the Punishment of the Rebel Angels [30.5] in the Gallery in Siena, the hectic emotional tension characteristic of the Mannerists is most apparent in the expressions on the faces and in the spasmotic spotting of the light. The yellow and vermilion tongues of fire flashing through these pictures have a startling and fascinating effect.

A fourth artist among the early Mannerists was Francesco Mazzola (1503–1540), better known as Parmigianino. Born at Parma, early in his career he was subjected to the influence of Correggio, which is apparent in the figure of SS. Lucy, Agatha, and Apollonia painted in 1522 in the first chapel to the left in San Giovanni Evangelista in Parma, where Correggio had frescoed the vault and the apse. At Rocca di Fontanellato (1523) the decoration of one of the rooms with an illusionistic trellis, behind the openings of which appear episodes from the legend of Diana and Acteon, shows the obvious influence of Correggio's trellis decoration in the abbess' room in the convent of San Paolo at Parma [28.11], even to the putti.

Parmigianino's stay in Rome from 1524 to 1527 naturally brought him into contact with Raphael's works and Michelangelo's Sistine ceiling. Although he absorbed Michelangelo's contraposto and developed it into his own *serpentinata* (or spiral) figure style, it was Raphael's gentle and suave style, more in keeping with his own, that affected him most. The figures of the women carrying vases on their heads in the later ceiling decoration of the Steccata in Parma are obvious derivatives from Raphael's girl carrying a jug on her head in the fresco of the Fire in the Borgo [21.11] in the Vatican Stanze.

What attaches Parmigianino most closely to the Mannerist group is the use of the *disegno interno,* as sixteenth-century writers called it. In contradistinction to the Classical High Renaissance which drew its ideals from nature, the Mannerism's source of ideals was the artist's inner compulsion that manifested itself in exaggerations and distortions of forms as well as of expressions. In Parmigianino the *disegno interno* appears in his occasional extreme elongation of form, of which the most striking example is the Madonna dal Collo Lungo (Madonna with the long neck) [30.6], now in the Pitti Gallery in Florence. Here all the forms are pulled out of proportion in order to stress the vertical, the columnar, the conical, the oval. Movement

30.5 (*left*). BECCAFUMI: Punishment of the Rebel Angels (*c.* 1524). Panel, 136³⁄₁₆″ x 88³⁄₈″. Pinacoteca, Siena (Anderson)

30.6 (*right*). PARMIGIANINO: Madonna dal Collo Lungo (*c.* 1535). Panel painting, 84³⁄₈″ x 52³⁄₈″. Pitti Gallery, Florence (Alinari)

is achieved solely by the spiral rippling of the drapery and the hair and by diagonal rhythms.

The emotional content in Parmigianino's figures is not exaggerated as was the case with the other Mannerists we have mentioned. For the most part, his Madonnas express a gentle dignity. Attendant figures of saints and children often display the softness and sweetness of Correggio. Whatever there is of an underlying unrest is produced by the flickering lights moving across the shadows on forms, backgrounds, and landscapes.

The Pupils of Raphael

The emotional restlessness and anxiety found in the figures of Pontormo and Rosso particularly and of Beccafumi to a certain degree seem in part to reflect the general state of mind produced by the Protestant Reformation. The so-called "anti-Classical movement" of the Mannerists against the High Renaissance Classicism began at almost the same time that Protestantism was attacking Catholicism. Even Michelangelo and the group around his friend Vittoria Colonna reacted sympathetically to the Protestant ideas of reform to such a degree that they were in danger of being investigated by the Inquisition. Michelangelo's own disturbed soul, as we saw, was certainly reflected in the stern troubled figures in his Last Judgment [20.12] and in the frescoes of the Pauline chapel [20.14] whose faces externalize the fear of damnation. This same fear of damnation and death we also found on the faces of the figures by Pontormo and Rosso.

In Rome during this period from about 1520 to 1550, the Mannerist tendency was also apparent, primarily in the work of such pupils of Raphael as Giulio Romano (c. 1492–1546), Pierin del Vaga (1501–1547), and Polidoro da Caravaggio (c. 1500–1543). These men undertook to finish the work still uncompleted when the great master died. These included the Transfiguration and various Madonnas and the frescoes in the Stanza di Costantino and the Loggie in the Vatican and those in the Villa Farnesina. In all a turbulance both physical and emotional is very apparent. The stepped-up emotional content in the Madonnas of Giulio Romano, for instance, is achieved in part by the hectic lighting in the landscapes or in the architectural elements that form the backgrounds of his pictures, such as tunneled passageways or doorways opening into rooms beyond.

In their frescoes in the Vatican Loggie and elsewhere these painters carried on the Raphaelesque tradition of using actual or illusionistically painted stucco reliefs and delicately painted grottesque motifs [30.7]—so called because they imitate motifs of ancient Roman wall paintings found in grottolike ruins—as decorative accompaniments to the mythological, historical, or religious scenes that are the main features of their frescoes. The influence of Michelangelo is also apparent in their figure styles. Excellent examples are to be found in the frescoes by all three of these pupils of Raphael in the apartments of the Castel Sant' Angelo, the former tomb of

30.7. SCHOOL OF RA-PHAEL: *Grottesque* decoration (*c.* 1520). Fresco. The Loggie of Raphael, Vatican, Rome (Anderson)

the Roman emperor Hadrian that was turned into an elegantly furnished papal fortress as well as a prison during the sixteenth century. It was here that Pope Clement VII immured himself during the siege of Rome in 1527 and here that Benevenuto Cellini was imprisoned for a while. Giulio Romano's elaborate frescoes in the Palazzo del Tè in Mantua are further excellent examples of this Roman Mannerist type of decoration. So are the frescoes on the exterior of palaces for which Polidoro became famous.

Although the general decorative set-up of these frescoes was Raphael-inspired, increasingly the figure style owed more to the influence of Michelangelo. After all, Michelangelo lived until 1564 and Raphael had been dead since 1520. Later even *vedute* (views) and landscapes imported in part from north European artists were also inserted or used as major items in the decoration.

The Second Generation of Mannerists (*c.* 1550–*c.* 1575)

The second generation of Mannerists, active from the fifth decade of the century onward, drew the sources of its style more definitely from the great accomplishments of Raphael and Michelangelo at Rome. These were, of course, Raphael's frescoes, already mentioned, in the Stanze and the Loggie and his tapestries in the Vatican, and Michelangelo's Sistine ceiling frescoes, his Last Judgment in the same chapel, and his frescoes in the Pauline chapel in the Vatican. The works of Bronzino will perhaps show us best how these Michelangelesque forms were used by the làter Mannerists.

30.8. BRONZINO: Resurrection (*c.* 1552). Panel. SS. Annunziata, Florence (Brogi)

Bronzino

Agnolo Bronzino (1503–1575) was a pupil of the early Mannerist Pontormo and assisted his master in the painting of the frescoes in the Certosa del Galuzzo outside Florence as well as in the painting of the roundels with the Evangelist heads in Santa Felicità in Florence, the church in which Pontormo's famous Deposition is located. It is therefore no surprise to find in Bronzino's earlier work influences from the early Mannerist style. Except for a short visit to Rome in 1546, Bronzino spent most of his life in Florence and worked primarily under the patronage of Cosimo I de' Medici. He was a fanatical admirer of Michelangelo's work, which must have been available to him in sketches and copies before he actually saw it in Rome. Bronzino's own creations, such as the Christ in Limbo, in the former refectory of Santa Croce in Florence, or the Resurrection of Christ [30.8], in the church of the Annunziata, illustrate well his obsession for the nude form in contraposto. His handling of these forms, however, is typically Mannerist in that he pushes them into a crowded front plane, emphasizes vertical, diagonal, and angular rhythms by highlighting arms, legs, and torsos, and,

30.9. BRONZINO: Martyrdom of St. Lawrence (1567–1569). Fresco. San Lorenzo, Florence (Alinari)

in contrast to Michelangelo, makes the forms rendered in contraposto seem flat as though they were pressed between two parallel planes. These elements, repeated over and over again, eventually become dry conventions not only in Bronzino's own pictures but in those of many other Mannerists of the later period.

Another characteristic feature of the second-generation Mannerists, possibly begun by Bronzino, is the use of figures in the lower foreground, re-

clining, sprawling, or sitting, some turning and pointing toward the main scene, others looking out at the spectator. One particularly common pose is that of a seated figure turned in contraposto with one knee up and one arm raised over its head. These groups create a kind of setback or horizontal platform in front of the vertical plane in which the major episode takes place. The painter Vasari at times actually used steps of a staircase leading up into the scene.

In contrast to the emotional tension present in the figures by early Mannerist painters, Bronzino's figures have a certain cool aloofness, at times a mannered affectedness of pose reducing the content of the picture to insipidity. The vogue at that time for false modesty, blatantly referred to in Pietro Aretino' scurrilous letter to Michelangelo on the Last Judgment, is also present in Bronzino's late pictures. Bits of drapery, fig leaves, and covering gestures and poses appear frequently to control nudity. This is to be true of many other painters of the period as well. All these late Mannerist features are present in Bronzino's fresco in San Lorenzo in Florence of the Martyrdom of St. Lawrence [30.9].

Vasari

Giorgio Vasari (1511–1574) is undoubtedly best known today for his famous publication of *Lives of the Most Eminent Painters, Sculptors and Architects,* the source of much of our information about Italian artists up to his time, but in the sixteenth century Vasari had fame as both painter and architect. It was he who under orders of Cosimo de' Medici remodeled the interior of the Palazzo Vecchio in Florence and drew the plans for the building now known as the Uffizi. The Palazzo de' Cavalieri in Pisa was also assigned to Vasari to build, and late in his life, after Michelangelo's death, he was appointed as successor in the work at St. Peter's in Rome. His many activities in the service of popes, cardinals, and especially of the Medici family (Alessandro and Cosimo I) made his life a restless one, for he was continually on the move between Arezzo (where he was born), Florence, Rome, and the many places he visited to get information for his writings.

As a painter, having studied with Andrea del Sarto and Michelangelo among others, Vasari became a leading figure with Bronzino among the later Mannerists who were so powerfully influenced by Michelangelo. His painting of the Forge of Vulcan [30.10], now in the Uffizi, is an excellent example of his style with its Michelangelesque forms arranged in affected poses and highlighted to bring out self-conscious and balletlike rhythms. The use of the tunnellike architecture and of rooms leading off into dark backgrounds dramatically lighted was characteristic of the followers of Raphael of the early Mannerists group in Rome, particularly of Giulio Romano. We have met with this feature also in the painting of Beccafumi cited on page 558, in which the tunnel effect is achieved by the figures and the flickering fires of Hell in the distance.

30.10. VASARI: The Forge of Vulcan. Painted on copper, 15″ x 11″. Uffizi, Florence (Alinari)

30.11 (*below, left*). PONTORMO: The Halberdier (*c.* 1525). Panel, 36¼″ x 28⅜″. C. Stillman Collection, New York. 30.12 (*below, right*). BRONZINO: Eleanor of Toledo and Son (1553–1555). Panel, 45″ x 37″. Uffizi, Florence (Alinari)

As a fresco painter Vasari was much in demand. In this field his style was considerably freer than in his paintings of altarpieces. His best-known wall decorations are those in the *sala grande* in the Palazzo Vecchio in Florence (done with his friend Salviati), those in the Sala Regia in the Vatican, and the very delightful ones in his house at Arezzo. To a large extent Vasari's wall decorations follow in the traditions of the history paintings established by Raphael and his school in the Stanza of Constantine in the Vatican. He had also seen the work of Giulio Romano in the Palazzo del Tè in Mantua. Vasari's last large-scale undertaking in fresco was the decoration of the dome of the cathedral in Florence, completed after his death by Federico Zuccari.

We should also note that Vasari was the first to start a collection of drawings of old and contemporary masters, which he assembled in a book embellished with the portrait of Michelangelo on its title page. Most of these are now in the drawing collection of the Uffizi.

As a group the Mannerists were also excellent portrait painters. They imparted to their sitters a certain elegance and aloofness of attitude. There is no distortion of form or emotion even in the portraits by the earlier Mannerists, but there is a meticulousness in the rendering of the details of the costumes, of the jewelry, and of other appurtenances that calls to mind the work of Holbein. Outstanding examples are to be found in Pontormo's portrait of Cardinal Cervini, in the Borghese Gallery in Rome, and in his portrait of the Halberdier [30.11], now in a private collection in New York City, and in Bronzino's portraits of various members of Cosimo de' Medici's family, notably the portrait of Eleanor of Toledo with her son [30.12] in the Uffizi Gallery.

Conclusion

Centered as it was chiefly in the regions of Rome and of Tuscany, Mannerism had exhausted itself by the second half of the sixteenth century. There had been very little acceptance of it in Venice, although some would consider Tintoretto as a Mannerist. It had been transplanted to France by Italian artists summoned to execute the decoration of the chateau at Fontainebleau, and a local French school of painting was the result. In Spain, El Greco manifested many of the external characteristics of Mannerism but the content of his paintings was ecstatically Roman Catholic.

In Italy the empty though elegant artificiality of later Mannerism brought a reaction during the last half of the sixteenth century. Some of the painters taking part in this reaction against Mannerism wished to salvage from the disintegration of Renaissance art and culture certain elements with which they could construct a new movement. Others felt the effects of the Counter Reformation and the Council of Trent (1545–1563) which reaffirmed the essentials of Roman Catholic dogma. The Jesuit movement also furnished a new focus for the emotional content of religious painting. There was, further,

a reaction in favor of nature apparent in the painting of landscapes, of still life, and of human forms as they appeared in everyday life. These new directions are reflected: in the establishment of the Academy at Bologna by the Carracci family in which the best of Renaissance traditions in painting were studied along with nature (landscape and genre); in the religious paintings full of devotional sincerity by artists like Federigo Barocci (c. 1530–1612); and in the breath-taking paintings of Caravaggio (1573–1610), which included an astounding rendering of still-life subjects, of genre, and of mythological and religious episodes in which we find dandies, gypsies, adolescents, and characters from the slums used as the models. Caravaggio most usually painted his figures and subjects against a dark background in order to emphasize with spots and shafts, or planes, of light the types represented and their emotional reactions. He had a great following throughout Europe.

These painters and their varied accomplishments during the latter half or quarter of the sixteenth century in their reaction against Mannerism were the forerunners of that new movement, culminating in the seventeenth century, known as the Baroque. It was a movement full of new directions and impulses that made it an important unit in the history of art and culture, just as the Renaissance had been. Its scope is so great and the important works of art produced so numerous that they deserve to be treated in a separate publication. They fall outside the limits of this book.

Epilogue

It has sufficed for us to discuss the paintings of that period of human culture in Italy known as the Renaissance. In so doing it was necessary for us first to consider the beginnings that eventually led to the great achievements of that period. These beginnings were to be found in the thirteenth century when Christian painting was breaking away from the restraints of the dogma and conventions of the earlier medieval period, breaking away in order to give greater human emotional content to religious subject matter. The life and teachings of St. Francis of Assisi had been largely responsible for this as had also the contacts with French Gothic art. Once attention had been drawn to human emotion it was only natural that interest in the human being himself and in his physical surroundings should follow. The resulting secularization of religious subject matter is apparent in the paintings of the fourteenth century. More detailed observation of man himself and of nature followed in the fifteenth century with the growth of interest in anatomy, perspective, details of nature, landscape backgrounds, and form and color in light. Paintings of the fifteenth century also reflect the growing curiosity about man's achievements in Italy's past—that is, the Classic past. It is this preoccupation with and study of Classic culture and art that gave the Renaissance in Italy its particular character. Classic culture also brought with it mythology and the ideal of beauty. It was when the attempt was made to harmonize or fuse these elements with

Christian thought and doctrine that an impasse was reached. Michelangelo in the ceiling of the Sistine Chapel and Raphael in the Vatican Stanze as representatives of this movement at the beginning of the sixteenth century brought the Renaissance to the highest achievement in painting in Rome. But the attempt to reconcile paganism and Christianity foundered. The Reformation intervened, and we have seen in the works of the Mannerists what resulted in painting. This was the last act in the extraordinary drama of Renaissance painting. The Counter Reformation was to usher in the new period, the Baroque.

BIBLIOGRAPHY

Carden, R. W. *The Life of Giorgio Vasari; a Study of the Later Renaissance in Italy*. New York, Henry Holt & Company, 1911.

Clapp, F. M. *Pontormo, His Life and Work*. New Haven, Yale University Press, 1916.

McComb, A. *Agnolo Bronzino. His Life and Works*. Cambridge, Mass., Harvard University Press, 1928.

Becherucci, L. *Disegni del Pontormo*. Bergamo, Istituto Italiano d'Arti Grafiche, 1943. (Facsimiles of Pontormo drawings)

Freedberg, S. *Parmigianino, His Work in Painting*, Cambridge, Harvard University Press, 1950.

Friedlaender, W. *Mannerism and Anti-Mannerism*. New York, Columbia University Press, 1957.

Hartt, F. *Giulio Romano*. New Haven, Yale University Press, 1958. 2 vols.

Appendix

A General Bibliography
in English

To supplement the Special Bibliographies at the end of each chapter

Vasari, G. *Lives of the Most Eminent Painters, Sculptors and Architects*. Florence 1550, 1564. Various English editions: de Vere translation, 10 vols. London, Medici Society, 1912–1915; Everyman Library, E. P. Dutton & Co., Inc. New York, 1949; abridged ed. by Betty Burroughs, Simon and Schuster, New York, 1946

Berenson, B. *The Italian Painters of the Renaissance*. Revised ed. Oxford, Clarendon Press, 1930; plates for this ed. in Phaidon Press ed. London, 1953. (Originally the text material for this Clarendon Press publication was issued as four separate essays by G. P. Putnam's Sons, New York and London: *The Venetian Painters of the Renaissance*, 1894; *The Florentine Painters of the Renaissance*, 1896; *The Central Italian Painters of the Renaissance*, 1897; *The North Italian Painters of the Renaissance*, 1907.)

Berenson, B. *Italian Pictures of the Renaissance*. A list of the principal artists and their works with an index of places. Oxford, Clarendon Press, 1932. (This is being re-edited with plates by the Phaidon Press, London, of which two volumes *The Venetians* appeared in 1957.)

Berenson, B. *The Study and Criticism of Italian Art*. London, G. Bell and Sons. 1901; second series, 1902; third series, 1916

Crowe, J. A., and Cavalcaselle, G. B. *A New History of Painting in Italy*. London, J. Murray, 3 vols., 1864, and various subsequent editions especially those of L. Douglas, London, J. Murray, 1903–1914, 6 vols., and E. Hutton, New York, Scribners, 1912, 3 vols.

Marle, R. van. *The Development of the Italian Schools of Painting*. The Hague, M. Nijhoff, 1923–1938. 19 vols.

Brown, A. V. V., and Rankin, W. *A Short History of Italian Painting*. New York, E. P. Dutton and Co., 1914.

Mather, F. J., Jr. *A History of Italian Painting*. New York, Henry Holt and Co., 1923, rev., 1938

Schmeckebier, L. E. *A Handbook of Italian Renaissance Painting*. New York, G. P. Putnam's Sons, 1938 (extensive bibliography lists)

Shapley, F. R. *Comparisons in Art* (with introductory essays by John Shapley). New York, Phaidon Publishers, 1957

Three excellent small guidebooks by E. Sandberg-Vavalà:

—*Uffizi Studies. The Development of the Florentine School of Painting*. Florence, L. S. Olschki, 1948 (a guide to the Uffizi, Florence)

—*Sienese Studies. The Development of the School of Painting of Siena*. Florence, L. S. Olschki, 1953 (a guide to the Pinacoteca, Siena)

—*Studies in Florentine Churches*. Florence, L. S. Olschki, 1959. Vol. I

Glossary

ACROTERIA: blocks placed along the roof line and at the ends and peak of the pediment, *e.g.*, of a Classic temple, to support ornaments. The term is also applied to the ornaments themselves.

ANCONA: a painted panel, essentially rectangular in shape, set on top of an altar, *i.e.*, an early type of altarpiece.

ANTHEMION: a honeysuckle or palmette ornament used to decorate moldings, cornices, and the neckings of capitals in Classical architecture.

APRON PANELS: the panels flanking the body of Christ below the crosspieces of a painted crucifix.

APSE: In Christian times, the semicircular or polygonal termination covered with a half dome or vaults at the end of a choir.

ARCHED CORBEL TABLE: see CORBEL TABLE

BALDACHINO: a canopy supported by uprights over an altar or a tomb. It also appears on exterior buttresses of Gothic cathedrals.

BILLET: a molding made up of short, broken cylindrical and square elements whose axis runs parallel to that of the molding.

BEAD AND REEL: an ornamental motif frequent on moldings. It consists of round bead forms alternating with spool forms.

BISTRE: a brown pigment prepared from soot.

CARTOON: a preparatory drawing made to scale before a fresco or painting was begun.

CIBORIUM: a canopy supported on columns (usually four) over an altar of a Christian church. See also BALDACHINO.

COFFER: a sunken panel of geometric form in a ceiling, vault, or dome.

CONSOLE: a bracket or corbel in the form of a scroll of reverse curvature.

CONTRAPOSTO: in figure painting and sculpture, as seen in the works of Michelangelo, Leonardo, and others influenced by them, the representation of various parts of the body (such as the head, the torso, and the lower limbs) in contrasting positions. The transition from the one to the other is achieved by a twist at the nonrigid areas of the body, such as the neck and the waist. A spiral design results and lends to the form so represented the dynamic power inherent in a coiled spring.

CORBEL: a block of stone projecting from a wall and used as a support.

CORBEL TABLE: a projecting course of masonry carried on corbels. If the corbels are connected by arches the whole is called an ARCHED CORBEL TABLE.

CROSS NIMBUS: a cross-inscribed halo set behind the head of Christ in contradistinction to the simple halo worn by saints.

CROSS VAULT: the vault formed by the intersection of two semicircular vaults.

CRYPT: a space beneath the floor level of a building. In churches it is generally beneath the chancel area at the sanctuary end.

DEÏSIS: name applied to the representation in which Christ enthroned as Judge is flanked by the Virgin Mary and St. John the Baptist as intercessors. Frequent in Byzantine art.

DIAPERED DRAPERY: drapery covered with losenge or other small designs. The term presumably is derived from the motifs used on tapestries made in medieval times at Ypres in Flanders.

572

DIPTYCH: two panels of ivory, wood, or metal hinged together, like the covers of a book. *See* page 6.

DOSSAL: a painted altarpiece of basically rectangular shape, essentially the same as an ANCONA. (*See* page 6.) The term is derived from the fact that a dossal was usually placed at the rear of the altar.

DUOMO: cathedral.

EGG AND DART: an ornament on Classical architectural moldings consisting of alternating egg and spear-head forms.

FLEURON: a flower-shaped ornament.

FRESCO PAINTING: painting applied to a plaster wall or vault. (*See* pages 578–580.)

GENRE: subject matter taken from ordinary life in contradistinction to religious subject matter.

GESSO: a mixture of plaster of Paris and animal or fish glue which when applied to wood panels became the surface for gilding and painting.

GLORY, A: an aureole or halo; an effulgence of light surrounding a figure.

GRISAILLE: painting in gray monochrome.

GROTESQUES: decorative painting consisting of intermingled fantastic human, animal, and plant forms.

GUILLOCHE: an ornament of braided or interlacing bands.

HATCHING: the drawing or painting of fine parallel lines resembling engraving, or the representation of sets of such lines crossing each other.

HISTORIATED: decorated with figures of men or animals.

ICON: literally an image; here used as referring to painted single panels containing representations of Christ, the Virgin, saints, or religious scenes as found in Byzantine or Greek Orthodox churches.

ICONOGRAPHY: the way in which figures and episodes are represented in scenes of sacred history.

ICONOSTASIS: the screen at the entrance to the sanctuary of a church to which the icons or holy pictures are attached, especially in Byzantine churches or in those of the Greek rite.

IMPASTO: an opaque white medium used profusely by Titian and later Venetian painters, which when employed in connection with transparent colored glazes made possible the rendering of the varying textures of objects, human forms, and drapery.

INTARSIA: wood inlay.

LACERTINES: interlacing bands composed primarily of elongated animal bodies biting each other and themselves while intertwining.

LAUDE: a poem or song in praise of the Virgin primarily.

LESBIAN LEAF: a tonguelike leaf ornament found on Classical architectural moldings.

LOW RELIEF: sculptured ornament or figures raised only slightly from their background, or the simulated effect of the same in painting.

LUNETTE: the flat wall surface or the space enclosed by an arch or by the end of a vault.

MACHICOLATION: an opening in the floor of a projecting gallery for the sake of dropping missiles on the enemy.

NIMBUS: halo.

PANTOCRATOR: the All-powerful, *i.e.*, God or Christ as God.

PENDENTIVE: the spherical triangle of masonry making the transition from a square base to the circular drum supporting a dome.

PLASTRON: a leather-covered breastplate.

POLYCHROME: many colored.

POLYPTYCH: an altarpiece made up of more than three vertical sections.

PREDELLA: the lowest horizontal section of a rigid Gothic or Renaissance altarpiece. (*See* page 6.) It usually contained painted scenes from the lives of the holy figures represented in the main section of the altarpiece, *i.e.*, of Christ or the Virgin as the central figure and of the various accompanying saints.

PRIMING: preparing a surface for painting.

PUTTO: a small cupidlike figure frequent in Roman art. In Christian art it became an angel in the form of a nude child.

QUATREFOIL: a four-cusped ornamentation, like a clover leaf, found in Gothic architecture, especially in tracery.

ROOD SCREEN: a wooden or stone screen separating the nave of a church from the sanctuary. *Rood* is the old English word for the cross of Christ that frequently topped the screen.

ROUNDEL: a circular medallion.

SANCTUARY: as used in this book refers to the eastern end of the church in which the main altar for celebrating the Mass was to be found.

SCRIPTORIUM: room in a monastery where the writing or copying of manuscripts took place.

SEVERIES: the compartments of a vault.

SINOPIE: preparatory or guiding drawings or sketches in red ochre frequently found below the plaster surface on which a fresco is painted.

SIZING: application of glue or any adhesive.

STIGMATA: as used in religious literature, the marks of Christ's wounds or the wounds themselves.

STRIGILLATED: covered with a series of pulled-out S-shaped grooves resembling the Classical *strigil* or scraper used by an athlete. This decoration is frequent on Roman and Early Christian sarcophagi.

SUPPEDANEUM: the block at the bottom of the cross on which Christ's feet rest.

SYMBOLS OF THE EVANGELISTS: from Early Christian times on, certain symbols were associated and frequently represented with the Evangelists: the angel with Matthew, the lion with Mark, the ox with Luke, and the eagle with John.

TEMPERA PAINTING: painting in which the medium used is egg. (*See* page 577).

THRENODY: a song or poem of lamentation.

TONDO: a frame or painting of circular form.

TRIBUNE: a raised platform. In churches it is usually present in the apses, the chapels, and the sanctuary.

TRIFORIUM: the covered passage above the nave arcade in Romanesque and Gothic churches.

TRIPTYCH: an altarpiece made up of three, usually hinged, sections. (*See* page 6.)

VERMICULATE: wormlike; applied to the ornament frequently found in art that resembles a series of small wiggling grooves or lines.

The Making of a Fourteenth-century Painting

Few people realize that the making of a painting in the later Middle Ages was very different from the painting of a picture today. Now anyone who wishes can go to an artists' supply shop, buy canvas or paper and brushes and tubes of oil or watercolor paints, start painting, and call himself an artist. Not so during medieval days nor for most of the period covered in this book. At that time, painting was essentially a craft, and the painters belonged to a guild (the Guild of St. Luke) and were known as *masters* and *apprentices*. Each master had his *bottega*, or shop, wherein the apprentices were trained and worked their way up to become masters. The studio, as we know it today, with its possibly social or Bohemian overtones, did not exist. We do, however, still use the terms of "old master" and "masterpiece," surviving from the guild days.

In order to realize how much craft, skill, and patience were required of the medieval artist beyond the inspiration and ability to create a painting, let us examine, step by step, the making of, for example, an altarpiece in the time of Giotto.

A Panel Painting

First, a contract had to be signed between the donor or patron, such as the bishop of a church, the abbot of a monastery, or a person of private means, and the master painter. What was wanted often was described in detail as to subject and colors. The price agreed upon was paid one third when the contract was signed, one third when the work was half finished, and one third on delivery.

Once the contract was signed, the master painter set the apprentices to work on the preparation of the panels and the specified colors.

Medieval paintings were done on wood and not on canvas, so in every painter's *bottega* a stock of wood panels was kept on hand. The wood had to be of a kind that had little or no grain, because wood grain interfered with the preparation of the panel's surface. In central Italy, poplar was used almost exclusively. Because their sizes varied in different levels of an altarpiece, the panels for a specific painting had to be chosen first by size. Next the side of the panel to be painted had to be carefully leveled to remove all surface irregularities. Then, since paint was never applied directly to the wood surface, the

panel had to be faced with another absolutely smooth surface. This meant the application of gesso, a mixture of plaster of Paris and animal glue. Gesso is a tougher material than plaster by itself and will withstand more successfully the changes in temperature that followed with the changing seasons. Usually the heated gesso was applied to the wooden surface primed with glue, but sometimes, in order to make the gesso adhere more securely, a finely woven linen cloth was stretched over the wooden panel and the gesso applied to the linen. This primed linen, of course, was the ancestor of the later painter's canvas. The gesso could never be put on all at once but had to be applied in a series of thin coats until the desired thickness had been achieved. It also had to be put on with extreme care lest small air bubbles remain when it had dried to interfere with the desired smoothness of the surface on which the painting was done. When thoroughly dried, the gesso was smoothed to an eggshell surface, because no unevenness could be tolerated when minute details had to be painted on with tiny brushes.

Once the gesso had been applied and smoothed, the panel was still not ready in every case to receive the paint. We have noticed that the backgrounds of most scenes and figures in the so-called "primitive" paintings—those of the thirteenth, fourteenth, and often fifteenth centuries—are gold, a survival as well as an imitation of the gold backgrounds of Byzantine enamels and mosaics. In panel paintings this meant that gold leaf had to be applied to the gesso before painting. But gold leaf is paper-thin, disintegrates when touched by hand, has to be handled very carefully, and will not of itself adhere to the gesso surface. Hence a size for the gold leaf had to be applied to the gesso, and this was a red Armenian clay called *bole,* which, mixed with water to form a thickish watercolor, was applied in possibly as many as six coats to the gesso. The ticklish job of applying the gold leaf was done with the underside of a broad, flat badger-hair brush. The brush was rapidly stroked against a man's hair or his woolen clothes to create the static electricity that would make the gold leaf adhere to the underside. When the moistened surface of the bole-covered gesso panel was held at an angle to let the water run off, the gold leaf could be released from the brush to the panel. When dry, the overlapping edges of gold leaf were brushed off and the remaining leaf burnished with a round piece of agate or crystal. We have seen that large panels painted with a large figure or scene had gold leaf laid only around the silhouette of that figure or scene. In those cases where the panel, the figures, or scenes were small, the entire panel had to be covered with gold leaf and the painting done directly on it.

Once the gold leaf was burnished, the panel was ready for painting, but in the meantime the apprentices had been busy with other work. The colors designated by the master had first to be ground and then prepared.

The most durable colors are the clays or earths—the yellows, reds, and browns that take their names from the localities in which they are found, such as raw and burnt siena, raw and burnt umber, Venetian red. In certain parts of Italy there is a green earth, *terra verde,* that was used for special purposes, as we shall see. But earth colors are matt, and so for more brilliant effects

mineral crystals were used to make the blues and vermilions. Both the earth colors and minerals had to be ground—that is, placed in a mortar with water and ground with a pestle until they were reduced to a mixture with the consistency of thick cream which when dry made a powder as smooth as talcum. No grit could be tolerated. These dry colors would then be made fluid by the addition of water before a medium (see below) was added. The difficulty and patience involved in producing these colors can hardly be understood today, especially in the case of ultramarine, a famous and expensive color that was made of ground lapis lazuli.

Colors were always reground before they were prepared for the master, and preparation meant that three tones had to be made of each color with an admixture of water. The No. 1 tone was the color full strength; the No. 2 was 50 percent of full strength plus 50 percent of white lead; No. 3 was 50 percent of No. 2 plus 50 percent of white lead. The full-strength color was used for the shadow parts of a painting, the 50-percent tone for the intermediate parts, and the No. 3 tone for the highlights. With pure color used full strength for the shadow parts of draperies, for example, these paintings of the thirteenth, fourteenth, and early fifteenth centuries had the same brilliant color effects of medieval enamels, stained glass, or illuminations. Not until later, with the advent of visual realism, were blacks and browns used for modeling, for the shadows. Then, as a result, the color effects became somber, except where bright local colors were applied to counteract a monochrome tendency of light and shade.

Because the ground colors had been made fluid with water, they would not adhere to an eggshell gesso or a gold-leaf surface so that a medium was needed to make them stick. In medieval times the medium was tempera, an egg medium, and not oil. There are various traditions about the use of this egg medium; some masters used the whole egg, others the white, and others just the yolk. In every case, however, the egg was about one third of the medium and water two thirds, so that tempera was really a glorified watercolor.

Once all this had been done by apprentices the master could undertake his painting. He probably had made his sketch or sketches on parchment or paper, which could be transferred to the prepared panels by tracing over the sketches after the back side of the paper or parchment had been covered with lampblack and laid against the panel. The tracings acted as guide lines when the artist started to paint, but since the traced lines had a tendency to smear the artist would incise the outlines with a sharp instrument. Although they were usually filled up in the course of the painting, these incised lines should be visible when a genuine panel painting is held at the proper angle.

The actual painting was done in the following manner. First, a flat silhouette was established within the outlines of each figure. Since tempera was glorified watercolor, the areas to be established had to be gone over and over. The first few coats of paint, probably with the No. 2 tone, would scarcely be visible over the white gesso or gold leaf. Not until the artist had laid in about thirty coats would a good color silhouette be established. Why wasn't tempera

made thicker and applied in few coats? Presumably, experience had proved that if it were, the painted surface would crack and curl off. Patience and application paid off in the long run. After the flat silhouette had been established, the shadings were hatched in with the No. 1 and No. 3 tones. For this work, very tiny and fine-haired brushes were used.

In most sections of Italy, the flesh parts of the figures were rendered according to the convention established in Roman times that the colors for flesh were green and red. Hence in early Italian panel painting we find that the underpainting for faces, arms, torsi, and legs was first modeled up in the three tones of *terra verde* and then hatched over in the three tones of red. This explains why today the flesh parts of primitive paintings look green; time and wear have rubbed down the red hatchings. The same is true of the backgrounds where the thin gold leaf has worn off entirely or in spots to reveal the red color of the bole under the gold.

Since the figures represented in the panels were for the most part holy personages, the artist had to provide them with haloes. These were incised and/or punched into the gold backgrounds around the heads. A punch is a nail-shaped instrument, the narrow end of which terminates in a cutting edge of specific shape—circle, dot, diamond, etc.—with which the halo design was made by striking the other end of the punch with a wooden mallet. Some haloes, for example those appearing on some of Simone Martini's figures [7.1], are built up in relief with gesso and then covered with gold leaf. The borders of the panels also were frequently decorated with a punched design.

Finally, since tempera dries matt, the painted areas of the panels either were varnished or were rubbed with beeswax and polished.

Meanwhile, carpenters had built the framework of the altarpiece into which the panels were to be fitted. As the fourteenth century advanced, this woodwork became more and more elaborate, resembling a cross section of a Gothic cathedral with three or five aisles. With the framework completed, the altarpiece was ready to be delivered, with or without ceremony, to its destination.

In the fifteenth century oil varnishes glazed over the tempera to give greater transparency to the colors were employed by Flemish painters. This practice appeared in Italy in the works of Domenico Veneziano and his followers, in the works of Antonello da Messina and of certain Venetian painters, as we have indicated previously. It was this use of oil varnishes plus the advantages provided by the use of impasto—as explained in the chapter on Titian— that prepared the way for modern oil paints. As brush strokes became more and more important to convey movement and emotion—as shown in the works of Tintoretto, El Greco, and many of the baroque painters—the fluidity provided by an oil medium had its definite advantages over the tempera medium.

A Painting in Fresco

Fresco painting was the decoration applied to the plastered surfaces of walls, domes, ceilings, or apses. Whether the areas to be covered were of stone, brick, or rubble they were first covered with a coat of rough plaster, a mixture of sand

and slaked lime. This surface would often receive the guiding sketches or drawings for the frescoes painted on a surface of finer plaster applied over the rougher plaster. These preparatory drawings were frequently done in red and consequently are called by the Italian name *sinopie.**

There were three methods of fresco painting: buon (good) fresco, fresco secco (dry), and fresco à secco (in the dry manner).

Buon fresco is so called because it is more durable than fresco secco. The paint, which was watercolor without the admixture of any medium, was applied to the plaster while the latter was still wet. The advantage of this method lay in the fact that the watercolor mingled with the wet plaster surface, was drawn into the plaster as it dried, and became a permanent part of this surface or skin. But when working by the buon fresco method, a master would apply only so much wet plaster to the undersurface as he could completely finish in fresco in one day. If the fresco was not completely finished by the time the plaster was almost dry, the plaster containing the unfinished work would be cut away and a fresh wet patch would be added the following day. In a raking light these irregular patches can be seen and counted to ascertain how many sessions were required to complete the work, should that be of any interest. Naturally, to avoid damage from dripping plaster to work already finished, the painter would begin at the top of the wall, work across and then down.

Two methods were used to apply the painter's designs to the surface to be frescoed. In the earlier one, the *sinopie* mentioned above would be sketched on the rougher plaster undersurface. Then as each patch of wet plaster covered these underdrawings the painter presumably sketched in on the new surface with the help of the guide lines what had been covered up. By the second, and later more usual method, a small-scale sketch of the whole project was prepared on paper from which cartoons—that is, preparatory drawings done to scale— were rendered. These cartoons were then transferred to the wet plaster surface by slapping them against the plaster and incising their designs into the plaster with the pointed end of one of his brushes. These incisions or depressions could then be made more prominent as guiding outlines to the painter by following them up with brush lines of umber.

The colors for frescoing would have been prepared in the same three tones as they were for panel paintings, but no medium was added. It was straight watercolor. The wet plaster being very absorbent, the work would progress easily and much more rapidly than with panel painting. Only a few coats were necessary to establish a color silhouette that would then be modeled with hatch strokes. *Terra verde* was also used for the underpainting of flesh parts.

In the fresco secco method, the painting was done directly on the fine plaster surface after it had dried. This presumably called for a similar pro-

* Excellent examples of *sinopie* can be seen on the walls of the Campo Santo in Pisa. These came to light beneath the frescoes of this cloister that were ruined or damaged during World War II and were subsequently salvaged or detached for preservation and restoration. The exhibition opened during the spring of 1960 showing the detached frescoes side by side with the *sinopie* was very instructive and showed how details in the preparatory drawings were often modified in the finished frescoes. (See the illustrated catalogue of this exhibition: *Camposanto Monumentale di Pisa—Mostra Nazionale degli affreschi e delle sinopie.* 1960.)

cedure for transferring the designs to the rigid surface as was used in panel painting.

At times the painter, whether he worked in buon fresco or in fresco secco wished to reinforce or give greater permanence to the color of certain draperies or flesh parts. In such cases he would use a tempera medium over these areas. This procedure is called *fresco à secco*. Many of Fra Angelico's heads and hands in the frescoes of the St. Nicholas chapel in the Vatican are done in this manner.

The buon fresco method, incorporating the painting as it does into the plaster surface, has also proved advantageous when in modern times it has been necessary to remove frescoes from damaged walls or for other reasons of safety. By facing the fresco to be removed with a strong adhesive and then covering it with a tough cheesecloth, trained experts can peel off the surface of the frescoed wall and then reset it on a new plaster. At times it has been of advantage to remount these detached frescoes on tightly stretched linen or on panels.

General Index

~~~~~~~~~~~~~~~~~~~~~~~~~~~~~~~~~~~~~~~~~~~~~~~~~~~~~~~~~~~~~~~~~~~~~~~~~~~~~~~~~~~~~

Abdiah, Melozzo da Forlì, 323–324
abnormalities, sketches of Leonardo, **19.8, 19.9,** 362–363
Abraham, by Filippino Lippi, 304
Acciaiuoli, Niccolò, by Andrea del Castagno, 233
Acquasparta, Cardinal, tomb of, 98
Aquinas, Thomas. *See* St. Thomas Aquinas
Adam, by Filippino Lippi, 304
Adam and Eve, Tintoretto, 506, 508; Vecchietta, **18.7,** 342
Adam receiving the Will, Michelangelo, **20.6,** 382, 383
Adoration of the Magi, Angelico, **12.1,** 241; Benvenuto di Giovanni, **18.10,** 345; Bonfigli, 306; Botticelli (2), **14.3, 14.4,** 276; Cavallini, 96; Domenico Veneziano, 269*n.;* Gentile da Fabriano, **10.2,** 191, 423; Ghirlandaio (2), **15.8,** 296, 297–298; Guido da Siena, 80*n.;* Leonardo, **19.3,** 304, 357, 358, 360, 371, 372; Filippino Lippi, 305; Filippo Lippi, **13.12,** 270; Mantegna, detail, **23.8,** 437–439, 451, 453; Tintoretto, 509; A. Vivarini-d'Alemagna, 423
Adoration of the Shepherds, Ghirlandaio, **15.6,** 293, 295; Francesco di Giorgio, **18.11,** 345–346; Giorgione, **25.9,** 478; van der Goes, 295
Aeneas Sylvius received by James I of Scotland, Pintoricchio, **16.9,** 315
Agostino di Duccio, 217
Alba Madonna, Raphael, **21.15,** 410
Alberti, Leon Battista, 197, 216, 217, 229
Albertinelli, Mariotto, 538
Albizzi family, 332; Giovanna degli, 280
Alemagna, Giovanni d'. *See* Giovanni d'Alemagna
Alexander IV, 88
Alexander VI, 312, 313, 374, 484
Alessandro dei Filipepi. *See* Botticelli
Allegory, Giovanni Bellini, **24.16,** 460–461
Allegory of the Cross, Botticelli, 285
Allegri, Antonio. *See* Correggio
altarpiece, 5, 7, 575; illus., 6
Altichiero, 431
Ambrogio da Predis, 357

*Amico di Sandro,* 298–299
Amos, Melozzo da Forlì, 323–324
ancona, 5; illus., **6**
Andrea del Castagno, 229–234, 235, 239, 291, 369, 431; Equestrian portrait of Niccolò da Tolentino, **11.16,** 209, 233–234; Pippo Spano, **11.14,** 233; *San Tarasio chapel frescoes,* 230; *Sant' Apollonia frescoes: Crucifixion,* **11.15,** 230, 231, 233, 287, Entombment, **11.13,** 229, 230, 232, 287, Last Supper, **11.12,** 230–231, 292 and Resurrection, 230, 231, 287; Villa Pandolfini frescoes, **11.14,** 233
Andrea da Firenze, Campo Santo (Pisa) frescoes, 171*n.; Spanish chapel frescoes:* Ascension, 173, Crucifixion, 173, Descent into Hell, 173, 175, 318*n.;* Dominican Allegory, **8.10,** 173–174, Glorification of St. Thomas Aquinas, 173, the Navicella, 173, 175, Pentecost, 173, St. Peter Martyr, life and activities, 173, Resurrection, **173**
Andrea del Sarto. *See* Sarto, Andrea del
Andromeda panels, Piero di Cosimo, **17.7,** 334, 541, 543
angel(s), Leonardo, **19.2** (painting), **19.6** (drawing), 356, 361; Filippo Lippi, **15.10,** 299; Melozzo da Forlì, **16.19, 16.20,** 323, 324
Angel appearing to Zaccharias, Ghirlandaio, 296
angel heads, Giotto, 136
Angelico, Fra (Guido da Vicchio), 182, 240, 241–254, 264, 270, 273, 286, 288, 316, 317, 339, 364, 374, 389, 402, 406, 425, 580; Adoration of the Magi, **12.1,** 241; Annalena Madonna, **12.10,** 250, 268; Annunciation (2), **12.1, 12.11,** 241, 252; Assumption of the Virgin, **12.1,** 241; (with Gozzoli) Christ coming as Judge, 316; Consecration of St. Lawrence as Deacon, **12.12,** 253; Coronation of the Virgin (2), **12.4, 12.6,** 245, 246, 262; Deposition, **12.7,** 246; Last Judgment, **12.3,** 243; Madonna of the Linaiuoli, **12.5,** 246, 252; Madonnas (4), 250,

# Index of Works of Art by Cities